FLAMMARION ICONOGRAPHIC GUIDES

BUDDHISM

WITHDRAWN

D1262484

St. Louis Community College
at Meramec
Library

FLAMMARION ICONOGRAPHIC GUIDES

BUDDHISM

Louis Frédéric

Flammarion
Paris - New York

Designed by Jean-Claude Auger
Design adapted for the English edition by Michael Phillips
English translation by Nissim Marshall
Edited by Jane Havell

Origination by Bussière Arts Graphiques, Paris
Printed and bound by Mame Imprimeurs, Tours

Flammarion
26, rue Racine
75006 Paris

Copyright © Flammarion 1995.
All rights reserved. No part of this publication
may be reproduced in any form or by any
means, electronic, photocopy, information
retrieval system, or otherwise without written
permission from Flammarion.

ISBN: 2-08013-558-9
Numéro d'édition: 1022
Dépôt légal: September 1995

Printed in France

Photograph credits
Colour plates XIX and XXIV: Shimizu

CONTENTS

FOREWORD

Now opens the store of mystic words
Where the hidden treasures emerge into the daylight,
Where all the virtues and powers materialize.
The Buddhas in the innumerable Buddhist kingdoms
Are nothing more than the Unique Buddha in the depth of our soul;
And the lotuses of gold, as many as the drops of water in the ocean,
Are our body.

Kōbō Daishi (774–835)

This work aims principally to describe most of the deities of Buddhism which have been the subject of representations in India, Sri Lanka, South-East Asia, Tibet, China, Korea and Japan, and to make their identification easier.[1] This task may appear difficult at first glance, due to their number and organization within a teeming and, for the western reader or art lover, somewhat bewildering pantheon. Nor would it be very useful to compile a list of these deities in alphabetical order, since their names are unfamiliar to most of us. We have therefore chosen to present them in groups according to their significance. The index at the end will help the reader to find any particular deity easily from among the wealth of representations.

Each deity is described here under its traditional names (with their transcriptions in the different Asian languages) and in its different religious, popular and local aspects. This is followed by a short history of the representations, and of their religious significance, the rites and practices attached to them, and the legends concerning them. For each great deity, an attempt has been made to describe its various aspects and the divine figures connected with it. The notes will enable curious readers to learn more and, if they wish, to refer to specific works. In these notes, whenever possible, we have indicated the location of the paintings, engravings and sculptures in the various museums and temples.

The first chapters are devoted to a brief history of Buddhism and the evolution of its artistic manifestations in all the countries concern. They also describe the 'attributes' specific to the different figures, such as posture (āsana), gesture (mudrā), throne, aureole, accessories, etc. which often allow precise identification. Each of the following chapters is devoted to a group of figures, the Buddha and the Buddhas, the Bodhisattvas, the 'kings of magic knowledge', the ordinary gods, etc.

It is important to remember that there is no single Buddhist orthodoxy: teachings vary from sect to sect and the doctrines of these sects also often vary with the years and with their disciples. A set of living beliefs, Buddhist doctrines are essentially in movement, adaptable to the needs of men and the temper of the times: nothing is ever fixed, except in the texts. But even these, as well as the maṇḍalas which materialize them visually, are merely media for thought, arrangements designed to help believers in their personal representation of the deity and of the place that it occupies for them in the universe. Hence it is not surprising that so many different representations have been conceived over the centuries.

Tibetan Buddhism is a form of Buddhism apart, and we have described only the main deities here. An iconography of Tibetan Buddhism demands a whole volume to itself, because the subject is extremely complex and extensive. Readers should refer to the bibliography for any subject in which they are specifically interested. The apparatus at the end of the volume, in addition to the bibliography, contains the correspondence tables of the names of deities in Sanskrit, Japanese and Chinese, with their ideographic characters.

The logical presentation of the deities of Buddhism raises many problems, not all of which have yet been resolved, but we considered it useful to exhibit the entire 'international' Buddhist pantheon in its full complexity, so that readers can find their way more easily within the structure and understand better the *raison d'être* of the deities that are venerated in a large part of the Asian world.

PREFACE

If, according to the Judaeo-Christian concept, God created humanity in his image, humanity, at all times and in all places, has tried to retrieve the image of this God. Sometimes one but seen in different ways, sometimes multiple in its manifestations and in its essence, the deities thus created by man (or the images that have been imposed on them, by intuition or by revelation) have been impersonal and abstract: idols, fetishes, supports or symbols that have been very rudimentary or, on the contrary, highly evolved. In most cases, the very idea of divinity has been the object of representations, concrete or symbolic. These representations are extremely numerous. The same deity has been represented in various ways in different countries and eras. These innumerable forms have been devised to illustrate mythologies and philosophical, metaphysical or even social concepts, and their representations, in turn, have given birth to other myths, other beliefs: through the ages and the countries, there has been a ceaseless interaction between the idea that men have derived of deity and the representations that they have developed of it. To understand the *raison d'être* of these deities, of their representations and of the evolution of these representations, requires penetrating deeper into the mythology of the peoples and, accordingly, developing a better understanding of human psychology. Ultimately, one cannot conceive of a deity (even if it exists) without being human.

The work that we present here is devoted to the deities of Buddhism. Buddhisms would be a better term, so different are the philosophies and the representations of these divinities in their various regions: India, South-East Asia, Tibet and Mongolia, China, Korea and Japan. Hence it is essentially aimed at describing the deities of the Buddhist pantheons, their *raison d'être* and their differences; at providing an idea of their origin, their relationships and their significance; at identifying the variations of the iconographic forms that they have assumed through the centuries and according to doctrines and countries; and at furnishing information on the representations of those that have given rise to artistic manifestations, in sculpture, engraving or painting.

Clearly there can be no question of presenting all the deities of Buddhism here, in their full complexity. Many of them have always remained theoretical, described only in the innumerable *sūtra* or canonical scriptures, and have never been the object of a representation or even of a cult. We have therefore deliberately set aside these theoretical figures and have described only those that have been (and still are today) the object of veneration, or those whose memory still remains in the minds of men. In this book we have distinguished between Mahayana (exoteric) and Tantra (Southern) Buddhism, which were current in South-East Asia and periodically in Sri Lanka until at least the twelfth century; non-Mahayana (esoteric, or Northern) Buddhism, which continued up to at least the eighteenth century in these areas and developed in China, Korea, Japan and Vietnam (it survived up to the 1970s in Cambodia, when it was destroyed by the Khmer Rouge); and Tibetan Buddhism, more specific to Tibet, Nepal and Mongolia.

We have laid special emphasis on Japanese Buddhism, which retains intact many iconographic forms that disappeared long ago from other countries. The 'esoteric' sects of this country have represented many deities that were never (or barely) the object of a cult or representation in the other regions of Asia. We have accordingly described its forms in detail within the general framework of Northern Buddhism.

To place correctly all the deities of the Buddhist pantheon in their historic or artistic context, we have preceded their description with short histories of the evolution of the Buddhist sects in the different countries where they have prospered. Before going on to the description of the deities themselves, we have devoted a few pages to the accessories of their representations – such as the positions of the body, gestures (mudrā), thrones and various attributes – to enable readers to find their way more easily through the dense thicket of symbols characterizing them.

Most of the line drawings have been taken from woodcuts in a Japanese work on the gods of Buddhism, the *Butsuzō-zu-i*, a work published in 1783 describing the Japanese gods of Buddhism. By a few simple lines, they depict the deities in the forms common to all the sects of Northern Buddhism, indicating their names in Sino-Japanese characters; they also offer a number of explanations in Japanese. Also indicated in these engravings are the seed-syllables (*bīja*), corresponding to these deities. For most of the ancient deities, these woodcuts were drawn from Chinese maṇḍalas. Hence they represent accurately most of the iconographic forms that we describe here.

We would like this study (for which the author recognizes his debt to the authors listed in the bibliography and in the notes) to enable readers to draw distinctions among all the deities of the Buddhist pantheon, and to understand better their *raison d'être*, their organization and the rites associated with them. Buddhism is one of the world's major religions. At one time or another, and to varying degrees, it has modelled the minds and the feelings of, and offered philosophies and metaphysics

to the whole of Asia. Hundreds of millions of men and women are indebted to it for the civilization in which they live. Although it has disappeared from a number of Asian countries and is retreating before the tide of modern ideas in others, for more than two thousand years it was the very spirit of the Asian peoples. Similarly, the artistic, architectural, sculptural and pictorial forms which it engendered still account today for the majority of the works of art of most Asian countries. In these many ways, Buddhism is an important cultural element in the world which needs to be better known and understood.

I take pleasure here in acknowledging my thanks to my many teachers and friends who expressed an interest in my project from the outset, and who, by their encouragement, suggestions and remarks have enabled this work to be more than a mere catalogue. My special thanks go to Professor Paul Lévy, my director at the Ecole Pratique des Hautes Etudes; Professor Bernard Frank of the Collège de France, who spared no pains in guiding my researches with competence and forbearance; and, above all, Professor André Bareau of the Collège de France, who read an early draft and offered many corrections and clarifications. My thanks also go to Otani Chōjun, a Japanese Buddhist divine and professor in Kyoto; and to the many friends who supported me throughout the preparation of the manuscript.

Louis Frédéric
Tōkyō/Paris, 1989

Notes on the transcriptions

In this book, we have used various transcriptions of the names and words of Asian origin. In general, the long vowels are indicated by a macron.

In **Sanskrit**, most of the consonants are pronounced as in English; a guide to the exceptions, to vowels, and their nearest English equivalents is given below.

a	as in *cup*	ā	as in *car*
e	as in *day*	ai	as in *high*
i	as in *sip*	ī	as in *seep*
o	as in *coat*	au	as in *out*
u	as in *soot*	ū	as in *suit*
c	as in *chap*	g	as in *got*

h after a consonant represents the aspirated form of that consonant. So:

ph	as in *top-hole*, not as in *photograph*
m	a pure nasal sound
ñ	as in *banyan*
ṛ	a vocalic 'r' sound
ś, ṣ	as in *ship*
t, d, n	pronounced with the tip of the tongue against the teeth
ṭ, ḍ, ṇ	pronounced with the tongue curled up against the roof of the mouth

In **Chinese**, we have used the modern Pinyin method, but without noting the tones.

c	similar to the first consonant in *tsetse*
q	as the first consonant in *church*
z	as the first consonant in *jaw*
u	usually as in *food,* unless it follows the consonants j, q or x, in which case it is pronounced like the German *ü*.

Japanese has been transcribed using the widely adopted Hepburn system. Note, however, that the sound r is pronounced midway between English *r* and *l*.

Mongolian raises a number of problems due to the differences in transcription recommended by various authors. We have preferred to use the German system, but with some variants.

In **Tibetan**, the groups of consonants are not always pronounced as written, and a few erudite authors sometimes transcribe the 'mute letters' in lower case, writing the real consonants in capitals (or vice versa). We have decided to transcribe all the letters, regardless of their pronunciation. But we must point out that the letters g, d, b and m, which are generally mute when located at the beginning of a phoneme, are pronounced when they follow a word that ends with a vowel: thus, for example, *Sku-bum* is pronounced 'Kum-bum', and *Bla-ma* is read as 'La-ma'. In general, only the letters preceding or following a vowel are pronounced. Note also that, when the vowels a, o and u are followed by mute letters d, n, l or s, they are pronounced like the German letters *ä, ö* and *ü*.

Other languages are transcribed according to the general pronunciation in use today.

Notes on the captions

In Japanese, the suffixes -ji, -tera (-dera) and -dō indicate Buddhist temples, and -jinja and -jingū denote Shintō sanctuaries; the suffix -si in Chinese indicates a Buddhist temple or monastery. For example, Kōryū-ji means the Kōryū temple.

Some brief definitions

Kami

Used as an adjective in ancient Japanese to refer to anything mysterious, wonderful or sacred, ranging from simple objects of folk cults to the deities of great clans. Kamis may be deities of nature, controlling certain natural phenomena; conceptual deities, embodying certain values, ideals or sentiments, or the protective deities of a clan. At first, the Buddha was thought of as the kami of China. As the influence of Buddhism spread, local kamis were made protectors of Buddhism and were worshipped near Buddhist temples; in time, they became identified with Buddhist deities. The idea that kamis were beings in transmigration led to the siting of Buddhist shrines near those to kamis; Buddhist texts were recited before altars to them.

Shintō

Not an established set of dogmas or theology, this is rather the traditional Japanese way of life and beliefs. Meaning 'the way of the kami', it was named in the sixth century, after the introduction of Buddhism to Japan in 538, to distinguish it from Butsudō, 'the way of the Buddha'. Shintō religious practices include prayer to kamis, festivals, ascetic practices and social service.

Triguhya (Japanese, *san-mi*)

Meaning 'the three mysteries of body, speech and mind', this term refers to the practice whereby believers realise that their bodies, speech and consciousness in meditation are identical with those of Mahāvairocana. This understanding leads them to the realization that *bodhi*, spiritual Awakening, exists within them.

Tripiṭaka

A Sanskrit word meaning 'three baskets', this term is used to refer to the three collections of texts which make up the canon of Mahāyāna Buddhism, whose language is Sanskrit. *Tipitaka* is the equivalent in Pali, the language of Theravāda Buddhism (whose terms are often similar); in this form it refers to the texts considered authoritative by the Theravāda tradition.

Vedas

The earliest religious texts of India known to us, handed down by a very precise technique of oral transmission. The earliest parts may date from the second millenium BC.

Periods

China	
Han	206 BC–AD 220
Wei	220–581
Sui	584–618
Tang	618–907
Song	960–1279

Japan	
Asuka	538–710
Nara	710–794
Heian	794–1185
Kamakura	1185–1333

India	
Maurya	320–185 BC
Sunga	185–72 BC
Kuṣāṇa	AD 78–200
Gupta	320–510
Pāla	765–1175
Sena	1095–1206

The famous Indian schools of art – Amarāvatī (from AD 150), the Indo-Greek Gandhāran and Mathurā – all flourished during the Kuṣāṇa period.

INTRODUCTION

The Buddha, probably the historical personage Śākyamuni Gautama, is thought to have been born in India in the sixth century BC. He was a wandering renunciate, one among many, seeking a method of salvation, an explanation for the human condition, and a remedy for the sufferings of humanity. According to legend, he was the son of a sovereign among the Śākya people in the Indo-Nepalese foothills, hence his name Śākyamuni, meaning 'sage of the Śākyas'. He was surrounded with every luxury by his father who was over-protective as the result of a prediction made by a seer at his son's birth that he would renounce household life. In spite, or perhaps because of, his father's precautions, the young prince became disillusioned with life after seeing a sick man, an old man, and a dead body, and realising that sickness, death and old age were inescapable for everyone. Then he observed the serene appearance of a wandering renunciate, and became hopeful that it was possible to find an escape from suffering. He stole away from his home and, for a period of six years, learned different religious methods from various spiritual teachers and practised severe asceticism. He always excelled at whatever practice he tried, and his teachers recognized that his ability was as good as, if not better than, their own. Yet still he did not find the answer to his quest: he did not accomplish release from Saṃsāra (the round of existence) and the inevitable suffering it entails. Asceticism, too, he found to be of no avail and he gave it up. After this, he sat down to reflect under a tree and that night awoke (hence his name: the Sanskrit *bōdhati* means 'he awakes') to the Truth. He realised that he had attained Nirvāṇa – that he was beyond the three fires of greed, hatred and delusion, and would not be reborn again.

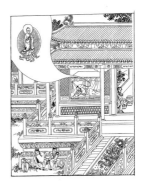

Buddha appears to the Emperor of China in a dream
Woodcut, from *Shijia Rulai Yinghua Siji*, Chinese, Ming era

In his first sermon, this Truth was formulated as the four truths of the noble ones: that there is inevitable suffering; that there are causes to this suffering, and an account of those causes; that there is a remedy to end suffering; and the path to follow to achieve freedom from suffering. The religious path taught by the Buddha, then, is the path taught in the fourth of these truths. This religious path is frequently formulated as moral conduct, meditation and wisdom. The moral conduct

taught is a set of universally applicable ethics. The fact that the ethics and the Buddhist spiritual path are universally applicable reflects two aspects in the Buddha's background. First, he seems to have lived at a time when the part of India in which he preached was undergoing a process of urbanization, which led to the need for a moral code which would be accepted by all as the basis for a new and larger society. Many metaphors and similes in the Buddhist scriptures use the language of trading and merchants, and this probably reflects the social background of the origins of Buddhism (in Christianity, similarly, there are metaphors to do with agriculture). In connection with this social change, it seems that the previously accepted spiritual hierarchy was challenged. Much of the Buddha's teaching seems to be expressed in contradistinction to the orthodox Brāhminical tradition, particularly the belief that one class in society, the Brāhmin, is purer and is the only group with spiritual knowledge and authority. The Buddha asserted that all humans were capable of spiritual attainment, which depended not on birth, but on moral conduct and understanding of the 'way things really are'. His teaching also involved a reinterpretation of the Brāhminical teaching of karma, 'action'. Brāhminical religious practices revolve mainly around action, specifically ritual action, and the Brāhmins were the expert group with the innate purity necessary to perform these rituals, which were considered efficaceous in maintaining the desired order of the cosmos. The Buddha rejected these rituals and interpreted karma in terms of the intention which is behind actions, thus laying the stress on internal and moral dimensions rather than on external rituals. As with the Brāhminical rituals, every karma has a consequence and it is because of previous wrong action that misfortunes befall a person. Other contemporary renunciates interpreted karma in the most extreme way possible, namely that every single action has consequences for us, and that the only way to be freed from the continous cycle of rebirth is to cease entirely from all action.

Another concept against which the Buddha seems to have been reacting is the concept of Ātman, the Self. Some contemporary Brāhminical philosophers conceived of an underlying unity to the cosmos which was also part of man, and projected on to it the qualities of permanent existence, consciousness and bliss – consciousness being the perceived common denominator among living things, and permanence and bliss being the factors necessary in combination for everlasting happiness. Salvation consisted of realizing this. In contrast, the Buddha defined all phenomena in existence as impermanent, without self (or, more agnostically, not-self) and suffering. The goal of the spiritual path was to realize this truth, and be freed from delusion, which would then lead one to be free from greed and hatred. Meditation was considered an aid to gaining this wisdom, and moral conduct a necessary prerequisite to obtain the peace of mind to practise meditation, or mental cultivation, and realize the truth.

With a well-organized religious community for the preservation, and

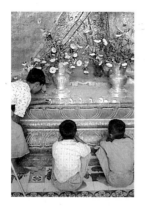

Burmese faithful worshipping an image of the Buddha

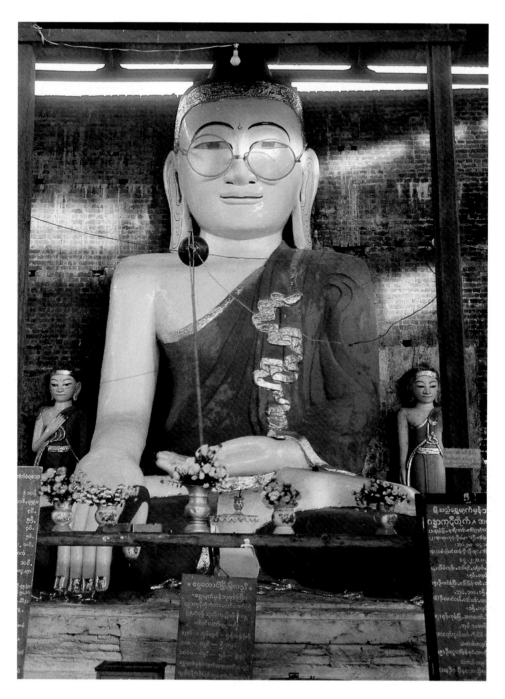

Great Buddha, Burma, near Mandalay, nineteenth century

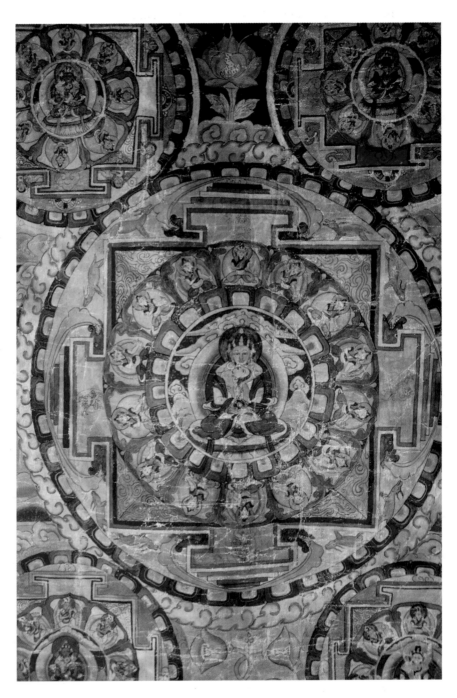

Maṇḍala of the Ādi Buddha, painting on cloth, Tibet, nineteenth century, Private Collection

ideally the practice, of the Buddha's teachings, and under the patronage of wealthy merchants and even royalty, Buddhism thrived and spread. On the impetus of a number of powerful kings, such as the famous Mauryan King Aśoka in the third century BC, it began to spread beyond the Indian subcontinent – to the Indo-Greek borderlands in the north-west, and to the island of Sri Lanka in the south-east. From the earliest years of our era (and, some say, even earlier), Buddhism crossed mountains and seas to spread along the trade routes into the countries of South-East Asia and Malaysia, and through the deserts of Central Asia into Persia and China. From China, it naturally advanced to Korea and then to Japan, which it reached in AD 538. From Bengal it spread to Nepal, and then to Tibet around the seventh century, extending throughout Mongolia. It is identified in China from the second century AD, although some traditions trace it back to the first century.

As it spread and as time passed, Buddhism developed and adapted to the new cultures and times. At the beginning of the first century AD or slightly before, the Buddhist doctrine postulated by the Buddha underwent a sort of crisis: from the simple philosophy of life originally intended, destined above all to help men to live in harmony while enabling them to achieve greater spiritual progress (and thus to reduce the number of their reincarnations and accordingly escape sooner from the vicious circle of births and rebirths which, according to common belief in India, conditioned their earthly existence), Buddhism was progressively transformed into a set of religious doctrines, turning the person of the Buddha into a deity on the same level as the Hindu gods. While the Buddha himself was chiefly concerned to put an end to the successive rebirths of living beings, and while he never preached the adoration of a particular deity (though, as a good Indian, he acknowledged the existence of many gods of the Brāhminical pantheon), his followers, many of whom were converts from Brāhminism, nevertheless desired a faith that was less austere and more charged with hope: in short, they felt dependent on a higher Entity and could not conceive of a life without belief in this Entity. Humanity cannot live by intellect alone, even that of a Buddha. The human imagination, the dreams that we cherish, our thirst for the Unknown – which, from our first earthly moments, haunt us and ceaselessly urge us to find ourselves – have always encouraged us to project, on to the infinite, the inconceivable and the unknowable, an ideal self that eludes our definition. The Buddha himself, in fact, never projected himself as a divine incarnation and even less as a deity, nor did he pose as an absolute master. He demanded from his followers merely a personal attainment, through meditation and reflection, of the truths that he stated: namely, that everything on earth is ephemeral, subject to change and, consequently, a source of pain; that desires engender a never-ending cycle of this impermanence and this suffering, and that it is therefore necessary to rid oneself of these desires to succeed in liberating oneself from the cycle of rebirths and ultimately to reach Nirvāṇa, the state of absolute beat-

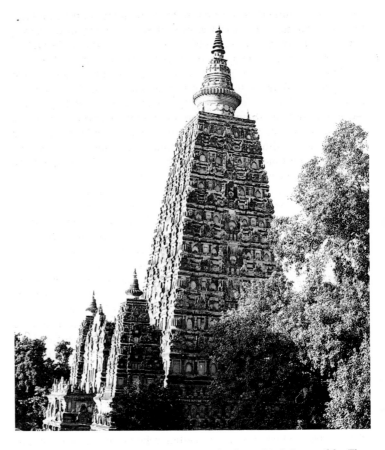

**The largest
Buddhist temple**
at Bodh-Gayā in India

itude and absence of desire in which no further rebirth is possible. The path that he proposed towards the achievement of these truths, called the 'Noble Eightfold Path', presumed a steadfast effort on the part of his followers, an effort that could only really bear fruit if they abandoned the world to enter the monastic community (*Samgha*), to follow with assiduity the Good Law (*Dharma*), which is obviously possible only for a minority. For the laity, it was more difficult to achieve salvation because of the distractions of worldly life.

Divergencies in doctrine soon emerged because, from the time of the Buddha or shortly after his death, specific religious conceptions were grafted on to his teachings. The Brāhminical deities (which, as we have seen, were not formally denied by the Buddha) were annexed by certain Buddhist monks, and later the very person of the Buddha was conceived as a divine entity that could assume different aspects; a whole pantheon, largely drawn from that of Hinduism, was organized around the Buddha, the Tathāgata, or the Jina, 'Conqueror'. Many theories were built around this theme. The words that the Buddha had spo-

ken, or which hitherto had provided the foundations of the canonical texts of Buddhism (*sūtra*, from the Sanskrit word meaning 'thread'), were enriched with innumerable texts of exegesis or explanation, often rather fantastic, in which the imagination played a significant part. These new religious theories, originally conceived by monks and for monks, were readily accepted by the Indian laity, who found themselves on familiar ground and saw in them nourishment for their hopes. However, a few monks rejected these new theories and insisted on the scriptures to the letter. Hence there were two great 'schools' of Buddhism, one more or less faithful to the philosophical and monastic doctrine preached in his time by the Buddha, representing all the antique sects, and the second covering a complex movement composed of various philosophies and whose first elements emerged shortly before the Christian era. The first was designated by its opponents with the term Hīnayāna, 'small conveyance' or 'small vehicle', a somewhat derogatory term coined by the adepts of the second, the Mahāyāna, the 'great conveyance' or 'great vehicle'. These two 'vehicles' were paths, narrow or wide, leading to the same Nirvāṇa. Naturally, there were a number of intermediate schools which claimed to reconcile both viewpoints.

The sects of the Mahāyāna spread in India, Nepal, Tibet, China, Korea and Japan, and later in Vietnam. Those belonging to the Hīnayāna, while they accompanied the others to Japan, were much less successful with the masses. Ultimately they disappeared altogether from their country of origin, and are now found only in Sri Lanka and a few South-East Asian countries (Burma, Thailand, Laos, Cambodia), where they continue to thrive. In China, the theories of the Mahāyāna were confronted with the Confucian and Taoist philosophies, and also, via Central Asia, with the Iranian and Christian religions (Nestorianism). In China, Buddhism was even confused in the early centuries with Taoism, from which it borrowed certain religious terms. Accordingly, it spawned many local sects. In Tibet, which it reached rather late, in the seventh century, it was coloured by practices belonging to the indigenous cults (*bön-po*) and a special sort of Buddhism developed, sharing the Indian Tantric doctrines, which spread beyond the Mongolian regions and soon impregnated the doctrines of a number of Chinese Mahāyānist sects.

Thus Mahāyāna Buddhism progressively deviated from the thought of Gautama Buddha, and split into many sects and sub-sects, while the pantheon of its gods and demi-gods gradually pullulated with new elements drawn from the different folklores – one of the reasons for its influence and its popularity. This Mahāyāna Buddhism, or Buddhism of the sects, is also generally called the 'Buddhism of the Northern schools', as opposed to the traditional Buddhist sects which make up the 'Buddhism of the ancient schools' (Theravāda) or 'Southern Buddhism'.

Northern Buddhism, which essentially belongs to the religious philosophies of the Mahāyāna sects, differs substantially from the forms

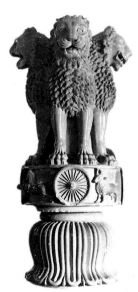

**Lions of Aśoka,
symbolizing the strength
of Buddha's Law**
Sarnāth, India,
third century BC

of Buddhism developed in India, both in its philosophical conceptions and in the representations that it assigns to the deities and the 'forces' venerated by its many sects and schools.

It is perhaps in Japan that these Mahāyāna deities were the most diversified and are the most commonly represented. To present the many deities of Northern Buddhism in a more coherent order, we have relied on two maṇḍalas (cosmological diagrams) specific to the esoteric or Tantric sects. The representations of the gods of Japanese Buddhism stem largely (especially from the early ninth century) from the tradition of esoteric Buddhism, that is to say Buddhism in its most elaborate form, in which the 'forces' of the deities are the most differentiated and represented. These are two great complementary maṇḍalas: the Vajradhātu, the 'world of the Diamond' (Japanese *Kongō-kai Mandara*); and the Garbhadhātu (or *Mahākarunāgarbha Maṇḍala*), the 'world of the Embryo' (Japanese *Taizō-kai Mandara*). The representations of the deities not belonging to these two major maṇḍalas participate either in the tradition of ancient Buddhism (mixed in Japan with certain esoteric elements predating the ninth century, sometimes called *Ko-mikkyō* or ancient esoterism), or with forms of esoteric Buddhism such as the Chinese Chan (Japanese *Zen*) or sects venerating Amitābha, or in the Buddhism of Tibet and Mongolia, or finally in popular Buddhism which, in China, Korea and, above all, in Japan, is very often syncretic, mixing in its beliefs forms belonging to Taoism, religious Confucianism, and even ancient indigenous cults (Shintō in the case of Japan).

20

I

EVOLUTION OF
BUDDHIST REPRESENTATIONS

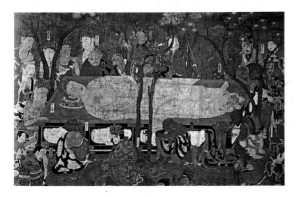

The Parinirvāna of the Buddha
Kongōbu-ji, Japan, dated 1086

India and Sri Lanka
South-East Asia
Tibet and Nepal
China and Korea
Japan

INDIA AND SRI LANKA

The very beginnings of Buddhist statuary in India are virtually unknown to us. At the very best, we have found a few small bas-reliefs representing a naked woman with dishevelled hair in ancient *stūpas*, associated with relics. And, even here, we cannot be certain that these effigies belong to Buddhism. Among the first specifically Buddhist works of art – besides the statues of animals (lions of Sarnāth, bull of Rāmpurwā, etc.) from the time of King Aśoka, which are reminiscent of the style of the Achemenides we can hardly list with relative certainty anything but the statues, often colossal, of Yakṣa (local genii) found in Parkham, Mathurā and Pāṭaliputra in the Ganges valley. The figures modelled in the round are still rather rustic, and a really 'Indian' style only began to appear in the first century AD, with the bas-reliefs ornamenting the gateways (*toraṇa*) of the Bharhūt *stūpa* and the paintings of the first caves at Ajantā (cave number 10). The Buddhist bas-reliefs and sculptures of the doors of the Sāñchī *stūpa* (first century BC) already reveal some progress in the organization of space, although the figure in the round is still not fully developed. By contrast, painting techniques seem already to have become remarkably advanced.

At the beginning of our era, three Buddhist art schools made their appearance nearly simultaneously: the schools of Gandhāra, Mathurā and Amarāvatī (in south-east India). The sites of the Amarāvatī school (Amarāvatī, Jagayapeta, Nāgārjunakoṇḍa, Goli, etc.) have given us many vestiges of *stūpas* ornamented with marble plates sculpted in bas-relief. It was thought by modern scholars that the earliest Buddhist schools did not represent the very person of the Buddha, but only symbolized him by a throne, a lotus, a footprint, etc. However, iconic representations of the Buddha are found from the same period, and it is now thought that these 'aniconic' representations of objects in fact depict contemporary worship of items associated with the Buddha. Brāhminical deities associated with Buddhist cults are generally represented in the same way as they are at Hindu sites. Among the rare sculptures in the round of this time are the 'tree deities' on the doors of the Bharhūt and Sāñchī *stūpas*. At Amarāvatī, work in the round was rare.

In north-east India, on the other hand, where satraps of Greek ori-

**Faithful venerating the
wheel of the Law**
Sāñchī, India, first century

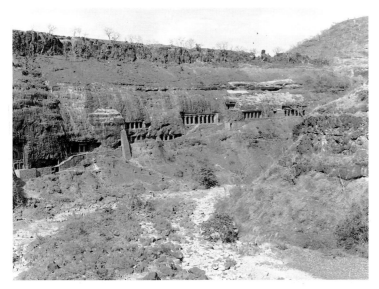

**General view of
Sāñchī caves**
India

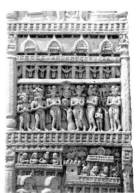

**Meeting of the
Buddhist faithful**
Gateway pillar, *stūpa* no. 1,
Sāñchī, India

gin flourished, the confluence of Greek plastic art and Indian art cul-
minated in a representation of the human person of the Buddha and
of the various deities or divine beings honoured by Buddhism. The pro-
file of the faces, first obviously Greek, was progressively Indianized, fol-
lowing the example of the statuary of Mathurā: the cranial protuber-
ance, first a simple chignon, became flatter and ornamented with curls.
The drapery of the monastic robe, first treated in spacious folds simi-
lar to the Greek *khiton*, became supple and clung to the body in reg-
ular folds. Divine beings appeared alongside the Buddha such as winged
angels and many accessory personages, in a Hellenistic treatment or
strongly influenced by later Greek art. These *desiderata* travelled with
the missionaries and lie at the source of the ancient Buddhist styles of
Sri Lanka and China.

The period of the Gupta Empire (fourth to sixth centuries) marked
a sort of blossoming of Indian arts in general, and Buddhist art attained
its classicism. The features of the person of the Buddha were clearly
defined and, drawing a lesson from earlier styles, were completely
Indianized. The art observed the precepts of the ancient technical meth-
ods (the *Silpaśāstra*) and conformed to Indian aesthetic traditions, seek-
ing stability and serenity in the apprehension of the subjects. In sculp-
ture and in painting, the Buddha and Bodhisattvas were rendered in an
elegant style, with an extreme purity of line. The statues of the Buddha
are often very large, the robe clinging to the body, of which the mus-
cles are barely suggested. From the fifth century, the drapery became
barely visible, revealing the very subtle modelling of the body. By con-
trast, the images of the archetypal Bodhisattvas and divine beings were
more decorated. Generally represented bare to the waist, wearing a long

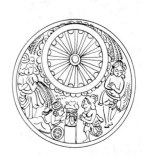

**Veneration of the
wheel of the Law**
Medallion from Sāñchī,
India, first century

skirt with large folds (like the *dhoti* of today), they are ornamented with jewels (necklaces, tiaras, bracelets, earrings) similar to the apparel of Indian princes of the time. Aureoles, formerly rare, became increasingly common and, especially in the images of the Buddha, densely ornamented.

With the sixth and seventh centuries, the positions were 'standardized', and the ornaments and jewels of the Bodhisattvas and various divine beings became heavier. The attitudes became less supple and more hieratic. Sculptures in the round and bas-reliefs became conventional, while painting developed unrestricted (especially at Ajantā) and supplemented the divine representations with secular scenes and extremely realistic floral and animal décors. The human figure (deities in human form or attractive women) became infinitely gracious (e.g. the Guptan frescoes of the caves at Bāgh in western India and the fifth-century frescoes at Sīgiriya, Sri Lanka).

From the ninth century, however, while Hindu art seemed to diversify, Buddhist art tended to stabilize: it really survived only in the local art schools, particularly those of the Pāla and Sena dynasties in Bengal (eighth to twelfth centuries). Through exchanges of monks, these local schools in turn influenced the artistic schools of Nepal and Tibet. On the other hand, the Buddhist arts developed until about the sixth century in Gandhāra, spread into Afghanistan in Central Asia, and in turn influenced Chinese styles from the fourth century.

There remain practically no works in wood, although some must have existed. Most of the existing sculptures in the round are made of stone, generally a relatively soft sandstone of the Ganges Valley (Chūnar quarry), as are the bas-reliefs. Marble predominates at Amarāvatī, marvellously treated in bas-reliefs: the same style is also found at the same time in Gandhāra, on the ivory plates found at Begrām. Also in Gandhāra, the first statues were made of schist, a difficult material to work, which was soon replaced by terracotta, and then by stucco, particularly for the sculptures decorating the *stūpas*. Bronze was used mainly for works transportable to south-east India and Nepal, and also Sri Lanka. In Sri Lanka, stone was reserved for the larger and stationary images, which ornamented monuments and buildings. In some later Buddhist monasteries of India, as at Nālandā, the styles of the Buddhist bas-reliefs and sculptures reveal a certain aesthetic degeneration, as well as foreign influences, especially Chinese, conveyed by the many pilgrims who visited this famous university to study.

Buddhism, degenerating in northern India, found refuge for some time in the south of the peninsula, but no longer produced major works in this region, except for Sri Lanka. From then on, and until the eruption of Islam in the early thirteenth century, Buddhist art was confined to Bengal where, in turn, it gradually disappeared.

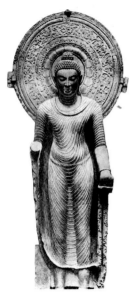

Great Buddha of Māthurā
India, fifth century,
Delhi Museum

SOUTH-EAST ASIA

Buddhist missionaries brought their doctrines and aesthetic canons very early to the countries of South-East Asia, with varying success. From the first centuries of our era, wooden statues of the standing Buddha appeared in Cochin China (Go-oc-éo) and in Funan (southern Cambodia). Missionaries also having penetrated into the lower valley of the Irrawaddy and into the Menam Chao Phraya valley, Buddhist states such as Dvāravatī were created, which raised large monuments, both *stūpa* and monasteries, decorated with sculptures revealing an Indian treatment and more or less obeying the canons of the Gupta and post-Gupta schools. However, the effigies representing the Buddha

Head of Buddha
Wood, Go-oc-éo, Vietnam,
first/second centuries

Effigy of Lokeśvara
Banteay-kdei, Angkor,
Cambodia,
late twelfth century

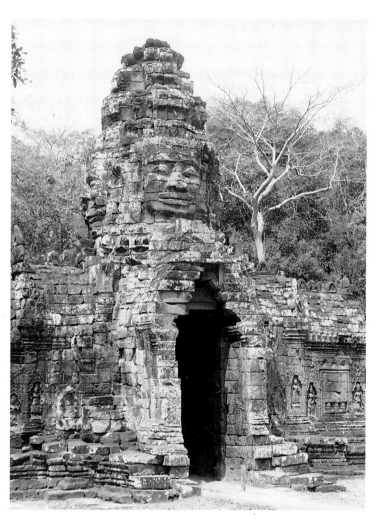

assumed a local character, and the faces of the deities were influenced by local ethnic types and the aesthetic canons of these regions. The attitudes are still stiff. Stone is the main material used, or sometimes sculpted brick. On the east coast of Indo-China, Buddhism developed together with Hinduism, but only in the ninth century, at Champā, did great Buddhist works appear, with the monastery of Dŏng-du'o'ng. These works, sculptures and bas-reliefs, no longer belong to the sects of the Small Vehicle as in lower Burma and in the Kingdom of Dvāravatī, but to the Mahāyāna. The personages represented are not only the historical Buddha, but other deities belonging to the pantheons of the Mahāyāna. Their silhouettes are stout, and their ethnic character is pronounced – thick lips, moustaches, joined eyebrows – perhaps under the influence of the Buddhist art of Java. Around the same time, Champā produced a few images of bronze, chiefly representing Avalokiteśvara.

In Indonesia, which Buddhism appeared to reach rather early (bronze statues in Indian style are found on the west coast of Borneo, dating from the fifth century), Mahāyāna Buddhism spread rapidly in the eighth century, mainly in Java, with the monumental ensemble of Borobudur. The art of bas-relief reached its apogee here, to represent, alongside the images of the Jinas (influenced by the Gupta styles), innumerable deities on narrative bas-reliefs. The large statues are rare but of excellent proportions – for example, the seated Buddha of Borobudur, or the statues of Chandi Mendut, both sites in Java. They are of stone. Bronze only appears to have been used for very small statuettes. After the ninth century, Buddhist art appeared to decline, to be supplanted by Hindu art.

Great Buddha of Kyaik Pun
Pegu, Burma, 1476

Buddha of Arakan
Mandalay, Burma, restored in the eighteenth century

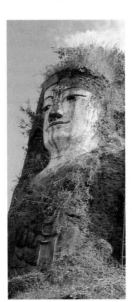

In Cambodia, after a certain decline, Buddhist art was revived with the accession of Buddhist kings. The most famous, Jayavarman VII (1180 to c. 1218), covered the country with Buddhist monuments and images. This was the triumph of the representations of Lokeśvara and of minor deities of the Mahāyāna, as well as the Apsarās, whose dances decorate most of the monuments.

In Burma, after a brief appearance of the Mahāyāna doctrines which came from Bengal, the sects of the Small Vehicle gained ascendancy, especially in Pagan, where contributions from Sri Lanka somewhat modified the ancient style created in the lower Irrawaddy Valley: sculpted brick predominates, and stone is relatively rare. The statues are made of brick, terracotta or wood. Many of them are influenced by the Indian styles from Bengal. This style continued subsequently, but deteriorated. Gigantism became the rule to represent the Buddha, seated or recumbent. The brick bodies are often coated and painted, often in bright colours.

In Thailand, the Buddhism of the Dvāravatī schools was perpetuated in the north and gradually transformed, partly under the influence of the Khmers, who occupied the Chao Phraya Valley for some time, and partly by a sort of 'Siamization' of the attitudes, which obeyed to the letter certain texts belonging to the Hīnayāna doctrines. The heads of the Buddhas lengthened, the nose curved into a 'parrot's beak', the attitudes became more supple, almost fluid. Many schools were created, and the art of bronze flourished. This art subsequently became more hieratic and lost most of its characteristics: the poses became stiff, the fingers all of equal length, and the silhouettes burdened with ornaments. Laotian art followed the Siamese tendency, but with local differences. Here also, bronze was the most popular material, together with wood. The 'walking Buddha' type appeared in these styles, together with friezes on *stūpa* bases in the form of elephant protomas (as in Sri Lanka and Siam), or processions of disciples. Many statues of the seated or standing Buddha ornament the sides and levels of the *stūpas*.

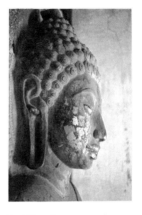

**Buddha of
Nakhon Pathom**
Thailand, sixth century

TIBET AND NEPAL

Buddhist art only penetrated into Tibet with the introduction of Buddhist doctrines in the country in the seventh century. These arrived from various regions of India, but chiefly from Bengal, where a specific type of Mahāyāna Buddhism developed, strongly influenced by syncretic and Tantric doctrines. Tibetan art (and hence Nepalese art) thus obeyed Indian canons, and tried to reproduce faithfully the images of the deities as they were described in Sanskrit texts, which nearly all belonged to the Mahāyāna. The image-makers, mostly monks, added to the Indian Mahāyāna pantheon many 'incidental' or evolved deities from the pantheon of the ancient popular Tibetan religion, the *bön-po*. Tibetan art

Akṣobhya
Painted clay, Bhūtan,
twentieth century,
Author's Collection

was chiefly focused on the production of paintings (*thangka*) intended to help the monks meditate. These paintings are usually done on canvas or cloth and are easily transportable. Sculpture included small metal statuettes, the style of which was first inspired by models from Bengal. Many schools subsequently emerged, created by the great monasteries. From the sixteenth century, paintings and sculptures often revealed a strong Chinese influence. The largest statues ornamenting the lamaseries are generally of moulded and dried earth, while the medium-sized décors are usually made of sculpted and gilded wood (sometimes on a red lacquer background). Stone is rarely used. Most of the works are polychrome, others gilded. Metal sculptures, first made by the lost wax process, were subsequently cast in one or more parts, and then welded together, or worked by repoussé and welded in the same way.

CHINA AND KOREA

The earliest sculpted images of Buddhist deities that appeared in China were copied from imported models which probably originated in Gandhāra and were conveyed via the oases of Central Asia, in the first centuries of our era. This means that the oldest images of the Buddha produced in China (probably around the middle of the fourth century) are strongly influenced by the Indo-Greek style. The sculptures representing the deities of the Mahāyāna pantheon were excavated according to Indian models; they are rarely executed in the round, but rather in high relief, to be viewed from the front, and they decorated the walls of chapels and caves. From the very first period, the styles appear to be different in the various regions. However, the major style, that of the Wei period, shows images of divine personages with a wide forehead, a sharp bridged nose, and a small smiling mouth. The folds of the garment fall in broad superposed waves, covering the base of the statue, and leaving only one or two feet visible (as at Longmen). The attitudes are stiff and hieratic, full of majesty, and the faces and bodies are lean and slender. The aureoles are wide and in the form of pointed leaves. Although clay was the preferred working material of the Chinese sculptors until the sixth century, small bronzes in the same style were cast in large numbers. These bronzes were exported, particularly to Korea, where they were copied.

During the subsequent centuries, Buddhist images underwent a radical transformation: new models were brought from India, displaying the features of the Gupta styles. Hence the onset of the Tang period witnessed the transformation of the images of the Buddhas, which were increasingly denuded and tended to assume fuller forms. The garments of the Bodhisattvas began to be overloaded with ornaments (jewels, tiaras, bracelets, pendants, etc.). The bodies assumed a more supple attitude, in Tribhaṅga ('triple flexion'), dear to the Indian plastic arts, espe-

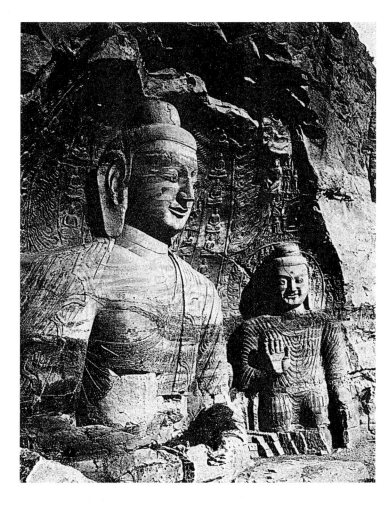

**Great Buddha of the
Yungang caves**
China, sixth century

cially in the images of the standing deities. As in the art of the Gupta,
the aureoles became round, and were decorated with floral motifs.
However, the general lines still remained stiff, and the appearance of
the Buddhas hieratic. The faces were gradually humanized and became
more realistic (as in the sculptures of Tianlongshan). The necks of the
images of the Buddhas were decorated, as in India, with the 'three folds
of beauty', and the lotus decorations appeared to be increasingly numer-
ous. The garments, barely outlined, no longer covered the throne of the
deities. The Chinese and Indian traditions attempted to interpenetrate,
but the Indian styles were favoured. Local schools were formed, some
in which only Chinese artists worked, and others which appear to have
been attended by Indian artists.

In the late seventh century, the styles evolved significantly, and
opted more strikingly for the Chinese canons of art: the faces became

more realistic, the bending of the body more pronounced. The folds in the garments showed an orderly arrangement. The faces were now full, with heavy eyelids. The headdress became complicated, and the jewels numerous and detailed. The decorative art of the caves continued to predominate, and small statuary was more infrequent, of wood or of stone.

It was in the Tang period that Buddhist sculpture began to appear in pottery, an art that attained its full maturity in the next period, the Song. Yet it appears that, from the late ninth century, the art of sculpture fell somewhat into decline in favour of painting. The walls of the caves (Dunhuang) and the walls of the monasteries of Central Asia were covered with admirable frescoes, while painting on rolls spread considerably within China itself. The court painters all dealt with Buddhist subjects, although their preference was for more austere matter, such as the representation of the Luohan or of the minor deities. These painters followed the general trends of the arts of their time. Subsequently, Chinese Buddhist art fell into decadence: the same images were ceaselessly reproduced, with the early works being copied with varying degrees of success. After the persecutions of 845, Buddhism declined in China and, from then on, the images produced by the artist monks were mediocre.

In Korea, where the first Buddhist images arrived from China, the styles adhered rather closely to Chinese models, although as a provincial school. Yet the Koreans did not always show a preference for the same subjects as the Chinese, and the image-makers appeared to be more comfortable in the representation of the Buddhist deities belonging to the esoteric schools, representations which broadly influenced Japanese images.

JAPAN

Japanese Buddhist art can be broken down into periods corresponding approximately to the historic periods. This art displays a continuous evolution up to our own time.

In the Nara period (710–794), sculptures, which had hitherto been imported from Korea and China, or produced in Japan in the particular style that characterized the works of the previous period (Asuka, 538–710), assumed a more specifically Japanese character from the outset. At the time, the arts of Tang dynasty China were, to some extent, influenced by the works of Buddhist statuary from India, travelling pilgrims such as Xuanzang having conveyed from that country sacred scriptures and images of the Buddhist monasteries which flourished in Kashmir and at Nālandā. Japanese artists (mostly monks) visited China and brought back images in turn, following the same line of inspiration, and their works naturally bear the stamp of the Gupta influence. A certain realism, already discernible in the statues of the Asuka period

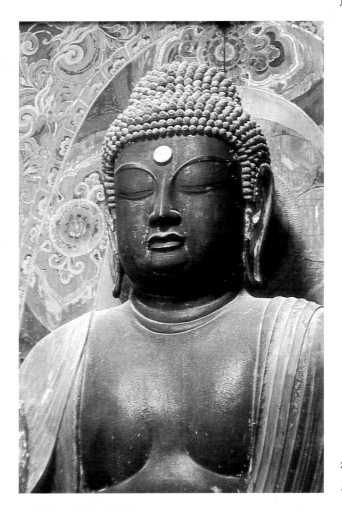

Statue of Shaka Nyorai
Bronze, Japan,
eighth century

(mostly of Korean origin), appears to be accentuated, and the typical archaistic smile of the period disappears from nearly all the faces. The treatment of the folds in the garment tends to be simplified, the paintings (Kondō frescoes from Hōryū-ji) revealing a treatment that bears some analogy with that of the paintings of the Ajantā caves in India.

At the end of the Nara period, Japanese Buddhist art appeared to detach itself largely from the influence of the art of the Tang period. Bronze was used less and less, in favour of more flexible materials such as wood, dry lacquer and clay. Although the bodies became stiffer, the images acquired greater power. The faces were more realistic and expressive, their aureoles assuming the characteristics of the goldsmith's art. Large bronze statues were still produced (Daibutsu of Tōdai-ji, 749), but they were rare; it was more popular to carve from solid wood. As for reli-

gious painting, entrusted to the painters of the official bureaux (which included Chinese artists in their ranks), it was limited to the illustration of *sūtras* and the production of images drawn in ink and brightly coloured, in imitation of works from China or Central Asia.

The following period, the Heian (794–1185), witnessed the apogee of Buddhist art in Japan, with the appearance of the esoteric doctrines and their deities, Buddhas and Bodhisattvas. This period marked the transition between the art of the Tang influence of the Nara period, and the art of the specifically Japanese style which was gradually imposed from the time of the Fujiwara regents in the tenth century. From China, monks brought many images, painted and sculpted, of the deities of the esoteric pantheon. The texts, now more abundantly imported, inspired artists who attempted to produce innumerable images of deities, conforming both to the texts and also to their own genius. The age was no longer one of slavish imitation of Korean or Chinese models, but of a genuine re-creation.

Wood was henceforth used almost exclusively, sometimes left bare (this was true of aromatic woods), but usually lacquered and gilded. Three styles shared the favour of the artists: those that were directly derived from the previous period, those that were influenced by the Chinese styles of the end of the Tang period, and the provincial styles. Towards the end of the period, solid wood sculptures were progressively supplanted by composite works, in assembled pieces, which served to produce series. The paintings consisted mainly of mandalas and banners, and then, from the twelfth century on, painting was almost always devoted to the characteristic representations of the Amida cults.

The Kamakura period (1185–1333) saw the triumph of realistic sculpture made of coloured wood, with incrustations of glass eyes. Genuine portraits of monks were fashioned, and the anatomy was more naturalistic. The pictures became genuine paintings, and many rolls were painted on Buddhist subjects, sometimes clearly intended to be incisive caricatures.

After this period, the art of sculpture declined and disappeared almost completely in favour of painted images. The popular iconography tended to replace the traditional Buddhist iconography which, from the fourteenth century, witnessed virtually no renewal. This popular iconography, extremely rich, accounted for most of the Japanese Buddhist representations until the modern era.

II

ICONOGRAPHY

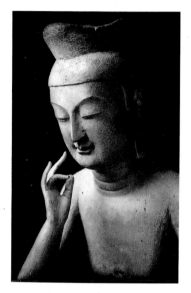

Miroku Bosatsu
Pinewood, Kōryū-ji, Kyōto, Japan,
late seventh century

Diagrams (Maṇḍalas)
Symbolic Gestures (Mudrās)
Postures of the Deities
Thrones
Aureoles
Implements and Accessories of the Deities

DIAGRAMS (MAṆḌALAS)
(Japanese, *mandara*; Tibetan, *dkyil-'kor*)

An ancient Brāhminical tradition resumed by Tantrism, the making of diagrams representing a deity and his forces, or groups of divinities, remains the best way to represent the invisible universe of the forces that govern the cosmos. These 'organized' representations of the divine universe are still widely used in India on many occasions, ritual and other – to invoke the deity, to expel evil spirits, to reconcile wandering souls, or to ask a favour of the celestial powers. They are still attested today by the ritual designs drawn on the ground before their houses by the women in the Indian countryside (Alpona in Bengal, Aripana in Mithilā, Osa in Orissā, Chowk in Uttar Pradesh, Mehndi Mandana in Rājasthān, Rangoli in Mahārāshtra, Kolam in Tamilnadu, Sathia in Gujarāt, etc.). These ritual diagrams are in fact a sort of writing to communicate with the deities, and perhaps derive their origin from magic signs. The *Agni Purāna*, one of the earliest Sanskrit texts, describes one of these diagrams, the *Sarvato-bhadra* (considered as one of the most powerful) as consisting of forty-two crosses attached together. These collective representations of symbols or deities are reputed to have great magical powers. Hence it is not surprising that Buddhism adopted this idea and also developed maṇḍalas to serve its need for the organization of the material world as well as the subtle world. In a maṇḍala, the deities (or their symbols), assembled in a certain order, represent the 'whole universe in its essential lines, in the dualism of its process, of a divine emanation, and of its resorption into the human, in its dialectic of disintegration and reintegration, a cosmogram which is the paradigm of cosmic evolution and involution.[1]

A maṇḍala is always organized around a deity, a point (*bindu*) or a major symbol. In Tibet, it is sometimes centred on a historical personage, such as Padmasambhava or the translator Marpa. It is formed of circular or square concentric enclosures, provided with four 'doors' directed along the cardinal points (in Tibet, the south is represented at the left, the north at the right, the east and the zenith at the bottom, and the west and the nadir at the top). Each circle or enclosure is occupied by deities or symbols. If the central deity is a 'wrathful' divinity,

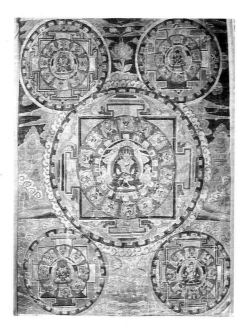

Great maṇḍala of Ādi Buddha
Tibet, nineteenth century,
Author's Collection

an outer circle encloses the images of the places of cremation or 'eight charnel grounds'. In general, the central deity is surrounded by three circles of lotus petals, vajra (thunderbolt–sceptre) and flames. But this is merely a convention, and maṇḍalas may have several enclosures. In fact, any figure formed by a central deity surrounded by other deities (aspects, emanations, acolytes, symbols and accessory personages) constitutes a maṇḍala.

In the Buddhist world, four categories of maṇḍalas are normally distinguished. They are graphic representations in which all the powers and forces of the phenomenal world and the world of the spirit are grouped together, iconographically and symbolically, and whose organized meeting forms the person, the entity of the Buddha, identified with the universe. These maṇḍalas, described in detail in many *sūtras*, and different from each other according to the text concerned, are generally painted on silk, cotton or paper, and sometimes wood, or engraved on metal and wood. In Japan, some were made in bronze bas-reliefs. In many Buddhist temples in Tibet, as well as China and Japan (for example, at Tōdai-ji in Kyōto or at the Sangatsudō of the Tōdai-ji in Nara), the statues of the deities, by their very grouping, form maṇḍalas.

The largest Buddhist maṇḍala is undeniably formed by the concentric terraces of the *stūpas* of Borobudur, in Java, dating from the eighth century. This gigantic monument, capping the summit of a hill, is in fact composed of several square terraces surmounted by a triple circular terrace crowned by a central *stūpa*. It is an initiatory monument,

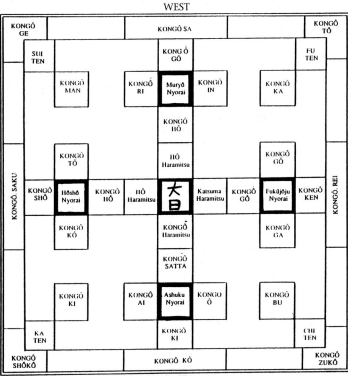

Maṇḍala of the Gochi Nyorai
Kongō-kai, Japan

a sort of cosmic labyrinth. The very structure of the complex tends to become a representation of the cosmos. It comprises three levels: the world of Desires (Kāmadhātu), hidden by a large additional terrace; the world of Form (Rūpadhātu), consisting of four square terraces decorated with 1,800 bas-reliefs representing scenes from the stories of the former lives of the Buddha Gautama (second and third galleries) and the Buddhas to come; and, finally, the world without form (Arūpadhātu) or the world of Pure Perception, which is represented by another four circular terraces, the first undecorated, and the remaining three ornamented with Buddhas half-concealed in open-work *stūpas*. The believer who ascends this prodigious monument passes through the successive circles of a maṇḍala starting from the Earth and its desires, follows the teaching of the Buddha by going through the square galleries (earthly aspect), and finally reaches the circles in which nothing remains to distract him from his ambulant meditation. Facing the great central *stūpa*, he can then meditate on the formless All, the very person of the supreme Buddha never reached, who can be neither perceived nor conceived, and who has neither beginning nor end. In fact, any temple or

stūpa is a maṇḍala in itself, and the terraces surrounding the *stūpas*, in India and elsewhere, are concentric enclosures surrounding the central deity. Maṇḍalas may be based on the plan of temples in India.

The four main categories are found in the two great maṇḍalas that we have selected to guide our discussion. All four are also found in one of them, the Vajradhātu Maṇḍala (Japanese *Kongō-kai*): the maṇḍala of the Elements (*Mahābhūta Maṇḍala*, Japanese *Dai Mandara*); the maṇḍala of the Attributes (*Samaya Maṇḍala*, Japanese *Sanmaya Mandara*); the maṇḍala of the Syllable Symbols (*Dharma Maṇḍala* or *Bīja Maṇḍala*, Japanese *Hō Mandara*); and the maṇḍala of the Actions (*Karma Maṇḍala*, Japanese *Katsuma Mandara*).[2]

Maṇḍala of the Gochi Nyorai
Taizō-kai, Japan

According to the *Guhya Tantra*, the number of maṇḍalas that can fall into these categories amounts to 3,500. Yet this number is in no way limiting because, theoretically, maṇḍalas can be an infinity. Although their origin is Indian, they were used in Tibet and China by Tantric and esoteric sects. Their appearance in Japan coincided with the creation (on the Chinese model of Shenyan) of the Shingon sect, in the early ninth century. They accordingly assumed extreme importance in Japan (much more than in China) because they provided models for the artist monks to produce the innumerable statues and paintings of deities demanded of them by the sects and temples. In fact, most of the Buddhist deities venerated in Japan in connection with esoteric doctrines were chiefly drawn from the two great maṇḍalas adopted by the Shingon sect – and also by others, such as the Tendai (Chinese *Tiantai*); those of the double maṇḍala of the Two Worlds (Japanese *Ryōkai Mandara*); the Garbhadhātu Maṇḍala (Japanese *Taizō-kai*), sometimes called the 'maṇḍala of the Emanations of the Three Stages' (Japanese *Sanju Mandara*); and the Vajradhātu Maṇḍala.

Both the Garbhadhātu and the Vajradhātu maṇḍalas are external projections of the reality that practitioners must realize internally through the Triguhya, the 'three mysteries', by which they identify themselves with Mahāvairocana who is at the centre of the cosmos, and thus realize Awakening. Realization of the two maṇḍalas is integration of the known and the knower, the knowledge of Mahāvairocana as immanent in every being and as the creator of the universe. Transmitted from India to China in the eighth century, one legend tells of the Indian tantric adept Śubhākarasiṃha painting them after witnessing their miraculous manifestation in the skies above a monastery in Gandhāra; he arrived at the Tang court in China in 716. Another story tells that Vajrabodhi brought the Vajradhātu Maṇḍala to China with him in 720. The present forms are based on the rendition by the Chinese tantric master (746–805) who is said to have passed on their tradition to the monk Kūkai (774–835), founder of the Japanese Shingon sect.

The Garbhadhātu Maṇḍala (Mahākaruṇāgarbha Maṇḍala), drawn from the *Mahāvairocana sūtra*, is symmetrically arranged: around the Great Illuminator the Buddha Mahāvairocana are distributed, in order of their importance and according to their directional location,

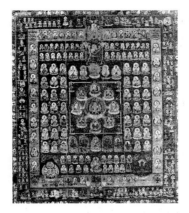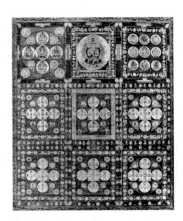

The two maṇḍalas of Taizō-kai and Kongō-kai
Painting on silk,
Tō-ji, Kyōto, Japan,
ninth century

all the groups of the deities of esoteric Buddhism. These groups are divided into 'classes' according to their functions. There are 414 deities shown, with a graphic representation of the cosmos as a transformation of Mahāvairocana; three courts represent the three aspects.

- Representing *bodhi*, Awakening, with an eight-petalled lotus showing Mahāvairocana enthroned, surrounded by four Buddhas and four Bodhis.
- Representing *saṃbhogakāya*, compassion, showing the embodiments of compassion such as Kṣitigarbha, Avalokiteśvara and Mañjuśrī.
- Representing *nirmāṇajāya*, skill in means: the outer court, Vidyārāja and the Hindu gods in the six *gati*.

The Vajradhātu Maṇḍala, drawn from the *Sarva-tathāgata-tattva-saṃgraha,* is composed of nine different maṇḍalas (belonging to the four categories mentioned above), positioned in a clockwise spiral starting from the centre; each is devoted to a certain category of deities, symbols or seed-syllables (*bīja*). More abstract and symbolic than the Garbhadhātu Maṇḍala, it symbolizes the spiritual forces and shows 1,461 deities. One of the nine maṇḍalas is for Mahāvairocana, and the others for the eight levels of consciousness. All derive from the central one, which represents the five-fold wisdom that is the basis for enlightenment. In the centre, Mahāvairocana is in his Akaniṣṭha Palace, on a lunar disc, surrounded by four Buddhas. Elsewhere he is surrounded by the Buddhas of the past, present and future. On the outer perimeter, 20 Hindu divinities act as protectors of the Law.

Apart from these two major maṇḍalas, the various maṇḍalas that have inspired painters and sculptors, in China, Tibet and Japan, by defining for them the forms and attitudes of the Buddhist deities, are relatively numerous. All these maṇḍalas had considerable importance at one time, not only as a material support for the meditations of the monks, but also for teaching. They visually define each deity by assign-

ing to it a precise place in the cosmic order in relation to the central deity and in relation to man, by including the latter in 'qualitative' classes according to the laws of Buddhist logic. A maṇḍala represents the supreme deity in its unity or diversity; the world created in its cosmic organization; the whole of humanity in relation to this organization; and, finally, man himself in his entirety, material and spiritual. It therefore represents a particular visualization of the whole universe.

Hand of Miroku Bosatsu
Wood and dry lacquer,
Hōryū-ji, Nara, Japan,
eighth century

SYMBOLIC GESTURES (MUDRĀS)

(Japanese, *in-zō*; Chinese, *yin*)

Many hand positions were used in Buddhist sculpture and painting, in India, Tibet, China, Korea and Japan, to indicate to the faithful in a simple way the nature and the function of the deities represented. These mudrās are gestures which symbolize forces or divine manifestations. Used by the monks in their spiritual exercises of meditation and concentration, they are considered to create 'forces' and to 'invoke' the deity. They are used routinely by the monks in their ritual practices of worship, incantation and concentration.

However, the schools of Southern Buddhism no longer use them in their practices (except perhaps for the mudrā of veneration, Añjali, for prayer), and have retained only a few of them for their representations of the Buddha, chiefly those of assuaging fear (Abhaya mudrā), made with one or two hands; that of welcome or offering (Varada mudrā); that of preaching the Doctrine (Dharmacakra mudrā) or of argument (Vitarka mudrā); and, finally, that of taking the earth as witness by the Buddha (Bhūmisparśa mudrā). Representations of the Buddha in India, Sri Lanka and South-East Asia which exhibit mudrās other than these are extremely rare. The Añjali (veneration) is the rule for the representations of praying figures.

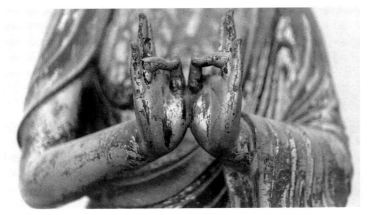

Hand of Amida in salutation (Jō-in)
Wood and dry lacquer,
Japan, tenth century

In Northern Buddhism, on the other hand, mudrās were widely used. Most of them correspond to those which were practised by Indian Buddhists of the Mahāyāna and which were supplemented at a relatively late date by the monks of the sects of Tibetan Buddhism, and of Chinese and Japanese sects. In Japan, they were not used systematically before the return from China of Kūkai (Kōbō Daishi).[3] Very few are found in Japan before the early ninth century, except perhaps on copies of Chinese or Korean works. Noteworthy is one of these mudrās in a group of five figures ornamenting a repoussé copper plate showing the Buddha Gautama in Dharmacakra surrounded by Bodhisattvas and two disciples (*śrāvakas*), dating from the eighth century (in the Hōryū-ji). This is perhaps the earliest example of a representation of a mudrā in Japan.

The traditional classification recognizes two categories of mudrās: formless (Japanese *mugyō*), i.e. without accessories such as characteristic ritual implements or symbols, and with forms or accessories (Japanese *ugyō*).[4] We shall be concerned here only with mudrās in the first category, since the others will be discussed in the descriptions of deities which use implements or accessories (*lakṣana*) in their representations. For the sake of convenience, these 'formless' mudrās are divided into three classes: mudrās of the Great Buddhas; mudrās used chiefly by minor deities and Bodhisattvas, and mudrās of the wrathful forces (some may belong to more than one class).

Mudrās are very numerous: chapter IX of the *Mahāvairocana-sūtra* lists 31 for the Great Buddhas, 57 for the great deities, and 45 for others. In chapter XIV it is indicated that the nine esoteric mudrās correspond to the Five Buddhas of wisdom and to their four great acolytes.[5] However, many mudrās mentioned in the sūtras and other canonical texts were never, or only rarely, used for representations of deities. We shall deal here only with mudrās that are recognized in connection with the images of deities that have been, or still are, venerated in Asia. The others, which are more or less rare or theoretical, shall be described only in connection with the deities which use them exceptionally.

Mudrās of the Great Buddhas

These are the mudrās that characterize the effigies of the historical Buddha and the five Jinas that symbolize events in his life. These mudrās, which materialize the nature and the functions of these Buddhas, are often made with both hands, either separately or together. They are, however, also sometimes used by Bodhisattvas or by other deities, except for those that are specific to Mahāvairocana and his various esoteric forms.

Hand in Abhaya mudrā
Thailand,
eighteenth century,
Author's Collection

Abhaya mudrā

(Japanese, *Semui-in*; Chinese, *Shiwuwei Yin*)

This mudrā symbolizes protection, benevolence and peace, and the dispelling of fear. In the Southern schools, it is generally made with the

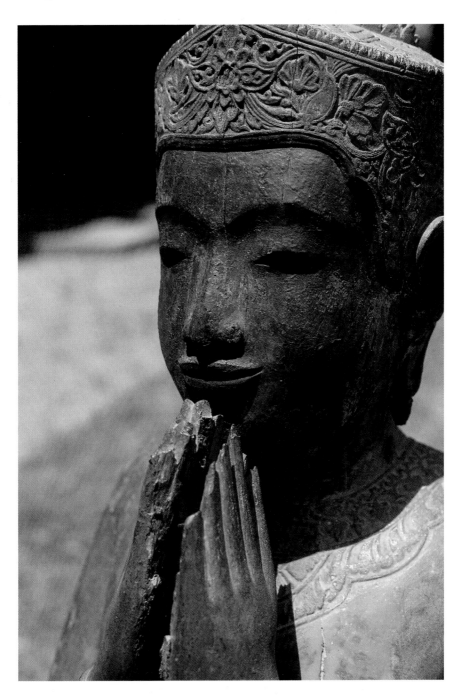

Praying figure, coloured wood, Udong, Cambodia, eighteenth century, Phnom-Penh Museum

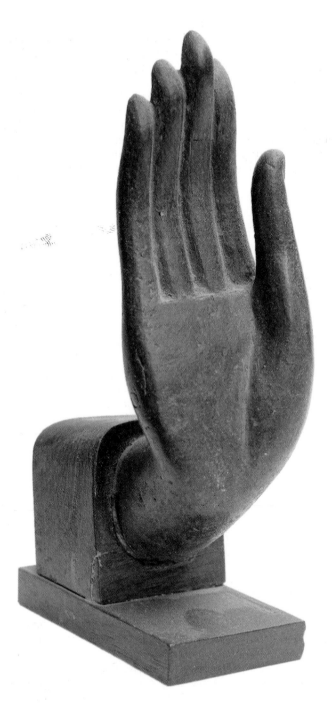

Hand in Abhaya mudra, bronze, Ayuthyā, Thailand, eighteenth century, Private Collection

IV

right hand raised to shoulder height, the arm crooked, the palm of the hand facing outward, the fingers upright and joined. The left hand hangs down at the side of the body. In Thailand, and especially in Laos, this mudrā is associated with the movement of the walking Buddha (also called 'the Buddha placing his footprint'). It is nearly always used in images showing the Buddha upright, either immobile with the feet joined, or walking. In South-East Asia there are mainly statues of the upright Buddha making this mudrā with the two hands placed symmetrically on either side of the chest. A variant of this mudrā (*Buddhasmaraṇa*, 'being mindful of the Buddha') is sometimes, though quite rarely, used in South-East Asia. It is made with the right hand in Abhaya, raised to the level of the head. The Abhaya mudrā is very rarely made by deities other than the Great Buddhas or the Bodhisattvas.

One of the Buddhas of the Tōdai-ji
Gilded wood, Nara, Japan, eighteenth century

This mudrā, which initially appears to be a natural gesture, was probably used from prehistoric times as a sign of good intentions – the hand raised and unarmed proposes friendship, or at least peace; since antiquity, it was also a gesture asserting power, as with the *magna manus* of the Roman Emperors who legislated and gave peace at the same time. It was the traditional Indian gesture of appeasement made by the Buddha when he was attacked by an angry elephant, which immediately calmed the animal. Accordingly, it indicates not only the appeasement of the senses, but also the absence of fear; and it confers such absence of fear on others, which is a liberating factor.

In China, Japan and Korea, this mudrā of the right hand is often used in combination with another mudrā made with the left hand. In Japan, according to certain monks, if the second finger of the right hand in Abhaya is projected slightly forward, it would indicate that the deity belongs to the Shingon sect. In Gandhāra art, this mudrā was sometimes used to indicate the action of preaching. This is also the case in China where it is very commonly found in images of the Buddha, mainly in the Wei and Sui eras (fourth to seventh centuries). In the Buddhist representations of the Northern schools, it is often made by deities, in combination with another mudrā made with the left hand – either the Varada mudrā (see below) or, when seated, a gesture with the palm turned upward, with the legs crossed. The combination of Abhaya and Varada mudrās is called *Segan Semui-in* or *Yogan Semui-in* in Japan.

Abhaya mudrā

Varada mudrā

(Japanese, *Yogan-in*, *Segan-in*, *Seyo-in*; Chinese, *Shiynan Yin*)

This mudrā symbolizes offering, giving, welcome, charity, compassion and sincerity. It is the mudrā of the accomplishment of the wish to devote oneself to human salvation. It is nearly always made with the left hand.[6] It can be made with the arm naturally hanging at the side of the body, the palm of the open hand facing forward (the most widespread form in statues of South-East Asia); with the arm crooked, the palm offered or slightly turned upward; or with the arm crooked next

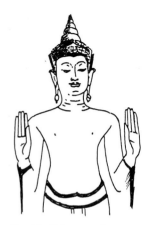

Double Abhaya mudrā
South-East Asia

41

to the body, the palm turned upward, the fingers upright or very slightly bent. This mudrā is rarely used alone, but usually in combination with another made with the right hand, often Abhaya. When both the hands are in Abhaya/Varada mudrā and have the thumbs touching, they indicate appeasement of the senses.[7] This composite mudrā is often confused with the Vitarka mudrā (see below), which it closely resembles.

In the statues of the Wei period in China and of the Asuka period in Japan, the fingers are stiff, and then gradually they begin to loosen, with the second finger and the forefinger separated from the other fingers; in certain statues, such as those of Yakushi in the Kondō of Hōryū-ji, the small finger and the ring finger only are detached. Finally, in the Tang period, the fingers lose all rigidity and are naturally curved.

In India, this mudrā is characteristic of the images of Avalokiteśvara, from the Gupta period (fourth to fifth centuries). In the *Kāraṇḍa-vyūha*, it is stated that Avalokiteśvara, visiting the kingdom of the dead, allows to flow from his hand in Varada mudrā the water of life that nourishes and soothes the tormented in Avīci, the worst of the hells.

Vitarka mudrā

(Vyākhyāna mudrā; Japanese, *Seppō-in, An-i-in*;
Chinese, *Anwei Yin*)

This mudrā is made with both hands in Abhaya and Varada, but with the thumbs touching the tips of the forefingers. It is mainly used for images of the Great Buddhas, and symbolizes one of the phases of the preaching of the Buddha, that of discussion or argument of the Doctrine (dharma). This is the mudrā that convinces hearers and leads them to conversion. It is sometimes given the name of 'mudrā of explanation' (*vyākhyāna mudrā*). If the right hand is in Varada and the left hand holds a piece of the robe, the Vitarka mudrā thus formed is called *Kesa Ken-in* in Japan. This mudrā is specific to the effigies of Ratnaketu (Japanese Hōtō Nyorai), where it is held away from the body (*Gai-Segan-in*, right hand in *Yogan-in* exterior, left hand holding the part of the robe before the breast), and to effigies of Saṃkusumitarāja (Japanese Kaifuke-ō Nyorai), called *Nai-Segan-in* (right hand in *Yogan-in* before the breast, left hand holding the part of the robe on the thigh). A few

Abhaya/Varada mudrā

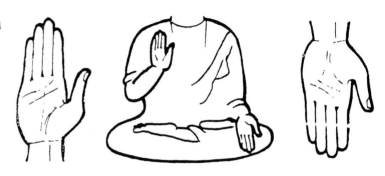

other deities also make the *Kesa Ken-in*, but with the left hand holding the piece of the robe away from the body. These positions are mainly represented on paintings and in maṇḍalas.

A variant of this Vitarka mudrā, specific to Chinese and Japanese effigies of Bhaiśajyagura (Japanese Yakushi Nyorai), is called *Yakushi-in* in Japan: the right hand is in Abhaya, the left in Varada or Vitarka, holding a medicine jar.

The Vitarka mudrā may display a number of variants. Thus the thumb may not completely touch the forefinger, or it may extend beyond it on the side. A Japanese and Chinese variant (Japanese *An-i-shōshu-in*, Chinese *Anwei Shechu Yin*), which assumes the sense of calming and consoling, appears as a Vitarka mudrā made with the left hand, but with the right hand open in Varada at the level of the hip.

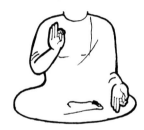

Vitarka mudrā

In Japan, another variant shows the ring finger joined to the thumb. This is the mudrā of Good Fortune (*Kichijō*), peculiar to the goddess Kichijō-ten. Rarely are Buddhas represented with this mudrā.

If the thumb and forefinger are joined at the tips, this forms a circle representing perfection, which is eternal. In Tibet, Tārās and other Bodhisattvas make this circle by joining the thumb and any one of the other fingers (Tibetan *Pa-dan rtse-gsum*). In esoteric Buddhism and cults devoted to Amitābha, different sorts of Vitarka mudrā are used (they are examined in connection with the representations of Amitābha in Chapter IV. In Tibet, there is a variant used mainly by the deities in Yab-yum (embracing), the hands crossed at the wrists, palms towards the breast, fingers slightly separated. The Sanskrit name for this mudrā is *Prajñāliṅganābhinaya*.

Vitarka mudrā

In the Borobudur *stūpa* in Java, the statues of the Buddha of the fifth balustrade, which crown the square stages of the maṇḍala monument, all show the right hand in Vitarka mudrā, the left hand remaining in the lap, palm upward. This mudrā appears to be specific to the Bodhisattva Samantabhadra.

Dharmacakra mudrā

(Japanese, *Tenbōrin-in, Chikichi-jō, Hōshin-seppō-in*;
Chinese, *Juanfalun Yin*)

When the two hands close together in front of the breast, both in Vitarka, the right palm forward and the left palm upward or facing the breast, the separated fingers of one of the hands nearly touching those of the other hand, this is the position of 'the turning of the wheel of the Law'. It symbolizes one of the most important moments in the life of the Buddha, the occasion when he preached to his former companions the first sermon after his Enlightenment, in the Deer Park in Sarnāth. It is therefore generally reserved for the effigies of the Buddha Gautama.

It has several variants. In the frescoes of Ajantā (India), the two hands are clearly separated, and the fingers do not touch. In the images of the Indo-Greek style of Gandhāra, the clenched fist of the right hand

**Hand in
Dharmacakra mudrā**
Java, twelfth century

43

Dharmacakra mudrā

Dharmacakra mudrā
(another form)

Right hands of
Bhūmisparśa mudrā
(variants)

Bhūmisparśa mudrā
(normal)

appears to overlie the fingers joined to the thumb of the left hand. In the frescoes of Hōryū-ji in Japan, the two hands in classic Dharmacakra are superposed, with the right hand on top. Another variant, which is quite different (and unknown outside Japan, where it is also extremely rare), shows the hands back to back, fingers interlaced and touching at the tips.

Apart from the Buddha Gautama, only Maitreya (the Buddha to come) can, as a dispenser of the Law, form this mudrā. In India, Maitreya is sometimes represented in the 'European' seated position, making this mudrā. However, some figures of Amitābha making this mudrā were represented in Japan before the ninth century.

Bhūmisparśa mudrā

(Japanese, *Gōma-in, Anzan-in, Anchi-in, Sokuchi-in;*
Chinese, *Chudi Yin*)

This mudrā, literally the 'gesture of touching the earth', portrays the Buddha taking the earth as witness. It describes the moment in the life of the Buddha Gautama when, armed with his resolve to remain seated under the pipal tree at Bodh-Gāya until he had solved the problem of the cessation of suffering, he took the earth as testimony of the merits that he had accumulated during his previous incarnations. It is hence the symbol of unshakeable faith and resolution.[8] It is typical of representations of the historical Buddha and of Akṣobhya. With the Buddha represented seated in the lotus position (Padmāsana), the right hand touches the ground with the finger tips near the right knee, all the fingers extended, or only with the tip of the forefinger, while the left hand rests, palm upward, in the hollow of the thighs. Some variants can be found, in which the right hand is placed flat on the ground or extended, palm downward, parallel to the ground. In Japan, these variants are called *Anzan-in* (pacification of the mountain) or *Anchi-in* (pacification of the earth).

The texts contain many versions of the legend of the Buddha taking the earth for witness: sometimes he takes the earth as witness of his resolve, and it proclaims that Gautama, through his past experiences, enjoys the right to sit on the 'diamond throne' (*vajrāsana*). Sometimes at the Buddha's prayer the earth sends an army of deities who kill the demons of the horde of Māra; in this case, it is the mudrā of the subjugation of the demons. In certain esoteric representations, Akṣobhya is seen touching the earth with his right hand, but he holds in his left hand a piece of his robe on his breast. In Korea, confusion in the high period led to a few rare images of Amitābha being represented with this mudrā.

Dhyāna mudrā

(Samādhi mudrā; Japanese, *Jō-in, Jōkai Jō-in;*[9] Chinese, *Ding Yin*)

This is the mudrā of meditation, of concentration on the Good Law, of the attainment of spiritual perfection, *bodhi*, 'awakening'. The hands

are generally held at the level of the stomach or on the thighs, the right above the left, palms upward, fingers extended and thumbs touching at the tips, thus forming a mystic triangle, symbolic of the spiritual fire.[10] This mudrā, particular to Amitābha, is sometimes used in certain representations of Bhaiṣajyaguru as the Buddha of medicine (Yakushi Nyorai in Japan); in this case, a medicine bowl is placed on the hands. The most common type in Japan, it is used only for seated representations of the Great Buddhas, and has many variants and different names. It is often found in India, where it appears to have originated in the Gandhāra, and in the China of the Wei period. The fingers are sometimes interlaced, and sometimes the palms intersect at an angle of 45 degrees. This mudrā is frequently used in the images of the seated Buddha of South-East Asia; however, the joined thumbs do not form a 'mystic triangle' and are placed against the palms.

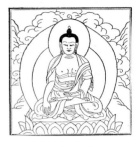

Bhūmisparśa mudrā
Tibetan engraving

According to tradition, the normal position of the Dhyāna mudrā derives from the one assumed by the Buddha when meditating under the pipal tree before his Enlightenment. The position was adopted, even before this time, by yogins during their meditation and concentration exercises. It indicates the perfect balance of thought, rest of the senses, and tranquillity.

Dhyāna mudrā

A second type, similar but forming a mystic triangle with the thumbs, is found more frequently in China from the Wei period, and only exceptionally in India and South-East Asia. Variants of this type are quite numerous. In one of them, the thumbs are slightly separated from each other, and in another (very rare) the left hand is placed on the right.

A third type, absent from Indian representations, infrequent in China but often used in Japan especially from the tenth century, shows the fingers of both hands (forefingers, second and ring fingers) bent at right angles upward, back to back and joining the thumbs. These positions of the fingers, specific to the Japanese worship of Amitābha (Japanese *Amida*) and called *Amida Jō-in*, represent meditation, teaching and welcome in the paradise of Amida (the pure Land); they correspond to the nine categories into which human beings are divided when they enter the pure Land. They are made with both hands joined on the hollow formed by the crossed legs, in normal Dhyāna mudrā, with the two hands symmetrically placed in front of the breast in three varieties of *Seppō-in* or with the two hands in *Raigō-in* (the right hand raised to the level of the shoulder in Vitarka mudrā, the left in Varada mudrā). When the thumbs are joined to the forefinger, this is the higher position (Japanese *Jō-bon*); the thumbs joined to the second fingers represent the median position (Japanese *Chūbon*); the thumbs joined to the ring fingers indicate the lower position (Japanese *Gebon*). These mudrās are more fully described in Chapter IV, under Amitābha in its Japanese representations.

The position of the Dhyāna mudrā with the joined thumbs forming a triangle is symbolic of the *Triratna* (Three Jewels) – namely the

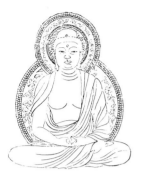

Meditation posture
Japanese engraving

Buddha himself, the Good Law and the Saṅgha (monastic community). This triangular form also indicates the firmness of the body (in the Padmāsana position the body is extremely stable), and of the mind. The esoteric sects obviously attributed to this mystic triangle a multitude of meanings, the most important being the identification of the mystic fire that consumes all impurities. In Japan, in the esoteric interpretation of the two great complementary Vajradhātu and Garbhadhātu Maṇḍalas, the two circles formed in the third variant of the Dhyāna mudrā represents these maṇḍalas. And, in this case, it is made by Mahāvairocana (Dainichi Nyorai) in the Garbhadhātu Maṇḍala. However, the mudrās that Amida can assume, and which form part of the concentration mudrās, may be rather diverse and have different names, according to which of the two maṇḍalas they belong to.

Dainichi Ken-in
(Japanese, also *Mushofushi-in*, *Ritō-in*; Chinese, *Wusobuzhi Yin*)

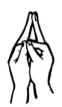

Dainichi Ken-in

This mudrā of the sword of Knowledge, typical of Korea and Japan, is specific to the representations of Mahāvairocana (Dainichi Nyorai) in the maṇḍala of Taizō-kai, where the three openings of the fingers signify the Three Mysteries (*triguhya*; Japanese *san-mi*) of esoterism, of body, speech and mind. This refers to a practice whereby the believer realizes that his body, speech and consciousness are identical with those of Mahāvairocana, and thus that *bodhi*, Awakening, exists within him. The mudrā is formed with the hands joined in an attitude of prayer, but with the two forefingers bent and joined at their tips, the other fingers of the hand also touching at their tips, but extended. It is rarely found except in the maṇḍalas and on some paintings of the esoteric sects.

Depending on the sects, different names have been assigned to this mudrā, more theoretical than practical, such as *Biroshana-in* (mudrā of Vairocana), *Mushofushi Tō-in*, *Ritō-in* (mudrā of the ubiquity of the *stūpa*), and even *Sanmitsu-in* (mudrā of the Three Mysteries).

Chiken-in
(Japanese, also *Kakushō-in*, *Daichi-in*; Chinese, *Zhiquan Yin*)

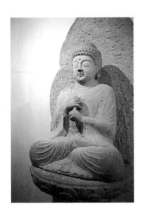

Dainichi Nyorai
Stone, ninth century,
Seoul, Korea,
National Museum

This mudrā is typical of Korea and Japan, but unknown in India. It is particular to Mahāvairocana (Dainichi Nyorai) in the Vajradhātu Maṇḍala (Kongō-kai). Called the 'mudrā of the six elements' or 'mudrā of the fist of wisdom', it is made by enclosing the erect forefinger of the left hand in the right fist. This mudrā stresses the importance of Knowledge in the spiritual world. The five fingers of the right hand also represent the five elements (earth, water, air, fire, ether), protecting the sixth, man. Another interpretation claims that the erect forefinger represents Knowledge, which is hidden by the world of appearances (the right fist).

In Tibet, this mudrā also represents the perfect union between the deity and his Śakti (the deity's feminine power or energy in Tantric doctrines). Their close sexual union, Yab-yum, is the equivalent of the

Indian *lingam* of Śiva represented penetrating the *yoni*. This sexual symbolism suggests that this mudrā could possibly have originated in India, although it appears to be unknown there. It is also used in Tibetan art (Bodhyagrī mudrā).

The alternative terms *Kakushō-in* and *Daichi-in* mean 'mudrā of great wisdom'. It is little represented in China except on maṇḍalas, but sometimes in Japan and Korea in sculptures. It could correspond to the Sanskrit terms Vajra mudrā, Bodhyaṅgi mudrā and Jñāna mudrā.[11]

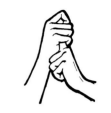

Chiken-in

A variant called *Nyorai Ken-in* (fists of wisdom of Nyorai), with the two fists clenched and superposed in front of the breast, is rare. Sometimes the left fist encloses the right forefinger.

Buddhapātra mudrā

(Japanese, *Buppatsu-in*; Chinese, *Fobo Yin*)

This mudrā is particular to the representations of the historical Buddha and to those of a few other personages of the Buddhist pantheon, such as certain Bodhisattvas. The two hands placed horizontally in opposition hold a begging bowl (*pātra*, Japanese *hachi*) at the level

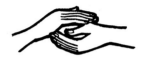

Buddhapātra mudrā

of the breast, one hand above and the other underneath. The bowl has sometimes been accidentally missed out of some representations. A particular form of this mudrā, in which the bowl is replaced by a 'wish-granting jewel' (*cintāmaṇi*, Japanese *hōshu*) which is held very tightly, takes the name of 'mudrā of the treasure bowl' (Japanese *Hōbuppatsu-in*). In a few other deities of Japanese Buddhism (for example, Senju Kannon Bosatsu), the two hands joined hold the bowl from below: this is the 'mudrā of the bowl' (*Hachi-in*). Another variant, used mainly by Seishi Bosatsu and Shō Kannon Bosatsu, is called *Hōkyō-in* ('mudrā of the treasure box'): the two hands in opposition appear to be protecting a small object. This mudrā closely resembles one called *Hōbuppatsi-in*, and was mainly represented in Japan and Korea before the appearance there of the esoteric doctrines. They are shown by deities in the standing position, while the Buddhapātra mudrā is generally shown by deities seated in Yogāsana. This mudrā seems to have appeared in Gandhāra art with the first images of the Buddha, represented as a monk begging for food.

Mudrās of the Other Deities and Bodhisattvas

The mudrās used by Bodhisattvas and ordinary deities are relatively few in number, and generally representative of a clearly defined category of deities. They serve chiefly to distinguish each from the other, while symbolizing their nature and their functions. We shall describe here only the most widely used mudrās, and shall describe the less common ones when we encounter them in our study of the different deities.

Praying figure with hands in Añjali mudrā
Coloured wood,
Cambodia,
fifteenth century,
Phnom-Penh Museum

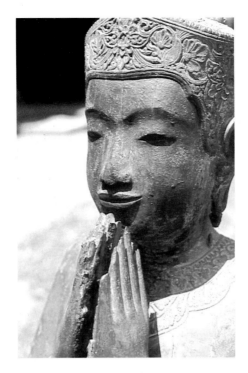

Añjali mudrā

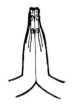

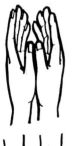

Añjali mudrā

(Japanese, *Gasshō-in, Renge Gasshō-in, Sashu Gasshō-in, Kimyō Gasshō-in*, etc.; Chinese, *Hezhang Yin*)

This is the mudrā of offering and veneration. It is rarely made by the Great Buddhas, who are at the summit of the Buddhist hierarchy in the Mahāyāna, nor by the historical Buddha. It is made with the two hands joined vertically in front of the breast, as in the attitude of prayer. This mudrā is reserved for praying figures, which often accompany a statue of the Buddha in the art of India and South-East Asia. It is, however, exceptionally used by Amitābha when this Great Buddha assumes the function of a Bodhisattva, particularly in its Japanese form of Gokōshiyu Amida. Universally used by people in India and South-East Asia for salutation, it evokes an offering (of good feelings, of one's person, of art, etc.) and also indicates veneration if it is made at the level of the face.

Several variants of this mudrā were developed later by the esoteric sects. The Vajra/Añjalikarma mudrā (Japanese *Kongō Gasshō-in*, Chinese *Jingang Hezhang Yin*) is made like the Añjali mudrā, but with the thumbs crossed over each other and the tips of the fingers interlaced, the arm projected slightly forward instead of adhering to the breast. A variant of this position shows the hands joined in Añjali with only the thumbs crossed, and is used in the ordination rites of certain esoteric

Añjali mudrā
(variants)

sects. In the symbolism of these sects, the union of the two hands represents that of the two parts of the great maṇḍala of the deities, the Vajradhātu and the Garbhadhātu Maṇḍalas. It also symbolizes the intimate union of the world of beings (left hand) and the world of the Buddha (right hand). This position is also called *Kimyō-Gasshō* or *Kenjitsushi-in* in Japan. In the specific case of Fukūkensaku Kannon Bosatsu, this mudrā (which assumes the name of *Jū-in*) shows the two hands facing each other as for the Añjali, but very slightly apart and holding a small crystal ball between them (which has often disappeared from the sculptures).

Ongyō-in
(Chinese, *Yinxing Yin*)

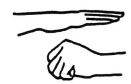

Ongyō-in

This mudrā of the dissimulation of forms, used exclusively in Japan and China on a few rare occasions, is also called *Marishi-ten Hōbyō-in* (from the precious receptacle of Mārīcī), and is considered to confer invisibility. A magic mudrā, specific to the esoteric sects, it is made with the right hand extended, palm downward, on the left fist which is kept clenched before the breast.[12] (It is described in greater detail in Chapter VIII.) This mudrā, to be effective, must be made at the same time as the recitation of the corresponding *mantras* – that is to say, the ritual invocations of the deity concerned, Mārīcī in this case. It is used not only to become invisible, but also to exorcize demons. In certain esoteric sects, it serves for concentration: the left fist, not completely closed, forms a cavity into which the meditator must try to penetrate by the spirit, ultimately to coil up completely, while a slow rotary movement of the right hand blocks the hollow of the left fist.

Hōshu-in
(Japanese, also *Jizō-in*)

Hōshu-in

This mudrā of the wish-granting Jewel (the jewel is called *mani* or *cintāmaṇi* in Sanskrit, *hōshu* or *nyo-i hōshu* in Japanese, *ruyizu* in Chinese, and *nor-bu* in Tibetan) is Japanese, and particular to Jizō Bosatsu. It is sometimes found in China on representations of the Chinese Dizang. It is used by other personages of the Buddhist pantheon, mainly in painting and in maṇḍalas. An exceptional form of this mudrā is made by the statue of Guze Kannon of Hōryū-ji in Nara. The *cintāmaṇi* has sometimes disappeared, and the hand is empty.

Kichijō-in
(Japanese, also *Chikichijō-in*)

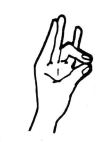

Kichijō-in

According to tradition, this Japanese mudrā 'dispenser of Good Fortune' is specific to the deity Kichijō-ten, but it is rarely found associated with it. It is made with a single hand, the thumb joined to the ring finger, the other fingers remaining extended. This mudrā is theoretically one of the three mudrās of the historical Buddha Gautama, preaching the Law.[13] In this case, it is a form of the Vitarka mudrā.

Maitreya mudrā

(Japanese, *Shiyui-in*)

This mudrā of Maitreya or of reflection is used mainly for images of Maitreya (Japanese *Miroku*, Korean *Mi-rüg*) in the Korean representations of the Asuka period in Japan (sixth and seventh centuries). The left hand is placed on the right ankle (in the pose called *Hanka-shiyui*, 'of thought') while the right hand, with the forefinger and second finger extended, touches the cheek.

Abhiṣeka mudrā

(Japanese, *Kanjō-in*; Chinese, *Guanding yin*)

Abhiṣekha mudrā

This is the mudrā of anointing, characteristic of holy personages.[14] The hands are together, palm against palm, forefingers extended interlaced against each other. It is qualified in Japan as *Nairenge-in* (*Naibaku-in*) when the fingers are interlaced inward, and as *Gairenge-in* (*Gebaku-in*) when interlaced outward. This mudrā is used only by esoteric sects for the anointing ceremony, performed at the entry of a novice into the Buddhist community. It probably stems from the ancient habit of anointing the head of a king at his investiture, to show that he has been chosen. In esoteric Buddhism, this practice of initiating a novice magically confers on him the aptitudes necessary for his spiritual practices. This mudrā is also made by the one who receives unction. He may be a Bodhisattva, a 'force' or a simple deity, a personage from the scriptures, or a monk.

Muṣṭi mudrā

(Japanese, *Ken-in*)

Nyorai Ken-in

Funnu-ken-in

This term is applied to a whole category of mudrās (including Dainichi-ken-in, already discussed above) belonging to the 'fists of wisdom' and used by many deities of the esoteric pantheon. In the representations belonging to the domain of the Vajradhātu, the fist is kept clenched, with the thumb inside: it is called Vajramuṣṭi mudrā (Japanese *Kongō ken-in*, Chinese *Jingang Yin*) and symbolizes firmness of spirit. In those that belong to the domain of Garbhadhātu, the thumb is outside the clenched fist: it is called Garbhamuṣṭi mudrā (Japanese *Taizō-ken-in*). When the fists of wisdom are crossed at the wrist, palms turned towards the breast, the mudrā is called Trailokyavijayarāja mudrā (Japanese *Sankaisaishō-in*), that is to say 'mudrā of the Conqueror of the Three Worlds'. If the palms are turned outward, it is the Vajrahuṃkāra mudrā (Japanese *Bazara-kongō-in*, Chinese *Juanyuelehong Jingang Yin*), a mudrā in which the right hand sometimes holds a vajra, and the left a *ghaṇṭā* (bell). These mudrās are characteristic of the images of Vajrasattva and, in Japan, of Kongō-zō-ō.

Muṣṭi mudrās can be made with a single hand (usually the left hand), placed on the hip or in the hollow of the thigh. Yet sometimes the same Muṣṭi mudrā, thumb inside, palm turned outward, is also used

by the wrathful form of a deity. It is a mudrā of wrath. It is called *Funnu-ken-in* in Japanese.

Another aspect of these Muṣṭi mudrās, but which is slightly different, is that of the Vajrarāja mudrā (Japanese *Kongō-ō-in*, Chinese *Jingang Wang Yin*): the clenched fists are crossed on the breast as for the mudrā of the Conqueror of the Three Worlds, but with the forefingers extended.

Muṣṭi mudrā

Mudrās of the Wrathful Forms

These mudrās (which include some Muṣṭi mudras) are particular to the wrathful forms emanating from the Great Buddhas and Bodhisattvas to conquer desires, passions and forces of evil, forms generally called Vidyārāja (Japanese *Myō-ō*) or 'kings of magic knowledge', falling into the general category of menacing forces (Tarjanī, Japanese *Funnu*).

Tarjanī mudrā

(Japanese, *Funnu-in, Fudō-in*)

Tarjanī mudrā

This mudrā, particular to Acalanātha (Japanese *Fudō Myō-ō*) indicating menace, is sometimes made with a single hand, the little finger and forefinger extended, the other fingers closed. It is curious to note that this mudrā, which is considered to have a magic power of malediction, is still made by many Latin peoples to threaten with a curse or to cast a spell. These are the 'devil's horns' of western folklore.

Gōzanze-in

(Japanese, also *Niwa-in, Shisetsu-in*)

This mudrā of the Japanese esoteric sects is characteristic of the Vidyārājā called Trailokyavijayarāja (Japanese *Gōzanze Myō-ō*). The two hands are joined on the breast by the interlaced little fingers, palms turned outward, and thumbs joined to the middle fingers.

Gōzanze-in

Gundari-in

This mudrā is particular to the Japanese esoteric form of the Vidyārāja Gundari (Sanskrit *Kuṇḍalī*) called *Gundari Myō-ō*. It is made with a single hand (usually the right), the forefinger and second finger extended, the other fingers closed, and the palm facing the ground. A variant of the mudrā, called *Tsurugi-in* ('of the sword'), shows the right hand holding the two fingers of the left hand in *Gundari Ken-in* (also called *Myō-ō-in*).

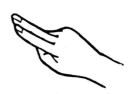

Gundari-in

Batō-in

This Japanese mudrā is particular to Batō-myō-ō, a form of Hayagrīva: the two hands face each other with the fingers interlaced inward (*Nai-batō-in* or *Nai-baku-in*) or outward (*Ge-batō-in* or *Ge-baku-in*), except for the second fingers and little fingers, which are pressed against each other.

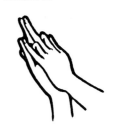

Batō-in

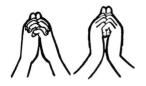

Baku-in

(Chinese, *Quan Yin*)

This esoteric mudrā is formed by the fingers interlaced outward (*Gai-baku-in*) or inward (*Nai-baku-in*), palms against each other, thumbs crossed, the right on the left. It is considered to signify that the one who makes it is free of the bonds of desire which attach him to the world and has attained the perfection of the ten stages of Knowledge. It is never made by a Buddha.

Gai-baku-in

Many other sorts of mudrā, generally derived from the principal mudrās, theoretically exist, sometimes described on maṇḍalas, but only exceptionally represented by the esoteric sects. However, besides the mudrās that we have discussed here, many other positions of the hands exist, classed in the traditional category of 'mudrās with form' (Japanese *ugyō-in*), which are ways of holding ritual objects or attributes in the hand. They are, strictly speaking, not mudrās.

Nai-baku-in

POSTURES OF THE DEITIES

The postures (āsana) that the representations of the deities may adopt, both in statuary and in painting, are widely varied, and characteristic of the nature and the function of these deities, in the same way as the mudrās are. They can be divided into two main groups: static postures and dynamic postures.

Static Postures

These are generally adopted by most of the Buddhas and Bodhisattvas, and by many Devas, who are usually represented seated, lying or standing.

Seated or lying postures

These are both the most numerous and the most diversified. They are generally reserved for the Great Buddhas, but can also be adopted by other deities.

Bhadrāsana, Pralambapādāsana (Japanese, *I-zō*)

This is the so-called 'European' or 'Chinese'[15] seated posture, either the blessed posture (*Bhadrāsana*), or the posture with pendant feet (*Pralambapādāsana*), on any throne, the two legs pendant, feet on the ground, sometimes crossed at the ankles (Japanese *Kōkyaku-zō*) and the knees apart. A typical posture of the Buddha Gautama and of some images of Maitreya, it is found in all Buddhist countries; in India, it is symbolic of royalty. In Gandhāra art in particular, the feet may be placed on a small stool, thus raising the knees. It is found very early in the Gandhāra and in India (Buddha of Sarnāth, Gupta period, fourth and fifth centuries), and in South-East Asia (Chandi Mendut near Borobudur,

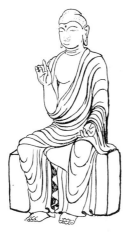

Bhadrāsana

Buddha in Bhadrāsana
Stone, Java, ninth century,
Djakarta Museum

Java, eighth century), as well as in many statues and paintings in Tibet, China, Korea and Japan (where it is a typical posture of Maitreya).

Kiza-zō (Japanese, also *Sonkyō-zō*)

Kiza-zō

This kneeling posture is frequently used in India and South-East Asia, as well as Japan, for praying figures and the faithful. In South-East Asia, the images of the Buddha are often flanked by statues of praying figures kneeling in this posture on the heels, the hands in Añjali. In Japan it is also reserved for praying figures and minor personages, and represents the attitude typical of veneration. The personages of Seishi Kannon (Mahāsthāmaprāpta) and Shō Kannon (Aryāvalokiteśvara), in particular, are sometimes represented in this posture when they are considered as acolytes of another deity (usually Amitābha).

Lalitāsana

Lalitāsana (Japanese, *Tōka-zō*)

This is the posture of relaxation, one leg bent (usually the left, but sometimes the right) on the throne, the second pendant or resting on the ground, and the knee slightly raised. The pendant leg may be on the side or brought to the centre, and rests on a pedestal or a lotus flower. This posture is often adopted for the effigies of deities resting on the backs of support animals, although it is also customary for deities shown seated on a throne or any other seat. It is typical of the images of the Bodhisattvas on the paintings in the Ajantā caves and the Chinese representations of Guanyin (Avalokiteśvara) from the Tang and Song eras.

Kōkyaku-zō

A variant of this posture, Rājalīlāsana (or Mahārājalīlāsana, Japanese *Rinnō-zō*), is the posture of royal ease: left leg bent horizontally, right leg bent vertically, heels touching or the right foot on the left heel, and is characteristic of many images of Mañjuśrī and Avalokiteśvara, although it is sometimes made by other deities. Reserved for royal personages, this posture is never used by minor or accessory deities. The

Rājalīlāsana

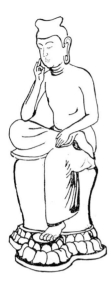

personages that adopt this attitude are often represented with the elbow (right or left, depending on which leg is raised) nonchalantly resting on the knee, the other arm supported by the ground (or the throne) behind the thigh bent flat, to maintain equilibrium. A variant sometimes shows the personage in Lalitāsana, with the right hand in Varada mudrā placed on the knee of the pendant leg: this is Ardhaparyaṅka-āsana. The Buddha himself was, on rare occasions, represented in this attitude, either on images from Gandhāra, or on more recent works.[16]

Maitreyāsana (Japanese *Hanka-shiyui-zō, Hanka-i-zō*)
This is the posture of the 'thinker', one leg pendant (foot placed on the ground or on a lotus), the second leg resting horizontally, the ankle on the knee of the pendant leg. The hands are in *Shiyui-zō*, pressing gently against the cheek. This posture is typical of the ancient representations of Maitreya in China, Korea and Japan. In Japan and Korea, Maitreya represented in this posture has the right elbow resting on the right knee, the left hand placed on the right ankle. The earliest example of an image showing this attitude of reflection dates from the Mathurā period in India (second century). It was taken up in the art of Gandhāra, from where it probably passed into China (Wei period). It was very popular in Korea from the sixth century, and especially in China under the Tang and Sung. Japan imported this image from Korea, and made magnificent examples of it (for example, in the statue of Maitreya from the Chūgū-ji in Nara). Also in Japan, this attitude was adopted to represent Nyoirin Kannon (see under *Avalokiteśvara*).

Maitreyāsana

Maitreyāsana

Parinirvāṇāsana (Japanese, *Ga-zō, Nehan-zō*; Chinese, *Daniepan*)
This is the attitude of the Buddha entering Nirvāṇa, lying on his right side, the right hand supporting the head, feet joined, left arm extended along the left hip. The head is sometimes shown resting on a cushion. In a few rare Japanese and Chinese painted representations, however, the right hand, instead of supporting the head, rests near it, palm upward. This is one of the four major postures of the Buddha, materializing the last 'event' in his life. It is very often represented in images in India and South-East Asia.

Parinirvāṇāsana
Swetalyaung, Pegu, Burma,
restored twentieth century

Great Buddha recumbent

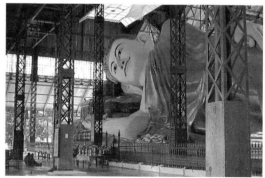

Seated lotus postures

These (called *Padmāsana*) are the postures most frequently represented for the images of the Great Buddhas. They have many variants.

Vajraparyaṅka (Japanese, *Goma-za-zō, Kichijō-za-zō*)
Posture with the left foot on the right thigh, or the right foot on the left thigh. These two postures are mainly used for seated effigies of the Great Buddhas. However, the second (*Kichijō-za-zō*) is more often used in the representations belonging to the esoteric sects than the first, which is more popular with the non-esoteric sects. When the two feet are hidden by the robe, this indicates the esoteric (hidden) nature of the deity represented: Paryaṅkāsana. These lotus postures (Japanese *Kekka-zō, Kekka-fuza-zō, Renge-za-zō*) have been universally adopted from the earliest antiquity (as in the seal of Mohenjo-darō) by men and women throughout the East, particularly in India where it is the position assumed by ascetics for meditation. In the non-esoteric sects, all the seated Buddhas are represented in this posture.

Vajraparyaṅka

Kichijō-za-zō

Sattvaparyaṅka (Japanese, *Yūga-za-zō*)
This posture, or 'noble posture', represents the seated 'tailor' posture – the two legs bent, the feet resting on the ground or the throne. When the knees are raised and the legs held by a strip of fabric, to facilitate the maintenance of the posture during long hours of meditation, it is called *Yōgāsana*, often represented in India and South-East Asia for meditating ascetics.

Vīrāsana (posture of the hero) or Vajrāsana (diamond posture), or even Ardhapadmāsana (half-lotus posture) are Padmāsanas with a single foot showing. Two variants also exist in the representations of the esoteric sects: Gōma Hanka-za-zō (left leg on right leg), and Kichijō Hanka-za-zō (right leg on left leg).

Sattvaparyaṅka

Padmāsana

Embracing postures

These postures show two complementary deities, a main deity and its Śakti or 'energy', face to face, in a very tight embrace, sexual organs joined. The god is generally seated in Padmāsana (but may also have one leg hanging outside the throne, his partner facing him, gripping

Padmāsana

Yab-yum

his back with his legs). This posture is called Yab-yum (father/mother). In the earliest representations, the Śakti is simply seated on one of the knees of the god, a representation frequently found in Hindu images in India, and sometimes used in Khmer art. It is chiefly in Nepal and Tibet that the so-called 'tight embrace' attitudes are the most common, representing the divine force of creation, of the gift of life.

Standing postures

Kāyotsarga

These can be divided into two categories: standing in a perfectly frontal position, with the feet slightly apart and the legs extended, on a lotus, a throne or an animal (*Samāpada, Kāyotsarga*, Japanese *Ritsu-zō*); or resting on a single leg, the hips slightly swayed, adopting the 'triple flexion' (*Tribhaṅga*, Japanese *Yūkyaku-zō*)) indicated in traditional Indian treatises on art (*Śilpaśāstra*). These positions may be very stiff and symmetrical, or more or less swaying. In the latter case, it is usually the left leg that serves as a support, with the right very slightly advanced. These are postures that can be assumed by virtually all the deities, except for the 'wrathful emanations' (*Vidyārāja*) and many minor deities of Tantrism (including Tibetan).

Dynamic Postures

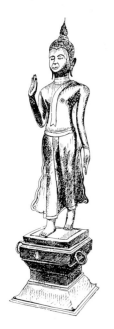

These 'dynamic' or 'moving' postures are relatively numerous in the Mahāyāna and Tantric sects. The most characteristic appears to be the image of the 'walking Buddha' (or 'placing his footprint') in Thai and Laotian art. In these images, which seem to have been 'invented' from certain texts of the Sukhōthai period, perhaps even from the reign of Rama Khamheng (late thirteenth century), this form generally corresponds to the description given of the Buddha in the Pāli canon. Certain representations are made of brick and stucco and placed against a wall (at Sukhōthai), while others are cast in bronze. The general attitude shows the Buddha walking, left foot supporting the body, the right foot slightly behind and raised. In these images, the left hand is in Abhaya mudrā. In some images, however, the right hand is in Abhaya mudrā, and the left hangs beside the body. This walking attitude is found, also at Sukhōthai, in the friezes in the round surrounding the base of a *stūpa* and showing a rank of disciples. Among them, it is the right foot that supports the body, with the left slightly behind. These disciples have the hands in Añjali mudrā on the breast. To the best of our knowledge, these effigies are the only 'dynamic' postures present in Buddhist art of the Hīnayāna sects, except perhaps for certain images of Tevoda or Kiṃnara as flying celestial beings.

In the Tantric and esoteric sects of the Mahāyāna, the dynamic postures are adopted by the four Guardian Kings (Caturmahārāja), wrathful emanations (Vidyārāja), the King of Anger (Krodharāja) and their acolytes; the Dharmapālas; certain goddesses of the Tibetan pantheon, and the fierce masculine deities.

Walking Buddha
Bronze, Vietnam,
seventeenth century,
Hanoi Museum

Acalāsana

This is theoretically a typical attitude of Acalanātha. It is made by bending, the right foot on the ground, the left knee touching the ground behind the body, the left foot raised towards the buttocks. This 'dance' attitude is still typical of certain moments of the traditional dances of Burma, Thailand and Cambodia. In these spectacles, it tends to represent a deity 'flying in the air', the way in which many flying beings (Tevoda, Tepanom, Apsarās, etc.) are represented in the arts of South-East Asia. This attitude is found in the representation of Hi-ten (celestial beings) in Japan (Sui-en at the Yakushi-ji in Nara) and Tiannü (celestial feminine divinities) in the art of China. In Tibet, its use appears to have been rather restricted. It is nonetheless found represented on some statuettes of Mahāsiddhas[17] and on images representing Acalanātha.[18]

Ardhaparyaṅka

This is a much more common dancing attitude, especially in Tibet and in Khmer art. It is typical in Tibet and China of certain goddesses or Ḍākini such as Vajravarāhī, Siṃhavaktrā,[19] of Hevajra and, especially in Cambodia, of certain Apsarās.[20] In this dancing attitude, the slightly bent left leg rests on the ground, supporting the whole weight of the body, while the right leg is bent very high in the space between the legs. It is sometimes more an attitude of 'fierce trampling' than that of a dance. It is perhaps a development of the attitude of Śiva Naṭarāja, the king of dance of the Hindu pantheon, showing Śiva 'dancing' the creation and destruction of the world, while trampling the dwarf Mulāyaka, a symbol of human passions.

Ardhaparyaṅka

This trampling attitude is also comparable to certain Japanese representations characteristic of the Chaturmahārāja (Japanese *Shi Ten-nō*) and of certain Vidyārāja shown in the upright position on demons, on animals or on rocks, one foot slightly higher than the other, which is firmly anchored to the ground. Certain acolytes of deities (Achalanātha, for example) and some specifically Japanese wrathful forms, like Zao Gongen, are also shown in the walking or trampling position, with the right foot raised. These two positions are called *Ja-ritsu-zō* and *Teiji-ritsu-zō* in Japan.

Ālīḍha and Pratyālīḍha

These postures (the first with right knee bent forward and left leg stretched behind; the second the reverse) are more common, especially in the Tibetan representations of the Ḍākini and the fierce masculine deities. The body is bent on the right or left leg, the opposite leg being extended laterally and very far from the other. Hevajra is thus sometimes represented, embracing his consort whose left leg follows that of the deity. The deities adopting this posture are often mounted on animals or gods of Hindu origin. However, whereas the fierce masculine deities (Kālacakra, Yamāntaka, Hayagrīva, Hevajra, Saṃvara, Mahākāla,

Mahāvajrabhairava) of the Tibetan pantheon more readily adopt this posture, the Dhāraṇī usually opt for the Ālīḍha, although they are also often represented in the Pratyālīḍha.

THRONES

The thrones and pedestals on which the deities are placed often condition the postures (āsana) assumed by them. These thrones (pīṭha; Japanese *za, daiza*; Chinese *zuo*) appeared in India and at Amarāvatī and Gandhāra around the second century of our era.[21] They were subsequently universally used in Buddhist iconography. They are generally divided into several categories: lotus thrones (*padmapīṭha*), stands or chairs (*pīṭhikā*), demons and lower deities (such as Yakṣa, for example) or Hindu deities, or support animals (*vāhanas*).

Lotus seat

Lotus Thrones and Pedestals

(*Padmapīṭha*; Japanese, *renge-za*)

These symbolize divine birth, the total purity of the divine being that they support. The lotus flowers usually have three rows of petals, the bottom row with petals curved downward, and the top row supporting the disc on which the deity rests. However, some lotus supports may have many rows of petals. They may be simple, with normal or reversed petals; or double, that is to say placed on a platform or pedestal; or even in a double lotus, with the corolla of the upper lotus normal (Japanese *renben*) and the corolla of the bottom lotus reversed (Japanese *kae-rib-ana*), separated by a ball or ring of horizontal sepals and necks or stems (Japanese *shikinasu*). This particular pedestal is called *kamachi-za* in Japan.

The upper disc supported by the lotus petals and on which the deity is found, either seated or standing, is sometimes bordered with stamens of the lotus flower (Japanese *renniku*). The lotus may also be placed on a large lotus leaf (Japanese *kayō-za*). There may be two lotuses, one for each foot of the deity (Japanese *fumiwari-renge-za*). These lotus flowers may also be placed on the backs of support animals (*vāhana*) corresponding to the deities that they bear: elephant, lion, tortoise, goose, etc. (Japanese *chōjū-za, kinjū-za*) or on stylized clouds (Japanese *kumo-za*).

Certain images of Maitreya in Hanka Shiyui-zō have a simple throne with a projection supporting a lotus flower on which the left foot is placed. Sometimes, especially in the case of the representation of a deity 'straddling' the back of his *vāhana*, the feet rest on lotuses. Finally, certain deities are represented, standing or seated, on lotus leaves.

Stands

These may be square, cubic (Japanese *hō-za, kongō-za*) or diamond-shaped, imitating the mythological Mount Meru (*shumi-za* in Japanese). The diamond-shaped throne (*vajrāsana*, Japanese *shumi-za, sendai-za* and *shitsushitsu-za*) is formed of two inversed pyramids, each theoretically having 16 steps, corresponding to the 32 principal deities of the world of the Vajradhātu. It recalls the seat of the Buddha during his solitary meditation under the pipal tree at Bodh-Gāya. This type of throne is used mainly for the images of the Great Buddhas (especially in China and Japan), although it has also been used to support other deities, sometimes Acalanātha. It signifies the deity's firmness of spirit.

The other simple thrones may have several levels, square, rectangular or octagonal. When covered by fabric falling in several folds, they are called *ten-i-za* in Japan. This type was probably created in Gandhāra, and is found in all Buddhist countries. The thrones may also be made of a rock, a symbol of stability and firmness (Japanese *iwa-za*). The Vidyārāja are often represented on rocks, more or less stylized. Also found are 'river banks or beaches' (Japanese *suhama-za*), a very thick tatami (Japanese *agedatami-za*), an animal skin (Japanese *senku-za, jūhi-za*), a lotus leaf with inversed edges (Japanese *kashō-za*), or a rectangular base ornamented with historical panels on the sides (Japanese *raiban-za*).

The thrones found particularly in Japan are simple folding chairs (*kyokuroku-za*), chairs of religious personages (*shō-za*) and actual thrones. These are usually found, with or without backs, on paintings and frescoes (at Kondō at the Hōrū-ji, in Nara, Japan).[22]

Demon Stands
(Japanese, *shōryō-za*)

Demons that serve as supports for representations of the deities are usually Yakṣas or other lesser deities such as Vināyaka. Ordinary demons are sometimes replaced by animal demons, but this is more uncommon (Shi Tennō at the Hōryū-ji, in Japan). In Tibetan art, animal symbols, miscellaneous personages and Hindu gods often serve as stands (and objects of trampling) for the Ḍākinī and the fierce masculine deities.

Animal Stands
(*vāhana*; Japanese, *chōjū-za, kinjū-za*)

In Buddhist and Hindu iconography, a particular animal is often associated with a particular deity. Both in painting and sculpture, many deities are found mounted on their support animals. Thus lions are found (Great Buddhas and Bodhisattvas, such as Mañjuśrī); elephants (Bodhisattvas, Indra); peacocks; *Garuḍas*; horses; buffalo of various colours; and sometimes, for some specific deities, a wild boar (for Mārīcī); goats, rams, etc. Tibetan, and especially Japanese and Chinese iconography, makes considerable use of these support animals, whereas they are rather rare in the representations of the deities belonging to the Southern schools.

Mahāmayūrī on his peacock

AUREOLES
(*cakra*; Japanese, *kōhai*)

The aureoles, haloes or auras that indicate the divinity or saintliness of a personage are placed behind the statue or image. These *cakras* are of two main types: head aureoles (Sanskrit *śiraścakra*, Japanese *zukōhai*) and body aureoles or auras (Sanskrit *prabhāvalī*, Japanese *kyoshinkōhai*). These aureoles may be simple, in several parts, flaming (*jvāla*) or composite. They may be solid, hollow, ornamented with rays, lotus flowers, celestial damsels (Apsarās), celestial birds (Kalaviṅkas), celestial musicians (Gandharvas), Kiṃnaras or, in esoteric Buddhism, with 'bodies of transformation, of apparition' (Japanese *Kebutsu*). These are sometimes replaced by wish-granting jewels (Sanskrit *cintāmaṇi, maṇi*, Japanese *hōshu*), or by seed syllables (Sanskrit *bīja*, Japanese *shūjī*). These aureoles, of metal or wood for the sculptures, are sometimes works of extreme delicacy, fixed either to the base or the body of the statues (the latter position was common in the Asuka period in Japan).

In India, aureoles are found very early in Buddhist art, but not before Gandhāran art of the Kushāna period in the second century of our era. They are round, sometimes highly decorated. Some Nāgarāja (e.g. Ajantā, cave number 19) have a sort of aureole formed of hoods of *Nāga* serpents. In the Pāla and Sena art of Bengal, from the eleventh and

Mārīcī on his wild boar

twelfth centuries, this aureole is enlarged to include the entire body, 'in glory', and the heads of the Buddha and Bodhisattvas are also ornamented with smaller, elongated aureoles, which seem to be attached to the shoulders. In South-East Asia, the aureoles are less common and generally simple, sometimes elongated and fixed to the shoulders. In Central Asia and China, from the Wei period, the body of the Buddha is sometimes ornamented with a 'mandorla', where the head itself is surrounded by a sort of pointed halo attached to the shoulders, sometimes ornamented with emblems symbolizing the flames of the spirit. Many personages are represented with a halo pointed at the top like a pipal leaf; this halo is duplicated by a head aureole. Composite aureoles appeared in the Tang period and were commonly used in Japan by the esoteric sects. The art of Tibet made considerable use of these composite aureoles.

Śiraścakra in flames

Head Aureoles
(*śiraścakra*; Japanese, *zukōhai*)

These are usually circular and consist of a gilded or coloured circle, perforated or solid, or a simple circle (Japanese *rinkōhai*) sometimes surrounded by extended spokes. These aureoles sometimes assumed the form (in images of the Caturmahārāja, among others) of wheels with four or eight spokes (Japanese *rinbōkōhai*). Certain head aureoles assume a form slightly pointed upward, either as a pipal leaf (rare) or as a *cintāmaṇicakra* (Japanese *hōshugatakōhai*). Others are ornamented with short flames. These head aureoles are usually fixed to the body of the statue, but some of them may be fixed to the base or the throne.

Cintāmaṇicakra

Body Aureoles
(*prabhāvalī*; Japanese, *kyoshinkōhai*)

We have seen that these can assume several forms: simple aureoles may be rectangular (rare) and slightly pointed at the top, like lotus petals (Japanese *rengengatakōhai*), or have the form of a boat, narrow at the base (Japanese *kofunagatakōhai*), or a sharply pointed keel, curved forward as if to protect the head of the deity (Japanese *shin-funagatakōhai*). These simple aureoles are sometimes decorated with clouds (Japanese *kumo-kōhai*) or celestial beings (Japanese *hiten-kōhai*). They are characteristic of certain divine images of the Wei period in China, and images of Amida in Japan.

Aureoles in several parts are usually composed of two round aureoles placed one above the other, either simply superposed and touching edge to edge, or overlapping, the higher (of the head) being smaller than the one surrounding the body and overlapping it, or inscribed in a third circle (Japanese *ensōkōhai*), or formed of a head aureole placed on a sort of rectangular paravent (Japanese *mibu-kōhai*). They usually indicate that the deity belongs to the esoteric domain.

A B

A: Kofunagatakōhai
B: Shin-funagatakōhai

A: Kyoshinkōhai
B: Kumo-kōhai

A: Tokoshin-kōhai
B: Kumo-kōhai

Flaming aureoles (*jvāla*) are those surrounding the head of the wrathful or fierce deities such as the Vidyārāja. However, some flaming aureoles may also surround the head of the Buddha. They may also consist of flames surrounding the entire body, as in the case of Vidyārāja, for example: these flames devour the passions and consume desires, signifying the zeal of the deities in defending the Law and the Buddha. Composite aureoles are relatively diverse, either in richly worked mandorlas ornamented with divergent rays (Fukūkensaku Kannon of the Tōdai-ji, in Japan), or ornamented with 'a thousand Buddhas' (Japanese *senbutsu-kōhai*).

IMPLEMENTS AND ACCESSORIES OF THE DEITIES

In the traditional category of mudrās with forms, the hands of the deities hold various implements that symbolize their virtues and powers, both material and spiritual. These symbols, *lakṣana* (to which the nearest equivalent in Japanese is *jimotsu*)[23] or *cihna*, 'emblems' (also called *dhvaja*, 'flag', 'standard'), can be divided into several categories for the convenience of description, at least the most important of them: lotuses (*padma*), thunderbolt–sceptres (vajra), bells (*ghaṇṭā*), wheels (*cakra*), weapons (*āyudha*), pots (*kalaśa*), maces (*gadā*), ritual accessories and instruments typical of certain sects. The list given here is not comprehensive, since these attributes are extremely numerous, and vary with sect and region.

Lotus

Lotuses are symbols of purity and 'spontaneous' generation (*svāyambhū*) and hence symbolize divine birth. According to the *Lalitavistara*, 'the spirit of the best of men . . . is spotless, like the new lotus in the [muddy] water which does not adhere to it',[24] and, according to Tajima Ryōjun,[25] 'in esoteric Buddhism, the heart of the beings is like an unopened lotus: when the virtues of the Buddha develop therein, the lotus blossoms; this is why the Buddha sits on a lotus in bloom'. In Tantrism, it is the symbol of the feminine principle, and, in Śaktism, it represents the female sex organ, because, according to the *Śatapatha Brāhmaṇa*, the lotus leaf symbolizes the womb. The lotuses are usually differentiated by their colour and grouping, in three or five flowers, which may or may not be combined with leaves.

Lotus leaves and flowers

White lotus

(*puṇḍarīka*; Japanese, *byakurenge*)

This symbolizes *Bodhi*, the state of total mental purity and spiritual perfection, and the pacification of our nature. It generally has eight petals corresponding to the Noble Eightfold Path of the Good Law. It is the lotus found at the heart of the Garbhadhātu Maṇḍala, being the womb

or embryo of the world. It is characteristic of the esoteric sects, and the lotus of the Buddhas.

Red lotus

(*kamala*; Japanese, *gurente*)

This symbolizes the original nature of the heart (*hṛdaya*). It is the lotus of love, compassion, passion, activity and all the qualities of the heart. It is the lotus of Avalokiteśvara.

Blue lotus

(*utpala, nīlotpala*; Japanese, *seirenge, shōrenge*)

This is the symbol of the victory[26] of the spirit over the senses, of intelligence and wisdom, of knowledge. It is always represented as a partially opened bud, and (unlike the red lotus) its centre is never seen. It is the lotus of Mañjuśrī, and also one of the attributes of Prajñāpāramitā, the embodiment of the 'perfection of wisdom'.

Pink lotus

(*padma*; Japanese, *renge*; Chinese, *lianhua*)

This is the supreme lotus, generally reserved for the highest deity, sometimes confused with the white lotus. It is the lotus of the historical Buddha.

Purple lotus

(Japanese, *shirenge*)

This is the mystic lotus, represented only in images belonging to a few esoteric sects. The flowers may be in full bloom and reveal their heart (Japanese *kairenge*), or in a bud (Japanese *jirenge*). They may be supported by a simple stem, a triple stem (symbolizing the three divisions of Garbhadhātu: Vairocana, lotus and vajra),[27] or a quintuple stem (symbolizing the Five Knowledges of Vajradhātu). The eight petals represent the Noble Eightfold Path and the eight principal acolyte deities of the central deity on the maṇḍalas. The flowers may also be depicted presented in a cup or on a tray, as a symbol of homage (Japanese *rengedai*).

In place of a lotus flower, some deities, like Bhaiṣajyaguru or Avalokiteśvara, hold a willow branch in the hand (representing medicine) or a bunch of grapes, or another flower (rare). Plants and flowers other than these are not attributed to the deities, but to other personages and acolytes.

Thunderbolt–Sceptres

(vajra; Tibetan, *rdo-rje*; Japanese, *kongō-sho*; Chinese, *jingangchu*)

Thunderbolt–sceptres have an unclear and distant origin (they are found on Mesopotamian effigies). Mainly employed by Tantric Buddhism in Tibet, and in the Chinese and Japanese esoteric sects, they were used in Vedic ritual to dispel evil forces from the sacrificial enclosure, and

Bell and vajra
Esoteric symbols, bronze,
Tibet, Author's Collection

A: Single-pointed vajra
B: Cintāmaṇivajra

Three-pointed vajra

Five-pointed vajra

hence came to symbolize spiritual forces and firmness of spirit.[28] They can perhaps be compared with the tridents often used in India to symbolize power. In the esoteric sects, they symbolize (as absolute weapons) the victorious power of knowledge over ignorance, of the spirit over the passions: 'the vajra symbolizes knowledge as the lotus flower symbolizes innate reason.'[29] They are considered to annihilate spiritual poisons and to be an effective weapon against evil thoughts and desires.

The thunderbolt–sceptre is the favourite weapon of Indra in the Hindu pantheon, with which – according to Buddhist tradition – he cleaves in two the enemies of Buddhist Law. In many Tantric sects (and especially in Śaktism), the thunderbolt–sceptre represents the male genital organ, and is accordingly often combined with the lotus flower, or shown in one hand when the other holds the bell (*gaṇthā*), which represent the vagina. Thus it may also symbolize the masculine principle, with the bell representing the feminine principle.

Single-pointed vajra
(Japanese, *tokkosho*)

This possesses only one point on each side of the short handle. The point has a square section, short and not tapering. This vajra appears to symbolize the vertical axis of the universe[30] and the union of the material world with the spiritual world, as well as that of the two great maṇḍalas, the Vajradhātu and the Garbhadhātu Maṇḍalas. In the Tantric sects, this instrument is used only by monks of lower rank, and represents the Unique Reality of the Dharma.[31]

Two-pointed vajra
(Japanese, *nikosho*)

This resembles the nippers of an earwig, and represents the duality of appearances. It is very rarely used or represented.

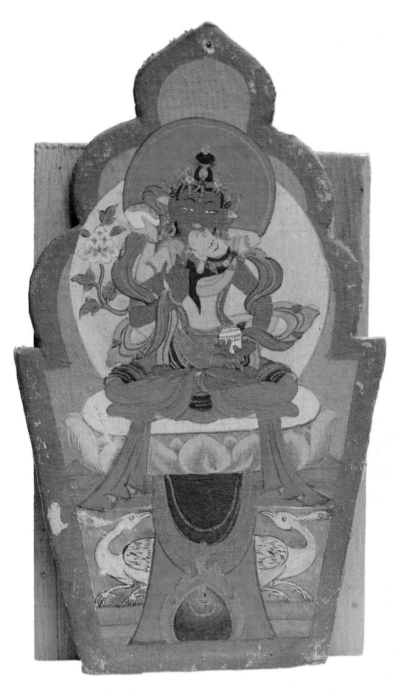

Headdress of a Tibetan Lama, detail representing a deity in Yab-yum, Tibet,
twentieth century, Private Collection

Head of a walking Buddha, gilded bronze, Sukhōthai, Thailand, fourteenth century, Bangkok Museum

Three-pointed vajra

(Japanese, *sankosho*)

This is the most common, to which the term vajra is most often applied. It has three points on each side, the two outer points curved towards the straight central point, or three points curved towards the middle. In the material and spiritual universe, these three points represent the *Triratna*, the 'three jewels' of Buddhism (the Buddha, the Dharma and the Samgha), and the three mysteries of word, thought and action.[32]

The karmavajra (Japanese *katsumasho*) is formed of two double vajras with three points arranged in a cross. It symbolizes the Four Knowledges and corresponds to the Wheel of the Law. It is also called *viśvavarṇa-vajra* (Japanese *kongōsho*).

Four-pointed vajra

(Japanese, *shikosho*)

This is a rather uncommon form. It symbolizes the four 'events' in the life of the Buddha Gautama, the four Buddhist periods and the Four Great Buddhas.[33]

Five-pointed vajra

(Japanese, *gokosho*)

The points of this vajra are arranged in a crown, or are grouped in fours arranged around an axis. Many varieties exist with different forms and decorations. Many of these quintuple vajras decorate bell handles. They symbolize the five elements, the five Jinas and the five sorts of wisdom.

Nine-pointed vajra

(Japanese, *kyūkosho, kukosho*)

This vajra, rather rare (mainly used in Tibet), has nine points on each side, usually arranged in a crown. Its significance is unclear. It may symbolize the Five Jinas and the four great Bodhisattvas.

Bells

(*ghaṇṭā*; Japanese, *kongōrei, kane*; Chinese, *zhong*; Tibetan, *dril-bu*)

Bells are often found, as stated above, in opposition or as a complement to the vajras in the representations of the esoteric deities. Like the vajras, they also serve as ritual instruments. They are generally small and have a short handle terminating either in a vajra, or in a small *stūpa* or triple jewel (*cintāmaṇi*). They symbolize sound, the creative word, the vibration generated by the repetition of a *mantrā* and of the *bīja*, and thus have a creative, innovative function. They are also intended to call hearts to the Awakening. When vajras and ghaṇṭās are combined, they represent the two great maṇḍalas, the Vajradhātu and Garbhadhātu Maṇḍalas. Since the sound is generally very brief, the bell, through its tinkling, represents that everything is of short duration, that all is fleeting.

A B

A: *Stūpa* bell
B: *Cintāmaṇi* bell

C D

C: Three-pointed vajraghaṇṭā
D: Single-pointed vajraghaṇṭā

Karmavajra

Two forms of the Dharmacakra

At least seven sorts of bell are found, depending on the shape of their handles: with a single-pointed vajra (Japanese *tokkorei*); a three-pointed vajra (Japanese *sankorei*); a four-pointed vajra (Japanese *shikorei*); a five-pointed vajra (Japanese *gokorei, godai, myō-ō-rei*); a nine-pointed vajra (Japanese *kyūkorei*); with a handle terminating in a triple jewel (Japanese *hōshurei*), and with a handle terminating in a small *stūpa* (Japanese *tōrei*).

Wheels

(*cakra, dharmacakra*; Japanese, *rinbō, hōrin*)

Wheels symbolize the Wheel of Buddhist Law, the endless cycle of birth and rebirth. They are round, with four spokes, symbolizing the Four Jinas or the four 'moments' in the life of the Buddha; or with eight spokes, or octagonal, symbolizing the Noble Eightfold Path. The spokes sometimes extend beyond the circle, in points. These wheels, represented in Indian art even before the period of King Aśoka (c. 272–232 BC), were generally placed on four lions, back to back, and facing the four cardinal points. They are also the Buddhist counterpart of the 'disc' of the Hindu god Viṣṇu and, like the vajra, represent the absolute weapon that conquers the passions and annihilates desires. Intersecting vajras (*karmavajra*) are sometimes considered as wheels.

Weapons

(*āyudha*; Japanese, *buki*)

Weapons held by the deities serve to symbolize the combat offered by them against the adverse forces – demons, ignorance and stupidity – and symbolize the protection of the Buddha and the Buddhist Law. In some cases, they also represent the virtues and powers. These weapons are never found on representations belonging to the Hīnayāna sects. On the contrary, they were widely employed for representations of the

deities belonging to Tantrism and the esoteric sects, in Tibet, as well as China and Japan. They can be divided into four major groups (in addition to the vajras and *cakra*s that we have just reviewed): swords, spears and tridents, axes, and bows and arrows.

Swords

(*khaḍga*; Japanese, *ken, tsurugi, katana*; Chinese, *jian*)

These serve to cut away ignorance and attack the powers of evil. They are also a sign of command and wisdom, of supreme knowledge and of perfect understanding. Many varieties exist.

Straight two-edged swords

These have a hilt of which the guard consists either of a three-pointed vajra (the blade forming the central point of the vajra), or a five-pointed vajra (Japanese *sankotsuka-no-ken, gokotsuka-no-ken*). The sword of knowledge, which Acalanātha often holds vertically, is often represented surrounded by flames or a dragon (also called *gomagatana* or *shibauchi* in Japan).

Vajrakhaḍga

Curved single-edged sabres

Typically Japanese (Japanese *katana, tachi*), they are practically never used except by the minor personages, Caturmahārājas or Dharmapālas.

Spears and tridents

(*kunta, triśūla, śūla*; Japanese, *sho, kō, hoko, sankogeki, sansageki, sansabō*; Chinese, *mou, sanguji*)

Spears, associated with the idea of fire and virility, symbolize the male power of penetration, the power of good and of truth over ignorance. They are single, terminating in a vajra or a point, or in a trident. The tridents are symbols of the Triratna (the Buddha, the Dharma and the Saṅgha) and the Tripiṭaka (the three collections of scriptures which make up the Buddhist canon). They are very ancient, and can be seen on at least one seal of the Indus Valley, crowning a seated deity. From the earliest testimonies of Buddhist art, they are represented crowning the Wheels of the Law (as at Sāñchī). A 'triple staff' (*tridaṇḍa*), which could be compared with a trident, is one of the attributes of Avalokiteśvara in India, which originally served as a vase support.[34] In Japan, when the spears terminate in two vajras with three points fixed at right-angles, they are called *ko* (Chinese *ge*) or *hōko*. When they terminate as a pike with three vajras, they are called *katsuma-sho*.

Triśūla (three forms)

Axes

(*paraśu, ṭaṅka*; Japanese, *ono, etsufu, eppu*; Chinese, *fu*)

Axes symbolize the cutting away of obstacles, hence the beginning a task, or the clearing of the path that leads to knowledge. They also serve the minor deities (or those with multiple arms) to indicate their protective role of the Buddha or of the Law.

Paraśu

Bows and arrows

(*cāpa, śara*; Japanese, *yumi, sen, ya, bōkyō, bōsen*;
Chinese, *gong, shi*)

As well as serving to destroy the passions, these weapons symbolize concentration and wisdom. The union of the bow and arrow may also symbolize love. Some arrows terminate in a point with three teeth (*triśūlaśara*) or in flowers, as is the case of Aizen Myō-ō in Japan. The arrow of Kāma, the deity of carnal love, is made of five flowers placed end to end.

Vases

(*kalaśa, kamandalu*; Japanese, *byō*; Chinese, *ping*)

Vases symbolize the offerings made to the deity and sometimes the offering of treasures: 'the flowers of the vase represent the innumerable virtues whose blossoming results from the union of innate reason and knowledge.' Several sorts are distinguished.[35]

Kalaśa (Kuṇḍikā)

Flower vases

(*kalaśa, bhadraghaṭa*; Japanese, *kebyō*)

With rounded bellies and wide necks, they are often used in the rituals of esoteric sects. The vase with lotus flowers is one of the attributes of Avalokiteśvara, and certain esoteric sects claim that the union of the lotus and vase is symbolic of the union of the two great maṇḍalas. The flower vase is of very ancient origin, and is found in India from the beginnings of Buddhist art, as the base or capital of a pillar, or in decoration, symbolizing the earth and its riches (*pūrṇaghaṭa*, or 'pot of plenty', Japanese *honnōgata, hichijōbyō*).

Water pots and vases of nectar

(*kuṇḍikā, amṛta-kalaśa*)

These are also diverse and may have several forms. They usually have a long neck and often a spout (Japanese *suibyō, gunji, sōbyō, suikan*), or are ornamented with a bird's head (Japanese *hōbyō, kōbyō*). However, the traditional form of the *kuṇḍikā* has a sealed lid, at the centre of which is a narrow neck. These water vases are often of the type once used in India to pour water in the ritual of the consecration of a king. They play a very important role in all the esoteric cults, being nearly always associated with the lotus, which symbolizes supreme understanding. In the case of Avalokiteśvara, the vase is considered to contain the nectar of his compassion: it assuages the thirst of those who pray to him. Vases also represent the five Jinas, and in this connection are usually placed at the four corners and at the centre of shrines. They are considered to contain all medicines, all foods, all good things and perfumed water.

Monk's sceptre
Decorated with five lions,
tortoiseshell, gold and
silver, Japan,
ninth century

Staves (daṇḍa) and Clubs (gadā)

These are of many kinds.

Staff of wisdom or treasure

(khaṭvāṅga; Japanese, hōbō)

Khaṭvāṅga means 'club-shaped like the foot of a bedstead'. It has a skull at the top, and is considered as the weapon of Śiva by esoteric devotees of that god. This symbolizes the possession by its bearer of the infinite treasure of the wisdom of the Buddha.

Monk's sceptre

(Japanese, nyo-i, sekaki; Chinese, ruyi)

This sceptre has a spatula curved as a scratcher, and is considered to contain a jewel.

Beggar's staff

(khakkhara; Japanese, shakujō, yūshōjō; Chinese, xizhang)

This monk's or begging staff is ornamented at its top end with metal rings. It appears to have originated in Central Asia, since the earliest representations of this type of staff were found on the wall paintings of Dunhuang (c. fifth century) and at Turfān. It was often used in Tibet, China and Japan, but does not appear to have been used in India. Intended to warn animals of the approach of a holy man, and to announce to the villagers that a monk is arriving to beg for food, it was used in Tibet to expel demons.[36] In China, it is one of the eighteen personal possessions permitted to a monk. Its shaft is generally of wood, with a hexagonal or round cross-section, and the rings are of metal so as to make a noise when they clash.

Khakkhara with six rings
Symbolic of Kṣitigarbha

Theoretically, the Buddha himself can have a khakkara with twelve rings. Others may have four, six or eight rings, depending on the country and the period: there are six on the staff of a Bodhisattva (symbolizing the six gati, 'the destinies of rebirth') and two on the staff of an Arahant or mortal sage. Different symbolisms are attached to these numbers. This staff is a typical attribute of Kṣitigarbha (Japanese Jizō

Bosatsu, Chinese *Di-zang*), but may be held by Amoghapāśa or Bhaiṣajyaguru in China, in particular.[37] In Japan, it is also called *chi-jō* (staff of knowledge) and *tokujō* (staff of virtue).

Staves terminating in a skull
(Japanese, *dokurojō*)

These may also terminate in a human head placed on a crescent moon (Japanese *jintōjō*)[38] or in a head placed on a mirror,[39] or even two human heads (in the case of Yamarāja). They symbolize the impermanence of this world; the magical implements are used to expel demons.

Other Instruments and Accessories

Begging bowl
(*pātra*; Japanese, *hachi*; Chinese, *bo*)

All Buddhist monks must possess a begging bowl in which they may collect food offered by lay supporters. There is a legend about its origin according to which the Buddha, being offered food by some merchants and having nothing in which to hold it, magically combined into one four stone bowls offered to them by the four guardian kings. It subsequently became a symbol of the Law, therefore of the Buddha himself. Its origin is undeniably Indian: images of the Buddha holding a bowl are found in the art of Gandhāra. The representations of the historical Buddha (sometimes also of Amitābha, more rarely of Avalokiteśvara) show these deities holding the bowls either in one hand, or with both hands (see Buddhapātra-mudrā, p. 47). Bhaiṣajyaguru is also represented holding an unguent jar in both hands or, more often, in the left.

Rosary
(*mālā*; Japanese, *nenju*; Chinese, *nianzhu*)

Probably an adoption by Buddhism of the Hindu rosary, the *mālā* assumed considerable importance in the Tantric rites, in Tibet and especially in Japan. This rosary normally has 108 beads (as does the Hindu rosary), plus four separating beads (for easier counting) called Caturmahārāja. Rosaries may, however, differ slightly according to region. In Tibet, they generally terminate in three large beads considered to represent the *Triratna*. In Japan, the symbolism of the Shingon elaborated it, and the 108 beads were divided into two series of 54 by one or two large beads (*bindu*, Japanese *odome* and *oyadama*). In India, since the Gupta period, it has been an attribute of Avalokiteśvara. Theoretically the 108 beads symbolize the one hundred and eight human passions that Avalokiteśvara assumed while telling the beads; it is also an auspicious number as it is divisible by three. Amitābha is represented holding a rosary, as are a number of other deities and holy men. Although uncommon, rosaries with beads in other multiples of

three are also found: nine, 18, 21, 42 and 54 beads. In China, the rosary
with 18 beads represents the 18 Arahant.

The 'wish-granting jewel'

(*cintāmaṇi, maṇi*; Japanese, *hōshu, nyo-i-shu*; Chinese, *ruyizhu*)

Cintāmaṇi
'Wish-granting jewel'

This is the gem which 'grants wishes or satisfies all desires', in the form
of a ball pointed at the top. It represents all the treasures, and especially
understanding of the Buddhist Law, which brings freedom from desire
and therefore satisfaction. It has the power of clarifying turbid water
– that is to say, the heart.[40] Many legends recount its origin. It is one of
the *Saptaratna*, the 'seven jewels' of the universal king, Chakravartin
(Japanese *shippō, shichihō*). The others are: the wheel (*chakraratna*,
Japanese *hō-rinbō, kinrin*); the elephant (*hastiratna*, Japanese *hō-zō, zō-
hō*); the horse (*ashvaratna*, Japanese *danpō, ba-hō*); the woman
(*strîratna*, Japanese *nyo-hō*); the intendant or assistant (*grihapariratna*,
Japanese *shuzō-hō*), and the guide or commander-in-chief (*par-
ināyakaratna*, Japanese *shuhyōshinpō*). This list has variants, and the
seven jewels may also be 'seven precious metals'.[41]

It is sometimes represented alone, sometimes in threes, or sur-
rounded by flames. The triple jewels placed at the end of a short han-
dle, like a vajra, form an instrument used in esoteric rituals, called
hōshusho in Japan.

Fly-whisk

(*cāmara*; Japanese, *bossu*; Chinese, *fuzî*)

Cāmara
Fly-whisk

This represents obedience to the Buddhist Law: by avoiding the death
of the insects, it has become a symbol of the compassion of
Avalokiteśvara towards all beings. It is theoretically formed of white hairs
(yak or horse hair) or thin cords fixed to a short handle; some texts say
that it is made of deer hair. In India, it was the insignia of courtesans.
In Indian Buddhist art, the effigy of the Buddha is often accompanied
by two carriers of *cāmar*; it then became the typical accessory in rep-
resentations of all holy men.

Conch shell of the Dharma

(*dharmaśaṅkha*; Japanese, *hōra*; Chinese, *faluo*; Tibetan, *dung-dkar*)

Used as a horn in India in religious ceremonies and by armies, the conch
shell, by virtue of its low and prolonged sound, symbolizes the sound
of the Buddhist Law. Of Indian origin (it is one of the four major attrib-
utes of the Hindu god Viṣṇu), it was adopted by Buddhism to symbolize
the dissemination of the Law by the voice of the Buddha.

Mirror

(*ādarśa*; Japanese, *kagami*; Chinese, *jing*)

This symbolizes emptiness, 'idea' as opposed to 'phenomenon'.[42]
Reflecting material things, it gives only ideas of them and strips them
of any reality; hence it is a symbol of the illusion of existence. In Japan,

however, it may also represent the disc of the sun, as for the Japanese deity Nichi-ten.

Rope

(*pāśa*; Japanese, *saku, kensaku, ryūsaku*; Chinese, *luoso*)

The rope or noose may be simple, with each end terminating in a knot, a vajra or a hook, or it could have a slip knot possibly terminating in a dragon's head. It symbolizes the instrument with which souls are bound, hooked or drawn by the Buddhist Law. In the hands of some deities, it is the bond that prevents demons from doing harm. Yet it also symbolizes the bond that ties the soul to the material world of desires.

Book of scriptures

(*pustaka*; Japanese, *kyō, ō-kyō*; Chinese, *jing*)

It represents the Buddhist canon which contains the Law, the *Tripitaka*. It is sometimes associated with a brush, and sometimes replaced by a roll.

Reliquary

(*stūpa*; Japanese, *sotoba, tō*; Chinese, *shuaidupo, ta*;
Tibetan, *mchod-rten, chorten*)

Held in the hand by certain deities, or placed on the head, the scaled-down *stūpa* (also considered as a reliquary) participates in the same symbolism as the full-scale *stūpa*, and represents the body of the Buddha and his Law, both his person and his 'spiritual body' (*Dharmakāya*). It is also an attribute of Maitreya, the future Buddha. In the Garbhadhātu Maṇḍala, it is the particular attribute of Mahāvairocana.

In esoteric symbolism, the form of the *stūpa* was schematized by a succession of simple geometric figures. From the bottom upward these are: a square, a circle, a triangle, a semi-circle, and a jewel or flame, superposed and considered to represent the cosmos. The square represents

Reliquary
Bronze, Kurama-dera,
Kyōto, Japan,
twelfth century

Reliquary
Bronze, Tibet

matter, the circle knowledge, the triangle the spirit, the semi-circle the
Law, and the flame the supreme Principle. However, other interpreta-
tions of these symbols have been given which differ according to the
sects and authors: it symbolizes the supreme Deity, and is the Japanese
Gorintō (*stūpa* of the hundred senses). In China and Japan it is dis-
tinctive of the effigies of Vaiśravaṇa, one of the four guardian kings.

In practice, while the original form of the *stūpa* continued in India,
it was slightly modified in Gandhāra and Tibet, finally becoming a
'pagoda' in China and Japan. In these two countries, the original form
of the *stūpa* is preserved only in the reliquaries and in certain pagodas
called *tahō-tō* in Japan.

Miscellaneous symbols and accessories

Various implements are held by deities with multiple arms, to symbolize
their material and spiritual powers, especially in the case of the thou-
sand-armed Avalokiteśvara. They also vary with the minor deities, indi-
cating whether their nature is esoteric or not.

Among the most common of these accessories are: the elephant goad
(*aṅkuśa*, Japanese *kō*); the key (*kuñcikā*, Japanese *kagi* or *hōyaku*); the
fan, generally not folding (called in Japan *uchiwa* or *tensen*, and *jōsen*
if made with peacock feathers), or *ōgi* if it can be folded; straw sandals
(Japanese *waraji*); the *sūtra* box (Japanese *kyōkyō*); incense burners, with
handles (Japanese *egōrō*) or without handles (Japanese *gōrō*), which are
also ritual implements; the shield (*khetaka*, Japanese *bōhai*), sometimes
ornamented with a monster's head; the seal, called *hō-in* in Japanese,
and the 'five-coloured cloud' (Japanese *goshiki-un*). See also under
Avalokiteśvara in Chapter V.

Aṅkuśa
Elephant goad

Ritual Implements

In addition to incense burners, these are sometimes represented on
images showing several deities and their officiants, especially in
Japan. The last three listed are particularly important in Tibetan ritu-
als.

Gong

Of spherical wood, in the form of a fish (Japanese *mokugyo*) or flat, also
in the form of a fish (Japanese *gyoban*), of metal, in the form of a bowl
(Japanese *in-kin, kinsu*), and serving to punctuate the reading of the
sūtras.

Staves of the Zen monks

(Japanese, *shippei*)

Used to keep the monks awake during *zazen* exercises (seated non-med-
itation).

Flower trays
(Japanese, *keko*)

Trays designed to hold various instruments of the esoteric cults, like the vajra and *ghaṇṭā*.

Portable cupboards
(Japanese, *oi, katabako*)

These serve to hold the personal effects of the wandering monks, as well as cult accessories and the rolls of *sūtras*, used in China since the sixth century.

Prayer wheel
(Tibetan, *hkor-brten*)

This is generally made of a cylindrical body of repoussé metal, penetrated along its axis by a wooden or metal handle. The cylinder can turn around the handle, with a slight rotation of the wrist, thanks to a cord or ballasted chain which keeps it in movement. Inside this cylinder, written on paper or skin, are esoteric texts, usually invocations (*dhāraṇī* or *mantra*), the most common being that of Avalokiteśvara: '*Oṃ Maṇi Padme Hūṃ* [Oṃ the Jewel in the Lotus Hum]'. These prayer wheels may be small and carried by pilgrims, or larger and fixed to the gates of monasteries or around *stūpas* and *mchod-rten* (as at Bodhnāth in Nepal). Each turn of the cylinder generates as much merit as the reading of the *sūtra* or the formula enclosed therein. All these objects are also called *chhos-hkor* in Tibetan, 'Wheel of the Law'. Some are very large and, enclosed in small structures, turn under the action of a 'mill' driven by water.

Prayer wheels
Exterior and interior,
copper repoussé, Tibet

Nail

(Tibetan, *phur-bu*)

This may be made of metal, simply drawn, or painted. It affects the shape of a short dagger with a triangular blade, with a hilt ornamented with a head and a vajra. It is used in rituals to expel demonic forces or diseases, with the hilt or the base of the blade often inscribed with *dhāraṇī*. Three joined *phur-bu* form an instrument considered to be extremely effective.

Chopper

(*karttṛkā*; Tibetan, *gri-gug*)

This is a sort of semi-circular blade with a handle inside at the middle of the circle, which serves symbolically to 'cut off ignorance'.

Miscellaneous Symbols

Musical instruments

No musical instrument appears to have been specifically represented in connection with the personages of the Buddhist pantheon in India or in South-East Asia, apart from a few representations of instruments in the hands of celestial personages such as Kiṃnara and Gandharva, or secular figures (e.g. in the bas-reliefs of Amarāvatī). Most of the typical Indian instruments were nevertheless used as attributes of Hindu deities. Some of these instruments were adopted by the sects of esoteric Buddhism of the Northern schools, especially in Tibet and, exceptionally, in Japan. Drums with one or two skins, as well as various cymbals used in Asia, are among the ritual instruments, in addition to a number of wind instruments, conch shells and trumpets. In Tibet, a sort of short trumpet (Tibetan *rkang-gling*), made of a human or animal thigh bone, is sometimes represented in the hands of deities. Also in Tibet, an instrument of Indian origin was adopted, the *ḍamarū*, a small two-sided drum struck by a small weight fixed to the end of a cord and which, by a twist of the wrist, alternately strikes each of the two sides. It is made with the top halves of two skulls joined at the peak, with hide stretched over the hollows of the two outer sides. Note also the bells (Tibetan *dril-bu*) which also originated in India.

The Hindu deities adopted by Buddhism (e.g. Sarasvatī, or Benzaiten in Japanese) retain their characteristic instruments, although these are sometimes replaced by corresponding local instruments.

Seed-syllables

(*bīja*; Japanese, *shūji*)

The symbol sounds or seed-syllables symbolically represent the essence of each deity. They are Sanskrit syllables derived from the so-called Siddham alphabet, of which the pronunciation is considered to evoke

Phur-bu
Magic dagger, Tibet

Karttṛkā
Magic cleaver, Tibet

the corresponding deity. They are nearly always found associated with the representations of esoteric deities. Various opinions have been expressed concerning their origin and their attribution to the different deities. In this study, we discuss the *bīja* taken from the *Butsuzō zu-i*, in the illustrations where they accompany the name of the corresponding deity. In painting and in sculpture, these *bīja* may be represented with the deity, often on the surrounding aureoles.

Footprints of the Buddha
(*buddhapāda*)

Footprints of the Buddha
Pegu, Burma,
twentieth century

The footprints of the Buddha are venerated in all Buddhist countries. These highly schematized footprints generally show all the toes to be of equal length, and are incised in stone. They often bear distinguishing marks (especially, in India, those of the feet of Viṣṇu) – either a *cakra* at the centre of the sole, or the 32, 108 or 132 distinctive signs of the Buddha, engraved or painted on the sole and inscribed in a sort of chequerboard pattern. These imprints are especially venerated in countries such as Sri Lanka, where they are protected in a special structure, sometimes highly elaborate. Finally, a few images are found chiefly in Tibet on the *thangkas*: the prints of the hands and feet of holy personages, generally applied during the ceremony of consecration of the image.

Ornaments and robes
(*cīvara, kaṣāya*; Japanese, *kesa*)

The very person of the historical Buddha is rarely represented other than clothed in a monastic robe sometimes leaving the right shoulder bare in the representations belonging to the Southern schools, although certain so-called 'robed Buddhas' appeared late in Laos and Thailand. In the representations of the Great Buddhas or Jina of the Mahāyāna schools, both shoulders may be covered, differently according to the sect. Maitreya, the future Buddha, is nearly always represented as a robed Buddha, with a robe covering both shoulders, a crown (*mukuṭa*) or a tiara, and many jewels (bracelets, earrings, breast jewels). Amitābha, like the other Jinas, may be represented covered with jewels and crowned. Sometimes Bodhisattvas wear a robe (which may or may not cover both shoulders), and they may also be richly ornamented with jewels and tiaras. Monks are dressed according to the custom of their sect.

Svastika
(Japanese, *manji*; Chinese, *wanzi*; Tibetan, *gyung-drung, geg-gsang*)

Sv-asti means 'it is well'; the svastika is a very ancient sign of Indian origin, used as an auspicious mark on structures, images or instruments. It is a cross with the extremities of each arm bent at right-angles. It is sometimes drawn on the breast of the Buddha or on one of the Jinas, or on their palms or the soles of their feet.

III

THE BUDDHA AND THE GREAT BUDDHAS

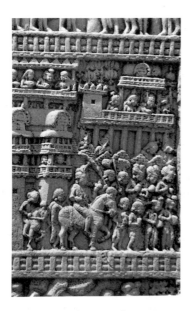

**The departure from
the Palace of Kapilavastu**
Sāñchī, India, pillar of *stūpa* no. 1,
first century

Characteristic Attributes
The Historical Buddha
Bhaiṣajyaguru
Buddhas of the Past
Maitreya, the Buddha of the Future

CHARACTERISTIC ATTRIBUTES

The Buddhas may be represented as 'simple Buddhas' or as 'robed Buddhas'. The simple Buddha (irrespective of the name given to him) is nearly always represented clothed with a monastic robe covering the left shoulder or both shoulders. In a few rare cases, he is bare-breasted. He possesses a number of distinctive marks such as long ear-lobes (as do the Bodhisattvas), a mark of the nobles of ancient India whose ears were stretched by the weight of their jewels. He also has a skull protuberance, called an *uṣṇīṣa*, which is a development of the chignon of hair of the first representations of the Buddha. He may have a tuft of white hairs in the middle of the forehead or between the eye-brows, called an *ūrṇā*, which is usually symbolized by a round spot (sometimes projecting), or a jewel.

Other signs may be distinctive of the Buddhas only. Tradition lists 32 main marks and many others, ranging up to a total of 108 – such as webbed hands and a nose 'like that of a parrot' (especially in Siam and Laos) – but they may vary according to type and region.

But who are these deities, these deified beings, these Great Buddhas on which the human imagination has conferred visible forms, sculpted, engraved and painted, so that they can always be present, so as to remind us relentlessly of the reality of existence and, if need be, to guide us on the thorny path that leads to it? This is what we shall now try to elucidate.

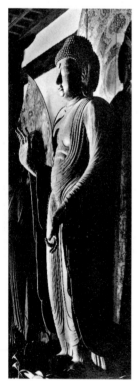

Shaka Nyorai
Wood, Mūro-ji, Japan,
ninth century

THE HISTORICAL BUDDHA

As the founding master of Buddhism and the earliest expounder of the Dharma (the Good Law), it is perfectly natural that, in Asia, the Buddha Śākyamuni Gautama is venerated above all by those who profess his teaching. He is venerated by all Buddhists, with the possible exception of the Japanese Jōdo-Shinshū sect or 'true sect of the pure Land', which almost exclusively devotes its veneration to one of his forms, Amida Butsu (Amitābha).[1] However, Gautama is never really considered as a deity, but rather as the most perfect of holy men, as an ideal example

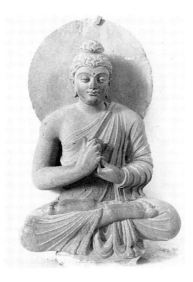

Buddha of Seiryō-ji
Wood, Japan,
fourteenth/fifteenth
centuries

Teaching Buddha
Polished shale, Gandhāra,
India, fifth century

of the Buddhist virtues.[2] Although the rites offered to him seem to have enjoyed fluctuating favour through different ages and countries (as, for example, in Japan during the Heian period, 794–1185[3]), they nevertheless seem never to have been completely abandoned.

According to the texts brought from India to China by the Chinese pilgrims Faxian (Japanese *Hokken*, c. 340–420) and Xuanzang (Japanese *Genjō*, seventh century), Mahāyānist tradition has it that the first images representing the Buddha Gautama were made in his lifetime by two faithful disciples, the Indian kings Prasenajit and Udayana. These kings are reported to have made two statues in the image of their spiritual master, during his absence, when he rose to the Heaven of the 33 Gods[4] (*Trāyastrimśa*, Japanese *Tōriten*) to preach the Dharma to his deceased mother, Queen Māyā. One was of gold, the other of red sandalwood;[5] the second image was subsequently thought to have been carried off to China by the Indian monk Kumārajīva (340–409), together with many sacred texts. Japanese tradition claims that this statue is now at the Seiryō-ji in Kyōto and that it provided the model for all other Japanese statues representing the Buddha.[6] This tradition could have emerged fairly late, perhaps in the seventh century, due to a similarity of style existing between this statue at the Seiryō-ji[7] and the famous 'standing Buddha' from the town of Mathurā in India (now in the Delhi Museum), represented clothed with a monastic robe adhering closely to the body like a wet garment, forming many regular folds and covering both shoulders, the right hand in a gesture of fearlessness (Abhaya mudrā), fingers slightly apart, the other hand in a gesture of offering (Varada mudrā).[8] This tradition apparently ignores the six centuries that elapsed between the work of the two kings and the statue that is now the pride of the Delhi Museum – images of similar style must have

reached China with the wandering monks and, from there, been taken on to Japan. The story of the statues conveys the impatience of the faithful to have the Buddha return among them. Representations of this phase of his life are relatively rare in sculpture,[9] and this rarity in itself, in the later periods, sharpened the imagination. Since the early twentieth century there has been a theory that, at the beginnings of Buddhist art, perhaps in deference to the Buddha, artists refrained from representing his person and symbolized him aniconically by a vacant throne, a lotus flower, a footprint, a Wheel of the Law (*Dharmacakra*), a *stūpa*, etc. It was thought by some European scholars[10] that the first representations of the human person of the Buddha appeared in Gandhāra, under the influence of Hellenistic art, only around the beginning of the Christian era.

While some Indian scholars[11] argued against the idea that the first representations were of western influence, and claimed that the first images of the Buddha were made in the region of Mathurā (the Kushāna kings having become fervent Buddhists[12]), the theory of aniconism was not dismissed until recently. One recent theory is that the scenes are not aniconic at all, but in fact show contemporary scenes of lay people worshipping things connected with the Buddha, such as his throne or the ladder built in memory of the one by which he descended from the Trāyastrimśa heaven. Recent archeological finds of sculpted Buddha images from the pre-Kuṣāṇa period support this view, and also the claim that iconic reprentations of the Buddha were dated later than the surrounding archeological evidence would suggest, precisely in order to fit in with the theory of aniconism.[13]

In fact, the earliest statue identified as that of a Buddha is a red sandstone statue from Mathurā (now in the Sarnāth Museum), which bears an inscription indicating that it was a gift of the monk Bala. This statue,

Shaka Nyorai from Saga
Kyōto, Japan

Shaka Nyorai from Zenkō-ji with two acolytes
Nagano, Japan

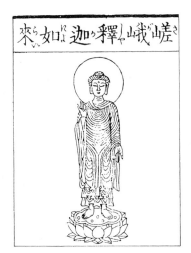

Birth of the Buddha, gilded bronze, Japan, eighth century, Nara Museum

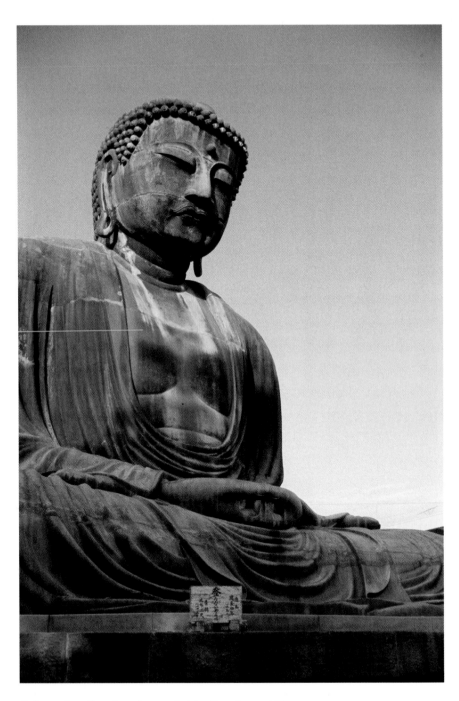

Daibutsu from Kamakura, bronze, height 15 m, Japan, 1252

both in its style and in its treatment, closely resembles the Kuṣāṇa statues of the Yakṣas or other personages. The monastic robe leaves the right shoulder bare, and the left fist holds a piece of the robe on the hip. This statue, which is dated AD 131 (or 147), while probably not the earliest, nevertheless reveals a concern, existing already at the time, to represent the Buddha in his human form. This enjoyed growing success throughout north-west India and especially in Gandhāra, from where it probably spread to the Āndhra country, to Amarāvatī. We know in fact that close links existed between these two distant regions. The personage of the Buddha does in fact appear, pacifying an angry elephant, his robe covering both shoulders. On the earliest representations of Amarāvatī, marble medallions treated in bas-relief, one can observe the Buddha, his robe covering both shoulders, pacifying an angry elephant. In these first images, the headdress of the sage is formed only of a chignon on the top of the skull.

The Graeco-Buddhist art of Gandhāra nevertheless appears (but this is not certain) to have represented first the Bodhisattvas and Maitreya, the Buddha of the Future, perhaps in order to perfect an image of the Master by trial and error on less important personages.

Indian art differs substantially from Hellenistic art in the sense that its ideal is more interiorized: perfection is not found in the human person and its plastic perfection, but in the spirit penetrating through the appearance. The first Buddhas represented therefore have these two characteristics, a body and a soul. The body is clothed, somewhat in the Greek fashion, with a sort of *khitōn*. The hairstyle is first treated in the Greek style, with broad waves, and gathered into a voluminous chignon. The hairstyle in time changed and became more schematic: the hair was curled towards the right, the chignon became a lump on the skull (*uṣṇīṣa*) symbolizing spiritual power. Later, the hair formed an infinity of small 'snail' curls turned towards the right and, in southern India and South-East Asia, the chignon was supplanted by a lotus flower or a flame.

A whole symbolism and iconography subsequently developed around this image. The folds of the garments, still treated in a realistic manner during the Kushāna period, were supplanted by simple lines which, in the Gupta era (fourth to sixth centuries), sometimes disappeared completely. The robe, which at the outset covered both shoulders, subsequently covered only one, like the garments of the monks. The very face of the Buddha became Indianized. Shortly after, around the fifth century, lotus thrones appeared, on which subsequently the Buddha was almost always installed. With the contributions of Chinese painting and sculpture, he assumed the appearance that we now recognize. However, it appears that the Indian Buddhists often hesitated to represent the Buddha himself, and generally preferred to represent his aspect as a Bodhisattva, which allowed more freedom in the style (some Bodhisattvas and Maitreya in the art of Gandhāra have moustaches) and in the ornamentation.

Crowned Buddha
From Ājantā, India, cave no. 1, c. 600 (drawing)

Around the Gupta period, it appears that the image of the Buddha became firmly fixed. The lines are serene, the face is full, the ear-lobes are extended. The robe always covers both shoulders, and he is represented upright, the feet slightly apart, in a frontal posture, with the hands in Abhaya and Varada mūdras, or with the right hand in Abhaya and the left in Varada holding a piece of the robe; or seated in Padmāsana, the soles of the feet visible; or making the gesture of turning the Wheel of the Law (Dharmacakra mudrā). An image of the Buddha at Sarnāth is represented seated on a throne, a open-work aureole behind his head. A scene is sculpted between the feet of the throne showing the first disciples venerating the Wheel of the Law. Two other celestial beings (perhaps Hindu deities) adorn the aureole. Another effigy from Sarnāth, perhaps more recent than the first, depicts the Buddha standing and is less ornate; a large halo surrounds the entire body. On one of the octagonal pillars of cave number 9 at Ajantā, a painting probably dating from the late fifth century shows the Buddha standing with a round aureole behind the head. The slightly more recent sculptures of the Buddha in the Ellorā caves, show, in the same style, the sage seated on a chair in the 'European' posture and turning the Wheel of the Law (cave number 2 and *caitya* number 10, for example). In the sixth century, caves (as at Kanherī) always present images of the standing Buddha, in a non-canonical posture: the right hand is extended along the thigh, in Varada mudrā, while the left hand holds a piece of the robe, at the level of the shoulder. At this time, the positions of the Buddha were not yet absolutely defined.

They only began to be codified around the end of the Gupta period, in the bas-reliefs describing the 'eight episodes in the life of the Buddha' (Sarnāth Museum) – his birth, his descent from the Tuṣita heaven, the gift of honey, the miracle of Śravasti, the taming of Nālāgiri, his victory over the forces of Māra, his first sermon to his disciples at Sarnāth, and finally his entry into Nirvāna. These eight scenes were soon reduced to four, which were considered to be essential: his birth, his victory over the forces of Māra, his sermon, and his entry into Nirvāna. These four 'attitudes' were adopted by Mahāyāna Buddhism, which transformed them into 'emanations', each with different features, as the Four Great Jinas. The Buddhism of the Southern schools preserved these four attitudes as symbolic of the four greatest events of the life of the Master and depicted them repeatedly in sculpture and in painting. In South-East Asia, a fifth attitude was often added, representing the Buddha standing with both hands in Abhaya mudrā. Another attitude was also adopted in Laos and Thailand, that of the Buddha walking or placing his footprint.

In Tibet, China, Korea and Japan, except for the style, the images of the historical Buddha barely differ from the Indian ones. It is not precisely known when images representing the Buddha were introduced into China, undoubtedly by monks coming from the oases of Central Asia. Buddhism progressed rapidly in all directions from the Gupta era,

The eight episodes in the life of the Buddha
Drawing from a terracotta, Pagan, Burma, twelfth century

monks established monasteries in Afghanistan (the Great Buddhas of Bāmiyān, of the late Gupta style, have robes covering both shoulders), and examples of Buddhist statuary and painting travelled with pilgrims. It is therefore probable that images of the Buddha existed in China from the third century AD. However, it is only in the late fifth century, with the Wei dynasty in the north, that the appearance of effigies of Gautama became common. During the period of the Six Dynasties (220–589), Buddhism spread rapidly in China, and many Buddhist caves were excavated. The style of the Buddhas appears to have emerged first in the Yungang Caves up to around 495, and then the Longmen Caves up to the mid sixth century. It appeared to reach its maturity with the Tang dynasty (620–910). The style of the northern Wei shows figures of the Buddha that still bear traces of Hellenistic influence (Yungang), whereas the style developed in the Longmen Caves shows more elongated statues, with a profusion of draperies. The robe always covers both shoulders. This style passed into Korea, and from there to Japan, which it reached around 548. The style of the Sui and Tang also became standardized in these two countries, and enjoyed considerable favour, before being 'nationalized'.

In Tibet, where Buddhism became a significant influence in the seventh century, the traditional Indian image was more or less preserved. However, with the popularity enjoyed in this country by the traditions of Tantrism and of the Mahāyāna, the person of the historical Buddha was represented less often than those of the Jinas. He continued to be shown in one of the four postures marking the significant events in his spiritual evolution.

In Japan, it appears clear that the introduction of the first image representing the historical Buddha (very different from that at the Seiryō-ji) took place in 538, with the sending of a bronze statue of the Buddha and of sacred texts (probably including an illuminated manuscript, *Inga-kyō*, on the 'Relations of cause and effect' preached by the Buddha) to the Yamato Court established at the time in Asuka, by the king of Kudara, a kingdom of Korea.[14] This bronze image had been entrusted by the emperor to the head of the Soga clan, then chancellor of the kingdom. But when a smallpox epidemic broke out in the country, those opposed to the introduction of Buddhism, a religion alien both to Japan and the political enemies of the Soga clan, hurriedly declared that the statue was responsible for the evils afflicting the people. Consequently the emperor decreed that the supposedly malevolent statue be thrown into the waters of the Naniwa River, near his palace, situated near the present city of Osaka.[15] The traditional beliefs and way of life at this time came, in the sixth century, to be known as Shintō, 'the way of the Kami', to distinguish it from the way of the Buddha. Shinto adepts believed in the 'superior spirits' or Kamis and used practices derived from those of Korean/Siberian shamanism: for them, an object could be inhabited by superior powers, and could accordingly exert a good or an evil influence.

The statue of the Buddha was later retrieved from the waters after the victory of the Soga clan and the triumph at court of the partisans of Buddhism, and is the one currently installed in the main hall (Hondo) of the Ango-in (a temple also called Asuka-dera).[16] This seated statue, at 2.8 metres, is very large; the size (in Japanese, 1 *jō* 6 *shaku*)[17] corresponds to the height attributed by later tradition to the physical person of Buddha, and hence to his representations. The Buddha, great in thought, could not be small in size: this idea clearly corresponds to the Asian taste which demanded that the representations of important personages should loom larger in painting than those of a lower standing. In reality, however, it is highly improbable that the statue of the Ango-in is the one that was brought from Korea: its transport would have raised insoluble problems at the time. Perhaps it is simply a copy, made to the dimensions prescribed by tradition from a portable model, and produced locally by bronzesmiths who likewise came from Korea. Furthermore, its style, far from being Indian, is on the contrary comparable to that of certain Korean Buddhas of the same period, and to the more monumental Buddha of Binyangdong at Longmen, in China.[18] As to the statue at the Seiryō-ji discussed earlier,[19] it could be of Chinese origin: tradition recounts that it was brought from China in 987 by a monk named Chōnen[20] and installed in the monastery of the Tōdai-ji in Nara. It is in the Chinese style. It is hollow and, in addition to bronze and silver objects and written invocations (*dhāraṇī*), contains reproductions of viscera made of fabric.[21] This last detail clearly shows that, in the eyes of the faithful of the time, the statue represented a human being and not a deity. This points to a very sharp distinction which, over the centuries, was gradually blurred.

In Japanese the person of the Buddha is not always venerated alone, but in a group with other personages. Thus, for example, in the Nison-in of Kyōto (a temple of Tendai obedience) and at the Kenkō-in (temple of sending and welcome, near Takagamine),[22] the statues of Shaka (Śākyamuni Gautama) and of Amida (Amitābha) are placed side by side on the same altar, and make symmetrical gestures of fearlessness (Abhaya) and of giving (Varada). According to the monks of these temples, the brochures distributed to the faithful of the temple of Kenkō-in (although of Jōdo-Shinshū obedience)[23] and the text of the Tendai sect (the *Nihon Shaji Taikan*), a formula attributed to the two 'saviours' (Shaka consoling the souls on earth, Amida consoling them in the beyond), states that on this river bank (the river of existence separating life from death), Shaka despatches us saying, 'Go,' while on the opposite bank Mida (Amida)[24] welcomes us saying, 'Come.'[25]

Similarly, in the temple of Sennyū-ji (Mitera)[26] in Kyōto, a temple that formerly belonged to the Shingon, Tendai, Zen and Ritsu sects, a group of three Buddha images is found – that of Shaka, flanked by Amida, the Buddha of the beyond,[27] and Maitreya, the future Buddha.[28] This Sanzon (group of three venerables) symbolizes the three worlds or Buddhist periods. These statues are not really an object of worship, but

together they remind the faithful that the Law exists both for human beings here below and for those of the world beyond, and that it will continue to be so in the future.[29]

The Buddha, or at least his memory, is honoured on many occasions and, above all, at birthdays, births and deaths. Thus in China (*Yufuhui*) and Japan (*Kanbutsu-e*), 8 April is the anniversary of his birth: his statues are washed with perfumed water and special decoctions. The same applies in South-East Asia. Since the Buddha cannot be absent from the daily activities of the faithful, they are accustomed, particularly in China, Korea and Japan, to accord him, on the appropriate day, a lucky or an unlucky influence. In Japan and China, an inauspicious day of the Taoist calendar has been 'Buddhicized': the day qualified as *Butsumetsu* (death of the Buddha) is reputed to be especially unlucky. Nothing must be undertaken on this particular day; funerals alone are permitted.

Every statue representing the Buddha is considered to be alive and to possess some power: 'in the traditional belief, each image of the Buddha inherits a fraction of the *tejas*, "energy", that the Buddha himself possesses in extreme abundance, and which is conventionally represented by a halo, a flame surging from the top of his head, from the gilt surface of his body.'[30] People attribute a part of this *tejas*, this divine energy, to the statues representing him. In South-East Asia, especially in Burma and Thailand, many small statuettes of the Buddha are made for insertion into the large statues, so that the cumulative *tejas* give it greater power. This is also why many Buddhists wear a chain around the neck holding a small image of the Buddha: it is considered to impart power to them, and even invincibility according to some popular beliefs.

Yet a statue of the Buddha (or of another Buddhist personage) can only have life if it is 'animated'– i.e. consecrated by the ancient custom of the opening of the eyes (Chinese *Kaiguang*, Japanese *Kaigen-kugyō*). To do this, it was formerly common to make a cavity in the back of the statue into which a small animal was inserted, or images of the viscera. The cavity closed and the ritual offerings made, a monk painted (or sculpted) the pupils of the eyes. The image thus animated was considered to be living. In Thailand, in the Ayuthyā period, the mutilation of an image of the Buddha was considered a crime, and punished as such. Also in Thailand, it is commonly believed that certain statues of the Buddha are more powerful than others, that two statues may even hate each other – the 'Emerald Buddha' in Bangkok and the Phra Bang at Thonburi had a 'combat' in the eighteenth century that provoked a revolution and poor harvests in 1867. It is even believed that, in certain circumstances, the effigies of the Buddha can be unlucky to those who possess them: the only remedy is to entrust these images to a monastery. Miracles have also been attributed to a number of statues of the Buddha considered to be extremely powerful, such as the one called Jinarāja, at Phitshanulok in Thailand, which shed tears of blood when the region was conquered by the Prince of Ayuthyā in 1438.

Shaka Nyorai
Wood, Japan, ninth century

Examples of this belief abound. In the Theravāda countries, the faithful frequently offer yellow or gilded scarves to the statues, in order to honour them. In Burma, the author had the opportunity to encounter a large Buddha of brick and stucco, freshly painted, which village piety had adorned with spectacles, 'because the Buddha was a great scholar,' explained a *bonze*.

It is customary to offer the Buddha monastic garments and sometimes richly ornamented crowns. In Thailand, the 'Emerald Buddha' (in Bangkok) has three sorts of costume: that of a prince during the hot season, a monastic robe during the rainy season (the season of the annual retreat), and a golden cloak during the cool season.

A statue of the Buddha is generally considered (more than a painting) as a *stūpa*: it is a substitute for the physical presence of the Buddha, and it sometimes contains relics (exactly as the reliquaries of the Christian Middle Ages were sometimes fashioned in the image of the saint whose remains they contained), and may also contain manuscripts of religious texts. Merit (*puṇya*, Thai *tam-pun*) is acquired by erecting a *stūpa* or a statue representing the Buddha, whether of colossal size or of very small dimensions. In Tibet and Nepal, to earn merit, pilgrims are accustomed to making prints of *stūpas* or Buddhas with specially engraved wooden blocks or metal moulds.

Similarly, a statue representing the Buddha must be treated with deference: the Buddhist installing one at home will do so in such a way that the feet of the statue are positioned at the height of the face of the worshipper. Thus the Buddha is always placed higher than men, and does not risk being soiled. He is always installed in the finest part of the dwelling. It is rare for a statue of the Buddha to be considered simply as a work of art. Whereas a stranger may derive pleasure from exhibiting part of a statue of a Buddha at home – a head or a hand, say – the Buddhist would find this sacrilegious and morbid, and may even regard it as bringing bad luck to the house. If part of a statue is found or unearthed, it must be placed immediately in a monastery: the monks will enclose it in a reliquary and bury it, with the requisite prayers, in a *stūpa* erected for the purpose.

Representations

We have seen that the person of the historical Buddha has been represented in many forms. Below are described the scenes of his life (Japanese *Hassō, Hachisō*) which recall the most characteristic or important events of his earthly career.

The descent from the Tuṣita heaven

Tuṣita is the 'heaven' where Gautama dwelt as a Bodhisattva before his final incarnation. This scene, where the future Buddha is shown in the form of a white elephant calf descending from the clouds (medallion of the Bharhūt *stūpa* in India), is virtually never represented outside India.

The descent from the Tuṣita Heaven
Drawing from a wood sculpture, Pagan, Burma, twelfth century

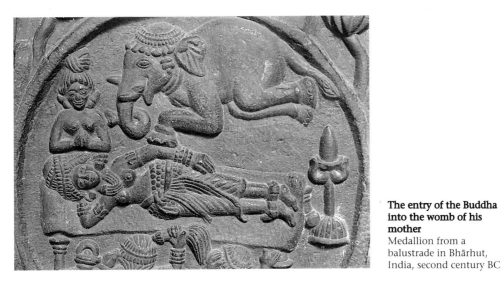

The entry of the Buddha into the womb of his mother
Medallion from a balustrade in Bhārhut, India, second century BC

The entry of the Buddha into the womb of his mother

This is represented in the form of a white elephant calf entering through the right side of Queen Māyā (medallion in Bhārhut, India). This image, which is often confused with the first, is only rarely represented outside India, mainly in painting.

The birth of the Buddha

This aspect was very often represented, both in India[31] and in China and Japan, because it is more concrete and draws more on human feelings

Birth of the Buddha
Bronze, Nālandā, India, tenth century

Birth of the Buddha
Gilded bronze, Japan, seventh century, Tokyo National Museum

Birth of the Buddha
Chinese engraving

Birth of the Buddha
(Tanjō-e)

than on a legend. Everyone knows what a birth is, how much joy it can bring into a home. And the birth of a future Buddha could not fail to rouse the deep family sentiments of the Asians. The text of the *Dīrghāgama-sūtra* (Japanese *Chō Agongyō*, Chinese *Foshuo chang, Ahang Jing*) alleges that the young Prince Śākyamuni Gautama, immediately after his birth (according to Indian tradition, from the right side of his mother), took seven steps in each of the four directions and proclaimed: 'In the Heavens and on Earth, only I am the Venerable One,'[32] an expression which became common in China and Japan, where it is employed somewhat ironically to tease a person who vaunts his superiority. The infant Buddha is shown standing, bare to the waist, his right arm pointing to the sky. In this form, in Japan, it is usually placed in the centre of a circular basin designed to contain and collect the sweet tea (*amacha*)[33] that the faithful are accustomed to pour over the statue every year on the anniversary of the Buddha's birth, a day traditionally set on the eighth day of the fourth month, 8 April.[34]

This feast day is observed by all the followers of the Korean and Japanese sects (including that of Jōdo-Shinshū), and also by many non-practising persons, and it is the occasion for family rejoicing. It is called *Kanbutsu-e* (Chinese *Yufuhui*) or the 'feast of the sprinkling of the Buddha' – popularly named *Hana Matsuri* in Japan, 'feast of flowers',[35] because the small temple (*Hanamidō*, room of the vision of flowers) raised in the temple courtyard to shelter the statuette of the newborn Buddha (Japanese *Tanjō-Butsu*) is decorated with flowers.[36] Tradition relates that, at the birth of Gautama, the rejoicing gods of the Hindu pantheon let fall a rain of flowers[37] on him from the heights of their celestial domain, and sprinkled him with jets of perfumed powders. A popular custom in Japan claims that, if the bodies of sick children are rubbed with the *amacha* that has been poured over the statue on the Buddha's birthday, these children will be cured.[38] This points to the association, natural in Asia, according to which the physician of the soul is also the physician of the body. On the occasion of this feast, children write poems – mixed with Indian ink, the purifying *amacha* also has the virtue of giving the children a talent for fine penmanship.[39]

This custom of sprinkling the statues of the Buddha to celebrate his birthday is widespread in Buddhist India, Sri Lanka and in the countries of South-East Asia. But it does not involve sprinkling a special statue. On this birthday, all the statues representing the historical Buddha are washed with copious quantities of water, repainted and sometimes regilded with gold leaf.

On certain *tanghkas* of Tibet[40] the infant Buddha is represented naked, in Abhaya mūdra, and the seven steps that he made in each direction are symbolized by as many lotus petals. In Japan, many paintings show the birth of Shaka, called *Tanjō-e*.[41] Among the sculpted works dealing with this subject, most of which represent the infant Buddha with his arm uplifted, is a small bronze statuette, possibly of Chinese origin of the Tang period, in which he is accompanied by two other

kneeling personages, also dressed in the Chinese fashion. One is clearly his mother Queen Māyā, in a robe with long sleeves; from the right sleeve emerges the young Prince Śākyamuni, hands joined,[42] an allusion to the supernatural manner in which the queen gave birth.

Departure from the family

This is the flight of Prince Śākyamuni from the royal palace of Kapilavastu, and sometimes the traditional meetings that the future Buddha made on this occasion with an old man, a sick man, a corpse and an ascetic, described in the oldest texts. This aspect, represented in India from the earliest times[43] of Buddhist iconography (called *Shukke* in Japan), is rarely shown, except on illuminated manuscripts describing the life of the Buddha, or on bas-reliefs illustrating his life. It is usually replaced by representations of Śākyamuni descending from the mountain, to which he first removed to practise asceticism.

This part of the life of the future Buddha is very often represented, especially in painting, in the countries where the Mahāyāna predominates, and in Gandhāra. This aspect (called *Shussan no Shaka*, *Shutsuzan no Shaka*, *Shussan Butsu* in Japan) symbolizes the accomplishment of the future Buddha who descends from the (spiritual) heights in which he sought refuge to seek the means to save living beings, thus adopting the virtuous and redeeming conduct of a Bodhisattva.[44] On the fourth day of the twelfth month of the year, in memory of the day when the Buddha resolved to abandon ascetic practices as vain, religious Buddhists celebrate a feast (Japanese *Jōdo-e*) of the illumination of the Buddha. On the eighth day, in China, the faithful eat a gruel specially prepared by the monks for the purpose and called *labazhu*.[45] The Buddhists then make the firm resolution, like

One of the departures of Prince Śākyamuni
Detail of a gateway pillar from *stūpa* no. 1, Sāñchī, India, first century

Śākyamuni descending from the mountain
(Shussan no Shaka)

Prince Śākyamuni cuts his hair
From a high relief, Pagan, Burma, early twelfth century

Bodhisattvas, to help other beings to gain salvation and to resist the ego-istic temptation of personal salvation.[46]

The earliest representations of this 'moment' in the life of the Buddha appear to have been 'invented' in Gandhāra (see the 'ascetic Buddha' of the Peshawar Museum). Paintings of this type appear to have originated in China. The Chan and Zen sects, which particularly hon-our the historical Buddha, see in this aspect of the Buddha an exam-ple to be followed for the accomplishment of their spiritual aim through their *zazen* exercises. However, it is perhaps in Japan that the most numerous representations of this type of Buddha are found. He can be an ascetic, thin, with a short beard, the hands in Añjali mudrā[47] (he is accordingly given the name Kugyō-zō) – a form that was mainly in favour in the Zen monasteries from the fourteenth century,[48] but which nevertheless remains relatively rare. Or he can be clothed as a prince, as an ornamented Buddha, and named Airaku-zō. Or he can be hold-ing the begging bowl (*pātra*), symbol of his asceticism; in this case he is called Jihachi-sō Shaka.

The victory over Mārā

This is the victory over the Prince of Demons, the attitude of taking the Earth for a witness of the good deeds that Gautama accomplished in his past existence, and of the right that he has acquired by his merits to occupy the 'diamond throne' (*vajrāsana*) at Bodh-Gayā. This theme is often represented in the iconography of the sects of the ancient schools and of the Mahāyāna schools, where it represents the distinc-tive attitude of the Jina Akṣobhya. In Japan, this attitude was rarely rep-resented, except on paintings, and is often confused with Bodhi (below).

The accomplishment of the Way (Bodhi)

The Buddha is shown seated on the 'diamond throne', under the pipal tree at Bodh-Gayā. This is the aspect that was probably the most often represented, and in which the esoteric sects raised him to the rank of the Great Buddha. The forms may vary considerably, but are always seated: they observe the general iconography of the representations of the Tathāgatas.

The Buddha is represented in the seated position called Padmāsana (lotus) or seated 'in the Chinese manner' (or in the 'European manner', Bhadrāsana), with the monastic robe (*kāṣāya*, Japanese *kesa*)[49] covering both shoulders. The Buddha's fingers are webbed (covered with a web, *jālāvanaddhahastaoāda*, Japanese *manmōzō*),[50] one of the 32 distinc-tive signs of the Buddha according to the ancient texts. He holds the right hand either in fearlessness (Abhaya mudrā), or in discussion of the Law (Vitarka mudrā) or, more rarely, in offering (Varada mudrā),[51] the left hand nearly always being in Varada mudrā,[51] sometimes with the ring finger and little finger slightly bent, or (frequently) resting, the palm turned upward, in the lap.

Particularly in China and Japan, he is also represented in the pos-

Śākyamuni holding the begging bowl
Tibetan engraving

ture of the taking the Earth as witness,[52] the fingers of the right hand touching the ground or the lotus petals near his right knee (in Bhūmiṣparṣa mudrā), but attended by two acolytes, Mañjuśrī at the left and Samantabhadra at the right, the two Bodhisattvas of knowledge. This ensemble assumes the name of 'the three venerables of Śākyamuni' (Japanese *Shaka Sanzon*).

In the Japanese Ritsu and Zen sects (which do not recognize the Bodhisattvas), the two acolytes of the Buddha are two of his major disciples (see below), Kāśyapa (Japanese *Kashō*), who represents knowing asceticism, and Ānanda (Japanese *Anan*), the closely attentive auditor of the master's sermons.[53]

When the Buddha is simply represented seated in meditation under the pipal tree, he is called in Japan Shiyui-zō and, in a number of sects of Zen obedience, he assumes the position of the hands in meditation (Dhyāna mudrā, Japanese *Butsu Jō-in*).[54] This aspect was taken up by the esoteric sects to symbolize the Buddha of meditation, Amitābha.

In India, and especially in South-East Asia, particularly in Khmer Cambodia, the Buddha in meditation is often represented seated on the wound coils of the serpent (king of the Nāgas), Mucilinda, who protects him from the weather with the outspread hoods of its seven heads. According to legend, this serpent sheltered the Buddha during a rainstorm that lasted seven days, when he was in his sixth week of meditation after his Awakening. When the sun returned, Mucilinda was transformed into a young prince who rendered homage to the Buddha. Thus, according to the earliest popular beliefs in southern and South-East Asia, the king of the Nāgas, Nāgarāja, symbolizing all the Nāgas and Nāginīs, male and female chthonian genii 'possessors' of the ground, was mythologically associated with the personage of the historical Buddha, making him a 'genie of the ground', a Buddhist adaptation of an ancient cult still anchored in the popular mentality.

The Buddha teaches his first five disciples in Sārnāth
Chinese engraving, Ming period

Shaka Nyorai preaching

The preaching of the Law

This aspect was excellently represented, especially in India, by the sculptures of the type of the Buddha of Sārnāth, in the Gupta style,[55] and in Gandhāra and South-East Asia. Its image also spread in the Sino-Japanese world, where it enjoyed great popularity. The Buddha is represented seated, the hands making the gesture of turning the Wheel of the Law (Dharmachakra mudrā)[56] or making the gesture of the discussion of the Law (Vitarka mudrā) with his disciples, with the right hand only, the left resting palm upward on the lap.[57] When this representation is provided with a robe covering both shoulders, and is ornamented with a double halo, it belongs to an esoteric sect. This attitude was adopted by the same sects to symbolize the Buddha.

In the same attitude of the preaching or discussion of the Law, the Buddha is sometimes shown no longer seated but standing. In this case, his hands are usually in Abhaya and Varada mudrās.

The Parinirvāna

This is the image of the Buddha on the point of passing from life to death. This aspect is inspired by the description of the final moments of the Buddha in the text of the *Mahāparinirvāna-sūtra* (Japanese *Nehan-gyō*) and shows the Buddha lying on his right side, his right arm folded under his head or at the level of his head, his left arm resting on his side[58] (although some rare images represent the Buddha lying with both arms extended along the body). Chinese and Japanese imagery often show the Buddha on his funeral pyre, surrounded by a crowd of creatures – gods, disciples and animals – in lamentation. One unusual aspect of this Parinirvāna in Japan is the one of 'Shaka leaving a golden

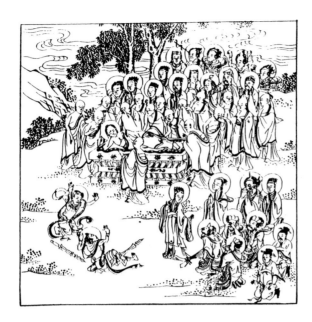

The Parinirvāna of the Buddha
Chinese engraving,
Ming period

coffin' (Japanese *Kinkan Shutsugen-zō*), illustrating a passage from the *sūtra* of Queen Māyā, the *Mahāmāyā-kyō*: 'When the Tathāgata entered into Nirvāna, Maya Bunin, his mother, learning the news in the Heaven of the 33 Gods where she was, joined the Devas who descended to earth to place her son in a golden coffin. But the deceased, raising the lid, arose like an escaped lion, spreading a heavenly light in which one could see resplendent the Buddhas of the past and of the future.'[59]

In Japan, the anniversary of the Buddha's death is observed, with relatively little ceremonial, every year on the 15th day of the second month.[60] In other countries, this anniversary is similarly largely overlooked. The statues representing the Parinirvāna of the Buddha are numerous, especially in South-East Asia and Sri Lanka, where they reach gigantic proportions. Even in India, one of the earliest representations of the 'recumbent Buddha' is sculpted in *chaitya* number 26 of Ajantā (c. 600–642).

A curious legend (probably late) tends to explain the origin of the twelve animals which characterize the years of the 60-year cycle, a calendar of Chinese origin which was adopted by many Asian countries. These twelve animals are rendered in a predetermined order. The legend in fact recounts that, during the entry of the Buddha into Nirvāna at Kushināgara (northern India), all those who had heard his sermons hastened to the place of cremation of his earthly body to render him a final homage. The animals also hurried and arrived one after the other in an order that is preserved by tradition: the rat, the cow (or bull), the tiger (or cat in Vietnam), the hare (or rabbit), the dragon, the

Kishū Kumanoyo, Ofuda
Pious image from the
Hōtokō-ji, Kumano, Japan

**Prabhūtaratna (Tahō
Nyorai)**

**Gautama Buddha and
Prabhūtaratna**
Bronze, Nichiren sect,
Japan

Tahō Nyorai
Wood, Tōshōdai-ji, Nara,
Japan, eighth century

serpent, the horse, the sheep (or goat), the monkey, the cock, the dog and, finally, the boar (or pig). In remembrance, the names of these twelve faithful animals are hence given to the successive years of the zodiacal cycle.

Other aspects

Besides these aspects of the life of the historical Buddha, other aspects (or forms) are also found, some single, some grouped, especially in the representations belonging to the esoteric sects and the Chan and Zen sects (the sects of Southern Buddhism venerated only the person of the historical Buddha as the perfect guide). In their worship, the esoteric sects of Japan sometimes associated two or more aspects (or forms) of the Buddha (see Jinas, Chapter IV). They also often associated the form of the historical Buddha with that of Prabhūtaratna (Japanese *Tahō Nyorai*), 'a Buddha of the ancient ages about whom the Lotus Sūtra (*Saddharmapuṇḍarīka-sūtra*, Japanese *Hoke-kyō*) tells that he emerged one day from the ecstasy in which he was immersed to invite Śākya-muni to share his throne and his glory.'[61] This double image, probably of Chinese origin,[62] was also venerated in Korea and Japan. In Japan, it is found in particular hidden in *tahō-tō*, round structures with square roofs (imitating *stūpas*) characteristic of the Shingon sect, and also on a few rare paintings, engravings and ancient bas-reliefs[63] directly inspired by the Chinese art of the Wei period.

In the Nichiren sect in Japan, images of these two Buddhas, Śākya-muni and Prabhūtaratna, are also found seated on either side of a ver-tical tablet on which the mystic invocation in the Lotus Sūtra[64] is inscribed. In the Japanese esoteric sects (chiefly the Shingon and Tendai), the historical Buddha is sometimes identified with two of the Japanese aspects (Fukujōju Nyorai and Kaifuke-ō Nyorai) of the Great Solar

Buddha Vairocana[65] of whom he is considered one of the two acolytes, thus forming, with Bhaiṣajyaguru, a 'Trinity of Light'.[66]

Deities and Personages related to the Historical Buddha

In the popular mind of the followers of the Mahāyāna (in China, Korea and Japan mainly, and to a lesser degree in other countries, such as Java), just as a great lord could not act on his own but only through an intermediary or by delegation, the deity (whether an imagined being or a historical reality) itself emanates from the 'forces' that act in its place, in its name, with a specialization that gives them even greater effectiveness. Sometimes (and this is perhaps the *raison d'être* of the groups of deities that are so frequently found, as by analogy with magic), the forces of the different divine entities are cumulated for a clearly defined purpose, usually to save beings or to conquer the human passions and thus help men along the path to salvation. The different popular syncretisms in Tibet and Japan have greatly indulged in these 'divine emanations'. While in Tibet the syncretic deities were perfectly identified with the different 'forces' of Tantric Buddhism, in Japan, according to the doctrine of the Honji-suijaku, they are merely the descent or *avatāra* (Japanese *gongen*) of the Buddhist deities in the Kamis of Shintō,[67] and these *avatāra* represent only temporary manifestations. At least two of these *avatāra* (which are relatively numerous and were created as a result of the need for monasteries to attract Shintō followers to Buddhism) enjoyed considerable favour in Japan: Zaō Gongen and Izuna Gongen.

Besides these, often associated with 'forces' that emanated from the Buddha to help and guide the faithful, other historical personages who were part of the entourage of the Buddha were formerly venerated, such as his ten great disciples; the five hundred Arahants; Māyā, the mother of the Buddha, and the monk Bodhidharma, a later personage who enjoyed tremendous popularity. These personages are important, not so much because of the worship directed to them in the past as for the considerable place that, in various respects, they have held in the iconographic representations and in Buddhist art in all Buddhist countries.

It is necessary to describe them here, albeit briefly, because they are so often represented. A description of them helps us to recognize them, to situate them in the Buddhist pantheon, and accordingly helps us appreciate many *objets d'art* whose subject would be likely to elude us without this knowledge.

Zaō Gongen

This Japanese syncretic deity appears to have been conceived following a vision of the sorcerer monk Ennō Gyōja on Mount Yoshino in the tenth century. This deity has since been the principal object of the Shugendō cult of the priests of the Kumano-Oji-jinja on Mount Kinbu.[68] Its image, sometimes considered as that of a wrathful force (Krodha) or a Vidyārāja, is often engraved on circular mirrors hung on the wall (*kakehotoke*, or *hotoke* when suspended) in place of an effigy of Śākyamuni.

It is represented in a dynamic pose[69] (standing on a rock, right foot raised as if to crush the passions), brandishing a simple vajra or a five-pointed vajra in its raised right hand, the left resting on the hip in a mudrā of wrath, the entire face enveloped in flames intended to consume the desires of the follower who seeks its protection. This could be a temporary incarnation of the historical Buddha.

Izuna Gongen

Izuna Gongen

This Japanese aspect, mainly worshipped by the priests of the Shintō Buddhist sanctuaries on Mount Izuna in Shinano Province, has no particular name: it is simply the *gongen* of Mount Izuna. People often confuse this wrathful form (emanation of Shākyamuni) with Zaō Gongen or, when it assumes a human form, with Acalanātha (Japanese *Fudō Myō-o*). It is often represented with a bird's head, surrounded by flames, standing on a white fox,[70] holding in the right hand a sword with a handle which terminates in a three-pointed vajra (Japanese *sanko-ken*) and in the left hand a rope terminating in a hook in the form of a dragon's head (Japanese *ryūsaku*) to catch and bind the evil ones and thus prevent them from harming the faithful who invoke it. According to a tradition, this 'force' was perceived for the first time at the temple of Hachiō-ji, on Mount Takao, by the monk Gyōki (670–749) who began to disseminate the syncretic doctrines of Ryōbu-shintō,[71] derived from the esoterism of the Shingon sect.

The Ten Great Disciples of the Buddha

The ten great disciples of the Buddha transmitted by Buddhist tradition were formerly worshipped, but are apparently worshipped no longer today. They were the companions of the historical Buddha. They lived with him and some of them survived him. They are very often mentioned in Sanskrit, Pāli, Tibetan, Chinese and Japanese texts (like the *Yuima-kyō*),[72] although their combined representations have been rather rare, except on paintings showing the Parinirvāna of the Buddha. The different texts place them in various orders of priority, although it is usually Maudgalyāyana, Ānanda and Śāriputra[73] who are placed at the top of the list, and whose images are sometimes placed alongside that of the Buddha. They are usually represented clothed in monastic garments, heads shaved, hands joined, holding the begging bowl, or making various gestures not classifiable as mudrās,[74] the latter being reserved for the deities.

Mahākāśyapa

(*Pippali*; Japanese, *Makakashō, Dai Kashō*; Chinese, *Chang-mei, Chanshi, Jigong Laofo Pusa*; Tibetan, *Od-srung Chen-po*; Mongol, *Gas-cib*)

'He who is first in asceticism' is represented holding a book or leaning on a long staff. This great disciple is also one of the Arahants (see p. 100).

Head of the Buddha, stone, Nakhom Pathom, Thailand, sixth century

Preaching Buddha, stone, Borobudur, Java, c. 900

He was born in a village of Magadha into a family of the Brāhmin caste. He earned a reputation of extreme rigour, not only regarding himself but towards the other disciples, and lived to a very old age. Tradition relates that he was praised by the Buddha for his skill in preaching and in observing the additional ascetic practices (*Dhūtaguṇa*) permitted to a monk. It is he who presided over the Buddha's funeral, assumed the direction of the Saṅgha (monastic community) and summoned, at Rājagṛha, the first Buddhist council immediately after the death of the Buddha.

Mahākāśyapa (Dai Kashō)

Ānanda

(Japanese, *Anan, Ananda*; Tibetan, *Kun-dgah-bo*)

'He who is first in having heard the word of the Buddha' was the zealous attendant of the Buddha and his first cousin, born on the same day. He served the Buddha loyally for 25 years, accepting no privilege. He pressed the Buddha to agree to found an order of nuns and undertook their instruction. The Buddha designated him as the best in erudition, memory, goodness and resolution. Having memorized all the words of the Buddha, he was summoned to the council in Rājagṛha and charged with reciting the *sūtras*. A Buddhist sūtra traditionally begins with the phrase, '*Evaṃ mayā śrutaṃ* [Thus have I heard]', indicating that what follows is considered to be a text recited by Ānanda at the first council. According to some traditions, he succeeded Mahākāśyapa at the head of the Saṅgha. He is noted for his gentleness and humility. He is generally represented with a young man's face, hands joined. His effigy is often shown at the feet or, more rarely, at the head of the Buddha at his Parinirvāṇa.

Śāriputra

(*Upatiṣya*; Japanese, *Sharihotsu*; Chinese, *Sheli-fo, Shelo-zi*; Tibetan, *Nid-rgyal*)

'He who is first in Wisdom (*Prajñā*)' was the regent of the Saṅgha in charge of discipline (*Vinaya*) and died a few months before the Buddha. He is the oldest spiritual son of the Buddha, teaches the Law in many *sūtras* and is the grand master of *Abhidharma*. His relics were enclosed in the great *stūpa* of Sāñchī in India. He is represented holding a long-handled fan (Japanese *uchiwa*) in his hand.

Subhūti

(Japanese, *Subodai, Shubodai*; Chinese, *Shubojia*; Tibetan, *Rabhbyor*)

'He who is first in expressing emptiness (*śunyatā*)' is shown in the Mahāyāna texts as the principal spokesman for the Buddha, especially in the different texts of the *Prajñāpāramitā* literature.[75] Having ceaselessly meditated on goodwill (*maitrī*), he became an Arahant. He is represented standing, holding a priest's sceptre (Japanese *nyo-i*) in his hand.

Ānanda

Sāriputra

Subhūti

Pūrṇa

Maudgalyāyana

Kātyāyana

Aniruddha

Upāli

Rāhula

Pūrṇa

(*Maitreyāniputra*; Japanese, *Furuna*)

'He who is first in explaining the Good Law' was a rich merchant from the north-west coast of the Deccan (the origin of many settlers in South-East Asia and China), who was converted when listening to a sermon by the Buddha in the town of Śrāvastī. He travelled far to spread the Law, and is therefore sometimes considered the protector of sailors. He is represented holding a long-handled incense burner (Japanese *egōrō*) in both hands.

Maudgalyāyāna

(*Kolita*; Japanese, *Dai Mokkenren, Mokukenren, Mokuren*; Chinese, *Mulian*; Tibetan, *Mu-dga-li-bu*)

'He who is first in supernatural powers (*Rddhipāda*)' was born on the same day as Śāriputra, and they were both converted at the same time. His ashes are also said to be enclosed in *stūpa* number 1 in Sāñchī. He is generally represented holding a book (or a box) in his hands, or sometimes with a vase containing a lotus.

Kātyāyana

(*Nalada*; Japanese, *Kasenen*)

Born in Ujjain (western India), he was Brāhmin chaplain to the kings of this city. Converted by the Buddha, he converted his own king in turn. He was an extremely effective preacher. He is represented holding a begging bowl, or hands joined, fingers interlaced.

Aniruddha

(Japanese, *Anaritsu*)

'He who is first in the sharpness of his divine eye (*Divyachakshus*) and for his memory' was also a cousin of the Buddha, and died after him. He is represented making a gesture of explanation or with his hands joined.

Upāli

(Japanese, *Ubari*; Tibetan, *Nye-var-khor*; Mongol, *Chikola Akchi*)

'He who is first in keeping discipline' was an Indian barber whose task it was to shave the heads of those who entered the Saṅgha. His accounts of the rule of discipline (*Vinaya-piṭaka*)[76] were adopted at the council in Rājagṛha. He is represented with hands joined, forefingers extended, in Abhiṣeka mudrā.

Rāhula

(Japanese, *Ragora*; Chinese, *Luohuluo*; Tibetan, *Sgra-gchan-jin*; Mongol, *Raoli*)

'He who is first in esoteric practices and in desire for instruction in the Law' was the son of the Buddha, born either before his father left home to begin his search for salvation, or on the day of his father's Enlightenment. He decided to leave the palace of Kapilavastu to seek

Rāhula
Tibetan engraving

the Truth.[77] He died before the Buddha. He is considered as one of the Arahants (see p. 104) and as the patron of all novices. He is represented holding his right wrist, or with a fly-whisk (*cāmara*) in the right hand and a scroll of scripture in the left.

Arahants

(*Arhat*; Japanese, *Arakan*, *Rakan*; Chinese, *Luohan*; Tibetan, *Gnas-brtan*; Mongol, *Batu-aqchi*)

The Arahants are 'saints' or sages who have fully realized for themselves the Buddhist Doctrine,[78] and have attained freedom from the cycle of suffering and rebirth. In some texts the Buddha is described as being accompanied by 50 arahants, sometimes by 500 or other multiples of this number (the figure is taken by some simply to mean a large crowd). Only 16 Arahants are actually worshipped, and these are perhaps symbolic of the four Arahants that tradition assigns to each of the four cardinal points[79] (materialized as a region of India or of China[80] and as a special 'paradise'). Thus, for example, the first of them, Piṇḍola Bharadvāja, is said to reside with 1,000 of his disciples in Aparagodanī, to the west; the second, Kanakavatsa, with 500 disciples, in Kashmir in the north; the tenth, Panthaka, with 1,300 disciples, in the Heaven of the 33 Gods. It appears that Piṇḍola, the only one with Mahākāśyapa who did not enter Nirvāna, became the Arahant *par excellence* after the disappearance of Mahākāśyapa, and that the others are merely replicas.

According to the *Fazhu Li*, translated in 654 by the Chinese pilgrim Xuanzang, 'there was in the capital of King Prasenajit of Sri Lanka an Arahant with the name of Nandimitra who explained how the Buddha, when he entered his Parinirvāna, had entrusted the Supreme Law to 16 great Arahants and to their disciples, ordering them to protect it from extinction and to preserve it.' The Arahants are thus mainly the protectors and preservers of the Buddhist Law. These 16 Arahants distinguished by the Buddha formed part of the 500 claimed by tradition to have attended the council in Rājagrha: there they vowed to renounce Nirvāna in order to devote themselves more effectively to the relief of human misery, like the Bodhisattvas. They are considered in Northern Buddhism in general and in Japan in particular as Śrāvakas or auditors of the Good Word, all disciples of the Small Vehicle and, as very wise human beings, destined to become Bodhisattvas.

They are quite often represented, especially in China and Japan, in sculpture and painting, in poses and with attributes that are often rather different, and this sometimes makes them difficult to identify. They may be shown as young or old men (depending on the style of the painter and the period), usually clothed as monks, heads shaved (except for Rāhula). These 16 Arahants are the only ones described briefly here, since the others do not obey any particular rule of representation.

With the exception of Piṇḍola Bharadvāja, they are all relatively unfamiliar to the faithful in Japan and are offered only general worship,[81]

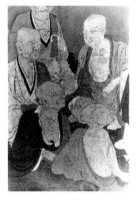

The 500 Arahants
Deatil from a painting by
Minchō (1325–1451),
Japan

being given the title of 'venerable' (Japanese *sonja*).[82] They are represented (whether 16 or 500) in groups of varying size (sometimes of only two or three in paintings). They may also be symbolized by roughly finished statues, hewn out of stone or wood, or modelled in clay, in the image of monks. Since their large number enhances their collective power, they are usually worshipped in groups. In Japan they are sometimes found headless on account of a popular belief that the head of an Arahant brought luck, so the faithful gladly broke them off to take them home.[83] According to a Chinese legend, the 500 Arahants lived on Mount Tiantai, in China.

Traditions tend to disagree as to the origin of the 500 Arahants.[84] According to the *Mahāparinirvāṇa-sūtra* and the *Saddharmapuṇḍarīka-sūtra*,[85] they are 500 beggars (or blind monks) who had been rich merchants in former lives. The Buddha, having met these merchants, 'gave them the light': the moralizing intent of the symbol is obvious. It is apparently the Japanese monk Eisai (twelfth century) who, having worshipped them on Mount Tiantai, brought their images back to Japan. These images (100 painted kakemonos, of which only 92 can be found today) were made in 1178 by the Chinese monk painters Lin Tinggui and Shi Jishang. They are kept at the Daitoku-ji in Kyōto. Their cult was propagated in Japan by the monks of the Zen sects (Rinzai-shū, Sōtō-shū and Obaku-shū). Many popular beliefs are attached to them, differing by region, temple, sect and period, and they belong to folklore[86] much more than to the Buddhist pantheon.

Piṇḍola Bharadvāja

(Japanese, *Binzuru Sonja*, *Binzuru Baradaja*, *Bindora Baradaja*, *ō-Binzuru-san*; Chinese, *Bintouluo*)

According to one of the innumerable legends attached to this Arahant, he was reprimanded by the Buddha for having demonstrated marvellous powers to confuse Brāhmins, by flying in the air to seek a bowl that an unbelieving merchant had deliberately placed at the top of a pole.[87] He was expelled from India and from the monastic community, and entry into Nirvāṇa was refused him until the advent of the Buddha of the Future, Maitreya. According to other legends, Piṇḍola was expelled from the community for having broken the vow of chastity. These are the reasons why his effigy is placed on the threshold of religious edifices, although sometimes it is placed in monks' refectories. However, according to a Hīnayānist commentary, the *Ekottara Āgama Śāstra*, 'Śāstra on the discrimination of merits and virtues' (Japanese *Funbetsu Kudoku-ron*), translated into Chinese under the eastern Han dynasty (25–220), Piṇḍola was, on the contrary, congratulated by the Buddha and called 'He who is first in stamping out heresy'.[88]

In Japan, where he is mainly worshipped by lay people, he is represented as an old man seated on a high-backed chair, with white hair and bushy eyebrows. Statues of him, in painted wood or stone, are usually well worn, since the faithful follow the custom of rubbing a part

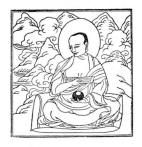

Piṇḍola Bharadvāja
Tibetan engraving

of the effigy corresponding to the sick parts of their bodies, as he is reputed to have the gift of healing. He is also very frequently offered red and white bibs and children's caps to watch over the health of babies, so that his statue is often decked in rags. He is represented in painting as an old man seated on a rock, holding in his hand a sort of sceptre (Japanese *shaku*, Chinese *gui*), or a *sūtra* box and a feather fan.[89] According to the texts, Pindola resides with 1,000 disciples in a western region (Japanese Saikudani-shū).[90] All the other Arahants are usually worshipped in Japan in his person.

Kanakabhadra

(Japanese, *Kanakabaridaja*; Chinese, *Biliduoshe*)

Represented standing in the clouds, holding a scroll of Buddhist scripture in the hand, he is sometimes accompanied by one of his 6,000 disciples who strikes a gong. He resides in the east (Japanese *Tōshōshin-shū*).

Kanakavatsa

(Japanese, *Kanakabatsusa*; Chinese, *Jianuojia Facuo*;
Tibetan, *Gser-be-u*)

Represented seated on clouds, holding a fly-whisk and said to reside in Kashmir, in northern India, with 500 disciples.

Subinda

(Japanese, *Subinda*; Chinese, *Supinte*)

Represented seated on a mat with his hands placed together on his thighs, he resides in the north (Japanese *Hokukuru-shū*) with 600 disciples.

Nakula (Vakula)

(Japanese, *Nakora, Bakura*; Chinese, *Nuojuluo*)

Represented accompanied by a child and a beggar, or seated on a chair, holding a rosary. He is endowed with exceptional longevity due to the merit he has accumulated in previous lifetimes. He resides in the south (Japanese *Nansenbu-shū*) with 800 disciples.

Bhadra

(Japanese, *Badara*; Chinese, Botuoluo)

Often accompanied by a tiger and reputed to be a magician, he resides in Tanmora-shū (Japan).[91]

Kālika

(Japanese, *Karika*; Chinese, *Jialijia*)

He is represented as an old man reading a text. He resides in the region of Sōkada (Japan) with 1,000 disciples.

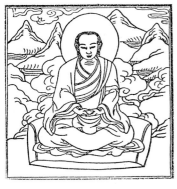

Kanakabhadra

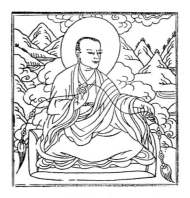

Kanakavatsa

Bhadra

Kālika

Vajraputra

Panthaka

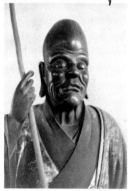

Vajraputra
Wood, Mampuku-ji,
Kyōto, Japan,
seventeenth century

Vajraputra

(Japanese, *Bajaraputara*; Chinese, *Fasheluofuduoluo*)

He is represented with a long staff. He resides in the region of Harana with 1,000 disciples.[92]

Jīvaka

(Japanese, *Jubaka*)

Son of a courtesan of Rājagṛha and abandoned at birth, he became doctor to King Bimbisāra of Magadha, and later a monk. Being a doctor, he is often confused with Piṇḍola, which could have led to the attribution of curative virtues to certain statues representing Piṇḍola. He is seated on a chair, hands hidden in his sleeves. A lotus is sometimes placed alongside.[93]

Panthaka

(Japanese, *Hantaka*; Chinese, *Bantuojia*)

He is the brother of another Arahant, Chūdapanthaka (with whom he is often depicted), and resides in the Heaven of the 33 Gods. He holds a *cintāmaṇi* (wish-granting jewel) in the hand and is accompanied by a dragon. He directs 1,300 disciples.[94]

Rāhula

(Japanese, *Ragora*; Chinese, *Luohuluo*; Tibetan, *Sgra-gchan-jin*; Mongo, *Raoli*)

The son of the Buddha and one of his ten great disciples (see p. 99). He sometimes wears a beard, and is often accompanied by a deer or a disciple. Sometimes he is represented seated next to a bamboo thicket, hands joined. His residence is set in the Hiriyōku-shū (Japan) with 1,000 disciples.

Nāgasena

(Japanese, *Nagasena*)

The discussion between this sage and the Indo-Greek king Menander (Milinda) is the subject of the text of the *Milindapañha*, 'The Questions of Milinda'.[95] He is represented with a bowl from which springs the fountain of knowledge. He resides on Mount Handoha with 1,200 disciples.

Angaja

(Japanese, *Ingada*; Chinese, *Yinjietuo*)

This Arahant is also sometimes confused with Piṇḍola, because he has long eyebrows and is represented seated, holding a priest's sceptre (Japanese *nyo-i*). He resides on Mount Kōkyō (Japan) with 1,300 disciples.

Vanavāsin

(Japanese, *Banabasu*; Chinese, *Fanaposi*)

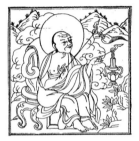

Angaja

He is represented with hands joined, seated next to a vase. He resides on Mount Kajū with 1,400 disciples.

Ajita

(Japanese, *Ajita, Daitaka*; Chinese, *Ashiduo*)

He is shown seated near a vase of flowers, holding a long staff. He resides on Mount Jūbu with 1,500 disciples.

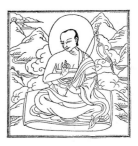

Vanavāsin

Chūdapanthaka

(Japanese, *Chudahantaka*; Chinese, *Zhucha Bantojia*)

The brother of Panthaka, he was famous for his stupidity. However, thanks to the Buddha, he studied the Law and became an Arahant celebrated for his magical practices.[96] He is represented seated looking at the sky, holding a fly-whisk, often accompanied by his brother. He resides on Mount Jijiku with 1,600 disciples.

These representations are typical but not immutable. They depend largely on the legends on which the artists relied to represent them. Mostly created in China, the images of the Arahants were strongly influenced by representations of the Taoist deities. With few exceptions, the regions assigned to them are unreal and form part of Indian or Chinese mythology. The number of disciples allocated to them is perhaps symbolic of their importance.

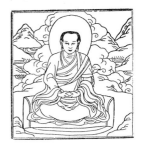

Chūdapanthaka

In China, a group of 18 Arahants (Chinese *Luohan*) is traditionally worshipped, and this group came into existence only in the late tenth century: their portraits were painted at the time by the poet–painter Guanxiu (832–912).[97] The two extra Luohan added to the traditional list were of Chinese origin and probably belonged to the popular Taoist pantheon; they were most likely added by Buddhists to counterbalance the influence of Taoism.[98] 'He who tames the Dragon' and 'He who tames the Tiger' are purely imaginary: even their names vary from one place to another and from one period to another. They include Nandimitra, a second Piṇḍola, Kumārajīva, and even Maitreya and Avalokiteśvara, not counting the names of personages like Liang Wudi (502–550) or Aśvaghoṣa.[99]

Other series of Chinese Luohan were invented, particularly those worshipped in some temples of Anhui, and who mostly appeared to belong to the Chan sects: Wuke Chanshi; Zizai Chanshi (Iśvara, an Indian monk); Daotong Chanshi; Fenggan Chanshi (eighth century); Huiyuan Chanshi; Shide Zi and Hanshan Zi (two famous poets); Huizang Chanshi; Judi Heshang (the Indian monk Guṇamati, a disciple of the Buddha); Daoyue Chanshi; Singhalaputra (Indian monk); Congshen Chanshi (eleventh century); Rāhulata (Indian monk who died c. 113 BC); Shenzan Chanshi (c. 742); Kumārajīva (Indian monk, 360–415); Mahākāśyapa; Aśvaghoṣa (Chinese Maming Zunzhe); Budai Heshang or Budai Chanshi (a form of Maitreya).

The 16 Arahants of Indian tradition are worshipped in Tibet, plus two others, the monks Dharmatala and Huashan (the latter possibly

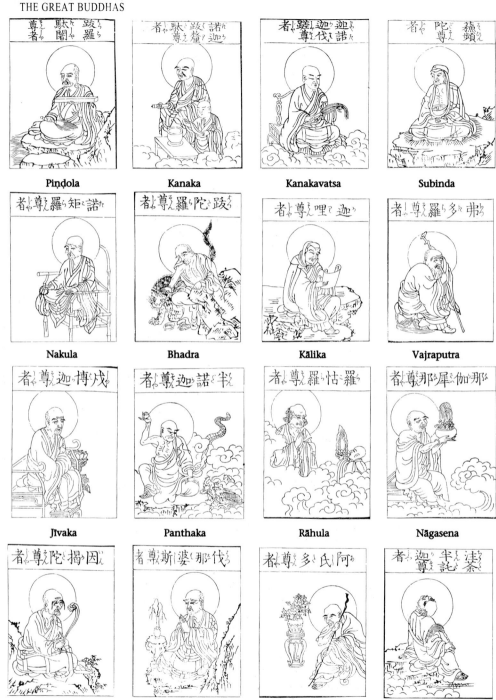

Piṇḍola

Kanaka

Kanakavatsa

Subinda

Nakula

Bhadra

Kālika

Vajraputra

Jīvaka

Panthaka

Rāhula

Nāgasena

Angaja

Vanavāsin

Ajita

Chūdapanthaka

resembling Maitreya). The representations of the Chinese and Tibetan Arahants vary considerably. There are even groups of female Arahants,[100] ten in number, according to a Nepalese version of the *Avadāna-śataka* and the Pāli work *Saṃyutta-Nikāya*. They are rarely represented.

Other Personages

Māyā, mother of the Buddha
(*Māyā*; Japanese, *Maya Bunin*; Chinese, *Moyo, Zhende Pusa*; Tibetan, *Sgyū-phrul-ma*)

She is often represented in the scene of the birth of the future Buddha (see p. 87). The theme of the birth of the Buddha was commonly represented in India, especially in the Pāla period, and also in Burmese paintings (the Lokatheikpan of Pagan, twelfth century, for example). Māyā is also depicted having the dream which foretold that she would give birth to the future Buddha. In certain late Buddhist texts, she is sometimes identified with a Bodhisattva, or with a Tārā.

Bodhidharma
(Japanese, *Daruma*; Chinese, *Damodashi, Putidoluo, Zunshe*)

Bodhidharma is a semi-mythical figure, mainly worshipped by the Chan and Zen sects, attached by legend to Śākyamuni, who bears some resemblance to the Arahants. His effigy, which became extremely popular in Japan under the name of Daruma or Bodai-daruma, is the object of many beliefs and practices, most of which have very little in common with the religious doctrines of Buddhism. He is claimed to have introduced the Indian meditation techniques of the Dhyāna into China around the sixth century. The anniversary of his birth is celebrated in China on the fifth day of the tenth month. He lived for nine years in the Chuzu'an monastery (temple of the First Patriarch) at Songshan (Henan Province), during which he remained in meditation turned towards a rock, thus losing the use of his arms and legs. He died in 535.

Bodhidharma

According to legend, Bodhidharma was born in India. He disembarked at Canton with his brother Daxisekong, and then went to the palace of King Liang Wudi in 527. He travelled to Henan where his brother remained, and later died in a temple of the Nanhai. One belief is that the personage whom the Japanese name Daruma is not Bodhidharma but rather a Buddhist monk (perhaps Dhyānabhāra) who travelled from India to Korea, where he died in 1363.[101] However, this opinion is not shared universally by scholars, and is generally rejected by the Japanese, who are firmly convinced that Daruma and Bodhidharma are one and the same personage.

In Japan, the effigy of Daruma has become a popular toy. Some figurines called *poussah* (from the Chinese *pusa*, 'Bodhisattva'), which are called *okiagari koboshi* in Japan ('the little monk who raises himself'), sometimes assume the form of Daruma. These figurines, due to an inte-

rior weight and a rounded base, always return to the upright position. This sort of toy probably existed in Japan before the introduction of the Chan doctrines and before the personage of Bodhidharma was known. His legend supplied a theme that fitted naturally with such a toy, since he is usually represented (mainly in painting) seated in meditation, the legs and arms concealed beneath his robe. In Japan, painted *papier-maché* effigies of Daruma are generally sold with the pupils of the eyes not shown, because Bodhidharma is thought to have become blind towards the end of his life. Those who make a wish paint a pupil on one eye, and if the wish is granted during the year they 'give life' to Daruma by painting the second pupil. This little ceremony is perhaps similar to that of the opening of the eyes which is found in all parts of the world and at all times.[102] In Japanese, the expression 'to have one's eyes open' means 'to have luck': the effigies of Daruma are hence considered good luck charms. They are offered as gifts for the New Year, when throngs visit the Daruma Market in the Hachiōji quarter of Tōkyō. A common belief among the geishas of the nineteenth century and of many artists today is that anyone who succeeds in stealing a figurine of Daruma from a shop without being seen by the owner will be lucky throughout the year, so shopkeepers keep a watchful eye out at New Year.

Bodhidharma Daruma is also naturally a religious symbol and an example: like him, no force can indefinitely strike down one who obeys the Good Law. In Japan, this is called *Nanakorobi Yaoki* (seven falls, eight recoveries), because, according to a tradition, Bodhidharma claimed that a follower struck down seven times will rise an eighth time, thus demonstrating that one cannot strike down a firmly established spirit: the number eight is a symbol of infinity and stability in Japan.

The figurine representing Daruma soon came to be considered a powerful talisman. It is generally painted red (a bright colour, symbolizing luck and joy, both in China and Japan), except for the face which is white, bearded and moustached, with large bulging eyes, the frowning eyebrows betokening resolute concentration, which sometimes gives it a fierce air. Curiously, in certain regions of Japan, feminine effigies of this Daruma also exist, called *hime-daruma* (Princess Daruma); the red body is adorned with flowers and symbols. In Kanazawa, this is an effective amulet for protecting babies. According to another pop-

Nanakorobi Yaoki Daruma
Tōkyō, formerly
Collection of R. de Berval

ular belief, if an *okiagari koboshi* is placed in a chest of drawers, the chest will always remain full.

A number of Japanese and Chinese representations, which are quite rare and probably late, show a laughing Daruma: confusion is possible with Warai Hotoke, the 'laughing Buddha', the guardian of monastery libraries, or perhaps with Hotei, one of the popular forms of Maitreya. The figurines of Daruma are also often grouped in pairs, or in pyramids of seven, eight or nine or, even more commonly, in series of eight (to multiply their effectiveness). Other effigies claimed to be Daruma are not *poussah* but works of art or useful objects. In Kōfu (Yamanashi Province, Japan), some figurines of Daruma have a child's head (*oyako* or *komochi daruma*) painted on the belly. Custom (seldom observed) dictates that all the Darumas bought in the previous year must be burned every year in February, when decorations are purchased for the New Year festivities. This takes place during the Setsubun Festival (change of season), or on the day of Risshun which marks the beginning of spring. Bodhidharma was a favourite subject with Chan and Zen painters, who tried to reproduce his image in every possible way, both serious and humorous.

BHAIṢAJYAGURU

(Japanese, *Yakushi Nyorai*; Chinese, *Yaoshi Fo*; Tibetan, *Sangs-rgyas, Sman-bla*; Mongol, *Otochi*)

Bhaiṣajyaguru (Yakushi Nyorai)

Apart from the form of the historical Buddha, popular Buddhism in Japan has consecrated two other forms of Buddha, or rather of his substitutes, which enjoyed tremendous popularity due to their very specialization: Bhaiṣajyaguru and Amitābha. These two Buddhas, although essentially different, in fact represent two opposite poles that lie outside the strictly philosophical doctrine of the Buddha himself. The first represents the 'healer', and the second the 'consoler' of beings. (For a discussion of Amitābha, one of the five Jinas, see Chapter IV.)

No better description can be offered of this aspect of the Buddhist deity than the qualifications attributed to Bhaiṣajyaguru (or Bhiṣak), considered here as a genuine deity invoked to obtain something. He is the 'master of remedies',[103] the 'doctor of souls and bodies', the 'sage and knowing doctor of the sufferings of this world'.[104] According to a Tibetan version of these texts, Bhaiṣajyaguru taught medicine to a group of sages.[105] In India and in South-East Asia, representations of Bhaiṣajyaguru are relatively rare,[106] whereas in Tibet and also China, where Buddhists were strongly influenced by the paramedical practices of the Taoists, his image is found more frequently, especially in the Wei period.[107]

He is shown in the same attitudes and in the same manner as Gautama Buddha; one way in which he is distinguished is by the appearance, above him, of his seven 'bodies' (see p. 112). In Tibet, where images of him are quite common, he is blue. He may have five forms,

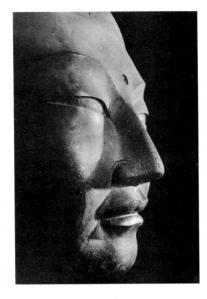

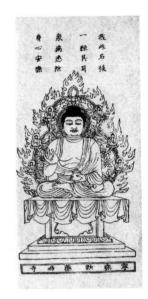

Yakushi Nyorai
Bronze, Kōfuku-ji, Nara,
Japan, seventh century

Bhaiṣajyaguru
Japanese engraving

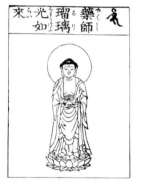

Yakushi Rurikō Nyorai

which possibly derive from adaptations of esoteric texts of the Vajrayāna doctrines. In most paintings which represent him, he is seated in Vajrāsana on a lotus support. The palms of his hands are coloured red. His right hand is in Varada mudrā on the knee (sometimes holding a myrobolan fruit), the left placed in his lap and holding a cup (or a vase full of medicine or myrobolan fruits). His cranial bump is usually in the form of a small sugarloaf shape (contrary to the one characterizing Gautama Buddha, which is broad and flat).

In Japan, where his cult enjoyed great favour until the twelfth century, he is called Yakushi Rurikō Nyorai, the 'Great Buddha master of remedies with the brilliance of beryl', or Dai-o-ō, 'great king of physicians'.[108] His functions are commonly confused with those of the Arahant Piṇḍola Bharadhvāja (see p. 101). The Japanese grant him such importance that, in certain circumstances, he is placed at the centre of the Buddhist pantheon, in the place of Dainichi Nyorai (*Mahāvairocana*) or Ashuka Nyorai (*Akṣobhya*)[109] – in the Vajradhātu Maṇḍala of the Shingon sect, for example.[110] In the Kamakura period (1185–1333), when the popular fervour for the Amida Buddha was considerable, he was sometimes unhesitatingly identified with this Buddha, against all orthodoxy. Three Japanese sects – those of the Hosshō, Tendai-shū and Shingon-shū – worshipped him separately, and considered him as the Supreme Being, whereas the other sects (including the Zen) regarded him merely as one aspect. The followers of the Pure Land of Amida (Jōdo-shū) and of Nichiren now grant him very limited consideration.[111] However, the popularity of this healing Buddha extends largely beyond the dogmatic frameworks of the sects, and he is still venerated individually by many Japanese.

110

One of the characteristic features of this Buddha is the fact that, when still a Bodhisattva, he expressed twelve great vows,[112] some of which concerned the physical healing of the sick. Another of his wishes was to illuminate the world with the light emanating from his body, and this is why he is sometimes identified in Japan with the Great Buddha of sunlight, Dainichi Nyorai.[113] Like every Jina, he has his territory for preaching. This area, which tradition places in the east, on the side of the rising sun, predestined him to become an essentially Japanese Buddha, since the islands of Japan, the easternmost of Asia, are situated under the sign of the sun, 'born from the sea'. And it is perhaps the easterly situation of his preaching territory (the Pacific Ocean) that encouraged in men the belief that his divine residence, his paradise in some sense (connected with his second wish) was a land of 'pure beryl',[114] hence the name he also assumes of Bhaiṣajyaguru Vaiḍūryaprabhāsa (Japanese *Yakushi Rurikō*), 'with the brightness of beryl'.

These features probably underlie the fact that Bhaiṣajyaguru was one of the first Buddhist deities to be venerated in Japan, and became one of the most important. The famous temple of Hōryū-ji in Nara was built by the Regent Shōtoku to accommodate a large bronze statue of Yakushi Nyorai, in the hope of securing from this physician Buddha the cure of the Emperor Yōmei (c. 587). In 680, the temple of Yakushi-ji was built in Nara, then the capital of Yamato, on the order of the Emperor Tenmu, to ensure the recovery of the ailing Empress.[115] Familiar at the outset only to the dignitaries of the court and then, as the Buddhist doctrines spread throughout the country, to increasingly broad levels of the population, the reputation of Yakushu Nyorai grew steadily. He was worshipped on a considerable scale, particularly from the eighth century onward.[116] Readings of the *Yakushi-kyō* (text invoking this Buddha) were performed in temples, where the followers also processed in ceremonies of repentance called Yakushi-keka when they temporarily renounced hunting and warfare, and when they freed imprisoned animals.[117] These ceremonies, which included a rite of circumambulation called Gyōdo-keka around the statue of Yakushi,[118] were performed either to elicit a cure,[119] or to ward off national evils (catastrophes, epidemics, drought, etc.) or personal misfortunes.[120] Similarly, the followers of the Tendai-shū offered both Yakushi Nyorai and Dainichi Nyorai lamps and lights, by analogy with a magical rite intended to enhance the luminous power of the sun, identified with their 'luminous bodies' – at the end of the year or on other occasions to expel the evil powers of darkness.[121]

The virtues generally attributed by the faithful to the statues of Bhaiṣajyaguru are many: they are believed to be capable of watching over the health of the people, of protecting them against epidemics, diseases, dangers to families and pregnant women, of preserving them from the hazards incurred during sea voyages, and even of curing barrenness.[122]

There are many effigies of Yakushi Nyorai in Japan to which marvellous powers are popularly attributed: the effigy in the Kaizō-ji in

Kamakura was apparently discovered – the head only – by a monk named Genno as it groaned night after night in the earth where it was buried following a catastrophe. These murmurings miraculously ceased when the monk repaired the statue.[123] The Japanese also venerate statues of Yakushi Nyorai in spas, particularly at Kumano Yunomine Onsen.

In Tibetan painting, almost all the images of Bhaiṣajyaguru reveal the same overall pattern. In China and Japan, these images are more diversified, although they obey approximately the same rules: he is usually represented seated, with the right hand in the gesture of fearlessness (Abhaya) or giving (Varada), the left arm stretched along the hip (standing position) or resting in the lap, possibly with a medicine bowl in his hand.[124] This medicine bowl is sometimes wrongly called a begging bowl (*pātra*); in fact, it is the 'beryl medicine bowl' (Japanese *ruri yakkō*). A Chinese text, the *Yaoshi Rulai Niansong Yigui* (Japanese *Yakushi Nyorai Nenzu Giki*), states: 'In the left hand make Bhaiṣajyaguru hold a medicine jar or a precious pearl. The right hand should be in the mudrā of the Union of the three worlds.'[125] This mudrā corresponds to Abhaya. This is the most common iconographic form in Japan and China. However, it appears that the earliest known representations of Yakushi Nyorai in Japan do not have a medicine bowl, although it may simply have disappeared. Bhaiṣajyaguru observes the iconographic forms of the Great Buddhas.[126]

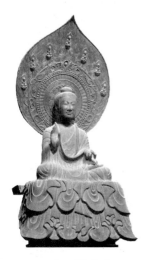

Bhaiṣajyaguru
Bronze, Hōryū-ji, Nara,
Japan, seventh century

There is a particular form of Yakushi Nyorai (effigy in the Hōkai-ji in Yamashiro, Japan)[127] whose hands are in Dharmacakra mudrā, holding the medicine jar. Other iconographic forms exist, based on different texts (for example, representing Bhaiṣajyaguru with the right thumb touching the ring finger of the left hand),[128] but these different forms are chiefly mentioned in theoretical treatises or appear only on maṇḍalas.[129]

Another detail found in Japan, but unexplained, is that Yakushi Nyorai is not included in the two great maṇḍalas, the Vajradhātu and Garbhadhātu Maṇḍalas, of the Shingon sect. Tajima Ryōjun[130] states the reasons that could possibly explain this absence of representation. Those we consider the most obvious associate Yakushi Nyorai with Akṣobhya, the Buddha of the East in the Vajradhātu Maṇḍala, and with Mahāvairocana in the Garbhadhātu Maṇḍala.

The seven bodies or forms of Bhaiṣajyaguru

Bhaiṣajyaguru (Yakushi)

Some Sanskrit texts, such as the *Sapta-tathāgata-purva-praṇidhāna-vi-ceṣṭā-vistara*, and Chinese texts[131] describe seven 'bodies' or emanations that Bhaiṣajyaguru can assume during his functions as a healer, including that of Bhaiṣajyaguru himself. One of these emanation bodies (Japanese *Busshin*)[132] is sometimes considered as an independent deity in Japan: this Zen Myōshō Kichijō-ō Nyorai[133] is in this case confused with Yakushi Nyorai. These emanations are usually represented

above the image of Bhaiṣajyaguru:[134] they have a red or golden-yellow flush tint and make different gestures. They are also all seated in Vajrāsana (in Tibetan paintings), or placed on his corporeal aureole, holding a *cintāmaṇi* in the hand.[135] These emanations are sometimes symbolized only by their respective seed-syllables, drawn in Sanskrit Siddham characters. Distinct paradises, all of which are located in the east, and a number of vows, are attributed to each of these emanations.[136]

In Japan, a syncretic deity called Gion Tenjin, protector of the sanctuary of Gion in Kyōto, is often identified as being an emanation of Yakushi Nyorai as the mythical hero Susanoo no Mikoto, the turbulent brother of the solar Kami Amaterasu Omikami of the Shintō legends. This deity has no set form, but is sometimes distinguished, under the name of Gozu Tennō, by a cow's skull placed on his head. It has the appearance of a Deva, with two or more arms. However, this syncretic identification is often disputed.

Bhaiṣajyaguru

The acolytes of Bhaiṣajyaguru

In sculpture and painting, this deity is often attended by two Bodhisattvas, Sūryaprabha, 'splendour of the sun' (or Sūryavairocana, Japanese *Nikkō Bosatsu*), and Candraprabha, 'splendour of the moon' (or Candravairocana, Japanese *Gakkō Bosatsu*), one watching over mortals by day, and second by night.[137] Together they form a group called the 'august triad of Bhaiṣajyaguru'[138] (Japanese *Yakushi Sanzon*). Sūryaprabha and Candraprabha are shown standing or seated in Lalitāsana. In painting, Sūryaprabha is coloured orange, while Chandraprabha is white. They are clothed in long-sleeved monastic garments, beltless, their feet in slippers (exceptional for Bodhisattvas), and their hair tied in high chignons surrounded by a crown of suns for Sūryaprabha, and moons for Candraprabha. Yet their apparel may vary from one painting to another, as well as their jewels and tiaras.

Yakushi Sanzon

Although the mudrās attributed to them are not absolutely fixed, they often make the gesture of fearlessness and offering (Abhaya and Varada), in symmetry to each other, or have their hands joined in Añjali mudrā. They sometimes also bear a lotus in their right hand and, in the left, a solar disc; or Sūryaprabha holds a lotus, and Candraprabha a crescent moon. They are also shown as adolescents, with their hair falling in long locks. The blue lotus held in their hands is, in this case, surmounted by a solar disc or a crescent moon. In painting, Sūryaprabha is sometimes represented on a chariot drawn by three horses, or on horseback. Candraprabha is sometimes shown riding a goose.[139] They are rarely represented independently of Bhaiṣajyaguru.

Acolytes of Yakushi Nyorai
Fresco from the Hōryū-ji,
Nara, Japan, c. 710

**One of the warriors of
Bhaiṣajyaguru**
Dried clay, Yakushi-ji,
Nara, Japan,
eighth century

The twelve warriors of Bhaiṣajyaguru

Bhaiṣajyaguru also commands twelve warriors (sometimes considered as Yakṣas[140] or titans), called Shinshō in Japan (or Daishō in the *Butzsuzō-zu-i*). They are believed to protect the faithful by presiding over the daylight hours, the months and the directions of space. They are twelve, or sometimes only nine, generals whose armies wage war on sickness. These twelve warriors are also representative of the twelve vows of Bhaiṣajyaguru. They are said to command the 80,000 pores of the skin, thus defending the health of the faithful in the name of Bhaiṣajyaguru.[141] Although described in Sanskrit,[142] Chinese[143] and Japanese[144] texts, the attributes assigned to them, as well as their colours (and sometimes their names), may vary. The paintings of central Asia (from Khara-khoto especially) represent them as Indian Yakṣas, with fierce expressions, adorned like Devas or Asuras: they are then considered as the guardians of space (Dikpālas). Particularly in China and Japan, they are also treated as the guardians of the four cardinal points (Lokapālas or Caturmahārājas), as warriors in armour. They are rarely represented independently of Yakushi Nyorai, without whom they would have no existence. They are (in the order given by the *Butsuzō-zu-i* and the *Bukkyō Daiji-ten*):

- Khumbīra (Japanese *Kubira*),[145] yellow, armed with a vajra.
- Vajra (Japanese *Bazara, Bajira*), white, armed with a sword.
- Mihira (Japanese *Mekira*), yellow, armed with a vajra.
- Aṇḍīra (Japanese *Anteira*), green, armed with a mallet or a fly-whisk.
- Anila (Japanese *Anira*), red, armed with a trident or an arrow.
- Śāṇḍilya (Japanese *Sandeira*), grey, armed with a sword or a conch shell.
- Indra (Japanese *Indara, Indatsura*), red, armed with a staff or a halberd.
- Pajra (Japanese *Haira*), red, armed with a mallet, a bow or an arrow.
- Mahōraga (Japanese *Makora*, Makura), white, armed with an axe.
- Sindūra (*Kiṃnara*, Japanese *Shindara*), yellow, armed with a rope or a fly-whisk and a pilgrim's staff (*khakkara*).
- Cātura (Japanese *Shōtora*), blue, armed with a mallet or a sword.
- Vikarāla (Japanese *Bikyara*), red, armed with a three-pointed vajra.

They are usually represented standing, in armour, in a martial or menacing stance, helmeted or with their hair in spikes, wearing a fierce expression. In Japan, after the Kamakura period (1185–1333), these twelve warriors were sometimes confused (or associated) with the twelve animals (Jūni Shi) of the twelve-year cycle.

114

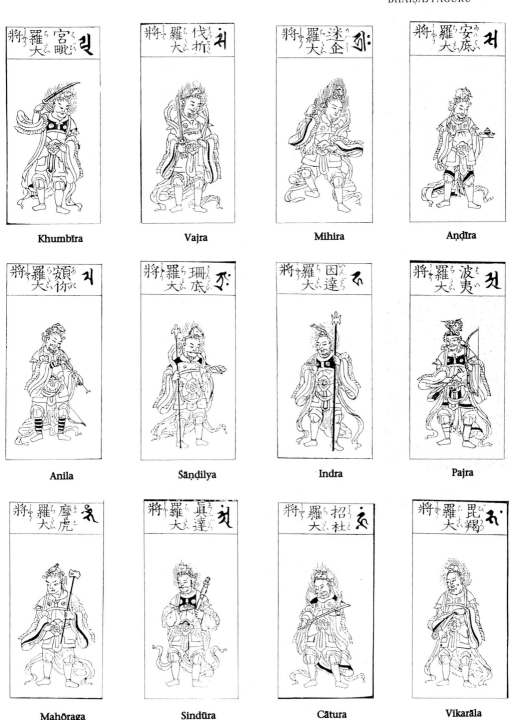

Khumbīra Vajra Mihira Aṇḍīra

Anila Sāṇḍilya Indra Pajra

Mahōraga Sindūra Cātura Vikarāla

Besides his two acolytes and his twelve warriors, Bhaiṣajyaguru is theoretically surrounded by eight great Bodhisattvas: Mañjuśrī, Avalokiteśvara, Akṣayamati, Mahāsthāmaprāpta, Maitreya, Bhaiṣajya-samudgata and Bhaiṣajyarāja and, in Japan, Hōdange Bosatsu.[146] These eight Bodhisattvas are intended to show the faithful the road to the paradise of Amitābha. Among them are two Bodhisattvas of medicine (Bhaiṣajya-samudgata and Bhaiṣajyarāja, Japanese *Yaku-ō* and *Yaku-jō*) who are two brothers in the retinue of Amitābha in his 'descent' (Japanese *Raigō*) or 'welcoming of the faithful to the paradise of Amitābha', and who represent the purifying power of the sun.[147] In painting, they are shown holding a willow branch.[148]

Yet the association of these Bodhisattvas with the effigy of Bhaiṣajyaguru appears to be quite late, and probably represents the attempts of the sects worshipping Amitābha to try to include in their doctrines those associated with Bhaiṣajyaguru and hence to win over a portion of their followers. It is difficult to assign any absolute symbolic value to these attributions, which remain quite theoretical, and are of little interest to the believer.

BUDDHAS OF THE PAST

**Bhaiṣajyaguru , with his
two acolytes and his
twelve warriers**
Japanese pious image

In theory there have been innumerable Buddhas, each having had the charge of a *Kalpa*, as a teacher and a master of the Law. They are often described collectively as the '1,000 Buddhas' (Chinese *Qian Fo*), and many caves (especially China, at Dunhuang) were devoted to them. In Burma (Pagan), moulded tablets of the '1,000 Buddhas' are also found. There are lists of 56 or 84 human Buddhas, but only Vipaśyin, Śikhin, Viśvabhū, Krakucchanda, Prabhūtaratna, Dīpaṅkara Buddha, Kanakamuni, Kāśyāpa and Śākyamuni have been taken into consideration by the faithful. Among them, in addition to Śākyamuni himself, only four have been the object of representation in Japan, and are very often cited in the texts as belonging to our present *Kalpa* and being human Buddhas: these are the Manushi Buddhas who, like all the Buddhas in the Mahāyāna system, have at least three bodies (*Kāya*):[149] that of mortal appearance (*Nirmāṇakāya*), that of total purity and pure knowledge (*Dharmakāya*), and a body of abstract essence (*Sambhogakāya).* Some sects attribute a further two bodies to the Buddha, reinforcing the theory of the *Trikāya* of each Buddha. However, the Manushi Buddhas belong to the first of these bodies; the *Nirmāṇakāya.*

**Gautama Buddha and
Prabhūtaratna**
Gilded bronze, Japan,
Private Collection

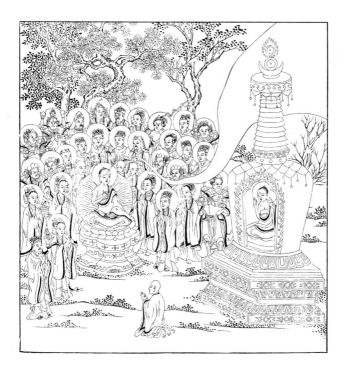

The Buddha and Prabhūtaratna
Chinese engraving, Ming period

Prabhútaratna
(Japanese, *Tahō Nyorai*; Chinese, *Duobao Rulai*)

In his person, he is the concrete form of all the Buddhas of past ages. He is himself divided into seven Buddhas representing the Manushi Buddhas (see above). In certain sects, particularly in Japan and China, he sometimes replaces Ratnasambhava, in the south of the maṇḍalas.

Dápankara Buddha
(Chinese, *Dingguang Fo*; Tibetan, *Mar-me-msdad*;
Mongol, *Chula Choqiaqchi*)

He was the 24th master of the Law, immediately prior to Śākyamuni according to the Southern schools; the 52nd, according to the Mahāyāna. He lived for 100,000 years on Earth. His name, which means 'Creator of Light', is sometimes pronounced Dvīpankara, meaning 'Creator of the Islands'. He is a protector of the sailors and is venerated mostly outside India. He is always represented as a Buddha, his robe revealing his right shoulder (although some statues in India show him with both shoulders covered, as in Japan in his earliest representations). His right hand is usually in Abhaya mudrā, his left holding a fold of the robe; in Thailand, he sometimes makes Abhaya mudrā with both hands symmetrically.

In China, this Buddha of the past was venerated for a long time, and is represented very early in the Yungang and Longmen caves: he is usually seated, with a fold of his robe covering both shoulders, his right hand in Abhaya. Rarely represented alone, he is found at the centre of triads together with Mañjuśrī and Vajrapāṇi (in Java), Avalokiteśvara and Vajrapāṇi (in Sri Lanka), or with Śākyamuni and the future Buddha Maitreya (in Nepal and Tibet). He is sometimes represented standing, particularly in China and Siam.

Kanakamuni
(Chinese, *Jiunashimuni*; Tibetan, *Gser-thub*; Mongol, *Altan Chidakshi*)

Unlike Krakucchanda, the first Manushi Buddha, Kanakamuni, the second, is virtually never represented.

Kāśyapa
(Japanese, *Kassapa, Kashō-butsu*; Chinese, *Jiaye Fo*; Tibetan, *Hod-srung*; Mongol, *Ghasiba, Gerelsaqiqchi*)

He is the immediate predecessor to the Buddha Gautama Śākyamuni. He is represented as a Buddha, his right hand in Varada mudrā and his left holding a fold of his robe folded in two. He is often seen seated on his *vāhana*, a lion. He is yellow or gold because he represents the light of the sun and of the moon.

Maitreya (Miroku Bosatsu)

MAITREYA, THE BUDDHA OF THE FUTURE
(Japanese, *Miroku*; Chinese, *Miluo Fo*; Tibetan, *Byams-pa*; Mongol, *Maijdari*; Vietnamese, *Di-lac*; Korean, *Mi-rüg*)

According to some Buddhist traditions, the period of the Buddhist Law is divided into three stages: a first period of 500 years, of the turning the Wheel of the Law; a second period of 1,000 years, of the deterioration of the Law, and a third period of 3,000 years (called Mappō in Japan) during which no one practises the Law. After this, Buddhism having disappeared, a new Buddha will appear who will again turn the Wheel of the Law. This future Buddha is still in the Tuṣita heaven, in the state of a Bodhisattva. Gautama Buddha himself will enthrone him as his successor. The name means 'benevolence' or 'friendship'. He is now living his last existence as a Bodhisattva. In anticipation of his imminent arrival, he is sometimes considered as a Buddha and given the title of Tathāgata.[150]

Maitreya is the only celestial Bodhisattva recognized by the sects of the Small Vehicle, who represented him from the outset. His images appear in Gandhāra, perhaps even before those of the Buddha (with whom he was perhaps confused): he is represented standing or seated,

as an ornamented Buddha, with long thin hair on the shoulders or tied in a chignon on his head, his hands in Dharmacakra mudrā when seated, or in Vitarka and Varada mudrās when standing.

In Tibet, when he is represented seated, his legs hang (in the European manner) and he is clothed as a Buddha. This is the form he assumes in Java in the eighth-century temple, the Chandi Mendut. His representations abound throughout Buddhist Asia. Yet he is usually shown as a Bodhisattva, standing and adorned with jewels, rather than seated. In certain images representing him in the sky Tuṣita, he appears seated with his legs in Padmāsana. He is recognized by wearing a small *stūpa* in his headdress. His attributes may vary, and he may hold a vase or a wheel (*cakra*) placed on lotus flowers. A scarf is always tied around his waist. Sometimes an antelope skin covers his left shoulder. He often forms a triad with Śākyamuni and Avalokiteśvara; in fact, in Sri Lanka, sculptures thought to depict Avalokiteśvara have been reinterpreted as showing Maitreya.[151]

Maitreya
Tibetan engraving

In Korea and Japan, where his cult enjoyed great favour from the sixth century, he is often confused (as in China) with Amitābha[152] and Śākyamuni. In sculpture, he was sometimes confused with Nyoirin Kannon in Japan, a form of Avalokiteśvara. He was also given the name of Jishi Bosatsu, 'He who is full of pity'. He was first likened to Kami Hachiman, a deification of the Japanese Emperor Ojin (third century), and was later considered an incarnation of Amitābha, serving as an intermediary between Gautama (the world of mortals) and Amitābha (the world of the beyond).[153]

The cult of Maitreya is attested in Japan from the seventh century in the Hossō sect. In 612, the temple of Taima-dera[154] was built for his worship. Although his tradition remained virtually uninterrupted in Japan, and the Shingon sect attached great importance to the cult of Miroku Bosatsu,[155] the latter, despite the efforts of the Shingon sect and the Nara sects, was eclipsed by the growing favour enjoyed by Amida. A revival of his worship occurred in the twelfth and thirteenth centuries. In the Garbhadhātu Maṇḍala, Maitreya (under the name Jishi Bosatsu) is placed to the north-west of Mahāvairocana[156] where he represents the 'treasure of the beings who profit inexhaustibly',[157] Maitreya being 'the root, the bud, the stem, the leaves which are born in the *Garbha* (womb) of the seed of the pure heart of Bodhi (spirit of Awakening)'.[158] In the maṇḍala, Jishi Bosatsu is placed to the north-east of Vairocana, representing in this case the action producing wisdom (*Kṛtyānusthāna-jñāna*),[159] thus granting the petitions addressed to the Divya-dundhubhi-megha-nirghoṣa Buddha. In the Vajradhātu Maṇḍala, he is one of the sixteen Bodhisattvas of the Bhadrakalpa. He is represented with a flask in the hand or sometimes holding a small *stūpa*.[160] This *stūpa* is perhaps related to the belief according to which Maitreya, during his advent as Buddha, will open a *stūpa* inside which Kāśyapa is said to await his arrival.

Miroku Bosatsu
Pine wood, Kōryū-ji, Kyōto, Japan, late seventh century

We have seen that representations of him are found throughout the

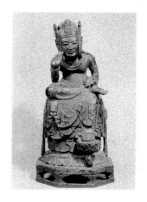

Miroku Bosatsu
Bronze, Nara, Japan, seventh century

Asanga
Tibetan engraving

Vasubandhu
Tibetan engraving

art of the Southern schools[161] and of the Mahāyāna, both in India[162] and
in South-East Asia, particularly on the galleries of the *stūpa* of
Borobudur in Java. He also enjoyed great favour in Tibet, and is rep-
resented seated in the 'European' posture.[163] In China, in 680, a pious
donor had 500 statues to him executed in the caves of Longmen.

Maitreya is represented in Korea and Japan either seated in
Padmāsana, or in a pensive posture (Hanka-shiyui), legs crossed, right
ankle on left knee, left leg hanging or placed on the ground, or on a
lotus. Among the many types of representations, the most common are
the following.[164]

- In Hanka-shiyui, bare-breasted, with a crown 'in three moun-
 tain peaks' or 'in a peacock's wheel',[165] or with two chignons
 tied in round coils, the left foot resting on a lotus (separated or
 joined to the seat), the right hand barely touching the cheek
 (or with only two fingers), the left hand resting on the right
 ankle. This type appears to be of Korean origin:[166] it is found on
 many statuettes of the Silla period in the sixth and seventh
 centuries. In Japan, this type was chiefly represented before
 and during the Nara period (until 794).
- Seated in Padmāsana, like a Buddha, the right hand in Abhaya
 or holding a lotus flower, the left hand in Bhūmisparśa or
 touching a lotus petal of the seat. Or the right hand in Abhaya
 or in Vitarka mudrā, and the left hand resting, palm upward,
 on the lap.
- Seated in Padmāsana, like a Bodhisattva, with a high chignon
 and a crown sometimes adorned with effigies of the five Jinas,
 the right hand in Varada, the left hand holding a lotus or a
 small *stūpa*. Or hands joined, holding a small *stūpa*.[167] Or with
 the hands in Dharmacakra mudrā.
- Standing, like a Buddha, the right hand in Varada, the left
 hand in Abhaya mudrā.
- Standing, as a Bodhisattva, the right hand hanging, the left
 hand holding a vase sometimes containing a lotus supporting a
 small *stūpa*.

The Arakan Buddha, bronze, Mandalay, Burma, c. sixteenth century

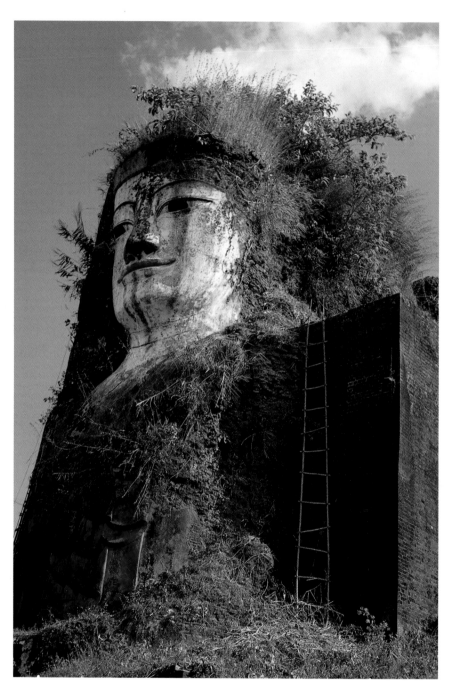

Great Buddha of Kyaung-pyu, Pegu, Burma, fourteenth century

In painting, Maitreya is represented, mainly towards the end of the Kamakura period in Japan, as Amida Nyorai in his *Raigō*: he sometimes holds a red lotus in the left hand.[168] An exceptional form shows him seated in Padmāsana with 1,000 arms,[169] the principal right hand with the forefinger raised, the principal left hand holding a lotus surmounted by a *stūpa*, the other hands with the different attributes – lotuses, *sūtra* scrolls, *cintāmaṇis*, vases, etc.

In Japan, the god of happiness, Hotei, is considered to be an incarnation of Maitreya and he is often found in this form: seated, with a large belly, and smiling broadly. This is the form of the 'large-bellied Buddha', well known in China, from where it was imported into Japan in the seventeenth century by the Zen Obaku sect. Maitreya is particularly venerated in this form in the temple of Manpuku-ji in Kyōto. He was called Xiao Luohan in China, where his image was installed in nearly all the temples. Also in China, he was the patron saint of goldsmiths and artisans and, in this case, owing to a popular legend, he is sometimes called Baisosheng, 'Rope of a hundred strands', because the artisans who venerated him surround his body with many green and red threads. The artisans also call him Ouji Fo and Xiao Fo.

Acolytes of Maitreya

Besides the triads, Maitreya is often represented with two acolytes: Asaṅga (Japanese *Muchaku*), founder of the Hossō sect, and Asaṅga's brother Vasubandhu (Japanese *Seshin*). Tradition relates that Maitreya descended from the Tuṣita heaven at the request of Asaṅga and his brother to teach them the content of the five *śāstras*.[170] These two Arahants then composed many other enlightening *śāstras* for the followers of the doctrines of the Mahāyāna.[171] In Japan, Asaṅga is sometimes called Genjō and is then confused with the Chinese pilgrim Xuanzang. Asaṅga lived in India, in Pāṭaliputra (present-day Patna in the state of Bihar), with his brother in the fourth century. They are represented in the form of monks, and are given the title of Bodhisattva. In Japan, the cult of Maitreya and of his acolytes is little maintained except by the Zen and Shingon sects.[172]

The pilgrim Xuanzang (Genjō)

IV

THE FIVE JINAS AND THE ĀDI BUDDHA

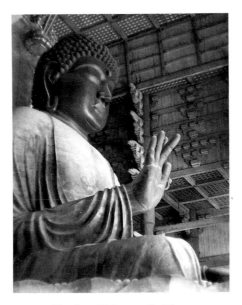

The Great Vairocana Buddha
Bronze, Tōdai-ji, Nara, Japan, 749

The Five Jinas:
Vairocana
Akṣobhya
Ratnasambhava
Amitābha
Amoghasiddhi
The Ādi Buddha

THE FIVE JINAS

The Sanskrit term Jina means 'conqueror' and refers in a religious context to one who has conquered spiritual knowledge and overcome the cycle of rebirth and suffering. The five Jinas, also called the five Tathāgatas, or the five Great Buddhas of Wisdom, are of uncertain origin, although their existence and their representations appeared relatively early in India.[1] Many theories have been advanced attempting to clarify their origin and their *raison d'être*. Corresponding to the five directions of space (the four cardinal points and the zenith) of Indian cosmology, they symbolize the five members of the historical Buddha. According to a report by the Chinese pilgrim Xuanzang,[2] the Indian king Aśoka had five *stūpas* erected in honor of the 'Tathāgata composed of five parts'[3] near his capital Pāṭaliputra. Some authors claim that these five Jinas are individualizations of the principal mudrās used, in esoteric Buddhism, to symbolize the most significant moments of the career of Gautama Buddha.[4] Others believe that they represent the five Manuṣya (human) Buddhas.[5] Buddhist thought may have conceived a spiritual Buddha condensing in five hypostases the five great historical moments in the life of the Buddha,[6] the five human Buddhas, the five typical elements of Indian philosophy,[7] and the five directions.[8] Considered together, however, they could very well hypostasize the five attitudes, functions and attributes of the Buddha Śākyamuni Gautama. They accordingly substantiate five epithets and fix five outstanding episodes of his career, which are commemorated by five distinct statues. This is an aspect that the researches of Paul Mus[9] have clarified admirably.[10] 'The idea seems to be that each mortal Buddha (those of the past, the historical Buddha, and the future Buddha) possesses his counterpart, pure and glorious, in the spiritual world, and free of the constricting conditions of this material life. Or that the historical Buddha in his material condition is merely an appearance, the "reflection" or emanation of an immanent Buddha living in the regions of a world of idea and of mystic spells. Consequently, the number of these Buddhas of Wisdom is theoretically infinite, like the number of Buddhas, although only five of them have been recognized.'[11]

Since *stūpas*, which are thought to be derived from funerary tumuli

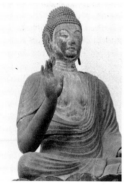

Vairocana Buddha
Bronze, Japan,
ninth century

and later to have become commemorative monuments specific to Buddhism, are themselves images of the cosmos and symbolize the Buddha and his teaching, they should therefore also symbolize the five aspects in which the Buddha could be conceived. Yet it appears that the images of the four hypostasized Jinas of the Buddha were only added late[12] to the directional sides of the *stūpas*. For the esoteric sects, these Five Jinas represent the essential symbol of the Law. These Five Jinas were subsequently identified with all the groups of five objects or ideas existing in the Hindu conception of the world: the five historical Buddhas; the five senses; the five *Skandhas* (the 'aggregates' which make up the psycho-physical organism which is the human being: form, sensation, apperception, volition and consciousness); the five cardinal points, and the five virtues. A point of space was attributed to each of these Buddhas. Thus, according to certain theories, each Jina is presumed to be the reflection or the magical projection of one of the five historical Buddhas (seven in Nepal). In fact, each of these Jinas is three entities in one: a historical Buddha, his mystical projection, and his acting emanation. We therefore have these possible correspondences:

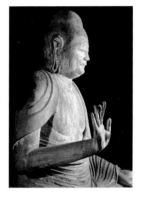

Vairocana Buddha
Wood, Murō-ji,
Miroku-dō, Nara, Japan,
middle ninth century

Zenith	Mahāvairocana, Krakucchanda, Samantabhadra
East	Akṣobhya, Kanakamuni, Vajrapāṇi
West	Amitābha, Gautama, Avalokiteśvara, Padmapāṇi
South	Ratnasambhava, Kāśyapa, Ratnapāni
North	Amoghasiddhi, Maitreya, Viśvapāṇi

These Five Jinas also correspond to the five steps on the road to salvation:

Mahāvairocana	immaculate spirit, means of salvation
Akṣobhya	accumulated spirit, awakening of the heart
Amitābha	pure spirit, spiritual awakening
Ratnasambhava	passionate spirit, ascetic life
Amoghasiddhi	the five material senses, entry into Nirvāna

Whereas the sects of the non-Mahāyāna have mainly held Gautama Buddha for their veneration, those of Mahāyāna Buddhism have made any one of these Buddhas of wisdom the principal object of their worship. Thus the Japanese Jōdo-Shinshū sect venerates Amida (Amitābha), whereas the esoteric sects of the Tendai and Shingon have chosen Vairocana as their principal deity. The other 'aspects' have occupied only a subsidiary place in the veneration of the faithful and, most of the time, are represented only on maṇḍalas, or in groups with the other Jinas. According to the esoteric Buddhism of Mahāyāna schools, the joining of the two great maṇḍalas of Vajradhātu and Garbhadhātu shows the harmony existing in the universe between the forces that govern it, and reconciles divine unity with diversity of aspects,[13] these aspects being potential entity (Vajradhātu) and dynamic manifestations

(Garbhadhātu). The respective ranks of the Buddhas of wisdom and their corresponding Bodhisattvas are noted therein, owing to their potential power or their activity in the world. These two maṇḍalas are oriented inversely to each other, because they can be united only by merging (or coincidence), face to face. In certain esoteric ceremonies, they are placed facing each other, on either side of the priests, with the maṇḍala of Vajradhātu hung on the west wall, and the other on the east wall. At the centre of the diagram, the Vajradhātu Maṇḍala shows Vairocana in concentration (with hands in Chiken-in), surrounded by four other Jinas who awaken the dynamic forces of the universe. They are each attended by four Bodhisattvas and all have a white halo.[14]

The Garbhadhātu Maṇḍala shows the different groups of deities and divine beings arranged according to their intentions, their forces or their possibilities of action. The centre of the universe is symbolized by a lotus, at the centre of which reigns Vairocana, his hands in Dhyāna mudrā. On the eight petals of the lotus are placed the four other Jinas and four great Bodhisattvas, each surrounded by a red double halo. Around this are arranged all other manifestations together with their attributes, their symbols and the seed-syllables (bīja) representing the sound that corresponds to them. These deities are divided into two main categories, wisdom and contemplation. Various other deities are sometimes associated with the Five Buddhas of Wisdom, and are also represented on other maṇḍalas.

The two great maṇḍalas of esoteric Buddhism were probably imported from China to Japan by Kūkai in 806,[15] although it is quite conceivable that other copies had been introduced into Japan and Korea before then. Their esoterism was chiefly used by the Shingon sect, but also, incidentally and less rigidly, by the Tendai sect and some others.[16]

The order of depiction and even the names of the five Jinas vary according to the sects. Thus sometimes (mainly in Japan), Bhaiṣajyaguru is found in the place of Akṣobhya (they are both in the east); Prabhūtaratna replaces Ratnasambhava; and, in some cases, the historical Buddha replaces Amoghasiddhi. Kṣitigarbha is sometimes also considered as a Buddha of Wisdom.[17]

The sects that worship Amitābha consider that all the Buddhas of Wisdom are simple emanations of Amitābha, and hence do not worship them in any particular way. The other Mahāyāna sects venerate them in very different ways, but it is mainly the different forms of Vairocana on the one hand and the personage of Amitābha on the other who enjoyed the greatest favour among the faithful. The others are generally worshipped together with the other Buddhas of Wisdom.

The representations of the five Tathāgatas are relatively rare in Indian sculpture, where they are found on the sides of late stūpas (such as the Dhāmek in Sarnāth, and in Nālandā, for example, dating from about the seventh century). They are more often represented in painting, chiefly on technical works and sometimes on the aureoles of Bodhisattvas. In Nepal, the statues of the four Bodhisattvas are often

found around the base of the *stūpas*, Vairocana being symbolized by the very body of the *stūpa*. They are also well represented in the great maṇḍala *stūpa* of Borobudur in Java (eighth century), where their statues (92 on each side) are located in niches corresponding to the horizons. Statues of Vairocana are placed inside the open-work *stūpas* of the three end terraces of this complex.[18]

In Japan, where the esoteric doctrines enjoyed great success from the fourteenth to the sixteenth centuries, the five Jinas (Gochi Nyorai) are often represented in sculpture, placed on maṇḍalas. One aspect of Vairocana common to both maṇḍalas, and which appears to provide a link between them, is also sometimes represented: this is called Ekākṣara Uṣṇīṣacakra Tathāgata (Ichiji Kinrin Nyorai). Some sects also recognize a sixth Tathāgata, Vajrasattva.[19]

The study of these esoteric deities is often an arduous task, and it is often difficult to understand what their functions were in the minds of the priests who created them and worshipped them. But they are so frequently represented it is essential to describe them, although the description may sometimes prove a little sparse.

Vairocana

(Mahāvairocana; Japanese, *Dainichi Nyorai, Rushana, Birushana*; Chinese, *Palushena*; Mongol, *Masi Geigülün Djogiaqchi*; Tibetan, *Rnam-par-snang-mdsad*)

This is the principal deity, identical in both of the great maṇḍalas of Vajradhātu and Garbhadhātu, the esoteric doctrines of Northern Buddhism, and chiefly the doctrines of the Yogācāra school.[20] In Japan, Vairocana is the Great Solar Buddha of light and truth,[21] being 'he who is resplendent'.[22] He is the sun, just like the Kami Amaterasu Omikami of Shintō to whom the syncretic doctrines have likened him; other solar or intellectual aspects of the deity are of little importance to him. He is the spiritualization of Gautama Buddha in Buddhist Law, and in all

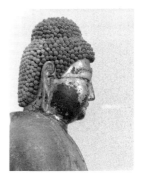

Vairocana
Gilded wood, Japan, Heian period, tenth century

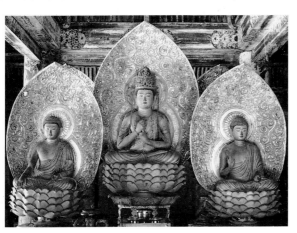

Dainichi Nyorai (Vairocana)
with, right, **Miroku Nyorai** and left, **Ashuku Nyorai**
Sambai-in, Mount Kōya, Japan, thirteenth century

matters he remains pragmatic. He accordingly corresponds to the 'first turning of the Wheel of the Law' by the Buddha in the deer park at Sarnāth near Benares (Vārānasī). His typical mudrā is hence the Dharmacakra mudrā. He is attributed the colour white, because it is the synthesis of all the other colours and symbolizes all that is 'spotless' (Japanese *muku*).[23] He is a personification of the Absolute.

The names by which he is called, and his attributes, vary according to the sects, and according to whether he is considered as the supreme Buddha (Japanese *Makabirushana*), a sort of Ādi Buddha or primordial Buddha (see p. 146), or as the first among the Jinas. In the Tendai sect, he is named Birushana Butsu (or Nyorai),[24] Rushana Butsu or Roshana.[25] In the Shingon sect, he is worshipped in three aspects: that of the supreme Buddha, of a Jina (or Tathāgata, Japanese *Gochi Nyorai*) , and as a Vidyārāja.[26] The other four Jinas are then considered simply as manifestations of him. We have already seen that in Japan he is called Ichiji Kinrin Nyorai when he is considered as the unifier of the two parts of the world (the two maṇḍalas). Apart from Amitābha, Vairocana is the only one of the five Jinas who is the subject of living worship in Japan, and he is especially popular among the followers of the esoteric Shingon and Tendai sects. The other Tathāgatas only appear to be there for reasons of symmetry. While they were worshipped at the outset of the introduction of the esoteric doctrines into Japan, they enjoyed very little favour subsequently, and the popular tendency was to supplant these different Jinas by more familiar deities, more readily accessible to an understanding of their role, such as Bhaiṣajyaguru, Śākyamuni or even Kṣitigarbha.

Vairocana is considered by some esoteric sects, such as the Hossō, Kegon, Tendai and Shingon sects of Japan, to be the transmitter of the Yogācāra teachings to the Indian sage Vajrasattva who, according to legend, lived in an iron tower in southern India. In his turn, Vajrasattva transmitted the doctrine to Nāgārjuna and taught him the significance of the great two-part maṇḍala. After him, Nāgabodhi, Vajrabodhi and Amoghavajra introduced this doctrine into China around 720, from where is spread to Korea and Japan, and then Nepal and Tibet. In this doctrine, which was grafted on to those of the Mahāyāna, as expounded by Asaṅga (who in turn was inspired by Maitreya) in the fourth century, the follower's principal aim is to achieve mystic union (*yoga* in Sanskrit) with the deity. This union is symbolized in Nepal and Tibet by the 'embracing' of the deity and of his partner (or Śakti) in the Yab-yum, 'father–mother' attitude, in which the deity Yab represents the world of the Vajradhātu, while Yum represents the world of the Garbhadhātu. Their sexual union hence symbolizes the intimate union of the spiritual and the material, without which there is no existence. In China and Japan, this perhaps too blatant representation was supplanted by the symbol of the mudrā of the fist of wisdom (Japanese Chiken-in) or of the six elements. But we have seen that the personality of this great deity could be conceived from several angles, depending

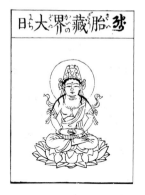

Dainichi Nyorai
in the Taizō-kai

on sect and country: supreme being, Jina or wrathful force.

According to the *Bon-mō-kyō*,[27] Vairocana, sitting on a 1,000-petalled lotus, 'emitted' one thousand billion real Buddhas[28] to teach the worlds. By the Shingon sect he is represented seated on a lotus, the right hand in Abhaya mudrā, middle finger bent, the left hand resting in the lap, palm upward. His aureole is adorned with an infinity (in principle 1,000) of images of the historical Buddha.[29] In Tibet, he is represented clothed in a monastic garment, with the usual attributes of the Buddha: ūrnā, ushnīsha, etc., and the hands in Dharmacakra mudrā. When he is represented embracing his Śakti (called Locanā or Vajradhārīśvarī), he is dressed as a Bodhisattva, holds a Wheel of the Law or a bell, and is seated on a blue lotus. Locanā clasps her legs tightly around him and holds a skull cup and a knife (sometimes a cakra). Their bodies are white. The lion is their support animal (vāhana).

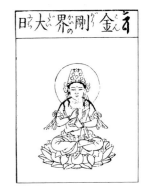

Dainichi Nyorai
in the Kongō-kai

As the supreme Buddha, the mudrās used by the various forms of Vairocana are different in the representations belonging to the aspect of Vajradhātu and to that of Garbhadhātu,[30] although the general aspect of the Great Deity is more or less the same: he has a Buddha's head with the hair tied in a cylindrical chignon surrounded by a high crown (which is sometimes absent from certain sculptures, either due to loss or to the artist's nonconformism). He is represented as a robed Buddha, wearing princely attire, the right shoulder bare, wearing necklaces and bracelets.[31] In the Vajradhātu Maṇḍala, his hands are in Dhyāna mudrā, with the thumbs touching, whereas in the maṇḍala of Garbhadhātu the hands form a particular mudrā, such as a fist of wisdom or one of the six elements,[32] representing mystic union. In other cases, he may hold attributes in his hands: in the right hand, a wish-granting jewel (*cintāmaṇi*), a trident, sword or rope (like Acalanātha). In the left hand, he may hold a three-pointed vajra, a rosary or a bell.

He is virtually never represented in sculpture in Nepal and Tibet, where he nevertheless often appears in painting, either as Vairocana or representing the Ādi Buddha. In China and Japan, on the contrary, his effigies in sculpture are numerous, and observe the iconographic rules indicated in the two great maṇḍalas. In this case, he is sometimes represented holding a Wheel of the Law, with his hands in Dhyāna mudrā.

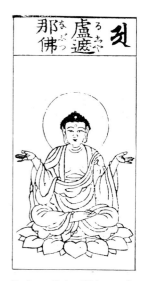

Rushana Butsu (Vairocana)

Vairocana in his normal aspect is nearly always accompanied by four Bodhisattvas assuming a feminine form and called Pāramitā (Japanese *Haramitsu*), symbolizing the four wisdoms and relating him to the great Bodhisattvas.[33]

Vairocana identified with Vajrasattva

(Japanese, *Kongōsatta*; Chinese, *Wozi Luosa-zin*;
Tibetan, *Rdo-rje Sems-dpa*)

In the Shingon sect, Vajrasattva[34] represents an active form of Vairocana, and is considered as the supreme Buddha in the secret ritual.[35] He is Ādi Buddha in Tibet (see p. 148). He is also sometimes considered a 'direct disciple' (or emanation) of Vairocana.[36] In the

Vajrasattva (Kongō-satta)

Butsugen Butsumo

Ichiji Kinrin Nyorai

Garbhadhātu Maṇḍala, he is the supreme Buddha. He is represented seated in Padmāsana on a lotus, both feet hidden by his robe, clothed in a simple monastic garment leaving one shoulder bare, with a very high chignon[37] and bracelets. His right hand holds a double five-pointed vajra on his breast, his left hand holds on the hip or in the lap a bell, the handle of which terminates in a five-pointed vajra. Much more seldom, particularly in Japan, his hands are in Vajramuṣṭi mudrā or in Sankaisaishō-in. He can also sometimes be seen represented with several arms and mounted on an elephant, although this is rare.[38] His wrathful form is that of a Vidyārāja, generally Rāgavidyārāja.[39] In this case he is accompanied, in his multiple and secret form, called Go-himitsu Bosatsu[40] in Japan, by four 'diamond kings' (Vajrarāja) represented together in the same aureole and seated on the same lotus.[41] Vajrasattva is often represented accompanied by the four guardians of the four horizons, chiefly on maṇḍalas. He may also be mounted on four directional elephants on which the effigies of the four Lokapālas are found. The Five Jinas may be represented in his crown. His partner is a Tārā.

In Japan, he may assume a wrathful form with four or six arms, and with a vajra and a human skull (or a lion's head) in his headdress. He holds a vajra and the bell, a bow and arrow, a rope and a sword (see Rāgavidyārāja, Chapter VII).

Mahāvairocana identified with Bhaiṣajyaguru[42]

He is represented as a Bodhisattva, with a high crown, the robe leaving his right shoulder bare, but without ornament. His hands may be in Dhyāna mudrā with the thumbs touching or in Dharmacakra mudrā or Chiken-in. This identification is specific to Japan.

Mahāvairocana identified with Ekākṣara Uṣṇīṣacakra

(Japanese, *Ichiji Kinrin Nyorai*)

He may assume several names and aspects.[43] In Japan, this form is also considered as being 'the eyes' of Vairocana. In the Garbhadhātu Maṇḍala, he may assume a feminine form and have the name of Buddhalocanī (Japanese *Butsugen-son, Butsugen Butsumo*). He sometimes has a lion's head on his headdress, and the hands joined in Dhyāna mudrā, thumbs touching. This supreme Buddha of the Tendai sect in Japan is symbolized by an eight-spoked golden wheel. He may also assume other appearances in the various maṇḍalas.[44] Under the name of Buddhalocanī, Ekākṣara Uṣṇīṣacakra (hands in Dhyāna mudrā) joins the two great maṇḍalas and reconciles the two cosmic aspects that they represent. Each sect or sub-sect sees this 'bridge' in a different light[45] and has invented a large number of transitory aspects of Ekākṣara Uṣṇīṣacakra,[46] aspects that are far from always fixed and whose names are very often different according to the function and the powers, or the place they are expected to occupy between the conceptions entertained by these sects of Vajradhātu and Garbhadhātu.[47] Ekākṣara Uṣṇīṣacakra is sometimes called Daishō Kongō in Japan. In this form, he has twelve arms, including two hands in Chiken-in and two

others holding the bell and the vajra. The other hands hold, on the right, the sword, rosary, staff and triple jewel, and on the left, the wheel, rope, double vajra in a cross, and open lotus. His headdress is tied into seven chignons and he is seated in Padmāsana on a lotus. He combines the forces of Vairocana and Vajrasattva.[48]

Sudṛṣṭi or Dhruva
(Japanese, *Myōken, Myōdō Bosatsu*)[49]

Under this name, Dainichi Nyorai is invoked in Japan as the Bodhisattva of the Pole Star, 'which apparently never changes with time, the point at the centre of the circle from which one cannot exit.'[50] He is also identified with Soma (Japanese *Kanro*), incarnating divine ambrosia, the elixir of immortality. This form is mainly venerated in northern Japan, especially in Fukushima and on the island of Hokkaido, where he is regarded as a protector of horses and wild animals under the name of Sōzen (which formerly meant 'a white horse').[51] He is also named Sonshō-ō and Myōjin when identified with the white horse and messenger of the Kami of Shintō. In other regions, Myōdō Bosatsu is regarded as the protector of silkworms. He is represented, especially in painting, seated on a white lotus, a crown on his head, and his hands in Dhyāna mudrā.[52] He is sometimes identified in popular belief with Kṣitigarbha.

In maṇḍalas, Myōdō is represented accompanied by the seven stars of the Great Bear.[53] According to a Japanese legend, they denote the seven lives of the famous warrior Taira no Masakado, who dared to rebel and proclaim himself emperor in 939, but was defeated the following year and killed in a fierce battle. Some say that Myōdō Bosatsu is the Japanization of the Chinese god of literature Guixing (a star). In painting, he is represented in the following four main forms.

Daishō Kongō

Sudṛṣṭi (Myōken)

- Feminine personage riding a dragon, standing on a single foot in the clouds, with four arms, the two upper arms bearing stars, the other two a brush and a book. A Yakṣa and a Deva are the usual acolytes.[54]
- Feminine personage seated in Padmāsana on a cloud, head crowned, with a high chignon and a tuft of white hair between the eyebrows (*ūrṇā*), the right hand holding a lotus supporting the constellation of the Great Bear,[55] and the left hand in Varada mudrā.
- Feminine personage seated on a cloud, the head bristling with serpents and a gaping mouth revealing fangs, with four arms (right hands holding sword and brush, and left hands holding books and cakra).[56]
- Male personage standing or seated on a turtle and holding a book or a sword, sometimes accompanied by two acolytes.

An image of Vairocana is often found in the headdress of Mārīcī (see Chapter VIII).

Uhō-dōji
Wood, Hokke-ji, Nara, Japan, fourteenth century

Uhō-dōji, a temporary incarnation in Japan

The Shintō Buddhist syncretic doctrines created this feminine deity, a temporary incarnation (Gongen) of Vairocana. She is reputed to have the power of expelling ill-luck, and assumes the general form of the Kamis (when these are represented in human form), but with a small *stūpa* (or reliquary, *hōtō*), placed on her head.[57] She holds a *cintāmaṇi* in the left hand and a staff of wisdom (Japanese *hōbō*) in the right. A white mongoose walks on her feet. This deity is sometimes confused with one of the forms of Mārīcī (see Chapter VIII). Its representations are rare in sculpture, and even more infrequent in painting after the Muromachi period (sixteenth century).

Kūkai, a Japanese monk
(posthumously named Kōbō Daishi)

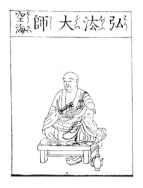

Kūkai (Kōbō Daishi)

Kūkai (774–835) was the founder of the Shingon sect. After converting to Buddhism he came across the *Mahāvairocana-sūtra*. Disillusioned by the Buddhism prevalent at that time in Japan, he went to China as a sponsored student monk and studied esoteric Buddhism, later returning to Japan where he enjoyed the patronage of the emperor. He revealed himself to be a form of Vairocana during a discussion of the doctrine of Shingon with the chiefs of the other sects.[58] This image is called Hasshūron Dainichi Nyorai (Vairocana of the eight sects). Kūkai is represented with a high chignon on a dais of seven stars, making the fist of wisdom (Chiken-in).

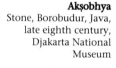

Akṣobhya
Stone, Borobudur, Java,
late eighth century,
Djakarta National
Museum

Jinarat Buddha
Gilded bronze, Bangkok,
Thailand,
late eighteenth century

Akṣobhya

(Japanese, *Ashuka Nyorai*; Chinese, *Achu*; Tibetan, *Mi-bskyod-pa*, *Mi-khrugs-pa*; Mongol, *Ülü Kudelüki*)

This is the second of the five Jinas. He is 'the Imperturbable'[59] Tathāgata, corresponding to the historical Buddha Gautama when he took the earth as witness. Akṣobhya hence subjugates the demonic passions and manifests the pure spirit of unstained Awakening.[60] He

expressed the wish never to experience anger or repulsion and to remain imperturbable in the accomplishment of any task that he set himself. He presides in the paradise of the east, Abhirati (Japanese *Myōki*) and, with respect to Amitābha (the setting sun), he corresponds to the rising sun. This is why he is sometimes replaced by Bhaiṣajyaguru, whose adopted land is also in the east.

Ashuku Nyorai (Akṣobhya)
Esoteric form

Akṣobhya is mentioned from the beginning of the third century in the *Prajñāpāramitā-sūtra*, and also later in the *Saddharmapundarīka-sūtra* and *Sukhāvatī-vyūha*. His cult appears to be attested in China from the later Han period. Introduced into Japan at the same time as the two great maṇḍalas, he enjoyed little popularity and was replaced by Yakushi Nyorai, whose brilliance soon eclipsed his own. After the Heian period, during which he was worshipped by the followers of the esoteric sects, he was no longer represented except in maṇḍalas, in the company of the other Jinas, in the Gochi Nyorai series. However, in Japan he is still one of the thirteen Buddhas of the Shingon sect.[61]

He is attributed the virtues of 'mirror-like wisdom' (*Ādarṣajñāna*), namely 'emptiness' (the mirror, symbol of this emptiness, can also symbolize the sun and, in this case, he has the 'perfect knowledge' of Vairocana). In the Garbhadhātu Maṇḍala, he takes the name of Ratneketu (Japanese *Hōtō Nyorai*) and represents the 'respect of the Buddha'.

In Tibet, he is represented as being the Gautama Buddha, but sometimes takes the name of Vajrāsana. He is then represented in Bhūmiṣparṣa mudrā, but with a vajra placed before him on the lotus seat (this vajra is sometimes placed on the palm of his left hand). Also in Tibet, he may be represented embracing his Śakti in Yab-yum who has the name of Māmakī (also called Locanā). He is sometimes supported by an elephant, and a svastikā is often engraved on the base of his images or on his breast.

In maṇḍalas, Akṣobhya is represented in gold or blue (contrasting or blended colours),[62] seated in Padmāsana, both feet showing, or seated in Vajrāsana (right foot on left leg), the right hand in Bhūmiṣparṣa, the left closed on the knee, or palm opened upward in the lap (possibly holding a vajra), or holding a fold of his robe. He wears neither crown nor jewels.

Ashuku Nyorai (Akṣobhya)

In the maṇḍala of Garbhadhātu, he is normally attended by four Bodhisattvas.[63] In the Vajradhātu maṇḍala, with the name of Ratnaketu, he is represented as Akṣobhya, but his right hand is turned away from his body and at the level of his shoulder, while the left hand holds a fold of his robe at the level of the shoulder (this form is rare).

An image of Akṣobhya is sometimes found in the headdress of Mañjuśrī, of Yamāntaka, of Prajñāpāramitā and of the Tārās. In his Tibetan form in Yab-yum, he embraces his Śakti who holds a skull cup in her left hand. He himself holds a vertical vajra in the right hand and a bell in the left. He wears a tiara around his hair tied in a high chignon. His body is dark blue, while that of his partner is light blue. The

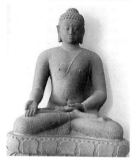

Ratnasambhava
Stone, Borobudur, Java,
late eighth century,
Djakarta National
Museum

**Hōshō Nyorai
(Ratnasambhava)**

Bodhisattva who corresponds to him is Vajrapāṇi and he is also thought to represent the Manuṣya Buddha Kanakamuni. He is associated with the element air.

Ratnasambhava

(Japanese, *Hōshō Nyorai*; Chinese, *Baosheng Fo*;
Tibetan, *Rin-chen-hbyung*; Mongol, *Erdeni-in Oron*)

This is the Tathāgata who is the 'source of secret things', 'He who manages the treasures', 'He who is born of the jewel'. He is the third of the Jinas of the series of five, and perhaps the least popular. His Buddha field is in the south. Ratnasambhava was practically never the object of worship as an independent deity. Very seldom represented in sculpture (except in Borobudur in Java), he is found only on maṇḍalas, where he is sometimes accompanied by four Bodhisattvas.[64] In the maṇḍala of Vajradhātu, he is represented in gold (or yellow), seated in Padmāsana, the soles of the feet showing (sometimes, but more seldom, he is standing), the right shoulder bare or covered. Sometimes he is crowned. His right hand is in Varada on the knee (sometimes with jewels pouring through his fingers), and his left hand holds a fold of his robe on his hip or in his lap. This hand may also hold a *cintāmaṇi* or be clenched in a fist of wisdom. In the maṇḍala of Garbhadhātu, he exhibits the same general appearance, but the right hand is in Varada mudrā before the breast.

In Tibet, he is often represented (in connection with the five Jinas) embracing with his Śakti Māmakī. He is golden and holds a *cintāmaṇi* in the right hand, and a bell in the left. His partner (light yellow in colour) holds a skull cup in the left hand. He is crowned and his hair is tied in a high chignon. A horse, his support animal (*vāhana*), is sometimes represented on his lotus seat.

He represents the Manuṣya Buddha Kāśyapa, the element fire, and his Bodhisattva of correspondence is Ratnapāni. Theoretically, the lotus that serves him as a throne should be yellow, but in fact it is nearly always pink. In his direction, he is sometimes replaced by Prabhūtaratna.

Amitābha

This is the fourth Jina, who represents the historical Buddha Śākyamuni Gautama. 'He whose splendour is immeasurable' is the Buddha of the beyond, death and the afterlife. Of Indian origin, like most of the other forms of the historical Buddha, Amitābha is nevertheless not formally attested in India, despite the existence of *sūtras* to his glory already translated into Chinese in the second or third century AD.[65] Testimony of the worship of Amitābha was borne out by the voyage to India of the Chinese pilgrim Huiren (Canmin) in 712–719. In the eighth century his cult was introduced into Tibet by Padmasambhava.[66] Attempts have sometimes been made to identify an Iranian origin, which would be

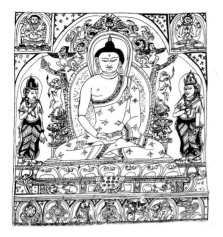

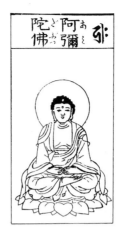

Amitābha
Tibetan engraving

Amida Butsu

plausible owing to the westerly situation that he occupies in the Buddhist space, and because of his solar aspect. It is obviously tempting to make of him a sort of 'Buddhicization' of the Zoroastrian god Mithras, but his real origin is still uncertain.

The name of this Buddha in Japanese is Amida (Mida by poetic licence), corresponding to the Sanskrit forms Amitābha; Amitāyus, 'of immeasuble life-span', and Amṛta, 'immortal'.[67] His preaching territory (his paradise) is situated in the west and hence he symbolizes the setting sun, as well as life in the beyond. His western paradise is the Pure Land (Sukhāvatī, Japanese Gokuraku Jōdo), the paradise in which all mortals are reborn without distinction of sex, similar to the gods. It is there that the 'souls', rid of their straitjacket of impurities, pure of all desire, go to the call of Amitābha.[68] In the beyond he welcomes and consoles; out of compassion he delivers creatures from their sufferings and welcomes them to his Pure Land. He is also a Buddha of 'intellectual power',[69] the 'excellent cause' of the 'wisdom of marvellous discernment' (Pratyavekṣanajñāna).[70]

Amitābha
Stone, Borobudur, Java, late eighth century, Djakarta National Museum

However, Amitābha, like the other Jinas, is a personification of one of the episodes of the life of the historical Buddha.[71] While he was still a Bodhisattva (an aspiring Buddha), Amitābha meditated for five Kalpas (Indian aeons) before pronouncing his great vow in 48 points by which he undertook to save all beings, irrespective of who or where they were.[72] This role as saviour, added to the simplicity of the doctrine of the different sects of the Pure Land, earned him great popularity in Tibet, China and Japan, where the Jōdo-shū sect made him its principal deity, and the Jōdo-shinshū sect made him its only deity.

It is difficult to determine the factors which led to the immense favour enjoyed by Amitābha among the faithful in Japan. The simplicity of the doctrines founded on faith no doubt pleased the masses as well as the warriors and aristocrats, and it is likely that his consoling aspect spoke as strongly to the hearts of men. It is also undeniable that the

Daibutsu Amida
Bronze (height 15 m), Kamakura, Japan, 1252

135

growing popularity of the Amida cults and doctrines in Japan from the ninth century[73] completely transformed Japanese Buddhism in its relations with the people, by disseminating fragments of his doctrines to the most humble levels of the population. The cults of Amida (first that of the Jōdo sect, followed by that of the Jōdo-shinshū sect) profoundly altered the attitudes of the Japanese people, whereas in other countries its influence was no stronger than that of the other deities of the Buddhist pantheon. Before the ninth century, the Japanese saw the Buddhist deities (perhaps with the exception of Yakushi Nyorai) as foreign, aristocratic entities, whom it would be certainly wise to avoid offending, and who were worthy of reverence, but with whom they did not maintain direct relations, since they were separated from them by a mass of religious texts (mostly written in Chinese, a language inaccessible to most of them) and by priests who were little concerned to make them more accessible and whose discourse seemed rather obscure.

But the monks predicted the era of degeneration of the Buddhist Law as being due to start in the mid-eleventh century; there was a sort of holy terror at the end of the world, and everyone felt a sudden need to believe in something better. The security that henceforth, despite their errors, they could enjoy access, at the price of a little faith, to the paradise of the Pure Land of Amida, meant that they came to consider their earthly life in a different way, as a simple transitory period. This feeling of the impermanence of all things, a concept dear to Buddhism, deeply impregnated the Japanese mind, and significantly altered the behaviour of its people; by the twelfth century Japanese society had been transformed.

The popular mind had already been somewhat prepared for the appearance of the cults of Amida by the syncretic doctrines (which appeared in the early ninth century) associating Buddhist deities with the Kamis of the land. In this conception (and also due to his solar nature), Amida was first identified with another solar deity, the most important Kami of the Shintō cult, the ancestor of the imperial dynasty, Amaterasu Omikami, venerated in the national sanctuary of Ise. In the same *Ryōbu-shintō* (syncretic doctrine founded on the *Honji-suijaku* or 'Doctrine of the Descent', or *avatāra*), in which a relationship of manifestational reality was established between the Buddhist deities[74] and the Kamis of Shintō, Amida was also identified with Hiyoshi Shoshin, a Kami of Mount Hiei (near Kyōto),[75] with Shōjo Gongen (Ietsu no Mikoto) of Kumano, and with Hachiman (or Yawata), a Kami of war appointed as the guardian of the temple of Tōdai-ji in Nara.[76]

From the late ninth century, many temples to Amida were built throughout Japan, either by court officials, or by private persons or village communities, and the number of his followers grew steadily. These temples were called Amida-dō (hall of Amida), or Muryōju-in,[77] depending on location and on whether the founder belonged to an Amidist or esoteric sect. These temples tended to reproduce on earth

Amitābha
Gilded bronze, China,
sixth/seventh centuries,
Private Collection

the 'paradise of Amida'. In 1020, for example, the Regent Fujiwara no Michinaga (966–1027) had the temple of Hōjō-ji built for this purpose and, in his words, the *Eiga-monogatari* tells that he 'built so many rooms that we felt that we had the Pure Land before our eyes.'[78] The architecture of the Buddhist temples was also transformed: it became essential for the statue of Amida to be placed in the centre of the room of worship, so that worshippers could perform a circumambulation[79] while reciting the ritual invocation of the name Amida or Nembutsu.[80] Certain temples had to be built in an oblong[81] to accommodate the nine aspects of Amida within the Pure Land (aspects or Kubons corresponding to the nine degrees of maturity of the beings received by him into his paradise). The decoration of temples, originally austere, also changed: the edifices became luxurious, adorned with flowers, gardens and innumerable lights. Festivals and processions were celebrated there day and night, sometimes with unprecedented festivities, in the hope of equalling the enchantment conceived in the people's minds of the Pure Land of Amida. The temples became the centre for social life, celebrations and festivities. Covered stands were erected next to them, where peasants and monks danced, sang and intoned the name of Amida. The 14th day of the sixth month, Amida's day, was celebrated as a brilliant holiday (at least until the Kamukura period).[82]

The fact that devotion to Amitābha was joyful was certainly a factor in the popularity of his worship. Followers observed the custom of offering him many lamps, to give more strength and life to the setting sun, during ceremonies called Mando-e (myriad lights) in Japan; he was also called the 'Buddha with the twelve lights' (Japanese *Jūnikō Butsu*). Yet this offering was also a symbol: by this act, believers offered their own existence to the deity, sacrificed themselves symbolically. This identification of the life of the individual and of the lighted lamp is found in many folklores and even in the *Thousand and One Nights*.

The worship of Amida Nyorai is still very widespread in Japan today (it has practically disappeared from the other countries). The invocation of his name (Japanese *Nembutsu, Namu Amida Butsu*, 'homage to Amida Buddha', Chinese *Nanwu Omituo Fo*), propagated in Japan by the monk Kūya Shōnin in the tenth century, is reputed to be all-powerful. But while the Japanese sects of the Jōdo-shū and Jōdo-shinshū, and sometimes that of the Tendai, often make use of this invocation, it is little used by the Zen sects and totally rejected by the Nichiren sect.[83] Many popular works were written and disseminated in Japan on devotion to Amida,[84] with an equal number of legends attached to his functions, mainly describing the miracles performed by this redeeming Buddha. A statue of Amida was made as recently as 1923 with the cremated bones of the victims of the great earthquake that destroyed Tōkyō (it is now in the Jikō-in temple).

In China, Amitābha was first treated as a special Buddha, the Buddha of the Precious Law (Fabao), and was identified as Omituo Fo (Chinese transcription of Amitābha Buddha). Amitābha was known by several

Amida Nyorai
Japanese engraving

Amida Nyorai
Gilded wood, Seiryō-ji,
Kyōto, Japan,
early tenth century

Amida Buddha
Gilded wood, Byōdō-in,
Uji, Japan, 1053

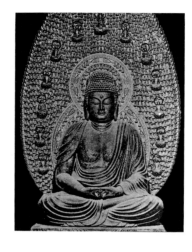

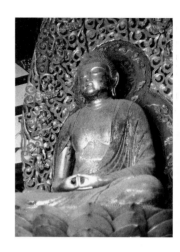

Pious image
From the Koyasi Amida-ji,
Japan

names, including 'Master' (Upadhyāya, Chinese *Benshi Heshang*),
'Sovereign Master of the Western Paradise' (Chinese *Xitian Jiaozhu*),
'Great Compassion and Sympathy' (Chinese *Daci Dabei*). It is believed
that the name of Omituo Fo was introduced into China by a monk from
Central Asia, named Jilugacan or Jiloujiachan, who settled in the
monastery of the White Horse (Chinese *Baima Si*) in Luoyang, in order
to translate the texts relating to Amitābha. The cult of Amitābha spread
progressively, but never reached the scale that it enjoyed in Japan. The
birth of Omituo Fo was celebrated with great pomp on the seventeenth
day of the eleventh moon.

Representations of Amitābha

As might be expected, few representations of Amitābha are to be found
in India.[85] Some can be found in South-East Asia, on monuments belong-
ing to the Mahāyāna, particularly on the great *stūpa* of Borobudur (late
eighth/early ninth century); in Java, where 92 effigies of him (seated
in the lotus position with the hands in meditation, Dhyāna mudrā)
adorn the niches of the western galleries,[86] and on the headdress of the
representations of the Avalokiteśvara Bodhisattva (called Lokeśvara in
Cambodia).[87] In Nepal and Tibet,[88] Amitābha is often represented in
sculpture and on maṇḍalas, in the close embrace of Yab-yum[89] with
his Śakti or complementary feminine energy Pāndarā. He is shown more
often on *thangkas* and maṇḍalas in the form of Amitāyus, as a crowned
Bodhisattva,[90] seated in the lotus position, hands in meditation
(Dhyāna mudrā) supporting a vase of ambrosia (*amrita*, Japanese *kanro*),
the divine nectar of immortality that confers wisdom. He is then some-
times seated next to an aśoka tree.[91] Amitābha is shown in the same posi-
tion in China, but very often accompanied by his two acolytes,
Avalokiteśvara and Mahāsthāmaprāpta, seated on either side of him.
In China, when represented standing, he bears the name of Jieyin Fo,

'the Buddha who guides to Paradise'. He is sometimes attributed very long arms which enable him to reach all his followers.

Images of Amitābha appeared very early in Korea and Japan, practically at the same time as the doctrines of Buddhism. One of the oldest images of this Buddha in Japan appears to be that of the *zushi* (a sort of portable altar in the form of a cupboard), which belonged to a lady of the Tachibana family (eighth century). In the *zushi* Amida is shown seated in Vajrāsana (or Ardhapadmāsana), the right ankle on the left thigh, the hands making a gesture of welcome (the right hand raised,[92] the left in Varada). His two acolytes[93] stand on lotus flowers. In the other Japanese images, he may adopt different positions, have the hands in Dhyāna mudrā, placed on each other, thumbs and forefingers joined to form two adjacent triangles (Amitābha Dhyāna mudrā), or with both feet showing, seated in Lalitāsana or, more seldom, the hands making the gesture of turning the Wheel of the Law (Dharmacakra mudrā) at the level of the chest. This last gesture is generally reserved for Śākyamuni, but Amida was confused at the time with the historical Buddha. In painting, his image is often multiple, as if to enhance his effectiveness.

Amitābha
Tibetan engraving

In sculpture, Amida is usually represented seated with the hands in Dhyāna mudrā or Vitarka mudrā, alone or accompanied by his acolytes. He is also sometimes shown standing, though this is more common in painting. If shown standing in sculptures belonging to the Jōdo sect, his bodily aureole assumes the form of a boat (Japanese *funagata-kōhai*), to recall that Amida ferries the faithful beyond the ocean of suffering.[94] Under the influence of the Japanese doctrines of esoterism (Mikkyō), Amida's hands are portrayed in Dhyāna mudrā, particularly from the final Heian period (around 900 to about the end of the twelfth century), and during the Kamakura period, up to the beginning of the fourteenth century.

Gokoshiyui no Amida

As the principal Buddha of esoterism, Amida wears a crown. His body and his robe (fold falling on the right shoulder) are red: in Japan he is accordingly called Guhari-shiki no Amida or Guhari no Amida (purple Amida). In sculpture he is sometimes shown seated with the feet completely hidden by his robe as a sign of belonging to esoterism, wearing a very large headdress (his head was said to have grown during the time of the five *Kalpas* that he spent in meditation before making his vow).[95] His hands are in Añjali mudrā.[96] This particular aspect is named Gokōshiyui no Amida ('Amida of the five *Kalpas*') or Inni Hōzō Nyorai ('Great Buddha of Meditation on the Cause').

Yamagoshi no Amida

In painting in Japan, Amida is sometimes represented 'appearing behind the mountain' (Yamagoshi no Amida, Shutsugen no Amida), as if he were the setting sun.[97] In some paintings he is also shown standing on a path lying between a river of fire and a river of water separating his paradise from the earthly world, beckoning the faithful to follow him.[98] Sculpted and painted representations of Amitābha are extremely varied and numerous, owing to his popularity. In Japan, private indi-

viduals raised many statues to him, and had his images painted: Taira no Shigenori (1138–1179) had 48 statues of Amida erected , one for each of his vows.[99] In general (although this is far from being an absolute rule), the esoteric sects represented him seated on a lotus, while the Amidist sects rather tended to show him standing, without the crown, the hands in Abhaya and Varada mudrās. Some sculptures and paintings, however, created to illustrate particular beliefs, may display exceptional forms.[100]

The image of Amitābha is found standing or seated in the headdress or on the crown of Avalokiteśvara and of his emanations, which are considered as hypostases of Amitābha. During the anti-Christian persecutions that took place in Japan during the Edo period (seventeenth and eighteenth centuries), some Christians, to ward off suspicion, had images of Amida created that they placed on crosses. This association was perfectly natural for people accustomed to religious syncretism, especially since the redeeming personality of Amida did, in some respects, resemble that of Christ. For Japanese converts to Christianity, the Christian faith could thus be readily combined with faith in Amida.

Cross of Amida
Drawing, Kyūshū, Japan,
seventeenth century

It is striking to observe that the appearance in Buddhism of a 'Buddha of the beyond' such as Amitābha corresponded to a deep desire in people to be assured of a life after death. The philosophy of the historical Buddha did not contain any metaphysics, and people filled this gap by creating, in the spirit of Buddhist compassion, a deity who, residing in this unknown beyond, would be capable of affording them welcome and solace.

Amitābha's nine sorts of welcome into his paradise

In painting in Japan, Amida is very often represented in *Raigō*, that is to say in the position of welcoming the faithful to his Pure Land, surrounded by 20 or 25 Bodhisattvas, as well as celestial beings, musicians and others.[101] He may be seated or standing. The description of this paradise, the Sukhāvatī, situated in the west, varies with different *sūtras* and authors. According to the *Sukhāvatīvyūha-sūtras*,[102] women are not admitted to this paradise but, by virtue of their merit, they can be reborn there in masculine form. In other scriptures, the gender of the 'guests' to the paradise of Amitābha is not mentioned at all. And, according to the 35th wish of this Buddha, all women who believe in him must be reborn in his paradise. According to the Japanese text of *Kan Muryōju-kyō*, three classes of welcome exist, each with three levels corresponding to the qualities of the follower, who is received into the Pure Land by Amitābha attended by Avalokiteśvara and Mahāsthāmaprāpta.[103] To each of these[104] levels there is a corresponding mudrā[105] characteristic of the aspiring believer.

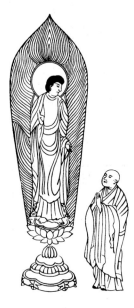

Amida
Pious image by Eikandō,
Kyōto, Japan

• The first class, the highest (*Jōbon*),[106] is called that of the contemplation of the Bodhisattvas. It is reserved for followers who have perfected the three attitudes of sincerity, faith and the firm

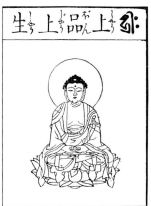
生₍₎上₍₎品₍ん₎上₍ぼ₎ 𑖌

Jōbon Jōshō

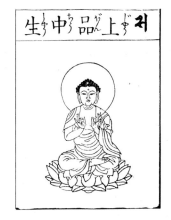
生₍₎中₍ぅ₎品₍ん₎上₍ぼ₎

Jōbon Chūshō

生₍₎下₍げ₎品₍ん₎上₍ぼ₎

Jōbon Geshō

生₍₎上₍₎品₍ん₎中₍ぅ₎

Chūbon Jōshō

生₍₎中₍ぅ₎品₍ん₎中₍ぅ₎

Chūbon Chūshō

生₍₎下₍げ₎品₍ん₎中₍ぅ₎

Chūbon Geshō

生₍₎上₍₎品₍ん₎下₍げ₎

Gebon Jōshō

生₍₎中₍ぅ₎品₍が₎下₍げ₎

Gebon Chūshō

生₍₎下₍げ₎品₍ん₎下₍げ₎

Gebon Geshō

Amida Nyorai
Wood and dry lacquer,
Saidai-ji, Nara, Japan,
eighth century

desire to be reborn in the Pure Land. They are enthroned on a diamond throne.

- The second, or middle, class (*Chūbon*),[107] is the class of the contemplation of the 'Disciples' (*Śrāvaka*, Japanese *Shōmon*). It is reserved for the followers who, having taken paths to salvation other than exclusive devotion to Amida, have nevertheless felt the desire to be reborn in the Pure Land. These followers will be enthroned on lotus flowers in various degrees of bloom, according to their purity.
- The third, or lower, class (*Gebon*),[108] is the class of the contemplation of the laity. It is reserved for all others, even those who have greatly sinned, but who have nevertheless been instructed in the Law and, even if only once, have pronounced the invocation of the name of Amida (*Nembutsu*) at the moment of their death.

The three levels in each class correspond to the maturity and the degree of perfection attained by the faithful belonging to each class; there are thus nine degrees of perfection, among which all the faithful are distributed. Each accordingly receives a welcome corresponding to his spiritual state, a state that is indicated by the mudrā made by Amida at the time he receives them.

1	*Jōbon Jōshō*	Jō-in, thumb on forefinger
2	*Jōbon Chūshō*	Seppō-in, thumb on forefinger
3	*Jōbon Geshō*	Raigō-in, thumb on forefinger

Amida's nine 'mudrās of welcome' into his paradise of the Pure Land
Left: Japanese engraving
Right, the hand positions:
top, first class;
centre, second class;
bottom, third class

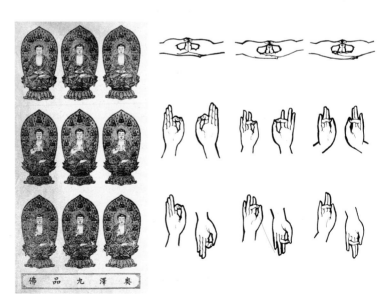

4	*Chūbon Jōshō*	Jō-in, thumb on middle finger
5	*Chūbon Chūshō*	Seppō-in, thumb on middle finger
6	*Chūbon Geshō*	Raigō-in, thumb on middle finger
7	*Gebon Jōshō*	Jō-in, thumb on ring finger
8	*Gebon Chūshō*	Seppō-in, thumb on ring finger
9	*Gebon Geshō*	Raigō-in, thumb on ring finger

The positions most often represented are the first three; the others are much rarer, possibly due to accidental destruction. But it is also likely that artists were eager to show how the most meritorious followers were welcomed into the Pure Land, thus enabling them to create an image of paradise that was more striking and, above all, more attractive to the eyes of the people.

The exact significance of these classes and of the welcoming mudrā has been hotly debated, and it has sometimes been claimed that they were not exclusively concerned with the followers of Amida, but with all people – the followers of Amida being received at the highest level; the Preta (Japanese *Gakki*), or 'hungry ghost' who wanders in a state of torment while awaiting rebirth, welcomed in the second class, followed by the animals in the last. The positions of Amitābha's welcome are described in the *Amitāyurdhyāna-sūtra* and are evoked in a number of Nō plays.[109] Some of them were even represented in sculpture in the Amida-dō in the Jōruri-ji near Kyōto, and in painting on the walls of the Hōō-dō in the Byōdō-in in Uji (dating from 1053).[110]

The Jōdo-Shinshū sect generally represents Amida standing, with his hands in Hōben-Hōshin (of the natures of Dharmakāya), the right hand raised with the palm in front, forefinger and thumb touching, left hand extended downward making the same mudrā, which signifies the welcome of Amida into his paradise of the Pure Land.

Especially in painting, the *Raigō* of Amida are represented from the tenth century[111] and seem to be inspired by the Chinese mural paintings of the Tang period.[112] In these images, he is always accompanied by 20 or 25 Bodhisattvas,[113] including his two acolytes, Avalokiteśvara and Mahāsthāmaprapta.[114] Amitābha is also sometimes shown accompanied by his twelve bodies of light (Busshin and Kōbutsu in Japanese).[115] Alongside these Bodhisattvas and emanations are many musicians and various celestial beings: celestial damsels (Apsarās, Japanese Tennin, Chinese Tiannü); the guardians of the world (Lokapālas); and sometimes also Arahants and singing birds, Gandharvas and Kiṃnaras. The same image sometimes shows a representation of the six destinies of transmigration (*Gati*, Japanese *Rokudō*).[116] These acolytes of Amitābha are found standing, seated or kneeling on clouds and lotuses.

Three types of painting of *Raigō* are distinguished.

- In the earliest (called *Muka-e no Mandara*), Amitābha and his retinue of Bodhisattvas are seated, seen from the front, and their

group is in the distance, above a landscape.

- Those that are normally called 'descent of Amitābha': he is seated or standing like his acolytes. The group thus formed is shown in three-quarter profile as if moving towards the earth, symbolized at the bottom of the image by a landscape.
- Amitābha in 'rapid descent': these images, named *Haya Raigō-zu* (rapid *Raigō*), show the group in an accentuated movement of 'descent towards the earth' and give a certain impression of speed. They were mainly executed in Japan in the Kamakura period (1185–1333).

Also worth mentioning is an exceptional form of *Raigō*, particular to Japan and called *Amida Jizō Raigō*, which shows Amida accompanied by Kṣitigarbha (*Jizō Bosatsu*) in addition to his usual Bodhisattvas.[117]

Groups of Amitābha and his acolytes

When Amitābha is represented with only two acolytes, usually Avalokiteśvara and Mahāsthāmaprāpta (sometimes Mahāsthāmaprāpta is exceptionally replaced by Kṣitigarbha), the triad thus formed assumes the name of the venerable triad of Amitābha (Japanese *Amida Sanzon*). Avalokiteśvara holds a lotus in his hand to welcome the follower into the Pure Land, while Mahāsthāmaprāpta keeps the hands joined in Añjali mudrā.[118] Sometimes these two acolytes hold their hands as guardians of the treasure (Japanese *Hōkyō-in*), but this position is rare. In at least one case, these two acolytes (it is unknown why) stand on a single foot and are bare-breasted. But they are generally described as being standing, or seated in Padmāsana, or even kneeling, sometimes simply crouching, one knee touching the ground.

Amida Sanzon, the venerable triad of Amida
Japanese engraving

Amitābha is also sometimes shown in the company of the historical Buddha, on the same altar, because Amitābha is (rarely) also associated with the historical Buddha and with Maitreya: this exceptional triad is believed to symbolize the three ages. Another type of ensemble, called *Amida Goson* or 'venerable group of five' in Japan, contains in addition to Amida and his acolytes two Śrāvakas regarded as Arahants,[119] or alternatively as Bodhisattvas aspiring to become Buddhas. A Japanese tradition identifies them with Kṣitigarbha and with the Indian monk Nāgārjuna (Japanese *Ryūju Bosatsu*).[120]

Acolytes and personages associated with Amitābha

As we have seen, the usual acolytes of Amitābha are Avalokiteśvara and Mahāsthāmaprāpta, sometimes replaced by Kṣitigarbha. Avalokiteśvara and Kṣitigarbha are described in detail in Chapter V.

Acolyte Bodhisattvas
Bronze, detail of the aureole, Tōdai-ji, Nigatsu-dō, Nara, Japan, tenth to twelfth centuries

Mahāsthāmaprāpta (Japanese, *Seishi Bosatsu, Dai Seishi*; Chinese, *Daishize, Dashizi*). 'He who has obtained great force' represents the power[121] and wisdom of Amitābha. With Avalokiteśvara on his right, he assists at the welcome of the faithful into the Pure Land.[122] Little rep-

Jinarat Buddha, gilded bronze, Bangkok, Thailand, sixteenth century

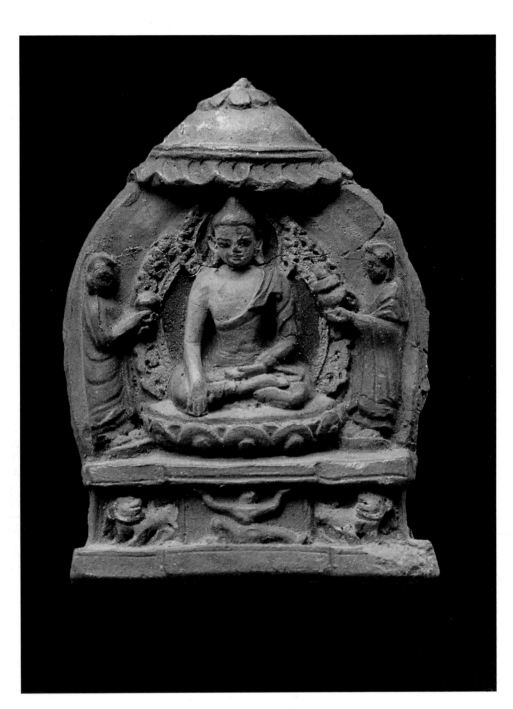

Akṣobhya Buddha, painted clay, Bhūtan, twentieth century, Private Collection

resented in India and South-East Asia, he appears in the company of Avalokiteśvara in the Yungang caves in China (standing, right hand in Vitarka, left hand in Varada). This Bodhisattva is also considered as a deification of Maudgalyāyāna, one of the ten great disciples of Gautama Buddha.[123] Few temples are consecrated to him, so that few effigies of him alone are found.

He has the general appearance of a Bodhisattva.[124] He is represented (other than in the *Raigō*) either seated in Lalitāsana, or standing or kneeling. His hands are joined in Añjali mudrā or Vitarka and Varada mudrās (Japanese *Raigō-in*).[125] He may be recognized by a precious vase on his crown, but this distinctive sign is often absent, possibly because its exact significance is uncertain. He is sometimes shown with a blooming lotus in the right hand, the left being in a sort of Varada mudrā (forefinger extended, other fingers folded) or holding a lotus.[126] However, he may also have the hands in the posture of 'guardian of the treasure' or holding a lotus corolla to receive the follower into the Pure Land of Amitābha. In paintings showing the 'descent of Amitābha', Mahāsthāmaprāpta is almost always represented to the left of Amitābha.[127]

Mahāsthāmaprāpta

The Japanese monk Kūya Shōnin. In Japan, the cult of Amitābha can be associated with the works of art representing this monk (904–972), said to be a son of the Emperor Uda. In 937, he preached the *Nembutsu Odori* or chanted and danced the invocation of the name of Amida, contributing to the spread of the festival of the Dead in Japan (*Urabon-e*) and of the dances performed on this occasion (Bon Odori) to invoke the spirits of the dead.[128] In his time, Kūya Shōnin wandered regularly and caused the construction of many Amida temples[129] and dancing stages. He is represented as a monk – thin, head shaved, leaning on a long staff surmounted by a stag's antlers and striking a gong placed on his chest. His mouth spouts[130] effigies representing Amida, connected together like the words of a *sūtra* (this word meaning both 'thread' and 'sacred text'): they represent the invocations or *Nembutsu* he intoned. However, some statues or paintings represent him simply as a wandering monk, without any special attributes.

Amoghasiddhi

(Japanese, *Fukūjōju Nyorai*; Tibetan, *Don-grub*)

This fifth and last Jina, 'He whose accomplishment is not in vain',[131] is 'He who presides in the north', where his paradise is located. He is sometimes identified with (or replaced by) Gautama Buddha. Never the object of separate worship, he is rarely represented except in maṇḍalas and in the group showing the five Jinas. In the domain of Garbhadhātu, he is called Divya-dundhubhi-megha-nirghoṣa (Japanese *Tenkuraion Nyorai*), and Mimyōshō Nyorai in the *Suvarṇaprabhāsa-sūtra*. He is normally accompanied by four great Bodhisattvas.[132] His hands and feet are

Kūya Shōnin
Coloured wood,
Rokuharamitsu-ji, Kyōto,
Japan, fourteenth century

145

**Amoghasiddhi
(Fukūjōju Nyorai)**

hidden by his robe. In the Vajradhātu Maṇḍala, he holds his right hand in Bhūmisparśa, his left hand closed in his lap.

He is normally represented as a Buddha of wisdom, green in colour, seated in Padmāsana, the right hand in fearlessness, the left holding a fold of his robe. He is then sometimes attended by two Bodhisattvas of medicine, Bhaiṣajyarāja and Samudgata (*Yaku-jō*) who are two forms of Avalokiteśvara.

In China, he was sometimes shown seated 'in the European fashion', hands in Abhaya and Varada mudrās (especially in Dunhuang), thus representing his Manuṣya Buddha, Maitreya. In India and South-East Asia (e.g. at Borobudur in Java), he is represented as a normal Buddha – hair forming small curls, ūrṇa, uṣṇīṣa, right shoulder bare, right hand in Abhaya mudrā, left hand open in his lap. In Tibet, he is sometimes represented in Yab-yum with his Śakti, Tārā, dark green in colour (his Śakti is a lighter green), holding a fourfold vajra in the right hand, and a bell in the left. Although his lotus support is theoretically blue-grey, it is usually painted pink. His vāhanas are represented on his base, winged dwarfs or Kimnaras (called Shenshang in Chinese). He corresponds to the element earth and to Maitreya, the future Buddha.

THE ĀDI BUDDHA

(Tibetan, *Dus-khyi-hkor-lohi Btsan, Mchog-gi Dang-po-hi sangs rgyas*; Mongol, *Anghan Burhan*)

Fairly late, probably in Nepal around the tenth or eleventh centuries, a theory emerged that tended to make a monotheistic religion out of Mahāyāna Buddhism. This theory, which spread among the followers of the Aiśvārika sect, was based on a sentence of the *Gunakāraṇḍa-vyūha* claiming that there was a 'Svayambhū' Buddha ('self-emanating Buddha'), also called Ādi Buddha ('the primordial Buddha'), long before anything else. According to the Nepalese school, this Ādi Buddha, from the beginning of eternity, is infinite, omniscient, and can be considered as the true creator of everything that exists. It is from him, also qualified as Anupapādaka, that the five Jinas emanated: 'one who has no birth', 'the unborn'. He is the emanation of the mystic syllable *Oṃ*, represented by a flame surging from a lotus. He resides in the uppermost heaven, the thirteenth, according to Nepalese cosmology.

The Svābhāvika sect (also Nepalese) also believed in an Ādi Buddha. This supreme being assumed several names – such as Svayambhū, Īśvara, Svabhāva, Vajrapāṇi, Vajrasattva, Vajradhāra, Vairocana. These conceptions of a supreme Buddha were not accepted everywhere and, in Nepal as well as Tibet, enjoyed little popularity, each sect conceiving its Ādi Buddha differently, and generally identifying him with one of the Great Buddhas of wisdom. In Tibet, an ancient sect recognized Mañjuśrī as the supreme deity; the 'Red Hats' venerated Vajrasattva, and the 'Yellow Hats' Vajradhāra. In China, Vajrasattva was

mainly considered as the supreme Buddha, and in Japan Vairocana assumed this function for the esoteric sects. In the Mahāyāna of South-East Asia (mainly in Java), a higher entity called Advaya, the principle of all things, was worshipped as the omniscient Buddha. In Japan, various Jinas, such as Amitābha and Bhaiṣajyaguru, also assumed the foremost place in the Buddhist pantheon.

In Nepal and in Tibet, Ādi Buddha is represented as a robed Buddha, wearing all the ornaments of a Bodhisattva. His Śakti is Ādi-dharmā (or Ādi-prajñā). When this Ādi Buddha is represented in Yab-yum with his Śakti, he is named Yogāmbara, and his partner takes the name of Digāmbarā or Jñaneśvarī. They are represented as Buddhas, without ornaments. Yogāmbara has his hands in Dharmacakra mudrā and Jñaneśvarī in Dhyāni mudrā.[133]

Vajrasattva
(Japanese, *Kongōsatta*; Chinese, *Woziluosazui*; Tibetan, *Rdo-rje-sems-dpah*)

In this form, this Ādi Buddha, worshipped particularly in Tibet and China, is the 'representative of all the Buddhas', according to the *Abhidānottara-tantra*.[134] In Nepal he is identical to Svabhāva, accord-

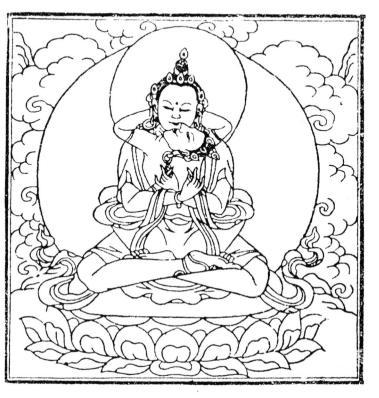

Vajrasattva in Yab-yum with his Śakti
Tibetan engraving

ing to the Svābhāvika sect, and resides (or revealed himself) on Mount
Meru. He is symbolized by a flame surging from a crescent moon placed
on a lotus, or by a trident placed on the same flower. In the later
Mahāyāna pantheon, he is the equivalent of the Hindu deity Brahmā.
He sometimes replaces Akṣobhya in the group of the five Jinas, and
sometimes carries a small image of this Dhyāni Buddha in his headdress
(Jakarta Museum).

Usually represented as a robed and seated Buddha, he may assume
several leg postures, such as Paryaṅkāsana (right foot on left thigh), or
Padmāsana, or with the legs crossed at the ankles. He is mainly repre-
sented in sculpture in Tibet, Java and Thailand, while he appears more
frequently in maṇḍalas in Nepal and China. In the standing position,
he also appears on steles, in the company of other Buddhas and
Akṣobhya. In this case, he has many heads and arms, but he always
holds a vajra and a bell. In Tibet, he is often represented in Yab-yum
with his Śakti Ghaṇṭāpāṇi, and this form belongs to secret ritual.

In Japan, under the name of Kongōsatta, he was often represented,
not only in maṇḍalas but also in sculpture. He is frequently shown on
his vāhana, a white elephant.

Vajradhāra
(Tibetan, *Rdo-rje-hchang*; Mongol, *Ochirdara*)

The form of Vajradhāra is sometimes indistinguishable from that of
Vajrasattva – they are in fact both confused with the Tantric aspects of
Vairocana. Certain sects, however, assign him an independent existence.
He is the Ādi Buddha of the 'Yellow Hats'. He is represented as a
Bodhisattva, wearing all his ornaments, hands crossed on the breast with
the vajra and the bell, dark blue in colour. The vajra and bell are some-
times supported by a branch held in his crossed fists. When represented
with his Śakti Prajñāpāramitā in the Yab-yum position, he holds his two
implements behind the back of his partner.

This Ādi Buddha may also be called Karmavajra (when his left hand
holds a lotus and his right is in Vitarka mudrā) and Dharmavajra (when
he holds a double vajra on the breast and a bell on the hip).[135] However,
these two aspects are rare.

V

THE BODHISATTVAS OF COMPASSION

Jūichimen Kannon
Coloured wood, Mūro-ji, Nara,
Japan, ninth century

Avalokiteśvara
The Tārās
Ākāṣagarbha
Kṣitigarbha

INTRODUCTION

Bodhisattvas are 'beings destined for Awakening',[1] preparing, through their merits and their virtues, to become Buddhas. Although in fact they can be the equals of the Buddhas, the Mahāyāna has conceived them as having renounced the ultimate state out of pure compassion towards all beings.[2] As such, 'for the most devout of their followers, the Bodhisattvas are beings of the imagination and absolutely do not exist.'[3] In fact, what is called Bodhisattva and 'perfection of wisdom'[4] is merely a name, and this name is perceived neither internally nor externally, nor between the two. One speaks of beings, but no being exists. 'All these words are simply designations and exist only as designations.'[5]

The term Bodhisattva refers to someone on the path to Awakening, and can therefore refer to anyone *en route*. In non-Mahāyāna Buddhism, it usually refers either to Maitreya, the Buddha of the Future, or to the historical Buddha Gautama prior to his enlightenment – either during the life in which he became enlightened or in one of the innumerable lives before that in which he was developing the requisite virtues for enlightenment, such as generosity. The stories of these lives are called the Jātakas, or 'birth stories', and they are a very frequent subject of Buddhist art.

For most of the followers of Mahāyāna Buddhism, the Bodhisattvas represent intermediaries between the inaccessible, unimaginable and indescribable Buddha (conceived as a supreme deity, Vairocana or Ādi Buddha), and the beings living on this earth of impermanence and imperfection. They are the divine intercessors, the 'heroes of charity and sacrifice',[6] endowed with all virtues and qualities, possessing all strengths and an unshakable resolution in the accomplishment of their vows. They are perfect models, dear to the hearts of the faithful, because, endowed with tenderness and sensitivity, they are closer to them. In this respect, they are usually worshipped and invoked more than the Buddhas themselves. Devoted to the salvation of the suffering world, they do not enter final Nirvāṇa – which is why they are not normally represented in Samādhi (meditative concentration) with the hands in Dhyāna mudrā, but in more dynamic postures. They are eminently active beings: they have taken the 'vow to experience all torments in

Bodhisattva

the place of living beings.'[7] Thus their appeal is immense throughout the world of Mahāyāna Buddhism, and the number of their representations is considerable. They are assigned many names which reflect the qualities or activities attributed to them, because a number of these Bodhisattvas are worshipped according to their attributes.

Bodhisattvas are described in many Indian religious works[8] and in several works and *sūtras*.[9] According to these texts, the Bodhisattvas begin their 'career' with the thought of compassion (*Karunācitta*), of knowledge of non-duality (*Advayajñāna*) and the vow to bring all beings to liberation, literally the 'thought of Awakening' (*Bodhicitta*):[10] 'Bodhisattvas are the shoot (*aṅkura*) sprouting from the Great Compassion, while the Buddhas are the far-off fruit (*phala*).'[11] According to the *Avataṃsaka-sūtra*, there are ten birthplaces (*Janmasthāna*) for Bodhisattvas.[12] Since they have renounced Nirvāṇa in order to help humans to attain salvation, they create for the purpose 'bodies of metamorphosis' (*Nirmāṇa*) or 'emanations', correspondences in the guise of which they appear to people. In this way, they can appear everywhere at once.[13]

The Bodhisattvas were known very early in the history of Buddhism, and appeared in China from the introduction of the Mahāyāna doctrines, from which they became inseparable. Following the introduction of the esoteric doctrines, their worship diversified, and many Bodhisattvas were created to satisfy the popular taste. However, some forms enjoyed greater favour than others. In Japan, where their worship is attested from the late sixth century, they became the most venerated deities in the Heian period. On certain occasions, the Emperor of Japan could even confer the title of Bosatsu (Bodhisattva) on especially venerated priests,[14] a practice that can undoubtedly be identified, in Shintō, with the deification as Kamis of personages who had really existed, a practice that was relatively common at the time. Esoteric Buddhism recognizes four great Bodhisattvas or 'great acolytes' (*Mahāparivāra*, great entourage), who are the symbols of the virtues of the Great Solar Buddha Vairocana.

**Vajrapāramitā
(Kongōharamitsu)**
Gilded wood, Tō-ji,
Nara, Japan,
seventeenth century

- south-east: Samantabhadra, considered as the chief of the Bodhisattvas,[15] represents the merits of the 'heart of Bodhi'.
- north-east: Maitreya, who represents the Great Compassion of the Buddha.
- south-west: Mañjuśrī, who represents wisdom and the merit of the teaching of the Law.
- north-west: Sarvanīvaraṇaviṣkambhin, a form of Avalokiteśvara, who represents the merits resulting from the destruction of obstacles on the path of the Bodhi.

In the Garbhadhātu Maṇḍala, some Bodhisattvas represent the causes of which the four Buddhas surrounding Vairocana are the effects. In the Vajradhātu Maṇḍala, the Bodhisattvas, numbering 16, represent the

virtues of the four great Bodhisattvas. They are attended by 16 other Bodhisattvas of contemplation, four 'perfections' (*Pāramitā*), eight 'offerings' (*Pūjā*), and four 'means of conversion' (*Samgraha*, Chinese *Shi*).

According to the *Bukkyō-Daijiten*,[16] the four Samgraha serve to 'call/invite' the beings, to guide them, to hold them firmly, and to make them happy: these are the means or methods of conversion. Some of these Bodhisattvas accordingly, unusually, assume a feminine form; while the Bodhisattvas are not deities in the strict sense of the term, they are nearly always considered in India as being of the masculine gender.[17] The gods and deities (Deva, Devatā) who are not Bodhisattvas (at least in essence) are sexed, hence masculine or feminine, when they appear in the world of sensual desire (Kāmadhātu) because, like all the beings of this world – gods, men and animals – they are subject to the law of sexual desire. The gods of the two higher worlds, Rūpadhātu (the world of form) and Ārūpadhātu (world without form), are, on the contrary, asexual. Beings who are reborn in the paradise of Amitābha or of other Buddhas have asexual bodies. In the paradises of the gods, everything depends on the type of world to which the paradise concerned belongs.[18]

The Mahāyāna conceived the principal Bodhisattvas as corresponding to the Great Buddhas of Wisdom. These Bodhisattvas are considered as being the 'bodies of essence' (*Sambhogakāya*) of the Jinas: they are Samantabhadra, Vajrapāṇi, Ratnapāṇi, Avalokiteśvara and Viśvapāṇi. According to some doctrines, each of these Bodhisattvas 'creates' a world over which he presides until the advent of the Manuṣya Buddha of his cycle, and which he rules after the death of this Nirmāṇakāya. Thus Samantabhadra created the first world of this Kalpa (aeon), until his 'spiritual father' Vairocana materialized on earth as the Krakucchanda Buddha. Similarly, Vajrapāṇi created the second world on behalf of Akṣobhya and Kanakamuni; Ratnapāṇi created the third on behalf of Ratnasambhava and Kāśyapa; and, finally, Avalokiteśvara is presumed to have created the present world for his spiritual father Amitābha and the Gautama Buddha: he therefore rules the present world. Vishvapāṇi will do likewise at the advent of Maitreya.

Some sects recognize not five but eight great Bodhisattvas, divided into two groups of four: Avalokiteśvara, Ākāśagarbha, Vajrapāṇi and Kṣitigarbha on the one hand, and Sarvanīvaraṇaviṣkambhin, Maitreya, Samantabhadra and Mañjuśrī on the other. Their effigies are represented on either side of a Buddha.

Only four great Bodhisattvas are recognized in China and Japan: Kṣitigarbha who presides over the earth, Avalokiteśvara who presides over the waters, Samantabhadra who presides over fire, and Mañjuśrī who presides over the ether. In Japan, they are rarely found in groups except in maṇḍalas and paintings, and are worshipped independently of each other. However, in Tibet, China, Korea, Japan, and South-East Asia, it is Avalokiteśvara, the great Bodhisattva of compassion, who is the most deeply venerated, in countless forms.

The Bodhisattvas are always represented clothed as princes and adorned with thirteen ornaments including a crown with five gems, earrings, a necklace, armlets, bracelets, anklets, long necklaces, scarves and a belt. Their crowns may bear the effigy of their 'spiritual father', one of the five Jinas. Their hair is tied in a high chignon and they have an *ūrnā* on the forehead. They are usually represented standing when worshipped alone, and seated when accompanied by a Jina. In Nepal and Tibet, they are sometimes represented in Yab-yum with their Śaktis. The sects of Tibetan Buddhism in Tibet and Nepal usually represent only five Bodhisattvas – Avalokiteśvara, Mañjuśrī, Maitreya, Vajrapāṇi and Bhaiṣajyaguru – although the others are sometimes represented in company with them, or alone. The amount of adornment may vary greatly, especially in Tibet and Japan. They may wear more or less than thirteen ornaments, or may be restricted to a high headdress.

AVALOKITEŚVARA

(Āryāvalokiteśvara, Lokeśvara; Japanese, *Kannon, Kanzeon*; Chinese, *Guanyin, Guanshiyin*; Tibetan, *Spyan-ras-gzigs*; Mongol, *Nidubarüsheckchi*; Vietnamese, *Quan-ām*)

Among the Bodhisattvas, it is Avalokiteśvara who has the largest number of forms and is perhaps the most venerated and most popular Buddhist deity. His sex, originally masculine, is sometimes considered feminine in China and Japan, although this discrimination is unsupported by any canonical text. Where definitions in the following text are given as feminine, it should be remembered that this interpretation may be dubious. In the Buddhism of the Northern schools, however, it is acknowledged that feminine beings can be accepted into the paradise of Amitābha or the other Buddhas only in the form of masculine beings: certain deities have the power of transforming their sex to ensure their access to paradise. This interpretation is primarily a popular one and stems from a tendency within the societies to assert male pre-eminence. On the other hand, men are often tempted to attribute a feminine quality to all the deities who appear to them to be endowed with essentially 'feminine' virtues, such as compassion, gentleness, goodness of heart or purity. This is why Avalokiteśvara was often considered in China and Japan as the 'mother of the human race' and, in this respect, worshipped in the form of a woman.

Avalokiteśvara, 'bestower of children'

Avalokiteśvara is known from very early in the development of the Mahāyāna doctrines and, until Buddhism disappeared from India, enjoyed great favour there. His cult passed from India to South-East Asia and Java, where it met with great success, and also in Nepal, Tibet (where he arrived with Buddhism and where King Srong-btsan Sgam-po, 519–650, was considered to be his incarnation), and in China, from where he went on to Korea and Japan. All these countries imagined him in different forms according to their own temperaments and spiritual

needs; he also assumed as many different names. Some sects recognize certain forms of Avalokiteśvara which others do not. Most of the forms are found only in specific maṇḍalas or paintings, while others are syncretic or belong more to popular belief.

In the late ninth century, the Chinese pilgrim Faxian reported his worship in Mathurā. Some representations of him are found in Ājantā, India, on frescoes and in sculpture,[19] on at least one temple in Bhūvaneshvar[20] and in many other places in India, as at Nālandā, for example. In South-East Asia, sham bronzes,[21] Javanese and Sumatran, pre-Angkor[22] sculptures and bronzes, as well as the bas-reliefs of the *stūpa* of Borobudur in Java, foreshadow the gigantic four-faced effigies of Lokeśvara, so typical of the period of Jayavarman VII (late twelfth century) in Cambodia, where representations are also found of Lokeśvara with the body covered with hundreds of small images of 'radiating Buddhas'[23] and where at least one sanctuary, that of Neakpean in Angkor, was dedicated to him.

The first representations in India of Avalokiteśvara approximately resemble those of Brahmā, the god and creator of Hinduism, and Śiva. He assumed an extremely wide variety of forms, and an equal number of attributes and mudrās were assigned to him. However, the most characteristic mudrā of this great Bodhisattva is in Varada, the symbol of charity and giving. There are images of Avalokiteśvara in Sri Lanka, dating mainly from the eighth and ninth centuries.

In Tibet, Avalokiteśvara is associated with Dalai Lamas who are said to be incarnations of him. The Potala, the palace of the Dalai Lama in Lhasa, in fact bears the name of the paradise of Avalokiteśvara. In Vietnam and Cambodia, under the name of Lokeśvara, 'Lord of the world', Avalokiteśvara was singularly honored, chiefly from the tenth to the thirteenth centuries. And in Thailand, his cult is also attested as having enjoyed great popular favour.

Avalokiteśvara
Stone, India,
seventh century,
Patna Museum

Avalokiteśvara is usually represented standing, with an effigy of Amitābha in his headdress. His normal attributes are the lotus (symbol of purity), the water or flower vase (which slakes thirst and appeases the senses), and the rosary with 14, 27, 54 or 108 beads. In theory, his mount (*vāhana*) is a goose (*hamsa*) or a peacock (*mayūra*); this is sometimes replaced by a phoenix or a pheasant, but these animals are rarely represented in sculpture.[24]

- In the *Amitābha-śāstra Maṇḍala*, he is the acolyte of Amitābha: his hands are in Añjali mudrā or in Abhaya and Varada mudrās.
- In the *Kanmuryōju-kyō* he has no fixed posture. When he is an acolyte of Amitābha in his 'descent', he holds a lotus in his hand (or a tray of lotus flowers) to welcome the soul of the believer.
- In the *Saddharmapuṇḍarīka Maṇḍala* (Japanese *Hoke-kyō Mandara*), he is the deity who represents compassion.

In esoterism, Avalokiteśvara is usually represented holding a lotus stem

in the right hand. He is then standing, clothed like a Bodhisattva (with or without an effigy of Amitābha in his headdress), with an *uṣṇīṣa* in the form of a mitre or high chignon, the eyes half-closed, with long ears and sometimes a thin moustache, and very long arms.

Japan

The important forms of Avalokiteśvara which were worshipped at some time or other in Japan are nine in number, approximating to the ones that were originally developed in China and Tibet: Ekādaśamukha ('with eleven heads'), Sahasrabhuja ('with 1,000 arms'), Sahasranetra ('with 1,000 eyes'), Cintāmaṇicakra, Hayagrīva ('horse-neck'), Cundī, Amoghapāśa, Bhṛkuṭī and Avalokiteśvara in the feminine form of 'giver of children' (sometimes identified with Cundī, see p. 174). The Shingon, Tendai, Zen and Jōdo sects pay particular tribute to Avalokiteśvara in various forms, especially to the form Shō Kannon Bosatsu. The Shingon sect does not recognize Amoghapāśa (Japanese *Fukūkensaku Kannon*).

Kōzeon Bosatsu

Shō Kannon Bosatsu

Under this name, Avalokiteśvara was worshipped virtually from the inception of Buddhism in Japan. One of the first temples devoted to a triad of Amida (including Avalokiteśvara) was erected in 602 by Shōtoku Taishi[25] at the Zenkō-ji in Nagano (near Shinano). Shōtoku was then considered as an incarnation of Shō Kannon Bosatsu.[26] At the Yakushi-ji in Nara, a bronze statue of Avalokiteśvara was erected in the late seventh century.

This is the saviour Bodhisattva *par excellence*, 'He who looks down upon the suffering of the world',[27] the 'Lord who shines',[28] the spiritual son of Amitābha.[29] His virtues of infinite compassion made him the 'Great Compassionate', 'He who is able to face everything'. In misfortune, in danger, it is to him that the people flock: he hears prayers, procures peace and safety for his followers, performs countless miracles to save them, assuming all sorts of bodies and metamorphoses.[30] He is very frequently represented associated with Amitābha, whose acolyte he is, as is Mahāsthāmaprāpta.[31]

Legend has it that he was born from a ray of light emanating from the right eye of Amitābha, causing a lotus to open.[32] He is also called Lokeśvara, 'Lord of the world', and Lokanātha, 'Protector of the world'. The 24th chapter of the Lotus Sūtra is devoted to him,[33] and in it he is called 'He who regards on all sides', a name which possibly inspired certain image makers to place his eyes in the palms of the hands, in order to symbolize 'the regard that embraces the entire world'.[34] He is also the one who refreshes, who slakes thirst, as suggested by the frescoes of the Dunhuang Caves in China, on which Pretas ('hungry ghosts' perpetually tormented by insatiable thirst and hunger) are seen to swallow avidly the drops that fall from the vase he holds in his hands.[35] He is

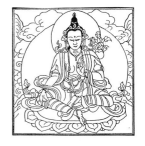

Avalokiteśvara
Tibetan engraving

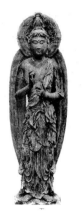

Shō Kannon
(Shō Kanzeon)

Shō Kannon
Wood, Kurama-dera,
Kyōto, Japan, 1226

also the 'good boatman' who conveys in the ship of mercy the beings who wish to travel to the Pure Land of Amitābha.[36]

In or on his headdress, or in his crown, he generally wears a small effigy (Japanese *kebutsu*) of Amitābha standing or seated.[37] However, it seems that this effigy, recalling that Avalokiteśvara is a hypostasis of Amitābha, was added much later.[38] In the Garbhadhātu Maṇḍala, he is called Kanjizai Bosatsu in Japanese. He is seated to the north of Vairocana (Dainichi Nyorai) on a white lotus, and is surrounded by several other Bodhisattvas who symbolize his compassionate virtues.[39]

His 'normal' forms (namely with one head and two arms) can be classed into five main types according to the postures and periods.

- Asuka (552–645): standing, hands in Ongyō-in (holding a round object, perhaps a *cintāmaṇi*), with crown and ornate tiara.
- Nara (645–795): standing, left hand holding a vase, right hand in Abhaya mudrā or in Varada mudrā.
- Hōryū-ji (seventh century): standing, left hand holding a lotus or in Abhaya mudrā, right hand hanging.
- Yakushi-ji (eighth century): standing, right hand in Varada mudrā, left hand in Abhaya mudrā.
- 'Meditative': standing, head inclined to one side, bowed slightly forward or upright, studying a lotus held in the left hand, right hand making the gesture of plucking the petals. With or without the effigy of Amitābha in the crown.

These five types, all originating in China, are found with many variations of detail. However, aberrant forms are sometimes found represented, assuming specific names depending on their appearance or the functions attributed to them. These irregular forms include those designated by the generic term of 'The 33 Forms of Kannon'.

The 33 Forms of Kannon

In China and Japan, it is said that Avalokiteśvara (Chinese *Guanyin*, Japanese *Kannon*) has 33 forms. In actual fact, he has many more if one counts the images that have received particular names, either due to their origin, or because of the specific qualities ascribed to them, or even according to the different aspects that he is likely to assume in specific cases.[40]

The 33 forms are emanations of correspondences (Japanese *Sanjūsen ōgeshin*)[41] which are 'bodies of metamorphosis',[42] related to Japanese or Chinese legends (the legends of Miaoshan),[43] and are very often associated with the images of the principal forms of Avalokiteśvara which gave rise to pilgrimages devoted to the '33 sanctuaries of the western provinces' of Japan.[44] It is believed that one who has performed the complete pilgrimage to all these sanctuaries is forever delivered from the fear of hell. In this connection, the temples distribute printed effi-

gies of Shō Kannon on which spaces are reserved where, to prove that he has made the pilgrimage, the believer may secure the stamp of the authorities of each temple visited. The different forms of these 33 Kannons are relatively late, and most of them appeared only after the Kamakura period (1333). Some were often represented, usually in painting,[45] while others failed to inspire any artist. Their names also vary according to author and text. Some derive their name from legends, others from Hindu deities. According to the *Butsuzō-zu-i*, the following are the 33 forms of Shō Kannon Bosatsu.

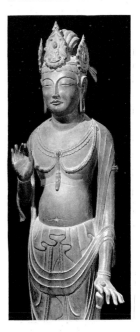

Shō Kannon (Yume Tagae)
Bronze, Hōryū-ji, Nara,
Japan, c. 700

1 **Yōryū Kannon (Yaku-ō Kannon).** Kannon the 'king of medicine', 'Kannon of the weeping willow' is a form of Yakushi Nyorai (Bhaiṣajyaguru), with whom he is often confused. The leaves and bark of the weeping willow contain salicylic acid which cures many ailments and calms fever, medicinal properties which have been known in Asia from antiquity and which are now used in the manufacture of aspirin. With Yakujō Bosatsu, Yōryū Kannon is the acolyte of Fukūjōju Nyorai. In sculpture he is represented standing, mouth open, brow frowning, with a high chignon.[46] In painting he is also shown seated in Rājalīlāsana, the right hand holding a willow branch, left hand leaning on the elbow, hand falling or at the level of the breast. He can assume a feminine form. He was often represented in China.

2 **Ryūzu Kannon.** Represented as a woman seated on a dragon (Japanese *Ryū*) or on the back of a sea-turtle, her veil folded over her high chignon (partly concealing the image of Amitābha in her headdress), holding a blooming lotus in the hand or making a Dhyāna mudrā with the hands hidden under her robe. In China, this form sometimes holds a child in her arms, and is confused with a 'giver of children'.

3 **Jikyō Kannon.** Represented as a woman holding a scroll of the scriptures in the right hand.

4 **Enkō Kannon.** Represented as a woman radiating rays of light, or seated on a rainbow. Her hands are joined.

5 **Yūge Kannon.** Perhaps the Bodhisattva of joy, possibly feminine. Seated in royal ease on a brilliant cloud.

6 **Byakue Kannon.** 'Kannon in a white robe'[47] corresponding to Pāṇḍaravāsinī. This feminine form which witnessed many representations[48] is generally seated in Padmāsana on a lotus[49] with the right hand holding a scroll of the sūtra of the *Prajñāpāramitā* (or sometimes a *cintāmaṇi*) pressed against the breast,[50] the left hand resting on the seat and holding a rosary or a rope. She is often shown with a fold of her robe covering her hair, like Ryūzu Kannon, with whom she is often confused. She is also sometimes seated on a rock, without any attribute, or standing on two lotuses, one under each foot, at the edge of the sea,[51] possibly holding a lotus in the hand, or with the hands in Dhyāna mudrā. This is perhaps a form called

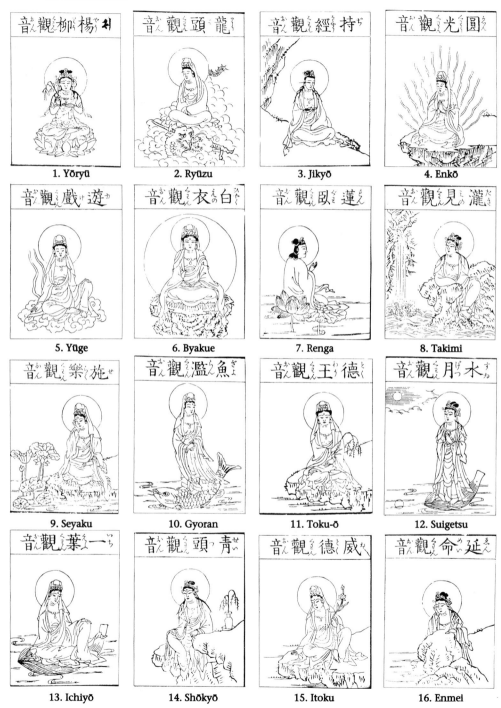

1. Yōryū

2. Ryūzu

3. Jikyō

4. Enkō

5. Yūge

6. Byakue

7. Renga

8. Takimi

9. Seyaku

10. Gyoran

11. Toku-ō

12. Suigetsu

13. Ichiyō

14. Shōkyō

15. Itoku

16. Enmei

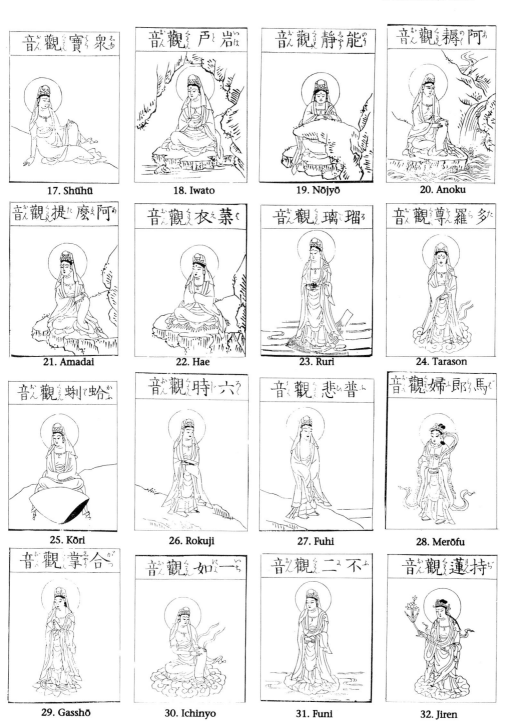

17. Shūhū

18. Iwato

19. Nōjyō

20. Anoku

21. Amadai

22. Hae

23. Ruri

24. Tarason

25. Kōri

26. Rokuji

27. Fuhi

28. Merōfu

29. Gasshō

30. Ichinyo

31. Funi

32. Jiren

Guohai Gunyin in China (see form 13). She generally holds a rosary in the right hand but, in certain Tantric forms, she holds the right wrist in the left hand. This type of Kannon, which is found on a stele of Xi'anfu (Shanxi, China), apparently inspired the Japanese representation of Nyoirin Kannon (see p. 172). She is also sometimes confused with Byakushin Kannon (Shvetabhagavatī).[52]

7 Renga Kannon. Woman seated on a lotus.

8 Takimi Kannon. A Bodhisattva of virtue. Feminine form watching a waterfall.

9 Seyaku Kannon. Kannon 'giver of joy', represented in a pensive attitude, at the water's edge, observing a lotus.

10 Gyoran Kannon. Kannon in the form of a woman holding a basket of fish, or seated or standing on the back of a large carp. She is associated with an ancient Chinese legend and is the Bodhisattva of fish and of mariners. Hokusai (1760–1849) drew a remarkable image in his *Manga*, and this subject was frequently represented on kakemonos. The general appearance of Gyoran Kannon is the same as that of Byakue Kannon (form 6), with a veil partly covering her headdress.

Gyoran Kannon
Drawing by Hokusai

11 Toku-ō Kannon. Kannon 'king of virtue'. He holds a willow branch in the hand, and is often confused with Yōryū Kannon (form 1).

12 Suigetsu Kannon. Represented seated in royal ease on a rock, or standing on a lotus leaf floating on the water, looking at the reflection of the moon in the water. Sometimes (but seldom) with three heads and six arms.[53]

13 Ichiyō Kannon. 'Kannon of the leaf'. Sometimes seated or standing on a lotus leaf floating on the ocean. This Chinese form is also called Guohai Guanyin (see form 6).

14 Shōkyō Kannon (Seitsu Kannon). Represents Nīlakaṇṭhī, 'Avalokiteśvara with the blue neck', mainly represented in painting. This Tantric form is compared with the Indian god Śiva who drank poison extracted from the sea of milk after it was churned, and whose throat remained blue thereafter. This form is attributed the power of banishing difficulty or misfortune. He is shown seated on a lotus or a rock. His skin is blue-black. His images offer two aspects: with two arms, the right hand in Abhaya, the left holding a lotus, leaning on a rock, a vase placed nearby; or with three heads and four arms, holding a staff, a lotus, a ring and a conch shell: the frontal head expresses compassion, the head on the right is that of a lion, the head on the left that of a boar. This form is possibly an aspect of Mārīcī.

15 Itoku Kannon. Kannon of majesty, seated in royal ease, a lotus stem in the left hand. This is the form most commonly represented in China.

16 Enmei (or Enmyō) Kannon. Kannon protector of the life of the faithful. She stands behind a rock.

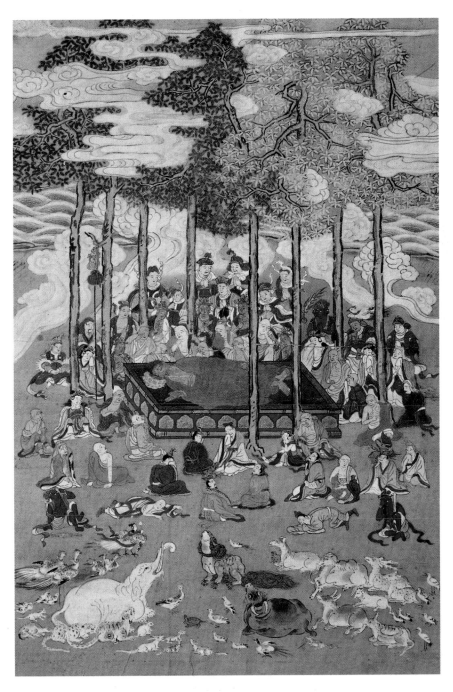

The Parinirvāna of the Buddha, painting on paper, nineteenth century, copied from a fifteenth-century painting, Japan, Private Collection

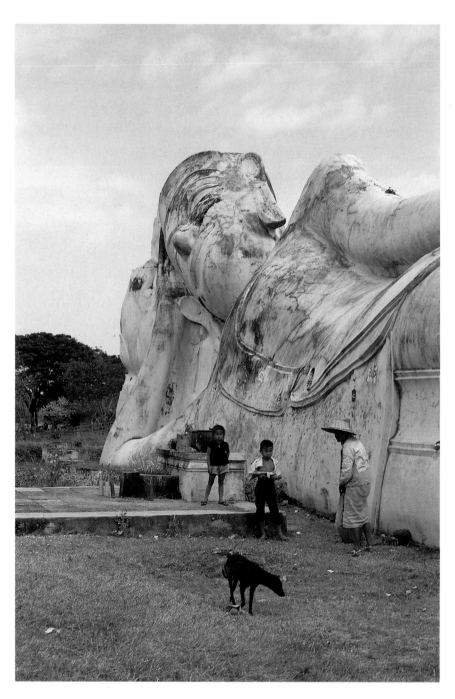

Recumbent Great Buddha, brick and stucco, Ayuthyā, Thailand, seventeenth century

17 Shūhū Kannon. Kannon, the female dispenser of the treasure. Seated in royal ease.

18 Iwato Kannon. 'Kannon of the gate of the rock', perhaps a 'Buddhicization' of the Shintō Kami Amaterasu Ṇmikami. She is seated at the entrance to a cave.

19 Nōjyō (or Nōshō) Kannon. Kannon who gives calm. Shown leaning on a rock.

20 Anoku Kannon. Represented as a woman seated on a rock at the edge of the sea, holding the knee, or with a sūtra scroll or *cintāmaṇi* in the hand. She protects aquatic demons and saves the faithful from drowning.[54]

21 Amadai Kannon. This form[55] was introduced from China to Japan in the ninth century.[56] Represented in royal ease on a rock or on a white lion. Sometimes has one head with three eyes and four arms: the principal hands play on the *hokugō* (a small *koto*, or zither of Korean origin), or on a sort of Chinese harp adorned with the head of a phoenix, the upper right hand supporting a *Haku-kichijō* (white pheasant, bird of good luck), the upper left hand holding a *Makatsugyo* (fantastic fish). The precise significance of these attributes has not been identified.

22 Hae (or Hiyoe) Kannon.[57] This form of 'Kannon who carries leaves' is perhaps identifiable with Parṇaśabarī, 'the witch of the leaves' of the Indian pantheon. In the Garbhadhātu Maṇḍala, it has two arms and holds a jewel surrounded by flames or a rope in the right hand, and the left hand holds a lotus. Represented with a very pale skin, sometimes of a feminine appearance with four arms: the right hands in Varada mudrā and holding a *cintāmaṇi* on the breast, the left hands holding an axe and a rope. When seated on a mat or a rock, the hands are hidden in the sleeves. Its esoteric name is *Jogyō Kongō*.

23 Ruri Kannon. 'Kannon with the beryl jewel'. Holds a round jewel in the hand and stands on a leaf floating on the water.

24 Tarason Kannon[58] **(Tarani Bosatsu).** This is a Tārā, the Śakti of Avalokiteśvara already mentioned in the seventh century by Xuanzang.[59] This feminine form was 'born from the light of the eyes of Avalokiteśvara'. Some sūtras identify her with Māyā, the mother of Gautama Buddha: in the Garbhadhātu Maṇḍala, she is represented as a mature woman. She can be blue or white in colour, and holds a lotus in her hands, which are joined in Añjali mudrā.[60] She assumes two main aspects. In one, light green or blue in colour, she stands on a lotus, she has three eyes, an image of Amitābha in her headdress, the hands in Abhaya and Varada mudrās, or holding a knife or sword in the right hand and, in the left, a blue lotus, skull or pomegranate. In the other form she is seated on a lotus, the hands are joined in Añjali mudrā and hold a lotus, or the right hand is in Varada mudrā, touching the petals of her seat, and the left holds the lotus. Kannon appears to symbolize the resolution made by this

33. Shasui Kannon

Bodhisattva to save all beings.

25 Kōri Kannon. 'Kannon of the shell'.

26 Rokuji Kannon. 'Kannon of the six hours of the day' (in ancient Japan each hour was about twice the length of the present-day one). He holds a book in the hand.

27 Fuhi Kannon. Kannon of universal compassion. His hands are hidden in the sleeves of his robe.

28 Merōfu Kannon. Represented as a merchant or a Chinese lady. Legend has it that she married a Chinese holy man named Ma and is considered in China to be an incarnation of Guanyin.[61]

29 Gasshō Kannon. 'Kannon with the joined hands'.

30 Ichinyo Kannon. Kannon of oneness. Seated in royal ease on a cloud.

31 Funi Kannon. 'Kannon unequalled'. Standing on a lotus leaf, the hands crossed over the belly.

32 Jiren Kannon. Kannon holding a lotus in his two joined hands.

33 Shasui Kannon. Kannon of sprinkling. He holds a rod in the right hand and a bowl in the left.

This list is not absolutely fixed, and many variants can be found. Similarly, many of these forms are not definitive, and it is not always clearly known to what they correspond. The aspects of Avalokiteśvara are not limited to these 33 forms. Since Avalokiteśvara is by nature a merciful deity, he was always deeply venerated. In consequence, people created different forms at all times and in all places, forms which often took on a syncretic aspect. The aspects of Avalokiteśvara were sometimes multiplied, so that their number could increase his capacity for vision and compassion. They include the '100 Kannons' in the Hōjō-ji, the '1,000 Kannons' of the Sanjūsangendō in Kyōto, and the '3,000 Kannons' of Shizuoka[62] for Japan; the groups of eight and 32 Guanyins in China; and the '1,000 radiant Buddhas' of Khmer and Burmese art.

In Japan, where these forms are the most numerous, they include the Nurete Kannon (Kannon standing on the water) in the Oku-no-in of the Kiyomi-zu-dera in Kyōto, which the faithful have the habit of immersing. As an acolyte of Amitābha in his 'descent', Avalokiteśvara may have one of the normal forms already described, but may also assume a particular form, bare to the waist and wearing a long skirt, for example. He stands upright, the left foot raised, the leg bent, with the hands joined. Mahāsthāmaprāpta forms a symmetrical pendant to him, with the hands in Dhyāna mudrā. However, Avalokiteśvara is most often represented in the images of *Raigō*, kneeling, presenting in both hands a lotus (or a tray of lotuses) to the believer who arrives in the Sukhāvatī, the Pure Land of Amitābha.

Esoteric Forms

To put the many powers of Avalokiteśvara, as well as his ability to reach all beings, wherever and however numerous they may be, into concrete

form for the faithful, other forms appeared very early, all belonging to the different Tantric Buddhisms or at least to the doctrines associated with esoterism. Among the most deeply venerated of these forms are those of Ekādaśamukha (with eleven heads), Sahasranetra (with a thousand eyes), Cintāmaṇicakra (with the wishing-jewel), Batō Kannon (with the horse's head), Cundī (the Pure, the giver of children), Fukūkensaku Kannon (the fisher of men), and Bhṛkuṭī (of the frowning brow).

Avalokiteśvara with the eleven heads (Ekādaśamukha; Japanese, *Jūichimen Kannon*). This form of Avalokiteśvara, perhaps also corresponding to Sītātapatrā, is characterized by the presence of eleven heads which are the Bodhisattva's apparitional forms (*Nirmāṇakāya*). These heads (Japanese *kebutsu*) are usually found placed on his crown, symbolizing his principal virtues which are indispensable to him in conquering the eleven desires, to attain Bodhi, the perfection of Awakening,[63] and to help human beings to attain it.

The heads in the crown of this Bodhisattva are divided into three main groups:

- principal head surmounted by three rows of three heads, plus one in the back and one at the top.
- principal head surmounted by three rows of five, four and one head, plus one on the front of the headdress.
- principal head surmounted by ten heads arranged in a crown and surrounding an eleventh (relatively rare).[64]

In these three groups, the heads are theoretically divided as follows:

- three faces on the front, serene, representing the 'three hidden treasures'.

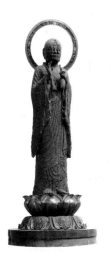
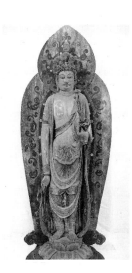

Hōshi Oshō
Wood, Japan,
eleventh century,
Kyōto Museum

Jūichimen Kannon
(Avalokiteśvara with
eleven heads)
Coloured wood, Hōrin-ji,
Nara, Japan, ninth century

163

- three faces on the left, wrathful, representing the 'three defenders'.
- three faces on the right, calm; but revealing fangs, representing the 'three guardians'.
- one head at the top or a figure standing on the front of the headdress and representing Amitābha.

When a face or head is present on the back of the headdress, it is smiling and represents Karma. According to the Garbhadhātu Maṇḍala, these three groups of heads represent the series of the 'three worlds' (demons, humans and Buddhas).

The aureole in the eleven-headed representations of Avalokiteśvara usually contains the images of five suns on each side and a *cintāmaṇi*, symbols of the eleven apparitional forms of this Bodhisattva.

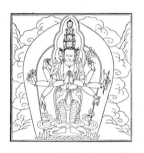

**Avalokiteśvara with
eleven heads**
Chinese engraving

- Standing on a lotus, with two very long arms: the right hand in Varada, the left holding a vase of flowers, or the right hand in Varada, and holding a rope of jewels, the left holding a vase of lotus flowers against the breast, or the right hand holding a fold of his celestial scarf (Japanese *tenne*), the left hand holding a lotus or a vase.
- Seated on a lotus, with four arms: central effigy of Amitābha in the crown upright, the head of the summit with an aureole, a necklace of gemstones, the right hands holding a rosary and a pilgrim's staff (*khakkhara*), the left hands holding a lotus and a vase of flowers.
- nine-headed (*Ku-men*): this irregular form has only nine heads in a crown. Avalokiteśvara is standing, the right hand hanging or holding a pilgrim's staff, the left hand holding a vase, with the arm bent.[65]

Many other types exist, generally derived from these forms. Despite slight differences in detail, they can be classed in these categories.

An exceptional wooden form called *Hōshi Oshō*, from the Kamakura period, can be seen in Kyōtō Museum. It shows Jūichimen Kannon appearing from the open mouth of a monk. The monk holds a vase in the left hand and makes a gesture of appeasement (Abhaya mudrā) with the right hand. He stands on a lotus. This Chinese monk, a persecuted preacher, died around the year 514 in China, at the age of 97, and was revealed to be an incarnation of Ekādaśamukha Avalokiteśvara. One of the images of his crown is that of Kikuta Sanzō, an Indian monk who visited Japan between the seventh and eighth centuries: his hands are hidden by his robe.[66]

Avalokiteśvara with 1,000 arms (Sahasrabhūja; Japanese, *Senju Sengen, Kanjizai Bosatsu*) and 1,000 eyes (Sahasranetra; Japanese, *Senju Kannon*). This Bodhisattva, whose Sanskrit names are two epithets of

Umā, the consort of Śiva, is the deity of pure bounty, omniscient and omnipotent. He theoretically has 1,000 arms symbolizing the multitude of his powers; in reality, he is more commonly represented with 42 arms. However, a few rare images show him, standing or seated, with his 1,000 arms,[67] sometimes with eleven or 27 heads. His upper hands are in worship (Añjali mudrā), while another pair of hands supports a begging bowl (*pātra*). The other hands, sometimes adorned with an eye in the palm (a concept possibly of Tibetan origin which symbolizes the omniscient vision of Avalokiteśvara), each holds a symbol or makes a mudrā. The are normally arranged in a fan around the Bodhisattva's body. The uppermost hands carry effigies of the sun and the moon. The following list of attributes of this Bodhisattva indicates those that are most commonly used, mainly in Japan, for the representations with 42 arms.

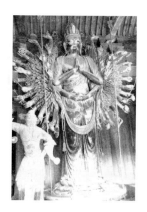

Avalokiteśvara with the '1,000 arms'
Coloured wood, Tō-ji, Nara, Japan, tenth/eleventh century

Right hands (except the first two):
 Pilgrim's staff (*khakkhara*, Japanese *shakujō*)
 Arrow (*śara, bāṇa*, Japanese *ya*)
 Moon (*soma, candra*, Japanese *gesseimani, getsurin*)
 Blue lotus (*utpala, nīlotpala*, Japanese *seirenge*)
 Vase (*kalaśa*, Japanese *kebyō*)
 Five-coloured cloud (Japanese *goshiki-un*)
 Sword (*khaḍga*, Japanese *tsurugi, ken*)
 White lotus (*puṇḍarīka*, Japanese *byakurenge*)
 Skull (*kapāla*, Japanese *dokuro*)
 Mirror (*ādarṣa*, Japanese *hōkyō*)
 Bunch of grapes (*drākṣā*, Japanese *budō*)
 Halberd (*śūla*, Japanese *kushitetsukō*)
 Scriptures (*sūtra*, Japanese *hōkyō*)
 Varada mudrā (Japanese *yogan-in, segan-in*)
 Trident (*triśūla*, Japanese *hōgeki, sansageki*)
 Rosary (*mālā, akṣamālā*, Japanese *juzu*)
 Gesture (*mudrā*, Japanese *hō-in*)
 Buddha (Japanese *butsu*)
 Bowl with lid (*pātra*, Japanese *hō hatsu, hoppatsu*)

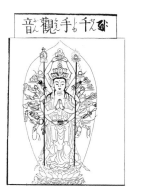

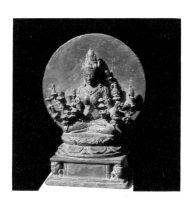

Avalokiteśvara with the '1,000 arms'

Avalokiteśvara with the '1,000 arms'
Bronze, central Java, tenth century, Djakarta National Museum

Left hands (except the first two):
Shield (*khetaka,* Japanese *bohai*) sometimes ornamented with a mask
Celestial palace (*vimāna,* Japanese *ke kyūden*)
Lace, rope, noose (*pāśa,* Japanese *saku, kensaki*)
Fly-whisk (*cāmara,* Japanese *hossu*)
Double vajra with one point (Japanese *tokkosho*)
Box or book (*pustaka,* Japanese *kyōkyō, hōkyō*)
Bow (*dhanus, cāpa,* Japanese *hōkyū*)
Red lotus (*kamala,* Japanese *gurenge*)
Conch shell (*śaṅkha,* Japanese *hōra*)
Bracelet (*kaṅkana nūpura,* Japanese *gyokkan, sen*)
Water vase (*kamaṇḍalu,* Japanese *sōbyō, gunji*)
Purple lotus (*kamala,* Japanese *shirenge*)
Willow branch (Japanese *yoji, yōryū*)
Bell (*ghaṇṭā,* Japanese *sankorei, hōtaku*)
Three-pointed vajra (Japanese *sankosho*)
Wishing jewel (*ratna, cintāmaṇi,* Japanese *hōshu*)
Wheel of the Law (*dharmacakra,* Japanese *futaitenbōrin, hōrin*)
Axe (*paraśu,* Japanese *etsufu, ono*)

In addition to these attributes, this Bodhisattva has two hands in worship (Añjali mudrā) and two hands in Dhyāna mudrā. These attributes are those of a particular form of Jūichimen Kannon (with 27 heads and 42 arms, at the Hosshō-ji in Kyōtō), but they may vary depending on the statue. The order in which they are arranged may also vary accordingly.

The origins of the representations of this Bodhisattva can be found in India, where his many-armed images are nevertheless rare and generally do not exceed four, six or twelve arms.[68] In Tibet, he is represented according to the traditional canons, but effigies of him with more than eight arms are uncommon. In maṇḍalas, he is often surrounded by other deities and Arahants or monks.

Avalokiteśvara with 1,000 arms usually has only a single head, adorned either with a high bare crown (*jaṭāmukuṭa*) or with a lower crown with the figure of Amitābha standing or seated on the front. The latter is of ancient origin and can be dated as far back as the Buddhist art of Gandhāra. Alternatively he may wear a crown ornamented with many heads; in this form, he also combines the attributes of Avalokiteśvara Ekādaśamukha. He is sometimes found crowned with 28 heads[69] which represent the 28 protective genii (Japanese *Nijūhachi Bushū*) of the faithful who are thought to assist Senju Kannon in his task. In the Garbhadhātu Maṇḍala, these 28 heads are described as representing the 28 constellations (*Nakṣatra*) in the form of ordinary deities.

When this Bodhisattva is represented seated in Padmāsana, his hands are arranged in an aureole around his body. When he presides over the 28 *Bushū,* he has a third eye. In painting, when crowned with eleven heads and confused with Ekādaśamukha, he has four hands in

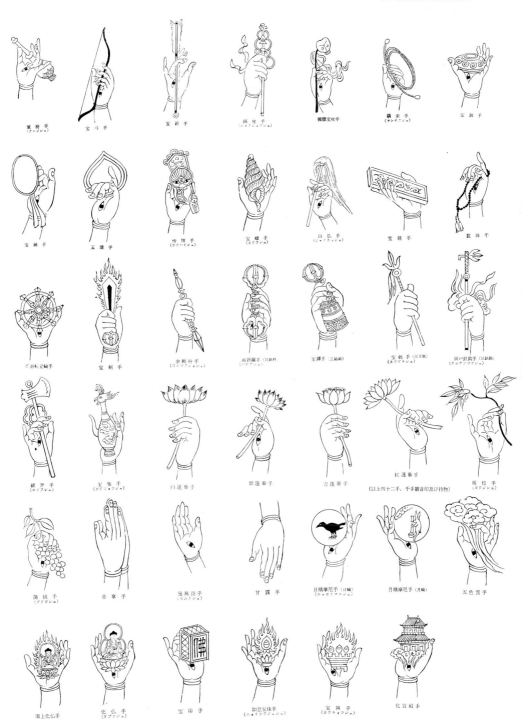

軍持手
（グンジレ）

宝弓手

宝箭手

錫杖手
（シャクジョウシュ）

羂索宝杖手

羂索手（ケンジャクシュ）

宝鉢手

宝鏡手

玉環手

傍牌手
（ボウハイシュ）

宝螺手
（ホウラシュ）

白払手
（ビャクホッシュ）

宝経手

数珠手

不退金輪手

宝剣手

金剛杵手
（コンゴウショ）

旁折羅手（三鈷杵）
（バザラシュ）

宝鐸手（三鈷鈴）

宝戟手（三叉戟）
《ホウゲキシュ》

倶尸鉄鈎手（三鈷鈎）
（クシテツコウシュ）

鉞斧手
（エップシュ）

宝瓶手
（ホウビョウシュ）

白蓮華手

紫蓮華手

青蓮華手

紅蓮華手

（以上四十二手、千手観音印及び持物）

楊枝手
（ヨウジシュ）

蒲桃手
（ブドウシュ）

合掌手

施無畏手
（セムイシュ）

甘露手

日精摩尼手（日輪）
（ニッセイマニシュ）

月精摩尼手（月輪）

五色雲手

頂上化仏手

化仏手
（ケブツシュ）

宝印手

如意宝珠手
（ニョイホウジュシュ）

宝篋手
（ホウキョウシュ）

化宮殿手

167

| 25 | 26 | 27 | 28 |

Abhaya mudrā, two hands in Añjali mudrā, and the others arranged in a fan.[70] On some maṇḍalas, he is shown seated with 1,000 arms, crowned with eleven heads, two hands in Añjali mudrā, another two holding the begging bowl, and four others in Dharmacakra mudrā, the remaining arms arranged in an aureole.

A particular form of this Bodhisattva in Japan, called Senju Yūgen Kannon, appeared to the monk Kūkai on the boat that conveyed him to China in 806. He has the appearance of Deva, is crowned with flowers, and calms the waves with a gesture of the hand. Senju Kannon possesses and commands 28 messengers or *Bushū* who, with Fūjin, a Japanese deity of the wind, and Raijin, Japanese deity of storm and thunder, are the 28 servants of Avalokiteśvara.[71] They are either 'Buddhicizations' of Hindu deities, or purely Japanese creations.

1 **Misshaku Kongō Rikishi** (Vajrapāṇi). Also one of the two guardians (Japanese *Ni-ō*) of the temples and an emanation of Vairocana. He is represented bare to the waist, the right hand in a fist of wisdom, the left placed on the hip, or with the right hand raised, open, and the left hand holding a short staff.

2 **Makeishura-ō** (Maheśvara). This is a Buddhist aspect of Śiva, one of the great Hindu deities. Represented bare to the waist, the right hand open, the left hand holding a rod terminating in a bird's head (Japanese *chōjō*), or wearing armour, the hair bristling, holding a sheet of paper in both hands.

3 **Naraen Kongō-ō** (Nārāyaṇa). This is an aspect of the Hindu god Viṣṇu. Represented bare to the waist, the right hand placed on the hip or the belly, the left hand raised or holding a short staff. Also one of the two *Ni-ō*.

4 **Kompira-ō** (Kuvera?). Warrior in armour, the right arm armed with an arrow, the left holding a bow or a *cintāmaṇi*.

5 **Manzensha-ō.** Warrior in armour, hair bristling, holding a mace in the right hand and a rope in the left. Also represented as a young man holding a mace in the right hand.

6 **Mawara-ō** (Mawara-nyo). Represented as a Deva, standing, sometimes also as an old woman, her hands joined on the breast.[72]

7 Hitsubakara-ō (Hibakara-ō, Bibakara-ō). Warrior in armour, sometimes bearded, hair bristling, holding a vajra or a sort of banner in the left hand.

8 Gobujō. Warrior in armour, sometimes with a boar's head in his headdress, holding a sabre in the right hand and a jewel in the left.

9 Taishaku-ten (Devendracakra). The chief of the warriors. Represented as a Deva, he holds a mirror or a bowl in the right hand, and the left is placed on the hip or closed at the level of the shoulder.

10 Dai Benzai-ten (Dai Benkudoku-ten). This is Sarasvatī, the Hindu goddess of the arts and music. She holds a *cintāmaṇi* in the left hand and sometimes a vertical sword in the right.

11 Tōho-ten (Jikoku Tennō). Warrior holding a three-pointed vajra (Japanese *sankosho*) in the right hand, a curved sabre in the left, or with both hands joined in Añjali mudrā.

12 Jinmo-ten (Jinbo-ten). Represented as a Deva, the left hand clenched or holding cymbals in both hands.

13 Birurokusha Tennō (Zōchō Tennō). This is the aspect of Virūḍhaka, one of the guardian kings of the four cardinal points (*Lokapāla*). His right hand holds a lance or sometimes is without the lance and placed on the hip. The left hand hangs. He also sometimes has the hands in Añjali mudrā.

14 Birubakuska Tennō (Kōmoku Tennō). This is an aspect of Vīrūpākṣa, one of the guardian kings of the four cardinal points, the right hand on the hip, the left holding a trident, or the hands in Añjali mudrā.

15 Bishamon Tennō (Vaiśravaṇa). The chief of the guardian kings of the four cardinal points. On some lists he is replaced by Zōchō Tennō. He is represented as a warrior, the right hand holding a trident or a halberd, the left supporting a small *stūpa*.

16 Kujaku-Tennō (Konjiki Kujaku-ō). This is Mahāmayūrī, a deity who protects against snakes. Represented as a warrior, with a phoenix or a peacock on the head, a seal in the right hand and a curved sabre in the left hand or in both hands.

17 Basu Sennin. Perhaps the Indian sage Vasubandhu. Represented as an old man, bearded, bare to the waist, leaning on a staff and holding a sūtra scroll in the right hand.

18 Sanshi Taishō (Jinja Taishō, Shoryōchi Taishō). This is Samjñeya, represented as a warrior,[73] brandishing a short sabre or halberd in the right hand, and holding a seal in the left. He is a Yakṣa, comparable to Vaiśravaṇa in the esoteric tradition.

19 Nanda Ryū-ō. Perhaps a 'Buddhicization' of Susanoo, the Shintō Kami of the storms, conqueror of the dragon. Represented as a warrior holding a dragon's tail and a tray of jewels.

20 Sakara Ryū-ō (Sakakatsura Ryū-ō). This is Sāgara, a Nāga king, represented as a young warrior brandishing a short sabre in his right hand and a serpent in the left. His hair bristles with serpents.

21 Ashura-ō (Asurarāja). The king of the Asuras, the king of hunger and of anger. He has a three-faced head and four or six arms. Usually bare

to the waist, he holds a mirror, a bow, an arrow (or the sun and the moon) and has two hands in Añjali mudrā. His hair is bristling.

22 Kendatsuba-ō (Kendabba-ō). This is the king of the Gandharvas (celestial musicians). He is bare to the waist, holds a Wheel of the Law in the right hand and a seal (or box) in the left. He is sometimes also represented as a warrior in armour with a lion's head on his headdress. In painting he is sometimes seated in royal ease, surrounded by the twelve animals of the twelve-year cycle and by three acolytes. In this case he holds a trident in the right hand, impaled with heads, and a *cintāmaṇi* in the left.

23 Karura-ō. The king of the Garuḍas, mythical birds that are enemies of the serpents (*Nāga*) in Hindu mythology. He is represented as a winged warrior playing the flute, sometimes with a bird's head, the hair bristling.

24 Kinnara-ō. The king of the Kiṃnaras (celestial musicians), half man, half bird. Represented as a young man (with or without a bird's head on his headdress) playing the drum.

25 Magoraka-ō (Mahorāga). Warrior bare to the waist, with a wrathful expression, hair bristling, like a demon, or as a noble of former times playing the *biwa* (a sort of Japanese lute).

26 Daibontennō (Mahābrahmādeva). Japanese form of the Hindu god Brahmā. Represented as a Deva, the right hand holding a seal, the left hand holding what appears to be a medicine jar, or holding a long-handled incense burner in both hands.

27 Kindai-ō. Warrior placing the right hand on his hip, the left brandishing a vajra. Sometimes he is a bearded noble, in a Chinese robe.

28 Mansen-ō (Mansen-nin). Warrior holding a vajra in the right hand and a trident in the left.

These 28 *Bushūs*, rarely represented together (an example is among the effigies at Sanjūsangendō in Kyōtō), are not a separate object of worship. They are venerated only as messengers of Avalokiteśvara, and are not considered as separate from him.

To these three principal forms of Avalokiteśvara (Shō Kannon, Jūichimen Kannon and Senju Kannon), the Japanese Shingon sect added three other forms: Nyoirin Kannon, Batō Kannon and Juntei Kannon. These six Kannons together were assigned the main task of bringing help from the compassionate Avalokiteśvara to the beings of the 'six destinies of rebirth' (Japanese *Rokudō*).[74]

Other Forms

Cintāmaṇicakra Avalokiteśvara Bodhisattva ('the Wheel of the wish-granting Jewel'; Japanese, *Nyoirin Kannon Bosatsu*; Chinese, *Ruyilun Guanyin*). This form of Avalokiteśvara was represented very early in China, particularly in the caves of Longmen and Yungang. It has a feminine form; in China, Turkestan and Japan, she is represented in several forms, but the Tantric forms are unknown in China.

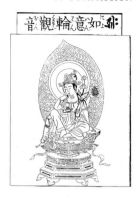

Nyoirin Kannon

- Seated in Padmāsana, with two arms (more rarely four[75]), the hands in Abhaya mudrā.
- Seated in Vajrāsana on a lotus, with two arms, a high decorated chignon, the right shoulder bare, the right hand holding a *cintāmaṇi*, the left hand a lotus.
- Seated in Lalitāsana on a support, with a high crown ornamented with three jewels, the right hand touching the cheek in a pensive attitude, the right hand placed on the right ankle. This is a typical Chinese form.
- With six arms,[76] seated in royal ease, bare to the waist,[77] the fists adorned with bangles. Its aureole is the one used for representations belonging to the Tantric sects, formed of two round haloes. The principal right hand touches the cheek with the forefinger (pensive pose) or supports the head, and the principal left hand rests on the lotus of the seat. The other hands hold a *cintāmaṇi* near the breast and a Wheel of the Law, sometimes a rosary.

When represented seated on a rock regarding the water, he is often confused with Suigetsu Kannon, one of the '33 forms'. He was represented in China from the tenth century, particularly at Dunhuang, in this attitude. Nyoirin Kannon may also assume other forms in painting, less common, with eight, ten or even twelve arms. In maṇḍalas,[78] the seven stars of the Great Bear constellation are sometimes found grouped around him.

Nyoirin Kannon is no longer an object of worship today. Yet he formerly enjoyed considerable favour and was used in Japan as the 'deity of private devotion' (*Nenji Butsu*). It is said that Taira no Shigemori (d. 1179) had a 9-cm statuette of him, which was his personal deity (it is now at the Kōfuku-ji in Nara). A Japanese syncretic form of Nyoirin Kannon, called Seiryū Gongen, is represented as a feminine Shintō Kami,

**Nyoirin Kannon in
pensive mood**
Wood, Japan,
thirteenth century,
Kyōto Museum

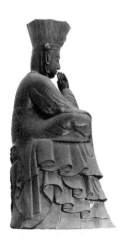
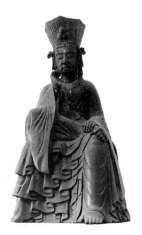

in the court costume of the Heian period, holding a *cintāmaṇi* in the right hand. This form was reportedly brought by Kōbō Daishi to the monastery of Jingo-ji (Kyōtō).

Hayagrīva (Japanese, *Batō Kannon*). Also sometimes called Mezu, Dairikiji Myō-ō or Batō Myō-ō when considered as a king of magic science (Vidyārāja), this aspect of Avalokiteśvara is a 'Buddhicized' Japanese form of Hayagrīva, the Tibetan Buddhist incarnation of the god Viṣṇu of the Hindu pantheon.[79] In the Garbhadhātu Maṇḍala, Batō Kannon is a terrible personification of Amitābha: in this case he does not wear a crown.

Nyoirin Kannon
Stone, Hannya-jī,
Nara, Japan,
seventeenth/eighteenth
century

His effigy is sometimes found placed alongside paths in Japan, where followers believe that he has the power of expelling evil spirits. However, he is confused with Batō Myō-ō in this aspect.

In Japan, the Shintō sanctuaries of Kumano-ō-ji worship a syncretic manifestation of Batō Kannon by the name of Kichijō Komagata. This manifestation was already known in Kashmir as a deity of horse-breeders, and is devoted to the salvation of animal destiny. In northern Japan, he is the object of a very popular cult as a protector of animals,[80] especially horses and cattle. In some of the sanctuaries where he is venerated, he is offered white votive horses of wood or plaster. In China, India and Japan, white horses are symbols of power and luck, and are regarded with great favour. This is probably a resurgence of Shamanic beliefs: one of the earliest Buddhist temples in China, at Luoyang, was named the 'Monastery of the White Horse' (*Baima Si*). Moreover, a white horse is often installed in the Shintō sanctuaries of Japan, and considered to be a messenger of the Kamis.

Batō Kannon is generally represented in two main aspects.

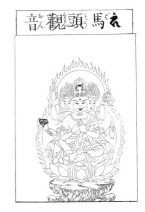

Batō Kannon

- With a horse's head on a human body.[81] This aspect, which is rare, is sometimes called Mezu.
- In human form carrying one or two horse's heads on his headdress: this is the most common aspect. Batō Kannon then wears a low crown adorned at the front with an effigy of Amitābha, one or three heads with three eyes each, and he wears a threatening expression with fangs protruding from the mouth, his hair twisted into locks. If there is only one horse's head, it is white. If there are two, they are white (purity) and blue (power). The horse's head is sometimes replaced by a vajra.

Batō Kannon is represented either standing on a lotus, or seated in Padmāsana or in royal ease (sometimes on a recumbent buffalo). He often holds an axe in the right hand. His aureole is enflamed like that of a Vidyārāja. The images of Batō Kannon usually have eight arms. The two principal hands are joined in Añjali mudrā, in *Renge-no-in* or in *Batō-in*, and the others hold a Wheel of the Law, a sword, a mace (or staff of wisdom), a rope and a five-pointed vajra. A common variant

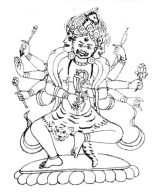

Hayagrīva
Tibetan engraving

Cundī
Tibetan engraving

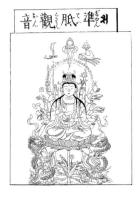

Juntei Kannon

shows him with the principal hands in Añjali mudrā, the other right hands holding an axe, a rosary and a sword, and the other left hands holding an eight-pointed wheel (Japanese *rinbō*), a staff of wisdom, or in *Ketsu-in* (a sort of Varada mudrā).

However, Japanese iconography contains many other forms of Batō Kannon (mostly confused with those of Batō Myō-ō) which show him with one head and two arms,[82] three heads and two arms, three heads and four arms, four heads and two arms, or four head and eight arms.[83]

Cundī (Japanese, *Juntei Kannon Bosatsu*). This Bodhisattva, 'the Pure', is a feminine form of Avalokiteśvara. She is also Juntei Butsu-mo, 'mother of the Buddhas' or, for certain esoteric sects, Saptakoṭibuddhamātā (Shichigūtei Butsu-mo, 'Mother of the Buddhas of the seven points'), also called Koti-śrī, reputed to be the mother of 700,000 Buddhas. She is perhaps also the Japanese form of the Indian goddess Durgā, an Indian feminine associate of Śiva. This manifestation of Kannon, often confused with that of Senju Kannon and mainly represented in painting, is not recognized by the Tendai sect.[84] It is an essentially feminine manifestation, wearing an expression sometimes gentle, sometimes wrathful.

Cundī (or Cundā) was originally a solar deity, Uṣas, the goddess of the dawn,[85] or a metamorphosis of the sun.[86] She is also sometimes identified with Mārīcī, and the seven wild boars forming her pedestal 'assume the role of the seven horses of the sun'. She is usually shown seated or standing on a lotus, and possessing two, four, six, eight, twelve, 18, 32 or even 64 arms. She wears a crown or a high cylindrical (or conical) tiara. The form with 18 arms is the most commonly represented: it has a gentle expression, wears a robe covering both shoulders, and the arms are ornamented with many bracelets. Behind her effigy is a large boat-shaped aureole (Japanese *funagata kōhai*[87]). She has the principal right hands in Abhaya mudrā, the principal left hands in Abhaya or Varada mudrā, the other right hands in Abhaya, with a sword, a rosary, a fruit, an axe, an elephant goad (*aṅkuśa*), a vajra and a pendant (Japanese *rōman*), the left hands with a pilgrim's staff ornamented with flames (Japanese *nyo-i hōto*), a lotus, a vase, a rope, a ring, a conch shell and a sūtra box.

When Juntei is represented seated, she has her four principal hands in Dharmacakra mudrā and in Abhaya mudrā in front of her breast. Her other right hands hold a trident, a rosary, a fruit, a *cintāmaṇi*, a sword and a lotus, while her other left hands hold a lotus, a Wheel of the Law, a jar, a rope and a vase. She has a celestial scarf on the left shoulder, necklaces and bracelets, the rest of the torso remaining bare. This representation bears the name of Shichigūtei Butsu-mo, and is found only in maṇḍalas. A particular form of Juntei Kannon is considered to bring fertility, facilitate childbirth and to protect children. This Koyasu Kannon is then likened to an ordinary Deva and represents a form of Hārītī (see p. 258).

Fukūkensaku Kannon. This Japanese form of Avalokiteśvara is particular to the Kegon, Nara and Tendai sects. Fukūkensaku corresponds to Amoghapāśāvalokiteśvara or Amoghavajra. This is 'he who fishes for men to bring them to Awakening'. Mainly represented in the Garbhadhātu Maṇḍala, this form is not, at least in principle, recognized by the Shingon sect.

Fukūkensatu Kannon is represented as a Bodhisattva. His main attribute is a rope (*pāśa*, Japanese *saku*, *kensaku*) with which he captures humans, and a hook to fish them from the troubled waters of the world. His other attributes are the lotus, the vase, the rosary and the pilgrim's staff. He has a high crown, sometimes adorned with heads. He is recognized to have two acolytes, Nikkō (Sūrya) and Gakkō (Chandra), two Bodhisattvas symbolizing the sun and the moon. His attributes may vary from one representation to another, and these reveal considerable differences.[88]

Fukūkensaku

- With a face with three eyes, eight arms, two of them in Añjali mudrā, the other arms with various attributes belonging to other forms of Avalokiteśvara. He has an image of Amitābha in his crown and is always accompanied by his two acolytes.
- With a face with three eyes and two arms.
- With a face with three eyes and four arms.
- With a face with three eyes and 18 arms.
- With three faces with three eyes and four arms.
- With three faces with three eyes, six arms, seated, the hands in Añjali mudrā and with various attributes.
- With three faces with three eyes and ten arms.
- With eleven faces and eight arms.
- With eleven faces and thirty-two arms.

Bhṛkuṭī (Japanese, *Bikuchi Kannon Bosatsu*). A Tantric form of Avalokiteśvara, 'she who knits her brows' was born from a knitting of

Amoghapāśa
Tibetan engraving

Nikkō and Gakkō Bosatsu
Clay, Tōdai-ji, Nara, Japan, eighth century

the brows of Avalokiteśvara, whose wrathful aspect she represents. This is the Japanese form of a 'yellow' Tārā of the Tibetan pantheon, sometimes confused with Tara Bosatsu (Darani Bosatsu). Also called 'she who is wrinkled', she is represented as an old woman, her face purple with rage. In the Garbhadhātu Maṇḍala she is seated in Padmāsana, with an effigy of Amitābha (of whom she is also a hypostasis) in her chignon: she has a single head with three eyes. She has four arms, the right hands in Varada mudrā and holding a rosary, the left hands holding a blooming lotus, a vase[89] or a *sūtra* scroll. In the rare representions of her with three heads and six arms, she has two hands in Varada mudrā, the others holding a trident, a rosary, a lotus and a garland. Instead of her third frontal eye, she sometimes, like the Buddha, has a tuft of white hair (*ūrṇā*).

In some Japanese esoteric sects, she is sometimes named Joshō Kongō. This form of Avalokiteśvara, which is not the object of any real worship, is represented only in paintings and in maṇḍalas.

Bhṛkuṭī (Bikuchi Kannon)

China

Avalokiteśvara's cult enjoyed tremendous favour in China. Called Guanshiyin, abbreviated to Guanyin, 'He who perceives the cries (of the world)', he is represented, in his normal form, with only two arms, standing on a lotus, holding a willow branch, lotus or vase (or sometimes a scroll of scriptures) in the hand, or (more rarely) with the hands in Dhyāna mudrā. He is very often seated, either in Padmāsana or in Līlāsana. He is also represented (in masculine or feminine form) in a group of eight (Banan) or 32 (Guanyin Sanshi'erxiang).

However, Avalokiteśvara may also assume several other forms: as 'giver of children' (Songzi Guanyin),[90] represented on a cloud, or on the sea (Guohai Guanyin), with a crown of eight heads, and he may have

Bhṛkuṭī
Tibetan engraving

Darani Bosatsu

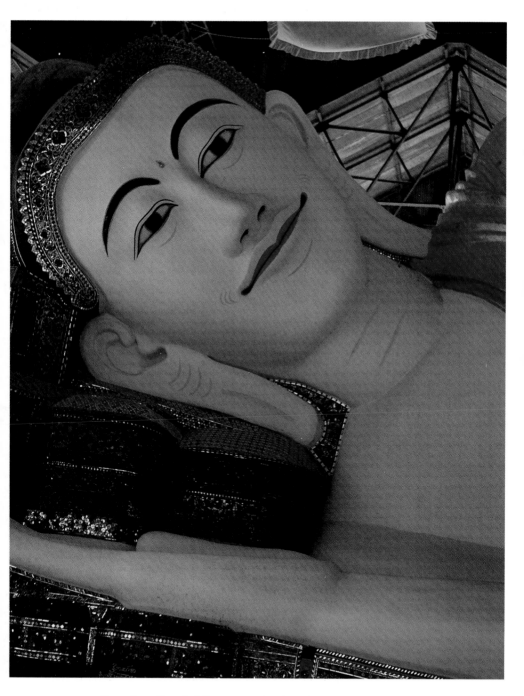

Recumbent Great Buddha, stone and coloured cement (length 60 m), Shvetayaung, Pegu, Burma, twentieth century

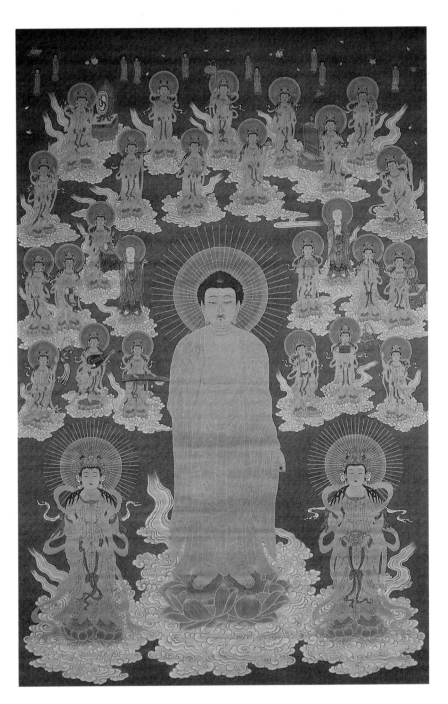

Amida in his *Raigō*, painting on paper, Japan, 1708, Musée Guimet, Paris

ten, 18 or 1,000 arms. A group of 33 forms of Guanyin also exists, possibly inspired by the legend of Miaoshan, and this group is also worshipped in Japan. His image is the subject of large paintings, both mural and on silk, especially in Dunhuang (ninth century).

India

The earliest form found of Avalokiteśvara (e.g. in the paintings of the Ajantā Caves) is under the name of Padmapāṇi (lotus carrier): he is represented as a young man clothed as a prince, in a gracious attitude, holding a lotus. He is upright with the hands in Vitarka and Varada mudrās. The Tantric schools represent him with four arms, holding a lotus and a book, and a *cintāmaṇi*, but they have also represented him in many other aspects. In Sri Lanka, he was sometimes represented seated in royal ease (Rājalīlāsana) holding a lotus, an attitude that is often repeated in China.

By the name of Siṃhanāda ('having the roar of a lion'), he is represented next to a recumbent lion, or seated on a lotus supported by a lion (rare). He may then hold a lotus, a sword, trident or a human skull. His body is white. He was usually invoked to cure leprosy.

Tibet

In Tibet Avalokiteśvara is represented as a Bodhisattva, white or red in colour, very often in the attitude of giving (Varada mudrā). He always holds a lotus in his hand. Here the Tantric forms predominate, and Avalokiteśvara is sometimes represented holding a vajra in his right hand. He may also have an antelope skin on the left shoulder.

South-East Asia

He takes the name of Lokeśvara ('lord of the worlds'). It is mainly in Champā and Cambodia that his images are found. He is generally represented bare-breasted, and wearing a simple very light sarong (or *dhoti*), held by an ornate belt. He sometimes has a third eye on the forehead. He may have two to eight arms holding various attributes including the lotus, vase, conch shell and rosary. He is either standing, or seated at royal ease.

He was represented at Banteay Chhmar, at Angkor-thom (Bayon), at Neak-pean and on many steles. In Thailand, his effigy was popular with four arms (sometimes more), and a crown (*mukuṭa*) containing an effigy of Amitābha. His female partner, named Prajñapāramitā, is represented bare to the waist, uncrowned, but with an image of Amitābha in her hair. This feminine deity often wears a crown, but without an effigy of Amitābha, and may also hold one or two lotuses.

Avalokiteśvara (Lokeśvara)
Sandstone, Bayon,
Angkor-thom, Cambodia,
thirteenth century

'Child-Giving' Deities

A feminine form of Avalokiteśvara, who facilitates childbirth and pro-
tects children, also exists. In Japan, this is a popular aspect of Juntei
Kannon Bosatsu. She is Hārītī, but a gentle[91] 'Buddhicized' form of this
'mother of demons'. She is often represented seated on a chair, clothed
in the Chinese manner and holding a child in her arms. Some popu-
lar images show her nursing a baby.[92] Owing to this aspect, she was ven-
erated as a representation of the Christian Virgin Mary during the per-
secutions against Japanese converts to Christianity which took place in
the Edo period, chiefly in the seventeenth and eighteenth centuries. In
fact, Japanese Christians may have created this form of Avalokiteśvara

Avalokiteśvara
Borobudur, Java,
late eighth century

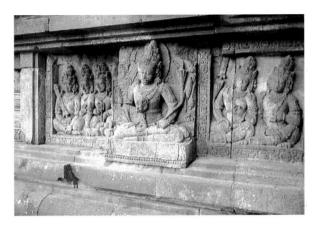

offering the breast, since it is not of Buddhist origin.[93] It is believed that this form was developed late by popular Buddhism to supplant the Shintō deity (Kami) of easy childbirth, Koyasu-sama or Koyasu-gami, just as in China the effigies of Guanyin shown with a child on the knees are probably merely popular Buddhist transpositions of Taoist 'child-giving' deities like Tianxin Songzi or Zhangxian. In China, Tonkin and Japan, she is venerated in a group of 20 deities, among whom she holds a secondary place. In Japan, the Shintō sanctuaries dedicated to Koyasu-sama are actually dedicated to the mythical princess Konohana Sakkuya Hime, goddess of Mount Fuji and of cherry trees in bloom, since legend claims that she gave birth to a son while her house was devoured by flames. This may be an allusion to the creation of the lakes during an eruption of Mount Fuji. Koyasu-sama was mainly venerated in the provinces of Kantō (environs of Tokyō) and Chiba, where the women had the habit of asking her for healthy milk after childbirth[94] in exchange for rice offerings.

Karitei-mo

This Koyasu-sama was subsequently confused either with Avalokiteśvara, or with Kṣitigarbha. Koyasu-Kannon (or Avalokiteśvara 'giver of children') is sometimes herself confused with a 'complementary' form, identical in form and aspect, called Kishimojin, who is the representation (originally terrible but substantially modified through the centuries) of an ogress, Hārītī, converted to Buddhism,[95] who later became a protector of children. Her image was popularized in the Kamakura period by Nichiren.[96] In the Shingon sect, she is named Karitei-mo. She is represented seated on a chair, holding a pomegranate (Japanese *zakuro*[97]) in the right hand (in Asia as well as Europe, the pomegranate is the symbol of progeniture, perhaps due to its many seeds) and surrounded with naked or semi-naked children (usually three, five, seven or nine). When represented standing, she holds a lotus, an attribute of Avalokiteśvara, in the right hand. In painting, she is sometimes seated under an octagonal dais capped with a jewel. She holds a fly-whisk and has two little girls as acolytes.[98] The most famous temples where she is worshipped are those of Meguro and Zōshigaya in Tokyō. Her followers believe that she also possesses the power of curing sick children. Her feast day is celebrated in November.

Kishimojin

Tradition relates that a statue of Koyasu Kannon was made in the eighth century in the image of the Empress Kōmyō (or Kōmei, 701–760), widow of the Emperor Shōmu and mother of the Empress Kōken, who became a nun in 749. Undoubtedly this feminine aspect of Avalokiteśvara, the symbol of abnegation and love, contributed greatly to the spread of her cult in Japan. However, it was only from the fourteenth century, perhaps under the influence of the Nichiren sect, that the people worshipped her statue as 'giver of children'.[99] Some statues of Kṣitigarbha are worshipped in the same way in Japan: they differ in no way from the normal images representing this Bodhisattva, except that she is named Koyasu Jizō Bosatsu, due to the powers attributed to her.

In Tibet, where her worship appears to date from early times, she is represented holding a child to her breast and a mongoose (*nakula*). She is also a 'dispenser of riches'. Her image appears to have been created in Gandhāra, where she is shown as a Bodhisattva, but with visible fangs. She was also represented at Ajantā, in cave number 2, seated in Rājalīlāsana, above a frieze composed of many naked children. Some representations of her are also found in Java (e.g. at Chandi Mendut) and in central Asia. Her effigy is often accompanied by that of a Yakṣa, Pañcika, reputed to be the father of her children and a general in the army of Vaiśravaṇa.

THE TĀRĀS

(Japanese, *Tarani Bosatsu*; Chinese, *Tuoluo*; Tibetan, *Sgrol-ma*; Mongol, *Dara eke*)

It was not until the adoption of the Yogāchāra system, taught by Asanga in the fourth century AD, that the feminine principle began to be venerated in Mahāyāna Buddhism. Around the sixth century, the goddess Tārā was considered as a Śakti of Avalokiteśvara (sometimes as his wife). The Chinese pilgrim Xuanzang (seventh century) claimed to have seen many statues of this deity in northern India. However, she was not accepted by followers of the Small Vehicle, and her image is not to be found in Sri Lanka or in South-East Asia (except perhaps in Java, where a temple was dedicated to her in 779).

Tarā Bosatsu

Many legends have sprung up around this goddess. According to one of them she was born in a beam of blue light emanating from one of the eyes of Avalokiteśvara; another has her born from a lotus, floating in a tear on his face. It was believed in Tibet in the seventh century that Tārā was reincarnated in every virtuous and pious woman: thus two of the wives of King Srong-btsan Sgam-po, Wencheng, who was Chinese, and a Nepalese daughter of Amśuvarman, came to be considered as incarnations of Tārā. To differentiate between the two wives, the Tibetans created two distinctive Tārās, white for the Chinese, with a full-blown lotus as her emblem, and green for the Nepalese, whose emblem is the blue (half-open) lotus. Each is believed to have been born from an eye of Avalokiteśvara (open and half-closed). Hence they came to be considered as symbols of the day (full-blown lotus, eye open) and the night (half-open lotus, eye half-closed). But this couple soon multiplied, and 21 Tārās are mentioned.[100]

Tārā
Sri Lanka,
eleventh century

In China, this goddess was practically unknown, and was not at all common. In Japan, she was given the rank of Bodhisattva (Tarani Bosatsu), and she combines both aspects (white and green) of the Tibetan Tārā. She is practically only found on maṇḍalas or temple banners. She holds a pomegranate (symbol of prosperity) and a lotus. She is pale green. Tantrism has at least five differently coloured Tārās who are the Śaktis of the five Jinas. In this case they are represented as wrath-

ful deities, with a third eye and bristling hair, whereas in their non-Tantric forms they have a benevolent appearance.

White Tārā
(Sitātārā; Tibetan, *Sgrol-dkar*)

In Tibet she is considered to be a form of the green Tārā, but in Mongolia she is considered to be superior. She symbolizes transcendent knowledge and perfect purity.

She is usually represented seated in Padmāsana, white in colour and dressed as a Bodhisattva. Her hair flows down on to her shoulders. Her right hand is in Varada mudrā and her left, holding a full-blown lotus, is in Vitarka mudrā. In Tantrism, she is considered to be the Śakti of Amoghasiddhi and, together with a full-blown lotus, she holds a vajra. In Mongolia she sometimes holds a painted eye in the palms of her hands. Another of her Tantric forms, called Jaṅgulī Tārā, and invoked to cure snake bites, has four arms and holds a lute and a white serpent. She is also a form of Sarasvatī (and could be the source of the Japanese image of Benzai-ten).

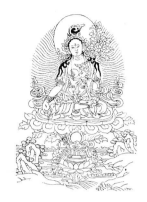

White Tārā (Sitātārā)

Green Tārā
(Śyāmatārā; Tibetan, *Sgrol-ljan*)

Supposedly the original Tārā who gave rise to all the others, she is represented seated, dressed as a Bodhisattva, and holds a blue lotus in her hands, which are in Varada and Vitarka mudrās. She may have certain attributes associated with Avalokiteśvara, such as a lion bearing her throne. She may also have an image of Amoghasiddhi in her headdress. She is either represented alone or accompanied by other Tārās, by Mārīcī and Mahāmayūrī. In this case she is considered to be the goddess of fortune and is called Dhanadā. She is also sometimes represented with her 21 Tārā forms surrounding her in a rainbow. The green Jaṅgulī Tārā has four arms.

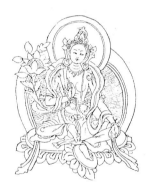

Green Tārā (Śyāmatārā)
Tibetan engraving

Yellow Tārā
(Bhrikutī; Japanese, *Bikuchi*; Tibetan, *Kro-gnyer Ch-ma*;
Mongol, *Kilingtü eke*)

This is a Tantric form of Avalokiteśvara, the 'goddess that frowns'. She is said to have been born from a frown on the face of Avalokiteśvara, and represents his wrathful form. Some say she is an emanation of Amitābha. In Japan, she ranks as a Bodhisattva. In Tibet, she represents the wrathful forms of the green Tārā and has several aspects.

- One head and four arms. The right hands are in Varada mudrā and hold a lotus and a rosary, while the left hands hold a trident and vase. She has a third eye and she knits her brows.

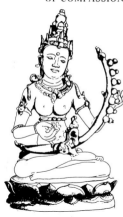

Tārā playing the harp
Java, tenth/eleventh
centuries

- Khadivarani Tārā is seated (sometimes in Līlāsana) with her hands in Varada and Vitarka mudrās, holding the stem of a blue lotus.
- Vajra Tārā has four heads and eight arms, and holds a vajra, an arrow and a conch shell in her right hands, which are in Varada mudrā. Her left hands hold a blue lotus, a bow, an elephant skin and a rope.
- Jañgulī Tārā has three heads and six arms, and she holds Tantric symbols.

In Japan, she may be confused with Tarani Bosatsu. When she is called the 'goddess with wrinkles', she is represented as an old woman whose face is purple with rage. In the Garbhadhātu Mandala, she is seated in Padmāsana with an effigy of Amitābha (of whom she is a hypostasis) in her chignon. She has one head with three eyes, four arms with the right hands in Varada mudrā holding a rosary, and the left hands holding a full-blown lotus, a vase and a sūtra scroll.

When she is represented with three heads and six arms (rare), two hands are in Varada mudrā and the others hold a trident, a rosary, a lotus (or a rope) and she is equivalent to the Tibetan form Jañgulī Tārā. In the place of the frontal third eye she sometimes has a tuft of white hair (urṇā). Some Japanese esoteric sects call her Joshō Kongō. However, this form of Avalokiteśvara is usually only to be found in maṇḍalas.

Blue Tārā
(Ekajatā, Ugrā Tārā; Tibetan, *Ral-gchig-ma*)

'She who has but one chignon' or the 'ferocious Tārā' is the fierce assistant of the green Tārā. She holds the chopper and skull cup, and in her chignon is a small image of Akṣobhya.

However, she may be represented on her own, and has from four to 24 arms. Her attitude is dynamic and her right foot tramples corpses. Her laugh reveals a forked tongue and prominent teeth. She is dressed with a necklace of skulls and a tiger's skin. Short and stout, she resembles a deformed dwarf. Her main attributes are the sword, knife, blue lotus, skull cup, chopper and vajra. She is almost only represented in paintings.

Red Tārā
(Kurukullā; Tibetan, *Ku-ru-ku-le*)

She represents the power of love of the original Tārā, and is also the hypostasis of Amitābha. She is represented in dancing attitude, standing on her left leg, sometimes on the demon Rāhu (he who devours the sun), or else seated. Her crown of skulls has a wheel in the centre and sometimes a small image of Amitābha. She draws the bow and arrow

and makes the Abhaya mudrā. She may hold a lassoo. She may also have eight arms and Tantric attributes.

In maṇḍalas, she is gentle in appearance and is surrounded by eight female deities and four wrathful ones representing forms of the Jinas.

ĀKĀŚAGARBHA

(Japanese, *Kokûzô Bosatsu*; Chinese, *Xukongzang*; Tibetan, *Nam-mka'i-snying-po*; Mongol, *Oqtarghui-in Jirüken*)

This is the 'encompasser of space', the great Bodhisattva of wisdom and compassion, the 'guardian of infinite treasures'.[101] In Japan, he was syncretically identified with Asama Daimyōjin, the Kami of Mount Asama in the province of Shizuoka.[102] The text of the *Kokûzô Bosatsu-kyō* describes this Bodhisattva as having come to destroy all obstacles, to help people to emerge from their errors and to teach them to practise the 'six perfections' (*Pāramitā*, Japanese *Haramitsu*). Mainly worshipped by the esoteric sects in China, Japan and Tibet, Ākāśagarbha is represented in the Garbhadhātu and Vajradhātu Maṇḍalas as a single deity, whose forms may be different. This Bodhisattva, formerly deeply venerated, is now almost completely neglected. He is no longer represented except in a few maṇḍalas. Only the Shingon sect still venerates him but, since this worship is kept secret most of the time, may people are generally unaware of it.

Ākāṣagarbha (Kokûzō Bosatsu)

There seem to have been no representations of Ākāśagarbha in India or South-East Asia. In China and Tibet, he is shown seated, the right hand in Varada mudrā, the left in Vitarka mudrā. His headdress bears the effigies of the five Jinas and sometimes a *stûpa*-shaped ornament.[103] He is considered as one of the two guardians (with Achalanātha) of Vairocana,[104] and is one of the eight Bodhisattvas who surround the major deities of the Mahāyāna.[105]

According to the *Gumonjihō*, translated in 717 by the monk Subhakarasiṃha, Ākāśagarbha is described as follows: 'he must have a body the colour of gold . . . He is seated with his legs half-crossed on a precious lotus flower and his right knee covers his left foot (Vajrāsana). His face is extremely handsome and expresses delight and joy. On his precious crown are the images of the five Jinas seated in Vajrāsana.[106] The left hand of the Bodhisattva holds a white lotus with a slight red tinge, and on this lotus is a *cintāmaṇi* the colour of lapis lazuli (*vaidūrya*) and emitting yellow rays. His right hand is in Varada mudrā with the five fingers straight and the palm turned forward.'[107] In the same sūtra he is called the 'Buddha of the full moon': he must be painted at the centre.

According to the *Dai-Kokûzō Bosatsu Nenjuhō* ['Rite Concerning the Thought and Recitation of the Dhāraṇī (sacred formula) of the great Bodhisattva Ākāśagarbha'][108] and the *Himitsu Jirin*,[109] he holds a blue

Ākāṣagarbha

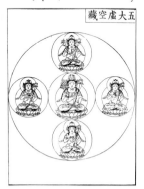

Ākāṣagarbha (Kokūzō Bosatsu)
Wood, Hōrin-ji, Nara, Japan, seventh century

lotus in the right hand supporting a 'red treasure' and the left hand makes an Abhaya mudrā.

In the Vajradhātu Maṇḍala he assumes five different forms, which are contemplative aspects of the five Jinas: these are the five great Bodhisattvas of Ākāśagarbha (Japanese *Godai Kokūzō Bosatsu*).[110] They are represented as Bodhisattvas, the right shoulder bare, with a high crown, necklaces and bracelets. They are seated in Vajrāsana, both feet hidden by the robe.[111] The support animals of these five great Ākāśagarbhas vary according to the texts considered.[112] They are usually the horse, the lion, the peacock, the elephant and the golden pheasant or a Garuḍa, animals that correspond to those of the five Jinas. Although these forms are nearly always represented in their contemplative aspects, various images of Ākāśagarbha are nevertheless found in the maṇḍalas in which they are represented, and they often assume different names.[113]

The normal aspects shown in the Vajradhātu Maṇḍala are:

- Standing, clothed as a Bodhisattva, the right shoulder bare, with a crown of the five Jinas seated on lotus petals, a *stūpa*-shaped chignon, the hands in Abhaya and Varada mudrās or holding a sun and a book.
- Seated on a lotus, with a high crown and a cylindrical headdress, clothed in a monastic robe adorned with bracelets and necklaces, the right shoulder bare, the right hand holding a lotus, the left hand holding a vertical elephant goad (*aṅkuśa*).
- In the form called *Gumonji Kokūzō Bosatsu*, he is seated in Rājalīlāsana on a lotus,[114] the right hand holding a budding lotus stem, the left hand in Varada mudrā or holding a *cintāmaṇi* or a white lotus.
- Seated on a lotus which is sometimes placed on the back of an animal, he wears a high crown, the right hand holds a *cintāmaṇi*, the left hand clasps a spear.[115] Alternatively the right hand is in Varada mudrā on the knee, the left hand holding a *cintāmaṇi*. This form is called *Fukūichiman Kokūzō Bosatsu*. The right hand may also hold a vertical sword surrounded with flames or a fly-whisk, while the left hand holds a lotus or a *cintāmaṇi*.

Mandala of the Godai Kokūzō

Kumonji Kokūzō

Fukūichiman Kokūzō

In the Garbhadhātu Maṇḍala, Ākāśagarbha is clothed in white and brandishes a sword[116] surrounded by flames[117] in his right hand, placed on a lotus, the symbol of radiant wisdom. In the left hand he holds a *cintāmaṇi* placed on a lotus. He wears a tiara containing the images of the five Jinas or the 'five perfections' (*Pañca-pāramitā*, Japanese *Goharamitsu*). He is flesh-coloured,[118] and surrounded by many deities who represent his virtues of wisdom.

KSITIGARBHA
(Japanese, *Jizō Bosatsu*; Chinese, *Dizang*; Tibetan, *Sai-snying-po*; Mongol, *Gachar-un Jirüken*)

Kokūaō of the Taizō-kai

The name of this Bodhisattva means 'He who encompasses the earth'. According to the *Ojōyōshū* of the monk Eshin (Genshin, 942–1017), he is also the master of the six worlds of desire and of the six destinies of rebirth.[119] When considered in particular as a Bodhisattva who consoles the beings in hell, he is identical to Yamarāja (Japanese *Enma-ō*), the king of the Buddhist hells (*Naraka*, Japanese *Jigoku*). In India, Kṣitigarbha, although known very early to the Mahāyāna sects (since the fourth century),[120] does not appear to have enjoyed popular favour, and none of his representations can be found, either there or in South-East Asia. In China, on the contrary, he was fairly popular since the fifth century, after the translation of the *Sūtra of the Ten Cakras* which lists his qualities.[121]

The Chinese *Dizang (Kṣitigarbha) Sūtra*[122] relates that, before being a Bodhisattva, he was a young Indian girl of the Brāhmin caste so horrified by the torment her late impious mother was suffering in hell that she vowed to save all beings from such torments. The Buddha himself announced to Mañjuśrī that she had become a Bodhisattva, yet Kṣitigarbha is only rarely considered as having a feminine nature, except in

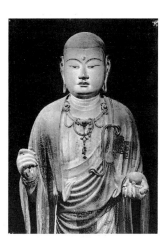

Kṣitigarbha (Jizō Bosatsu)

Jizō Bosatsu
Coloured wood, Tōdai-ji, Nara, Japan, eighth century

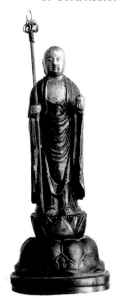

Kṣitigarbhha (Jizō Bosatsu)
Bronze, Japan, 1768,
Author's Collection

his aspect of Koyasu Jizō. In China, Kṣitigarbha is often shown surrounded by the ten kings of hell, because he is considered to be 'He who delivers from the torments of hell'. But it is chiefly in Central Asia that he was represented in the form of a monk holding a pilgrim's staff[123] and a *cintāmaṇi*.[124] In Dunhuang, he is represented with a sort of traveller's turban, whose folds fall on his shoulders, and sometimes also with a crown. In Tibet, he is mainly represented in maṇḍalas, as one of the eight Bodhisattvas surrounding the Buddha (see note 57). His hands are then in Vitarka and Varada mudrās with a fly-whisk, a book (*pustaka*) or a vase supported by a lotus. In this case, his right hand makes an Abhaya mudrā.[125]

His images reached Japan, very probably from Central Asia, and spread through China, where he was often shown as 'master of the six destinies of rebirth'. He is therefore sometimes depicted surrounded by a representative of each of these destinies: a Preta (or 'hungry ghost'), an Asura, a demon, an animal, a man and a god.[126]

Kṣitigarbha, moved by compassion, is said – like all Bodhisattvas – to have made the wish to renounce the status of Buddha until the advent of Maitreya, in order to help the beings of the destinies of rebirth. In hell, his mission is to lighten the burdens caused by previous evil actions,[127] to secure from the judges of hell an alleviation of the fate of the condemned, and to console them. Thus, in the popular mind, Kṣitigarbha has become the Bodhisattva of hells *par excellence*.

His cult remains immensely popular in Japan, where it spread from the ninth century in the Tendai and Shingon sects.[128] A popular custom made him the confessor to whom faults committed during the year were revealed, in the so-called 'confession of Jizō' ceremony.[129] Another belief which developed in about the fourteenth or fifteenth centuries under the influence of the Jōdo sect is that, in hell, on a sandy beach called Sai-no-Kawara, dead infants spend their time building votive structures with small pebbles to increase their merits and those of their parents. But every evening, demons, especially an old woman named Sōzu-no-Kawara no Uba, demolish their work. Kṣitigarbha then consoles the unhappy children, telling them, 'In this land of the shades, I am your

Kṣitigarbha
Tibetan engraving

Kṣitigarbha
Chinese engraving

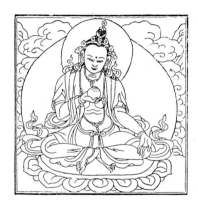

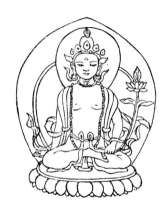

Sentai Jizō
Kiyomizu-dera, Kyōto,
Japan

father and your mother: trust me morning and evening.'[130]

The Shingon and Tendai sects worship six forms of Kṣitigarbha, three of which are recognized as being kings of hell.[131] According to certain monks, these six Jizōs are each assigned to one of the six destinies of rebirth and simultaneously represent longevity, the place of the treasures, the possession of these treasures, the earth, the possession of the earth, and determination.[132]

The images of Kṣitigarbha are numerous in Japan. To enhance their effectiveness, they are sometimes grouped in large numbers. These are the Sentai Jizō or '1,000 bodies of Jizō', that people sometimes confuse with the 500 Arahants. Effigies are sometimes also found, in groups of six, around Amitābha: these are images of the Kṣitigarbhas of the six destinies of rebirth. In painting, Kṣitigarbha is often represented surrounded by the ten kings of hell.

Jizō is considered by the Japanese people more as a 'venerable person' than as a deity: his gently benevolent nature, his monk's appearance, bring him closer to humans than the other deities, who appear more distant or more terrifying. He is closely associated with Amitābha, the Buddha of the beyond, and with Avalokiteśvara, the compassionate. This trinity is symbolized by the adage 'one Buddha, two Bodhisattvas'.[133] Popular belief grants him many powers and credits him with a large number of miracles. He is sometimes treated as a deity to whom questions are put, like the sphinx of Greek mythology. In this aspect he is then named Otsukiyare, 'inspired'. Some Japanese also believe that certain statues of Jizō have the power to do such things as move, fly, speak, or remove thorns from the feet of travellers. A very large number of popular beliefs are thus attached to Kṣitigarbha. Nearly all the statues of him have a specific name related to the qualities attributed to them. They include:

- Taue Jizō helping farmers to plant rice.
- Migawari Jizō helping peasants in their work.

Sōzu-no-Kawara no Uba

- Mawari Jizō protecting the villages.
- Ashi-arai Jizō washing his feet after having helped the peasants in the rice paddies.
- Tagenuki Jizō removing splinters and thorns.
- Mizuhiki Jizō bringing water to the rice paddies.
- Hanatori Jizō leading horses and cattle.
- Amagoi Jizō asking the sky for rain.
- Hikeshi Jizō protecting houses and harvests from fire.[134]

Jizō is above all a deity of the peasants, often merged with benevolent Kamis of Shintō: he is the protective family deity, well intentioned, with whom one can take liberties and who is never frightening, even to little children.

As is the case with Bhaiṣajyaguru, people venereate particlar statues of Jizō even more than the deity they represent: they send the statue letters to ask him for certain special protective favours. The rituals differ according to the localities or the properties attributed to the particular statues: offerings of rice, of *sake* (rice wine), flowers, children's clothing, and sometimes sandals (*waraji*) because Jizō is presumed to travel far to comfort beings in distress.

Popular Jizō
Granite, Tōkyō, Japan, formerly Collection of R. de Berval

His image is very often cut in stone, because his form when represented standing is simple, monolithic and easy to execute. It generally displays a certain affinity to a phallic representation, the symbol of fertility. His image is also often found engraved on rocks or on stone stele erected at roadsides or at the entrances to villages or towns. It may be confused with the images of the Dōsojin, popular deities represented by simple or inscribed stones which are often found on the roadside or at the edges of fields, or at the entrance to villages. These stones, originally associated with phallic cults and with those of the Kamis of the fields (Ta-no-Kami) or those of the roads (Sai-no-Kami), were incorporated by the Japanese Buddhist religion, which transformed them into Jizōs. They were erected for the protection of travellers and villages, and the people of the countryside believe that they also enjoy the power of making a marriage happy and protecting from sickness. These stones are either bare, engraved with characters signifying 'Dōsojin', or sculpted in bas-relief with an effigy of Jizō Bosatsu or another protective deity, such as Acalanātha or Shōmen Kongō, or with a couple holding hands or clasping shoulders. Some of these Dōsojins serve as boundary markers and are engraved with the date of their erection. Their feast day is generally celebrated on 14 January. On this occasion, the village children form a procession with long bamboo staves and torches with which they construct a giant bonfire.

Sentai Jizō
Cemetery in Kyōto, Japan

Exceptionally, Jizō Bosatsu can also assume a feminine aspect; this Koyasu Jizō is then invoked as 'bestower of children'. In this aspect he is often likened to (or confused with) an identical aspect of Juntei Kannon (Cundī). He is also invoked for the protection of children and to ease childbirth.[135]

In certain cases, Jizō Bosatsu may also assume a syncretic aspect, and be represented as a warrior when assimilated with Atago Gongen, a Kami considered to be a temporary incarnation of Jizō. This Kami, protector from flame and fire, mainly venerated on Mount Atago in Kyōtō province, has also been identified as being Kaguzuchi-no-Kami or even Susanoo-no-Mikoto and sometimes as Izanagi. He is represented with the features of a Chinese warrior on horseback, carrying a pilgrim's staff and a *cintāmaṇi*. Popular imagery sometimes also symbolizes him by statuettes of a horse carrying a *cintāmaṇi* on its back. This image is possibly of Tibetan origin and comparable to that of the Rlung-rta or 'the wind-horse', bearer of the prayers of the faithful to the deity. The support animal or messenger of this Atago Gongen is the wild boar, the symbol of courage, strength, and perseverance. Many legends relate that warriors in difficulty have been rescued by wild boars or Atago Jizō, which charged at their enemies, putting them to flight.

Jizō also performs the role of a 'prolonger of life' (Enmei Jizō Bosatsu). He is venerated in this form, especially in Kamakura, where he is asked to guarantee the safety of children. In Japanese villages, parents who work in the fields often leave their young children playing near a statue of Jizō during their absence; the statue is presumed to watch over them and to protect them.

One could almost say that every village in Japan has its own Jizō. And this Jizō is usually associated, in the minds of the villagers, with a Shintō Kami.[136] However, they do not lose sight of the primary function of Jizō Bosatsu, which is to console the beings in the beyond.[137]

Kṣitigarbha is often described as having two acolytes: Shōzen, a monk dressed in white, a Master of good, holding a white lotus; and Shōaku, a monk dressed in red, the Master of evil, holding a vajra in his hand. These two personages are very seldom represented, but are often symbolized by scraps of white and red cloth attached to the neck of the statues of this Bodhisattva.[138] As one of the great Bodhisattvas, Kṣitigarbha sometimes accompanies Amitābha in his 'welcome to the paradise of the Pure Land'. He is also shown on the images of the Parinirvāna of the Buddha[139] bewailing the death of the Master, although the personage thus represented is often identified as being Kāśyapa.

In Tibet, sculptures of Kṣitigarbha are extremely rare; he is virtually only represented in paintings and maṇḍalas. In China, where he is considered to be the chief of the ten kings of hell, he is often represented surrounded by them. The representations of Kṣitigarbha can be put into two main categories.

Maṇḍala representation: seated on a lotus, clothed as a Bodhisattva, crown on the head, the right hand holding the disc of the sun or a *cintāmaṇi*, the left hand holding a *stūpa* or a banner placed on a lotus. In the Garbhadhātu Maṇḍala he is surrounded by many deities, and is placed to the north of Vairocana.[140] He is sometimes seated and holds a *khakkara* in both hands. His crown (Tibetan *chod-pan*) may occa-

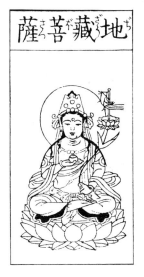

Jizō Bosatsu

Atago Jizō

Shōaku Dōji

sionally bear the effigies of the five Jinas. The deities surrounding him represent his virtues of patience and perseverance: they are merely symbols and are not the object of any worship. On banners in Turkestan, he wears a turban, the *khakkara* in the right hand and a *cintāmaṇi* in the left.

In sculpture and painting: he may have no attributes, be standing or seated, clothed in a monastic robe, head shaved, the right hand and left hand in Abhaya mudrā and Varada mudrā, standing or seated either in Rājalīlāsana with the right leg hanging, the left leg bent under him on his seat, or in Padmāsana, the right hand in Abhaya mudrā, the left hand holding a *cintāmaṇi*. When standing or seated in Padmāsana with his feet hidden by the robe, he may also be adorned with necklaces. The right hand holds a *cintāmaṇi* or a *khakkara* with six rings (representing the six destinies of rebirth), the left hand holds a *cintāmaṇi* or a *khakkara*, or the hands may hold other objects: the left sometimes holds a lotus, for example, but this is rare. The hands may also be in Añjali mudrā. In some rare representations of Kṣitigarbha forming part of the group of eight great Bodhisattvas, he is clothed as a Bodhisattva and holds a begging bowl in the left hand.

In many Japanese temples, there are a series of statues of Jizō, or of stones roughly cut to symbolize him, called *Sentai-Jizō* (1,000 bodies of Jizō), as for example in Kyōtō, at the Nembutsu-ji, where a statue of him is dedicated to the memory of aborted or stillborn children.

VI

OTHER BODHISATTVAS

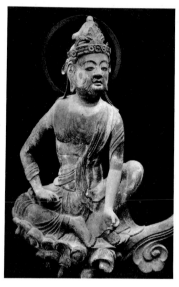

Bodhisattva accompanying Amida
Coloured wood, Byōdō-in, Uji,
Japan, 1053

Mañjuśrī
Samantabhadra
Yaku-ō and Yakujō Bosatsu
Sarvanīvaraṇaviṣkambhin
Siṃhanāda

Apart from the Great Bodhisattvas of compassion, a whole category of 'beings of Awakening' exists, whose principal mission appears to be to instruct the faithful and guide them step by step on the path of liberation. Some of them sometimes act as intermediaries between living beings and the souls that have passed into the beyond. These Bodhisattvas have different roles and have enjoyed varying degrees of favour in the minds of their followers. The most considerable are Mañjuśrī, Samantabhadra, Ākāśagarbha and Kṣitigarbha. Apart from them, other more theoretical Bodhisattvas were worshipped only by certain sects or in groups in Japan, such as Yaku-ō and Yakujō Bosatsu, Sarvanīvaraṇaviṣkambhin, Mahāpratisarā and Siṃhanāda.

Mañjuśrī
Tibetan engraving

MAÑJUŚRĪ

(Japanese, *Monju Bosatsu*; Chinese, *Wenshu*; Tibetan, *'Jam-dpal*; Mongol, *Manchushri*)

Mañjuśrī[1] is a disciple and, with Samantabhadra, an acolyte of Śākyamuni in the groups of images called *Shaka Sanzon* in Japan, 'the three venerables of Śākyamuni'. 'He whose beauty is charming', the Bodhisattva 'of marvellous virtue and gentle majesty',[2] represents wisdom, intelligence and willpower.[3] 'His adoration confines divine wisdom, mastery of the Dharma, an infallible memory, mental perfection, eloquence'. This Bodhisattva, known in India by the doctrines of the Small Vehicle which identified him with the king of Gandharva Pañcaśikha,[4] was originally known from many texts of the Mahāyāna.[5] Although some texts such as the *Saddharmapuṇḍarīka-sūtra* (the Lotus Sūtra)[6] assign him a universe in the east called Vimala (Japanese *Yuima*), Mañjuśrī does not seem to have any special place of manifestation. Certain texts nevertheless place him on a five-peaked mountain in the Himalayas, near Lake Anavatapta.[7] In China, from the fourth century, he was claimed to reside on the mountain with five terraces, the Wutaishan, in the province of Shanxi (Japanese *Godaizan*)[8] where he may have been worshipped from the first century AD.

Mañjuśrī was the initiator and master of the Buddhas of past ages and will be that of the future Buddha, Maitreya:[9] 'Mañjuśrī is the father

Mañjuśrī (Monju Bosatsu)

and mother of the Bodhisattvas, and he is their spiritual friend.'[10] The Buddha himself describes Mañjuśrī and praises him in the *Mañjuśrī-parinirvāṇa-sūtra*.[11] This Bodhisattva was consequently very often represented, in India[12] and Tibet, in China and Japan,[13] as well as Nepal, which tradition claims he founded on coming from China.[14] His images appear only late in Central Asia[15] and on a few Chinese stele, associated with Vimalakīrti (Japanese *Yuima Koji*) in the sixth century.[16]

Mañjuśrī
Tibetan engraving

His cult and images were introduced into Japan by Chinese monks who, during a voyage to Wutaishan, learned that Mañjuśrī was reincarnated in the person of the Japanese monk Gyōki and went to Nara in 736. One of these monks, Bodhisena (Japanese *Bodaisenna*), succeeded Gyōki as director of the Buddhist community of the Tōdai-ji (Nara) in 751 or 752.[17] In turn, another monk named Ennin travelled to China to Mount Wutai in the year 840, during a journey that lasted nine years from 838 to 847, and brought back scriptures and images of this Bodhisattva.[18]

In the Garbhadhātu Maṇḍala, Mañjuśrī is one of the four Bodhisattvas associated with Vairocana. He is placed to the south-west and is seated on a white lotus. He holds the scroll or book (*puṣṭaka*),[19] or a scroll of a Perfection of Wisdom Sūtra (*Prajñāpāramitā-sūtra*) in the right hand, and in the left hand a five-pointed vajra and a blue lotus. He symbolizes the universal wisdom of Vairocana[20] of whom he is the knowledge (symbolized by the vajra) and the innate reason (blue lotus).[21] He is also the 'treasure of the inexhaustible means of salvation of great compassion'.

Mañjughoṣa
Tibetan engraving

In the Vajradhātu Maṇḍala he takes the name of Apāyajaha (Japanese *Joshoakushu*).[22] He is the supreme wisdom (*Prajñāpāramitā*, Japanese *Chimyō-e*) and consecrates the 'equality of nature of all beings'.[23] He is also named Mañjughosha (Japanese *Myō-on*) and, by this name, he represents the virtue of the explanation of the Law.[24]

During the Heian period in Japan, a popular custom witnessed the installation of an effigy of Mañjuśrī clothed as a monk (or in a habit of made of rope), or in a Chinese robe in the Tang fashion) in the kitchens of places of residence, in order to symbolize the wisdom and discipline which should be observed for the maintenance of the home. Later, he was often confused in the popular mind with Tenjin-sama, the Shintō deification of the prime minister Sugawara no Michizane (who died in 903 in exile in Kyūshū). The popularity of Mañjuśrī was often great, especially after the twelfth century in Japan during the revival of the Buddhist faith, while at this time it declined in China. Mañjuśrī was particularly venerated by the Nara sects and by the esoteric sects (especially the Shingon). For his followers, he was 'He who shows the Holy Way'.[25]

Mañjughoṣa
(Myō-on Bosatsu)

The popularity of his worship subsequently diminished; in Japan today his memory is alive although he is hardly worshipped any more, and very few temples are devoted to him. The most famous of those that are is that of Amano-Hashidate. Students believe that the worship of

Mañjuśrī (Hachiji Monju Bosatsu) on a lion
Coloured wood,
Hannya-ji, Nara, Japan,
1324

Mañjuśrī (Monju Bosatsu)

Mañjuśrī can give them a gift for fine penmanship and guarantee success in examinations.[26] In Nepal, where he is believed to have been the initiator of civilization, Mañjuśrī is fêted on the first day of the year. In China he is fêted on the fourth day of the fourth month, when a great pilgrimage to Wutaishan takes place for the anniversary of his birth.

Mañjuśrī is most commonly represented as eternally young in appearance,[27] with a headdress with one or more chignons[28] (or a five-pointed crown symbolizing the Wutaishan), holding the scroll of knowledge[29] in the left hand, and in the right the vertical sword of wisdom, 'which cuts through ignorance' and liberates the spirit from darkness. He is clothed in a monastic robe and adorned with jewels. He is seated in Padmāsana or at royal ease (Rājalīlāsana). His earliest representation in Japan appears to be that in the Hōryū-ji, where he is seated in Padmāsana, his hair tied in a high chignon, the right hand in Vitarka mudrā, the left in Varada mudrā. He is very often shown with a priest's sceptre in the right hand and the 'book of wisdom' in the left, or with the hands joined in Dharmacakra mudrā or in Dhyāna mudrā.

In the Japanese *Monju-in Mandara*, he is represented on a blue lotus with the right hand in Varada mudrā, and holding a five-pointed vajra in the left hand. His hair may be tied in chignons or fall loosely on his shoulders. In Japan, the name given to him sometimes depends on the number of his chignons.

- One chignon (*Ichiji, Ikkei Monju Bosatsu*), often surrounded by a high crown. The 'book' is sometimes placed on the chignon, in which case he holds a sceptre in the right hand. But he is more commonly found with the right hand in Varada mudrā on the knee, the left hand holding a blue lotus on which a *cintāmaṇi* is placed, surrounded by flames.[30]
- Five chignons (*Goji,*[31] *Gokei Monju Bosatsu*): he holds a vertical sword[32] in the right hand and, in the left, a *sūtra* scroll or a book (*puṣṭaka*) placed on a blue lotus.[33]
- Six chignons (*Rokuji, Rokkei Monju Bosatsu*): his hands are in Dharmacakra mudrā.[34]
- Seven chignons (*Shichiji, Shichikei Monju Bosatsu*).
- Eight chignons (*Hachiji,*[35] *Hakkei Monju Bosatsu*).

In a relatively late form (after the Kamakura period), Mañjuśrī was represented seated on a lotus placed on the back of a roaring lion (symbolizing the voice of the Law), whose paws are themselves placed on lotuses in the clouds or on the sea. This particular form is called Kishi Monju Bosatsu:[36] he holds a sword of wisdom in the right hand, in the left a blue lotus or a scroll of the *Prajñāpāramitā*. The number of his chignons may vary, but is usually five. When represented as a child, he is called Chigo Monju Bosatsu.

When Mañjuśrī is mounted on a lion and crosses the sea,[37] he is accompanied by four acolytes: a young man (Sudhana, Japanese *Zenzai*

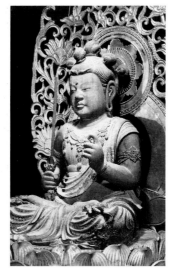

Shichiji Monju Bosatsu

Hachiji Monju Bosatsu
Coloured wood, by
Koshun, Nara, Japan

Dōji;[38] a monk (Vasubandhu, Japanese *Butsudahari Sanzō*);[39] an old man (Vimalakīrti, Japanese *Yuima Koji*) or, in some cases, Saishō Rōjin; and a warrior, King Udayana (Japanese *Utennō*). This group is called Tokai (Kaito) Monju Bosatsu.

In some paintings and maṇḍalas, Mañjuśrī is represented as a very young man or a child, surrounded by eight child acolytes, symbols of the 'eight characters of Mañjuśrī', the Hachidaidōji.[40] These 'vajra carriers' are presumed to answer prayers addressed to Mañjuśrī and to represent the eight virtues of wisdom of Mañjuśrī corresponding to the eight directions.[41] These child acolytes (Japanese *Dōji*) always have a triple chignon and a yellow body, like Mañjuśrī. Candraprabha ('radiance of the moon') and Manjughoṣa (Japanese *Myōon*), a form of Mañjuśrī,[42] are sometimes added to them.

Mañjuśrī is nearly always represented seated. In a number of rare cases, however, he is standing, clothed in a monastic robe which leaves his right shoulder bare.[43] Often drawn on his aureole are lotus flowers and sometimes Kalaviṅkas (Japanese *Karyōbinga*), celestial birds 'with marvellous voices'. This form, called Mañjughosha, has the hands in Varada and Vitarka mudrās.

Many other forms of Mañjuśrī are known in Tibet.

Mañjuśrī
(Chigo Monju Bosatsu)

- With his Śakti Sarasvatī on his knee, with five heads (the central head being that of Akṣobhya) and eight arms holding swords and books or blue lotuses. When represented in Yab-yum with his Śakti, he has three heads (red, blue and white), as does his partner. He carries vajras, a bow and arrows, a sword and a lotus. In this representation he is called Mañjuvajra.

195

- A particular form, called Vajrānaṅga, shows him armed with his bow drawn, the arrow on the bow terminating in a lotus bud. He has six arms and is yellow in colour. He is sometimes confused with Rāgarāja, although he carries the effigy of Akṣobhya on his headdress.
- With four heads (white, yellow, orange, pink) and eight arms. He is then called Dharmadhātu Mañjuśrī.

In maṇḍalas and paintings, Mañjuśrī is normally yellow. But in some esoteric representations, where he is called Siddhaikavīra, he may be white. Only in one form is he black: in this case he has a third eye, one knee on the ground, and brandishes a sword.

He may also be a wrathful force and considered as a Vidyārāja. He is then 'He who loosens fetters' and who conquers Yama, the god of death. He is named Yamāntaka.

Vimalakīrti (Yuima Koji)

Vimalakárti, associated with Mañjuśrī

Mañjuśrī is often represented discussing the Law with Vimalakīrti (Japanese *Yuima Koji*),[44] a lay disciple of the Buddha, of spotless reputation. His story is told in the *Vimalakīrti-nirdeśa Sūtra*: although a layman, he proved to be wiser than the Arahants and Bodhisattvas. In Tunhuang this personage is sometimes shown in the form of a Bodhisattva, but later portraits in the same place show him leaning back in his bed, his mouth open as if in energetic discussion. This difference resulted

Vimalakīrti (Yuima Koji)
Coloured wood and dried lacquer, Hokke-ji, Nara, Japan, thirteenth century

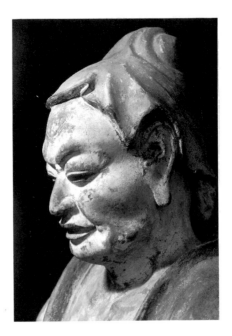

from his popularity among Chinese scholars, who identified with the layman who argued so brilliantly; he therefore came to be portrayed in the same manner as a Chinese scholar. He is shown with a fold of his garment pulled over his head, making the gesture of the discussion of the Law (Vitarka mudrā),[45] or holding a monk's sceptre in his left hand.

SAMANTABHADRA

(Japanese, *Fugen Bosatsu*; Chinese, *Puxian*;
Tibetan, *Kun-tu bzang-po*; Mongol, *Qamugha Sain*;
Vietnamese, *Pho-hien*)

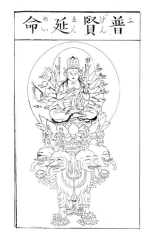

Fugen Emmei Bosatsu

This is 'He whose bounty is omnipresent':[46] he represents the Buddhist Law and compassion. He is often associated with Mañjuśrī, alongside whom he is one of the acolytes of Śākyamuni in the group of the three venerables of Śākyamuni. In Japan this Bodhisattva is mainly worshipped by the Tendai and Shingon sects, and as the protector of the Lotus Sūtra by the followers of the Nichiren sect. He is especially venerated by the followers practising *Hokkesanmai*[47] or 'concentration on the *Hoke-kyō*', for whom Samantabhadra represents 'the innate reason and practice of exercises and of concentration'.[48]

In the Garbhadhātu Maṇḍala, he is placed south-east of Vairocana and represents the cause of asceticism of which Ratnaketu represents the effect. He is then the spirit of the Bodhi and the 'excellent cause' of the 'mirror-like knowledge' (*Ādarśajñāna*).[49] In the Vajradhātu Maṇḍala, he is represented armed with a sheathed sword and a three-pointed vajra.

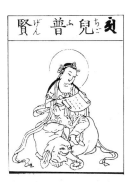

**Samantadhadra
(Chigo Fugen Bosatsu)**

Samantabhadra is also venerated, especially in Japan, as the 'prolonger of life' by the name of Fugen Emmei Bosatsu, the equivalent of Vajrāmoghasamayasattva, an esoteric interpretation of Samantabhadra. However, some authors and monks consider that these two aspects do not represent the same personage. The aspect 'prolonger of life' may betray the influence of Taoist doctrine and be of Chinese origin.

He is represented in Japan in two principal forms: seated on a square support, with twenty arms,[50] or seated on four white elephants.[51]

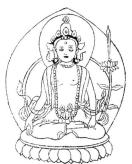

Samantabhadra

**Samantabhadra
(Fugen Bosatsu)**

**Fugen Emmei Bosatsu
on an elephant**

197

Samantabhadra
Vietnam, thirteenth
century

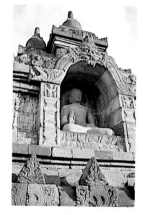

Samantabhadra
Stone, Borobudur, Java,
late eighth century

Yaku-ō Bosatsu

Represented as a young man (or a child, Chigo Fugen Bosatsu) with a high crown, sometimes adorned with the five Jinas, he is considered to be the foremost of them. He is mounted on a lotus supported by an elephant with six tusks.[52] He may nevertheless have several forms, both in painting and in sculpture.

- Seated on a lotus placed on the back of an elephant, with two arms, the hands in Añjali mudrā or holding a scroll of the scriptures.[53] Or the right hand holding a lotus, a *sūtra*, a sceptre, or in Abhaya mudrā, the left hand holding a *cintāmaṇi*. Or the right hand (palm open upwards) with three fingers extended on the breast, the left hand holding a lotus surrounded by flames (in the Vajradhātu Maṇḍala). Or the right hand in Varada mudrā on the knee, the left hand holding a *cintāmaṇi* on the breast.
- With multiple arms (especially in painting) and seated on a couched elephant, the right hand holding a three-pointed vajra on the breast, the left hand holding a bell at the hip.[54] He then resembles Vajrasattva.
- Standing on two lotuses (one for each foot), the right hand in Abhaya mudrā, the left hand palm facing downward, the fingers slightly bent. In this standing position, when he forms part of a group of eight Bodhisattvas, he is yellow and holds a lotus flower in the right hand, and a vajra in the left.

In the Lotus Sūtra, he is assigned ten female guardian acolytes, the ten Rākṣasīs (Japanese *Jū Rasetsunyo*). These acolytes, giant man-eating ogresses converted into the service of Buddhism, are rarely represented except in maṇḍalas.[55]

In China he is rarely alone, but usually forms part of a triad. In South-East Asia, especially in Java in the *stūpa* maṇḍala of Borobudur, Samantabhadra is probably represented at the top of the fifth balustrade. All of his 64 effigies look towards the horizons. His right hand is in Vitarka mudrā, and the left rests in his lap. This Bodhisattva is represented as a Jina, but his Bodhisattva ornaments may have been painted earlier on the stone. He hence represents the Bodhisattva conferring supreme wisdom on the pilgrim who has ascended the five steps of knowledge, a knowledge that enables him to see the images of Vairocana that are half-hidden in the open-work *stūpas* of the last three terraces of the formless world (Ārūpadhātu).

YAKU-Ō AND YAKUJŌ BOSATSU

These are two Japanese Bodhisattvas of medicine. Yaku-ō Bosatsu corresponds, like Bhaiṣajyaguru (of which he appears to be one of the hypostases) to Bhaiṣajyarāja, the Bodhisattva of medicine. He was represented only in painting, seated on a lotus, holding a willow branch

198

in the right hand,[56] his left hand remaining closed. He is sometimes likened to Yaku-ō Kannon Bosatsu (see p. 157), one of the 33 forms of Avalokiteśvara.

It is sometimes believed that Yakujō Bosatsu (Samudgata) is simply a different form of Yaku-ō Bosatsu. These two Bodhisattvas are the acolytes of Fukūjōju Nyorai, and this is why they are often confused with Nikkō (Sūryaprabha) and Gakkō (Candraprabha). In at least one case, Yaku-ō and Yakujō are acolytes of Śākyamuni. They are then standing, dressed as Bodhisattvas, with a high crown, and hold their hands in Vitarka mudrā (or in a similar pose). In the *Saddharmapuṇḍarīka-sūtra*, Yaku-ō (Bhaiṣajyarāja) burns his body to turn it into a lamp in offering to the Buddha.[57]

Yakujō Bosatsu

SARVANĪVARAṆAVIṢKAMBHIN
(Japanese, *Jogaishō Bosatsu*; Chinese, *Chuzhuzhang*,
Tibetan, *Sgrib-pa Rnam-sel*; Mongol, *Tüitker-Tejin Arilghaqchi*)

This is perhaps a Bodhisattva symbolizing the eclipses of the moon. In the text of the *Kāraṇḍavyūha sūtra* he asks questions about Avalokiteśvara; in its later versified development *Guṇakārṇḍavyū-hagāthā* he appears at the side of Maitreya,[58] and in the *Saddharma-puṇ-darīka-sūtra* he expresses the desire to see Avalokiteśvara. The Buddha then sends him to Benares where Avalokiteśvara appears to him.[59] He belongs to the group of the eight great Bodhisattvas. In the Vajradhātu Maṇḍala, he corresponds to Avalokiteśvara and represents the 'treasure of the inexhaustible vision of the pure wisdom'.[60] He is placed at the north-west. In esoteric Buddhism, he is also named Joissaigaishō; he is a form of Kannon and one of the four great acolyte Bodhisattvas. Like the deities of his family, he represents great compassion and mercy which set aside obstacles by removing all afflictions:[61] he is 'He who removes all obstacles caused by the passions, dharmas and acts.'

He is represented as a Bodhisattva. His attributes are the book (*pustaka*) and the moon, or a lotus and a lunar disc. He may also have the hands in Vitarka and Varada mudrās and hold a *cintāmaṇi* and a cup of ambrosia: he is then considered as the 'protector from serpents' and is in the company of the Śākyamuni Buddha, Maitreya, Avalokiteśvara and Mañjuśrī.

He is seldom represented except in painting, and is not the object of any separate worship from that of the eight great Bodhisattvas.

Sarvanīvaraṇaviṣkambhin
Tibetan engraving

SIMHANĀDA
(Japanese, *Shishiku Bosatsu*)

This Bodhisattva's name means 'one who roars like a lion'; he represents the lion-roar of the voice of the Buddhist Law. Some authors claim that

Daizuigu Bosatsu

he is an esoteric personage; others believe that he is not recognized as a Bodhisattva, but merely as a personification of the voice of the Law that causes demons to show repentance and enables the 'hearers' (*śrāvaka*) to acquire merits. He is represented standing, wearing a monastic robe, a scarf knotted at the stomach, with a headdress containing a high chignon.[62] He was very seldom represented in sculpture (except perhaps in Japan) and is found mainly in maṇḍalas or paintings.

Countless other Bodhisattvas exist, all having qualities and virtues defined by the *sūtras* or other religious texts. Yet, apart from in the maṇḍalas, they are virtually never represented, and one may say that popular Buddhism ignores them completely. They are not worshipped in any way, and artists have rarely felt the utility of representing them other than out of concern for symmetry and completion of the maṇḍalas. These Bodhisattvas are in fact merely names and thus are not described here.[63]

Triad of Shaka, painting on silk, c. eighteenth century, Musée Guimet, Paris

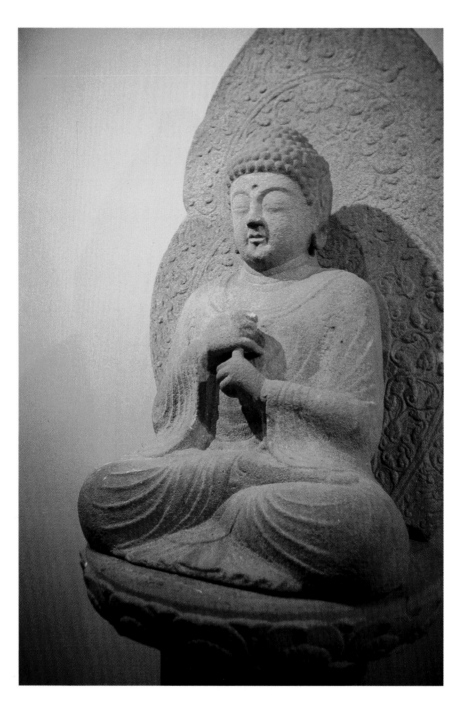

Vairocana Buddha, stone, Korea, ninth century, Seoul National Museum

VII

THE VIDYĀRĀJAS

Ekō Dōji
Coloured wood, Japan, 1197, Nara Museum

Acalanātha
Trailokyavijaya
Kuṇḍalī
Yamāntaka
Vajrayakṣa
Rāgavidyārāja
Other Vidyārājas

The Vidyārājas (Japanese *Myō-ō*) are kings of mystic or magical knowledge symbolizing the power and the victory of the five Jinas over the passions and desires. They are wrathful (*krodha*, Japanese *funnu*) emanations of the Jinas and of their servants. They possess the knowledge and force contained in *mantras*. According to another explanation, they are also 'irritated forms which the energy of the adept himself assumes on meeting obstacles';[1] these deities with an irritated expression 'demonstrate the wrath of the great compassion which brings to beings the succour of the Good Law'.[2] In Japan they are also named the Daison Myō-ō (great and venerable kings of magic knowledge). In India and in the Hindu pantheon, they are represented by the Bhairavas (the 'terrifying') and the Krodharājas, or kings of wrath[3] who devour flesh.

Their cult was introduced from China into Japan by the followers of the Shingon sect. Initially considered as esoteric deities, they were popularized, probably from the thirteenth century,[4] the monks ascribing to them the power of protecting humans against the evil influences coming, according to an ancient Chinese belief, from the Kimon (in the north-east) or the 'gate of demons'.

Among these kings of magic knowledge, five great Vidyārājas are distinguished (called *Godai Myō-ō* or *Godai-son* in Japan) corresponding to the five Jinas, while various other Vidyārājas correspond to the Bodhisattvas. In Japan, it is sometimes considered that eight of the Vidyārājas are emanations of the Bodhisattvas (according to the *Himitsu Jirin* especially). In addition to the five great Vidyārājas, the other three in this group of eight are Rāgavidyārāja, Mayūrarāja and Aṭavaka. But, besides them, many other terrible forms of deities also exist who, although less important, nevertheless play a substantial role in Buddhist iconography and in popular worship. They are classed under the generic term of Vidyārāja and represented in various maṇḍalas.

According to the *Ninnō-kyō Mandara* ('the maṇḍala of the Good Kings'), the five great Vidyārājas are:

- the centre, Acalanātha, corresponding to Vairocana.
- in the east, Trailokyavijaya, corresponding to Akshobhya.
- in the south, Kuṇḍalī, corresponding to Ratnasambhava.

- in the west, Yamāntaka, corresponding to Amitābha.
- in the north, Vajrayakṣa (Vajrapāṇi), corresponding to Amoghasiddhi.[5]

The Japanese Buddhist ritual of the 'five altars', intended to protect the state against catastrophes, included the erection of five statues or images of the five great Vidyārājas positioned according to their respective horizons, with Acalanātha at the centre. These five great Vidyārājas are found represented either in groups or separately, in sculpture, in painting and in maṇḍalas.

ACALANĀTHA
(Japanese, *Fudō Myō-ō*; Chinese, *Budong Fo*)

Chiefly represented in Japan, Fudō Myō-ō, by his mystic name Jōjū Kongō, 'the eternal and immutable diamond',[6] is the chief of the five great kings of magic science. The Sanskrit name for him, Acalanātha, means 'immutable lord'. He is the Vidyārāja of the dark green or black body, the destroyer of the passions.[7] In the doctrines of esoterism he is considered as a 'body of metamorphosis' (*Nirmāṇakāya*) of Vairocana, whose firmness of spirit and determination to destroy evil he personifies. His symbol is a vertically held sword around which winds a dragon (Japanese *kurikara*) surrounded by flames. His halo of flames is thought to consume the passions. He is described in many *sūtras* and particularly in the *Mahāvairocana-sūtra*.[8] He assumes 'faced with obstacles, the energy of the adept himself',[9] thus demonstrating the power of compassion of Vairocana. His sword aids him to combat the 'three poisons': greed, anger and ignorance. In the left hand he holds a lasso (*pāśa*) to catch and bind the evil forces and to prevent them from doing harm. Fudō Myō-ō, having taken a vow to prolong the life of the faithful by six months[10] and to give them an unshakable resolution to conquer the forces of evil,[11] is sometimes invoked in this respect as the 'prolonger of life'. In the Vajradhātu Maṇḍala, he is the terrible manifestation of Kongō Rikishi, and is situated in the north-east, from where he protects humans from evil influences. In the Garbhadhātu Maṇḍala, he is the force of Vairocana and is placed to the west of him.

Achalanātha (Fudō Myō-ō)

Acalanātha is sometimes identified with another Vidyārāja, Ucchuṣma Vidyārāja (Japanese *Ususama*), the deity of stinking places: in this connection he is often placed near the lavatories in Buddhist temples, so that he can devour all the sins and disgusting matter.[12] In the commentary written by the Chinese pilgrim Yijing (Japanese *Gijō*) on the *Mahāvairocana-sūtra*, Acalanātha, sent by the Buddha to Maheśvara (Śiva) to convert him, was covered with stinking substances by this deity – these being a magical way of breaking spells. Acalanātha greedily devoured these substances and crushed Maheśvara and his spouse Umā under his feet.[13]

Daishō Fudō

Although no representation of Acalanātha is known in India in the form attributed to him in China and Japan, it is generally believed that he corresponds (like other Vidyārājas) to an evolution of earlier types of genie of Indian folklore[14] and that he could derive even more directly from the forms of the yakṣa Vajrapāṇi mentioned in the Pāli canon. Some representations of him are found in China in the Dunhuang caves,[15] and in Tibet and Nepal, where he is sometimes called, in one of his Tantric aspects, Kālāmañjuśrī (black Mañjuśrī).[16]

In Tibet, Acalanātha is named Acala-Vajrapāṇi and is a Dharmapāla. He is represented with four heads, four arms and four legs, trampling demons. He holds the sword, the rope, a vajra and a skull cup (see under Vajrarakṣa, p. 211).

His cult and his images were introduced to Japan in the early ninth century by Kūkai, and since then form one of the essential elements of the doctrines of the Shingon sect, for whom he is one of the thirteen Buddhas. He is also the so-called Kongō Rikishi form of the manifestation of Vairocana in two forms (the Ni-ō, the 'good kings'). In this aspect, his mouth is closed, the symbol of latent force, and he holds a vajra.[17] He was deeply venerated, and many small altars to him were erected. The image of his sword is sometimes offered on an *e-ma* or votive tablet in Shintō sanctuaries, to thank him for his protection against various calamities – in Japan he belongs equally to Buddhism and to the syncretism underlying many aspects of Shintō and Buddhism, the distinction sometimes being blurred in the eyes of most followers.

Acalanātha often assumes the appearance of a child with a wrathful face, but this is possibly a confusion of this Vidyārāja with one of his eight acolytes, Chetaka (Japanese *Seitaka*). He is usually represented seated on a rock of precious stone. In a passage on the 'Mystic Rites of the Dhāraṇī of Acala the Messenger' (Japanese *Fudōshisha Darani Himitsu Hō*), he is described as having a red and yellow body.[18] The flames surrounding his body symbolize the passions, and the conflagration of all the impurities that are attached to the human heart. However, Acalanātha is more generally represented with a dark green body, wearing a red robe that leaves his right shoulder bare. He is standing or seated on a rock symbolizing the Mount Meru of Indian mythology and his unshakable determination. He is sometimes seated on a throne (more seldom on a lotus), in Vajraparyaṅkāsana[19] or in Vajrāsana or, more seldom, at royal ease (Rājalīlāsana). An aureole of flames, sometimes with a double round aureole, envelops his entire body. He has long hair, bristling or combed with a thick lock falling on the left shoulder. His face is menacing, his brows knit together, he squints or has one eye (usually the left) half-closed,[20] and the other eye is red. His grimace reveals two fangs, one aimed downward, the other upward, and he bites his upper lip with the teeth of his lower jaw. Many forms of him are known which, while having the same general features, nevertheless vary in certain details.

- In his most common form he has two arms,[21] a massive body, and a green and red robe. He holds his sword (Japanese *sankotsuka-no-ken* with a three-pointed vajra handle, or *tokkotsuka* with a single-pointed vajra handle) in the right hand, the left holding a rope terminating in a hook at each end (Japanese *saku, ryūsaku, kensaku*) or in a two-pointed vajra.
- With four arms,[22] with the principal hands identical to the foregoing form, while the others are in 'Fudō fists' (Fudō-in) at the level of the face.[23] He may also be represented with four heads and four arms (mainly in maṇḍalas). He then has a yellow body and is considered as the 'destroyer of the enemies'[24] of Buddhism.
- With six arms and six faces with three eyes:[25] the central face is smiling, the right face is yellow with the tongue hanging out, and the left face is white with a wrathful expression. His body is dark blue. His right hands hold a sword, a vajra and an arrow; his left hands hold a rope, the scroll of the *Prajñāpāramitā-sūtra* and a bow.

Chintaku Fudō

In Japanese painting, three images of Fudō are particularly famous and venerated: these are the 'three venerable Fudōs':

- Aka Fudō: red, seated on a support of flames, the right hand holding a sword surrounded by a dragon, the left hand clasping a rope (thirteenth century).
- Ki Fudō: yellow, standing in a static pose, without acolyte. He is attributed to the artist monk Eshin (942–1017), and is the earliest pictorial representation of Fudō in Japan.
- Aoi Fudō: dark blue in colour, surrounded by flames and seated on a large rock. His features are drawn in fine wire lines (Japanese *tessenbyō*).

Other images of Fudō Myō-ō show him with two acolytes, and running; or leaning on his sword.[26]

Acolytes of Acalanātha

Acalanātha is usually accompanied by eight child acolytes (Japanese *Dōji*) of whom at least two, Kongara and Seitaka, are often represented close to him. According to the *Butsuzō-zu-i* and the *Nihon Butsuzō Zuzetsu* (whose images differ) the eight are as follows.

Ekō Dōji

Clothed in a light monastic robe with a 'celestial scarf', the right shoulder bare or covered, seated or standing, the right hand holding a triple vajra or a double trident, the left with a stem of lotuses supporting a *cintāmaṇi* or a solar disc.

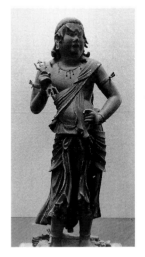

Eki Dōji
Coloured wood,
Kongōbu-ji, Japan, 1197,
Nara Museum

Anokuta Dōji
(Anokudatsu)

Seated or mounted on a unicorn (Japanese *kirin*) or standing with a crown ornamented with a phœnix (Japanese *hōō*), a vajra in the right hand, a lotus in the left.

Eki Dōji

Red, a gentle expression on his face, the right hand holding a spear or a trident, the left a *cintāmani*.

Shitoku Dōji

Identical to Eki Dōji, but wearing armour, with a halberd and a *cintāmani* in the hand.[27]

Ukubaga
(Ugubaga Dōji)

Hair bristling, with a vajra on the head and in the right hand.

Shōjōbiku

Clothed as a monk, head shaved, teeth fanged, a triple vajra in the right hand, and a book or *sūtra* scroll in the left

Kongara Dōji
(Sanskrit Kiṃkara)

A child, naked or with a celestial scarf, the face calm or smiling with or without a lotus crown, hair sometimes curled. Represented separately, he is sometimes mounted on a lion stepping on lotuses (and is then sometimes confused with Mañjuśrī). Always placed to the left of Fudō. His hands are in Añjali mudrā with or without a single vajra placed above, or he holds a sword and a rope.

Seitaka Dōji
(Sanskrit *Chetaka*)

A child, naked or with a celestial scarf and a skirt, the face wrathful, the hair sometimes bristling, hirsute or with several chignons. When alone, he is occasionally represented mounted on a horse. He is normally placed to the right of Fudō. His arms are crossed over his breast, or he holds a staff in the right hand and a triple vajra in the left.

The attitudes of Kongara and Seitaka can be compared with those of the acolytes of Śiva (Nandīsa and Mahākāla), Avalokiteśvara (Tārā and Bhṛkuṭī-Hayagrīva) and Mañjuśrī (Sudhana and Yamāri).[28] It should also be observed that Fudō Myō-ō in child form is often confused with Seitaka, and he is sometimes seen mounted on a lion surrounded by his acolytes.

Although Fudō can theoretically have two, eight, 36 or even 48 acolytes,[29] he is usually represented with only two of them, Kongara and

Ekō Dōji

Anokuta Dōji

Eki Dōji

Shitoku Dōji

Ukubaga Dōji

Shōjōbiku Dōji

Kongara Dōji

Seitaka Dōji

Seitaka. The eight child acolytes of Fudō are also sometimes attributed as messengers to Zaō Gongen, who can then be likened to (or identified with) Fudō. These messengers are venerated as such on Mount Kinbu, at the Shintō sanctuary of Kumano Oji. In the maṇḍalas of the Nichiren sect, Fudō is represented without acolytes.

Since he is considered as the purifier *par excellence*,[30] he is also very often associated with waterfalls, which are important in ritual purification in Japan. His image is therefore often sculpted near them.

Symbolically, Fudō Myō-ō is represented by his sword surrounded

Kurikara Fudō

by a dragon biting its tip. This image, called *Kurikara Fudō*, is presumed to be efficacious in preventing the calamities which may befall the state. Among the many temples dedicated to him, those called Narita Fudō in Narita (Chiba-ken) and Meguro Fudō in Tōkyō are among the most famous.[31]

Popular Cults of Fudō Myō-ō

Due to his combative force, Fudō is invoked in many circumstances, chiefly against attacks of sickness – not because he is considered as a healer, but as an effective force to combat the impurities and demons that cause illness. He is also invoked for protection against persons feared to be harmful and against spells cast by sorcerers. Fudō is also often considered as the defender of Japan against attack from external enemies. For all these reasons, he must be one of the Buddhist deities most often invoked in Japan, and also one of the most popular. The temples and sanctuaries dedicated to him are found throughout the countryside, in cities and at crossroads. Most of these temples belong to the Shingon and Tendai sects. Members of the Nichiren sect also worship him, mainly as the 'protector of the state'.

**Gōzanze Myō-ō
(Trailokyavijaya)**

TRAILOKYAVIJAYA

(Japanese *Gōzanze Myō-ō*; Chinese, *Jiangsanjie*)

Trailokyavijaya, 'conqueror of the three worlds' is, in the east, the terrible manifestation of Akṣobhya. He is sometimes called Vajrahumkāra (Japanese *Un-kara Kongō*) and is then one of the forms of the Ni-ō. In Japan he is also called *Shōzanze Myō-ō*, *Funnugatsu-enson* and *Sonba Myō-ō*.[32] As his name indicates, he triumphs over the 'three poisons' of greed, ignorance and anger[33] and the 'three worlds' or passions[34] symbolized by his three eyes. In the Vajradhātu Maṇḍala he is represented surrounded by flames, wearing a precious tiara and holding a vajra. In the Garbhadhātu Maṇḍala he is seated on a lotus against a background of flames. He is bare to the waist and adorned with necklaces and bracelets. He has four wrathful faces, each with three eyes. His two fangs devour ignorance and sin,[35] and his hair bristles. He is blue-black or black.[36] His distinctive mudrā is the mudrā of the 'two wings' (Japanese *Niwa-in* or *Gōzanze-in*): this symbolizes both the single-pointed vajra, which breaks the power of the three poisons, and his principal vow.[37] He also sometimes has the hands crossed over the breast in Krodhamuṣṭi mudrā (Japanese *Funnu-ken-in*).

In Nepal and Tibet, he was mainly shown as Vajrapāṇi. Images of him are rarely found in India[38] or in Java, and he seems to have been very little known in the rest of South-East Asia. He is scarcely venerated or represented in China. On the other hand, this Vidyārāja enjoyed a degree of popularity in Japan.

The images of Trailokyavijaya generally represent him standing, in a dynamic posture, placing the left foot on Maheśvara-Śiva (Japanese *Daijizai-ten*), who represents the human passions, and the right foot on the latter's spouse (Pārvatī, Umā, Japanese *Daijizai-tennyo, Umahī*),[39] who symbolizes the obscuration over objects of knowledge (*Jñeyāvarana*).[40] Thus he joins Acalanātha in his fight against these two deities of the Hindu pantheon, but for different reasons.

Trailokyavijaya is usually represented with eight arms, the two principal hands making his specific mudrā. In his other right hands he shakes a bell, holds an arrow and a sword. With his left hands he holds a trident or an *aṅkuśaa* (elephant goad), a staff, a bow and a rope (or sometimes a wheel).[41] His crown of flames expresses his anger against the 'three poisons'. Trailokyavijaya is sometimes represented seated on a white lotus.[42]

Other forms of this terrible deity are also described in the texts, but they are virtually never represented.[43]

KUṆḌALĪ
(Japanese, *Gundari Myō-ō*)

Kundalī (Gundari)

This Vidyārāja is seldom represented outside Japan[44] and, when so, almost exclusively in maṇḍalas. In Japanese he is also called *Kiri-kiri Myō-ō, Nanpo Gundari Yakṣa* ('Yakṣa Kuṇḍalī residing in the south'), *Kanro Gundari* ('Kuṇḍalī distributing ambrosia') or *Daishō Myō-ō*.[45] He is the Amṛta Kuṇḍalī or Amṛta Kuṇḍikā of some Sanskrit texts. In the Garbhadhātu Maṇḍala he is likened to a Bodhisattva and is named Kongō Gundari Bosatsu (Vajra Kuṇḍalī). His hand holds a jar of divine nectar (*amṛta*) which confers immortality. In the same maṇḍala, he is one of the acolytes of Vajrasattva (Japanese *Kongōsatta*) and is the wrathful manifestation of Ratnasambhava in the south.[46]

In the Vajradhātu Maṇḍala he is positioned in the south-west. In Japan, depending on the Bodhisattva from which he 'emanated', he assumes different names:

- Kanro Gundari Myō-ō, emanating from Ākāshagarbha.
- Kongō Gundari Myō-ō, emanating from Avalokiteśvara.
- Renge Gundari Myō-ō, emanating from Vajrarāja.

He is represented as a Vidyārāja, in a dynamic attitude, his foot striking the rock on which he stands (standing, one foot raised), or both feet placed on lotuses. He has a single face with three eyes, with a threatening expression, a grimace revealing fangs, bristling hair, sometimes with a human skull in his headdress. He is clothed in animal skin, adorned with necklaces and bracelets of poisonous snakes, and his red body is surrounded by flames. Several forms are known.

- With one face and eight arms:[47] the principal hands in Gundari-in on the breast, the other right hands in Varada mudrā or Tarjanī mudrā, holding a raised tripled vajra. The other left hands hold an axe, a trident and a Wheel of the Law. This is the most commonly represented form. However, a common variant shows him with a crown of skulls and twelve serpents wound around his neck, his arms and his legs (so that he is sometimes confused with another, syncretic, deity, named Shōmen Kongō). In this form, his principal hands are in Daishi-in (hands crossed on the breast);[48] the other right hands are holding a triple vajra, in a fist of wisdom and in Abhaya mudrā; the other left hands holdi a vajra, a trident and an elephant goad.
- With one face and four arms, or with four faces and four arms[49] (a much rarer form, found mainly in painting and in maṇḍalas).

Daiitoku Myō-ō (Yamāntaka)

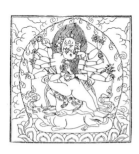

Yamāntaka
Tibetan engraving

YAMĀNTAKA

(Japanese, *Daiitoku Myō-ō*; Chinese, *Yanmandejia*,
Tibetan, *Gshin-rje-gshed*; Mongol, *Erlig-jin Jarghagchi*)

This is a wrathful manifestation of Amitābha, emanating from Mañjuśrī, and situated in the west. This Vidyārāja, often considered as a Dharmapāla, is presumed to fight pain and poisons. Having conquered the god of the dead, Yamarāja (Japanese *Enma-ō*), he is called *Gō-enma-son* or *Enmatokukainu-ō* in Japan. Due to his six faces and six legs, he is also named *Rokumen-son* ('the Venerable One with six faces') and *Tokuson Myō-ō* ('king of magic knowledge with six legs').[50]

He is mentioned as being one of the Bodhisattvas included in Amitābha's retinue when the faithful are welcomed to his paradise.[51] He is generally represented seated on a white cow (or on a white buffalo), his legs hanging either side of the animal; or with two legs in Padmāsana on its back, the others hanging on the same side (in the Daigo-ji in Kyōtō). He is also, but more seldom, seated on a rock. In painting, the buffalo is sometimes shown lying on a large lotus leaf. Yamāntaka is clothed in a monastic robe and is decorated with bracelets and necklaces.[52] His body is black, dark blue or dark green. He has six faces each with three eyes, and six arms and six legs. His faces have a ferocious aspect. His mouths are open to denounce all things that hinder enlightenment. When only one face is shown, the others are placed in his headdress. His six heads, six arms and six legs symbolize the six *gatis* or 'destinations (of rebirth)', accomplishing the six perfections and exerting the six magic powers.[53] He is always surrounded by flames.

In the Garbhadhātu Maṇḍala, under the name of Enmatokukai Kongō, he is positioned in the south-west. His body is blue-black and he is seated on a buffalo or a cow of the same colour.[54] In his right hands he holds a sword, an arrow and a staff, and in his left hands a trident, a bow and a rope. His commonest position is with two legs crossed in

Padmāsana, the other two resting on the ground to the right, and the remaining two bent on the side of the animal. In this case he has three heads from the front: the central one has the appearance of a Bodhisattva, sometimes surmounted by an image of Amitābha.[55]

In certain cases, Yamāntaka may have only a single head and two arms. He then holds an elephant goad or a trident in the right hand, and a vajra in the left. In others, Yamāntaka is represented standing on a running buffalo: his three right legs are raised, and the three left legs are placed on the animal's back. With two of his arms he aims an arrow terminating in a triple vajra. He then has six faces.

In Nepal and Tibet, he may have any one of these forms, or a buffalo's head crowned with skulls, with a third eye in the forehead, two arms whose hands hold a axe (Tibetan *gri-gug*) on the right and a human skull (*kapāla*) on the left. Yet some Tantric texts, such as the *Śrī-mahā-vajra-bhairava Tantra*, describe him as having 16 legs, 34 arms, nine heads, with the body naked and black. Mañjuśrī's image appears among his heads as does that of a buffalo. His right feet trample animals and his left, birds or demons; his hands hold Tantric attributes.

In most Tibetan paintings, he has a tiara of skulls, a belt of skulls and sometimes carries a human corpse. He is often represented in the Yab-yum attitude with his Śakti. As Yamāri, he is alone and holds a staff topped by a human head and a skull cup. His right foot steps on a corpse or a buffalo.[56] He is considered as the equivalent of Bhairava, and is also one of the Yi-dams of the Tibetan 'Yellow Hats' order.

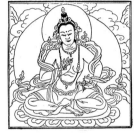

Vajrapāni
Tibetan form

VAJRAYAKṢA

(Vajrapāṇi; Japanese, *Kongōyasha Myō-ō*; Chinese, *Jingang*; Tibetan, *Phyag-na rdo-rje*; Mongol, *Vachirpani*)

Vajrayakṣa is the chief of the great Bodhisattvas, the wrathful manifestation of Amoghasiddhi in the north, and the emanation of Samantabhadra. In Japan, according to the Shingon sect, he is an active form of Vairocana and is identical to Vajrasattva (Japanese *Kongōsatta*)[57] in esoteric ritual. In this case, he is represented with a calm face, three eyes, seated in Padmāsana on a lotus, the feet hidden by the monastic robe that leaves his right shoulder bare. He has a high chignon and wears bracelets. He holds a five-pointed vajra in the right hand in front of the breast, and a corresponding bell in the left hand. This form, considered to be very secret by the followers of the Shingon and Tendai sects, is seldom shown.

According to the *Mahāvairocana-sūtra*, Vajrayakṣa is green in colour;[58] according to the Japanese *Hizōki*,[59] he is light yellow. The holder of the wisdom of the vajra, he answers all prayers. He combines the wisdom of the five Great Buddhas, symbolized by his five-pointed vajra and his five eyes.[60]

Vajrayakṣa is usually represented, especially in Nepal, Tibet and

Kongō Yasha (Vajrayakṣa)

Japan, in three forms in addition to his form as Vajrasattva. All three have a face with five eyes and sometimes a crown decorated with effigies of the five Great Buddhas: the eyes symbolize the vision and powers of each of them. It could be asserted that Vajrayakṣa represents by himself the five Great Buddhas taken together, in terms of their active aspects. In Vajrayakṣa's headdress, the effigies of the five Great Buddhas are symbolized by a lion's head. In his normal appearance, Vajrayakṣa's skin is pinkish-white in colour, this being a combination of all the colours of the five Great Buddhas. He assumes one gentle form and at least two ferocious forms.

- Gentle form: a face with five eyes and four arms. He is seated on a lotus, clothed in a monastic robe, the right shoulder bare, with a high chignon and bracelets. The principal right hand holds a five-pointed vajra, the left hand a corresponding bell, the other hands hold a bow, an arrow, a sword and a wheel, but are rarely represented.
- Ferocious, many-faced form: he has three heads, each with five eyes, and a wrathful expression, the hair bristling. He usually has six arms, and bracelets on the arms and at the ankles.[61] He is mounted on one or more elephants, or standing on a rock or lotuses, in a posture of trampling. He bears the same attributes as the gentle form.
- Ferocious, one-faced form: he has five eyes and stands on a rock, in a dynamic attitude. With his principal hands he makes a movement of anger (Trailokyavijayarāja mūdra, see p. 51). In his other hands, he carries the same attributes as in the previous forms.

In the different legends concerning Vajrayakṣa, he is likened sometimes to the Indian god Śiva, sometimes to the Indian god Indra. This divine personage with many powers and attributes has never been very clearly defined, and is often confused with other forms of deity. His many different representations vary according to the country. Besides his aspects as Vajrayakṣa, he sometimes takes the form of a Garuḍa (see p. 279) and has a blue body. His two hands may be in Añjali mudrā and he may hold a gourd and a sword.

In Tibet, he is considered as a Dharmapāla and a Yi-dam. As a Dharmapāla, he takes the name Vajrapāṇi Ācārya, in which case he has necklaces of serpents, bristling, hair and a belt of skulls, and is surrounded by flames; he stands in a dynamic attitude towards the right, and holds a vajra. Alternatively, he takes the name Vajrapāṇi Acala, in which case he has one head, four arms and four legs, tramples demons and holds a vajra, a sword, a rope and a skull cup. In this form he is identified with Acalanātha. As a Yi-dam, he may be named Nīlāmbara and has one head, three eyes, a crown of skulls, and snakes in his hair, or Mahācakra with three heads, each with three eyes, six arms and two legs. The three heads are red, blue and white. He is then represented

with his Śakti, Sujātā, in Yab-yum, and tramples on Śiva and Brahmā. He may assume many other forms in Tibet and Nepal.

In Japan, when Vajrayakṣa is identified with a Bodhisattva, he forms part of a group of five Bodhisattvas (group called *Godairiki Bosatsu* or *Godairiki-son*) which, according to the *Prajñāpāramitā-sūtra*, consists of the bodies of metamorphosis (*Nirmāṇakāya*) of the five great Vidyārājas.[62] These five Bodhisattvas have a ferocious appearance, with one head and three eyes each, and surrounded by flames like the Vidyārājas (with whom they are usually confused). They brandish a vajra in the right hand and the left hand makes a special mudrā, as if to cast a spell, in which the forefinger and ring finger are extended, while the other fingers bend to touch the thumb. They are also sometimes, but more seldom, represented seated on a lotus (the right hand near the shoulder, the left hand holding a Wheel of the Law on the breast).

These Bodhisattvas of power were sent to earth by Śākyamuni Buddha to protect the lands and goods of the sovereigns who complied with the Buddhist Law. They are no longer represented today, and are not worshipped anywhere. Their ancient representations are rare.

Rāgavidyārāja (Aizen Myō-ō)
Coloured wood, Japan, thirteenth century

RĀGAVIDYĀRĀJA
(Japanese, *Aizen Myō-ō*)

This Vidyārāja, who is venerated almost exclusively in Japan, is a deity of conception. He is the king of the magic science of attraction[63] or of love. 'Aizen Myō-ō represents in fact the amorous passion as it appears sublimated in the perspective of esoterism: victorious over itself, not by suppression as normally taught, but by a greater exaltation transmuted into a desire for Awakening.'[64] He is sometimes identified with a ferocious form of Vairocana, although he is not one of the five great Vidyārājas. He is even sometimes identified with Vajrarāja. In the Shingon and Tendai sects, where he is sometimes held to be a secret deity (Japanese *Hibutsu*), he represents the terrible strength of Vajrasattva.[65] This is why, as a Vidyārāja, he is armed with a bow and arrow, the characteristic attributes of Rāgavidyārāja.

In the Garbhadhātu Maṇḍala, he is one of the manifestations of Garbhavīra (Japanese *Kongō Rikishi*), the 'hero of the embryo', who is one of the two Ni-ō.[66] He is considered to be the destroyer of the passions and desires. The Japanese people have naturally adopted his attributes in a literal sense and, despite his ferocious appearance, consider him to be the deity who presides over physical and sentimental love (like the Greek Eros, he carries bow and arrows). Venerated first by the Shingon and Tendai sects, the Nichiren sect subsequently adopted him, and he then gained in popularity. Dyers consider him their patron, possibly because of his fine red colour.[67] In esoteric doctrines, he is also said to be an emanation of Rāgavajra and of the four Bodhisattvas, acolytes of Akṣobhya, in the Vajradhātu Maṇḍala. As such, he is placed in the east.

Aizen Myō-ō

王 明 染 愛

213

**Aizen Myō-ō with
two heads**

He is represented with a wrathful appearance. His colour is red, symbolizing the blood sweat of compassion. In his headdress is the head of a lion, symbolic of strength and of the five Great Buddhas.[68] He has three eyes (to see the 'three worlds') and holds a lotus in the hand, symbolic of the calming of the senses, among other things. His other attributes are a bow and arrows. He has two round haloes included in a large 'burning wheel', red in colour. His half-open mouth reveals fangs.

Several forms of his representations are known. The most common[69] shows him with a single face with three eyes and six arms. He is seated in Padmāsana on a lotus placed on a brimming vase from whose neck jewels and flowers pour forth. He is clothed in a monastic robe decorated with jewels. His arms are adorned with bracelets. He holds a five-pointed vajra and corresponding bell, the attributes of Vajrasattva in his hands, as well as an arrow, a bow and a lotus. He makes the fist of wisdom with the last hand.

In certain images, he is shown drawing a bow, either to one side or above his head towards the sky. In painting, he also sometimes holds a head in one of his left hands and draws his bow towards the sky; he is then named Tenkyū Aizen.[70] More rarely, he is represented with two heads (representing the masculine and feminine aspects of love[71]) and two or eight arms, seated in royal ease; he is then named Ryōtō Aizen.

There is also a three-headed representation of Aizen Myō-ō drawing the bow on one side: he is mounted on a lion whose paws crush serpents. This form is reported by the *Hōbōgirin*[72] to have been introduced to Japan by Chishō Daishi in the ninth century.

Aizen Myō-ō is also represented with his acolytes on the *Aizen Mandara*, which may have 17 to 37 personages.[73] When Aizen Myō-ō is identified with Kongō-ō Bosatsu, he is represented with four arms, the upper two drawing the bow above his head, the remaining two holding a five-pointed vajra and the corresponding bell. In this case he has a smiling face and knits his brows under a crown adorned with the effigies of the five Great Buddhas. He is then white in colour.[74]

Aizen Myō-ō is still venerated by the Japanese, and is often invoked in connection with petitions concerning love. Apart from this, he is not a popular deity[75] except among artists, geishas and others in professions connected with matters of love.

OTHER VIDYĀRĀJAS

Ātāvaka
(Japanese, *Daigensui Myō-ō, Daigen Myō-ō*)

This is the chief of the kings of magic knowledge (Vidyārājas),[76] and one of the eight great acolytes of Vaiśravaṇa, an ancient Indian deity adopted by Buddhism as the guardian of the Law (*Dharmapāla*). He does not appear to have been worshipped in India or in China, although he may have been represented with Hārīrī in certain bas-reliefs (especially at Ajantā and in China), facing the statues of Hārīrī. His cult was imported from China to Japan by the monk Ogurusu Jōgyō of the Shingon sect, who died in 865. His name appears in the *Kujaku-ō Kyō* and the *Hōshaku-kyō*.[77]

His image is chiefly found in painting and in maṇḍalas, and only rarely in sculpture. He has two main aspects.

- Seated on demons, with three or four heads and six or eight arms,[78] the principal hands in Añjali mudrā, the right hands holding a sword, a vajra, a *cintāmani* and a staff. The left hands hold a trident or an elephant goad, a Wheel of the Law and a rope.
- Standing in the midst of flames, one foot raised and trampling two demons, with three heads and six or eight arms.[79] His left head is ferocious, the central one is calm, with the lips pursed together. The eyes of the head on the right are yellow.

He is also sometimes found with a single head and six arms, one head and two arms,[80] six heads and eight arms, or 18 heads and 36 arms.

This Vidyārāja, who seems not to be worshipped any longer except perhaps in the Sanbō-in of the Daigo-ji in Kyōtō, is completely unknown to lay people.

Ucchuṣma
(Japanese, *Ususama Myō-ō*)

In his terrible form, this Vidyārāja enjoys the power of making the impure pure. It was formerly believed that he had the power of changing a female foetus into a male within the womb of its mother.[81] He was quite popular in China where he is found represented in the Dunhuang caves in particular, but it seems that he had no independent existence; in Japan, however, he is described in the *Darani Jikkyō* and the *Shuryō-gongyō*.[82] In the Tendai sect, Ucchuṣma is considered to be one of the five great Vidyārājas, replacing Vajrayakṣa. He is then placed in the north and appears to be an emanation of Amoghasiddhi. The Jōdo sect places his image, or his name written on a sheet of paper, with those of Acalanātha in the lavatories of the monasteries to purify them.[83] He would thus be the Buddhist counterpart of the Taoist deities of the

Ususama Myō-ō (Ucchuṣma)

Chinese latrines (Sangu). In impure places he rubs shoulders with the images of Piśāca, man-eating demons who became deities of impure places in the Shingon and Zen monasteries.[84]

Ucchuṣma is represented in many aspects, usually with the features of a hideous, wrathful personage, with a single head and three eyes, especially in painting and in *ofuda*, images drawn on paper and handed out in the temples. In this case, he may assume at least two principal forms.

- Seated on a lotus in royal ease, the body surrounded by flames, bare to the waist, hair bristling, with a celestial scarf. His body is red in colour. He gesticulates with his six arms[85] covered with serpents. In his right hands he holds a staff of wisdom, a lasso and a three-pointed vajra. In his left hands he holds a rosary and a Wheel of the Law, with one left hand being in Varada mudrā.
- Standing on a rock, in a dynamic attitude, sometimes trampling Vināyaka, a demon who ceaselessly pursues men to place obstacles in their path towards Awakening. He is considered to be the eldest of the 1,500 sons of Maheśvara and Umā.[86] His body is surrounded by flames, he is clothed in a short Chinese garment, and he is adorned with bracelets. He then assumes two aspects.
- With eight arms, a small image of the Buddha, of whom he is believed to be an emanation, above his head (relatively late representation); sometimes without it, holding in his right hands a staff or a sword, a vajra or a bell, a bow and arrows (or a lasso), and making a mudrā of wrath. In his left hands he holds a sword or a *cakra*, a bell or a sword, a lasso or a three-pointed vajra, and makes a mudrā of wrath.[87] His attributes vary according to the images.
- With six arms, standing, in a dynamic posture, but with the principal hands crossed on the breast in fists of anger, the other hands holding various attributes.[88]

Other representations of this Vidyārāja also exist, with two arms and a red body,[89] with four arms and different attributes,[90] sometimes even with a blue body.[91] In Japan, he is designated by the names *Eshaku Kongō, Jushoku Kongō, Fue Kongō, Fujō Funnu* and *Katō Kongō*.

Vajrakumāra
(Japanese, *Kongō Dōji Myō-ō*)

This Vidyārāja is a metamorphosed body (*Nirmāṇakāya*) of Amitābha. In Japan, where it appears he was particularly venerated, he is thought to be a god of war, often invoked against calamities afflicting the state.[92] He is known in two forms.

- With two arms, bristling hair, as a young prince (*kumāra*), in a dynamic posture, a wrathful expression on his face. He has the left

foot raised, the right placed on a lotus, the left hand brandishing a three-pointed vajra, and the right hand in Varada mudrā. His body is yellow. This form is particularly venerated in the esoteric sects, especially by the Taimitsu[93] or Jimon branch of the Tendai sect (at the Onjō-ji in Kyōtō).

- With six arms, blue in colour, with red eyes, and fangs protruding from his closed mouth. He emerges from the sea, the right foot still in the waves, the left foot placed on a lotus on a rock. He is surrounded by flames, his hair bristles (sometimes with a crown), his arms are encircled with snakes, and he is clothed in a tiger skin.[94] In his right hands he holds a vajra, a staff and an arrow, and in his left hands a staff and a sword, one hand in a fist of anger, forefinger raised. This form is especially venerated by the Tōmitsu branch of the Shingon sect.

Kongō Dōji (Vajrakumāra)

Mahācakravajra
(Japanese, *Dairin Myō-ō*)

This Vidyārāja is a Tibetan form of Vajrayakṣa, where he represents a Yi-dam (see Chapter X). He is also a terrible emanation of Maitreya. He is the 'diamond of the great Wheel' (of the Law) who symbolizes the forces of the struggle of the faithful against those forces which ceaselessly propel them towards rebirth. He is represented (in painting and in maṇḍalas only) seated in royal ease, the left knee raised. He has one head and three eyes, wears a threatening expression and reveals fangs. He is surrounded by flames. He holds a Wheel of the Law (*cakra*) in his raised right hand and in his left a one-pointed vajra at the level of the breast.

Padanakṣipa
(Japanese, *Buchaku Myō-ō*)

This deity, of whom only pictorial representations are known, is a terrible force emanating from Samantabhadra. He is sometimes considered in Japan as one of the eight great Myō-ō. In this case, he has a human head with three eyes, and his body is blue in colour. But in his normal representations, Padanakṣipa has a crowned monkey's head,[95] and is represented seated in Vajrāsana on a lotus, his body surrounded by flames. He holds a parasol in his right hand and a five-pointed vajra at the level of his shoulder.

There are also descriptions of him with 20 arms, crushing beneath his feet an image of the demon Māra (death), who is blue with four arms.[96]

Batō Kannon (Hayagrīva)

Hayagrīva

(Japanese, *Batō Myō-ō*; Chinese, *Binimatou Jingang*; Mongol, *Morin Qogholai-tu*; Tibetan, *Rta-mgrin*)

This is the terrible aspect of Avalokiteśvara, confused with this Bodhisattva (see Batō Kannon, p. 173).[97]

VIII

FEMININE DEITIES

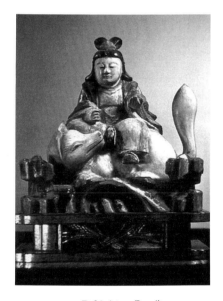

Dakini-ten (Inari)
Musée Guimet, Paris

Prajñāpāramitā
Sarasvatī
Vasudhārā
Mārīcī
Minor Feminine Deities
Groups of Feminine Deities

In general, Buddhism admits only to masculine deities and believes that women are reborn in masculine incarnations in the paradise of Amitābha. However, the adaptations of deities from the Hindu pantheon and popular beliefs, especially in Tibet, China and Japan, have led to the attribution of feminine qualities to many deities. Furthermore, it was believed that the prayers of the devout would be more effective if they were addressed not only to the principal deity, generally considered as latent energy, but also to his Śakti, representing his active energy. Thus a whole category of 'feminine' deities was created, apart from the typically feminine expressions of the Bodhisattva Avalokiteśvara in the Chinese and Japanese pantheons and the various Tārās (see Chapter V). Prajñāpāramitā, Mahāpratisārā, Sarasvatī, Vasudhārā, Mārīcī, the Rakṣās and the Śaktis should be regarded as some of the most important feminine deities, together with other minor deities which are sometimes venerated only in groups.

Hannya Bosatsu
(Prajñāpāramitā)

PRAJÑĀPĀRAMITĀ

(Japanese, *Hannya Bosatsu*; Tibetan, *Shes-rab-pha-rol-tu phyin-na*; Mongol, *Bilig-un Chinadu Kichaghar-a Kürük-sen*)

This goddess is the deification of the *Prajñāpāramitā-sūtra*, a text which legend says was delivered by the Buddha himself to the guardianship of the Nāgas until the time was ripe for its revelation to the faithful. It is said to have been 'restored' by Nāgārjuna. This goddess is therefore an incarnation of the divine word. She was not, however, deified in India, even though the *Prajñāpāramitā-sūtra* was venerated there. It appears that she was not worshipped in China.

Her images are found most often in Cambodia, and also in Java. In the countries of South-East Asia, she is considered to be the female counterpart to Avalokiteśvara, or his manifestation. She is often to be found alongside this great Bodhisattva, where she may assume two forms: one normal and more common, with one head and two arms, and the other Tantric, with eleven heads and 22 arms. In her right hand she holds the book of the *Prajñāpāramitā* and in her left a lotus bud. She is bare to the waist with a long sarong held by an ornate belt, and wears a *mukuta*

(crown) around a high chignon. When she wears three crowns, her chignon may contain a small image of Amitābha. In her Tantric form, she also wears an image of Amitābha in her crown.

In Tibet, she is white or yellow. Her right hand holds a white or a blue lotus, and she holds a blue lotus in her left hand (or a *Prajñāpāramitā* book). She is dressed as a Bodhisattva. In her four-armed form, she holds a rosary (*mālā*) as well as a blue lotus and the book, and makes a Dharmacakra mudrā. She may have a small image of Akṣobhya on her crown.

Prajñāpāramitā

In Japan, this 'goddess of perfect wisdom' is also called Hannya Bosatsu, Dai Hannya and Haramitsu (Japanese form of the Sanskrit Pāramitā). She is found more often in paintings than in sculptures. In paintings and in orthodox iconography, she is represented seated on a lotus, with two or six arms,[1] the principal right hand in Abhaya mudrā, and the principal left hand holding the *sūtra*. The other hands hold a book (*pustaka*), a blue lotus, a rosary, or they make mudrās. In Japan, there are very few representations of this deity.

Also very popular in Japan is a mask of a horned demon, also called Hannya. For some unknown reason, it was appropriated by popular iconography to symbolize the jealous nature of womankind. This mask assumes the form of a ferocious female from whose brow sprout two short horns. It has big, bulging eyes and a large mouth with fangs. The masks of Hannya are green or red. They are often used in ritual Shintō feasts and in Nō dramas. It is difficult to determine to what extent this mask can be attributed to Hannya Bosatsu.

SARASVATĪ
(Japanese, *Benzai-ten*; Chinese, *Dabiancaitian Nü*;
Tibetan, *Dbyangs-chan-ma, Ngag-gi Lha-mo*;
Mongol, *Kele-yin ükin Tegri*)

Benzai-ten (Sarasvatī)

A former Hindu deity associated with an Indian river of the same name, Sarasvatī was worshipped in Vedic times as the goddess of learning. In Brāhmin India, she became the consort of Brahmā and Mañjuśr, and was considered to be the goddess of music and poetry. In Japan, according to the *Konkōmyō-ō-kyō*, she was the sister of Enma-ten (Yamarāja), the king of the Buddhist hells. Her worship developed there in the eighth century, originating in China. In the *Konkōmyō-saishō-ō-kyō*, she is said to protect those who possess this *sūtra* and to help them acquire all sorts of materials gains. For certain Brāhmin sects, she is a sister of Viṣṇu and, in some Buddhist sects, a female manifestation of Vairocana. Every sect has tried to appropriate this goddess who, since time immemorial, has symbolized the two basic elements of all rituals for Indians: music and poetry. She has 15 or 16 sons, incarnations of various Buddhist deities, who symbolize the various crafts of which she is the patron.[2]

Vajra Sarasvatī

Benzai-ten
Coloured wood,
Hachiman-gū, Tsurugaoka,
Kamakura, Japan, 1266

Sarasvatī
Tibetan engraving

In India she is usually represented with two arms, playing the *vīnā*, or with one hand in Varada mudrā and the other holding the stem of a white lotus. In Tibet and China she is seldom represented. In Tibet she may be found in the Indian form, but may also be part of the Tantric pantheon, in which case she has three faces, a red body, six arms and various attributes; if she holds a vajra she is called Vajra Sarasvatī. Tibetan Buddhism sometimes portrays her as a Śakti of Amitābha, with only four arms and seated in Vajralīlāsana. She may also resemble certain aspects of the white Tārā, holding the *vīnā* with two of her four hands, and is then called Āryajāñgulī (see p. 227). Apparently, in Japan, the latter form is superposed on the form of a Kami from a small island in Lake Biwa, and on that of Ugajin, a water goddess represented as a large white serpent.

Around the fifteenth and sixteenth centuries in Japan, a mistake in the graphic representation of the characters spelling her name led to her being attributed the virtues of good luck, previously assigned to Kichijō-ten,[3] and she was included in the group of the seven goddesses of happiness. Like another goddess in this group, Daikoku-ten, she can assume two forms which resemble each other iconographically, but which have different attributions, both Buddhist and popular. These two forms may be difficult to identify and distinguish.[4]

In the Garbhadhātu Maṇḍala, she is represented as a pretty woman in her prime, playing a *biwa* (a sort of Japanese lute); she is also called Myō-on-ten. The *Hōbōgirin* gives her many other representations[5] and, on the strength of the texts, shows her in a male form, comparing her with the Gandharva, Indian celestial musicians. This male form is sometimes found in folklore, where she appears as a large white serpent with one or three bearded heads.

She is sometimes portrayed naked[6] in sculpture, for her followers must dress her in fine garments. A small *torii* is placed on her head or in her hair, the symbol of Shintō sanctuaries. She is nearly always represented in the company of a peacock or a white serpent, or both. She can be seated or standing (or, in paintings, seated on a lotus leaf). She can be shown in two forms.

- With two arms, playing the *biwa*, or holding a sword in the right hand and a *cintāmaṇi* in the left (in the latter case, she is one of the Nijūhachi-bushū, acolytes of Senju Kannon Bosatsu).
- With eight arms (Happi Benzai-ten),[7] holding a rope, a trident, a vajra and a bow in her right hands, and in her left hands a *cakra*, a chopper, a sword and an arrow.

She is usually surrounded by various attendants (including Mārīcī) and Lokapālas in the paintings and maṇḍalas. The attributes which she holds may, however, vary and include a sword, a key (or hook), a *cakra*, a bow (or lance, hook, rope and arrow) for the right hands; and a jewel, trident, *cakra* and bow (or lance, *sankosho*, *cakra* and bow) for the left. She is white and sometimes seated on a peacock.

**Benten-sama (Benzai-ten)
and Hakkuja**
Coloured terracotta,
Miwajinja, Nara, Japan,
formerly Collection of
R. de Berval

Āryā Sarasvatī

Her popular forms can be found principally in Japan, where inter-est in the 'aristocratic' arts of music and poetry was greatest. However, she was venerated more widely than this, due to her links with the water spirits. In the latter case she is dressed in pale green (a reminder of her aquatic nature) and has four arms holding a sword, a *biwa*, a jewel and a box of make-up. She is always seated, her legs crossed at the ankles, and is sometimes crowned with or surrounded by white serpents. A big white serpent with the head of an old man, called Hakuja,[8] is often her companion, and is often mistaken for Benzai-ten if the latter's image is absent.

In some Shintō sanctuaries, she is believed to be the incarnation of the Kami Itsukushima Hime. In the Kasuga sanctuary in Nara, she is ven-erated as Kayane Hime. However, the main sanctuary (apart from the one on the island of Lake Biwa) is on the isle of Enoshima, not far from Kamakura, where she is said to have appeared in a cave. Legend asso-ciates her with a dragon whom she married to render him harmless.[9] In this form, she is represented with eight arms and is supposed to be very jealous. Her temples and sanctuaries are always near water (the cult of serpents and dragons). Even today, this goddess is venerated by artists and geishas (she is said to watch over love), gamblers and jealous women, also speculators and tradesmen who ask her for luck in love, gambling or business.

VASUDHĀRĀ

Also called Vasundhārā, this Indian goddess is considered to be the Śakti of Jambala, a form of Kuvera, the god of prosperity. She is also an aspect of Hārītī. She is rarely found in India, although images of her abound in Tibet and, above all, in Nepal. She is usually portrayed seated, with one leg hanging (sometimes resting on a vase), one head (a small image of Ratnasambhava may be in her headdress), and two to six arms whose hands hold a vase, an ear of corn, a *cintāmaṇi* and the book of the *Prajñāpāramitā*; she is white. However, in some Nepalese miniatures she is yellow and holds a bow and arrows, an ear of corn and three peacock feathers. She is often confused with Prajñāpāramitā.

MĀRĪCĪ

(Vajravārāhī; Japanese, *Marishi-ten*; Tibetan, *Hod-zer Chan-ma*; Chinese, *Molizhi, Tiannu*)

In Brāhmin mythology, this deity is a Riśi, head of the Maruts, who are demons of the storm. In China, she assumes a female form and is believed to be the mother of the North Star. She was introduced into Japan at the same time as the Shingon and Tendai esoteric doctrines, and became the goddess of war and victory. Sometimes she took on a male form. She is believed to be a vassal of Taishaku-ten, the protector of warriors and god of fire. She is also the protector of the four Buddhist worlds.

In Tibet and Nepal, she is identified with Vajravārāhī and is represented with the head of a sow. This may be a false interpretation of

Mārīcī
Tibetan engraving

Marishi-ten
Japanese engravings

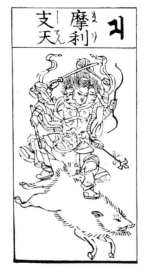

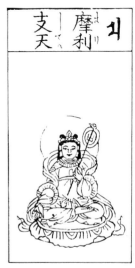

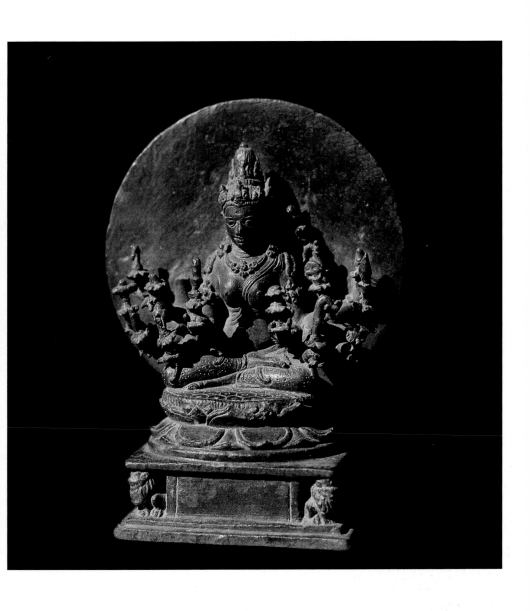

Avalokiteśvara, bronze, Java, tenth century, Djakarta National Museum

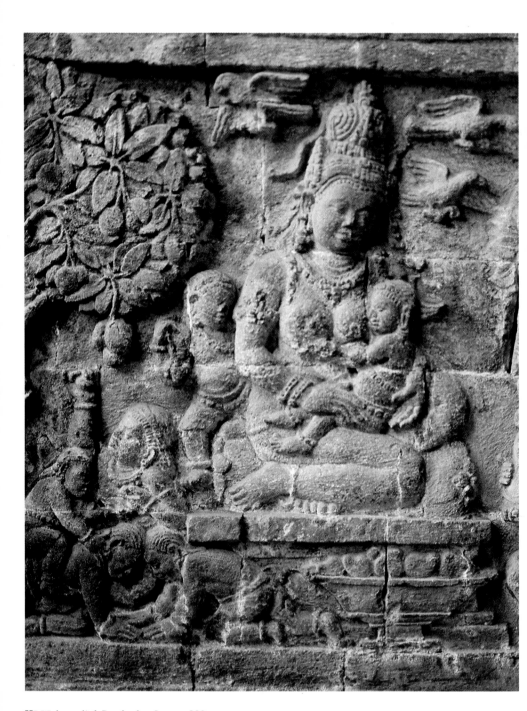

Hārītī, bas-relief, Borabudur, Java, c. 900

ancient Indian representations of this goddess of the dawn, whose chariot was pulled by seven animals resembling bears or boars, which could have been the source of the legend that these seven animals are stars from the Little Bear constellation, the eighth being Mārīcī Vārāhī.

In Tibet, Mārīcī often accompanies the green Tārā. In this case she is seated on a lotus held by a boar, or is astride the boar, and holds a branch of the aṣoka tree (alternatively her hands are in Varada and Vitarka mudrās, or she may hold a vajra and a fly-whisk).

She has several Tibetan forms. Her yellow form has many heads (one is a wild sow) and many arms holding Tantric attributes (vajra, hook, arrow, bow, aṣoka branch, etc.). The red form has three heads and ten arms, and is considered to be the Śakti of Hayagrīva (a horse's head is usually placed in her headdress). Her white form has ten arms and four legs resting on Brāhmin deities.

In her Vajravārāhī form, she is considered to be the Śakti of the tutelary deity Samvara, where she is dancing on a lifeless body, holding a bowl, a chopper, and a staff decorated with skulls. A wild sow's head can be seen behind her right ear. Her maṇḍala is composed of two interlaced triangles with her image in the centre, dancing, surrounded by four Dākinīs: Dākinī, Lāmā, Khandarohā and Rūpinī. Her headdress is bedecked with skulls and she is naked.

Marishi-ten astride his boar
Musée Guimet, Paris

She is also called 'the mother of the Dipper' (a constellation in Sagittarius), 'She who writes the names in the register of life', 'the shining one', 'the ray of light' and 'the diamond sow' (Vajravārāhī).[10] According to Waddell,[11] the Vedic deity Uṣas, goddess of the dawn (a metamorphosis of the sun), is her source. Mārīcī is sometimes identified with Cundī, a form of Durgā, as one of the wives of Śiva.[12] She is also described as belonging to the family of Brahmā and Sūrya.

She was worshipped in Japan during the Middle Ages by warriors, especially archers, who often wore her image, protecting those who invoked her name, and making them invisible in danger.[13] People can neither see her nor harm her.[14] She was also worshipped by disciples of Zen and Nichiren.[15] The Japanese have mostly forgotten her now, and she is worshipped only very occasionally. She assumes various forms.

- Dressed as a Chinese lady from the Tang period with three heads, one of a wild sow. She wears a small effigy of Mahāvairocana (Dainichi Nyorai) in the headdress of her main head, which is surrounded by an eight-beamed aureole. She is seated on a lotus placed on one or seven boars, her feet resting on a crescent moon or a lotus. She has six or eight arms, and holds thread, a needle, a vajra, a hook or a rope, a bow and arrows.[16]
- Her head tilted to the right, wearing a tiara. She has four faces, including one of a wild sow, and only two arms: the right hand is extended in Varada mudrā (or is holding a small *stūpa*), and the left hand holds a non-folding fan (Japanese *uchiwa*) decorated with a *svastika*.

- Seated on a lotus, with one head and two arms:[17] her right hand on her knee is in Varada mudrā, and the left holds a fan decorated with a *svastika*.
- In paintings, she is theoretically golden (or yellow) with a blue robe. She wears a small *stūpa* in her headdress.[18] She has eight arms: the right hands hold an arrow, a needle, a vajra and a lance, and the left hands a bow, a rope, a lace (Japanese *kensaku*) and an aśoka branch. When she has three heads, the left one has a furious expression and reveals fangs, the middle one is serene, and the right-hand one is that of a wild sow.
- Mārīcī can also be represented in paintings standing on a running boar,[19] and she has three heads each with three eyes, two legs, six arms, and her body is encircled by flames. She (or he) is shooting an arrow whose tip is a three-pointed vajra. Her attitude is dynamic and she brandishes a sword, a fan, a staff and a spear. Her hair bristles like the hair of a Vidyārāja.
- She may be seated like a Shintō, with a *stūpa* on her head. She is often confused with Uhō Dōji.
- A particular form of Mārīcī sometimes shows her galloping on an antelope (which is one of the attributes of Śiva, of Avalokiteśvara in his Tantric forms, and of Candra, the moon).[20] She has three heads each with three eyes, three heads in her headdress which is bedecked with a skull, six arms and six legs. She brandishes a staff, a sword, a spear, and a *cakra*, and is shooting an arrow whose tip is a three-pointed vajra.

MINOR FEMININE DEITIES

Parṇaśavarī

Parṇaśavarī
(Japanese, *Hiyōi-ten*; Tibetan, *Lo-ma-gyon-ma*)

This deity 'girded with leaves' is a former deity of the indigenous tribes of India, the Śavaras or the Śaoras, who was adopted by Buddhism. She was then made one of the 33 forms of Avalokiteśvara; her esoteric Japanese name is Jogyō Kongō. She can have two forms.

- With two arms, holding a lasso and a pomegranate on the end of a stick.
- With four arms, holding a lasso (or a rope), a pomegranate and an axe.

In Tibet she is believed to be a follower of the Tārās. She is represented kneeling on her right knee and holding an axe, a vajra, a bow, some arrows and a flowering branch in her six hands. Her body is yellow and her three heads are white, yellow and red.

Uṣṇīṣavijaya

(Japanese, *Butchō*; Chinese, *Foding*; Tibetan, *Gtsug-tor Rnam-par Rgyal-ma*; Mongol, *Rasiian Usnir-tu*)

This goddess, who 'has the intelligence of the most splendid Perfect One' and is the 'victorious goddess of the Uṣṇīṣa', is a deification of the Buddha's uṣṇīṣa (in legend a voice emerged from it while the Buddha was in deep meditation). She is rarely represented in Japan or China, and then only on maṇḍalas, but is very popular in Tibet and Mongolia, where she is often accompanied by Avalokiteśvara and Vajrapāṇi. Her high chignon may bear an image of Vairocana. She is always seated, and has three heads (yellow, white and black) all of which have a third eye. In her eight hands she holds a vajra, an ambrosia vase, a small image of the Buddha and various other symbols; or she makes a range of mudrās.

Sitātapatrā

(Japanese, *Byakusangai*; Tibetan, *Gdugs-dkar Chan-ma*; Mongol, *Chaghan Sigürtei*)

This esoteric deity, who is found only on maṇḍalas, is the powerful protector of the white parasol (an attribute of Avalokiteśvara). She may be found in different forms, depending on the maṇḍala: with one head and two arms, or with three (or four) heads and six (or eight) arms. Her hands hold various Tantric symbols, including a parasol, which is her main attribute.

Āryajangulī

(Jañgulī; Japanese, *Jōguri-dōnyō*)

This form of Tārā 'who removes poison' was represented only in paintings and maṇḍalas. Her female form is seated on a lotus. She has many arms and several heads, and in her right hands she holds a peacock feather and various attributes, and in her left hands a serpent.

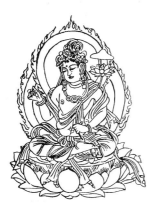

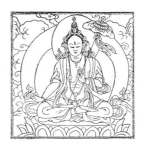

Sitātapatrā (Byakusangai)

Sitātapatrā

227

Kichijō-ten
Coloured wood, Jōruri-ji,
Kyōto, Japan,
twelfth century

Kichijō-ten

Kichijō-ten (Śrī)

Śrī

(Lakśmī; Japanese, *Kichijō-ten*; Tibetan, *Lha-mo, Dpal-ldan Lha-mo*)

This Hindu deity, who is also called Mahāśrī or Śrī Mahādevī, the wife of Viṣṇu, does not appear to have been adopted by the Northern school of Buddhism, except by the Japanese sects. There, she very soon appeared under the names of Kichijō-ten and Kudoku-ten, as goddess of good luck, beauty and merit. Her role is exalted in the *Konkōmyō saishō-ō Kyō*. Around the fifteenth and sixteenth centuries, she was replaced in the hearts of the faithful by Benzai-ten (Sarasvatī).[21] Before then she was represented as a very beautiful mature woman, beautifully dressed in Chinese clothes of the Tang period, with a long white robe shining with jewels. Her well-groomed hair falls thickly to her shoulders. Round her head[22] she wears a tiara of precious stones adorned with the image of a phoenix and a Wheel of the Law. Behind her head shines a solar halo. Her right hand is in Varada mudrā or Kichijō-in and her left hand holds a lotus or a jewel.

Kichijō-ten may replace the god Fukurokuju in the group of the seven goddesses of happiness. She is no longer worshipped, since Benzai-ten has taken over her followers, her functions and her attributes. But in Tibet, this form of the Hindu goddess is considered to protect the Dge-lugs-pa sect and the Bkra-shis Lhun-po monastery.

GROUPS OF FEMININE DEITIES

Dākinīs

(Sanskrit, *Khecara*, 'sky-goer'; Tibetan, *Mkna'-'gro-ma*)

These are lower-ranking goddesses of the Tantric pantheon, who often accompany other deities and may represent the power of their invocations. They are represented in a dancing attitude, holding a *khatvānga* or magic staff. There are many Dākinīs. Among them is a group of five which corresponds to the five Buddhas and the five Jinas.

Dākinī
Tibetan engraving

- Buddha Dākinī, holding a wheel. In one of her Tibetan forms, called Na-ro-mkha Spyod-ma, she is patron of the Sa-skya sect. She is represented as an acolyte of Vajravārāhī, dancing, with her left foot trampling on two people (blue and red), holding a chopper and a skull cup in her hands. She wears a garland of skulls and holds a *khatvānga*. She may, mainly in sculpture, be represented naked.
- Vajradākinī holds a vajra, and belongs to the Hevajra cycle. She is dancing and her left foot crushes a corpse (Nairṛti). She holds a vajra and a skull cup, and has a *khatvānga* under her arm.
- Ratnadākinī holds a *cintāmaṇi*.
- Padmadākinī holds a lotus.
- Viśvadākinī holds a double vajra.

There are other Dākinīs apart from this group, among whom are Karmadākinī (holding a sword), and Simhavaktrā, a Dākinī acolyte of Lha-mo in Tibet, who is usually represented with a white lion's head. She sometimes has two companions, one with a lion's head (the witch Vyāghravaktrā) and the other with a bear's head (the witch Rkṣavaktrā).

In Japan, the Dākinīs are not usually venerated or worshipped, except for one called Dakini-ten. A legend tells of a monk called Kangon who, on his return from a journey to China, dreamed of a demon Dākinī[23] and made a statue of her riding on a fox. In 1441, the monk Gieki took the statue to Mikawa, where he built the temple of Myōgon-ji in its honour. Thereafter, this Dākinī was associated with the fox (*kitsune*) which served as her messenger. She has even been identified with this animal, which played an important role in connection with the Shintō Kami of cereals, Inari-Myōjin. The fox was 'Buddhicized' under the name of Inari-ten.[24] Her cult became popular through a minister called Tanuma Okitsugu (1719–88), and spread mainly amongst the Samurai.[25] Popular belief associated her with Inari Myōjin (sometimes believed to be the former deity of harvest, Ta-Ukanomano-Mitama no Kami) and with her fox, in which case he was masculine and called Inari-ten, which caused further confusion. Inari-ten is represented as an old man standing up, holding a bunch of rice, with foxes lying at

Dākinī Savarī
Tibet,
Musée Guimet, Paris

229

his feet. He is also (rarely) represented as a woman called Uganoma no Kami, Miketsu no Kami, or Tome-Miketsu-gami, *tome* being an old Japanese word for fox.

Tibet sometimes places eight goddesses in the group of Dākinīs. They are also called the 'eight mothers', and are probably deities belonging to former Tibetan Shamanism. They are usually represented as beautiful young women.[26]

- Lāsyā (Tibetan *Sgeg-pa-ma*): white, holding a mirror in which she regards herself.
- Mālā (Tibetan *Phreng-ba*): yellow, holding a rosary.
- Gītā (Tibetan *Glu-ma*): red, holding a musical instrument.
- Puṣpā (Tibetan *Me-tog-ma*): red, holding a flower.
- Dhūpā (Tibetan *Bdug-spos-ma*): yellow, holding a bowl of incense.
- Dīpā (Tibetan *Snang-gsal-ma*): red, holding a lamp.
- Gandhā (Tibetan *Dri-chab-ma*): green, holding a shell-shaped flask of perfume.

Mahāpratisarā
Tibetan engraving

Five Rakṣās

In Tibet, these are the feminine forms of the 'five protectors', or the 'five parasols' in Nepal, of whom Mahāmāyūrī is the main one. These five deities correspond to the horizon and, of course, to the five Jinas.[27] In the east is Mahā-Vakṣa-Mantrānuśāriṇī. In the west, Mahāsītavatī protects against ferocious animals and poisonous plants: she is red and has one head and four arms, one of which holds a book against her chest. She corresponds to Amitābha.

In the south, Mahāpratisarā (Japanese *Daizuigu Bosatsu*) protects against bodily harm.[28] Representing a feminine force,[29] she is the divinization of a charm pronounced by the Buddha himself against all sorts of dangers. She is yellow, with an image of Ratnasambhava placed on her crown, and has three or four faces and eight to ten arms. She was likened to a Bodhisattva in Japan, under the name of Daizuigu, and was confused with Siṃhanāda. She is then represented with eight arms: the principal right hand with a five-pointed vajra on the breast, the principal left hand holding a lotus surmounted by a *cakra*. The other right hands have a rope, a sword and an elephant goad. The other left hands hold a trident, a *cintāmaṇi* and a *sūtra* scroll.[30]

In the centre, Mahāsāhasrapramardanī, protectress from earthquakes and storms, is white and has six arms (holding a sword, rope, bow, arrow and axe). She corresponds to Vairocana and carries a small image of him in her headdress.

In the north is Mahāmāyūrī or Mayūrarāja (Japanese *Kujaku Myō-ō*, Chinese *Gunsho Mingwang*, Tibetan *Rma-bya Chen-mo*). This is one of the rare feminine forms among the Vidyārājas, although she is not always considered as a Vidyārāja. 'Queen of the magic knowledge of the

peacock', 'Peacock mother of the Buddhas', she is a non-wrathful man-ifestation of Śākyamuni Buddha. The Japanese *Kujaku-kyō* claims that the Buddha himself announced to Ānanda the power enjoyed by Mahāmāyūrī as protector against poisons:[31] she is invoked for protec-tion against snake bites, calamities and also as a bringer of rain.[32] This ambiguous deity represents the productive virtue of all the Buddhas, and this is why she is also named in Japan Kujaku Butsumo. In the Garbhadhātu Maṇḍala, she also represents one of the merits of Ākāśagarbha.

Mahāmayūrī
Tibetan engraving

This deity was venerated in India, Nepal, Tibet, China and Japan, and enjoyed various fates. According to the *Butsuzō-zu-i*, she symbol-izes the mother of the Buddha (Buddhamātṛkā Mahāmayūrī). There is no Indian image of her, although the peacock has often been repre-sented as a symbol of the Buddha, or as representing the Buddha in one of his *Jātakas*. In Nepal, Mahāmayūrī is one of the 'five protectors' and a white parasol is her characteristic attribute. In China and Tibet, she has the same aspects as in Japan.

Mahāmayūrī is usually shown seated in Vajrāsana on a lotus placed on the back of a peacock, whose tail provides a sort of aureole. In paint-ing, this peacock's tail surrounds the two round haloes of the effigies belonging to esoterism. Her commonest form has a single head, of a youthful appearance, and four arms. Her robe is covered with jewels, and she has necklaces and bracelets. Her body is white,[33] whereas the peacock is golden. In her right hands she holds a blooming lotus, a lemon, a fly-whisk or a wheel. In her left hands she holds a pomegranate and a peacock feather. Less frequently, her hands are in Añjali mudrā and hold a bow and arrows.

In painting and in maṇḍalas, she is sometimes represented with six arms, the principal hands in Añjali mudrā, the other hands holding a bow, arrows, a pomegranate, a wheel, a lotus and a peacock feather. Some representations of Mahāmayūrī show her riding a peacock, with three crowned heads in addition to a head of the Buddha at the top, and six arms whose hands hold a wheel, a book, a vajra, a staff, and make indeterminate mudrās. She may also be green, with three faces and eight arms, and her main emblem a peacock feather: in this form she corresponds to Amoghasiddhi.

Butsumo Dai Kujaku Myō-ō (Mayūrarāja)

She was formerly often invoked in Japan during official ceremonies to ward off national calamities such as wars, epidemics, typhoons and earthquakes.[34] She is no longer an object of veneration, except perhaps in some esoteric sects for whom she is a secret deity.

Śaktis

In number almost equal to the masculine deities whose active energy they express, they are often represented in a sexual embrace (Yab-yum) with their partners, especially in Tibet and Nepal, and usually dressed as Bodhisattvas, with the five-leaved crown. When they are separated

from their deities, they are often seated in royal ease, with their hands in Varada and Vitarka mudrās. The five main Śaktis correspond to the five Jinas, especially in Tibet and Nepal.

- In the centre, Vajradhārīśvarī corresponds to Vairocana. Her hands are in Dharmacakra mudrā and she is white. Her symbols are the *cintāmaṇi* and the triangle.
- In the east, Locanā corresponds to Akṣobhya. Her hands are in Vajra and Vitarka mudrās. She is grey. Her symbols are vajras placed vertically on lotus flowers.
- To the south, Māmakī corresponds to Ratnasambhava. She is pale yellow. Her symbols are peacock feathers.
- In the west, Pāṇḍarā corresponds to Amitābha. She is pink and holds blue lotuses.
- In the north, Tārā corresponds to Amoghasiddhi. She is light green and holds double vajras on lotus flowers.

When these Śaktis are represented in Yab-yum, they may hold a skull cup in their left hands, which is raised to the height of their partner's mouth, their right arms around the neck of their deity.

Most of the masculine deities have a Śakti. These are generally represented with the same attributes as their male counterparts, and their bodies are the same colour, though a shade lighter. We do not know all their names, which often vary. The wrathful deities, in Tibet at least, each have their own Śakti:

- Viśvamātā (golden) for Kālachakra.
- Nairātmyā (or Vajravārāhī, or even Vajradhārīśvarī) for Hevajra.
- Vajravārāhī (red) for Saṃvara.

IX

DEFENDERS AND GUARDIANS OF THE BUDDHIST LAW

Zōchō-ten
Coloured wood, Japan

Dharmapālas
Guardian Kings
Ni-ō
Animal Guardians

DHARMAPĀLAS

(Tibetan, *Drag-shed, Chos-skyong*)

The Dharmapālas, 'protectors of the Dharma', are deities who defend and maintain the Buddhist Law. Of ferocious and warlike appearance, they wage war on the enemies of the Law and expel malevolent spirits. They are honoured mainly in Tibet, where they are worshipped individually or in groups of eight called the 'eight terrible ones' (*Drag-shed*). The eight are Kāladevī (or Śrī Devī, Tibetan *Lha-mo*), a feminine form; Brahmā (Tsangs-pa); Beg-tse; Yama; Kuvera (Vaiśravaṇa), Hayagrīva, Mahākāla and Yamāntaka. Hayagrīva (Chapter V, p. 173) and Yamāntaka (Chapter VII, p. 210) can be found under other classifications. Kuvera (or Vaiśravaṇa) is also one of the Guardian Kings, and is described with them (p. 242).

The Dharmapālas may also have different names, and be replaced by forms of Vajrapāṇi or Mañjuśrī. In Tibet, they are usually represented wearing a crown of five skulls (perhaps symbolizing the five Jinas) surmounted by a *cintāmaṇi* surrounded by flames, their hair dishevelled, their brows knit together. They wear a garland of skulls and either animal skins (elephant or tiger) or a human skin. Most of them are shown in Yab-yum with their Śakti. During ceremonies in honour of these 'wrathful deities', Tibetan priests and dancers wear headdresses composed of five leaves bearing the effigies of the five Jinas, each embracing his Śakti.

There is a series of 'eight guardian deities' in Japan, composed of Dainichi Nyorai, Fugen Bosatsu, Monjū Bosatsu, Senju Kannon, Seishi Bosatsu, Fudō Myō-ō, Kokūzō Bosatsu and the Kami Hachiman-daijin who, since the eighteenth century, are represented on 'medals' in the form of coins (circular with a square central hole), bearing on the obverse the effigy of these deities and on the reverse four Sino-Japanese characters designating them. These medals were coined by the temples for inaugurations, the beginning of pilgrimages, or to commemorate anniversaries.[1]

Kāladevī

(Tibetan, *Lha-mo*, *Dpal-ldan Lha-mo*; Mongol, *Ükin-tegri*)

This terrifying deity is the only feminine form in the group of the Dharmapālas. She was created and provided with weapons by the other deities to defend Tantrism. Brahmā gave her a fan of peacock's feathers, Hevajra two dice to determine the life of men, Viṣṇu two 'luminous objects', Kuvera a lion, Nanda a king cobra (*Nāgarāja*) to wear as an earring, Vajrapāṇi a hammer, and other gods a mule whose covering is the skin of a Yakṣa or demon, and whose reins take the form of venomous serpents.[2]

She has a third eye, and is often seated sideways on her mule. She wears the distinctive insignia of the Dharmapālas: the crown and the garland of skulls. According to legend, the skin that covers this mule is that of her son whose flesh she ate. She is also said to have been the wife of a Yakṣa king of Sri Lanka. She is often seen accompanied by two feminine acolytes: the Ḍākinī Makaravaktrā, '*Makara*-faced'[3] (blue, with the head of an elephant or a dolphin, and holding the bridle of the mule), and Siṃhavaktrā (red, with a lion's head, who follows her, holding a chopper and a skull cap). The group walks on a lake of blood.

In painting, Kāladevī is sometimes accompanied by four ferocious deities symbolizing the seasons: blue for spring, on a yellow mule; red for summer, on a blue yak; yellow for autumn, on a deer; and blue for winter, on a camel. These four accompanying deities are armed with swords, axes, hammers and knives, and hold a skull cup in their other hands.

This terrible and bloodthirsty deity is deeply venerated and representations of her are common. She seems to have been considered as the associate of Yama, the god of the dead. She is looked upon as the protectress of the Dalai Lama of Lhasa, and of the monastery of Tashi-lhun-po. She is sometimes called Cāmuṇḍī.

Brahmā

(Tibetan, *Tsangs-pa Dkar-po*; Chinese, *Fan Wang*;
Mongol, *Esrüa*)

This deity is an adaptation of the Indian god Brahmā, although he has none of his features nor his attributes in his Tibetan representations. When Brahmā is represented in his Indian form, he has four heads, and holds a Wheel of the Law in the right hand. As one of the group of the eight Dharmapālas, he is not represented with a ferocious appearance, unlike his associates, but rather as a warrior brandishing a sword and carrying a banner. He wears a turban under his crown, sometimes with a conch shell, and wears flowing garments with long sleeves. He rides a horse, or sometimes a ram.

Beg-Tse

(*Lcam-Sring*; Mongol, *Egechi Degüü*)

This ferocious warrior, in armour and wearing Mongolian boots, appeared late and was very little represented. According to legend, he is said to have attacked the Dalai Lama at the head of an army of animals, fighting for the Mongolian troops in the seventeenth century. The Dalai Lama having taken on the form of Avalokiteśvara, Beg-tse submitted to him and was then converted to Buddhism. He is represented with all the ornaments of the Dharmapāla, brandishing a sword in the right hand and sometimes holding in the left hand a human heart between his thumb and forefinger, or a weapon. He is in a dynamic position towards the right and treads on a horse and a human corpse. He is sometimes accompanied by two small acolytes: a nude woman seated on a lion (symbol of the Tibetan nation) and a warrior seated on a wolf (symbol of the Mongolian nation). This terrible deity is said to symbolize the conversion of the Mongols to Tibetan Buddhism.

Yama

(Japanese, *Enma-ō*; Chinese, *Yanluo Wang*;
Tibetan, *Chos-rgyal, Gshin-rje*; Mongol, *Erlig Khān*)

Yama
Tibetan engraving

Yama is the king of the dead, 'He who hobbles' humans, the master of hell. A number of Indian legends say that he was also the first man. Whereas in China he is merely the fifth king of hell (see 'The Ten Kings of Hell', Chapter X), he was looked on in Tibet as a Dharmapāla. He is often accompanied by his sister Yamī, and his associate Cāmuṇḍī (Lhamo). He is represented nude, wearing garlands of skulls, dark blue, red, white or yellow in colour, depending on his aspect, with a buffalo's head and in a dynamic position on this animal. But he may also be represented in human form, with one head and six arms, two of them joined in Añjali mudrā above his head. A wheel is drawn on his breast. In Tibet, however, where his images are numerous, he generally assumes one of the following three forms.

- A Gsang-sgrub aspect: in this form he is red, has a buffalo's head and the attributes of a Dharmapāla. He stands on a buffalo (sometimes running) and holds a chopper (*gri-gug*) and skull cup. He sometimes holds a *cintāmaṇi* in the place of the chopper, and is accompanied by two skeletons (*citipatī*, 'lord of the funeral pyre').
- A Phyi-sgrub, 'minister of the exterior' aspect: he is the protector of the Tibetan 'Yellow Hats'. He is dark blue in colour and resembles Gsang-sgrub when accompanied by Yamī. If not, he is white or yellow. He is never represented with his Śakti.
- A Snag-sgrub, 'minister of the interior' aspect: in this form he is a judge of hell, holding a chopper and a skull cup. In painting, he is dark blue and treads on a man. His assistants tread on buffaloes.

Mahākāla

(Japanese, *Daikoku*; Chinese, *Dahei Wang*; Tibetan, *Mgon-po*;
Mongol, *Yeke gara*)

This deity, the 'Great Black One', is the destructive form of the god Śiva;
he is particular to Tibet and was accepted in the seventeenth century
as the tutelary god of Mongolia, under Tibetan influence. He has never
been worshipped in China. In Japan, where his image appears to have
come from Mongolia, he does not have the same symbolism and, as
Daikoku, he was worshipped from the seventeenth century as a god of
good luck. In Tibet, Mahākāla is both a Dharmapāla and a protector
deity (Yi-dam). His attributions are poorly defined, apart from his duty
to defend the Buddhist Law. He may assume very many forms, and these
can be classed under five appearances and names.[4]

Mahākāla
Gilded bronze, China,
late eighteenth century,
Musée Guimet, Paris

- Mgon-dkar, protector of the Mongolians, is considered to be a god
 of wealth. He has one head (sometimes a buffalo's head) and six
 arms. He has the attributes of a Dharmapāla but holds a *cintāmaṇi*
 and a skull cup at his breast, the other arms holding various
 weapons. Covered with an elephant's skin and a celestial scarf, he
 treads on two elephants. He is white in colour.
- Mgon-po resembles Mgon-dkar, but holds a chopper instead of a
 cintāmaṇi at the breast. He treads on the demon Vināyaka. He is
 blue-black.
- Mahākāla took on a particular form (called Mgon-po Bram-zei)
 upon his appearance at Phags-pa in the thirteenth century: in this
 form he has a single head with a long beard. His distinctive
 attribute is a trumpet made of a human bone.
- As protector of science, Mahākāla is represented seated on a per-
 sonage and holding a trident. He is dark blue.
- As protector of the tent (Mongolian form), he treads on a per-
 sonage and holds a chopper, lasso and a stick.

Mahākāla
Tibetan engraving

The meanings of these attributes are extremely uncertain, and may vary
in different representations. Many Tibetan and Mongolian legends are
associated with Mahākāla, which tend to explain his different forms.

In Japan, he is named Daikoku-ten or Makiakara-ten and has two
distinct forms. It is uncertain whether the popular, benign and benev-
olent form is derived from the other, or whether it is related to the
Tibetan personage. In fact, the Daikoku-ten who is currently venerated
in Japan clearly appears to be the Buddhicization of a Kami of the land
(who is sometimes claimed to be Ōkuni-nushi no Mikoto, the Shintō
Kami of agriculture or of the 'great country').

In Japan, he is rarely represented in his Tibetan or Nepalese form,
except perhaps in a few maṇḍalas where he appears with three heads
and six arms, two of them drawing the curtain of night above his head.[5]
His hair stands upright and he appears both horrible and furious. In his
other right hands he holds a demon's head by the hair, a sword or a

Daikoku-ten (Mahākāla)

Sanmen Daikoku

hook and, in his other left hands, the skin of a gazelle (an attribute of the god Śiva) and a sword.

His popular form appears to belongs more to Shintō than to Buddhism. Daikoku-ten is then essentially one of the seven gods of good luck (Shichifukujin). His image, with the name of Kōjin-sama, became that of the Shintō Kami of the kitchen, because, in the popular mind, Kōjin is identical to Daikoku-ten.[6] Thus the images of Daikoku-ten placed in kitchens were called Kōjin and vice versa. In the kitchens of Buddhist monasteries, he is supposed to provide for the nourishment of the priests. He is also believed to be the 'protector of the three treasures of Buddhism' (the Buddha, the Law and the spiritual comunity, Sangha), and is worshipped by labourers as the 'saviour of the human race'. Several forms of him are known, which may be classed in two categories: those related to Buddhism and those that are merely the expression of a popular belief.

Forms related to Buddhism

He is sometimes represented with three heads: his own plus those of Vaiśravaṇa and Sarasvatī (the latter sometimes replaced by that of Mārīcī). This form, called Sanmen Daikoku ('Daikoku with three heads'), rides a boar. Other forms are sometimes attributed to Daikoku-ten in Japan. According to the *Butsuzō-zu-i*, there are ten forms of Daikoku-ten called Roku-daikoku-ten.[7]

Popular forms

Daikoku-ten is generally represented as a rather fat (i.e. prosperous) and smiling man, with a large sack on his shoulder (which was perhaps confused with the curtain of night drawn by Mahākāla) or with the sack next to him, being nibbled by rats. Seated or standing on bales of rice, he has a friendly air, wears a Japanese peasant's hat and holds his hands on his hips. The lobes of his ears are fat but not pierced. His right hand often holds a special kind of wooden mallet, called *uchide no kozuchi*, which he shakes to obtain abundant riches. His large sack is said to contain wisdom and patience. His effigy, which is deeply venerated, is often worn as a good luck charm. As god of prosperity he is classed among the seven gods of good luck.

Seven gods of good luck (Shichifukujin). This popular Japanese group of deities is made up of Daikoku-ten (Mahākāla); Ebisu; Benzai-ten (or Benten, Sarasvatī); Bishamon-ten (Vaiśravaṇa); Fukurokuju; Jurōjin and Hotei. (For Benzai-ten, Bishamon-ten and Hotei, see pp. 221, 242 and 240 respectively.) The number seven recalls the 'seven wise men of the bamboo thicket' or the 'seven wise men of the wine cup' whose images are popular in China. This heterogeneous group, formed of deities belonging to Buddhism, Japanese folklore and Chinese Taoism, was artificially created in the seventeenth century by the monk Tenkai (who died in 1643 and was posthumously named Jigen Daishi), who

wanted to symbolize the essential virtues of the man of his time for the Shōgun Tokugawa Iemitsu (1623–1650): longevity, fortune, popularity, candour, amiability, dignity and magnanimity. Although these deities, considered separately, existed before the formation of this group, either taken from the Buddhist pantheon (Benzai-ten, Daikoku-ten, Bishamon-ten, Hotei), from Shintō beliefs (Ebisu, Daikoku, Benten) or from Chinese folklore (Fukurokuju, Jurōjin, and perhaps also Hotei), they are found united for the first time by the brush of a painter of the Kanō family (perhaps Kanō Tan'yū). These seven deities are said to travel together on the 'treasure ship' (*Takara-bune*), which is abundantly represented in Japanese folklore by images and toys. These Shichifukujin are extremely popular even today, and their effigies (in groups or individually) are found in many Japanese houses and shops.

Ebisu

Ebisu. Thought to be a native deity, Ebisu is probably a personification of the Kami Kotoshiro-nushi no Mikoto, son of Ōkuni-nushi no Mikoto (hence son of Daikoku-ten), a mythical Shintō hero. Some say that he could also be identified with the Kami Hiruko no Mikoto, the third son of Izanami and Izanagi, the progenitors of the islands of Japan. As such, he is often considered as the ancestor of the first populations of Japan, formerly called Ebisu. In some parts of Japan, especially Kyūshū, the deity of farms is also named Ebisu, and some groups of hunters on this island call the monkeys by the same name. But perhaps even more than the peasants, Japanese fishermen invoke Ebisu before going to sea or diving: they symbolize him by a large stone which a young boy must fish from the bottom of the water at certain times of the year.

Ebisu is the central character of many popular legends and customs. He is attributed the virtue of candour. He is worshipped in the region of Osaka, where his feast is celebrated each year on 9 and 10 January and 20 October by tradesmen who strike the walls of his sanctuary with mallets to call him, because he is believed to be rather deaf. Large radishes (*daikon*) steeped in vinegar (*bettara*) are offered to him as tribute. Sanctuaries are dedicated to him throughout Japan: that of Nishi no Miya[8] is famous and attracts many pilgrims. Ebisu is represented wearing an ancient Japanese peasant costume, smiling broadly. He holds a fishing rod in the right hand and in the left a sea bream (*tai*), a fish that symbolizes good luck in Japan. Ebisu is also considered to be the patron of labourers, wealth and prosperity.

Fukurokuju. This semi-deity of Chinese origin is perhaps the divine representation of a Taoist hermit sage of the Song period. He is also said to be the god of the Southern Cross, of wisdom, virility, fertility and longevity. He is attributed the virtue of popularity. He was sometimes, but seldom, replaced in the assembly of the seven gods of good luck by Kichijō-ten. Fukurokuju is usually represented in the form of a little old man, with beard and moustache, with a bald head three times the height of his body. This disproportionate head sometimes assumes phallic

Maitreya
Gilded stone, Pak-hu, Laos

Hotei

forms and is then covered with a cloth cap. He holds a long, knobbly staff to which a book is attached. In paintings he is often shown in the company of a crane, the Taoist symbol of longevity. In sculpture, his hands are usually hidden in wide sleeves. Sometimes confused with Jurōjin, he is almost never invoked as a separate deity.

Jurōjin

Jurōjin. This is the god of good luck and longevity. He is very probably of the same origin as his godfather Fukurokuju, with whom he is often confused. Thought to be a great lover of rice wine (*sake*), he is represented as a small old man with a wide forehead (but narrower than that of Fukurokuju), holding a knobbly staff in the hand, to which the book of knowledge is attached. He is accompanied by a crane, a black deer or a tortoise. He is sometimes called Rōjinseishi when identified with the Chinese sage Laozi.

Hotei. He could be the Chinese hermit Budaishi (d. 917), who was thought to be an incarnation of Maitreya; the latter is venerated in some Zen monasteries of the Ōbaku sect (as in the Manpuku-ji in Kyōto) by the name of Hotei, the 'Miroku with the large belly'. Among the Shichifukujin, he is attributed the virtue of magnanimity. He is represented as a Buddhist monk: bald, unshaven, smiling, with a huge belly. He holds a non-folding fan in the right hand, and leans on a large sack which contains endless treasures, a sort of horn of plenty for his followers. He is also sometimes confused with Warai-Hotoke (smiling Buddha) or with Fūdaishi-ten (Japanese version of the name of the Chinese hermit Budaishi) when he is assigned to guard monastery libraries. In this case he is accompanied by his two 'sons'.[9]

The image of Hotei is often made as a toy for pulling or tilting. When it has wheels, the toy is called *kuruma-sō*, 'the rolling monk'. In some representations, Hotei has an eye drawn on his back, a symbol of universal vision.

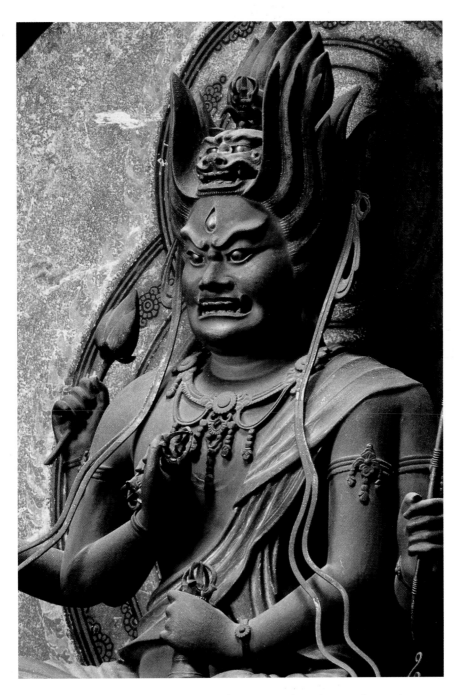

Aizen Myō-ō, coloured wood, Japan, thirteenth century

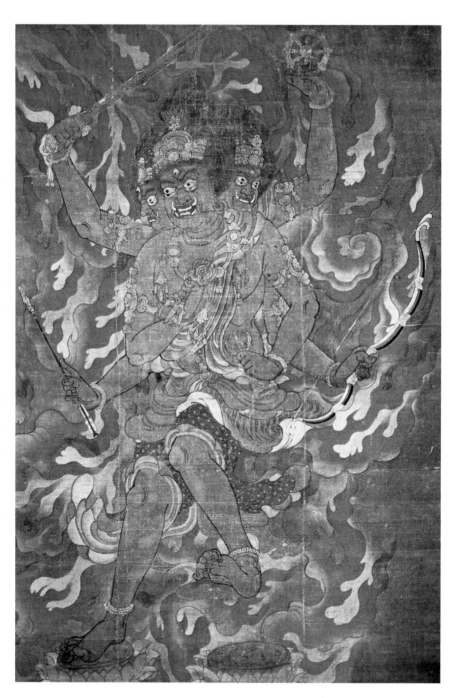

Kongōyasha, painting on silk, Daigo-ji, Kyōto, Japan, fourteenth century

GUARDIAN KINGS

(Lokapālas; Japanese, *Shi-Tennō*; Chinese, *Hushizhe*;
Tibetan, *Rgyal-chen-bhi*; Mongol, *Mahārāja*)

These are the four celestial kings believed to guard the four cardinal
points. Three are vassals of the fourth, Vaiśravaṇa.[10] They are thought
to live on Mount Meru, the home of the 33 deities (Trāyastiṃśa)[11] and
at the gates of the paradise of Indra, protector of Buddhism. Acolytes
of Avalokiteśvara, they are believed by some authors to be hypostases
of the four-headed Brahminical deities symbolizing the cardinal
points. They are the protectors of the world[12] and of the Buddhist Law.
As kings of the world, they were confused with their generals, and the
Lalitavistara describes them already carrying weapons and wearing
armour.[13] Buddhist legends about them are legion: they are said to have
assisted at the birth of the Buddha, and held up the hooves of his horse
when he left the palace of the king his father at Kapilavastu. They offered
the Buddha four bowls of food, which he miraculously merged into one.
They were also present at his Parinirvāṇa. Very early, Buddhism rep-
resented them at the four sides of *stūpas* (gates of Sāñchī, India) and
on bas-reliefs. They do not wear armour in their earliest representations,
but are bare-breasted and armed with lances or clubs. While these
guardian kings are represented in Indian art generally mounted on ele-
phants (*Dig-gaja*), in Tantric and esoteric art they are more often shown
trampling demons. Representations of the Lokapālas are thought to have
been introduced into China by Amoghavajra in the eighth century,
going from there to Korea and Japan, where they enjoyed great success.
China and Central Asia gave them the form of warriors, because they
were thought to protect the Buddhist kings against barbarian invasions.
In Japan, they were worshipped very early: they were attributed with
the power to give victory to Buddhist clans over their enemies. In
acknowledgement of their help, in the late sixth century, Prince Shōtoku
erected a large sanctuary to them, the Shitennō-ji, in Ōsaka, where he
placed their effigies. Temples were then raised in their honour in the
provinces so that they could watch over the safety of the territories and
the harvests. But their worship soon merged into the cult of the one that
appeared to be the most powerful, Vaiśravaṇa.

Guardian king (Shi-tennō)
Japan, thirteenth century

They are usually found in groups, placed at the four corners of altars
reserved for the major deities, or at the corners of maṇḍalas assembling
many divine effigies (as at the Tō-ji in Kyōtō, for example). They are
always shown standing, in martial positions, as befitting warriors whose
attention must never falter, on rocks (symbolizing Mount Meru and
hence their unshakable resolution), and treading on Yakṣas or
demons.[14] Most of the great temples of Japan and China have their
effigies, either in sculpture or in painting, so that the number of rep-
resentations of them is countless. They were mainly represented in
painting in Central Asia (particularly at Khara-khoto before 1227, and
on banners at Dunhuang) and in Tibet, on representations of *stūpas* or

reliquaries. In Tibet, they are also found in paintings: at least one mandala is devoted to Vaiśravana in his Tibetan form of Rnam-sras-ser-chen, one aspect of the god of wealth, Jambhala. In Japan, the Lokapālas were mainly sculpted, as these warriors needed an effective presence in order to intervene at any time.[15] In painting, the most famous representations are those in the Central Asian style – for example, on the eighth-century walls of the Kondō of the Hōryū-ji in Nara.[16] In the Garbhadhātu Mandala, they are distributed in their respective cardinal points.[17] The colours attributed to them may vary: in the *Mahāprajñā-pāramitā-sūtra* they surround and protect Śākyamuni Buddha. And according to the *Shi-tennō-kyō*,[18] they travel around the world during six days of abstinence to inspect kings, ministers, peoples, Nāgas and Pretas, insects and fish, and to enquire into the spiritual progress of all beings.[19]

They are usually represented as warriors in armour, with or without helmets, or with a tiara. The head of a lion or a demon is depicted on the central part of their armour. They wear arm-guards and greaves, as well as decorated breastplates. A garment ornamented with celestial scarves spreads out behind their armour. A round aureole is sometimes found behind their heads, surrounded by short flames. This aureole is often replaced by a spoked wheel. They nearly always wear shoes. They hold various attributes in their hands and assume dynamic postures, with a wrathful appearance. They are venerated either in the person of their chief, Vaiśravana, or collectively, but are not really worshipped except when Vaiśravana is considered as a separate deity.

Vaiśravana

(Japanese, *Tamon-ten, Bishamon-ten*; Chinese, *Duowen*;
Taoist name, *Molishou*; Mongol, *Bisman Tengri*;
Tibetan, *Rnam Thos-kyi Bu, Rnam Thos-sras*)

Vaiśravana is the guardian of the north[20] and the chief of the four guardian kings – 'He who is knowing', 'He who hears everything in the kingdom', the protector of the state *par excellence*, sometimes thought to be a god of defensive warfare. In China, he is considered to be a Buddhicization of the Indian god of wealth Kuvera, the north being considered to hold fabulous treasures. He presides over winter and is black, so is also called 'the black warrior'. His symbols are a jewel and a serpent, and he commands a large army of Yakṣas.[21] He may be pink, beardless, holding a parasol and a rat. In India his symbols are the flag, the jewel and the mongoose.

In Japan, he is called Tamon-ten when considered to be one of the four kings, and Bishamon-ten when considered as a separate deity. His worship appears independently of the other guardian kings from the ninth century. At this time, he was considered to be a healing god, and was accordingly the principal deity at the Chōgosonshi-ji on Mount Shigi, near Nara. An illuminated scroll, the *Shigisan Engi Emaki*, was

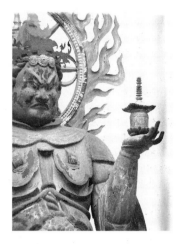

**Bishamon-ten
(Vaiśravaṇa)**
Japan, thirteenth century,
Kyōto National Nuseum

**Bishamon-ten
(Vaiśravaṇa)**
Sekkei-ji, Kōchi, Japan,
thirteenth century

painted in the twelfth century to the glory of Bishamon-ten, relating the miraculous cure of Emperor Daigo (898–930) and the miracles performed by the hermit Myō-ren, a fervent worshipper of Vaiśravaṇa.[22] From the Heian period, Bishamon-ten became the principal deity of the syncretic sanctuaries of Mount Kurama, where he was worshipped as the god of wealth, Kuvera (Kubira or Konpira),[23] a chief of the Yakṣas. In the Middle Ages, his name was given to warriors because he was considered to be their patron.[24] He is also believed to possess immense wealth and to dispense the 'ten sorts of treasure or good luck'.[25] This is why, in the seventeenth century, he was included in the list of the seven gods of good luck (Shichifukujin). His messenger animal is then a centipede, a poisonous insect with twenty pairs of legs. As in China, he is attributed the virtue of dignity. The people often take the *stūpa* that he holds in his hand for the tower where he guards his treasures.

In Japan, he is represented trampling two demons.[26] These sometimes take on an animal form (e.g. the effigy in the Hōryū-ji in Nara). These demons are interpreted as being Lambā (Japanese *Nirambā*) and Vilambā (Japanese *Biranba*, the 'suspended', sometimes named Vairambha, 'destructive wind'[27]), two sorts of witch. His main attributes are the *stūpa* and the lance (more seldom the trident and the staff). In the *Ryōbu Mandara* of the Shingon sect, Bishamon-ten is exceptionally represented seated, in Yogāsana, a crown on his head, holding in his left hand at shoulder level a reliquary tower in the form of a *stūpa* and, in the right hand, a staff of wisdom. In painting he is usually shown standing, crushing a demon under foot. In sculpture, especially in Japan, his forms are more fixed: he is standing and his armour is sometimes covered with a robe adorned with the 'seven precious jewels'. His face is normally blue.[28]

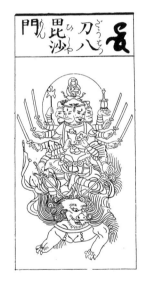

Tōbatsu Bishamon-ten

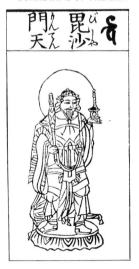

Bishamon-ten
(Vaiśravaṇa)

Vaiśravaṇa
Tibetan engraving

- right hand lance,[29] trident[30] or staff; left hand *stūpa*.[31]
- right hand *stūpa*;[32] left hand lance or trident.
- right hand lance; left hand as a visor over the eyes.

In painting and in sculpture, his round aureole sometimes has eight rays terminating in vajras with one or three points.

A Japanese variant, Tōbatsu Bishamon-ten, is represented as Bishamon-ten, but wearing very tight armour. His feet are supported by Nirambā and Biranba. Between them is the head of the earth, Pṛthivī (Japanese *Chi-ten*), or of Vināyaka, the 'demon of obstacles'[33] whom Bishamon-ten plans to conquer. Tōbatsu Bishamon-ten may also be represented with twelve arms and four heads, mounted on a lion (especially in maṇḍalas and in the *Butsuzō-zu-i*).

Vaiśravaṇa may also assume various forms, including that of one of his Yakṣas, Samjñeya (Japanese *Jinja Taishō, Sanshi Taishō, Shōryōchi Taishō*): his face has a ferocious expression and his hair is dishevelled. Standing on a rock, he wears a necklace of skulls, and his hands and feet have claws. A child's head appears on his belly. His left hand shakes a serpent.

An esoteric deity particular to the Taimitsu branch of the Tendai sect combines the image of Bishamon-ten with that of Kichijō-ten (Śrī) and places them back to back. This double deity is then called Sōshin Bishamon-ten. It is very seldom represented and virtually never shown to lay people.[34]

In the Middle Ages, effigies of Bishamon-ten were sometimes accompanied by those of Jūni-shinshō or the twelve warriors of Bhaiṣajyagura: it is thought that they may have represented the Yakṣa army of Bishamon-ten. Bishamon-ten is also thought to have commanded eight (or 16) large Yakṣas,[35] some of whom were 'Buddhicized' Kamis (higher beings belonging to Shintō) as, for example, the Jūro-kuyasha-shin of Kōya-san whose name appears after 841, imported by the monk Ogurusu Jōgyō (e.g. the painting in the Daigorishō-in of Kōya-san, with six heads and eight arms). Other Yakṣas, acolytes of Bishamon-ten, such as Kishin-Taishō (also called Kōya-shin or Kōya-kishin), and worshipped at the Kōya-san, were thought to hunt wild animals and to protect the country and the people. There are wooden effigies of them at the Akishino-dera. Vaiśravaṇa is also worshipped by the followers of the Nichiren sect as the protector of the Lotus Sūtra.

In India, Vaiśravaṇa is deeply venerated as Kuvera, a god of wealth, the son of the sage Viśravas. Promoted to this rank by Brahmā for his many austerities, he departed from Mount Kailāsa in the Himalayas and became the king of Lankā (sometimes identified with present-day Sri Lanka) where he is said to have used a marvellous flying car, called Puṣpaka, which was used by the demon Rāvaṇa in the Indian epic poem, the *Rāmāyaṇa*. He resides on Mount Alaka in the Himalayas with a large army of Yakṣas and Kiṃnaras.

The Yakṣas are commanded by 28 generals, of whom the chief is

Pāñcika – according to the *Mahāvaṃsa*, he was the father of the 500 sons of Hārītī. Worshipped very early in India (some of his representations are found in Gandhāra and in northern India) as well as in Java, this general of the Yakṣas was soon merged with Vaiśravaṇa. He is usually represented with a turban, holding a lance and a bag of jewels, sometimes accompanied by one or two birds (sculpture of Chandi Mendut, in Java). At Ajantā, he is shown in the company of Hārītī. The ornaments he carries sometimes vary: the lance is often absent, but the jewel bag rarely. He is often accompanied by a mongoose (although this animal is more typically an attribute of Vaiśravaṇa, on whose behalf it victoriously fought the Nāgas, the guardians of the earthly treasures). Sometimes the jewel bag takes on the form of a mongoose, and sometimes (especially in the Nepalese form of Vaiśravaṇa) the mongoose is shown vomiting jewels. This Nepalese form (called Jambhala perhaps because of a lemon, *jambhara*, which it always holds in its right hand) is a god of wealth. In Tibet and Nepal, his forms are sometimes slightly different from each other, some bearing a trident and accompanied by a dragon.

Kuvera Vaiśravaṇa is variously represented. Yet it does not appear that Buddhism made him a god of wealth, except perhaps in Nepal and Tibet, where he is fairly often represented holding a flat ritual vessel overflowing with jewels. He is always represented bare to the waist, seated on a throne with one leg pendant (the foot sometimes placed on a bag filled with jewels), or mounted on a horse or a pile of cushions (*kholbok*, series of cushions of which the pile, in Tibet and Mongolia, represents the rank of the Lama seated on it), or even seated on a demon. In his hand he holds a banner, a lance or a trident, and the inevitable mongoose. His attributes may be supported by a vase or a lotus. In some rare cases, Kuvera is represented with a third eye and a short beard: this is a Tibetan Tantric form. In this case, he may have three legs, five heads and eight arms, whose hands hold the Tantric ornaments – chopper, vajra and bell – and make a Vajrahūmkara mudrā. This form is invoked in Tibetan rituals to obtain wealth.

In Japan, his identity as Kuvera is disputed. Called Kompira or Kubira, he is considered to be a god of good luck and of wealth. However, the relationship between this deity and the Indian Kuvera is not quite clear. There may be some confusion of the name and personage. Mainly worshipped by the fishermen of the isle of Shikoku, Konpira-ten is a protector of mariners and the god of prosperity. A syncretic deity, he also takes the Shintō name Zōzugen-konpira-daigongen, and some authors believe that he is the same personage as a Kami of mythical times, Prince Ono-nushi no Mikoto. Others claim that he is identical to the legendary hero Kotohira or identify him with the Emperor Sutoku (1124–1141), who became a Kami.

He is represented in Japan as an old man, seated, legs crossed, sometimes dressed as a Buddhist monk, with a cap on his head and holding a peacock feather in his hand. His skin is very dark, nearly black. His

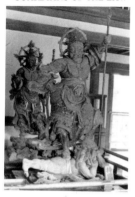

Jikoku-ten (Dhṛtarāṣṭra)

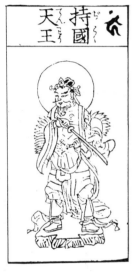

Jikoku-ten-ō

Virūdhaka
Tibetan engraving

feast is celebrated on 9, 10 and 11 October at Sanuki and Kotohira on Shikoku, and at Toranomon in Tōkyō, with lighted candles and dances performed by eight girls. One of the most famous of his many sanctuaries is that of the Jufuku-ji in Kamakura, where one of his effigies can be found.

Dhṛtarāṣṭra

(Japanese, *Jikoku-ten*, *Daizurata-ten*; Chinese, *Chiguo*; Taoist name, *Molihai*; Tibetan, *Yul-hkhor Bsrungs*; Mongol, *Orchilong Tetküchi*; Thai, *Thatarot*)

This guardian king governs in the east and presides over the spring. He is 'He who maintains the kingdom (of the Law)', 'the maintainer of the state'. In China, he is represented as blue or green and playing a guitar. He commands an army of celestial musicians (Gandharvas) and vampire demons (*Piśāca*). However, he may also be represented with a black face and a long beard, armed with a sword and a golden ring. In India and Tibet, he is represented as white.

In Japan, he is represented as a warrior in armour, standing on a rock or on one or two demons, the face green,[36] the hair bristling (or helmeted), the expression fierce,[37] holding a sword or trident in his right hand, the left hand placed on his hip (the sword is sometimes replaced by a *katana*, a short Japanese sabre).

In painting,[38] he is usually shown with a jewel in the right hand and a sword in the left.[39] His armour is sometimes covered by a Chinese robe that may be ornamented with serpents.

In the Garbhadhātu Maṇḍala, he is located in the east,[40] in the company of Śakradevendra (Japanese *Taishaku-ten*), a Buddhicized form of Indra. Seldom represented in painting (except in maṇḍalas), in sculpture Dhṛtarāṣṭra never appears alone, but in the group of the four kings.

Virūdhaka

(Japanese, *Zōchō-ten*, *Jōchō-tennō*, *Birurokusha-ten*; Chinese, *Zengzhang*; Taoist name, *Moli Hong*; Tibetan, *Hphags Skyes-po*; Mongol, *Ulumchi Tereltü*; Thai, *Virulahok*)

This guardian king governs in the south and presides over the summer. He is 'He who enlarges the kingdom', 'the powerful one'. In China he is represented as red, although he is sometimes shown with a white skin, a short beard, and holding a guitar. In Tibet he is given the colour green and his symbol is the parasol, although he is more often represented with a sword and a helmet made of an elephant's head.

In Japan, he is represented as a warrior in armour, standing on a rock or crushing one or two demons, holding a lance[41] in his right hand, a shield resting on the ground (on which he leans with both hands) or a sword. His left hand holds a sword or is placed on his hip. His face

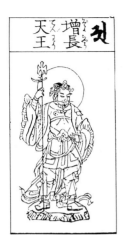

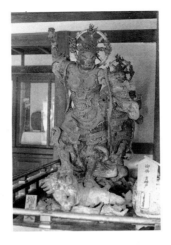

Zōchō-ten-ō

Virūdhaka (Zōchō-ten-ō)
Coloured wood,
Yakushi-ji, Nara, Japan,
fourteenth century

is green or blue[42] and he sometimes has a short beard. In painting he is sometimes represented accompanied by Yakṣas. He is not worshipped independently but only as part of the group.

Virūpākṣa

(Japanese, *Kōmoku-tennō, Birubakusha-ten*; Chinese, *Guangmu*;
Taoist name, *Moli Qing*; Tibetan, *Mig-mi-bzang*;
Mongol, *Sain Bussu Nidūdū*; Thai, *Virupak*)

This is the guardian king of the west, 'He who observes everything that happens in the kingdom', 'He who sees all'; he presides over the autumn. He is white in China, but more often represented as red in India and Tibet; his face may even be yellow. Standing on a rock or on demons, he also wears armour (over which a robe is sometimes thrown).

In the right hand he holds a lasso[43] or a brush. In the left he brandishes his *sūtra* scroll or clasps the sheath of his sabre or sword. His left hand is sometimes placed on his hip, or holds a lance. In painting, he sometimes holds a lance in the left hand. He is not worshipped separately from the group and is never represented alone.

NI-Ō

Among the many guardian deities, Japan has the Ni-ō (good kings, or kings of compassion). These two guardian kings are Vajradhāras, 'holders of vajras' (Japanese *Shūkongō-jin*), or rather adopted sorts of Rākṣa (man-eating demons of Indian folklore). They are guardians but also, in the esoteric doctrines, two aspects of the unique reality of Vairocana. In this respect they are sometimes confused with the wrathful forms of Rāgarāja and Acalanātha. Although apparently similar to these forms,

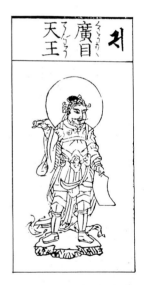

Kōmoku-ten-ō (Virūpākṣa)

they are in fact distinct from them, and are named Garbhavīra and Vajravīra.

Symbolizing a sort of alpha and omega of all things, they are mainly represented as Dvārapāla (gate guardians), who wear only a sarong (as in India, at Sāñchī) or, more rarely, are dressed as warriors in armour. They are placed on either side of the main gate of monasteries and temples to banish evil spirits and thieves,[44] and to protect children. They are not truly worshipped, although people often consider them as wish-granters. A widespread belief in parts of Asia requires that balls of papier mâché be thrown at their statues while making a wish; if they adhere for a certain amount of time, the wish will be granted. The same is done with other sculptures of deities (in Japan with effigies of Binzuru Sonja, of Fūjin and Raijin, Shintō gods of wind and thunder) and the guardians of the Shintō sanctuaries called Zuishin (or Yadajin), who represent military ministers of ancient times.

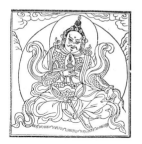

Virūpākṣa
Tibetan engraving

The Ni-ō are represented as powerfully muscled giants, half naked or with celestial scarves, heads shaved, sometimes with a chignon on the top of the head, and with a menacing expression. They stand upright on rocks, legs apart.[45] Their images are very numerous and are found at the entrances of nearly all temples. In Japan, the gates on each side of which they are placed are sometimes named Ni-ō-mon.

Garbhavīra
(Japanese, *Misshaku Kongō*)

Also called Misshaku Rikishi in Japan, the 'Vajra with secret traces', he is the guardian of the Garbhadhātu Maṇḍala, and symbolizes the power it expresses, that of exoterism. His mouth is open and his body is red.[46] He is always placed to the east of the so-called 'Sanmon' gate, to the right as one enters. His attitude is dynamic: his right hand is lowered, fingers outspread, the clenched left hand holding a long staff terminating in a vajra at each end. When wearing armour, his right hand holds a trident or a short sword. His hair is then combed into a chignon and he is given the name of Shū-misshaku-shin Kongō-ō.

Vajravīra
(Japanese, *Kongō Rikishi*)

He is found to the west (the left) of the 'Sanmon' gates and is the guardian of the Vajradhātu Maṇḍala, symbolizing the latent power of esoterism. He is sometimes named Sōkō or Bazara-un Kongō. He is similar to Garbhavīra, but his body is green and his mouth closed. His left hand is lowered, closed, and his right hand holds a staff terminating in a vajra at each end. When wearing armour, his right hand holds a trident or a short sword. His hair is then combed into a chignon and

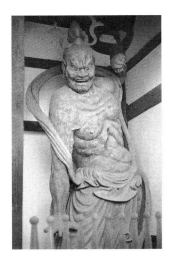

Misshaku Kongō (Ni-ō)
Clay, Hōryū-ji, Nara,
Japan, eighth century

Kongō Rikishi (Ni-ō)
Wood with glass eyes,
Sanjūsangendō, Kyōto,
Japan, thirteenth century

he is given the name in Japan of Shū-kongō-shin-ō (or Shitsu-kongō-shin). He is thought to be one of the forms of Acalanātha.

ANIMAL GUARDIANS

Frequently found among the temple guardians are effigies of more or less mythical animals. Chief among these are dragons, supposed to be the guardians of the ablution fountains placed at the entrance of each temple; and animals resembling lions, whose duty is to guard the temple alleys and sometimes the entrances of buildings.

Lions, which originated in Iran, are found in Asia in only very small numbers, in the forest of Girnar in Saurāṣtra, in India. Throughout Asia, however, their image serves as the symbol of strength and courage. It was adopted by Buddhism, and its roar represents the 'voice of the Law' (see Amoghasiddi, p. 146). It usually represents beneficial forces (in Bali, where a sort of Indo-Buddhist syncretism subsists, it is named Barong and represents the genie of good, as opposed to Rangda, the witch genie of evil). Very popular in China, where it is called 'Buddha's dog' (Bofo), its image, in the absence of real models, was widely interpreted, and in Japan and Korea as well. The shape of its head became square and it is sometimes adorned with short horns. It is then sometimes merged with a stag or a dragon, animals also considered beneficial. Buddhism made it a guardian of the Law. It is personified in many dances, some of them ritual, and its appearance is presumed to banish demons and evil spirits. Two types of lion usually guard the entrances of Buddhist temples and have a symbolism that is nearly identical to that of the Ni-ō.

- One, positioned at the right of the entrance, has the mouth open (sometimes holding a jewel symbolizing treasures), and is the offi-

cial guardian of the objects of worship. In Japan it is called
Karashishi ('Chinese lion').

• The second, placed opposite the first, at the left of the entrance,
has the mouth closed, symbolizing the latent powers. It has two
short horns on the forehead. In Japan, where it is named Koma-
inu ('dog of Korea'), two types are found, which are equally com-
mon: realistic, with a small mouth (style imitated from those of
the Sui and the Tang in China), and mythical, with a square
mouth (style imitated from that of the Song in China).

Other sorts of mythical lion are also found guarding in effigy the
Buddhist temples of South-East Asia – for example, the Chinthe of the
temples of Burma and the lions ornamenting the string-courses of the
staircases of the temples of Sri Lanka and Java (especially Borobudur).

X

GROUPS OF DEITIES

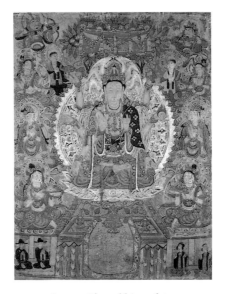

Amogapāśa and his acolytes
Painting on silk, tenth century,
Dunhuang, China,
Musée Guimet, Paris

The Ten Kings of Hell
The Five Great Kings
Yi-dams
Devas
Minor and Syncretic Deities

Besides the guardian kings, the Ni-ō and the Dharmapālas, certain groups of deities exist that are particular to specific forms or sects of Buddhism. These groups may be formed of deities also belonging to other categories and gathered together for a precise purpose of worship, or they may be special groups of minor deities.

Among the most deeply venerated of these groups in Japan are the ten kings of hell, the five great kings, the Yi-dams, the twelve Devas, the seven gods of good luck, and various groups of Buddhas and Bodhisattvas worshipped by certain sects.

THE TEN KINGS OF HELL

The ten kings of hell are in fact Dharmapālas (see Chapter IX) who, under the leadership of Yamarāja, preside over the Buddhist hells. According to Chinese tradition, nine kings (or judges) assist Yamarāja, who rules on the fate of the dead and who sends them to one of the 'cold' or 'hot' hells, or back to earth in one of the categories of living beings of the six paths of transmigration, according to their merits. The

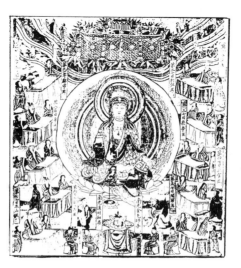

Kṣitigarbha surrounded by the ten kings of hell
From a fresco, Dunhuang, China

whole of Buddhist mythology concerning hells, punishments and the destinies of mortals is connected with the belief in Yamarāja.[1]

These ten kings are probably emanations of Yamarāja: they serve him as assessors. Apart from Yamarāja himself (and, in Japan, Tamonten Vaiśravaṇa, who is sometimes considered a Dharmapāla), they are personages of Chinese origin (except perhaps one of them, Citragupta, Japanese *Taizan-ō*, who is of Indian origin). In Japanese nomenclature,[2] they are Shokō-ō, Byōdō-ō, Shinkō-ō, Sōtei-ō, Gokan-ō, Hensei-ō, Taizan-ō, Toshi-ō and Godōtenrin-ō.

Yamarāja

(Japanese, *Enma-ō, Enra-ō*; Chinese, *Yanluo-wang*; Tibetan, *Chos-rgyal, Gshin-rje*; Mongol, *Erlig Khān*; Khmer, *Tevabot Yom*)

This is the most important king of the group, and is also the only one actually worshipped, although the others are sometimes worshipped in connection with religious duties performed for the deceased. In China, rather curiously, it is not Yamarāja who is the supreme ruler of hell, but Kṣitigarbha (see Chapter V) – Yamarāja ranks merely fifth among the ten kings, although he reigns over ten courts of judgement.

In Indian mythology, Yama is the supreme judge of the dead and is found in the centre of the sixteen hells (eight cold and eight hot) and places of punishment. He judges only men; his sister Yamī, who accompanies him, judges women. At the end of time, Yama is supposed to be reborn with the name of Samantarāja, after having also expiated his own faults.

In Tibet and Mongolia, Yamarāja is considered to have three forms (of which two are emanations from him), the principal one being that of Gsang-sgrub who, according to a Tibetan legend, was vanquished by Mañjuśrī who was subsequently called Yamāntaka, 'conqueror of Yama'. This esoteric form is shown with a bull's head (or a buffalo head, associated in India with a demon of death, vanquished by Durgā), the hair bristling with flames, with a third eye in the forehead. He dances on a buffalo's (or bull's) body, wears a crown of skulls, and holds in his hand a chopper, a skull cup (or club, as in the Indian representations) and a lasso. His body is red, and he is often accompanied by two *citipatī*, perhaps a personification of sickness.

His two 'ministers' (merged with him as his aspects) are Phyi-sgrub, 'minister of the exterior' (represented with a buffalo's head and a *cakra* at the breast, and dancing on the bodies of a buffalo and a woman): he is dark blue when accompanied by Yamī, and white or yellow if represented alone. In this form he is considered as the protector of the Tibetan sect of the 'Yellow Hats'. Snag-sgrub is the 'minister of the interior' and has the same appearance, but treading on a man. Yet Yama may be represented, in his Tantric aspect, with a human head and six arms (two of his hands are joined in prayer above his head). A *cakra* is drawn on his breast.

Yamarāja

It is commonly believed in Japan that Yamarāja, also named Enma-dai-ō (the great king of hell), is surrounded in the performance of his task by 18 generals and an infinity of soldiers (80,000 in Japan), as well as various demons and infernal guards with horses' heads (Japanese *Mezu*) and bulls' heads (Japanese *Gozu*),[3] plus others. He is also thought to be assisted by two 'secretaries' (Japanese *Gushōjin*). Citragupta (Japanese *Taizan-ō*) serves him as his clerk to register people's misdeeds.

Yamarāja passes judgement seated behind a table. On his right is a male head, the mouth open to report the acts of the deceased being judged, called in Japan *Kagu Hana* ('nose that sniffs misdeeds'), and on his left is a female head, the mouth closed, called *Mirume* ('eye that sees hidden faults').[4]

Enma-ten (Yamarāja)

Yamarāja is represented in China, Korea and Japan in Taoist costume or the garments of a Chinese judge, with a long black robe hiding both feet. Like the other kings of hell he wears on his head the large black hat worn by Chinese judges, pierced by a long horizontal needle, on the front of which is written the Chinese character for 'king'. His breast sometimes bears the distinctive *cakra* or a *svastika*, or possibly images of the sun and the moon, thus showing that nothing that exists in the universe can escape him. He is seated on a Chinese high-backed chair, or in the tailor's posture on the seat. His head, wrinkled and uncouth in appearance, is red-faced, sometimes bearded. His expression is hostile and his mouth is always open. In one of his two hands he holds a tablet (Japanese *shaku*, Tibetan *dbyug-pa*) or a priest's staff (Japanese *nyo-i*) derived from a back-scratcher. In the images that represent him, and in miscellaneous paintings and maṇḍalas, he often resembles his Tantric form, called *Enma-ten* in Japan. Formerly deeply worshipped and, above all, feared in Japan, he is barely the subject of any popular consideration today. However, he is not forgotten, and his feast day is celebrated every year on 16 January, particularly in Osaka, as the patron of apprentices, during a ceremony called Yabuiri.

In China, the kings of hell, all dressed as Chinese judges, are generally shown in a group surrounding Dizang Pusa (Kṣitigarbha). When Yamarāja is represented alone (especially in Tibet) in his Tantric form, his ornaments are a lasso, a chopper and a sceptre. His colour may be dark blue, red or yellow. His associate is Lha-mo.

Citipatī
(Tibetan, *Dur-khrod Bdag-po*)

The Citipatī
Tibetan engraving

The *Citipatī* are two acolytes of Yamarāja – two skeletons, one of a man and the other of a woman, usually represented in Tibetan art with arms and legs interlaced, dancing on two corpses. They hold a sceptre (or staff) topped with a skull, a skull cup and a vase. They are usually shown in the suite of Yama. They recall the skeletons that are sometimes represented in Hindu art in the company of Śiva when he dances the destruction of the world (Śiva Tāṇḍava).

Other Kings of Hell

Among the other kings of hell, the Shingon sect recognizes at least three forms of Kṣitigarbha. In China these kings are always represented standing in the presence of Dizang, while in Japan they are seated, like Yamarāja, but with their robes hiding only one of their feet. They are usually shown with the left hand raised, the right hand resting, palm upward, in the lap. Sometimes they have a writing tablet in their hand. Some sculpted forms appear to show that these kings were differentiated in Japan, at least in the Kamakura period. Since their Japanese names differ from those normally attributed to the ten kings, it is not known exactly to which they correspond: they are Shimyō, the director of the fate of life charged with registering the dead, who is shown with a brush in the hand (perhaps another form of Citragupta) and Shiroku, director of revenues, who reads a register held in both hands.[5]

One of the kings of hell
Vietnamese engraving, eighteenth century

In Japan, the ten kings of hell are worshipped by the Shingon sect as a group, in succession at certain intervals after the death of a believer. They are also thought to correspond to certain Buddhist deities, since with the three forms of Kṣitigarbha there are thirteen altogether, corresponding to a series of thirteen Buddhas which the Shingon sect honours especially during funerary ceremonies.[6] These are intended to placate the wrath of the judges of hell and to secure a pardon from hell's torments, by simultaneously invoking the protection of the corresponding deities. In these ceremonies, however, the thirteen Buddhas are invoked at different intervals from those observed for the kings of hell.[7]

Demons of Hell

The Buddhist hells (*Naraka*; Japanese *Jigoku*) are inhabited by an infinite number of demons which may take on all possible and conceivable forms, some resembling animals, others resembling humans with many eyes. They are not explicitly described in the texts, but their images, the fruit of popular imagination, are frequently found on illuminated Buddhist scrolls dealing with the Buddhist hells.

THE FIVE GREAT KINGS
(Tibetan, *Sku-lnga, Dam-chan*; Mongol, *Tabun Qaghan*)

This group of deities is worshipped in Tibet and Mongolia. They are ancient heroes of Mongolian folklore – five brothers, who were deified. They are not exactly gods, but rather spirits considered as protectors and wish-granters. Their cult was once very popular.

- Pe-har (Pe-dkar), protector of monasteries: white in colour, with six arms, mounted on a red tiger or a white lion. The chief of the five great kings.

- Choi-chung, director of oracles: with two arms holding a knife or a lasso, mounted on a yellow lion or a white elephant; in the latter case he is blue.
- Dra-lha, protector of warriors: holds a vajra and a *khakkara*. He is mounted on a blue lion or a yellow horse.
- Klu-dbang, protective deity of the *Nāgās*: he is mounted on a blue crocodile or mule.
- Tha-'og-chos: mounted on a black horse, brandishing an axe.

In paintings, these five kings often accompany the portrait of Padmasambhava, and are sometimes symbolized by their chief, Pe-har. Their attributes and origins are not entirely clear; they could be substitutes of the Lokapālas.[8]

YI-DAMS

These are the tutelary gods of Tibet and of Lamas, invoked by persons for protection during certain acts or during certain periods of their life. They are nearly always represented with their Śakti, although some of them, among the most important, may be represented alone and even worshipped separately. They are either gentle, and in this case represented with the ornaments of the Bodhisattva; or angry, wearing crowns of skulls. They bear the Tantric symbols and, with exceptions, are generally blue in colour. They are extremely numerous, since each deity of the Tibetan pantheon can be adopted as a Yi-dam by a person for his protection; they correspond somewhat to the *iṣṭa-devatā*, 'personally chosen deity', of Northern Buddhism. They may be extrapolations of the Jinas and Vajrasattva, or of Mañjuśrī (in this case called Mañjuvajra and Yamāntaka), Vajrapāṇi (under the name of Mahācakra), or Kuvera Vaiśravaṇa (under the name of Jambhala). But they may also be independent deities. However, the Yi-dams listed below have specific personalities.

Hevajra

Hevajra
(Tibetan, *Kye-ba Rdo-rje*; Mongol, *Kevajra*)

This deity, who was worshipped in Tibet, Mongolia, Cambodia and Thailand, does not appear to have had a cult in India, China or Japan. Only the Tantric sects of India may have worshipped him, but we have no Indian representation of him. He is usually represented in a dancing attitude, with four legs (often joined in pairs in the statuettes), eight heads (sometimes reduced to seven) and 16 arms. In Cambodia, especially at Angkor where some effigies of him have been found, he is not always in a dancing attitude. His 16 hands hold various ornaments, all of which are Tantric, usually supported by cups. These cups sometimes do not contain attributes, but representations of animals in the right

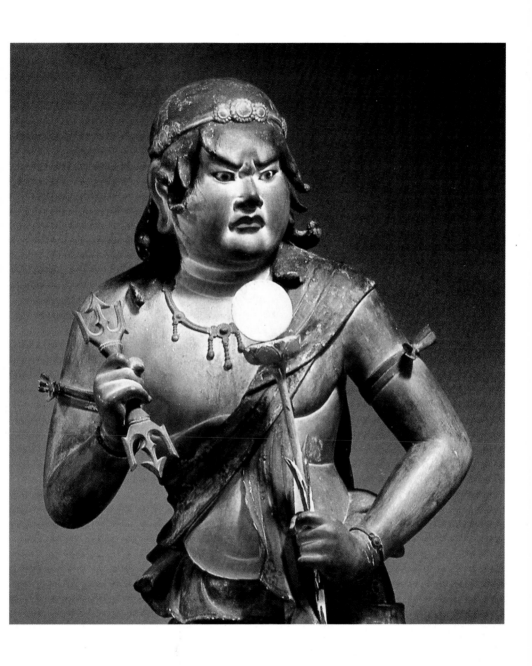

Ekō Dōji, coloured wood, Japan, 1197

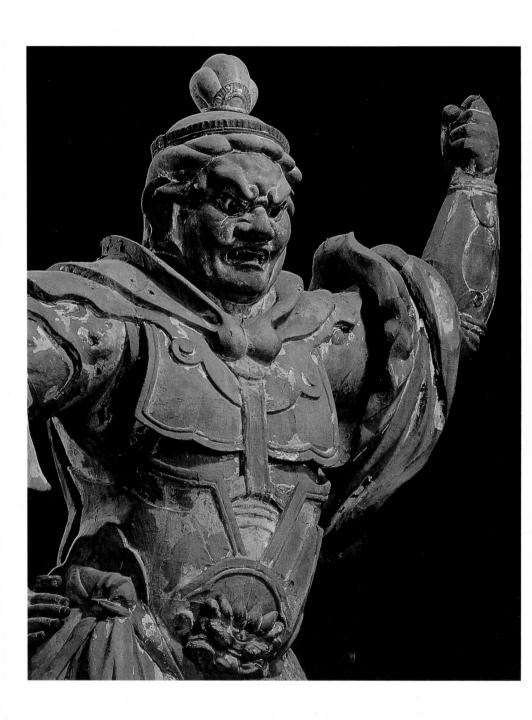

One of the Shi Tennō, coloured wood, Japan, thirteenth century

hands, and of divinities in the left hands. The feet that support him are placed on human bodies. In Thailand, however, some statuettes show Hevajra with only two legs, though it is possible that the pairs of legs have become merged. Similarly, in Cambodia, the image of Hevajra engraved on stele sometimes has two legs and five heads only, perhaps for simplification. His body is blue, and his heads have different colours. He is sometimes represented alone, but is usually in Yab-yum with his Śakti, who holds a chopper in her right hand. The personality of Hevajra is not very clearly defined, and his worship, although formerly quite popular, has remained rather obscure.

Saṃvara
(Chinese, *Sanbaluo*; Tibetan, *Bde-mchog*)

Saṃvara is thought to be a hypostasis of Akṣobhya, and represents the condensation of all the productive seed-syllables (*bīja*) and the principal deities. He was worshipped in China as incarnated in the person of the chief priest of Tibetan Buddhism in Beijing, and in Central Asia (e.g. in the frescoes of Turfān) as well as in Tibet. He has five heads of different colours, each wearing a crown of skulls. A small image of Akṣobhya may be found in the headdress of the central head. These heads have a third eye and a ferocious expression. He is generally represented standing, the feet firmly placed on a four-armed woman (on the left) and a four-armed man (on the right). He has twelve arms, two of them holding the bell and the vajra, two in Vajra-hūm-kara mudrā, two holding an elephant skin, the others a head of Brahmā and Tantric symbols. He is blue in colour. His Śakti, Vajravārāhī, who clasps him in a tight embrace, is naked, red, and holds a chopper and a skull cup. She may have a small image of Vairocana in her headdress.

Saṃvara

Mahāmayā
(Tibetan, *Tsangs-pa*; Chinese, *Dahuan Jingang*; Japanese, *Bon-ten*)

This Yi-dam is a Tibetan form of Brahmā, the discriminating Indian god. He has four heads (each with a third eye), four arms holding two skull cups, a bow and an arrow. He is represented with his Śakti, Buddhaḍākīnī, in Yab-yum, at the centre of a lotus, and is usually surrounded at the four cardinal points by four other Ḍākīnīs (Vajraḍākīnī, Ratnaḍākinī, Padmaḍākīnī and Viśvāḍākīnī) with a wrathful expression. Mahāmayā is often represented seated, but sometimes in a dancing attitude, tightly embracing his Śakti.

Kālacakra
(Tibetan, *Dus-'khor*; Mongol, *Chag-un Kürde*)

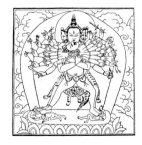

This is the deification of one of the divisions of the Tibetan *Kanjur* (*Bka'-'gyur*). Although this god is nearly always represented in the paintings

Kālacakra
Tibetan engraving

of the assembly of the gods, he is rarely represented alone, except on temple banners. Kālacakra is then invariably in a tight embrace with his Śakti. He usually has four heads, and may have two or four arms, while his Śakti has four or eight. His body is blue, and that of his Śakti orange. In some cases, however, the body of Kālacakra may also be in three colours (red, white, blue). He always carries a vajra, a sword, and sometimes, in very rare cases where he has more than four arms, various Tantric symbols. He walks on demons or four-armed personages holding a bow, arrow, trident, etc. His heads may be of different colours.

Guhyapati

(Tibetan, *Gsang-'dus*; Chinese, *Guanzizai Bimifo*)

This 'lord of secrets' is a Tantric form of Vajradhāra, and a popular Tibetan form of Vajrapāṇi (see Chapter VII).[9] He is represented seated, with three heads crowned with the five-leaved tiara. He has six arms and his hands hold a *cakra* (sometimes on the central leaf of his crown), a jewel (sometimes placed on his chignon), a vajra and a bell. He clasps his Śakti in Yab-yum, and she also has six arms, and her hands hold the same symbols. She sometimes has a small image of Amitābha in her crown. Deeply worshipped in Tibet, this form, although known in China, does not appear to have been popular except among the Tibetan Buddhists of the high plateaux.

DEVAS

(Japanese, *Ten, Tennin*; Chinese, *Tianshen*; Tibetan, *Lha Yi-dam*; Mongol, *Tegri*; Thai, *Tep, Deb*)

Devas are gods inhabiting the celestial stages of the world, and most of them are borrowed from the Indian pantheon.[10] As we have seen, early Buddhism did not deny the existence of gods, but merely considered them to be spiritually inferior to the Buddha. The gods of Buddhism are not saviours, but beings with more power than humans. They live in pleasure for extremely long lives, but are nevertheless ultimately subject to the cycle of rebirth and suffering. They may be worshipped for material gain, and the earliest Buddhist literature contains stories of their service to the Buddha, and their promotion and protection of Buddhism. Thus we find the gods of the Indian pantheon assisting at all the major events in the life of the Buddha, more as attentive servants than as followers. Tibet, followed by China, Korea and Japan, made a choice from among these representations which were offered to them, and developed certain divine forms according to their preferences; these were then endowed with a Buddhist colour. It seems that their worship truly spread only from the time when the esoteric sects expanded, first in China and Tibet, and then later in Japan. Many deities thus adopted assumed syncretic forms.

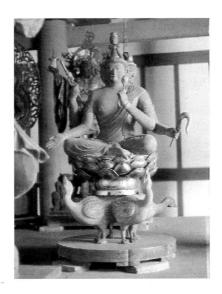

Bon-ten (Brahmā)

Subsequently, many of the Devas were merged, in the popular mind, with gods of local folklore, and the attributes and powers of the latter were added to those of the imported deities. This was particularly the case in Japan where, from the early ninth century, several syncretic Shintō Buddhist movements were created. Many Devas were never represented, except in maṇḍalas, and consequently were not popularly worshipped. Others were worshipped only by esoteric sects or in very specific cases. Yet others were adopted only locally. Some of these Devas were collectively worshipped by the people who, while preserving the individuality of each, nevertheless worshipped them together. The other Devas not belonging to these groups – especially, in Japan, the group of *Jūni-ten*, 'the twelve Devas' – were also venerated on certain occasions. From among them, some, called 'bestowers of children' (Japanese *Koyasu*), are still worshipped today. Some of the latter are designated by the people as Bodhisattvas, indicating the level of esteem in which they are held, but they are only prayed to for the same favours as those asked from the other Devas: hence they are merely forms of Bodhisattvas or deifications of personages of the Buddhist legends (often originally demons, such as Hārītī).

Only the most important are described here, notably those who were or still are worshipped or are the subject of representations in the Buddhism of the Northern schools. In the Buddhism of the ancient schools, the Indian Devas are not usually represented any differently from how they were by other contemporary Indian religions: they are always accessory personages, or more simply celestial beings, in representations of the Buddha.

Devas represent the first of the eight classes of supernatural beings (Japanese *Hachibushū*) mentioned in the Lotus Sūtra as being protec-

tors of the Buddha and the Law, victoriously waging war on opposing forces. The other seven classes are defenders and guardians (see Chapter IX).

The Twelve Great Devas

Of the twelve Devas (Japanese *Tohōki*), eight correspond to the eight directions, while four personify the earth, sky, sun and moon.

1 East: Indra (Japanese *Taishaku-ten*)
2 South-east: Agni (Japanese *Ka-ten*)
3 South: Yamarāja (Japanese *Enma-ten*)
4 South-west: Nirṛti (Japanese *Rasetsu-ten*)
5 West: Varuṇa (Japanese *Sui-ten*)
6 North-west: Vāyu (Japanese *Fū-ten*)
7 North: Vaiśravaṇa (Japanese *Bishamon-ten*)
8 North-east: Īśāna (Japanese *Ishana-ten*)
9 Sky: Brahmā (Japanese *Bon-ten*)
10 Earth: Pṛthivī (Japanese *Chi-ten*)
11 Sun: Sūrya, Āditya (Japanese *Nitten*)
12 Moon: Candra, Soma (Japanese *Gatten*)

In Japan, their images were first painted on processional banners, to replace costumed personages during the important ceremonies in which they appeared.[11] According to the Chinese text of the *Gongyangshi'er Daweidetian Bao'enbin* (Japanese *Kuyō Jūni Daiitoku-ten Hōon-bon*): 'all the Devas, as numerous as they may be . . . are represented in the twelve Devas'; they are 'manifestations of the Buddhas of yore wishing to guide all beings'.[12] Most are found in the external quarters of the Garbhadhātu Maṇḍala.[13] They are also represented in specific maṇḍalas in their own right or as acolytes of major deities. Some also received special worship. Apart from these twelve (discussed below, except for Yamarāja and Vaiśravaṇa, for which see pp. 253 and 242), the following were also worshipped to some degree in Northern Buddhism:

- Mahākāla (Japanese *Daikoku-ten*; see 'Seven gods of good luck', p. 237).
- Sarasvatī (Japanese *Benzai-ten*, *Benten-sama*; see p. 221).
- Mahāśrī, Śrī or Lakṣmī (Japanese *Kichijō-ten*; see p. 228).
- Skanda, Kumāra, or Kārttikeya (Japanese *Ida-ten*, *Kumara-ten*).
- Vināyaka (*Gaṇeśa*, Japanese *Kangi-ten*).
- Mārīcī (Japanese *Marishi-ten*; see p. 224).
- Āryajānguli (Japanese *Jōguri-dōjo*; see p. 227).
- Viṣṇu (Japanese *Bichū-ten*).
- 'bestowers of children' (see p. 178).

Indra

Indra (Japanese *Taishaku-ten*, *Indara*), meaning 'lord', is the most pow-erful lord of the Devas of Kāmadhātu (world of Desires). He is also called Śakra, 'the mighty one'; Śakra Devendra (Japanese *Shakudaikanin*), 'chief of the gods'; Śakra Devendrānām, 'chief of the lords of the gods', and Mahendra, 'the great lord'.[14] He is the master of the East, the chief of the guardian kings, the Lord of the Heaven of the 33 Gods, 'He who bestows wealth and power'. In certain *sūtras*, he is also Vajrapāṇi, the attentive servant of the Buddha.[15]

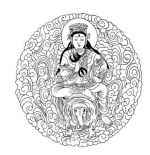

Indra

Although the texts[16] and canonical images[17] describe and show him in different ways, and with various attributes, he does not appear to have been represented in China or Japan in accordance with these models or the letter of the texts. In Japan, Indra ceased to be the object of wor-ship separate from that of the twelve Devas as a group after the appear-ance of the esoteric sects in the ninth century, except in a few cases, such as at the Nichirenite Shibamata temple, east of Tōkyō.[18] In China and Tibet, he is represented by Vajrapāṇi. In China he is also sometimes merged with the Precious Emperor Yüdi (also named Yühang Shangdi), when he is called Dishi or Yühuang Dadi by Taoists.

Theoretically he sits in the company of the other Devas, on Mount Meru,[19] very often in the company of Brahmā, depicted as a warrior wearing armour, with a celestial scarf, seated or standing on a white ele-phant[20] which holds a vajra with its trunk. His head is adorned with a single chignon; his face is that of a Bodhisattva. He holds a vajra at his breast, and his body is the colour of gold.[21] He is also represented in Japan wearing a long, wide-sleeved, belted robe, shoes on his feet, with the right hand in Abhaya mudrā, the left in Varada mudrā.[22]

In painting, he is shown seated in royal ease on the back of a white elephant in the midst of a cloud of five colours, especially in maṇḍalas. In this case, his right hand holds a vajra (with three or five points), and his left fist is pressed against his hip. He has a third eye, being considered as the chief of the Devas of the 'three worlds' – the earth, the heaven and the space between. In a few rare images, he is represented stand-ing on a lotus leaf, holding a vajra in the right hand, and a covered bowl in the left.

Agni

(Japanese, *Ka-ten*; Tibetan, *Me-lha*; Chinese, *Zhurong Dadi*)

Agni (Sanskrit for 'fire') is the Vedic deity of the sacrificial fire, and the governor of the South-east. In the *Mahāvairocana-sūtra*, he is consid-ered as one of the forms of Vairocana;[23] according to the esoterism of the Shingon sect, he symbolizes the destruction by the 'fire of wisdom of the *Bodhicitta*' of the three obstacles on the path to Awakening: illu-sion, activity and suffering.[24] In Vedic sacrifice he acts as intermediary with the gods by carrying the oblation to the other gods: his innate nature is the very flame of the sacrificial fire.

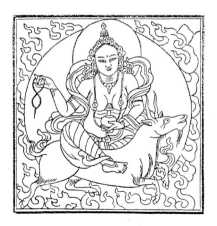

Agni
Tibetan engraving

Ka-ten (Agni)

Although this deity was known in Tibet, where he is one of the forms of Hevajra, and also in China, he does not appear to have been an object of worship separately from that of the twelve Devas in these regions. On the other hand, his representations are found quite frequently in Japan, where he is normally shown as a bearded old man seated on a blue ram[25] in the midst of flames. His colour is bright red and his hair is knotted into two chignons. He may have two or four arms[26] which symbolize the four 'wisdoms' of Vairocana. In his right hands he holds a staff, a vase or a branch, and in his left a rosary; one left hand is in Abhaya mudrā.

The Hizōki[27] describes him in the Vajradhātu Maṇḍala[28] as having the 'form of a bright red seer [Sanskrit ṛṣi], holding the staff of a seer in the right hand and in the left hand the emblem of the Knowledge of fire'. In the *Mahāvairocana-sūtra* he is described as carrying a rosary and a vase of water. He has three ashen spots on the forehead, and his breast is marked with a triangle, the symbol of fire. He is very seldom represented except in maṇḍalas because he is no longer an object of worship independently of the twelve Devas as a group.

Nirṛti
(Nairṛtirāja; Japanese, *Rasetsu-ten*)

Rasetsu-ten (Nirṛti)

Nirṛti, originally a Rākṣasa and not a Deva, is sometimes considered as the chief of the Asuras. This man-eating deity is supposed to devour the passions.[29] Japanese esoteric Buddhism made him a Deva who, in the Vajradhātu Maṇḍala, is merged with Ketu, one of the two demons of eclipses. According to the *Hizōki*,[30] he is red in colour and holds a club in his hand.[31] He normally presides in the South-west. He is represented in paintings wearing Chinese armour, seated on a lion, or as a bearded old man, his hair dishevelled, holding a vertical sword or a staff in his right hand, with the left hand closed, the forefinger and the middle finger extended.[32] He is not the object of independent worship.

Varuṇa
Tibetan engraving

Sui-ten (Varuṇa)

Varuṇa

(Japanese, *Sui-ten*, *Suisen*; Chinese, *Shui-sen*; Tibetan, *Chu-lha*)

Varuṇa is the ancient Vedic god of the waters, the 'governor of the West'. According to Manu, he 'ties the guilty with ropes'; he is also called Nāgapāśa, the 'magic rope of the *Nāgas*' (Japanese *Ryūson*, the Venerable Dragon). The Vajradhātu Maṇḍala places him in the South-west, assigns him a blue or a grey-green colour, and has him mounted on a nine-headed dragon. He is represented in Japan, especially in painting, seated on a turtle or dragon in the midst of the waters.[33] Serpents emerge from his hair. His right hand is closed or holds a sword vertically, and his left hand holds a rope or a serpent. He sometimes stands on a turtle or a dragon, holding a rope in the hand, or seated and holding a lotus supporting a triple jewel. Some consider him to be a healer and a protector against illness. He is not the object of any particular worship. In Tibet, he is known only as one of the acolytes of Hevajra. He does not appear to have been well known to Chinese Buddhists.

Vāyu

(Japanese, *Fū-ten*; Chinese, *Feilian*)

Vāyu is the ancient Vedic god of the wind. He presides over the North-west and is considered to be a protector against natural catastrophes. He was represented on the frescoes of the Dunhuang caves in China, among other places, although he does not appear to have been specially worshipped in Tibet or China. In the Vajradhātu Maṇḍala, he is shown light blue in colour and wearing a vajra in his headdress. In painting, he is represented seated on a deer in the middle of clouds, clothed in the Chinese manner, with wings in his hair. He sometimes also wears armour, holding a lance or a simple vajra in his right hand; in this case, the closed left hand is placed on his hip. In some paintings, he is represented as an old man with red skin,[34] wearing capacious floating garments or holding in his left hand a banner flapping in the wind.

Vāyu
Tibetan engraving

In Japan, Fū-ten is often confused with Fūjin who, with Raijin (also called Kaminari, the god of thunder), is associated with the 28 'acolytes' of Senju Kannon Bosatsu (see p. 169).[35] It is difficult to state

Raijin
Wood, Myōhō-in, Kyōto,
Japan, thirteenth century

Fūjin
Wood, Myōhō-in, Kyōto,
Japan, thirteenth century

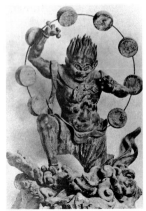 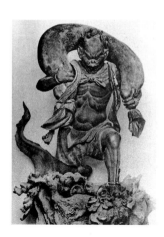

Fū-ten (Vāyu)

to what degree they actually differ in the popular mind. Fūjin and Raijin have often been represented in sculpture and in painting in Japan, yet their form is Chinese. Their statue sometimes replaces that of the Ni-ō at the gates of certain temples or Shintō sanctuaries, with Fūjin blowing away the evil influences and Raijin frightening the evil spirits with his drum rolls. Fūjin carries a large wind-filled sack on his back. Raijin carries two double mallets with which he strikes a series of small drums placed in an arc about his head in order to produce thunder. His body is green; Fūjin's is red. These two gods are those of the Shintō sanctuary of Kamo-jinja in Kyōto.

Neither Fū-ten nor Fūjin is individually worshipped (like Raijin or Rai-ten). Fū-ten is collectively venerated in the group of the twelve Devas, and with that of the Nijūhachi-bushū of Senju Kannon Bosatsu.

Īśāna

(Japanese, Ishana-ten, Jizai-ten, Makeishura-ten)

This deity, who presides in the North-east, represents the wrathful aspect of Śiva, the Indian god of destruction. In Japan he is sometimes syncretically identified with Izanagi,[36] one of the two originators of the islands of Japan, according to Shintō mythology. As Maheśvara, Īśāna is considered in esoteric Buddhism as one of the eight protectors of the world; in this form he presides in the South-west in the Garbhadhātu Maṇḍala, where he is also merged with Viṣṇu or the form of Viṣṇu called Nārāyaṇa. He is not the object of particular worship, and is invoked only in connection with the group of the twelve Devas.[37]

Associated with this deity is his consort, the goddess of dance and the arts, Devī (or Vāk), said to have been born from the fringe of Śiva Maheśvara's hair. This deity was formerly worshipped in Japan by the name of Gigei-ten (sometimes later confused with Benzai-ten Sarasvatī). Very seldom represented, there appear to be no images made after the

Ishana-ten (Īśāna)

ninth century. In sculpture,[38] she is shown as a young, pretty, smiling woman, with a high chignon. In painting, she stands on a lotus leaf, wearing a Chinese robe and shoes, her hair falling over her shoulders and a tiara on her head.[39] Her right hand holds a fold of her robe, her left supports a bowl of lotuses at shoulder level. She is no longer the object of any veneration in Japan, and probably never enjoyed popular favour, because Kichijō-ten and Benzai-ten performed similar functions.

Brahmā

(Japanese, *Bon-ten*; Chinese, *Fantian-wang*; Tibetan, *Tshangs-pa Dkar-po*; Mongol, *Esrua, Esrun Tengri*; Khmer, *Ta-Prohm*)

Brahmā is the chief of the world and the most glorious of the Devas: the ruler of heaven. In Brāhminical religion, he was originally the supreme deity, the first member of the Hindu triad of Brahmā, Śiva and Viṣṇu, the supreme spirit and creator. His influence subsequently declined with the expansion of the cults of Śiva and Viṣṇu. His cult does not appear to have enjoyed much favour in Tibet or China, whereas in Japan it existed very early, although it was very soon abandoned.

Before the Heian period he is often represented in the company of Indra. He is then dressed as a warrior in Chinese armour with a celestial scarf, or in a long, wide-sleeved robe, the feet hidden, in a standing posture, or sometimes seated on a lotus borne by four sacred geese (Sanskrit *haṃsa*). He has a serene expression, his forehead has a tuft of white hair (*ūrṇā*) and he wears a high crown around his hair. His right hand is in Abhaya mudrā, his left in Varada mudrā, or sometimes the reverse. He may also be represented holding a book in the left hand. He sometimes has four heads and four arms, as in Indian representations of him. One right hand is then in Varada mudrā and the other holds a lance. One left hand holds a lotus, the other a vase of ambrosia. He is no longer the object of separate worship.

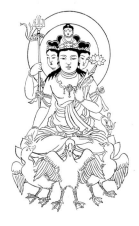

Brahmā

Pṛthivī

(Japanese, *Chi-ten*)

This deity, personifying the Earth, is also called Dhāraṇīdhārā (Japanese *Jishin* or *Kenrō-jishin*). Although one of the twelve Devas, she represents no particular horizon. She is chiefly associated with Vaiśravaṇa whose Japanese effigy, called Tōbatsu Bishamon-ten, she supports with her two hands. In painting, she is represented seated in Padmāsana in the midst of clouds, wearing a tiara, her hair tied into a high chignon leaving locks to float on her shoulders. She may have two or four arms,[40] the right hand holding a bowl full of seeds or placed on her breast, the left hand in Varada mudrā or holding a bowl of flowers, or sometimes a bowl and a lance. Seldom represented, she is not the object of any worship.

Chi-ten (Pṛthivī)

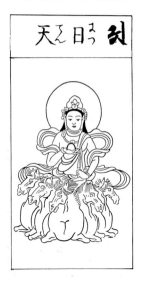

Nitten (Sūrya)

Sūrya

(Āditya; Japanese, *Nitten*; Tibetan, *Nyi-ma*; Thai, *Phra Atithi*)

This deity, personifying the Sun, is very rarely represented in Buddhism, except in Japan, where he is described as seated on a lotus placed on five or eight horses, or carried in a horse-drawn car. In the Vajradhātu Maṇḍala, he is sometimes mounted on a single horse, holding the sphere of the sun before him,[41] his closed left hand placed on his hip. In painting, he is also represented standing on a lotus leaf and wearing a long floating robe in the Chinese manner, possibly bearing a lotus in each hand. He is sometimes also given a solar nimbus with short flames. Two genii may also serve him as acolytes.[42]

In the sculpted *Sankō-ten Mandara* (maṇḍala of the Three Lights) of the Nichiren sect, he is represented with Gatten (see below) and these two deities are then merged with Nikkō and Gakkō Bosatsu. The light in the centre is then called Aruṇa, 'dawn' (Japanese *myōjō-tenji*). He receives separate worship only from the Nichiren sect.

Candra

(Soma; Japanese, *Gatten*; Chinese, *Yue*; Tibetan, *Zla-ba*; Thai, *Phra Chan*)

Candra is the personification of the Moon, a deity of indeterminate gender. Like Nitten, to which he is the complement, Gatten is no longer the object of particular worship in Japan, except as one of the group of the twelve Devas and of the Sankō-ten of the Nichiren sect.[43] Normally Candra is represented only in painting and in maṇḍalas. He is shown seated on a lotus leaf supported by three white geese. His long hair floats on his shoulders, and he wears a crescent moon in his high chignon and on his tiara.[44] He holds the lunar disc in the right hand, at the level of the breast: this disc is sometimes ornamented with the image of a hare pounding *mochi* (rice paste) in a mortar.[45] His left hand is placed on his hip.

Skanda

(Karttikeya; Japanese, *Ida-ten, Kumara-ten*; Chinese, *Weituo*)

This is one of the sons of Śiva, possibly a Buddhicization of the Chinese Lokapāla Weituo (this name possibly being the phonetic Sinization of Veda). He was adopted by Buddhism after a vision seen by a monk in the seventh century,[46] and his cult moved to Japan. A popular Japanese expression, '*Ida-ten bashira* [run like Ida-ten]' implies a very fast race: he is supposed to have caught up with a Yakṣa who, during the sharing of the relics of the Buddha on his funeral pyre, ran off with one of the teeth of the Master.[47] He is thought to be a Vihārapāla – protector of monastic communities – and is accordingly deeply venerated by Zen sects.[48]

He is usually represented as a young Chinese warrior wearing armour and a helmet, both hands resting on a sabre or a knobbly staff, or one

placed across his forearms as he joins his hands in prayer.[49] His feet are placed on the folds of his celestial scarf, in order to symbolize the appeasement of the senses; he presides over prayer, appeasement and rest. In certain monasteries, his effigy is placed in the refectory of the monks to guarantee calm and peace. This deity was never very popular, and his representations are relatively rare, although his worship has never been totally extinguished.

In China, his image is usually placed behind that of Maitreya, and is sometimes accompanied by the tutelary god Jialan, one of the Buddha's disciples. His image is also often found accompanying that of Avalokiteśvara. He is also considered in China as a protector of Buddhism, and is sometimes given the rank of Bodhisattva. His anniversary is celebrated in China on the first day of the sixth moon.

Another form of Skanda, venerated in Japan, is that of Kumāra-ten (from the Sanskrit for 'young prince'), considered to be a god of war. He is represented as a young boy, pale in colour, with a headdress of three tresses, seated on a peacock with outspread tail (the traditional Hindu aspect). In the Vajradhātu and Garbhadhātu Maṇḍalas, he has a single head and two arms, the right hand shaking a bell, the left hand closed. He is also represented in painting with two arms and six heads. His effigy is sometimes merged with that of Kujaku Myō-ō, due to their common mount, the peacock. He is a minor deity, formerly only little worshipped and now completely forgotten.

Ida-ten (Skanda)

Vināyaka

(Gaṇeśa, Ganapati; Japanese, *Kangi-ten, Binayaka, Shōten-sama, Tenson-sama*; Tibetan, *Log-'Dren*; Thai, *Vinatok*)

This Hindu deity, sometimes a demon,[50] is mainly venerated in Japan and sometimes found in syncretic forms.[51] He is certainly one of the most difficult to grasp of the gods of the Buddhist pantheon: few writings are devoted to him, and the monks never discuss him openly. He represents the Hindu god Gaṇeśa, the elephant-headed son of Śiva. He is thought to be the son of Śiva and Āryāvalokiteśvara in a form identical to that of Umā, spouse of Śiva. A dispenser of wealth, he is supposed to have formidable power.[52] He is invoked as the protector of the state and of private individuals. Both masculine and feminine, malevolent and benevolent, he is represented by two tightly interlaced bodies (Śiva and Āryāvalokiteśvara, in the form of Jūichimen Kannon 'Kannon with eleven heads'). According to the Tantric sects, the masculine portion is merely a metamorphosis of Vairocana, and the couple represents the intimate union of the faithful with the Buddha, the principle of all things. In Chinese philosophy, the two bodies symbolize the perfect union of the Heaven and the Earth [53] or the Confucian principles of the *Li* and the *Ji*. This secret deity, introduced into Japan by the Shingon sect, was subsequently used for Tantric purposes by the Tendai sect, among others. His image is never shown to lay people. Special rites, including immersions of the statue in oil, are attached to

Vināyaka
(Daishō Kangi-ten)

Kangi-ten, Shōten-sama
Coloured wood, Tōkyō,
Japan, eighteenth century,
formerly Collection of
R. de Berval

Kangi-ten
Bronze, Tōkyō, Japan,
sixteenth century,
formerly Collection of
R. de Berval

him. In the Japanese esoteric sects, his dual nature symbolizes the intimate union of the two great maṇḍalas of the Shingon sect (*Ryōbu Mandara*).

The atmosphere of secrecy surrounding these images, 'and, in general, everything associated with the god, explains why, in the Buddhist pantheon, he is one of the very rare deities who inspires fear in the Japanese'.[54] Kangi-ten is represented by effigies, generally small; these are usually of metal (due to immersions in oil), but wood is not excluded. His image is sometimes found at the centre of the rings of the stave of a pilgrim (*khakkara*), in the place of the small *stūpa* usually found there: this indicates that the pilgrim belongs to a Tantric sect. Kangi-ten may represent a fairly large number of forms that can be classed under two main headings: esoteric and exoteric forms.

Esoteric forms. Kangi-ten has a dual nature, especially in Tantrism.[55] He is therefore represented by two human figures with the heads of elephants, face to face and tightly interlaced. Their sexual organs are occasionally apparent and joined.[56] They wear a cloth thrown over the shoulders, and their hips are also covered. The feminine element wears a simple crown (or tiara), jewels and bracelets, and her feet step on those of her partner. This feminine body is supposed to be a metamorphosis assumed by Avalokiteśvara to contain the fearful energy of Vināyaka and to make it beneficial. Her right tusk is broken. Both bodies are white. At least three forms are known.

- Heads cheek to cheek and looking in the same direction, trunks intertwined.
- Heads resting on the right shoulder of the complementary deity, and looking in opposite directions.
- The male with an elephant's head, and the female with that of a wild sow (very rare and secret).

These forms are worshipped secretly because they are supposed to possess terrifying power. They are carefully sheltered from view in small portable sanctuaries (Japanese *zushi*) in the temples of the esoteric sects.

Exoteric forms. These forms usually consist of a single male figure, without a female counterpart. They are less secret and are usually venerated by individuals who attribute great power to them. They may assume several forms.

- A single human figure with an elephant's head (Gaṇapati). He is seated, with two arms, and holds various ornaments:[57] in the right hand a Japanese radish (*daikon*), in the left a ball of thread, a parasol, a bow and arrows, a rosary and a sword.
- With four arms and four legs (sometimes Tantric).[58] In his right hands he holds an axe, a ball of thread (sometimes on a tray) or

a rope and a trident. In his left hands he holds an elephant's tusk
or a stick, or an axe and a single-pointed vajra.
- With six arms. His head is turned to the left, the trunk raised, the
 right tusk broken, the body orange or red.[59] In his right hands he
 holds a stick, a rope, an elephant's tusk (or a needle). In his left
 hands he holds a sword, a tray of fruit (or a ball of thread) and a
 cakra.
 - Standing on a rock, with four arms.[60] In his right hands he carries
 an axe and a ball of thread, and in his left hands a rope and a knife.
 - Standing on a rock, with six arms.[61] His right hands hold a five-
 pointed vajra, a rope and a sceptre or a stick. His left hands hold
 a sword with the hilt ornamented with a five-pointed vajra, a ball
 of thread and a *cakra*.

These forms are far from being the only ones, because not all of them
are known, and the significance of their attributes is also unknown.
Kangi-ten is specially venerated in the Matsuchiyama sanctuary at
Asakusa, Tōkyō, and in the Ikoma sanctuary in Nara.

He does not appear to have been the object of a special cult in Tibet;
in fact, his image is found only in the form of Gaṇeśa, as a demon, hold-
ing a flower, a rat or a skull cap, under the feet of one of the forms of
Mahākāla. His cult does not appear to be attested in China, although
it is almost certain that this complex deity was venerated secretly in the
temples of the esoteric sects.We do not, however, have a single image
of him from China to the best of our knowledge.

MINOR AND SYNCRETIC DEITIES

Many other deities exist in the Buddhist pantheon, all of them more
or less theoretical, described only in the texts or sometimes also rep-
resented in maṇḍalas, but never objects of worship. They are usually
minor Hindu deities that were given Buddhist identities for expediency,
and that represent either protectors of Buddhism, or demons obstruct-
ing the spiritual development of man.

Apsarās
(Japanese, *Tennin, Hiten*; Thai, *Tevoda, Nang-fa*;
Tibetan, *Lha'i Bu-mo*; Chinese, *Tiannü, Feitian*; Khmer, *Tepanom*)

The Apsarās are celestial beings, which are not in fact deities subject to
worship, but merely the servants of the Devas. Mostly they are
dancers or musicians, and were widely used for the decoration of tem-
ples and sanctuaries, especially in Thailand, Burma and Laos. They are
usually represented from the front, crowned with joined hands, on the
ends of tiles and on various other decorations. In Cambodia, they are
usually dancers lavishly decorated with jewels and headdresses, and bare

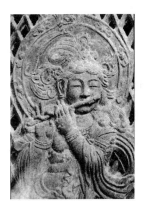

An Apsarās musician
Bronze lantern, Tōdai-ji,
Nara, Japan,
eighth century

to the waist. Some statues of them adorn the niches of the walls of Buddhist and Brāhminical sanctuaries. Throughout South-East Asian art, they probably symbolize the tutelary genii and the genii of the soil. They are not specially worshipped, although people do accord them some veneration by placing flowers, water and rice at their feet.

In their normal representations, particularly in China and Japan, they are found standing on lotuses, seated or standing on clouds. They are then sometimes treated as Bodhisattvas, as in the sculpture on the walls of the Hōō-dō of the Byōdō-in at Uji in Japan, or on lanterns (Tōdai-ji, eighth century). They usually wear light and floating celestial garments, embellished with scarves of gauze (Japanese *tenne*), and sometimes play musical instruments. Their attitudes are not codified by the texts, and are accordingly extremely varied. They are often represented in an attitude of flight, in aerial, graceful poses, either on bas-reliefs (bronze bells, as for example the bell of the King Seong-deog of Korea, cast in 771 at Gyeong-ju), or in open-work decoration (Sui-en of the pagoda of Yakushi-ji in Nara), or in many paintings accompanying the images of the Buddha or the Bodhisattvas. One of their earliest representations adorns the upper corners of the halo surrounding the famous 'preaching Buddha' of Sarnāth, in India.

Syncretic Deities of Japan

These deities are the result of Shintō Buddhist syncretism. Since Shintō is aniconic, it represents the Kamis or 'spiritual forces' only by symbols, such as a mirror, a sabre, or jewels. In the ninth century, the Japanese Buddhist monks, wishing to recruit specifically Japanese deities to the side of Buddhism, conceived the idea of creating syncretic deities for the cause. These *Gongen* or *avatāra* ('descents' or 'incarnations') are temporary incarnations of the Kamis in the Buddhist deities. Many Shintō deities were included in the Buddhist pantheon in this way. The Japanese syncretic deities belonging to the Suijaku or Doctrine of Descent, in which the traditional deities or Kamis are merged with those in Buddhism of whom they are thought to be the emanations or 'descents', were quite popular, especially among the priests following the doctrines of the Shugendō[62] or Way of the Yamabushi (monks of the mountain) since the ninth century.

Since religious art forms had been developed to satisfy the needs of these particular cults, new deities were thus created. Among them, the most common are Zaō Gongen, Shōmen Kongō, Sanbō Kōjin and Sōgyō Hachiman-shin. Special maṇḍalas were accordingly designed, such as the *Kasuga Shika Mandara*, the *Ikoma Mandara* and the *Kumano Mandara*. In the Kamakura period (1185–1333), many syncretic images were executed to illustrate the forms of these deities, usually in engraving or in bas-relief, particularly on round mirrors meant to be suspended (*kakebotoke*).

In Japan, other deities, belonging to Shintō Buddhist syncretism, are

sometimes difficult to classify accurately in a specific category: these *Gongen* of Buddhist deities in the Kamis of Shintō are nevertheless thought to be temporary esoteric creations. Others are Buddhicizations of Shintō Kamis, for example Sōgyō Hachiman-shin.

Zaō Gongen

Zaō Gongen (see p. 95) occupied an important place in Japanese Buddhism, but now seems to be nearly forgotten, except perhaps by certain esoteric sects observing the Shingon and Tendai doctrines. He appears to have been originally a Bodhisattva, and became its incarnation in the Ryōbu-Shintō; he is is also called Kongo Zaō, Himitsu Kongō ('secret Vajra') and Tokkyō Kongō ('He who bestows a special teaching').[63] Under the influence of Shintō, he was transformed from a Bodhisattva into a Vidyārāja. A temple was dedicated to him in the form of Gongen on Mount Kinbu, where he was deeply venerated by the Yamabushi (ascetic warrior monks of the mountain) in the thirteenth and fourteenth centuries.[64] The *Taiheiki* offers a precise description: 'He appeared in the form of a very strong and very furious being, holding a vajra in his right hand, the elbows raised by anger, the left hand with fingers separated clasping his hip, the face charged with indignation; he seemed to subjugate the demons who posed obstacles to the Law; with his feet raised high, he struck the ground while deploying all the virtues of Heaven and Earth.'[65]

He is now hardly found as a Bodhisattva, but chiefly as a Vidyārāja.[66] Added relatively late, he is included in the two-part maṇḍala of the Shingon sect. In the Garbhadhātu Maṇḍala, as Kongō-zō, he is found among the 'vajra bearers' (Vajradhāra) to the south of the Five Jinas, and is merged with Vajrasattva. In the Vajradhātu Maṇḍala, he is placed in the inner enclosure of the *Samaya Maṇḍala* and is one of the sixteen Bodhisattvas of the Bhadrakalpa. He is also represented in the *Sukṣma Maṇḍala* and in the *Pūjā Maṇḍala*. However, Zaō Gongen is thought to have been incorporated in these maṇḍalas only in the Kamakura period.

When this Vidyārāja is treated as a Bodhisattva, he is sometimes identified as being a form of Kṣitigarbha.[67] He is also considered to be a wrathful form of Śākyamuni Gautama. However, his most widespread form is that of a terrible deity.

Yoshino Zaō Gongen

Shōmen Kongō

This is perhaps a form of *Gongen* of Gundari Myō-ō or of Daigensui Myō-ō. He is represented standing with a necklace and bracelets of serpents, wearing a furious expression. His hair is bristling, fangs protrude from his mouth, and he has a third eye. He is thought to punish malice and to wage war on the demons of sickness. This deity is represented with six arms and sometimes three faces, the upper hands holding the sun and the moon above his head, the right hands holding objects including a sword sheathed in a vajra; the other left hands are in a fist

**Shōmen Kongō
(Ten-ō-ji Kōshin no Zō)**

Shōmen Kongō
Stone, Sendagaya-ku,
Tōkyō, Japan,
eighteenth century

Shōmen Kongō

of anger at the breast and holding a *cakra*.

As a popular deity, Shōmen Kongō is the principal deity of the Kōshin-shinkō, a separate cult created in Japan at the end of the middle ages on the basis of Taoist concepts. In this cult, he is also named Kōshin. In a popular custom, he is offered large straw sandals (*waraji*), because he is thought to wear out many shoes during his long journeys in pursuit of the wicked and of demons. He is sometimes represented with a blue face, holding a bow, arrows and a sword.[68] Two children (Dōji) and four Yakṣas serve him as acolytes. Often represented on the rock-support of his images are effigies of the 'three monkeys' (Sanbiki-zaru), who 'see no evil, hear no evil, speak no evil', which became popular in the sixteenth and seventeenth centuries.[69] Sometimes merged with the Kamis of the Shintō Saruta Hiko (in the Hie sanctuaries), these monkeys are often considered as messengers of the Kamis.

Sanbō Kōjin

This popular syncretic deity 'of the three treasures' also belongs to the Suija-ku doctrines. Very few representations are found before the Muromachi period (fifteenth century), and then chiefly in paintings. He is the god of the home, of the kitchen (sometimes also confused with Mañjuśrī). His origin is indeterminate, but he is probably the Buddhicization of a Kami. He may have three forms.

- With a smiling face, identical to Vajrasattva, but with eight arms and, in addition to the attributes of Vajrasattva, a *stūpa* and a lotus in his right hands, a *cakra* and a jewel in his left hands. He is then named Nyorai Kōjin. His principal hands are in the mudrā of the Six Elements, and he is said to be a form of Vairocana.
- With a wrathful face, eight heads, six or eight arms. When he has

Sanbō Kōjin

272

only six arms, he has the same attributes as in his smiling form, but without the hands in Chiken-in, and he is then named Sanbō Kōjin.

- With four arms, a high crown, carrying a jewel and a *cakra*, he is called Kojima Kōjin.

Sōgyō Hachiman-shin

This priestly Kami 'with the eight banners' is a Buddhicized form of the Kami of war, Hachiman (or Yahata, Yawata), who was enthroned as a god protector with the title of 'Great Bodhisattva' at the temple of Tōdai-ji, Nara, in 749. Subsequently, he became the special god protector (*Ujigami*) of a branch of the Minamoto family descended from the Emperor Seiwa. This Hachiman Daimyōjin is originally thought to have been the Kami of the Emperor Ōjin, the fifteenth according to the traditional list, and then became the god of war as Yawata. In Chapter Four of the *Taiheiki*, the Emperor Go-Daigo is found on the road to exile stopping in front of a sanctuary dedicated to Hachiman praying to 'the Bodhisattva Hachiman' to grant peace and safety to generations of emperors. He is usually represented as a Buddhist monk, seated in the tailor's attitude, his feet hidden by his robe, head shaved, with a round halo behind his head. He holds a *khakkara* in the left hand, and the right hand rests on his knee (he is then sometimes confused with Kṣitigarbha). The sanctuaries dedicated to him, called Hachiman-gū, are Usa-Hachiman-gū in Higo, Otoko-yama in Yamashiro and Tsurugaoka in

Sanbō Kōjin

Sōgyō Hachiman
Coloured wood,
Hachiman-jinja,
Tsurugaoka, Japan,
seventeenth century

Kamakura. Some representations show this deity in a seated position, clothed as a noble warrior, armed with a bow and arrows, perhaps by confusion with the Zuishin (seated noble warriors) who sometimes guard the gates of Buddhist temples or Shintō sanctuaries.

'Bestowers of children'

Many Chinese Buddhist deities also have a syncretic form, and are sometimes confused with gods of the Taoist and Confucian pantheons. They are represented in their Taoist and Confucian forms and adorn the Chinese temples belonging to these two streams of thought, but they are seldom found in Buddhist temples. Yet one category of popular syncretic deities enjoyed tremendous favour, both in China and Japan: the 'bestowers of children'.

Called Koyasu in Japan, these are popular forms of Avalokiteśvara and Kṣitigarbha, but are in fact merely special aspects that the Japanese and Chinese have attributed to certain statues of these Bodhisattvas rather than to others. But, due to their great popularity and their membership of the living Buddhist pantheon of Japan and China, they are identified here. Apart from the 'bestower of children' form of Kṣitigarbha, they are chiefly those of Koyasu, attributed to Avalokiteśvara and to a deity called Kishimojin or Karitei-mo (Hārītī).

XI

DIVINE BEINGS AND
DEIFIED HISTORICAL FIGURES

Kōbō Daishi
Wood, Japan, Kamakura period,
Musée Guimet, Paris

Protectors of the World
Astral Deities
Historical Figures
Tibetan Lamas and Great Sages
Shōtoku Taishi
Other Religious Figures

In the Buddhist pantheon, besides the recognized actual deities and the popular and syncretic deities, many divine beings and deified elements exist, gravitating around the major deities, either as guardians or acolytes, or more simply to complete in maṇḍalas an overall vision of the cosmos as conceived by the Buddhist authorities. These divine beings can be divided into two main categories: the protectors and the astral deities. Their representations are (or were) often important in Buddhist iconography. The protectors had a very important role; the astral deities were very seldom represented (and are therefore only listed here), but are nevertheless useful for an understanding of the Buddhist pantheon.

PROTECTORS OF THE WORLD

The protectors of the world (or of the Buddha and of the Buddhist Law) are traditionally divided into eight classes (collectively called *Hachibushū* in Japanese): the dragons or Nāgas, the Garuḍas, the Titans, the Yakṣas, the Gandharvas, the Asuras, the Mahoragas, the Kiṃnaras, and the Devas (see Chapter X). These eight classes of beings have not all been represented with the same frequency, even in maṇḍalas and paintings. Yet some of their images are found in sculpture, especially at the Kōfuku-ji in Nara, Japan (eighth century, lacquer, repaired in 1232), and in some other places.[1]

Dragons
(Nāga; Japanese, *Ryū*; Chinese, *Long*; Tibetan, *Klu*; Mongol, *Lus*; Thai, *Phi*; Khmer, *Neak*)

These are actually serpents, symbols of the chthonic powers associated with the element of water. In India especially, they were regarded as guardians of the treasures of the earth. Although they are minor deities, they are powerful beings, thought to possess all the sciences. According to legend, they took the great Buddhist philosopher Nāgārjuna to their realm where he rediscovered the lost Prajñāpāramitā texts – the Perfection of Wisdom Sūtras, the fundamental texts of Mahāyāna

Buddhist philosophy. The Nāga cult appears to have been propagated in China, and to have spread from there to Japan and southern India via Kashmir. Many sanctuaries were erected to these serpents: the seventh-century pilgrim Xuanzang saw one in Kashmir. These chthonic deities were adopted by Buddhism from the outset. Legend claims that a king of the Nāgas, named Elapatra, disguised himself as a human king to listen to a sermon of the Buddha. Kings of the Nāgas are depicted at the birth of Śākyamuni Gautama. One of them, named Mucilinda, is said to have sheltered the meditating Buddha during a great storm and torrential rain, by surrounding him with the coils of his body and forming a protective awning with his hood; images depicting this episode are numerous in Buddhist art, especially in South-East Asia. Other images show pairs of Nāgas, tails interlaced, or many-headed Nāgas in *stūpas*, as on the bas-reliefs of Amarāvatī in India, or accompanying images of the Buddha or of one of the Jinas, including Amoghasiddhi in Nepal. Some images show the Nāgas with a human bust and head, with a sort of aureole formed by cobra heads, and a serpent's tail, while others simply show them as cobras with one or more heads. Before the twelfth century, in India, the Nāgas were represented as human beings, but with a sort of aureole made of three, five or seven cobra heads.

Buddha on Mucilinda

The supreme king of the Nāgas is the Lokapāla Virūpākṣa, although he is not himself a Nāga. Another of their kings, Nanda, a Nāgarāja, is sometimes represented as half-man and half-serpent, either with a single head, holding serpents in his hands, or with four heads and six arms, two of which may bend a bow.

The Nāgas, in considerable numbers, are a type of benevolent genii, friends of human beings, controlling rainfall and providing protection against fires caused by lightning. In China and Japan, these qualities were assigned to dragons, although some serpents had also been venerated (sometimes they were associated with phallic cults). In Japan, in particular, a large white serpent is associated with the cult of Ugajin and of Sarasvatī (*Benzai-ten*). The Nāgas are traditionally pursued by the Garuḍas (see below).

In Japan and China, the dragon serpents (also called *Ryū-ō* or *Ryūjin*) are deities of the waters, living in the sea, rivers, lakes and clouds; they are mainly benevolent. In China and Japan, as well as South-East Asia, they are invoked in ritual dances usually performed to provoke rainfall. They are also considered to be depositories of the *cintāmaṇi*, the magic jewel that bestows treasures and gives knowledge. In these countries, they are represented with a composite body, as monstrous winged serpents with the head of a lion or a camel, ornamented with antlers. They have four reptile feet with eagle's claws. Some have no wings. The entire body is never visible, but always enveloped in clouds or only partly emerging from the water. The Chinese have several sorts of dragon reigning over different seas, each with its specific colour, or controlling rainfall, clouds, terrestrial waters and waterways. One of the largest Chinese rivers is called the Heilongjiang, 'River of the Black Dragon'.

Tentōki
Dragon, wood by Kōben,
Kōfuku-ji, Nara, Japan,
early thirteenth century

Dragon (Ryū) fountain
Bronze, Sengen-jinja,
Fuji-Kawaguchi, Japan

In Japan, different names indicate different forms: Kōryū (with scales), Kyūryū (with horns), Ō-ryū (large winged dragon), and Hanryū (small dragon of nine colours). Japanese dragons are usually represented with feet having three or four claws, while Chinese often have five. In Japan, in the Ise Peninsula, people worship a rain-making dragon called

Sand and stone garden
Symbolizing a dragon,
Daitoku-ji, Kyōto, Japan

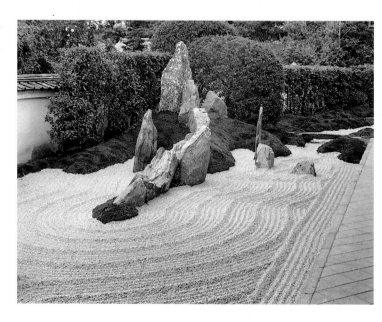

Ichimokuren which is one-eyed. A legend relates that Benzai-ten married a dragon to make it harmless.

Dragons are also associated with the equinoxes in Japan: Nobori-ryū is the 'ascending' dragon of the vernal equinox, and Kudari-ryū is the 'descending' dragon of the autumnal equinox. Many popular Chinese, Japanese and Vietnamese legends are attached to the dragon, which is also one of the animals of the twelve-year cycle of the Sino-Japanese calendar. Although their cult does not appear to have been strongly rooted in Tibet, they are sometimes found represented in paintings that show Chinese influence. In fact, like the serpent Nāga, the dragon belongs more generally to folklore than to the pure Buddhist tradition. Yet many representations of dragons are found in sculpture and painting in Buddhist temples, where they serve for decoration. Their effigies are also found on the roofs of pagodas, because they represent the liquid element that protects from fire, and on fountains and ablution basins of monasteries and temples, so that the water will not fail. They also provide a decorative motif for priestly objects, a theme for many decorative paintings (especially in Zen temples), and a subject of stone arrangements for monastery gardens in Japan.[2] Some sculpted or painted dragons also protect the entrances and roofs of Buddhist buildings, particularly in Thailand and Laos.

Mythical Birds

(Garuḍas; Japanese, *Karura*; Chinese, *Jinchi Niao*; Tibetan, *Gnam-mkha'-lding*; Thai, *Khut*; Khmer, *Khrut*; Burmese, *Galon*)

In Hindu mythology, Garuḍa is a mythical bird who acts as the mount of the god Viṣṇu. In Buddhism, the Garuḍas are the mortal enemies of the Nāgas; only Nāgas possessing a Buddhist relic or converted to Buddhism can escape them. Garuḍas were very seldom represented in Buddhist art, except perhaps as decorative subjects. They do not appear to have been represented in China or Tibet, and in Japan their effigies are extremely rare. Examples are found at the Kōfuku-ji in Nara and the Sanjūsangendō in Kyōto. They are then shown as men in armour, with

Chinthe
Brick, Mingun, Burma,
nineteenth century

Karura-ō (Garuḍa)

Garuḍa
After a sham sculpture,
Da-b-nang, Vietnam,
eleventh/twelfth century

Garuḍa
Tibetan engraving

279

a bird's head and playing the flute. Sometimes, as at the Kōfuku-ji, a bird's head is simply placed as a headdress on the human heads, a representation also called Konjichō.[3] In painting, Japanese Karuras take the form of a bird with a human head, walking on serpents or holding two of them in their hands. They have a ferocious expression. In South-East Asia, they often ornament the walls of temples, as at Angkor and Java.

Yakṣas

(Japanese, *Yasha*; Chinese, *Yecha*; Tibetan, *Gnod-sbyin*; Thai, *Yak, Nhak*)

Yakṣa
After a Prambanan
sculpture, Java,
eleventh century

The Yakṣas are the protectors of Buddha and of the Buddhist Law, a kind of genii of nature. They are semi-divine beings, sometimes merged with the Asuras (see below), and are mainly mentioned in legends. They have rarely been represented in connection with Buddhism, except in ancient India and in fairy-tales. In South-East Asia, as in Java, they are often used as temple guardians but, as in Tibet and China, they are without any clearly defined attributes. In Japan, special mythical beings are sometimes considered as Yakṣas – these are the Tengu, winged men with very long and sometimes phallic noses, which do not belong to Buddhism but to indigenous folklore. In certain cases, images of these beings are associated with ceremonies or figures connected with Buddhism: the *Tengu-zoshi*, a scroll painted around 1360, represents Buddhist monks disguised as Tengu. Japanese Buddhists associate the Tengu with Yakṣas, who play tricks on the faithful to test them.

Gandharvas

(Japanese, *Kandabba*; Chinese, *Gantapo*; Tibetan, *Dri-za*; Thai, *Tephakhōn*)

These are the musicians of the paradise of Indra, well known in the Vedic pantheon. In Japan they are seldom represented. In painting, they appear seated at royal ease, surrounded by the twelve animals of the years, holding a trident in the right hand and a fly-whisk in the left. A flaming aureole stands above their heads. They are rare in sculpture, but there are examples at the Kōfuku-ji in Nara from the eighth century, and at the Sanjūsangendō in Kyōto. These show them as young men in armour, standing, with a lion's head on the headdress.

Asuras

(Japanese, *Ashura*; Chinese, *Axiuluo, Axulun*; Tibetan, *Lha-ma-yin*; Mongol, *Assuri*)

Ashura-ō (Asura)

These are the 'anti-gods' of Vedic mythology, rivals and enemies of the Devas, often compared with the Titans of European mythology although they are not giants, and possibly related to Hindu deifications of Ahura, the Zoroastrian creator-god. Their representation in Buddhism

Dvarapāla (Yakṣa), stone, Kedu, Java, eleventh century, Djakarta National Museum

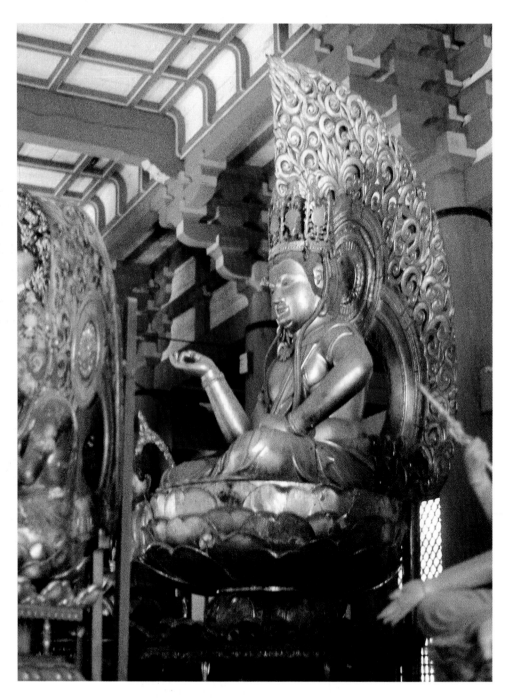

Acolyte of Amoghapāśa, gilded wood, Tō-ji, Nara, Japan, seventeenth century

is extremely rare: they are depicted in the Tibetan Buddhist wheel of life as among the inhabitants of one of the realms of unhappy rebirth, and in Japan (lacquer at the Kōfuku-ji in Nara, eighth century, and at the Sanjūsangendō in Kyōto). Chiefly Ashura-ō (Asurarāja), the king of the Asuras, is represented, symbolizing all the Asuras. He is the king of hunger, an ogre in perpetual anger, the king of quarrels. He is large and thin, with three heads: the central head has a suffering expression, and the others appear angry. He has a neat high chignon. He has six arms, the principal hands joined in Añjali mudrā, the other hands raised to the sky and carrying various ornaments: usually sun, moon, bow and arrows. He is ornamented with necklaces and wears sandals.

Kiṃnaras

(Japanese, *Kinnara*; Chinese, *Jinnaluo, Feiren, Yishen*; Tibetan, *Mi'am-chi*; Thai, *Kinon*)

These are mythical beings, celestial musicians with human bodies and horses' heads, officiating at the court of Kuvera. In China, Buddhist monks claim that the Taoist deity of the kitchens, Zao Jun, is in fact a Kiṃnara who, in the Tang period, was incarnated in the form of a monk. In Hindu legends, the Kiṃnaras are also birds of paradise; they are often mentioned in Buddhist tales and frequently represented in India in the bas-reliefs of the Buddhist caves as birds with human heads, playing musical instruments. In Japan, it appears that, among the many legendary birds, only the Kalavinka (Japanese *Karyōbinga*), supposed to

Kinnara (Kiṃnara)
Japanese postage stamp

Keman showing Kinnara
Gilded bronze, Konjiki-in,
Iwate, Japan,
twelfth century

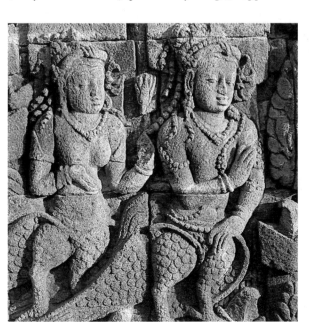

Kiṃnara
Stone, Chandi Mendut,
Java, late eighth century

possess a marvellous voice, was retained. Its image is mainly used to decorate banners and *keman*, a sort of open-work bronze or copper reflector hung in front of the lamps in Buddhist temples.

ASTRAL DEITIES

These are virtually the same as those of India; they were adopted by Buddhism and given local names. They are nine planets (Navagraha), composed of seven planets plus the two dragons of the eclipses, Ketu and Rāhu, ascending and descending (see Dragons, above). The Saptagraha (seven planets) correspond to the days of the week. The astral deities are represented only in maṇḍalas,[4] where the twelve signs of the zodiac also appear.[5] The Nakṣatras, or 28 principal constellations that govern the sky of the northern hemisphere, are virtually never represented, except in certain maṇḍalas.[6]

HISTORICAL FIGURES

Mahāyāna Buddhist iconography abounds in 'portraits' of wise men and monks, chiefly in Tibet, Nepal, China, Korea and Japan. These sculptures and paintings depicting the founders of sects, great adepts (Mahāsiddhas) and others are not genuine portraits, merely images that symbolize important personages – mostly priests according to the letter of the texts, although there have been exceptions, such as the images of the Tibetan King Srong-btsan Sgam-po and the Japanese Prince Shōtoku. The art of portraiture, although relatively ancient in China and Japan, appears to have taken root in Tibet only after the Yuan period, thanks to Chinese influence. Most of the time, these portraits, which are difficult to recognize even for initiates, can be identified only by their inscriptions. Apart from a number of probably mythical figures, such as the Mahāsiddhas, monks are represented wearing the characteristic robe and headgear of the order to which they belong. Since they are extremely numerous, a few essential indications only will be given here, concerning the most important ones.

Mahāsiddha

Mahāsiddhas

Mainly represented in Tibetan art, these 84 Indian or Tibetan sages are thought to have played a major role in transmitting the doctrines of Tibetan Buddhism. They are usually represented seated, making a gesture of teaching with the right hand, and holding a skull cup in the left – for example, in the case of Bir-va-pa (Virūpa), of the Sa-skya-pa order. This is not always so for all Mahāsiddhas, however: Avaddudhipa, for example, points at the ground between his folded legs,[7] Nag-po-pa presents his palms at the level of his breast, and Tilopa makes a gesture

Mahāsiddha

nearly identical to a Dharmacakra mudrā with the right hand, above his bowl which is held in the left.[8] They usually wear spiral earrings, although this feature has not always been observed by the artists. Some, instead of being represented seated, are standing, in a more or less dynamic pose.

TIBETAN LAMAS AND GREAT SAGES

Like the Mahāsiddhas, these priestly personages (Sanskrit *Bla-Ma*) are normally identifiable only by one or more inscriptions. They are always represented seated, making mudrās with one or both hands. They wear monastic robes and are bare-headed or wearing the distinctive cap of their order. In most representations they are surrounded by disciples, wearing monastic robes similar to theirs. In painting, their images are sometimes also surrounded by scenes representing different steps in their spiritual careers.

Padmasambhava
(Tibetan, *Pad-ma Hbyung-gnas*)

This Indian monk, invited to Tibet in the eighth century to preach Buddhism, introduced the practice of mystical incantations (*dhāraṇī*) and the Mahāyoga doctrines. He incorporated many local deities into the Buddhist pantheon, including those of the *bön-po*, the ancestral Shamanic religion of the Tibetans. Padmasambhava disappeared miraculously after having spent 50 years in Tibet; he was subsequently deified and is usually represented seated in Padmāsana, holding a vajra and a begging bowl (*pātra*). His distinctive ornament is the 'magic' staff (*khatvāṅga*), which he holds pressed against his breast. His robe and cap are red. He is virtually never invoked in China or Japan, but is in Bhūtan where, according to legend, he went to teach. He is sometimes depicted accompanied by his two wives, Mandārava and Yeshes Mtsho-rgyal, and his 25 or 26 disciples. His effigies and mystic appearances are extremely numerous in Tibet.

Padmasambhava in Phur-ba
Gilded bronze, Tibet, eighteenth century

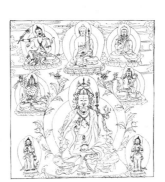

Padmasambhava

The eight forms of Padmasambhava
Tibetan engraving

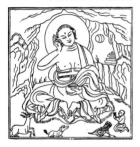

Mi-la-ras-pa

Mi-la-ras-pa
(Tibetan, *Grub-pa'i Dbyang-'phyug Mi-la*)

Mi-la-ras-pa was a famous Tibetan monk who lived in the early twelfth century, wandering ceaselessly and composing sacred songs. He was deified and is usually represented seated on a gazelle skin placed on a lotus. He has curly hair with an *ūrṇā* in the middle of his forehead and holds his right hand open behind the ear, as if to listen to something, his begging bowl supported on his thigh by his left hand. He is usually surrounded by disciples.

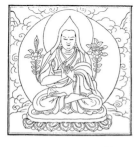

Tsongkhapa

Sumatikīrti
(Tibetan, *Tsongkhapa, Blo-bzang Grags-pa*; Mongol, *Chongqaba*)

Tsongkhapa (1357–1419), so called because he was born in the valley of Tsong-kha, was the founder of the Dge-lugs-pa sect or 'Yellow Hats'. On his death he was deified, and the Lamas believe that he awaits the next creation in the heaven of Tuṣita, in the company of Maitreya. He is thought to be an incarnation of Mañjuśrī. He is represented seated, holding a lotus or with the hands in Dharmacakra mudrā. On his head he wears the characteristic pointed yellow cap of his sect. The lotuses that emerge from his hands sometimes support the symbols of Mañjuśrī, the book and the sword. His garments are red.

Nāgārjuna
(Japanese, *Ryūju Bosatsu*; Chinese, *Longsuzixi*;
Mongol, *Naganchuna Baksi*; Tibetan, *Klu-sgrub*)

Nāgārjuna was an Indian Buddhist monk of the late second century, a native of southern India. He was one of the first propagators of the Mahāyāna doctrines and considered retrospectively to be the founder of the Mādhyamika school of Buddhist philosophy. Some claim that he rediscovered the Prajñāpāramitā texts in the underworld of the Nāgas,[9] and he is thus thought to be a reincarnation of Ānanda, the Buddha's disciple and personal attendant. Deified by most of the Northern schools, Nāgārjuna is usually represented as a Buddha, his hands in Dharmacakra mudrā, with an aureole of serpents' heads.

In Japan, he is called Ryūju Bosatsu or Daishi, Ryūshō Bosatsu and Ryūmyō Bosatsu. He is often associated with the second-century poet Aśvaghoṣa (Memyō Bosatsu) and is mainly worshipped by the Jōdo and Shingon sects.

The Prajñāpāramitā was formerly read in Japan in ceremonies to ask for rain, as the Nāgas were identical to the rain-making dragons (Ryū).[10] Nāgārjuna is thought to have appeared 800 years after the Parinirvāṇa of the Buddha.[11] By the benediction of Vairocana, who revealed to him the *Mahāvairocana-sūtra*, he opened an iron *stūpa* and was thus placed in the presence of Vajrasattva, who anointed his head with holy water

Nāgārjuna (Ryūju Bosatsu)

(*abhiṣeka*) and transmitted to him the great Maṇḍala of the Two Sections
(*Ryōbu Mandara*).[12] According to Ryūjun,[13] Nāgārjuna then transmit-
ted this maṇḍala to his disciple Nāgabodhi, who in turn gave it to
Vajrabodhi. In Japan, Nāgārjuna is represented as a Buddhist monk, head
shaved, seated on a lotus. He is sometimes confused with Kṣitigarbha.
His hands are joined in worship (Añjali mudrā) or in Dharmacakra
mudrā, or sometimes in Vitarka mudrā. Japanese images representing
him were mainly executed during and after the Kamakura period.

Aśvaghoṣa

(Japanese, *Memyō Bosatsu*; Chinese, *Maming Zunzhe*)

This Buddhist poet (first or second century) is represented mostly in
painting. Although, like Nāgārjuna, he is deified and assimilated to a
Bodhisattva, he is not an object of worship. However, he was very pop-
ular in Japan because he was attributed the power of 'clothing the poor',
identifying him with a god protector of silkworms and with the patron
of weavers, a cult of Chinese origin. In these forms he is surrounded by
acolytes called Sanhitsu ('room of silkworms'), Sanmyō ('life of silk-
worms'), San'in ('seal of silkworms') and Sanmo ('mother of silkworms'),
and with one or two disciples wearing Chinese robes, their hands in
Añjali mudrā. This group is shown wandering on clouds.[14]

In Japanese maṇḍalas, Memyō Bosatsu is represented as a
Bodhisattva mounted on a horse, and seated in royal ease on a lotus.[15]
He has six arms. In the *Memyō Bosatsu Mandara*,[16] he is accompanied
by six acolytes. Some popular images, distributed by the Buddhist tem-
ples and Shintō sanctuaries, and representing Memyō Bosatsu, serve as
charms for the protection of silkworms and silkworm-rearing houses.

Mar-pa

(Tibetan, *Chos-kyi Blo-gros, Chos-Kyi Dbang-'phyug, Sgra-bsgyur*)

This Tibetan layman (1012–1096) is thought to have imported songs
and texts from Bengal to Tibet, particularly those belonging to the
Mahāmudrā doctrine. He is mainly venerated for having translated
many Indian texts into Tibetan and as the master (*guru*) of Mi-la-ras-
pa. He was himself a disciple of Nāropa and Maitripa, and is considered
to be the founder the Bka-rgyud-pa sect. He is very often represented
in Tibet in *thangkas* and maṇḍalas, seated in meditation, dressed as a
monk, or in the process of writing.

Mar-pa

Shōtoku Taishi
As Prince Regent, left
(aged 49), and as a child,
right (aged 16), engraving
of the *Butsuzō-zu-i*

Shōtoku Taishi with his son
Painting on silk, Japan,
eighth century, Nara Museum

Shōtoku Taishi as a child
Coloured wood, Japan,
thirteenth century,
Nara Museum

SHŌTOKU TAISHI

A Regent of the Japanese Empress Suiko (593–c. 628; sister of the Emperor Yōmei), and Yōmei's son, Prince Shōtoku (known as Umayado as a child) is such a famous figure in Japan that he was ultimately considered an incarnation of Avalokiteśvara, and given the title of Bodhisattva. He became the guardian deity of masons and carpenters, since he commissioned the first Buddhist edifices. Very many representations still exist of this prince, who died in 622 at the age of 49 (the anniversary of his death is celebrated on 11 April).

- Seated, in Chinese robe, holding a priest's sceptre in both hands in front of him, or a 'function tablet' (at the Hōryū-ji in Nara).
- Standing, as an adolescent, wearing a ceremonial robe, holding a long-handled incense burner in both hands (at the Nara Museum, inter alia).
- Accompanied by his younger brother and one of his children, in Central Asian costume (seventh century, at the Shōsō-in in Nara, painted on silk).
- As a child, standing.
- As a child, standing in a long robe, hair wound in coils over his ears, his hands in his sleeves.
- As a child, standing in a long robe, his hands in Añjali mudrā.
- As an adolescent, seated in tailor fashion on a throne covered by his robe, the right hand placed on his leg, the left holding a round fan.

OTHER RELIGIOUS FIGURES

Throughout Northern Buddhism, but chiefly in China, Korea and Japan, important monks, without necessarily being deified, had their 'portraits' reproduced to decorate the halls of temples. Every important temple belonging to a given sect was keen to exhibit, if not the whole series of 'saints' of the sect, at least the effigies of its principal 'patriarchs'. Portraits of the temple founders were sometimes added to this gallery, usually executed in paint or, more rarely, in sculpture. The monks are usually shown in the monastic garments of their sect, in a seated position, either holding a religious accessory (often a vajra for the esoteric sects, or an incense bowl), or making a gesture of teaching (right forefinger raised), holding a fold of their robes, or making a mudrā of veneration. Some, especially in esoteric sects, have their hands hidden under their robes, and their feet are likewise rarely visible.

The founding monks of the Japanese Tendai sects are often represented in Dhyāna mudrā, seated in Padmāsana on high-backed chairs. Those belonging to the different Amidist sects are sometimes represented kneeling, the hands in Añjali mudrā. As to the monks of the Zen sects, they are depicted in many positions, except Bodhidharma, who is always in Dhyāna mudrā. He is often shown in meditation, turned to face a wall. But the art of the Zen sects is nonconformist, and may show the monks in all conceivable manners, especially in China. Other priests have been represented – for example, Enno Gyōja (b. 634), a Japanese monk whose syncretic theories were accepted only by certain categories of Yamabushi (monks of the mountain): he is sometimes shown seated on a chair, in the western manner, the legs apparent and holding a *khakkara* in the hand, with a fold of his monastic robe covering his head. The monk Kūya Shōnin was represented in various ways (see p. 145).

Also worth mentioning among the founders of sects in Japan is Shinran (1173–1262), of whom there exists only one portrait (at the

Nichiren

Shinran

Religious Buddhist
Wood, Rokuharamitsu-ji,
Kyōto, Japan,
thirteenth century

Nishi Hongan-ji, Kyōto), and Nichiren (1222–1282), shown in sculpture (at the Honmon-ji in Japan). Other monks, famous for a variety of reasons (as, for example, Musō Kokushi in Japan), have also been represented. In China, portraits of monks are innumerable, especially in paintings. We have seen that, in Tibet, some figures such as Padmasambhava, the translator Mar-pa and others, were the subject of *thangkas*, presented as examples of pious Buddhists. In Korea, Buddhist art followed the Chinese and Japanese tendencies, and portraits of famous monks were frequently executed. Buddhist monks were not the object of systematic representations in India or South-East Asia; in Sri Lanka, there are portraits, but they are relatively recent. Except perhaps in Japan, these pious representations became increasingly rare. Only a few artists, referring to tradition, have drawn their inspiration from the ancient iconography and tried, in the modern era, to offer their personal interpretation of personages that are in fact virtually forgotten.

Japanese–Sanskrit Correspondences

Japanese characters	Japanese	Sanskrit
阿耆尼	Agini	Agni
愛金剛	Ai Kongō	Rāgavajra
愛樂金剛女	Airaku Kongō-nyo	Rāgavajrinī
愛染明王	Aizen Myō-ō	Vajrarājapriya
阿氏多尊者	Ajita Sonja	Ajita
阿麼提（觀）観音	Amadai Kannon	Abhetrī
阿難	Anan	Ānanda
阿難陀	Ananda	Ānanda
阿那律	Anaritsu	Aniruddha
阿儞底耶	Anichiya	Āditya
阿儞羅	Anira	Anila (Majila?)
安底羅	Anteira	Andira
アバラジタ	Aparajita	Aparājita
阿遮羅曩他	Asharanata	Acalanātha
阿閦如来	Ashuku Nyorai	Akṣobhya
阿修羅	Ashura	Asura
阿修羅竜王	Ashura Ryū-ō	Asurarāja
阿吒縛迦	Atabaka	Āṭavaka
跋陀羅尊者	Badara Sonja	Bhadra
馬宮	Ba-gū	Dhanus
代闍羅弗多羅尊者	Bajarabutara Sonja	Vajraputra
伐折羅	Bajira, Bazara	Vajra
伐那婆斯尊者	Banabasu Son ja	Vanavāsin
半託迦尊者	Bantaka Sonja	Panthaka
縛嚕拏仙人	Baruna, Sui Ten	Varuṇa
婆藪仙大仙	Basu Sennin	Vasubandhu
縛藪仙大枳竜王	Basu-daisen	Vasūrṣi
婆藪仙	Basuki Ryū-ō	Vāsuki
	Basū-sen	Vāsu (Vasiṣṭhā)
馬頭観音	Batō Kannon	Hayagrīva
馬頭明王	Batō Myō-ō	Hayagrīva
馬頭金剛明王	Batō Kongō Myō-ō	Hayagrīva
伐折羅	Bazara	Vajra
伐折羅（吽）金剛	Bazara (un) Kongō	Vajrahumkāra
辯積菩薩	Benshaku Bosatsu	Pratibhānakūṭa
弁財天	Benzai Ten	Sarasvatī
毘羯羅	Bikyara	Vikarāla
毘倶胝観音菩薩	Bikuchi Kannon Bosatsu	Bhṛkuṭī
毘那夜迦天	Binayaka Ten	Vināyaka (Gaṇapati)
賓度羅跋囉惰闍	Bindora Baradaja	Piṇḍola Bharadvāja
秤宮	Bin-gū (Ten Bin-gū)	Tulā
賓度羅跋囉惰闍尊者	Binzura Harada Sonja	Piṇḍola Bharadvāja
毘藍婆	Biranba	Vilambā
毘楼博叉天	Birubakusha-ten	Virūpākṣa
毘楼勒叉天	Birurokusha-ten	Virūdhaka
毘盧遮那如来	Birushana Nyorai	Mahāvairocana
毘沙門天	Bishamon-ten	Vaiśravaṇa
ビ沙沙	Bishasha	Piśāca
毘首羯磨	Bishukatsuma	Viśvakarma
尾宿	Bi-shuku	Mūla

Japanese characters	Japanese	Sanskrit
蟹宮	Bokai-gū	Karkaṭaka
棒梗金剛薩埵	Boken Kongōsatta	Vajrayākṣavajrapāṇi
梵天	Bon-ten	Brahmādeva, Brahmā
梵天妃	Bon Tenhi	Brahmī
菩薩	Bosatsu	Bodhisattva
房宿	Bō-shuku	Anurādha
步擲明王	Buchaku Myō-ō	Padanakṣipa
仏頂	Bucchō	Uṣṇīṣa
仏頂尊	Bucchō-son	Uṣṇīṣa
步擲明王	Buteki Myō-ō	Padanakṣipa
仏	Butsu	Buddha
仏眼仏母	Butsugen Butsumo	Buddhalocanī
仏眼尊	Butsugen-son	Uṣṇīṣa
白衣観音	Byakue Kannon	Paṇḍaravāsinī
白毫	Byakugō	Urṇā
白衣人観自在	Byakujin Kanjizai	Śvetabhagavatī
白傘蓋仏頂	Byakusangai Bucchō	Sitātapattroṣnīṣa
白処観自在	Byakusho Kanjizai	Paṇḍaravāsinī
瓶宮	Byō-gū	Kumbha
智童	Chi-dō	Jnānaketu
智波羅蜜	Chi-haramitsu	Jnānapāramitā
鎮星	Chin-sei	Sanaiścara
智如来	Chi Nyorai	Dhyāani-Buddha
地天	Chi Ten	Pṛthivī
頂輪王	Chō Rinnō	Ekādaśa Uṣṇīṣacakra
張宿	Chō-shuku	Pūrvaphālguni
注茶半吒迦尊者	Chudahantaka Sonja	Cūḍapanthaka
大毘盧遮那如来	Daibirushana Nyorai	Mahāvairocana
大梵天	Dai Bon Ten	Brahmā
太元帥明王	Daigensui Myō-ō	Āṭavaka
大医王仏	Daii-ō Butsu	Bhaiṣajyaguru
大威徳明王	Daiitoku Myō-ō	Yamāntaka
大自在天	Daijizai Ten	Maheśvara
大自在天女	Daijizai Tennyo	Devī, Vak
大迦葉	Dai Kashō	Mahākāśyapa
大吉祥天明王	Daikichijō-Myō-ō	Śrīmahāvidyā
大金輪明王	Dai Kinrin Myō-ō	Ekādaśa Uṣṇīṣacakra
大黒天	Daikoku-ten	Mahākāla
大目犍連	Dai Mokkenren	Mahāmaudgalyāyāna
大日如来	Dainichi Nyorai	Mahāvairocana
大日金輪	Dainichi Kinrin	Ekādaśa Uṣṇīṣacakra
大力金剛	Dairiki Kongō	Mahābala
大力持明王	Dairikiji Myō-ō	Hayagrīva
大輪金剛	Dairin Kongō	Mahācakravajra
大勢至菩薩	Dai Seishi Bosatsu	Mahāsthāmaprāpta
太山府君	Daisen Fukun	Citragupta
大聖天	Daishō Ten	Gaṇapati, Vināyaka
大転法輪仏頂	Dai Tempōrin Bucchō	Mahoṣnīṣacakravartin
大隨求菩薩	Daizuigu Bosatsu	Mahāpratisarā
提頭頼吒天	Daizurata-ten	Dhṛtaraṣtra
茶吉尼天	Dakini-ten	Dākinī
達磨	Daruma	Bodhidharma
奪一切衆生精気	Datsu-issai Shujō-seiki	Sarvasattvajohāri
童子	Dōji	Kumāra
土曜	Do-yō	Sanaiścara
画波羅蜜	E-haramitsu	Prajñāpāramitā
翳曜嚩蹉	Erabasa	Elavāṣā, Airāvatī (?)
焰摩麗天	Enmama Ten	Citragupta

Japanese characters	Japanese	Sanskrit
焔摩天	Enma Ten	Yamarāja
閻魔王	Enma-ō	Yamarāja
穢積金剛	Eshaku Kongō	Ucchuṣma
不動明王	Fudō Myō-ō	Acalanātha
不動	Fudō-shisha	Acalaceta
不壊金剛	Fue Kongō	Ucchuṣma
普賢菩薩	Fugen Bosatsu	Samantabhadra
普賢延命菩薩	Fugen Enmyō (Enmei)	Vajrāmoghasamayasattva
不浄忿怒	Fujō Funnu	Ucchuṣma
不空成就如来	Fukūjōju Nyorai	Amoghasiddhi
不空羂索観音	Fukūkensaku Kannon	Amoghapāśāvalokiteśvara
不空金剛	Fukū Kongō	Amoghavajra
不空供養	Fukū Kuyō	Amoghapūjāmaṇi
忿怒	Funnu	Krodha
忿怒月天	Funnu Gatten	Krodhacandratilaka
富那	Furuna	Pūrṇa (Maitrāyāniputra)
補沙毘摩竜王	Fusabima Ryū-ō	Pūṣavimah
不思議童子	Fushigie-dōji	Acintyamatidatta
風天	Fū Ten	Vāyu
風天童子	Fū Ten-dōji	Vāyudevatā
風天女	Fū Tennyo	Vāyavī
月光菩薩	Gakkō Bosatsu	Candraprabhāsana
誐那鉢底	Ganabachi	Gaṇapati (Vināyaka)
合掌印	Gasshō-in	Añjali-mudrā
月天	Gatten	Candra
月天	Gatten-hi	Candra
月曜	Getsu-yō	Soma, Candra
伎芸天	Gigei-ten	Devī, Vak
降閻摩尊	Gō-enma-son	Yamāntaka
護軍	Gogun	Guptasena
業波羅蜜菩薩	Gō-haramitsu Bosatsu	Karmapāramitā
極広仏頂	Goku-kōdai Bucchō	Mahoṣṇīṣacakravartin
降魔印	Gōma-in	Bhūmisparśa-mudrā
劫比羅	Gopira	Kapila
降三世明王	Gōzanze Myō-ō	Trailokyavijaya
軍荼利明王(夜叉)	Gundari Myō-o	Kuṇḍalī, Amṛta Kuṇḍika
軍荼利観世	Gundari Yasha	Kuṇḍalī
救世観音	Guze Kannon	Avalokiteśvara
魚宮	Gyo-gū	Mīna
牛宮	Gyū-gū	Vṛṣabha
牛宿	Gyū-shuku	Śravaṇa
波夷羅	Haira	Pajira
白羊宮	Hakuyō-gū	Meṣa
般若菩薩	Hannya Bosatsu	Prajñāpāramitā
般若波羅蜜	Hannya Haramitsu	Prajñāpāramitā
壁宿	Heki-shuku	Uttarābhādrapadā
畢里底毘	Hiruchibi	Pṛthivī
畢宿	Hitsu-shuku	Rohiṇī
飛天	Hi-ten	Devatā, Apsarās
被葉衣観音	Hiyoe Kannon	Palāśāmbarī
宝瓶宮	Hōbyō-gū	Kumbha
法護	Hōgo	Dharmapāla
宝波羅蜜菩薩	Hō-haramitsu Bosatsu	Ratnapāramitā
法波羅蜜菩薩	Hō-haramitsu Bosatsu	Dharmapāramitā
法印手	Hō-in Shu	Ratna-mudrāhasta
宝冠	Hō-kan	Ratnakuśa
宝鈎	Hō-kō	Ratnākara
北斗妙見	Hokuto Myōken	Sudṛṣṭi, Dhruva
宝生如来	Hōshō Nyorai	Ratnasambhava
宝珠	Hōshu	Ratnapāṇi, Maṇi

Japanese characters	Japanese	Sanskrit
宝幢如来	Hōtō Nyorai	Ratnaketu
水掲羅天	Hyōgara Ten	Pingala
一字金輪	Ichiji Kinrin	Ekākṣaroṣṇīṣa
韋駄天	Ida-ten	Skanda, Veda
稲荷天	Inari-ten	Yakṣa Dākinī
因達(陀)羅天	Indara-ten	Indra
因掲陀尊者	Ingada Sonja	Angada
姪宮	In-gū	Mithtma
伊舎那天	Ishana-ten	Īśāna
意生金剛	Ishō Kongō	Iṣṭavajra
胃宿	I-shuku	Bharaṇī
持国天	Jikoku Ten	Dhṛtarāṣṭra
持金剛	Ji-kongō	Vajrasattva
持明	Jimyō	Vidyādhara
持明金剛	Jimyō Kongō	Suvajradhara
八馬宮	Jinba-gū	Dhanus
深沙大將	Jinja Taishō	Vaiśravaṇa
持世菩薩	Jise Bosatsu	Vasudhārā
慈氏菩薩	Jishi Bosatsu	Maitreya
地天	Ji Ten	Pṛthivī
持瓔珞	Jiyōraku	Mālādharī
自在女天	Jizai-nyo Ten	Raudrī
自在天	Jizai Ten	Śiva, Maheśvara
地蔵菩薩	Jizō Bosatsu	Kṣitigarbha
増長天	Jōchō Ten	Virūdhaka
除蓋障菩薩	Jogaishō Bosatsu	Sarvanīvāraṇaviṣkambhin
女宮	Jo-gū	Kanyā
蘘虞梨童女(天)	Jōguri-dōjo Ten	Jāṅgulī
定光仏	Jōkō Butsu	Dīpankara-Buddha
青頸観音	Jōkyō Kannon	Nīlakaṇṭhī
除障仏頂	Joshō Bucchō	Vikīrṇoṣṇīṣa
女宿	Jo-shuku	Abhijit
戒博迦尊者	Jubaka Sonja	Jīvaka
十一面観音	Jūichimen Kannon	Ekādaśamukha Avalokiteśvara
准提仏母	Juntei Butsu-mo	Cundībhagavatī
准提観音	Juntei Kannon	Cundī
十二宮	Jūni-gū	Rāśī
比羅	Kabira	Kapila
開敷華王如来	Kaifuke-ō Nyorai	Saṃkusumitarāja
蟹宮	Kai-gū	Karkaṭa
角宿	Kaku-shuku	Citrā
迦楼羅	Karura	Garuḍa
迦諾迦跋鷺堕闍尊	Kanakabaridaja Sonja	Kanakabharadvāja
迦諾迦伐蹉尊者	Kanakabassa Sonja	Kanakavatsa
歓喜天	Kangi-ten	Gaṇapati, Vināyaka
観自在	Kanjizai	Avalokiteśvara
観音	Kannon	Avalokiteśvara
観世音	Kanzeon	Avalokiteśvara
迦哩迦尊者	Karika Sonja	Kālika
訶利帝母	Karitei-mo	Hārītī
迦楼羅	Karura	Garuḍa
迦陵頻伽	Karyōbinga	Kalavinka
迦旃延	Kasenen	Katyāyana (Nalada)
華歯	Kashi	Puṣpadantī
火天	Ka-ten	Agni
火頭金剛	Katō Kongō	Ucchuṣma
蝎宮	Katsu-gū	Vṛścika
羯磨波羅蜜	Katsuma-haramitsu	Karmapāramitā
火曜	Kayō	Āṅgāraka, Pingala
奎宿	Kei-shuku	Revatī

Japanese characters	Japanese	Sanskrit
計都星	Keiti-sei	Ketu
熒惑天（星）	Keiwaku Ten (Sei)	Pingala, Āngāraka
肩目天	Kemmoku Ten	Amśalocana
堅牢地神	Kenrō-jishin	Dhāranīdhāra (Pṛthivī)
計設尼童子	Keshini-dōji	Keśinī
金輪如来	Kinrin Nyorai	Uṣṇīṣacakra
危宿	Ki-shuku	Dhaniṣṭhā
箕宿	Ki-shuku	Pūrvaṣādhā
吉祥天	Kichijō-ten	Mahāśrī, Śrī Mahādeva
鬼子母神	Kishimojin	Hārītī
緊那羅	Kinnara	Kimnara
金曜	Kin-yō	Śukra
金牛宮	Kingyū-gū	Mīna
吉利吉利明王	Kiri-kiri Myō-ō	Kundalī
吉祥天	Kisshō Ten	Mahāśrī, Śrī Mahādeva
広大仏頂	Kōdai Bucchō	Mahoṣṇīṣacakravartin
光聚傘蓋仏頂	Kōju Sangai Bucchō	Tejurācyuṣṇsa
黑齒	Kokushi	Makuṭadanti
虚空藏菩薩	Kokūzō Bosatsu	Ākāśagarbha
広目天	Kōmoku Ten	Virūpākṣa
金毘羅天	Kompira Ten	Kumbhīra
矜羯羅童子	Kongara Dōji	Kimkara
金剛愛	Kongō-ai	Vajrarāga
金剛舞菩薩	Kongō-bu Bosatsu	Vajranṛta
金剛童子	Kongō Dōji	Vajrakumāra
金剛牙菩薩	Kongō-ga Bosatsu	Vajrayakṣa
金剛華菩薩	Kongō-ge Bosatsu	Vajrapuṣpā
金剛護菩薩	Kongō-go Bosatsu	Vajrarakṣa
金剛語菩薩	Kongō-go Bosatsu	Vajrabhāṣa
金剛業菩薩	Kongō-gō Bosatsu	Vajrakarma
金剛軍荼利	Kongō-gundari	Vajrakuṇḍalin
金剛波羅蜜菩薩	Kongō-haramitsu Bosatsu	Vajrapāramitā
金剛宝菩薩	Kongō-hō Bosatsu	Vajraratna
金剛法菩薩	Kongō-hō Bosatsu	Vajradharma
金剛宝菩薩	Kongō-hō Bosatsu	Āryāvalokiteśvara
金剛因菩薩	Kongō-in Bosatsu	Vajrahetu
金剛食天菩薩	Kongō-jiki-Ten	Vajrabhakṣaṇa
金剛歌菩薩	Kongō-ka Bosatsu	Vajragītā
金剛界	Kongō-kai	Vajradhātu
金剛華菩薩	Kongō-ke Bosatsu	Vajrapuṣpa
金剛拳菩薩	Kongō-ken Bosatsu	Vajramuṣti
金剛嬉菩薩	Kongō-ki Bosatsu	Vajrasādhu
金剛鉤菩薩	Kongō-kō Bosatsu	Vajrānkuśa
金剛光菩薩	Kongo-kō Bosatsu	Vajratejas
金剛鉤女菩薩	Kongō-kōjo	Vajrānkuśī
金剛鬘菩薩	Kongō-man Bosatsu	Vajramālā
金剛面天	Kongō-men Ten	Vajramukha
金剛明王	Kongō Myō-ō	Vidyottama
金剛王	Kongō-ō	Vajrarāja
金剛鈴菩薩	Kongō-rei Bosatsu	Vajrāveśa
金剛利菩薩	Kongō-ri Bosatsu	Vajrarīkṣna
金剛力士	Kongō Rikishi	Vajravīravajrapāṇī
金剛鎖菩薩	Kongō-sa Bosatsu	Vajrasphota
金剛索菩薩	Kongō-saku Bosatsu	Vajrapāśa
金剛薩埵	Kongō Satta	Vajrasattva
金剛使者	Kongō-shisha	Vajraceta
金剛笑菩薩	Kongō-shō Bosatsu	Vajrahāsa
金剛焼香菩薩	Kongō-shōkō Bosatsu	Vajranṛtya
金剛手菩薩	Kongō-shu Bosatsu	Vajrasattva
金剛燈菩薩	Kongō-tō Bosatsu	Vajralokā
金剛夜叉（嬻）明王	Kongō-yasha Myō-ō	Vajrayakṣavajrapāṇī
金剛蔵	Kongō-zo	Vajragarbha
金剛塗香菩薩	Kongō-zukō Bosatsu	Vajragandha

Japanese characters Japanese Sanskrit

Japanese	Sanskrit
Konrin Nyorai	Uṣṇīṣacakra
Kō-ō Bosatsu	Gandharāja
Kō-shuku	Svātī
Kōtei	Kuntī
Koyasu Jizō	Kṣitigarbha
Koyasu Kannon	Hārītī
Kubanda	Kumbhāṇḍa
Kubira	Kuvera
Kudoku-ten	Mahāśrī, Śrī Mahādeva
Kugoe-dōji	Paritrāṇāśayamati
Kujaku Myō-ō	Mahāmayūrividyārājñī
Kumara-ten	Kumāra, Kārttikeya
Kumbira	Kumbhira
Kyokai-gū	Karkata
Kyokushi	Kūradantī
Kyo-shuku	Śatabhiṣa, Puṣya
Magoraka	Mahorāga
Makabirushana Nyorai	Mahāvairocana
Makakashō	Mahākaśyapa
Makakara Ten	Mahākāla
Makatsu-gū	Makara
Makeishura Ten	Maheśvara
Makora	Makura
Mandara	Maṇḍala, Mahācakra
Mani Kokuzō	Maṇi Ākaśagarbha
Manji	Svastikā
Manken	Pūrṇabhadra
Man-kongō	Mānavajra
Marishi-ten	Mārīchī
Maya Fujin (Bunin)	Māyā
Mekira	Mikila (Mihara)
Memyō Bosatsu	Aśvaghoṣa
Mezu	Hayagrīva
Miroku Bosatsu	Maitreya
Misshaku Rikishi	Garbhavīra
Moku-yō	Brhaspati
Monju Bosatsu	Mañjuśrī
Muchaku (Mujaku)	Asanga
Muensoku	Acalā
Mukukō-dōji	Vimalaprabha
Munōshō Myō-ō	Aparājita
Muryōju Nyorai	Amidāyus, Amitābha
Muryōkō Nyorai	Amitaprabha, Amitābha
Myōdō Bosatsu	Sudṛṣṭi, Dhruva
Myōjō Tenshi	Aruṇa
Myōken Bosatsu	Sudṛṣṭi, Dhruva
Myō-Kissho Bosatsu	Mañjuśrī
Myō-ō	Vidyārāja
Nagasena Sonja	Nāgasena
Nakora Sonja	Nakula
Nanda Ryū-ō	Nanda
Naraen Ten	Nārāyaṇa
Nehan	Nirvāṇa
Nichi-yō	Sūrya (Āditya)
Nikkei	Uṣṇīṣa
Nikkō Bosatsu	Sūryaprabhāsana
Ni-ō	Vajravīra
Nirambā	Vilambā
Nirichi	Nairṛtirāja
Nitten	Āditya (Sūrya)
Nyoirin Kannon	Cintāmaṇicakra

Japanese characters	Japanese	Sanskrit
如來	Nyorai	Tathāgata
囉怙羅尊者	Ragora Sonja	Rāhula
羅睺星	Rago-sei	Rāhu
來迎印	Raigō-in	Vitarka-mudrā
藍婆	Ramba	Lambā
羅剎童子	Rasetsu-dōji	Rakṣasa
羅剎天	Rasetsu-ten	Nairṛtirājyakṣasa
蓮花（華）	Renge	Padma
蓮華軍荼利	Renge Gundari	Padmakundalī
力士	Rikishi	Vajravīra
婁宿	Ro-shuku	Acvinī
嚢多羅尼菩薩	Ro-Tarani Bosatsu	Tārā
瑠璃光王	Rurikō-ō	Bhaiṣajyaguru
龍王	Ryū-ō	Nāgarāja
龍智	Ryūchi	Nāgabodhi
龍樹菩薩	Ryūju Bosatsu	Nāgārjuna
龍猛	Ryūmo	Nāgārjuna
龍星	Ryū-sei	Nirgnātaketu
柳宿	Ryū-shuku	Āśleṣā
摧碎佛頂	Saisai Bucchō	Vikīrṇoṣṇīṣa
歲星	Sai-sei	Brhaspati
最勝傘蓋佛頂	Saishō Sangai Bucchō	Vijayoṣṇīṣa
参宿	San-shuku	Ārdrā
散脂大將	Sanshi Taishō	Saṃjñeya
珊底羅	Santeira	Sandila
井宿	Sei-shuku	Punarvasu
星宿	Sei-shuku	Maghā
勢至菩薩	Seishi Bosatsu	Mahāsthamaprāpta
制吒迦童子	Seitaka Dōji	Cetaka
世自在王如來	Sejizai-ō Nyorai	Lokeśvarāja
施無畏印	Semui-in	Abhaya-mudrā
千手観音	Senju Kannon	Sahaśrabhuja Avalokiteśvara
世親	Seshin	Vasubandhu
釈迦牟尼	Shakamuni	Śakyamuni
釈迦如來	Shaka Nyorai	Śakyamuni
遮文荼	Shamonda	Cāmuṇḍā
舎利弗	Sharihotsu	Śāriputra (Upatiṣya)
七俱胝佛母	Shichigutei Butsumo	Saptakotibuddha
熾盛光佛頂	Shijō-kō Bucchō	Vikīrṇoṣṇīṣa
真達羅	Shindara	Sindūra, Kimnara
辰星	Shin-sei	Buddha
心宿	Shin-shuku	Ārdrā-jyeṣṭha
軫宿	Shin-shuku	Hastā
獅子宮	Shishi-gū	Simha
獅子吼菩薩	Shishiku Bosatsu	Simhanāda
觜宿	Shi-shuku	Mrigaśiras
四天王	Shi Tennō	Caturmahārāja
室女宮	Shitsu-shuku	Pūrṇabhādrapadā
處女宮	Shojo-gū	Kanyā
勝佛頂	Shō Bucchō	Jayoṣṇīṣa
聖観音	Shō Kannon	Āryāvalokiteśvara
商羯羅	Shōkara	Śankara
青頸観音	Shōkyō Kannon	Nīlakanthī
正了知大將	Shōryōchi Taishō	Saṃjñeya
勝三世佛頂	Shō Sangai Bucchō	Jayoṣṇīṣa
勝三世明王	Shōzanze Myō-ō	Trailokyavijaya
聖天社	Shōten-sama	Gaṇapati, Vinayaka
招羅菩提	Shōtora	Catura
須菩賢	Shubodai	Subhūti
珠雙魚宮	Shuken	Maṇibhadra
	Sōgyo-gū	Mīna

Japanese characters	Japanese	Sanskrit
双 姓 宮	Sō-in-gū	Mithuna
双 目 天 后	Sōmoku Tengō	Locana
尊 星 王	Sonsei-ō	Sudṛṣṭi, Dhruva
尊 勝 仏 頂	Sonshō Bucchō	Vikīrṇoṣṇīṣa
卒 都 婆 大 吉 祥	Sotoba Dai-Kichijō	Stūpamahāśrī
蘇 頻 陀 尊 者	Subinda Sonja	Subinda
須 菩 提	Subodai	Subhūti
水 星 天	Sui-sei Ten	Ketu
水 天	Sui-ten	Varuṇa
水 曜	Sui-yō	Buddha
塞 建 陀 院	Sukanda	Skanda, Veda
蘇 摩 那 竜 王	Sumana Ryū-ō	Sumana
蘇 利 耶	Sūruya	Sūrya
多 髪	Tahatsu	Keśinī
多 宝 如 來	Tahō Nyorai	Prabhūtaratna
太 白 星	Taihaku-sei	Śukra
太 陰	Tai-in	Soma, Chandra
帝 釈 天	Taishaku-ten	Śakra, Indra
太 陽	Tai-yō	Sūrya
泰 山 府 君	Taizan Fukun	Citragupta
胎 藏 界	Taizō-kai	Garbhadhātu
多 聞 天	Tamon-ten	Vaiśravaṇa
誕 生 釈 迦	Tanjō Shaka	Śākyamuni (birth)
多 羅 菩 薩	Tara Bosatsu	Tārā
多 羅 使 者	Tara-shisha	Tārācetī
帝 釈 天	Teishaku Ten	Indra
氐 宿	Tei-shuku	Viśākhā
転 法 輪 菩 薩	Tempōrin Bosatsu	Divyadundhubhime-ghanirghoṣa
天 神 宮	Tembin-gū	Tulā
天	Ten	Deva
天 鼓 雷 音 如 來	Tenkuraion Nyorai	Divyadundhubhime-ghanirghoṣa
天 鼓 雷 音 仏	Tenkuraion Butsu	Akṣobhya
天 人	Tennin	Devata, Apsarās
兜 跋 毘 沙 門 天	Tobatsu Bishamon-ten	Kuvera (?)
斗 宿	To-shuku	Uttaraṣāḍhā
都 史 多 天	Tosotsu Ten	Tuṣitā
烏 波 計 設 尼 童 子	Ubakeshini-dōji	Upakeśīnī
優 婆 離	Ubari	Upāli
烏 摩 妃	Umāhī	Umā
烏 枢 沙 摩 明 王	Ususama Myō-ō	Ucchuṣma
烏 枢 瑟 摩 明 王	Usushima Myō-ō	Ucchuṣma
藥 上 菩 薩	Yakujō Bosatsu	Bhaiṣajya, Samudgata
藥 王 菩 薩	Yaku-ō Bosatsu	Bhaiṣajyarāja
藥 叉 持 明	Yakusha Jimyō	Yakṣavidyarāja
藥 師 如 來	Yakushi Nyorai	Bhaiṣajyaguru
藥 師 瑠 璃 光 如 來	Yakushi Rurikō Nyorai	Bhaiṣajyaguru
夜 (藥) 叉	Yasha	Yakṣa
葉 衣 観 音	Yōe Kannon	Pālāśāmbarī
与 願 印	Yogan-in	Vara(da)-mudrā
羊 宮	Yō-gū	Meṣa
欲 金 剛	Yoku Kongō	Iṣṭavajra
翼 宿	Yoku-shuku	Uttaraphālgunī
楊 柳 観 音	Yōryū Kannon	Bhaiṣajyarāja
維 摩 居 士	Yuima Kōji	Vimalakīrti
善 無 畏	Zemmui	Śubhākarasiṃha
増 長 天	Zōchō-ten	Virūḍhaka

Sanskrit–Japanese Correspondences

Sanskrit	Japanese	Sanskrit	Japanese
Abhaya-mudrā	Semui-in	Aśleṣā	Ryū-shuku
Abhetrī	Amadai Kannon	Aśvaghoṣa	Memyō Bosatsu
Abhijit	Jo-shuku	Aśvinī	Ro-shuku
Abhiṣeka-mudrā	Kanjō-in	Asura	Ashura
Acalā	Muensoku	Āṭavaka	Daigensui Myō-ō,
Acalaceta	Fudō-shisha		Atabaku, Atabaka
Acalanātha	Fudō Myō-ō	Avalokiteśvara	Kannon, Kanjizai,
Acintyamatidatta	Fushigie-dōji		Kanzeon Bosatsu
Ādi-Buddha	Nyorai		
Āditya	Nichi-yō	Bhadra	Badara Sonja
Agni	Ka-ten	Bhaiṣajyaguru	Yakushi Nyorai
Airāvati	Erabasa	Bhaiṣajyarāja	Yaku-ō Bosatsu
Ajita	Ajita Sonja	Bharaṇī	I-shuku
Ākarṣaṇī	Shōjō-dōji	Bhṛkuṭī	Bikuchi Kannon, Bikuchi
Ākāśagarbha	Kokūzō Bosatsu		Bosatsu
Akṣobhya	Ashuku Nyorai	Bhūmisparśa-mudrā	Gōma-in,
Amitābha	Amida Nyorai		Sokuchi-in
Amitaprabha	Muryōkō Nyorai	Bodhidharma	Daruma, Bodai Daruma
Amitāyus	Amida Nyorai,	Bodhisattva	Bosatsu
	Muryōju Nyorai	Brahmā	Bon-ten
Amoghapāśā-	Fukūkenjaku,	Brahmādeva	Dai Bon-ten
valokiteśvara	Fukūkensaku	Bṛhaspati	Moku-yō
Amoghasiddhi	Fukūjōju Nyorai	Buddhalocanī	Butsugen Butsumo
Amoghavajra	Fukū	Buddhapātra-mudrā	Hachi-in
Amṛta	Kanro	Buddha	Sui-yō
Amṛtarāja	Kanro-ō		
Aṃṣalocana	Kenmoku	Cakra	Rimbō
Ānanda	Anan, Ananda	Cakradevānām Indra	Taishaku-ten
Anantasvaraghoṣa-	Muhen-onsei	Cakradevendra	Taishaku-ten
cakravartin	(jō)Bucchō	Candra	Gatten
Andira	Anteira	Candraprabha	Gakkō Bosatsu
Angaja	Ingada Sonja	Catura	Shōtora
Angāraka	Ka-yō	Caturmahārāja	Shi Tennō
Angkuśa	Kō	Cetaka	Seitaka Dōji
Anila	Anira	Cintāmaṇicakra	Nyoirin Kannon
Aniruddha	Anaritsu	Citrā	Kaku-shuku
Añjali-mudrā	Gasshō-in	Citragupta	Taizan Fukun
Anurādhā	Bō-shuku	Cūḍapanthaka	Chudahantaka Sonja
Aparājita	Munōshō Myō-ō	Chundī	Juntei Kannon
Apsarās	Tennin, Hiten	Chundībhagavatī	Juntei Butsumo
Arahant, Arhat	Arakan, Rakan		
Ārdrā	San-shuku	Dākinī	Dakini-ten
Āryācalanātha	Fudō Myō-ō	Deva	Ten
Āryavalokiteśvara	Shō Kannon,	Devarāja	Ten-ō, Tennō
	Kannon Bosatsu	Devatā	Tennyo, Tennin

Sanskrit	Japanese	Sanskrit	Japanese
Dhaniṣṭhā	Ki-shuku	Karmapāramitā	Gō-haramitsu Bosatsu
Dhanus	(Jin) Ba-gū	Kārtikkeya	Kumara-ten
Dhāraṇīdhāra	Jichi Jizō Bosatsu,	Kāśyapa	Dai Kashō
	Kenrō-jishin	Kātyāyana	Kasenen
Dharmacakra-mudrā	Hōkai Jō-in,	Kelikilavajra	Soku-kongō Bosatsu
	Tenpōrin-in,	Keśinī	Tahatsu
	Tembōrin-in	Ketu	Keito-sei
Dharmapāla	Hōgo	Khumbīra	Kompira-ten
Dharmapāramitā	Hō-haramitsu Bosatsu	Kimnara	Kinnara
Dhramanā(s)	Hō-in-shu Jizō Bosatsu	Kīnkara	Kongara Dōji
Dhṛtārāṣṭra	Jikoku Ten	Karttṛkā	Bō-shuku
Dhruva	Myōken Bosatsu	Kṣitigarbha	Jizō Bosatsu
Dhyāna-mudrā	Jō-in	Kumāra	Kumara-ten
Dhyānabara	Daruma	Kumbha	(Hō) Byō-gū
Dhyāni Bodhisattva	Chi Bosatsu	Kuṇḍalī	Gundari Myō-ō
Dhyāni Buddha	Chi Nyorai	Kuntī	Kōtei
Dīpankara	Jōko Butsu	Kūṭadantī	Kyōkushi
Ādivyadundhubhime-		Kuvera (Kubera)	Kompira Ten
ghanirghoṣa	Tenkuraion Nyorai		
Dvārapāla	Ni-ō	Lambā	Nirambā
		Locanā	Sōmoku Tengō
Ekādaśamukha	Jūichimen Kannon	Lokapāla	Shi Tennō
Ekādaśara Uṣnīṣa-cakra	Ichiji Kinrin Nyorai		
Ekākṣaroṣṇīṣacakra	Ichiji Kinrin Bucchō	Maghā	Sei-shuku
Elabasha	Erabasa	Mahācakravajra	Dairin Myō-ō
		Mahādeva	Daijizai-ten
Ganapati	Kangi-ten	Mahākāla	Daikoku-ten
Gandharva	Kandabba	Mahākāśyapa	Dai Kashō
Garbhadhātu	Taizō-kai	Mahāmayūrīvīdyārajñī	Kujaku Myō-ō
Garbhavīra	Misshaku Rikishi	Mahāpratisarā	Daizuigu Bosatsu
Garuḍa	Karura	Mahāṣṇīṣacakravartin	Kōdai Bucchō
Guptasena	Go-gun	Mahāśrī	Kisshō Ten (Kichijō Ten)
		Mahāsthāmaprāpta	Dai Seishi Bosatsu
Hārītī	Karitei-mo	Mahāvairocana	Dainichi Nyorai
Hastā	Shin-shuku	Maheśvara	Daijizai-ten
Hayagrīva	Batō Kannon,	Mahorāga	Magoraka
	Batō Myō-ō	Maitrāyāniputra	Furuna
		Maitreya	Miroku Bosatsu
Indra	Indara	Majila	Makora
Indracakra	Taishaku-ten	Makara	Makatsu-gū
Iśāna	Ishana-ten	Makuṭadantī	Kokushi
Iṣṭavajra	Yoku-kongō Bosatsu	Mālā	Juzu
		Mālādhari	Jiyōraku
Jālinīprabha	Kōmō-dōji	Mālāvajra	Man-kongō
Jāngulī	Jōguri-dojō	Maṇḍala	Mandara
Jayoṣṇīṣa	Shō Bucchō	Mani	Hōshu
Jīvaka	Jubaka Sonja	Mani Ākāśagarbha	Mani Kokūzō Bosatsu
Jyeshṭhā	Shin-shuku	Maṇibhadra	Shūken
		Mañjuśrī	Monju Bosatsu
Kalaviṅka	Karyōbinga	Mārīcī	Marishi-ten
Kālika	Karika Sonja	Mātrī	Shichigūtei Butsu-mo
Kanakabharadvāja	Kanakabaridaja Sonja	Maudgalyāyana	Mokukenren
Kanakavatsa	Kanakabassa Sonja	Māyā	Maya Fujin, Maya Bunin
Kanyā	(Sho) Jō-gū	Meṣa	(Haku) Yo-gū
Kapila	Kabira	Mikila	Mekira
Karkaṭa	(Kyō) Kai-gū	Mīna	($ō) Gyo-gū
Karma	Inga	Mṛgaśiras	Shi-shuku

Sanskrit	Japanese	Sanskrit	Japanese
Mudrā	In (So)	Ratnasambhava	Hosho Nyorai
Mūla	Bi-shuku	Revatī	Kei-shuku
Murugan	Kumara-ten	Rohinī	Hitsu-shuku
Nāga	Ryū	Sachittotpāda-	
Nāgārjuna	Ryūmō, Ryūju Bosatsu	dharmacakravartin	Temporin Bosatsu
Nāgasena	Nāgasena Sonja	Samantabhadra	Fugen Bosatsu
Nairṛtirāja	Rasetsu-ten	Samantabhadrāyus	Fugen-Enmei
Nakṣatra	Nijūhachi Shuku		(Enmyo) Bosatsu
Nakula	Nakora Sonja	Samjñeya	Sanshi Taisho,.
Nāmakāra-mudrā	Gassho-in		Jinja Taishō
Nandikeśvara	Kangi-ten, Shoten	Samkusumitarāja	Kaifuke-ō Nyorai
Nārāyaṇa	Naraen-ten	Samudgata	YakuJō Bosatsu
Navagrahā	Ku-yō	Saptakoṭibuddha-	
Nīlakaṇṭhī	Jōkyō Kannon	bhagavati	Shichigūtei Butsu-mo
	(Shōkyo Kannon)	Sarasvatī	Benzai-ten
Nirvāṇa	Nehan	Sarvanivaraṇa-	
		viṣkambhin	Jōgaisho Bosatsu
Pādanakṣipa	Buchaku Myō-ō	Sarvasattvajōharī	Datsu-issai ShuJō
Padma-mudrā	Renge no In	Śākala	Shakara
Padmapāṇi	Rengeshū	Śanaiścara	Do-yo
Pajira	Haira	Sandila	Santeira
Palāśāmbarī	Hiyoe Kannon	Śankara	Daijizai-ten
Pāṇḍaravāsinī	Byakue Kannon	Śāriputra	Sharihotsu
Panthaka	Bantaka (Hantaka) Sonja	Śatabhiṣā	Kyo-shuku
Parnirvāṇa	Nyu-nehan	Śiva	Daijizai-ten
Paritranaśyayamati	Kugoe-doji	Śravana	Gyū-shuku
Pārvatī (Umā)	Umahī, Umago	Śrī Mahādeva	Kissho Ten (KichiJō Ten)
Pāśa	Saku	Śukra	Kin-yo
Pātra-mudrā	Hachi-in	Simha	Shishi-gū
Piṇḍola Bharadvāja	Bindora Baradaja,	Simhanāda	Shishiku Bosatsu
	Binzuru Sonja	Sindūra	Shindara
Piṅgalā	Hyogyara Ten	Sitātapattroṣṇīṣa	Byakusangai Bucchō
Pippalayāna	Dai Kasho	Skanda	Kumara-ten, Ida-ten
Prabhūtaratna	Taho Nyorai	Soma	Homa, Getsu-yō
Prajnāparamitā	Hannya Bosatsu	Subhākarasimha	Zemmui
Pṛthivī	Chi-ten	Subhūti	Subodai
Punarvasu	Sei-shuku	Subinda	Suhinda Sonja
Pūrṇa	Furuna	Sudṛṣti	Myoken Bosatsu
Pūrṇabhadra	Manken	Sumana	Sumana Ryū-ō
Pūrṇabhadrapadā	Shitsu-shuku	Sunyadsa	Daruma
Pūrvaphalgunī	Cho-shuku	Sūrya	Nitten
Pūrvāṣāadhā	Ki-shuku	Sūryaprabha	Nikko Bosatsu
Pūṣavima	Fusabima Ryū-ō	Sūtra	Kyo
Puṣpadantī	Kashi	Svastikā	Manji
Puṣya	Ki-shuku	Svātī	Ko-shuku
Rāgarājapāga	Aizen Myō-ō	Tārā	Tara Bosatsu
Rāgavajra	Ai Kongō	Tathāgata	Butsu, Nyorai
Rāhu	Rago-sei	Tejorāchyuṣṇīṣa	Kōju Bucchō
Rāhula	Ragora	Trailokyavijaya	Gōzanze Myō-ō
Rākṣasa	Rasetsu-ten	Trratna	Sambō
Rāśi	Juni-gū	Tulā	(Ten) Bin-gū
Ratnakāra	Hoshō Jizō Bosatsu	Tuṣita	Tosotsu Ten
Ratnaketu	Hoto Nyorai		
Ratnapāṇi	Hōshu Jizō Bosatsu		
Ratnapāramitā	Ho-haramitsu Bosatsu		

Sanskrit	Japanese	Sanskrit	Japanese
Ucchuṣma	Ususama (Usushima)	Vajrapāśa	Kongō-saku Bosatsu
	Myō-ō	Vajrapuṣpā	Kongō-ge Bosatsu
Umā	Umagō (Umahi)	Vajraputra	Bajarabutara Sonja
Upakeśinī	Ubakeshini-dōji	Vajrarāga	Kongō-ai Bosatsu
Upāli	Ubari	Vajrarāja	Kongō-ō
Uṣṇīṣa	Nikkei	Vajrarājapriya	Aizen Myō-ō
Uttarabhādrapadā	Heki-shuku	Vajrarākṣa	Kongō-go Bosatsu
Uttaraphalguṇī	Yoku-shuku	Vajrasādhu	Kongō-ki Bosatsu
Uttarāṣādhā	To-shuku	Vajrasattva	Kongōsatta
		Vajrasphoṭa	Kongō-sa Bosatsu
Vairocana	Birushana Butsu,	Vajratīkṣṇa	Kongō-ri Bosatsu
	Dainichi Nyorai	Vajraveśa	Kongō-rei Bosatsu
Vaiśravaṇa	Tamon Ten,	Vajravīra	Kongō-rikishi
	Bishamon Ten	Vajrayakṣa	Kongō Yasha Myō-ō,
Vajra	Kongō		Kongō-ga Bosatsu
Vajra-Añjali-mudrā	Kongō-gasshō-in	Vanavāsin	Banabasu Sonja
Vajramudrā	Chiken-in (?)	Varada-mudrā	Yogan-in, Segan-in
Vajrabhāṣā	Kongō-go Bosatsu	Varuṇa	Sui-ten
Vajradhara	Kongō-shu Bosatsu	Vasubandhu	Basu Sennin, Seshin
Vajradharma	Kongō-hō Bosatsu	Vāsuki	Basuki Ryū-ō
Vajradhātu	Kongō-kai	Vāyu	Fū Ten, Fū Jin
Vajradhūpā	Kongō-shōkō Bosatsu	Veda	Ida-ten
Vajragandhā	Kongō-zukō Bosatsu	Vidyādhara	Myō-ō
Vajragītā	Kongō-ka Bosatsu	Vijayoṣṇīṣa	Saishō Bucchō
Vajrahāśa	Kongō-shō Bosatsu	Vikarāla	Bikyara
Vajrahasta	Kongō-shu Bosatsu	Vikīrnoṣṇīṣa	Jōshō (Sangai) Bucchō
Vajrahetu	Kongō-in Bosatsu	Vilambā	Biramba
Vajrahūṃkāra	Kongō-dōji	Vimalakīrti	Yuima Kōji
Vajrakarma	Kongō-kō Bosatsu	Vimalaprabha	Mukukō-dōji
Vaj rakumāra	Kongō-dōji	Vināyaka	Binayaka Ten, Kangi Ten
Vajrālokā	Kongō-tō Bosatsu	Virūḍhaka	Jōchō Ten (Zōchō Ten)
Vajramālā	Kongō-man Bosatsu	Virūpākṣa	Kōmoku Ten
Vajrāmoghaśa-	Fugen Enmei	Viṣakha	Tei-shuku
mayasattva	(Enmyō) Bosatsu	Viṣṇu	Bichu Ten
Vajrāngkuśa	Kongō-kō Bosatsu	Viśvakarman	Bishukatsuma
Vajrānṛta	Kongō-bu Bosatsu	Viśvaparipūraka	Jizō Bosatsu
Vajrapāṇi	Kongō-renge Shu	Vitarka-mudrā	An-i-in
Vajrapāramitā	Kongō-haramitsu Bosatsu	Vṛṣa	(Kin) Gyū-gū

Notes

* The introductory quotation on page 7 is by the monk Kōbō Daishi (formerly named Kūkai), taken from Masaharu Anesaki, 'Quelques pages de l'histoire religieuse du Japon', *Annales du musée Guimet*, XLIII, Paris, 1921, pp. 55–6.

Foreword

1 Most of the figures described are not deities in the Judaeo-Christian sense, who are relevant to the material world and to heavens, but Buddhas and Bodhisattvas, relevant to spiritual practice and goals.

Chapter II
Iconography

1 G. Nitschke, 'Kyōto, un urbanisme esotérique', *Est-Orient*, Tōkyō, 1967, I, p. 30.
2 R. Tajima, *Les Deux Grands Mandala et la doctrine de la secte Shingon*, pp. 34–36. Paintings: Tō-j in Kyōto (colours on silk, 1963); Jingo-ji in Kyōto (on violet silk, by Kūkai?, c. 824–834); Kangaku-in, Onjō-ji in Nara (on violet silk, eleventh century); Chōkoku-ji (Hase-dera) in Nara (dated 1934); Myō-ō-in in Kōyasan (on silk); Daigo-ji in Kyōto (painted on wood). Sculptures: Jizō-in in Kyōto (bas-relief on wood, eleventh century); Daigo-ji in Kyōto (bas-relief in bronze); Tokuman-ji in Ibaragi-ken. The following are mentioned for information only. Paintings: *Ichiji-Kinrin Mandara*, Minami-hokke-ji in Nara (on silk); *Sonshō Mandara*, Gokoku-ji in Kyōto; *Hōrōkaku Mandara* 'of the precious tower', Sanbō-in in Kyōto; *Hoke-kyō Mandara* (after an esoteric interpretation of the *Saddharmapundarīka-Sūtra*), in the Kaijūsen-ji in Kyōto; *Butsugen Mandara*, Tō-ji in Kyōto; *Hachidai-bucchō Mandara*, Onjō-ji in Shiga; *Ninmō-kyō Mandara* (of the 'good kings', taken from the *Prajñāpāramitā-sūtra*), in the Daigo-ji in Kyōto; *Shō-ugyō Mandara*, Sanbō-in in Kyōto; *Hossō Mandara*, Nezu Museum in Tōykō; *Kegon-kyō Mandara*, Kōzan-ji in Kyōto; Tōdai-ji in Nara; *Kusha Mandara* (of Shaka Nyorai), of the Hokkedō at the Tōdai-ji in Nara; *Sei Mandara* (of 'the stars'), in the Hōruy-ji in Nara; at the Kumeda-dera in Ōsaka; *Anchin Mandara* (of the Jūni-ten), in the Kokubun-ji in Yamaguchi; *Taima Mandara*, at the Taima-dera in Nara; *Bonmōkyō Mandara* (taken from the *Brahmājāla-sūtra*); *Muryōju-kyō Mandara* (taken from the *Amitāyus-sūtra*, the *Aparamitāyus-sūtra* and the *Sukhāvatī-vyūha*); *Shōmangyō Mandara* (*Shrīmālādevī-sūtra*); *Yuimalyō Mandara* (*Vimalakīrti-nirdesha*); *Konkōmyō-kyō Mandara* (*Suvarnaprabhāsa-sūtra*).
3 E. Dale Saunders, *Mudrā*, Bollinger Series, LVIII, New York, 1960.
4 E. Dale Saunders, *op. cit.*, p. 35.
5 R. Tajima, *Etude sur le Mahāvairochana-sūtra*, Paris, 1936, p. 122.
6 Whereas the texts prescribing the representation of iconographical forms state that this mudrā can be made with the right hand, the Buddhas or Bodhisattvas thus represented are extremely rare; the Kudara Kannon in the Hōryū-ji in Nara is one example.
7 With a variant called *Vitarkaparigraha mudrā* (Japanese *An-i-shōshu-in*): left hand in Vitarka, right hand advanced as if to pick up an object.
8 Or mudrā of subjugation of the demons invoked by Māra to prevent the Buddha from attaining Enlightenment.
9 Also called *Hokkai-jō-in* in Japan. It is not known to which Sanskrit expression the first two characters of this name correspond.
10 E. Dale Saunders, *op. cit.*, p. 102.
11 Dubious Sanskrit equivalents, according to M.-T. de Mallman. E. Dale Saunders (*op. cit.*, p. 102) also proposes *Vajra mudrā*, *Bodhaṣrī mudrā*. Others also propose *Jñānamushti mudrā*.

12 E. Dale Saunders, *op. cit.*, pp. 117–18.
13 *Hōbōgirin*, p. 309.
14 This means the monks or disciples. E. Dale Saunders (*op. cit.*, p. 112) indicates deities and Myō-ō. This mudrā is very rare in Japan.
15 This position would more accurately be called 'in the Iranian fashion' because it appears to have originated in Iran. First representations are in Gandhāra, before the fifth century.
16 See A. Getty, *The Gods of Northern Buddhism*, Clarendon Press, Oxford, 1914, plate X, where both hands rest on the raised knee.
17 For example, in the Los Angeles County Museum of Art.
18 In the Al Farahnik Collection, Brussels.
19 Victoria and Albert Museum, London.
20 Pillars of Bayon, Angkor.
21 A. K. Coomaraswamy, *Elements of Buddhist Iconography*, Harvard, Cambridge, 1935, p. 43.
22 J. Auboyer, 'Les influences et les réminiscences étrangères au Kondō du Hōryū-ji', pp. 45ff., p. 55. 'Le Trône et son symbolisme dans l'Inde ancienne', *Annales du musée Guimet*, Paris, 1941 and 1949.
23 No exact Sanskrit equivalent to *Jimotsu* exists. *Lakśanā* would be the closest approximation.
24 Translated by Foucaux.
25 R. Tajima, *op. cit.*, p. 65.
26 R. Tajima, *op. cit.*, p. 106.
27 E. Dale Saunders, *op. cit.*, pp. 159ff.
28 According to Jean Naudou, 'Les bouddhistes kashmîriens au moyen âge', *Annales du musée Guimet*, Paris, 1968, LXVIII, p. 113, 'his most venerable ancient appearance appears in the title of a *Prajñāpāramitā-sūtra*, the *Vajracchedikā*, which is often translated as the "diamond chopper". The intention is clear: the word vajra evokes the destructive power of the dialectics of the *Prajñāpāramitā-sūtra*, which, by a fine dissection, reduces appearances to nothing, as effectively as repeated bolts of lightning. Hence the semantic development is obvious: vajra denotes what subsists when appearances have been left behind, that is to say vacuity, as indestructible as diamond.'
29 E. Dale Saunders, *op. cit.*, p. 68.
30 E. Dale Saunders, *op. cit.*, p. 187.
31 E. Dale Saunders, *op. cit.*, p. 186.
32 E. Dale Saunders, *op. cit.*, p. 188. According to R. Tajima (*op. cit.*, p. 68), the three points correspond to the three classes of deities, Buddha, Padma and Vajra, and represent 'the truth of our heart, that the Buddha and the beings are not different in essence.'

33 E. Dale Saunders, *op. cit.*, p. 188.
34 According to M.-T. de Mallmann.
35 R. Tajima, *op. cit.*, p. 70.
36 *Hōbōgirin*, III, pp. 265-270.
37 Mounted on an elephant; see de Visser, *Ancient Buddhism in Japan*, p. 566.
38 *Taizō-zu-zō*, V, 540, central figure.
39 *Taizō-zu-zō*, I, 774, no. 242.
40 According to the *Mahāsudassana-sūtra* (M.-T. de Mallmann, *op. cit.*, p. 306).
41 J. Troup, 'Illustrations of Buddhism from Japanese Pictures', *Transactions of the Asiatic Society of London*, XII, London, 1914, p. 6.
42 E. Dale Saunders, *op. cit.*, p. 165.

Chapter III
The Buddha and the Great Buddhas

1 Yet all the followers of the Jōdo-Shinshū consider themselves to be sons of Shaka. After their death, the name Shaka is added to their own. According to Ōtani Chojun, a statue of Shaka is actually found above the entrance gate inside the Higashi Hongan-ji, the principal temple of the sect in Kyōto.
2 In Japan, small children sometimes call Shaka by the name they give to the moon, Nono-sama, perhaps because of the resemblance of the full moon with the halo surrounding the head of the Buddha in painted and drawn representations, also perhaps because of the idea that Buddha surveys the actions of men just as the moon appears to do from high in the firmament: '*Nono-sama ga mitara Wareware-masu yō*' (Mock Joya, *Things Japanese*, Tōkyō News Service, Tōkyō, 1964, pp. 401–2). Note also that, since the Meiji period (1868), the *tokyhon* (reading books for primary schools) include Shaka among the four great sages of humanity (Śākyamuni, Confucius, Socrates and Christ): *Sekai no Shisei*, p.138.
3 A. C. Soper, *Art and Architecture of Japan*, Penguin, London, 1960, p. 213
4 *Inde Classique*, §626, §2260 and §2270.
5 A. C. Soper, 'Literary Evidence for Early Buddhist Art in China', *Artibus Asiae*, Ascona, 1959, pp. 259ff.
6 *Hōbōgirin*, III, *Butsuzō*, pp. 259ff. Chinese legends relate that, in 122 BC, an image of the Buddha was sent to the Emperor of China.
7 Sculpture in the Delhi Museum, India.
8 L. Frédéric, *Inde, temples et sculptures*, Paris, 1959, pp. 123 and 127. On the subject of this tradition, see B. Frank, *Konjaku Monogatari Shū*, IV, 5, translation published by Gallimard, Paris, 1968, with

the title *Histoires qui sont maintenant du passé*, 'Connaissance de l'Orient' Series, sponsored by UNESCO.

9 Yet it must be pointed out that, in the local archaeological museum at Pagan in Burma, there is a relief in wood in the *Pāla* style, probably dating from the twelfth century, showing the Buddha at the bottom of the ladder leading to *Trāyastrimsha*, the Heaven of the 33 Gods (see L. Frédéric, *Sud-Est asiatique, temples et sculptures*, Paris, 1964, p. 81; *France–Asie*, ed. R. de Berval, *Présence du Bouddhisme*, Saigon, 1959, p. 274, plate IX). Some rare Japanese and Chinese paintings depict the same scene.

10 For example, Alfred Foucher; see 'The Beginnings of Buddhist Art' and 'The Greek Origin of the Image of the Buddha' in *The Beginnings of Buddhist Art and Other Essays in Indian and Central-Asian Archeology* (Paul Guenther, Paris, 1971; originally published in *Journal Asiatique*, January–February 1911).

11 Ananda Coomaraswamy, 'The Origin of the Buddha Image', *Art Bulletin*, no. 4 (1927), pp. 287–328.

12 A. Coomaraswamy, *op. cit.*

13 Susan Huntington, 'Early Buddhist Art and the Theory of Aniconism', *Art Journal*, Winter 1990.

14 Some authors claim 552: if this date were confirmed (which does not appear to be the case), this would be King Syeong-myeong (Japanese *Seimei*).

15 G. B. Sansom, *A Short Cultural History of Japan*, Appleton Century Croft, New York, 1943, p. 68; J. Buhot, *Histoire des arts du Japon des origines à 1350*, Paris, 1949, pp. 59–60.

16 Takaichi-gun, Nara-ken, Japan.

17 This dimension is given the name Jōroku in Japan.

18 O. Sirén, *La Sculpture chinoise*, plate 89.

19 J. Buhot, *op. cit.*, plate 35, no. 295.

20 J. Buhot, *op. cit.*, p. 209.

21 This statue was often imitated, especially in the Kamakura period in Japan. The most highly admired of these replicas are those in the Tōshōdai-ji in Nara, 1.64 m high, of wood (Kamakura period); in the Saidai-ji in Nara, Muromachi period; in the Gokuraku-ji, Kamakura period (late thirteenth century); in the Enmei-ji, and in the Sho-myō-ji.

22 Takagamine, Kamikyōku, Teramachi-dōri, Seiwa-in, Kyōto. Information communicated by Bernard Frank.

23 According to the tradition of the temple, these images date from 1194, and were commissioned from Kaikei by the Regent

Kujō Kanezane, who installed them in his house in Tsuki-no-wa. Temple of Kenkō-in, Kitano-ku, Takagamine, Koetsu, Kyōto.

24 In some texts, and by poetic licence, Mida is often written instead of Amida.

25 '*Shigan no Shaka Ikeyo, Higan no Mida Koiyo*'.

26 *Mitera*, name given to certain 'imperial' temples.

27 Hands in Jō-in (Dhyāna mudrā).

28 Right hand in Abhaya mudrā, left hand flat on the knee, statues attributed to Unkei, Kamakura period.

29 In the *Taizō-kai Mandala*, 'respect for the Buddha' is symbolized by a Buddha of wisdom called Ratnaketu (Japanese *Hōtō Nyorai*). The Śākyamuni Buddha is also symbolized in some cases by a parasol (distinctive sign of the Rājas), deified under the name of Byakusangai Bucchō (Sitātapatra Buddha uṣṇīṣa), 'the great white parasol of the Buddha', personification of an esoteric formula. See the *Hōbōgirin*, pp. 221–2.

30 According to A. B. Griswold.

31 See bronze statuette in Nālandā (India), L. Frédéric, *Dans les pas du Bouddha*, Paris, 1957, pp. 39, 116.

32 Japanese *Tenjō Tenga Yuiga Dokuson*. All the scenes of the birth of the Buddha are well illustrated in a Tibetan painting in the Musée Guimet in Paris. See *France–Asie, Présence du Bouddhisme, op. cit.*, plate V.

33 This *amacha* is made of an infusion of the leaves of *Hydrangea hortensis*. Yet this infusion has been used only since the eighteenth century; perfumed water was previously employed.

34 This ceremony took place for the first time in Japan in the year 840 (according to the *Masu Kagami*, historical chronicle of the late thirteenth century dealing with previous centuries). M. V. de Visser, *op. cit.*, pp. 53ff.

35 Next to the basin, two representations of mountains were formerly installed, ornamented with a red dragon and a blue (or green) dragon, supposed to symbolize the two kings of the Nāgas, Nanda and Upānanda, who, according to the later legends, immersed the Buddha at his birth.

36 Also called Kari-dō or Hana-tei, but more rarely.

37 Japanese tradition claims that the Empress Suiko had this ceremony celebrated for the first time in the year 606, in the courtyard of the temple of Senkō-ji (Ikoma-gun, Nara).

38 This *amacha* is also thought to cure diabetes (Mock Joya, *op. cit.*, p. 72). Before sugar was imported into Japan in the

seventeenth century, *amacha* was used to sweeten beverages.

39 B. Frank, 'Le panthéon bouddhique au Japan', *Mythologies*, Larousse, Paris, 1963, p. 158. This *amacha*, mixed with the ink of an inscription on paper glued to the wall, was thought to protect the house from the intrusion of insects and centipedes (*Daijiten*, I, p. 970), and against being struck by lightning, thanks to a different formula (*Kokushi Daijiten*, 1908, p. 929, and M. V. de Visser, *op. cit.*, p. 57).

40 In the Musée Guimet, Paris.

41 See the curious painting reproduced in J. Troup, *op. cit.*, p. 185, plate III, for example.

42 The child emerging from the right sleeve of the garment of his mother has the hands joined in worship (Añjali mudrā). His hair, not curled, nevertheless shows a cranial protuberance (*uṣṇīśa*). A stone bas-relief from the Lorian-Tangai in Gandhāra representing the birth of the Buddha shows the child in the same position as in the statuette described above, emerging not from the sleeve, but from the right side of his mother (*Zuzetsu Nihon Bijutsu-shi*, Tōkyō, 1959, vol. I, p. 38, and plate XIV). There is an identical scene, but in painting, in a maṇḍala of Dunhuang in China (Tang period) in the National Museum in New Delhi, India.

43 See the bas-relief of the north gate of the great *stūpa* of Sañchī (India), and the bas-relief of the Amarāvatī *stūpa* currently in the Madras Museum, in which Prince Śākyamuni is seen to take leave of his wife Yashodharā (shown in L. Frédéric, *Dans les pas du Bouddha, op. cit.*, p. 117, plates VII, X).

44 However, other sects may attribute different acolytes to Shaka Nyorai (wood, at the Murō-ji in Nara). In the *Hōrōkaku Mandara* (maṇḍala of the precious tower), Shaka is assisted by Seishi Bosatsu and Shō Kannon, sometimes also by Vajrahāra and Ratnavajra (J. Buhot, *Histoire des arts du Japon, op. cit.*, §228, plate 46, no. 228). In the Kondō of the Hōryū-ji in Nara, Shaka is assisted by Yaku-ō and Yaku-jō, two Bodhisattvas of medicine (in bronze, dated to 623, 2 m high). Sometimes, in addition to his two usual acolytes, Shaka has two Shōmons (Śrāvaka) or two of his disciples, and this group is called Goson ('Five Venerable Ones'). Repoussé copper plate in the Hōryū-ji in Nara.

45 See P. H. Doré, *Manuel des superstitions chinoises*, Zi-ka-wei, Shanghai, 1926.

46 Information obtained by Bernard Frank from a priest of the Tengen-ji, Azabu,

Minato-ku, Tōkyō (Rinzai sect), on 20 October 1962, and kindly communicated to the author.

47 The pictorial theme of the ascetic Buddha, often represented on *kakemono* in *sumi-e* (ink and wash), seems to be of Chinese origin, as testified by the famous picture by the painter Liang Kai (Japanese *Ryōkai*) dating from the thirteenth century, and reproduced in R. Grousset, *Histoire d'Extrême-Orient*, p. 339, plate 224 (Sakai Collection, Japan). In sculpture, however, the Buddha in ascesis, nearly a skeleton, already existed in the Gandhāra art of the fifth century (ascetic Buddha of Peshāwar).

48 See *Nihon no Hotoke-sama*, Ōta and Owadani, p. 136.

49 From the Sanskrit *Kāṣāya*, the reddish-brown colour adopted in India by the monks and ascetics for the colour of their monastic robe or Samnyasin.

50 *Inde classique, op. cit.*, II, §2275, p. 535.

51 The earliest Japanese styles of this aspect of Shaka, like the Shaka of Tori (723) in the Hōryū-ji, the Daibutsu in the Ango-in (Asuka-dera) and also the Shaka falsely called 'Yakushi' and dated 607 (in the Hōryū-ji), can be compared with the style of the Buddha of cave no. 135 of Maiji Shan (China) dating from the northern Wei period (386–534) from which it appears to have come directly. *France–Asie, Présence du bouddhisme, op. cit.*, XLI, p. 722, plate 41.

52 In Japan, when the Buddha is represented in the position of taking the Earth for witness, the tips of the fingers of his right hand touch the ground or the petals of the seat. It is then given the name Gōmajodo Nyorai. Painting: in colour on wood in the five-storey pagoda of the Daigo-ji in Kyōtō, from the Heian period. Sculptures: in the Kōmyī-ji in Kamakura; in the Hōryū-ji in Nara; also terracotta bas-relief dating from the seventh century in the Minami-Hokke-ji in Nara.

53 In the *Hōrōkaku Mandara*, Shaka is attended by Seishi Bosatsu (see note 47).

54 In the Kegon-shū sect, he is identical to Birushana Butsu, another name for Birushana Nyorai or Dainichi Nyorai (see Vairocana, chapter IV).

55 Fifth century; L. Frédéric, *Dans les pas du Bouddha, op. cit.*, p. 123, plate 46.

56 At the centre of an illustration of the *Dai Hannya Kyō* (*Prajñāpāramitā-sūtra*) surrounded by Fugen Bosatsu, Kannon Bosatsu and Śāriputra, and the 'protectors of the *sūtras*', including Xuan Zang and the four Lokapālas. J. Troup, *op. cit.*, p. 6, plate II.

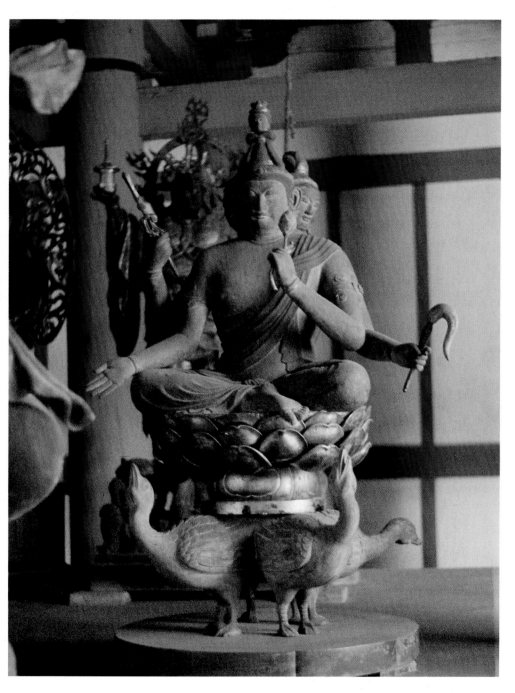

Bon-ten, coloured wood, Tō-ji, Nara, Japan, seventeenth century

Chinthe, brick, Mingun, Burma, nineteenth century

57 'Preaching of Shaka', on calligraphed and illustrated *sūtra*. J. Buhot, *Histoire des arts du Japon, op. cit.*, p. 253, plate 54. Painting: seated in I-zō, on embroidery in the Kanshū-ji, late Asuka period (seventh century). Sculptures: seated in I-zō, on gilt clay tablet, in the Hōryū-ji; seated in Padmāsana, on an engraved bronze lotus petal, in the Tōdai-ji in Nara.

58 J. Buhot, *op. cit.*, §245, p. 179. This scene is often described in Chinese paintings, particularly on a wall painting of the Northern Wei period (386–534) in the Dunhuang Caves (A. Bareau, *France–Asie, Présence du bouddhisme, op. cit.*, p. 351, plate XIV, and M. V. de Visser, 'A Japanese Painting of the Death of the Buddha in the Museum of Asiatic Art, Amsterdam', *Artibus Asiae*, X, Ascona, 1947, p. 43ff.). See also the 'Buddha in the coffin', mural painting of the Qyzil, from the sixth century, in the Museum für Völkerkunde in Berlin. Sculptures: on wood in the Kannon-ji in Kyōto; in clay in the Gojunotō (five-storey pagoda) in the Hōryū-ji; in gilded wood (thirteenth century) in the Nara Museum. Paintings: on silk in the Saikyō-ji in Nagasaki; in the Yata-dera in Kogawa; in the Koetsu-ji in Tokushima; in the Hemmyō-ji in Okayama; in the Jissō-in in Okayama; in the Jōkyō-ji and the Chōhō-in in Wakayama; in the Kongō-bu-ji in Kōyasan (dated 1086); in the Ishiyama-dera (Kamakura period); in the Engaku-ji in Kamakura; by Myōzen in 1323 (Fujita Collection); in the Kenchō-ji in Kamakura (dated 1697); in the Gokuraku-ji in Kamakura (thirteenth century).

59 *Taishō*, XII, p. 383. J. Buhot, *op. cit.*, p. 180. Painting: colour on silk, in the Chōhō-ji in Kyōto (eleventh century).

60 F. Jouön des Longrais, *Est–Ouest*, p. 90.

61 B. Frank, *Mythologies*, p. 90.

62 E.g. gilt bronze, dating from 518, Musée Guimet, Paris. See J. Buhot, *Arts de la Chine*, Paris, 1951, p. 72 and plate 54. Prabhūtaratna was a Buddha who lived in the world of the East, Ratnaviṣuddha ('of precious purity'), who had vowed to appear after his Parinirvāna wherever the *Lotus Sūtra* was expounded.

63 See bronze bas-relief dated 686 in the Hase-dera in Nara (J. Buhot, *op. cit.*, p. 91, §87).

64 Portable sanctuaries, in the Musée Guimet, Paris.

65 *Ofuda* in the Gochikokubun-ji in Echigo (Japan).

66 M. V. de Visser, *op. cit.*, X, p. 247.

67 *Hoke-kyō Mandara, Bodaijō Mandara, Shōgyō Mandara, Hōrōkaku Mandara,*

Kusha Mandara, Nehangyō Mandara. Painting: in the Hase-dera in Nara.

68 Sometimes called Kongō Zaō Gongen, especially in the Kimbusan-ji.

69 An exceptional static form, of wood, standing on a rock, is found in the Sanbutsu-ji in Tottori, Japan (thirteenth century).

70 And, for this reason, he is sometimes merged with Dakini-ten.

71 This cult was created in the temple of Yakuō-in, which was destroyed in 1673 ('Yakuō-in', *Shin Bukkyō Jiten*, p. 520).

72 *Hotoke-sama no Kosei Shirabe*, p. 141, and *Nihon no Hotoke-sama*, pp. 124ff.

73 These two disciples form the pair of the best disciples (Agraśrāvakayuga). A. Bareau, *op. cit.*, pp. 351ff.

74 In the list given here, the order is indefinite: it varies largely according to Oda, *Bukkyō Daijiten*, p. 922; Sawa Ryūken, *Butsu zo-zu-ten*, pp. 180–81; according to the *Daming sanzang fashu* (Japanese *Dainin sanzō bossū*), Chinese text dated 1151; and also according to the *Butsuzō-zu-i*, IV, p. 18. This list is far from comprehensive. The best-known representations in Japan of these ten great disciples of the Buddha are the following. Sculptures: in the Daihōon-ji in Kyōto (Shingi Shingon sect) attributed to Unkei (Kamakura period); in coloured dry lacquer in the Kōfuku-ji in Nara (1.47 m high, dating from 734, and representing Subodai standing on a rock, shod with sandals, as well as Ragora and Kasenen); in the museums of Nara and Kyōto; in the Kenchō-ji in Kamakura; in the Gokuraku-ji in Kamakura.

75 S. Yamaguchi, *History of Prajñāpāramitā-sūtra Thought* (Japanese, *Hannya Shisō-shi*), Kyōto, Hōzōkan, 1951.

76 H. Oldenberg, *Vinayapitaka*, London, 1879, 1885, 5 vols.

77 A. Bareau, 'Les Disciples', *op. cit.*, pp. 351ff.

78 They are thought to have renounced the state of the Buddha in order to help beings to follow the way to Perfection. According to A. Getty (*op. cit.*, p. 174), 'Gautama Buddha, before making the great vow of the Bodhisattva, was, in one of his incarnations, the Sumedha' (see *Sumedha Jātaka*). According to A. Bareau, the entire Buddhist tradition has acknowledged, since antiquity, that the future Buddha became a Bodhisattva only on the day that he met the previous Buddha Dīpankara and became his disciple, at the time when he was an ascetic known as Sumedha (there are some variants). The *Jātaka* of Sumedha

is hence the first in chronological order, while all the others refer to existences prior to those of Sumedha. Yet Sumedha was never an Arahant or he would have been reborn, since, by definition, an Arahant is a Buddhist saint who, like a Buddha, has reached the end of his existences. The fact that, according to legend, Sumedha was then reborn hundreds of times as a Bodhisattva, proves that he was not an Arahant. On this subject, see the articles on Sumedha in the dictionaries of Malasekhara and the *Bukkyō Daijiten*.

79 E. Chavannes and S. Levi, 'Les seize Arahant protecteurs de la Loi', *Journal Asiatique*, Paris, September/October 1916.

80 M. V. de Visser, 'The Arhats in China and Japan', *Ostasiatische Zeitschrift*, X, 1919, p. 62.

81 Japanese children play a game called *rakan-san* in which, seated in a group, they try to imitate the gestures made by one of them while singing '*Rakan-san ga sorottara mawaso-ja naika, Yoi ya sa, Yoi ya sa ...* [If all the Rakans are here, we can play turning round, Yoi ya sa, Yoi ya sa...]', a game something like our own 'Simon says ...'

82 M. V. de Visser, 'The Arhats in China and Japan', *op. cit.*, VII, 1918; H. Maspéro, 'Le monastère de la Kan-Yin qui ne veut pas s'en aller', BEFEO, IX, 1916.

83 Custom reported by a priest of the Daitoku-ji to the author in 1965. This priest added that he believed that the people at the time probably confused the five hundred Rakans (Gohyaku Rakan) with the thousand Jizōs (Sentai Jizō). See also S. Yamaguchi, *We Japanese*, Hakone, 1950, p. 129.

84 M. V. de Visser, 'The Arhats in China and Japan', *op. cit.*, VII, 1918.

85 English translation by H. Kern, London, 1909, SBE, XXI. Published by N. Dutt (BI no. 276), Calcutta, 1952.

86 Concerning some of these beliefs, see Mock Joya, *Things Japanese, op. cit.*, pp. 607, 665, 749.

87 H. Kern, *Histoire du bouddhisme dans l'Inde*, I, p. 152.

88 M. V. de Visser, *op. cit.*, n. 93.

89 In some cases, his effigy is placed in monastery refectories, as at the Jikidō (Shakudō) in the Tōdai-ji in Nara, and in the Hieizan. This role of the physician protector of the Samgha possibly stems from a confusion with Jîvaka (see n. 103).

90 Sawa Ryūken, *Butsuzō-zu-ten*, pp. 177–178.

91 He is mentioned, together with Vajraputra, in the *Samyuktāgama-sūtra* (Japanese *Zō Agongyō*).

92 *Ibid.*

93 According to a legend, Jīvaka was also thought to be the author of surgical cures by trepanning and laparotomy (*Inde Classique*, II, §1675).

94 His story, as well as that of his brother, is related in the *Mūlasarvāstivāda Nikāya Vinaya*.

95 Published by V. Trencker, RAS, London, 1928; H. Kern, *Manual of Indian Buddhism*, Strasburg, 1896, p. 9; P. Demiéville, *Les Versions Chinoises du Milindapaña*, BEFEO, XXIV, 1903 (for an English translation see T.W. Rhys Davids, *The Questions of King Milinda*, 2 vols., New York, 1963).

96 A. Bareau, *Présence du bouddhisme*, p. 360. These Jūroku Rakans are also described in the *Taishō Daizō-kyō*. Sculptures: in wood, in the Rakan-ji (Sōtō sect) in Wakayama, dating from 1766, and effigy of the sixteen Rakans on the second storey of the Sanmon in the Daitoku-ji in Kyōto (seventeenth century).

97 See note 94.

98 See *Journal Asiatique*, 1916, pp. 283, 287ff.

99 Watters, *Journal RAS*, 1898, pp. 346ff.

100 E. T. C. Werner, *A Dictionary of Chinese Mythology*, Julian Press, New York, 1961, pp. 276ff.

101 Takakusu Junjirō, *The Essentials of Buddhist Philosophy*, Honolulu, 1949.

102 This ceremony of the 'opening of the eyes', called *Kaigen Kuyō* in Japanese, is performed whenever a statue of a deity is completed, to consecrate it and give it life. The most important of the Kaigen Kuyō ceremonies took place in 749 during the consecration of the great bronze statue of the Daibutsu in the Tōdai-ji in Nara.

103 *Inde Classique*, II, §2332.

104 W. Rahula, *L'Enseignement du Bouddha*, Paris, 1961, p. 38. He is known as Sman-bla (Manla) in Tibet and Yaoshi-fo in China.

105 Quoted in *L'Amritabridayāstāngaguhyo-padeshatāntra* (pp. 72–786) or 'Livre d'enseignement des secrets médicaux, Essence de l'ambroise', *Inde Classique*, II, §1665.

106 Images of Bhaiṣajyagura in India and in South-East Asia: in the Khmer Empire, the central chapel of the 'hospitals' of Jayavarman VII contained the image of a Buddhist trinity composed of the Buddha 'Master of the remedies with the brilliance of beryl' and two Bodhisattvas named 'Solar Brightness' and 'Lunar Brightness', who, according to an inscription, 'both banish from the creatures the darknesses of illness' (G. Coedès, 'L'Assistance médicale au Cambodge au XVIe siècle', *Présence du bouddhisme, op. cit.*, p. 495. Section XVI

of the Say Fong stele of Jayavarman VII states: 'He erected the Sugata Bhaishajya with a hospital around it and the two sons of the Jina (here Sūryaprabha and Chandraprabha) for the perpetual relief of the illnesses of his subjects.' The following sections add: 'He established this hospital here with a temple of Sugata and a Sugata Bhaishajya by the heart, moon of his body, sky' (XVII), and 'He also erected here these two healers of sickness, the venerable ones Sūrya and Chandravairocana, sons of Jinas' (XVIII) (translation from the French of G. Coedès).

107 See the Yüngang Caves in China. Mission Chavannes, R. Grousset, *Les Civilisations de l'Orient*, III, p. 171 *inter alia*. Dunhuang Caves in China, in R. Grousset, *op. cit.*, p. 319. See also Sir Aurel Stein, *Serindia*, II and IV, and R. Petrucci, 'Les peintures bouddhiques de Touen-Houang (Mission Aurel Stein)', *Annales du musée Guimet*, pp. 1409–10.

108 Or Dai-i-ō Butsu, the Great Buddha king of doctors (R. Tajima, *op. cit.*, p. 314).

109 *Ofuda* of the Gochi Kokubun-ji in Echigo, Japan (document kindly communicated by Bernard Frank).

110 R. Tajima, *op. cit.*, p. 320. Yakushi is also counted among the thirteen Buddhas of the Shingon sect (A. Getty, *op. cit.*, plate XVII).

111 B. Frank, *Mythologies*, p. 158.

112 These twelve vows are (from R. Tajima, *op. cit.*, pp. 316–17): 1. To illuminate the world by the light emitted by his body and those of the others. 2. To make his body and the bodies of others pure as beryl (Vaidūrya). 3. To give living beings all that they could possibly desire. 4. To make the living enter into the path of salvation. 5. To make the living follow the divine precepts and commandments. 6. To cure all who are infirm. 7. To cure the sicknesses of living beings and procure medicines for them. 8. To aid those who are born women to be reborn in the body of a man. 9. To rid living beings of heretical opinions and to set them again on the path of Truth. 10. To save living beings from all misfortunes and all difficulties. 11. To save those who suffer from hunger and thirst. 12. To give fine clothing and ornaments to those who have nothing to wear. (See also M. V. de Visser, *Ancient Buddhism in Japan*, II, p. 534.)

113 Residing in the east, he is also likened to the rising sun, while Amida, in the west, is likened to the setting sun, and Dainichi Nyorai represents the sun at its zenith, in all its strength.

114 Or of lapis lazuli, deep blue, as considered formerly. Also named Setsudo.

115 *Nihongi*, XXIX, p. 541, and W. G. Aston, *Shintō, the Way of the Gods*, London, 1905, p. 376; Kuno Takeshi and Inoue Takeshi, 'Study of the Yakushi Triad in the Kondō, Yakushi-ji', *Acta Asiatica*, I, Tōkyō Tōhō Gakkai, 1960.

116 Dengyō Daishi (Saichō) had placed in the main sanctuary of the Enryaku-ji (Hiei-zan) a statue of Yakushi Nyorai, upon his return from China in 805 (B. Frank, *op. cit.*, p. 159). Moreover, the *Inabadō Engi-emaki* relates how Tachibana no Yukihira, Governor of the Inaba, caused a statue of Yakushi that had been thrown into the water to be fished out, and had a statue built to it in Kyōto (J. Buhot, *op. cit.*, §346, p. 233, and notice in Okudaira, *Emaki*, 'Zoku Nihon Emakimono Shusei-i' Collection). This Inabadō Yakushi is found in the temple of Byōdō-ji (of equality) of the Hondō of Gion (Jetavana) of the period of the Emperor Seiwa. It was placed on a Goban or *go* chequerboard (*Butsuzō-zu-i*, IV). See also study in *Kokka*, no. 563, and in Okudaira, *Museum*, II. According to M. V. de Visser (*op. cit.*, II, p. 547), Saichō had an image of Yakushi of human size established in 788 in the Chūdō. In 803, he had four images of Yakushi Nyorai made, measuring more than 6 shaku (1.80 m) in height, which he called Mushōjodo Zenmyōshō Kichijō-ō Nyorai (see n. 127), and which he placed in the Kamodo of the Yama-dera in Dazaifu (Kyūshū) to obtain the favour of a good voyage to China (M. V. de Visser, *op. cit.*, II, p. 548). Statues of Yakushi Nyorai were formerly commonly built during the ceremonies performed to obtain cures, as well as copies of the *Yakushi-kyō* (M. V. de Visser, *op. cit.*, II, p. 559), or to obtain a fortunate voyage (M. V. de Visser, *op. cit.*, p. 564). Yakushi was also petitioned to grant all wishes, sometimes even the most frivolous. One finds, at the beginning of the *Sarashina-nikki* (1059–1060), the daughter of Sugawara no Takasue, who had a statue of Yakushi built to the same size as herself (Yakushibotoke) praying to it secretly: 'Let me go to the capital city (Heian-kyō), because there I can find many books (to read). Let me read them all . . .' (*Sarashina Nikki*, Iwanami Shoten, Iwanami Bunko, Tōkyō, 1966, no. 643, p. 7, and A. Shepley Omori, *Diaries of Court Ladies of Old Japan*, Tōkyō, 1963, p. 3).

117 This cult used a flag of five colours called *Zoku Myōban* (var. *Zokumyō Shinban*); *Daijiten*, p. 1096, and M. V. de Visser, *op.*

cit. I, p. 300. Starting in 843, the repentance ceremony (Keka) was replaced by another called Yakushi Hō (*Himitsi Jirin*, p. 107, and M. V. de Visser, *op. cit.*, I, p. 306). In 994, it was resumed at the Shakuzen-ji (Hossō sect). See *Bukkyō Daijiten*, 'Hōkō-in', p. 4109, and M. V. de Visser, *op. cit.*, I, pp. 246–7. In this same temple, a statue of Vairocana (Dainichi Nyorai) was erected of the size of Jōroku, with Shaka and Yakushi for acolytes, the latter representing the healing power of the sun.

118 M. V. de Visser, *Ancient Buddhism in Japan*, I, p. 299.

119 To procure the healing of Fujiwara no Fubito in 720, for example (*Nihongi*, VIII, p. 123, cited by M. V. de Visser, *op. cit.*, I, p. 295), and, in 1015, for the healing of the Emperor Sanjō (M. V. de Visser, *op. cit.*, I, p. 306).

120 According to M. V. de Visser, *The Dragon in China and Japan*, Amsterdam, 1913, p. 33, Yakushi was thought to possess the power of stopping the rain if he was invoked by reciting the *Bhaiṣajyagurudhāraṇī*. The *Taiheiki* (VIII, p. 215 of the English translation by H. MacCullough) relates how Kōgon had a special rite performed to Yakushi by the monk Jiyū of the Uratsu-ji in order to secure victory against the armies of the Emperor Go-Daigo.

121 M. V. de Visser, *Ancient Buddhism in Japan*, I, p. 401. In the countryside, Yakushi is celebrated on the eighth day of the sixth month (around 14 July). On this subject, see F. Joüon des Longrais, *Est–Ouest*, p. 73.

122 *Gigeiki*, 'Geste de Yoshitsune', translated by H. MacCullough, pp. 47–49.

123 Mock Joya, *Things Japanese*, p. 268.

124 According to O. Sirén, Bhaiṣajyaguru often holds a small 'pharmaceutical' accessory or a covered bowl in the hand. The other hand rests on his knee where it holds the 'golden fruit' (mirobolam); E. Dale Saunders, *Mudrā*, p. 144. However, we doubt this, because in Japan Bhaiṣajyaguru always holds the jar (covered or uncovered) in the left hand, the other to the best of our knowledge being in the gesture of fearlessness (with exceptions cited in the text and below). Moroever, the 'pharmaceutical' accessory is almost invariably an unguent jar in Japan. It may also be replaced by a willow branch. In some paintings (like those surrounding the Jūni Shinshō at the Kōyasan, Wakayama), this position may be found reversed, and Yakushi holds a bunch of grapes in the right hand, while his left hand is in Abhaya mudrā. This position is extremely rare, and it can be considered as exceptional. It is described as being a Ratnamudrā in the *Unkadayagiki* (Chinese *Hongjia Toyeyigui*, *Taishō*, 1251) cited by R. Tajima, *op. cit.*, p. 318. In Tibet, the medicine jar is often replaced by a mirobolam fruit (or 'golden' fruit), according to P. Pelliot, *Bhaishajyaguru*, BEFEO, III, no. 1, 1903, p. 34.

125 *Taishō*, XIX, p. 29, and R. Tajima, *op. cit.*, p. 317.

126 At the end of the Fujiwara period, in the Kose school of the Yamato-e (twelfth century), in the *Yakushi Mandara*, Yakushi is found seated on a throne with an unguent jar in the left hand. Twelve of his manifestations (his Kebutsu or Busshin) are represented on his aureole (*kōhai*) with Nikkō and Gakkō Bosatsu holding the sun and the moon on lotus branches. The Jūni-Shinshō are positioned all around (*Kokka*, no. 32, I, Matsui Collection). In Chinese paintings, Bhaiṣajyaguru is sometimes seated on an elephant with a pilgrim's staff (*khakkara*) in the right hand and the unguent jar in the left. He is accompanied by Candraprabha on a goose and by Sūryaprabha on a horse (*Himitsu Jirin*, p. 1063). In Central Asia, he is represented with Sūryaprabha, Candraprabha and the twelve warriors. Sculptures: in bronze at the Kondō of the Hōryū-ji, dating from 607; at the Shin Yakushi-ji (Nara) he stands on a lotus and holds a jar in his hand in Varada mudrā (this hand is pendant, and it is possible that the jar was added later to an image which was perhaps not originally intended to represent Yakushi), Hakuhō period, 0.72 m high; in wood, like Honzon in the Shin Yakushi-ji, seated, a jar in the left hand, six of his Busshin on his aureole and the seventh represented at the top of the aureole in the form of a *cintāmaṇi*, Tempyō period; in dry lacquer, at the Kōzan-ji (Yamashiro), seated in Padmāsana, with Nikkō (or Gakkō) seated in Mahārājalīlāsana; in bronze, like Honzon in the Yakushi-ji, with Nikkō and Gakkō, and six of his Busshin on his aureole; in stone, accompanied by the Jūni Shinshō, at the Yogawamiya of the Enryaku-ji of Mount Hiei; in wood, standing, at the Gangō-ji in Nara; at the Tōdai-ji; in the Kondō of the Jingo-ji in Kyōto (he holds the jar in his left hand at shoulder level, 1.70 m high); in the Tōshōdai-ji (2.07 m high); seated, in the Empuku-ji in Niigata; in the Hōjōbō in Kanagawa; in the Jōruri-ji in Nara; in the

Rokuharamitsu-ji in Kyōto. A bronze head, 1.07 m high, in the Kōfuku-ji in Nara, possibly of a Yakushi Nyorai, was formerly the Honzon of the Kōdō of the Yama-dera, which burned in 1411, presumed dated between 678 and 685.

127 R. Tajima, *op. cit.*, p. 319.

128 The Yakushi Nyorai of the Hōkai-ji (Yamashiro) holds the jar in his hands in Dhyāna mudrā (Hōkaijō-in): fingers joined, thumbs touching. He is seated. This particular position is also found in a number of maṇḍalas (*Kokka*, no. 32, I, late Fujiwara period), and the Yakushi Nyorai of the Kakuon-ji in Kamakura.

129 *Taishō-zu-zō*, IV, V, VIII and IX.

130 R. Tajima, *op. cit.*, pp. 320–21.

131 Especially the *Yaoshi Rulai Niansong Yigui* (Japanese *Yakushi Nyorai Nenju Giki*), *Taishō*, 925, and the *Yaoshi Liuli guang Wang Cifo ben yuan gong de Jing nian Song Yigui gongyang fa* (*Taishō*, 926); R. Tajima, *op. cit.*, p. 320.

132 *Taishōzō*, XIX, 29. They are also called 'the Seven Healing Buddhas' (Shichi Butsu Yakushi) since Dengyō Daishi (806); *Bukkyō Daijiten*, Tōkyō, 1919.

133 Sometimes represented in painting with a *cintāmaṇi* in the left hand (or a triple *cintāmaṇi*) in the place of the medicine jar (Sawa Ryūken, *Butsuzō-zu-ten*, p. 31, fig. 10).

134 In China, in a niche, and representing Bhaiṣajyaguru, dating from 527, in Cave no. 13 of Longmen, *inter alia*.

135 Or without *cintāmaṇi* on the arch above the head of Bhaiṣajyaguru in the Yüngang Caves in China (Wei period). R. Grousset, *Civilisations de l'Orient, Chine*, p. 171, fig. 133.

136 These Busshin or emanations are, according to the text translated by Yijing (quoted by R. Tajima, *op. cit.*, p. 321; by Sawa Ryūken, *Butsuzō-zu-ten*, p. 30, and by Oda, *Bukkyō Daijiten*, pp. 740ff.): 1. Zen Myōshō Kichijō-ō Nyorai, virtuous name and king of happiness. 2. Hōgetsu Chigen Kō-on Jizai-ō Nyorai, precious moon, majesty of wisdom, luminous sound and independent king. 3. Konjiki Hōkō Myōkō Jōju Nyorai. 4. Muyū Saishō Kichijō Nyorai. 5. Hōkairaion Nyorai. 6. Hōkaishō Sui Yūgi Jintsū Nyorai. 7. Yakushi Ruriko Nyorai. Taken together, they are considered as the principal deity (Honzon) of the Enyū-ji (Yamashiro) and were installed in this temple in 983.

137 R. Tajima, *op. cit.*, p. 230, and A. Getty, *op. cit.*, plate XVII.

138 In 857, the two Kamis Ōaraiisaki and Sakatsura-isosaki, of the province of Hitachi, were considered to be incarnations of Nikkō and Gakkō (*Dai Nihon Chimeijisho*, III, pp. 3674 and 3703; *Nihon Montoku Tennō Jitsuroku*, IX, p. 560; M. V. de Visser, *Ancient Buddhism*, II, p. 567).

139 Mainly in Chinese paintings and maṇḍalas (*Himitsu Jirin*, p. 1063).

140 In the *Yakushi-kyō*.

141 An edict of Jayavarman VII of Cambodia (stele of Say Fong, §XIV) states: 'By warriors – doctors – wise in the science of arms – remedies –, he destroyed the enemies that overran the kingdom – illnesses – by means of his arms, the remedies' (translated from the French of G. Coedès).

142 The *Bhaiṣajyaguruvaidūryaprabhāsa-pūrvanidhānaviśeṣvistara* and the *Saptatathāgatapūrvanidhānaviśeṣavis-tara*.

143 The *Yaoshiliuliguang Wang Cifo ben Yuan gong te Nian song yigui* (Japanese *Yakushi Rurikō-ō Kebutsu Hongan Kudoku-kyō Nenzu Giki*), *Taishō*, 925.

144 *Son-yō shō* and *Kakuzen-shō* (R. Tajima, *op. cit.*, p. 322).

145 Also called Kompira in another version (Oda, *Daiji-ten*, p. 503).

146 This list is compared by M. V. de Visser (*op. cit.*, II, p. 554) with that of the personages who, he believes, are grouped around the Buddha Śākyamuni in a cave of Ellorā in India: Mañjuśrî, Avalokiteśvara, Maitreya, Ākāśagarbha, Samantabhadra, Vajrapāṇi, Sarvanīvarana-viṣkambhin and Kṣitigarbha, all acolytes of Amida in his *Raigō* (descent), except sometimes the Hōdange of the first list according to the *Himitsu Jirin*, p. 1038, and the *Daijiten*, p. 1709.

147 *Butsuzō-zu-i*, II, 9a, and M. V. de Visser, *The Bodhisattva Ti Ts'ang (Jizō)*, in *Ancient Buddhism in China and Japan*, p. 122. See also, by the same author, *The Dragon in China and Japan*, Intr. Section 4, p. 33, and J. de Groot, *Le Code du Mahāyāna en Chine*, VIII, p. 57.

148 *Taishō*, XIX, 603, and XX, 660. Sawa Ryūken, *Butsuzō-zu-ten*, p. 93, fig. 67. Yaku-ō is represented seated in Padmāsana holding a lotus in the right hand (*Butsuzō-zu-i*, IV, 8) or standing on lotuses with banners in his hand, when they are both (Yaku-ō and Yakujō) represented as acolytes of Amida in the *Raigō* (*Butsuzō-zu-i*, II, 9a). These two Bosatsu are sometimes considered as being two of the sixteen Dōji (child acolytes) of Benzai-ten (*Butsuzō-zu-i*, III, 10a, and M. V. de Visser, *Ancient Buddhism in China and Japan*, I, p. 20).

149 For the trikāya, see P. Williams, *Mahāyāna Buddhism*, Routledge Kegan Paul, London and New York, 1989. On the history of

Buddhism, see A. Skilton, *A Concise History of Buddhism* (Windhorse Publications, Birmingham. 1994). On Theravāda, R. F. Gombrich, *Theravāda Buddhism*, (Routledge Kegan Paul, London and New York. 1988.

150 *Inde Classique*, II, §2281 and §2337.
151 See John Strong, *op. cit.*
152 P. Mus, *Bārābudar*, p. 574.
153 H. de Lubac, *Amida*, pp. 83, 85.
154 See the Miroku of the Kondō at the Taima-dera, from the Hakuhō period, dated 682–686. Tradition claims that inside this statue is an effigy of Kujaku Myō-ō (T. Akiyama, *Art Guide*, I, p. 274).
155 B. Frank, *Mythologies*, p. 161.
156 R. Tajima, *op. cit.*, p. 65. *Taishō*, XVIII, 36.
157 R. Tajima, *op. cit.*, p. 69.
158 *Ibid.*
159 *Ibid.*
160 R. Tajima, *op. cit.*, p. 198. Symbol of continuity (B. Frank, *Mythologies*, p. 162). In Indian sculptures, he holds a round vase in the left hand, while in the sculptures of the Gandhāra this vase has a pointed shape.
161 Actually the only Bodhisattva known in the art of the Small Vehicle. Generally represented with Śākyamuni, the hands in Dharmacakra mudrā or in Vitarka/Varada mudrā (*Maitreyavyākarana*, ed. N. Guff, *Gilgit Manuscripts*, IV, 1959, Calcutta, pp. 187, 214.
162 In Nālandā (India), with the hair falling on the shoulders and represented as a Bodhisattva, adorned with jewels. Here he is standing (eighth century).
163 In the cells of the Ri-bo-Khang in Lhasa (L. Jisl, V. Sis and J. Vanis, *L'Art tibétain*, Paris, 1958, figs. 62, 76). He has his hands in Dharmacakra mudrā and is considered either as a Tathāgata or as a Bodhisattva.
164 *Taishō*, XX, 591, 595, 596. *Taishō-zu-zō*, I, 16.
165 A bronze image, with small *stūpa* (which also resembles more the stack of parasols of the *stūpas* than the complete edifice). Haloed with a sort of crown of feathers which can also be found on some Korean statuettes of Mirūg. This headdress forms a sort of cap from which the ties fall on the shoulders. This Miroku has a large necklace (Nara Museum).
166 Sculptures: in the Kōryū-ji, dated c. 603, in Kyōto; in the Hōryū-ji in Nara; in the National Museum of Seoul (Korea). See E. MacCune, *The Arts of Korea*, Tōkyō, 1962, figures in plates 130, 131; also *Trésors d'art coréen*, catalogue of the Cernuschi Museum, Paris, 1961–62 (Kingdom of Silla, plates 11, 18, 19); also illustration in Sawa

Ryūken, *Butsuzō-zu-ten*, p. 77, fig. 51.
167 Mainly in the representations of the Shingon sect and the Tendai sects.
168 M. V. de Visser, *op. cit.*, pp. 223–24. *Kokka*, no. 572 (1938), plate III, *kakemono* of Kamakura.
169 Illustration in Sawa Ryūken, *op. cit.*, p. 77, fig. 52.
170 These are the *Yogācāryabhūmiśastra* (Japanese *Yugashijiron*), the *Vibhāgayogaśastra* (Japanese *Funbetsuyugaron*), the *Mahāyānālamkkara* or *Sūtrālamkara* (Japanese *Daijōshō-gonron*), the *Mādhyānta-vibhāgaśastra* (Japanese *Benshūhenron*), and the *Vajracchedikāprajñāpāramitāśastra* (Japanese *Kongō Hannyaron*).
171 Especially the *Vidyāmātrasiddhiśastrakārikā*, by Asanga (Japanese *Jōyuishiron*). See R. Fujishima, *Le Bouddhisme japonais*, Paris, 1889, p. 35, and the *Abhidharmakośastrakārikā*, by Vasubandhu (*Inde Classique*, II, §2019 and §2022).
172 In the Mikkyō, one of the Great Bosatsu, Tenbōrin Bosatsu (Sachittotpādadharma-cakrapravartin), corresponds to Miroku Bosatsu. He is theoretically seated in Padmāsana, clothed as a Bodhisattva, with a high crown, and the left hand holding a wheel surrounded by flames and placed on a lotus, with a three-pointed vajra in the left hand (illustrated in Sawa Ryūken, *op. cit.*, p. 94, fig. 68). He is one of the great Bodhisattvas. Although symbolized by 16 deities, he is only represented by a single one. These 16 deities are Viśyakarma (*Bishukatsuma*), Kapila (*Kabira*), Dharmapāla (*Hōgo*), Amṣalocana (*Kenmoku*), Virūpakṣa (*Kōmoku*), Guptasena (*Gogun*), Manibhadra (*Shuken*), Pūrnabhadra (*Manken*), Vidyārāja (*Jimyō*), Ātavaka (*Atabaku*), Vāsuki (*Basuki Ryū-ō*), *Sumana* (Sumana Ryū-ō), Fusahima *Ryū-ō*, Hārītī (*Karitei-mo*), Airāvana (*Erabasa*), and Locana (*Sōmoku Tengo*). These deities are never represented in sculpture and are not separately worshipped in Japan (*Taishō-zu-zō*, XIX, 514). In the *Ninnō-kyo*, Tenbōrin Bosatsu is identified as Vajrapāramitā (*Kongō Haramitsuta Bosatsu*). He is then represented holding a *kongōrin* (ring) or a *rengejō hōshu* (jewel placed on a lotus) in the hand.

Chapter IV
The Five Jinas and the Ādi Buddha

1 See D. L. Snellgrove, *Indo-Tibetan Buddhism.*
2 Hiuan Tsang (Xuan Zang), *Mémoires,* translated by S. Julien, I, p. 427.
3 H. de Lubac, *Amida*, Paris, 1955, p. 31, n. 5.
4 B. Bhattāchārya, *Indian Buddhist Iconography*, p. 2; R. D. Banerji, quoted by P. Mus, *Bārābudur*, XXXIII, p. 878.
5 They are Krakucchanda, Kanakamuni, Kāśyapa, Gautama and the future Buddha Maitreya, all forming part of this cycle or *Kalpa.* The *Lalitavistara* gives a list of 56 Buddhas who belonged to the previous cycles and to the present *Kalpa* (A. Getty, *op. cit.*, p. 10).
6 Paul Mus, *Bārābudur*, BEFEO, XXXIV, p. 192.
7 These typical elements are ether, air, fire, water and earth. They are symbolized in Japan by a sort of small *stūpa* in five parts: the first, cubic, represents the Earth and Amoghasiddhi; the second, spherical, represents water and Amitābha; the third, pyramidal, represents fire and symbolizes Ratnasambhava; the fourth, hemispherical, represents air and symbolizes Akṣobhya, and the fifth, in the form of a sacred jewel or flame, represents ether and symbolizes Vairocana. These elements also correspond to the five parts of the body: hips (yellow), navel (white), heart (red), between the eyebrows (dark, black or blue), and the top of the skull (bright), or seats of the *cakras* in the *Kundalinī Yoga.* A sixth element, the spirit, is symbolized by the ensemble (R. Tajima, *op. cit.*, pp. 258–59, *Taishō*, XVIII, 31, and N. Péri, *Introduction au Nō Sotoba Komachi*, BMFJ, Tōkyō, 1944, pp. 144ff.).
8 P. Mus, *Bārābudur*, BEFEO, XXXIV, p. 199: 'The pentarchy of the Jinas is thus a résumé of the Universe: under new names, it is not difficult for us to recognize in them the religious cosmogram that causes all space to be held in the symbolic and oriented combination of the five positions.' Quoted by M. Bénisti, *Le Stūpa dans l'Inde ancienne*, Paris, 1960, p. 82, n. 5.
9 P. Mus, *Bārābudur*, BEFEO, XXXIII and XXXIV.
10 H. de Lubac, *Amida*, p. 30.
11 Werner, *A Dictionary of Chinese Mythology.*
12 M. Bénisti, *op. cit.*, pp. 83–85.
13 R. Tajima, *op. cit.*, pp. 72ff.
14 The *Kongō-kai Mandara* represents 'the indestructible and basic ideas present in the totally comprehensive spirit of the Great Illuminator' (Masaharu Anesaki, *History of Japanese Religions*, Tōkyō, 1964, p. 127). The *Taizō-kai Mandara* represents the dynamism of cosmic life. The 'ideas', deities in the domain of the *Kongō-kai*, are manifested in the domain of the *Taizō-kai* by their activity. The 'active' manifestations are indicated in these maṇḍalas by a double red halo. All the other deities are manifestations either of the infinite Wisdom of Dainichi Nyorai, or of his Infinite Compassion. Thus these two maṇḍalas tend to represent the universe in its two aspects, ideal and active, aspects which are also those of the Great Illuminator Dainichi Nyorai (Mahāvairocana). Hence these two maṇḍalas cannot be separated from each other. They are in fact a single maṇḍala in two parts, which is clearly indicated by the joint name given to them of *Ryōkai Mandara* (Maṇḍala of the Two Worlds) or *Ryōbu Mandara* (Maṇḍala of the Two Parts). Sawa Ryūken, *Butsuzō annai*, Tōkyō, 1963, p. 26. The *Rishkyō Mandara*, *Gobushinkan*, *Katsuma Mandara*, *Shūji Mandara*, *Sanmaya Mandara*, etc., are also found, represented in sculpture and in painting and, more seldom, in engraving. Sculptures: in bronze (Ryōkai) āt the Jizō-in in Uji; at the Dainichi-ji in Nara. Paintings: at the Enjō-ji and the Tōdai-ji in Nara; on silk at the Tō-ji and the Jingō-ji in Kyōto; at the Kanmuryō-ji; on wood at the Taima-dera (eighth century) in Nara; at the Gojunotō of the Daigo-ji (tenth century) in Kyōto. However, the most famous maṇḍalas in Japan describing the Gochi Nyorai are those of the Tō-ji in Kyōto, kept in the Kanjō-in (the original having been lost, the remaining copy dates from 1693; R. Tajima, *op. cit.*, Introduction, VIII), and that of Takao, kept at the Jingō-ji in Kyōto, and thought to be painted by Kūkai himself.
15 R. Tajima, *op. cit.*, Introduction, VIIff.
16 The Gochi Nyorai belonging to this maṇḍala are thought to make five sorts of meditation (Japanese *Chi*).
1. *Dharmadhātusvabhāvajñāna* (Japanese *Taishō Chi*), on the character of the body of the world of the Law, for Mahāvairocana. 2. *Ādarśajñāna* (Japanese *Dai Enkyō Chi*), on the 'great round mirror', for Akṣobhya. 3. *Samatajñāna* (Japanese *Byōdōshō Chi*), on the equal character of things for Ratnasambhava. 4. *Pratyavekṣanājñāna* (Japanese *Myōkansatsu Chi*), on the excellent observation, for Amitābha.

5. *Krityānusthānajñāna* (Japanese *Jōshosa Chi*), on the knowledge of the execution of the duties, for Amoghasiddhi. Each of these Gochi Nyorai, apart from Dainichi Nyorai and the four great Bodhisattvas, is assisted by a number of feminine or masculine Bodhisattvas, called Pūjā Bodhisattvas (Japanese *Kuyō Bosatsu*), who are supposed to pay him homage, and Samgraha Bodhisattva (Japanese *Shō Bosatsu*), who gives the means of salvation corresponding to the Pāramitā Bodhisattva (Japanese *Haramitsu Bosatsu*) and who represent the gods of contemplation. Thus there are 16 male acolytes (deities of wisdom) and 16 female acolytes (deities of contemplation) representing the virtues of the four Jinas. This makes a total of 37 major deities: Mahāvairocana, the four other Jinas and the 32 'virtues' protected by 20 Devas; R. Tajima, *op. cit.*, pp. 170–71. Each of these Jinas corresponds to a Bodhisattva (*Inde Classique*, II, §2358 and §2360). They are like their hypostases and represent the 'four wisdoms' (*pāramitā*) of Vairocana. They are: 1. Avalokiteśvara for Amitābha. 2. Maitreya for Divyadundubhimeganirghoṣa. 3. Samantabhadra for Ratneketu. 4. Mañjuśrī for Ratnasambhava. In the *Kongō-kai*, each of them also has four other Bodhisattvas as acolytes. These 16 great Bodhisattvas are the gods of wisdom symbolizing the qualities and virtues of the Five Buddhas of wisdom. Similarly, each Jina has one or more wrathful manifestation for the destruction of the passions and the protection of the faithful. These manifestations are the gods of magic science, the Vidyārāja (Japanese *Myō-ō*).

17 The Japanese esoteric sects (chiefly Shingon and Tendai) acknowledge a sixth Buddha of wisdom, Vajrasattva (Japanese *Kongō Satta*), materializing the sixth element, Wisdom or Intuition, and representing Perfection (white) resulting from the intimate mixture of the qualities and virtues of the other Five Jinas, because 'the sixth Jina is placed, according to certain schools (especially the *Guhyasamājatantra*), outside and above all the others' (*Inde Classique*, II, §2358).

18 These Five Jinas are found as 92 in number on each face of the Borobudur *stūpa* in Java (eighth century), Vairocana being represented by the open-work *stūpas* of the upper terraces and the Ādi Buddha (or Shunya, 'emptiness') by the terminal *stūpa*. On this subject, it is worth pointing out that the concept of the Ādi Buddha is unknown in China and Japan, and that this term belongs to another system of thought that is more specifically Indian (*Inde Classique*, II, §2358; E. Dale Saunders, 'Note on Śakti and Dhyāni Buddha', *History of Religions*, University of Chicago, 1961, I, p. 2).

19 According to some lists, the Five Jinas are Bhaiṣajyaguru, Ratnasambhava, Akṣobhya and Amoghasiddhi (or Gautama). In Japan, however, the Shingon sect considers that Akṣobhya, Ratnasambhava, Amitābha and Amoghasiddhi are actually diversified manifestations of Vairocana (A. Getty, *op. cit.*, p. 29).

20 *Inde Classique*, II, §2346. This school developed in India in the fourth century (N. Péri, 'Disciples et commentateurs de Vasubandhu', BEFEO, pp. 370, 390) or, according to some authors, in 445 (J. Takakusu, *op. cit.*) or in 450 (A. Grünwedel). Asanga (Japanese *Muchaku, Mujaku*) is thought to have been inspired by Maitreya (A. Getty, *op. cit.*, p. 31). The Tantric school of Mahāvairocana was introduced into China by the Indian priests Vajrabodhi and Amoghavajra in 720.

21 The exoteric Buddha Śākyamuni and the esoteric Buddha Vairocana are in fact identical because, according to the Shingon sect, Vairocana is the Dharmakāya or Śākyamuni (R. Tajima, *op. cit.*, pp. 21, 47). He is thought to be the historical Buddha idealized as a Dharmakāya, 'who is neither born nor dies' (R. Tajima, *op. cit.*, p. 48).

22 This name was originally an epithet of the Buddha (A. C. Soper, *Art and Architecture of Japan*, London, 1960, p. 35). Mahāvairocana 'dismisses the spirits of darkness and spreads light, performs all the functions, shines with an eternal splendour' (R. Tajima, *op. cit.*, p. 45).

23 *Taishōzō*, XVIII, pp. 6, 23, 242.

24 One of the names of Vairocana in the great room of the sermons of the Enryaki-ji on Mount Hiei (Kyōto), of the Tendai sect, was Dainichi Henjō (*Taiheiki*, II, p. 1).

25 In the Kegon sect in the eighth century. In some cases, he is also named Shana-ō.

26 The Kegon sect also worships Dainichi Nyorai in a triad formed with Monju Bosatsu and Fugen Bosatsu. The Shingon sect also worships thirteen Buddhas: Dainichi Nyorai and his eleven 'disciples' (Shaka, Monju, Fugen, Jizō, Miroku, Yakushi, Shō Kannon, Daiseishi, Amida, Ashuku and Kokūzō) together with Fudō Myō-ō (A. Getty, *op. cit.*, plate XVIII). Sculpture: at the Kakuon-ji in Kamakura.

27 *Brahmājāla-sūtra.*

28 Or 100 petals, or 100,000, depending on the version.

29 The bronze Great Buddha (Daibutsu) of the Tōdai-ji in Nara, by Ono Goraemon (749) rebuilt in the eighteenth century, is thought to be the image of a Birushana Nyorai. He was known by the name of Roshana Butsu in 749 upon his erection by the Kegon sect (B. Frank, *Mythologies*, p. 160; J. Buhot, *Histoire des arts du Japon*, §294, pp. 208–9, and §118, §119, p. 110; S. Elisséeff, 'The Bommōkyō and the Great Buddha of Tōdai-ji', HJAS, 1936, pp. 84–5).

30 The two images are found at the Daikōdō of the Mudō-ji-dani of the Enryaku-ji, on Mount Hiei (Edo period). Sculpture: in the Musée Guimet, Paris.

31 P. Mus, 'Le Buddha paré', *op. cit.*

32 Earth, water, fire, air, ether and wisdom (or intuition or spirit). Sculpture: in lacquered wood, dated 1176, by Unkei (0.99 m high), at the Enjō-ji in Nara. Paintings: at the Jingo-ji in Kyōto (ninth century); maṇḍala of the Kojima-dera (early Heian).

33 These Shi Haramitsu (four *Pāramitā*) are the following. In the east, Vajrapāramitā (Japanese *Kongō Haramitsu*), right hand in Bhūmisparśa, left hand in fist of wisdom. In the west, Ratnapāramitā, right hand with a golden ring, left hand with a *cintāmaṇi* on a lotus. In the south, Dharmapāramitā, hand in Dhyāna mudrā holding a lotus on which a *sūtra* scroll is placed. In the north, Karmapāramitā, right hand with a *Katshumasho* (staff topped by four vajras in a cross) and left hand with a lotus bearing a box.

34 'He whose essence is lightning' (A. Grünwedel, *op. cit.*, p. 96).

35 In the Borobudur *stūpa*, in Java, he is thought to be the Ādi Buddha symbolized (theoretically) by the terminal *stūpa*.

36 According to R. Tajima, *op. cit.*, p. 21, he received the Doctrine from the very lips of the Tathāgata (*Taishōzō*, XIX, 610, *Taishō-zu-zō*, I, 34).

37 He sometimes (but rarely) wears an effigy of Akṣobhya in his crown.

38 A. Getty, *op. cit.*, pp. 7–8.

39 A form of Vajrasattva (Japanese *Kongō Satta*), called Vajrarāja (Japanese *Kongō-ō*), she is also considered as an emanation of Mahāvairocana, and combines Vajrasattva and Rāgarāja (Japanese *Aizen Myō-ō*). She is represented on a lotus (as a Bodhisattva) with four arms, two of which bear the attributes of Vajrasattva (bell and five-pointed vajra), and the other two those of Rāgarāja (bow and arrow); Sawa Ryūken, *op. cit.*, p. 51, fig. 26.

40 *Taishōzō*, XX, §§510 and 513.

41 The other forms of *Pāramitā* are:
1. *Dānapāramitā* (Japanese *Danna Haramitsu*), perfect practice of alms.
2. *Sīlapāramitā* (Japanese *Shira Haramitsu*), perfect practice of morality.
3. *Kṣāntipāramitā* (Japanese *Sendai Haramitsu*, *Nin Haramitsu*), perfect practice of patience. 4. *Vīryapāramitā* (Japanese *Shōjin (Shin) Haramitsu*), perfect practice of energy. 5. *Dhyānapāramitā* (Japanese *Zenna Haramitsu*), perfect practice of meditation. 6. *Prajñāpāramitā*, perfect practice of wisdom. Apart from these six principal *Pāramitā* or virtues of perfection of the Bodhisattvas representing the practices necessary to attain the Bodhi, some are derived from the *Prajñapāramitā*: *Upāyapāramitā* (Japanese *Hōben-Hō-Haramitsu*), the means, *Pranidhāṇapāramitā* (Japanese *Gan Haramitsu*), the vows, *Balapāramitā* (Japanese *Riki Haramitsu*), the widom, *Jñānapāramitā* (Japanese *Chi Haramitsu*), the knowledge, and the four *Pāramitā* who accompany Mahāvairocana in the Japanese *Taizō-kai Mandara* (see n. 33 above). The five *Pāramitā*, besides Vajrasattva (sometimes merged with Samanthabhadra and then named *Daishō Kongō* in Japan), who all hold a bell on the belly and the five-pointed vajra on the breast, are Iśtavajra (Japanese *Yoku Kongō*, or *Kongō Sen*, or *Ishō Kongō*, or even *Gensen Kongō*) who holds an arrow; Kelikilavajra (Japanese *Soku Kongō*, or *Kongō Kietsu*, or *Kerikira Kongō*), who clasps Vajrasattva; Rāgavajra (Japanese *Ai Kongō*, or *Kongō Ai*, or *Aigetsu Kongō*), who holds a banner surmounted by a fish (Japanese *Makatsugyo*), and Mālāvajra (Japanese *Man Kongō*, or *Kongō Yoku Jizai*, or *Iki Kongō*), who holds a three- or five-pointed bell vajra.

42 See Chapter II.

43 These aspects are those of Ichiji Kinrin Bucchō-ō, Kinrin Nyorai, Dai Kinrin Myō-ō, Dainichi Kinrin, Chō Rinnō, Shaka Kinrin Nyorai and Daishō Kongō (name sometimes given to Kongō Satta, or Vajrasattva, see n. 46). See also n. 33.

44 Other aspects: Dainichi Kinrin Nyorai (in the National Museum of Tōkyō, Kamakura period), hands in Chiken-in. Dainichi Kinrin: hands in Hōkaijō-in (Dhyāna mudrā). Shaka Kinrin Nyorai: hands in Myōkansatsuchi-in with golden ring (Japanese *Kinrin*), in the Daigo-ji in Kyōto (thirteenth century). In the *Rokuji-kyō Mandara*, Shaka Kinrin has a head of curls, the hands in Dhyāna mudrā holding a

golden ring, and is surrounded by six acolytes: Shō Kannon, Senju Kannon, Batō Kannon, Jūichimen Kannon, Juntei Kannon and Nyoirin Kannon. At the bottom of the maṇḍala, Fudō Myō-ō and Daiitoku Myō-ō are represented. These 'assistant deities' can be interchangeable and are sometimes replaced by the five great Vidyārājas (see Sawa Ryūken, *op. cit.*, p. 52), Uṣnīṣa (*Bucchō Son*) or Ekāksaroṣnīṣacakrarāja (*Ichiji Kinrin Bucchō-ō*). The latter exists only in a few maṇḍalas (on silk, Kitamura Shiegeki Collection, in the Kōzan-ji in Kyōto, and on the *Sonshō Mandara, Hōbōgirin*, II, p. 148, plate XI). His hands are in Dhyāna mudrā and he is surrounded by three great kings (Mahācakravartin, Japanese *Dai Bucchō*): Mahoṣnīṣacakravartin (*Kōdai Bucchō*, also *Hossō Bucchō* or *Dai Tembōrin Bucchō)*, whose left hand holds a *cintāmaṇi* on a lotus in bloom; Goku Kōdai Bucchō, who is identical to him, but whose right hand holds a lotus in bloom in which a simple one-pointed vajra is placed, and Ānantasvaraghoṣacakravartin (*Muhen Onjō Bucchō*, also *Muryō Onjō Bucchō)*, 'with the limitless voice', whose left hand holds a conch shell placed on a lotus (*Taishōzō*, XIX, 230, 343, 376, and the *Taishō Zuzō*, I, 13), and by 'five ordinary kings' (Mahārāja, Japanese *Bucchō*): Sitātapattroṣnīṣha (*Byakusangai Bucchō*), who personifies the white umbrella sheltering the Buddha (J. Auboyer, *Les Influences du Kondō*, p. 59) and who carries a white umbrella on a lotus; Jayoṣnīṣna (*Shō Bucchō*, also *Shushō Bucchō*), 'He who is excellent', with a lotus bud in the right hand and a sword in the left placed on a lotus; Vijayoṣnīṣa (*Saishō Bucchō*), 'He who is the best', the left hand holding a *cakra* placed on a lotus; Tejorāṣyuṣnīṣa (*Kōju Sangai Bucchō*, 'concentrated light', also *Kakō Bucchō*, 'nascent fire', or *Hōkō Bucchō*, 'light giving'), with a *cintāmaṇi* in the right hand and a lotus stem in the left; and Vikīrnoṣnīṣa (*Joshō Bucchō*, 'outspread light'), with the hands in the mudrā of meditation holding a lotus on which is a vajra, or standing and clothed as a monk holding the begging bowl and a pilgrim's staff on the right shoulder, the feet placed on two lotuses (as in the Daigo-ji in Kyōto), with an aureole of flames. All these *Bucchō* are arranged around Ichiji Kinrin and placed on lotus petals (Sawa Ryūken, *op. cit.*, p. 50, fig. 24). In the *Sonshō Bucchō Mandara* (Sawa Ryūken, *Butsuzō annai*, p. 36), added to these eight are the

Vidyārājas Acalanātha (*Fudō Myō-ō*) and Trailokyavijaya (*Gozanze Myō-ō*), as well as the heavenly beings called Śuddhavāsadeva (*Jōgo-ten*). A ninth *Bucchō* is sometimes added to this list: Shōissai Bucchō, 'syncretic Bucchō', also called Henjō Bucchō, 'luminous Bucchō', or Shijōkō Bucchō, 'He who is very strong' (*Hōbōgirin*, II, 149, also indicates a group of ten *Bucchō*, plate XIII). In the *Ichiji Kinrin Mandara*, Ichiji Kinrin is surrounded by these 'seven treasures', represented surrounded by flames (*Inde Classique*, II, §2272, and É. Burnouf, *Le lotus de la Bonne Loi*, Paris, 1852, p. 321, note).

45 *Hōbōgirin*, II, pp. 20ff. (Butsugemmo), and illustrations 68 and 69 on plate XVIII.
46 A form of Ichiji Kinrin with twelve arms, named Taishō Kongō or Daishō Kongō, combines the forms of Dainichi and Aizen Myō-ō.
47 According to the *Rokuji-kyō Mandara*, Ichiji Kinrin is surrounded by six divine children (Japanese *Rokuji-ten*), each with one head and six arms, standing on one foot on a lotus or seated in Padmāsana (with only two arms).
48 fig. in Sawa Ryūken, *op. cit.*, p. 52, no. 25.
49 Also sometimes named Myōko Bosatsu.
50 A. Churchward, *Signs and Symbols of Primordial Man*, London, 1910.
51 In the Taima-dera in Nara, a statuette of Jizō Bosatsu is called Myōdō Bosatsu. He makes an indeterminate mudrā with his left hand.
52 A. Getty, *op. cit.*, p. 35.
53 These constellations have the following Japanese names: Donrō, Rentei, Kyomon, Rokuzon, Bungyoku (or Mongyoku), Bugyoku and Hagun.
54 In the Musée Guimet, Paris.
55 *Taishōzō*, V, 398; Sawa Ryūken, *op. cit.*, p. 135, figs. 138, 139, 140.
56 Sawa Ryūken, *op. cit.*
57 This *stūpa* may have one or five storeys. Sculptures: in the Hokke-ji in Nara (fourteenth century), late Hōtō; in wood in the Kongōshō-ji, in Ise, Mie ken (Heian period).
58 This debate, during which Kōbō Daishi was transfigured, took place in 813, in the presence of the representatives of the eight sects allowed at the time in Japan: Kusha-shū, Jōjitsu-shū, Ritsu-shū, Hossō-shū, Sanron-shū, Kegon-shū, Tendai-shū and Shingon-shū.
59 *Hōbōgirin*, I, 39, fig. 18.
60 *Hōbōgiring*, I, 24, 39, 40.
61 *Butsuzō-zu-i*, IV, p. 8. See n. 31.

62 *Taishō*, XVIII, 227 and 275.

63 These four Bodhisattvas are the following. In the east, Vajrasādhu (Japanese *Kongō Ki*), fists clenched on the breast. In the west, Vajrasattva (Japanese *Kongō Satta*), right hand holding a three-pointed vajra, left hand a bell with a three-pointed vajra. In the south, Vajrarāga (Japanese *Kongō Ai*), draws the bow or holds an arrow with both hands. In the north, Vajrarāga (Japanese *Kongō-ō*) has three forms: (a) fists crossed on the breast, (b) hair bristling, fists crossed on the breast with forefingers extended (*Kongō-ō-in*), (c) four arms, right hands with three-pointed vajra and arrows, left hands with three-pointed vajra and bows.

64 In the east, Vajratejas (Japanese *Kongō-kō*), holding the sun in the right hand. In the west, Vajraketu (Japanese *Kongō-tō*), with a banner. In the south, Vajrahāsa (Japanese *Kongō-shō*), holding his clenched fists on each side of his head. In the north, Vajraratna, right hand on the breast, left hand in 'exterior' Varada mudrā.

65 The *Sukhāvatīvyūha* (translated into Chinese in 223) and other *sūtras* mention him and the Pure Land.

66 Sir Charles Eliot, *Hinduism and Buddhism*, III, p. 384.

67 *Hōbōgirin*, I, 24. The birth of his cult within the Great Vehicle is still obscure.

68 See *Inde Classique*, II, §2331. This paradise is described in the two *Sukhāvatīvyūha*, 'Development (or Detailed Description) of the Happy' (*Inde Classique*, II, §2010, and in M. Müller, 'The Larger Sukhāvatīvyūha and the Smaller Sukhāvatīvyūha', *Mahāyāna Texts*, SBE, London 1894, II, pp. 1, 85, 89, 107). This paradise of the West, particularly that of Amida Nyorai, is called Saihō Gokuraku Jōdo. Also a 'Land of Retribution' or Hōdō (Ōtani Chōjun, *Tannishō, France–Asie*, August 1961, II, p. 2299). According to M. V. de Visser, *Ancient Buddhism in China and Japan*, pp. 322–3, the *Tenjukoku Mandara*, seventh-century embroidery (at the Chūgū-ji in Nara), is a representation of the Sukhāvatī.

69 H. de Lubac, *Amida*, Paris, 1955, p. 145; A. Lloyd, *Creed of Half Japan*, p. 201; A. Getty, *op. cit.*, p. 41.

70 R. Tajima, *op. cit.*, p. 75.

71 According to Paul Mus, *Bārābudur*, BEFEO, Intro., Part 1.

72 This vow in 48 points is cited in the *Sukhāvatīvyūha-sūtra* (SBE, vol. 49, II, pp. 11–12). For the followers of the Jōdo Shinshu, it is the eighteenth point of this vow which is the most important (the

nineteenth is more particularly prized in the Jōdo-shū), the one in which Amida declares that, when he will have attained the state of Buddha, any being who would call to him and would wish to be reborn in the Pure Land would be heard (chapter I of the *Muryōju-kyō* or the *Sūtra of Eternal Life*). Masaharu Anesaki, 'Vows', *Encyclopaedia of Religions and Ethics*, by Hastings, XII, pp. 644, 646.

73 It appears that the first temple consecrated to Amida was the Amida Jō-in of the Hokke-ji in Nara, in 761.

74 This Ryōbu-Shintō, begun in the eighth century, was 'codified' in the early ninth century by Kōbō Daishi.

75 H. Coates and R. Ishizuka, *Hōnen, The Buddhist Saint*, Kyōto, 1925, XV, pp. 290, 306.

76 M. V. de Visser, *op. cit.*, pp. 228–9. Hachiman has been the tutelary guardian of the Tōdai-ji since the year 750.

77 *Hōbōgirin*, I, p. 27.

78 Minoru Ōoka and Ōsamu Mori, 'History of Japanese Architecture and Gardens', *Pageant of Japanese Art*, Tōkyō, 1957, p. 19.

79 Amida-dō of the Hōkai-ji in Kyōto, and Amida-dō of the Shiramizu in Fukushima, *inter alia*.

80 This *Nembutsu* (Namu Amida Butsu, Nāma Amitabhāya Buddhāya) or Buddhānusmriti, 'meditation on the name of the Buddha', ceaselessly repeated, is similar to Hindu *Japa* and to Christian litanies.

81 And the room of the Nine Amidas (Ku-Amida-dō) of the Jōruri-ji in Kyōto.

82 F. Jōüon des Longrais, *op. cit.*, p. 73.

83 B. Frank, *Mythologies, op. cit.*, p. 159. This invocation was also recommended by Hōnen. The formula had been known for many years by the followers of the Tendai and Shingon sects, but appeared to be reserved for the use of priests. Kūya and Hōnen 'democratized' its use.

84 The *Taima Mandara Engi-emaki* of the Kamakura period offers a good example of devotion to Amida, as well as the *Ippen Shōnin E-den Emaki* (dating from 1299) and the *Hōnen Shōnin Emaki*.

85 An Indian miniature of unknown date represents Amitābha seated above Avalokiteśvara (A. Foucher, *Etude sur l'iconographie bouddhique de l'Inde*, pp. 76, 108, 196). At Sarnāth (India), an Amitābha is represented seated on a lotus above a seated Lokeśvara (L. Finot, *Lokeshvara en Indochine*, BEFEO). Amitābha is perhaps also represented in the Buddhist iconography of the Gandhāra

NOTES

(on the faces of the *stūpas*), but this has not been confirmed. According to A. Grünwedel and A. Foucher (*L'Art gréco-bouddhique du Gandhāra*, II, p. 374), the images of Amitābha occurred later than those of Avalokiteśvara. M. Bénisti, in his *Etude sur le stūpa dans l'Inde ancienne* (BEFEO, Paris, 1960, L, Fasc. I, pp. 84–5), cites a panel of Nāgārjunikonda (plate XXIV) where a Buddha is seated, the legs crossed, and is thought to be Amitābha (according to the *Nidhānakathā* cited by P. Mus in *Bārābudur*, BEFEO, XXXIV, p. 185, and A. Foucher, *Une liste indienne des actes du Bouddha*, Paris, 1908, p. 12).

86 L. Frédéric, *Sud-Est Asiatique*, Paris, 1964, p. 162, plate 172a. Although the *Hōbōgirin* (I, p. 25) states: 'Outside Chinese civilization, the existence of Amitābha does not appear to be attested by a single (other than in the headdress of Avalokiteśvara) other epigraphic or iconographic document.'

87 The Indian antecedents of Amida have been debated for many years. Several authors (Sir Charles Eliot, *Hinduism and Buddhism*, II, p. 29; *L'Inde Classique*, II, §2331; P. Pelliot, *Traité Manichéen*, p. 336; W. Willett, *Chinese Art*, London, 1958, p. 346) assign him Iranian origin, hence the notion of a luminous paradise that is superimposed on the Indian idea of the Brahmāloka.

88 A. Getty, *op. cit.*, p. 39, plate XVIII c and d, plate XIX b. See also V. L. Jisl and J. Vanis, *L'Art Tibétaini*, Prague, 1958, plates 71 (right) and 40.

89 The Amitāyus form does not possess a Śakti.

90 P. Mus, 'Le Bouddha paré', BEFEO, XXVIII, 1928.

91 The Amidist sects assert that Amida revealed himself as Ādi Buddha (primordial Buddha), to Nāgārjuna (Japanese *Ryūju Bosatsu*) in Nepal, coming from Tibet (Chinese apocrypha later than Aśvaghoṣa, the *Mahāyānaśraddhotpādaśastra*, Japanese *Daijō Kishin-ron*, 'Treaty on the Awakening of the Mahāyānist faith'). P. Démiéville, *Sur l'authenticité de Ta Tch'eng sin louen*, BMFJ, II, Tōkyō, 1929). Amitābha and Amitāyus, theoretically merged in Japan, were thought to be different but interchangeable in Tibet as well as Nepal. Opinions differ on this subject (G. Tucci, 'A propos d'Avalokiteshvara', *Mélanges chinois et bouddhiques*, 1951, IX, p. 176).

92 In Japan, this mudrā is either Yogan-in or Semui-in (Abhaya mudrā).

93 We return to this triad below (*Sanzon*).

94 B. Frank, *Mythologies*, p. 160.

95 Tradition reported in the *Dai Muryōju-kyō* (*Grand Sukhāvatīvyūha*).

96 Sculptures: in wood, at the Tōdai-ji in Nara; in stone, at the Kurodani (Kyōto cemetery). See Godard and Fukui, 'La Chine et le Japon', *Religions du monde*, Paris, 1966, p. 99.

97 On this subject, it should be recalled that, in China, the 'birth of Amida' is celebrated on the 17th day of the 11th moon, at the time of the winter solstice, that is to say when the sun is at its nadir on the horizon (P. H. Doré, *Manuel des superstitions chinoises*, *op. cit.*, p. 136). The origin of this form may be found in the Dunhuang Caves (Mogao-ku) in China (*Kokka*, no. 32, July 1915, and P. Mus, Le Bouddha paré', *op. cit.*, pp. 258, 261).

98 Paintings: 'Niga Byakudō zu' at the Kōmyō-ji. See Sawa Ryūken, *op. cit.*, p. 28.

99 Taira no Shigemori (1138–1179) had 48 statues of Amida erected, one for each of his vows.

100 Note also a sculpture of Koyasu Amida (Amida 'bestower of children') in the temple of Nanneri in Wakayama. Another statue of Amida, the work of Unkei, serves as a reliquary for the ashes of the famous sculptor, in the Kōmyō-ji in Kamakura. Information kindly communicated by Bernard Frank.

101 'La descente d'Amida', *Mélanges Linossier*, pp. 99–129.

102 M. Müller, 'The Larger Sukhāvatī-Vyūha' and 'The Smaller Sukhāvatī-Vyūha in *Buddhist Mahāyāna Texts*, ed. E. B. Cowell et al., Delhi 1965.

103 *Muryōju-kyō*, *Amida-kyō* (*Sukhāvatīvyūha-sūtra*), *Kanmuryōju-kyō* (*Amitāyurdhyāna*): these three texts form the canonical scriptures of the Jōdo sect. 'Here (in the Jōdo), once they (the faithful) have been grouped around him (Amida), they will rise by steps to the state of maturity where they will be able to obtain the final deliverance' (B. Frank, 'Le Konjaku Monogatari, miroir du Japon ancien', *France–Asie*, XIX, no. 181, 1963, p. 975).

104 Sawa Ryūken, *Butsuzō-zu-ten*, p. 24.

105 However, the theories differ slightly according to text and period. According to the *Taima Mandara* (in the portion called 'Gai-en Kubon') and in the *Kubon Amida Mandara* of the priest E-un, the mudrās indicated are not identical. These mudrās of Amida were also adopted (or became more frequent) at various times. During the Hakuhō and Tempyō eras (Nara period), it was mainly the Seppō-in

316

(Vitarka mudrā) that was used (sculpture at the Kōryū-ji in Kyōto and at the Saidai-ji in Nara). In the Heian period, and especially during the Fujiwara era, it was mainly the Jō-in (Dhyāna mudrā). As to the Raigō-in, it was mainly in favour in the Kamakura period. During this period, the Raigō-in was virtually the only one used to show Amida welcoming the faithful, and the other mudrās were reserved for those of the faithful who had already entered the Jōdo and who were allowed to see Amida in his other two positions (of teaching and meditation), according to their merits and their progress. Finally, most of the time, Amida welcomes his followers with the lower mudrā of the highest class (Jōbon Geshō) and practically never with the others. According to certain priests, the two lowest classes were intended to welcome non-human creatures in the Jōdo, Amida having vowed to save *all* beings without exception. This appears to be the reason why, in paintings representing the Raigō, only the Jōbon Geshō is used (the Jōbon Chūshō and Jōbon Jōshō being reserved for the faithful that have already entered the Jōdo). The sculpted representations of the 'nine bodies of Amida' (Kuhon, Kutai) in fact do not all display the mudrās corresponding to the nine degrees described by the texts or in certain images. These sculptures, like those of the Jōruri-ji for example, only show mudrās that we do not find to correspond with theory, because, in all likelihood, they do not always date from the same period on the one hand, and because they were assembled by the priests in order to make up a disparate ensemble, with the statues that they had at the time, the others probably having been destroyed. In fact, the statues in Seppō-in were infinitely rarer than those in Jō-in or in Raigō-in, many having disappeared during the troubles. It is therefore preferable to rely on the maṇḍalas and painted images, since the various forms of Amida could not have been interchanged on these objects.

106 Most common form in Japan.
107 Form mainly common in Korea.
108 Rare form.
109 *Nō Kashiwazaki, Nō Seiganji* (works by G. Renondeau on the Nō theatre).
110 Masaharu Anesaki, *Buddhist Art*, Boston, 1915, pp. 27–28.
111 According to a tradition, the Raigō were created by the monk Genshin (942–1017), but in fact they existed in Japan before this time. One of the first mentions of the 'Descent of Amida surrounded by his cortège' was the one that recounted the death of a monk named Gōmyō, of the Hossō sect, in 834. In the temple called Gangō-ji in Nara, Amida and his cortège are thought to have come to seek this priest on his deathbed ('Shoku Nihon Kōki', *Mélanges Linossier*, I, p. 102). His antiquity is also attested elsewhere (M. V. de Visser, *op. cit.*, p. 35).

112 Especially in cave no. 139A in Dunhuang (P. Pelliot, *Les Grottes de Touen Huang*, IV, and Sir Aurel Stein, *Serindia*, II).

113 List of the 25 Bosatsu of the Raigō of Amida (Nijūgo Raigō Bosatsu) in Japan. 1. Kanzeon Bosatsu. 2. Daiseishi Bosatsu. 3. Yaku-ō Bosatsu. 4. Yakujō Bosatsu. 5. Fugen Bosatsu. 6. Hōjizai-ō Bosatsu. 7. Shishiku Bosatsu. 8. Darani Bosatsu. 9. Kokūzō Bosatsu. 10. Tokūzō Bosatsu. 11. Hōzō Bosatsu. 12. Konzō Bosatsu. 13. Kongōzō Bosatsu. 14. Kōmyō-ō Bosatsu. 15. Sankai-e Bosatsu. 16. Kegon-ō Bosatsu. 17. Shuhō-ō Bosatsu. 18. Gakkō-ō Bosatsu. 19. Nisshō-ō Bosatsu. 20. Sanmai-ō Bosatsu. 21. Jōjizai-ō Bosatsu. 22. Daijizai-ō Bosatsu. 23. Hakuzō-ō Bosatsu. 24. Daiitoku-ō Bosatsu. 25. Muhenshin Bosatsu; exceptionally, in the *Amida Jizō Raigō*, Jizō Bosatsu (see illustrations overleaf).

114 Eshin Sōzu (Genshin, 942–1017) states, in particular: 'When a pious person dies, the Buddha (Amida) appears before him. The compassionate Lord (Kannon Bosatsu), one of his great Bodhisattvas, brings a lotus flower to carry the pious soul, and the powerful Lord (Daiseishi Bosatsu) stretches out his hands as a sign of welcome, while other saints and countless heavenly beings sing hymns of praise and welcome for the believer (faithful)' (Masaharu Anasaki, *History of Japanese Religion*, London, 1930, Tōkyō, 1963, p. 152). The 25 Bosatsu of Amida are symbolized, at the Hōnen-in (Amaku-ju) in Kyōto, by 25 fresh flowers placed every day around the statue of Amida by the temple priests.

115 These twelve Kō Butsu are also sometimes represented on the halo (Kōhai) of the statues of Amida. Sculptures: in gilded wood at the Seiryō-ji in Kyōto (ninth century), and at the Sangen-in in Kyōto (c. ninth century). List of the twelve Kō Butsu of Amida (Amida Jūni Kō Butsu) (the order given by the *Butsuzō-zu-i* is in parentheses). 1. Muryōkō (Amitāprabha), infinite light (1). 2. Muhenkō, limitless light (2). 3. Mutaikō, unequalled light (4). 4. Shōjōkō, pure light (6). 5. Kangiekō, light of joy (7). 6. Chiekō, light of intelligence (8). 7. Fudankō, uninterrupted

Some of the Bosatsu of
the Raigō of Amida (see
Chapter IV, n. 113)

薩尼陀
菩羅

Darani Bosatsu

薩菩至勢大

Daiseishi Bosatsu

薩菩王在自法

Hōjizai Bosatsu

薩菩吼子獅

Shishiku Bosatsu

薩菩尼羅陀

Darani Bosatsu

薩菩藏空虛

Kokūzō Bosatsu

薩菩藏德

Tokūzō Bosatsu

薩菩藏寶

Hōzō Bosatsu

薩菩藏金

Konzō Bosatsu

薩菩藏剛金

Kongōzō Bosatsu

薩菩王明光

Kōmyō-ō Bosatsu

薩菩惠海山

Sankai-e Bosatsu

薩菩嚴華

Kegon-ō Bosatsu

薩菩王寶衆

Shūhō-ō Bosatsu

薩菩王光月

Gakkō-ō Bosatsu

薩菩王照日

Nisshō-ō Bosatsu

薩菩昧三

Sanmai-ō Bosatsu

薩菩王在自定

Jōjizai-ō Bosatsu

薩菩王在自大

Daijizai Bosatsu

薩菩王象白

Yakuzō-ō Bosatsu

薩菩德威大

Daiitoku Bosatsu

薩菩身邊無

Muhenshin Bosatsu

The twelve 'lights' of Amida (see Chapter IV, n. 115)

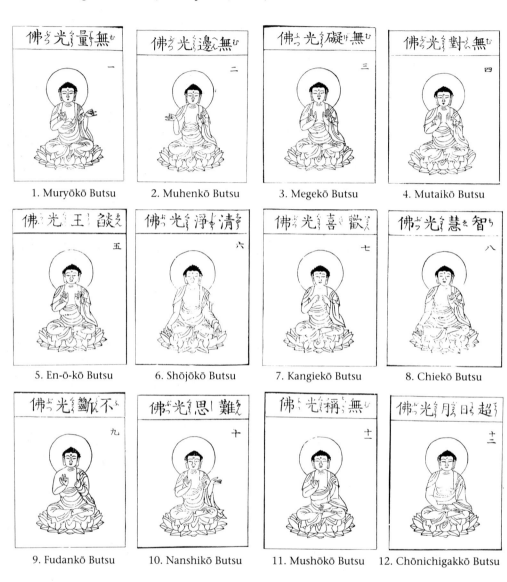

1. Muryōkō Butsu 2. Muhenkō Butsu 3. Megekō Butsu 4. Mutaikō Butsu

5. En-ō-kō Butsu 6. Shōjōkō Butsu 7. Kangiekō Butsu 8. Chiekō Butsu

9. Fudankō Butsu 10. Nanshikō Butsu 11. Mushōkō Butsu 12. Chōnichigakkō Butsu

light (9). 8. Mushōkō, indescribable light (11). 9. Nanshikō, inconceivable light (10). 10. Chōnichigakkō, light that exceeds that of the sun and the moon (12). 11. Mugekō, light that meets no obstacle (3). 12. En-ō-kō, flamboyant and ardent light (5). See illustrations above.

116 B. Frank, *Mythologies*, p. 160. Inoue Mitsusada, *Jōdo-kyō no Kenkyū*.

117 Some images, like the Ofuda by Eikandō, were also made, but they are rare and exceptions to the rule. A painting derived from the Raigō and probably unique in its class (which clearly shows the meaning

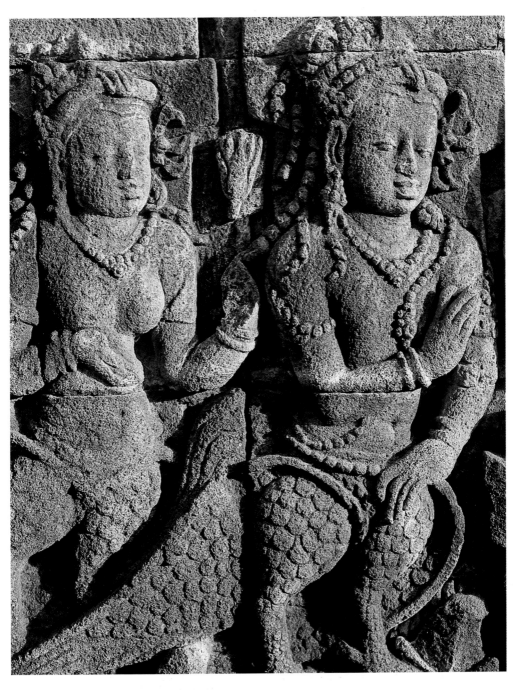

Kiṃnaras, stone, Borobudur, Java, c. 900

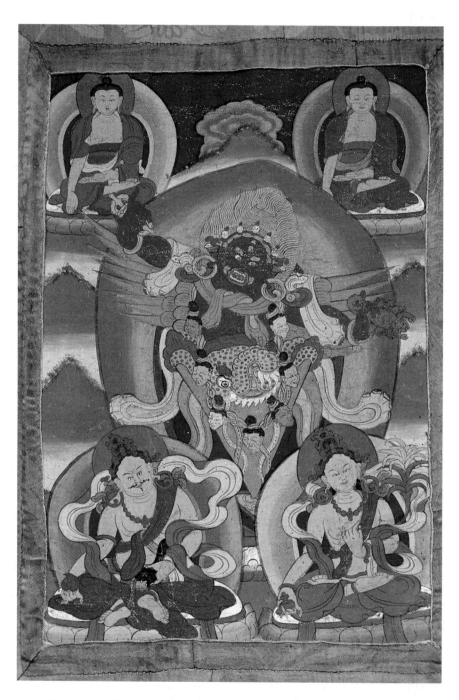

One of the aspects of Padmasambhava, maṇḍala, painting on silk, Bhūtan, nineteenth century, Private Collection

The Four Vajras (see Chapter IV, n. 120)

Kongō-hō Kongō-ri Kongō-in Kongō-go

given by the Japanese to the action of Amida) is the one, recently discovered, that shows Amida seated on a lotus and drawing a follower towards him with a rope. Shō Kannon on his right points his hand at the believer while Seishi Bosatsu pushes him from behind (the believer is also seated on a lotus): monochrome painting called *Amida Kōshō-hō*, drawn in ink by Genshō (1147–1208), a monk of the Getsujō-in of the Kōyasan, and found at the Kōzan-ji in Kyōto (Sherman Lee, *Far Eastern Art*, New York, 1964, p. 300, fig. 386). In the Heian and Kamakura periods, it was customary to tie the wrist of a moribund person to the hand of a statue of Amida using a red cord, so that Amida would not forget to take him along in the Jōdo. It is also said that Hōnen, on his deathbed, had refused this right, wishing to owe his salvation exclusively to the invocation of the Buddha Amida, by reciting the *Nembutsu* (G. B. Sansom, *A Short Cultural History* , New York, 1943, p. 330. See also F. Joüon des Longrais, *op. cit.*, p. 74).

118 Sometimes the contrary is true. This image (triad) appears in the mural paintings of the Dunhuang Caves in China in the late eighth century. But an Amida Sanzon was installed as early as 668, at Shiga (Ōmi, Japan) in the Shūfuku-ji (Shiga-dera), in the Kondō of the temple. See also the 'Zushi' of Tachibana.

119 *Hōbōgirin*, I, 30 and plate IV.

120 R. Tajima, *op. cit.*, pp. 179ff. (see illustrations above). In the east, Vajradharma (Japanese *Kongō-hō*) represents Shō Kannon: his right hand plucks the leaves of a lotus held in the left hand. He symbolizes purity. In the south,

Vajratīksna (Japanese *Kongō-ri*) represents Monju Bosatsu. He destroys sins. He holds a 'sword of wisdom' in his right hand and a *sūtra* box in the left (*Taishō-zu-zō*, I, 12). In the north, Vajrahetu (Japanese *Kongō-in*) represents Miroku Bosatsu. He is the Cause (Japanese *In*) that turns the wheel of the Law. He holds a *cakra* in the right hand on his breast and his left hand is clenched in a fist of wisdom (Japanese *Ken-in*). In the west, Vajrabhāsa (Japanese *Kongō-go*) explains the Law. He holds a *cintāmani* in the right hand against his breast and his left hand is clenched in a fist of wisdom. Or else, with both hands, he holds a three-pointed vajra placed on a lotus. In the *Taizō-kai Maṇḍala*, Amida also has the following. 1. Interior masculine Kuyō Bosatsu (Pūjā Bodhisattva) which is 'given' to him by Dainichi Nyorai and which is found in the north-west. This is Vajragīta (Japanese *Kongō-ka*) who presides over the virtues of preaching and religious song. He holds an Indian *vīna* or a *kugo* (small Korean *koto*) in the left hand (*Taishō*, XVIII, 296). 2. Exterior feminine Kuyō Bosatsu to make the offering of its virtues, and which is also situated in the north-west. This is Vajrālokā (Japanese *Kongō-tō*). In the right hand it holds a lamp on a lotus or an incense bowl, and its left hand is closed on its breast. 3. Possibly feminine Shō Bosatsu (Samgraha Bodhisattva) located in the west, which represents the means of salvation proposed by Amida. This is Vajrasphota (Japanese *Kongō-sa*). It holds a chain terminating in a hook (R. Tajima, *op. cit.*, p. 189), or a rope with a three-pointed vajra at each end.

121 'He who has obtained the highest authority', according to H. Coates and R.

Ishizuka, *op. cit.*, p. 100.

122 This Bodhisattva is mentioned, *inter alia*, in the *Sukhāvatīvyūha-sūtra* and in the *Saddharmapundarīka-sūtra*.
123 Sir Charles Eliot, *Hinduism and Buddhism*, II, p. 23.
124 *Taishōzō*, XII, 344, and XVIII, 800. Sculptures: Sanzon of Zushi de Dame Tachibana. Seated in Lalitāsana, in wood (1 m high) dating from 1151, at the Chōgaku-ji.
125 Sculptures: in wood, standing (thirteenth century), in the National Museum in Tōkyō; at the Saiko-ji, in Mie-ken. At the Zenkō-ji a Japanese legend relates that the image called Zenkō-ji Nyorai was made by Śākyamuni himself, with gold found at the foot of Mount Meru (A. Getty, *op. cit.*, p. 14).
126 Rare bronze form, dated 1271 (Sanzon) at the Engaku-ji in Kamakura.
127 Johnson, *Buddhist China*, pp. 103ff.
128 Celebrated in the Nō *Atago Kūya* and *Sumidagawa* (G. Renondeau, *Le Bouddhisme dans les Nō*, pp. 100, 106).
129 Especially that of the Saiko-ji in the Yamato (J. Takura, *The Essentials of Buddhist Philosophy*, Honolulu, 1946, pp. 170–71).
130 Kūya Shōnin said: '*Hito tabi mo, Namu Amida Butsu, Yū Hito no, Hasu no Utena ni, Noboramu wa Nashi* [He who calls, even if only once, the name of Amida, will not fail to reach the land of happiness]'. R. Tsunoda, *Sources of the Japanese Tradition*, New York, 1958, p. 193.
131 M. Bénisti, *Etude sur le stūpa*, p. 82.
132 *Taishō-zu-zō*, I, 12. These four Bodhisattvas are the following. In the east, Vajrayakṣa (Japanese *Kongō-ga*), the two fists clenched on the breast or right hand in fist of wisdom and left hand holding a lotus supporting a three-pointed vajra. In the west, Vajrarākṣā (Japanese *Kongō-go*), fists clenched, joined on the belly. In the south, Vajrakarma (Japanese *Kongō-ge*), hands in worship (Añjali mudrā) above the head. In the north, Vajrasamdhi (Japanese *Kongō-ken*, the two fists clenched on the breast, or right hand with *katsuma* (cross vajra), left hand in fist of wisdom on the thigh.
133 A. Getty, *op. cit.*, p. 3 and n. 3.
134 A. Getty, *op. cit.*, p. 5 and n. 4.
135 A. Getty, *op. cit.*, p. 4.

Chapter V
The Bodhisattvas of Compassion

1 *Hōbōgirin*, II, p. 136.
2 *Hōbōgirin*, II, p. 136.
3 E. Lamotte, 'Mañjuśrī', *T'oung-pao*, XLVIII, p. 9.
4 *Prajñāpāramitā* (Japanese *Chi Haramitsu*).
5 *Aṣtassāhaśrikā*, p. 4, quoted by E. Lamotte, *op. cit.*, p. 10, n. 24.
6 *Hōbōgirin*, II, p. 136.
7 *Hōbōgirin*, II, p. 136.
8 Treatise by Vasumitra on the sects, the *Vibhāṣa*, and the *Abhidharmakoṣa*.
9 Especially in the texts of the *Prajñāpāramitā*.
10 E. Lamotte, *op. cit.*, pp. 1–3.
11 E. Lamotte, *op. cit.*, pp. 94–95. The text of the *Kāśyapaparivarta*, §88, states: 'The Tathāgatas derive their origin from the Bodhisattvas.'
12 These ten places of birth or 'lands' (*Bhūmi*) are, according to the *Mahāvairocana-sūtra* (R. Tajima, *op. cit.*, p. 110), the following. 1. Pramuditā, of the Thought of the Awakening (*Bodhicitta*). 2. Vimalā, of the High Resolution (*Adyāsaya*). 3. Prabhākaharī, of the lands (*Bhūmi*). 4. Arciṣmatī , of the Great Vows (*Mahāpranidhāna*). 5. Sudurjayā, of the Great Compassion (*Mahākarunā*). 6. Abhimukhī, of the correct Reflection (*Yoniṣomanaśikāra*). 7. Dūraṃgamā, of the Great Vehicle (*Mahāyāna*). 8. Achalā, of the Maturing of Beings (*Sattvaparipācāna*). 9. Sādhumatī, of Knowledge (*Jñāna*) and of the means of Salvation (*Upāya*). 10. Dharmameghā, of the culture of the Good Dharma (*Sarvadharmabhāvanā*); Mañjuśrī, Avalokiteśvara and Maitreya belong to this tenth Land. In esoteric Buddhism, each of these 'ten lands' (Japanese *Jūji*) is divided into three 'steps': entrance, residence and exit, except for the first land, which has just two steps, before and after the entrance. Esoteric Buddhism considers only two steps in the career of the Bodhisattvas: before the 'ten lands' and the 'ten lands' which are considered as equal 'branches' of the 'merits of the pure heart of the Bodhi' (R. Tajima, *op. cit.*, pp. 61, 105–6). In exoteric Buddhism, it is considered necessary to complete 50 steps before becoming a Bodhisattva: the 'ten degrees of the Faith' (*śraddha*, Japanese *Shinjin*), the 'ten degrees of residence' (*Vihāra*, Japanese *Jūsho*), the 'ten degrees of practice' (*Caryā*), the 'ten degrees of change or maturing' (*Parināmana*, Japanese *Ekō*), and the 'ten degrees of ascesis' or 'lands' (*Bhūmi*, Japanese *Jūji*).

13 They can assume all possible forms. On this subject, tradition relates the appearance of Samanthabhadra (Japanese *Fugen Bosatsu*), in the thirteenth century, to the monk Shōkū (910–1007) in the features of a courtesan, thus showing that the 'nature of the Buddha' is found in all creatures (B. Frank, *Mythologies*, p. 164). These Bodhisattvas are divided into two classes, according to the 'duration' of their career. 1. Those who, having attained the Bodhi in their last incarnation, become Tathāgatas after having had a single rebirth in the Tushita heaven (Japanese *Tosotsuten*); Gautama Buddha belongs to this class. 2. Those who, by compassion for living beings, renounce becoming Tathāgatas. According to the *Prajñāpāramitā-sūtra*, the Bodhisattvas of this second category follow a 'career' in four steps: (a) preliminary (*Prakriticāryā*), during which the innate qualities are manifested; (b) of the thought of Illumination (Awakening, *Prathamacīttotpādika*), when the Bodhisattva makes his vow to help beings to achieve salvation; (c) beginning of his true career as a Bodhisattva and carrying into practice of the different points of his vow, and (d) practice 'without recoil' of the vow made. The first three steps constitute the 'first seven lands' of action of the Bodhisattvas (Joyous, Immaculate, Brilliant, Shining, Difficult to gain, Directly in front and Going straight (*Inde Classique*, II, §2334). The fourth corresponds to the eighth, ninth and tenth lands (Immobile, Good Thought, Cloud or Essence of the Law) (*Hōbōgirin*, II, p. 136, and *Inde Classique*, II, §2334). The Bodhisattvas for whom a single rebirth in the Tushita heaven is necessary to reach the state of 'non-return', or 'non-rebirth', of Tathāgata, belong to the tenth 'land'.

14 *Hōbōgirin*, II, p. 46.

15 According to the *Mahāvairocana-sūtra*, I (R. Tajima, *op. cit.*, p. 53).

16 *Bukkyō-Daijiten*, p. 1,854.

17 According to André Bareau, *op. cit.*

18 See detail in R. Tajima, *op. cit.*, pp. 170ff.

19 See L. Frédéric, *Inde, Temples et Sculptures*, p. 139, plate 108.

20 Especially the *Siśireśvara Mandir* in Bhūbhaneshvar, India (K. C. Panigrahi, 'Bhauma Arts and Architecture in Orissa', *Arts asiatiques*, Paris, 1957, IV, p. 288).

21 J. Boisselier, 'A Propos d'un bronze cham inédit d'Avalokiteśvara', *Arts asiatiques*, Paris, 1957, IV, p. 255.

22 Sculpture of Avalokiteśvara of Rach-Gia (J. Boisselier, *op. cit.*, p. 269, n. 4, fig. 11, and

P. Dupont, *La Statuaire pré-angkorienne*, pp. 52ff.

23 Especially among the Khmer and in Central Asia (H. Marchal, *Mythologie asiatique illustrée*, pp. 179–180, and L. Finot, 'Lokeśvara en Indochine', *Etudes asiatiques*, 1925, I, pp. 243–244).

24 *Taishō*, XII, 343 and 344.

25 J. Buhot, *op. cit.*, p. 138.

26 Shunjō, *Vie de Hōnen*, chapter XVI, and H. Coates, *Hōnen, the Buddhist Saint*, Kyōto, 1925, pp. 317–318.

27 Quoted in the *Avalokiteśvaragunakarandavyūha-sūtra* and in the *Saddharmapundarīka-sūtra* (E. Burnouf, *Introduction à l'etude du bouddhisme indien*, pp. 201–202).

28 According to P. Mus, quoted in the preface of M.-T. de Mallmann, 'Introduction à l'étude d'Avalokiteśvara', *Annales du musée Guimet*, vol. 57, 1948.

29 *Sukhāvatīvyūha* (long *sūtra*), Nos. 31 and 34 (S. Levi, *L'Inde et le monde*, p. 45).

30 B. Frank, *Mythologies*, p. 162. He was celebrated in the villages on the 17th day of the 6th month (F. Joüon des Longrais, *Est–Ouest*, p. 74).

31 An effigy of Kannon is placed inside the head of the great Daibutsu (Amida) of Kamakura, dating from 1252.

32 H. de Lubac, *Amida*, pp. 104–105.

33 Late interpolation, called *Sūtra d'Avalokita* (Japanese *Kannon-gyo*). J. Przyluski, 'Les Vidyārāja', BEFEO, XXIII, 1923, pp. 316–317.

34 M.-T. de Mallmann, *op. cit.*, pp. 81–82, n. 2.

35 Painting: in the Musée Guimet, Paris. *Guide/Catalogue du musée Guimet*, 1923, p. 40.

36 J. J. M. de Groot, *Sectarianism and Religious Persecutions in China*, Amsterdam, 1903, I, p. 230, plate II.

37 From this figure, it is said that rays of light sometimes emanate, illuminating distant worlds, according to the *Amitāyurdhyāna-sūtra* (Japanese *Kanmuryōju-kyō*).

38 M.-T. de Mallman, 'Headdresses with Figurines in Buddhist Art', *Indian Arts and Letters*, XX1, 1947.

39 *Ibid.* p. 90.

40 In the *Saddharmapundarīka-sūtra*, Avalokiteśvara is described as being incarnated himself in many different personages. For example, when he sees that it is easier, to save a certain class of people, to adopt a certain mode of expression, he assumes this particular appearance and exerts his influence in this way. He can be a philosopher, a tradesman, a man of letters, a person of low birth or anyone

according to the occasion, because his only aim is to deliver all beings without exception from ignorance and egoism.

41 *Hōbōgirin*, II, p. 185. According to the *Hoke-kyō Kanzeon Bosatsu Fumonbon* and the *Shōmu Gekyō*, Shō Kannon assumes 33 'bodies' (Japanese *Sanjūsan ōgeshin*) whose names differ from those of the traditional forms (they also differ slightly in the two texts), depending on the lands of election of this Bodhisattva. These bodies are described in the *Taishōzō-kyō Zuzō-bu*, XX, 126 and 127. The colour of the bodies and their attributes also vary. They were never represented (except perhaps in small sculptures, attributed to Unkei, in the Suginomoto no Kannon-ji in Kamakura). These 33 bodies or *Keshin* (*Ōshin, Ōgeshin*, Sanskrit *Nirmānakāya*), or bodies of transformation (Sawa Ryūken, *op. cit.*, pp. 55ff., and E. Burnouf, *Le Lotus de la Bonne Loi*, in the version of Kumārajīva, p. 264) are the following. 1. Body of a Buddha (Japanese *Butsu Shin*). 2. Body of Pratyekabuddha (Japanese *Byakushin Butsu Shin*). 3. Body of Śrāvaka (Japanese *Shōmon Shin*). 4. Body of Brahmā (Japanese *Daibontennō Shin*). 5. Body of Śakradevendra (Japanese *Taishaku Shin*). 6. Body of Iśavara (Japanese *Jizai-ten Shin*). 7. Body of Maheśvara (Japanese *Daijizay-ten Shin*). 8. Body of a Senāpati or general (Japanese *Tendaishōgun Shin*). 9. Body of Vaiśrāvana (Japanese *Bishamon Shin*). 10. Body of a prince (Japanese *Shō-ō Shin*). 11. Body of a rich man (Japanese *Chōja Shin*). 12. Body of a lay believer (Japanese *Koji Shin*). 13. Body of a courtesan (Japanese *Saikan Shin*). 14. Body of a Brāhmin (Japanese *Baramon Shin*). 15. Body of a monk (Japanese *Biku Shin*). 16. Body of a nun (Japanese *Bikuni Shin*). 17. Body of an *Upāsaka* or lay believer (Japanese *Ubasoku Shin*). 18. Body of an *Upāsikā* or pious woman (Japanese *Ubai Shin*). 19. Body of an ordinary man (Japanese *Jin Shin*). 20. Body of an ordinary woman (Japanese *Bunyo Shin*). 21. Body of a boy (Japanese *Dōnan Shin*). 22. Body of a girl (Japanese *Dōnyo Shin*). 23. Body of a Deva (Japanese *Ten Shin*). 24. Body of Devī (Japanese *Dōmokutennyo Shin*). 25. Body of Vajrapāni (Japanese *Shukongō Shin*). 26. Body of a Nāga or dragon (Japanese *Ryū Shin*). 27. Body of a Yakṣa (Japanese *Yaṣa Shin*). 28. Body of a Gandharva (Japanese *Kendatsuba Shin*). 29. Body of an Asura (Japanese *Ashura Shin*). 30. Body of a Garuda (Japanese *Karura Shin*). 31. Body of a Kimnara (Japanese *Kinnara Shin*). 32. Body of a Mahoraga (Japanese *Makoraka Shin*). 33. Body of a 'non-human' (Japanese *Hinin Shin*).

42 *Hōbōgirin*, II, p. 183.

43 These legends were brought to Japan by Chinese painters and sculptors of the Ming period (1334–1668). Many of the forms of Kannon thus belong to the Chinese legend of the Miao Shan (*Annales du musée Guimet*, Paris, and A. Getty, *op. cit.*, pp. 79, 84).

44 List of the 33 holy places (Japanese *Sanjūsan Sho*) of the pilgrimage to the 33 temples of the west, in Japan. 1. Seiganto-ji (Nachizan, Nyorin-ji), Wakayama. 2. Kongō-hō-ji (Kimii-dera), Wakayama. 3. Kokawa-dera (Seon-ji), Wakayama. 4. Makinoo-dera (Sefuku-ji), Ōsaka. 5. Fuji-dera, Nakano. 6. Tsubosaka-dera (Minami Hokke-ji), Nara. 7. Oka-dera (Ryūkai-ji), Nara. 8. Hase-dera, Nara. 9. Nanendō of the Kōfuku-ji, Nara. 10. Mimurodō-dera (Myōshōzan), Uji. 11. Kamidaigo-dera, Uji. 12. Iwama-dera (Shōhō-ji), Shiga. 13. Ishiyama-dera, Shiga. 14. Mii-dera (Onjō-ji), Ōtsu. 15. Ima (shin) Kumano Kannon-ji (Sennyū-ji), Kyōto. 16. Kiypmizu-dera, Kyōto. 17. Rokuharamitsu-ji, Kyōto. 18. Rokkakudō of the Chōhō-ji, Kyōto. 19. Kōdō of the Gyōgan-ji, Kyōto. 20. Yoshimine-dera, Kyōto. 21. Bodai-ji, Anō. 22. Sōzen-ji, Ōsaka. 23. Kachio-dera (Toyokawa), Ōsaka. 24. Nakayama-dera, Hyōgo. 25. Shin Kiyomozu-dera, Hyōgo. 26. Hokke-ji, Hyōgo. 27. Enkyō-ji (Shōshazan, Nyoirin-dō), Hyōgo. 28. Nariai-dera (Seisō-ji), Kyōto. 29. Matsunoo-dera, Kyōto. 30. Hōgon-ji (Chikubu-ji, Chikubujima), Shiga. 31. Chōmei-ji (Okushima), Shiga. 32. Kannon-ji, Shiga. 33. Kegon-ji, Gifu. (List according to the *Nihonshi Shōjiten*, Tōkyō, 1966, Appendix, p. 10.) In Eastern Japan, 33 places or temples also exist which constitute the stages of a pilgrimage to Kannon. With the 33 temples of the west pilgrimage (the most frequented) and two others, the total number of temples making up the complete pilgrimage that must preserve the pious pilgrim from the torments of hell and open to him the gates of a happy rebirth amounts to 88 (a symbolic number equivalent to infinity in Japan). Among the most important temples of the eastern pilgrimage are the Suginomoto-ji, the Iwadono-ji, the Anyō-in and the Hase-Kannon-ji in Kamakura.

45 An exceptional form, called Chigo Kannon (in the *Chigo Kannon Emaki*), shows Shō Kannon in the form of a child. Painting in

the Bodai-in of the Kōfuku-ji in Nara (Akimoto Collection).

46 *Taishō*, XX, 122. Sculptures: in wood at the Daian-ji, at the Hōryū (without ornament).

47 *Hōbōgirin*, III, pp. 217, 221.

48 *Hōbōgirin*, III, pp. 217ff., figs. 72–77 and plates XIX and XX.

49 *Taishō*, XVIII, 564, and XXXIX, 632.

50 *Zuzōshō*, *Hōbōgirin*, III, p. 279, fig. 17.

51 See O. Sirén, *Histoire de la peinture chinoise*, chapter I, pp. 59–60. Sculpture: in the Chikuron-ji in Kōchi, Japan.

52 *Hōbōgirin*, III, p. 222. This form of Kannon, mainly theoretical, by its esoteric Japanese name Fuke Kongō, 'Diamond of transformation', is shown seated on a lotus in Rājalilāsana, right arm resting on the knee, left hand holding a lotus. Its colour is very pale yellow. Its attributes (*Taishō*, 1092, and XXII, 349) are a *cintāmani* and a vase (*kuṇḍīka*, Japanese *byō*). It is only one of the aspects of Byakue Kannon.

53 With a single head, seated on a lotus leaf, head ornaments of gilt metal, attributed to Unkei, in the Tōkei-ji in Kamakura.

54 *Taishō*, XX, 271 and 490.

55 *Taishō*, XX, 503. Also called Mu-i, 'fearless'.

56 *Hōbōgirin*, I, p. 23, and fig. 12 (by Shūei).

57 'Clothed in leaves' (*Taishō*, XX, 134 and 448).

58 *Taishō*, XX, 453.

59 Vajradatta, 'Lokeśvaraśataka', translated by S. Karpelès, *Journal asiatique*, Paris, 1919, XIth Series, XIX, pp. 357–465.

60 *Mahāvairocana-sūtra*.

61 Maeda Collection, Tōkyō, included in Sawa Ryūken, *op. cit.*, p. 76. She is especially venerated by the fishermen of Nagasaki. Sculptures: in the Kōyasan cemetery, and in the Musée Guimet, Paris.

62 Quoted by P. Claudel, *Connaissance de l'Est*, 1907.

63 *Taishō*, XX, 141 and 150. According to this form, this tradition was imported from China in the early eighth century by the Chinese monk Kanshin Daishi, who offered a statue of it to the Emperor Shōmu in 746 (J. Auboyer, *Les Influences et les réminiscences étrangères au Kondō du Hōryū-ji*, p. 86 and n. 183).

64 Instead of the suns and *cintāmanis*, the aureole sometimes contains *bījas*, Sanskrit seed-syllables. Each deity thus has its syllable sound. Sometimes, however, the name of the temple is also inscribed on the aureole.

65 Copy of a Chinese work dating from 719 (at the Hōryū-ji in Nara).

66 Information communicated to the author by Miss Shirahata, of the Kyōto Museum, in 1966. Among the images of Jūichimen Kannon, are the following. Sculptures: in wood at the Hase-dera in Nara (holding a pilgrim's staff in the right hand, standing on a base without lotus, dating from the sixth century, 7.90 m high); in wood at the Hōki-in in Wakayama; at the Kojima-dera in Nara; at the Yakushi-ji in Nara.; at the Kiyomizu-dera in Kyōto; at the Jōfuku-ji in Shiga; at the Eishō-in in Shiga; at the Haka-dera in Fukui; at the Tōgan-ji in ōmi (eighth century). Paintings: a hypostase of this Bodhisattva is found on the *Shika Mandara* of the Kasuga Taisha (Shintō sanctuary) in Nara, engraved on the mirror placed on the skakaki tree which is shown there (dated 768, Nara Museum). A small statue of Jūichimen Kannon is also sculpted inside the head of a statue of Tenjin-sama (Shintō deification of the Minister Sugawara no Michizane), at the Tenmangū of Egara in Kamakura (Iso Mutsu, *Kamakura*, pp. 27, 29, 210). See also A. Getty, *op. cit.*

67 The history of one of these statues is found in the *Kokawa-dera Engi Emaki* (History of a Temple in the Province of Kii), attributed to Toba Sōjō (0.31 m high). Three copies of this scroll, dating from the eighteenth century, are in the Nara Museum. Painting: in colours on silk (late Heian) at the Kinbusen-ji in Nara. Sculptures: with 27 heads and 42 arms, at the Hosshō-ji in Kyōto; with 42 hands plus 911 small hands, by Tankei, at the Tōshōdai-ji in Nara; seated with 1,000 arms, at the Fuji-dera in Ōsaka; standing, in stone, of Jōroku size (2.64 m) at the Oya-ji in Utsunomiya.

68 See M.-T. de Mallmann, *Introduction à l'étude d'Avalokiteśvara*, *op. cit.*

69 At the Oku-no-in of the Kiyommizu-dera in Kyōto, this image, said to be secret, is shown to the faithful only once every 33 years; the next showing is due in 1997.

70 *Taishō*, XX, 120.

71 Sculptures: on wood, at the Jōroku-ji in Shiga; at the Sanjūsangendō in Kyōto; in dry lacquer, at the Kōfuku-ji in Nara (only eight effigies of these exist, corresponding to Nos. 7, 8, 20, 21, 22, 23, 24 and 25 of our list).

72 *L'Art japonais à travers les siècles*, Musée d'Art Moderne, Paris, 1958, caption 91, plates 17 and 18.

73 Sculpture: at the Kosō-ji in Gifu. This deity assisted the Chinese pilgrim Xuanzang in the desert. A simultaneous hypostase of Avalokiteśvara and Vaiśravana. Represented as a warrior with a garland of skulls around the neck (possibly of Tibetan

influence), a child's face on the belly (replacing the usual lion's head), and an apron ornamented with elephant heads (attributes of the soldiers of Māra, the demon of hell), J. Buhot, *Histoire des arts du Japon*, §208, p. 162.

74 The six destinies of transmigration (*Gati*, Japanese *Rokudō*) are also the 'six ways of existence' which, according to the *Kanmuryōju-kyō*, are those of the demons of hell, of the Pretas (Japanese *Gaki*), animals, Asuras, men and gods, categories in which beings are placed in retribution for the acts of their former lives (the Asuras were sometimes included with the Pretas – famished spirits of the deceased), in which only five categories are counted (*Inde Classique*, II, §2266). Illustrations of the *Ōjōyōshū* of Genshin (942–1017) reproduced in J. Troup, *op. cit.*, p. 178, plate I, and p. 182, plate II, show these 'six ways' plus the class of the Riṣis (Japanese *Sennin*) as well as the eight purgatories (*Naraka*, Japanese *Jikoku*) or earthly prisons, also called 'hells': 1. Sañgīva (Japanese *Tōkatsu Jigoku*); 2. Kālasūtra (Japanese *Kokujō Jigoku*; 3. Sanghāta (Japanese *Shūgō Jigoku*); 4. Raurava (Japanese *Kyōkan Jigoku*); 5. Mahāraurava (Japanese *Daikyōkan Jigoku*); 6. Tapana (Japanese *Shōnetsu Jigoku*); 7. Pratapana (Japanese *Daishōnetsu Jigoku*); 8. Avīchi (Japanese *Muken Jigoku*) or 'endless hell'. These eight hells (hot or cold) are included in the 21 Brāhmin hells. They are also called 'Buddhist hells' (H. Kern, *Manual of Indian Buddhism*, p. 58). These six forms of Avalokiteśvara were worshipped to obtain victory over enemies and good health, by repeating six magic words or the six *bījas* characterizing this Bodhisattva (H. MacCullough, *Taiheiki*, p. 12, n. 25). The images of the six *Gatis* are very often represented painted on the walls of temples and monasteries in Tibet, Sikkim and Bhūtan, between the spokes of a large 'wheel of the Law' which appears to devour a monster representing Time.

75 *Taishō*, XX, 193. Sculptures: in bronze, at the Shōrin-an in Fukui; at the Jinnō-in of the Tōdai-ji in Nara; at the Kanshin-ji in Ōsaka; in wood at the Kōryū-ji in Kyōto; at the Ishiyama-dera in Shiga.

76 *Taishō*, XX, 193.

77 Or with only the right shoulder bare, with a high crown. Sculptures: Seki Butsu at the Hannya-ji in Nara, in stone, Edo period.

78 In the *Nyoirin Mandara*, he is found at the centre of a large wheel of the Law between the spokes of which are his eight acolytes (*Devas*). Another representation of this

mandala shows Nyoirin Kannon surrounded by his eight acolytes but without the wheel of the Law.

79 Form of the 'saviour horse', Balāha or Valāha. To re-cross the ocean, the shipwrecked seeking refuge on an island inhabited by ogresses (Rākṣasī) cling to its mane. *Inde Classique*, II, §2361. This form is possibly represented in Angkor in the sanctuary of Neak Pean, in connection with Avalokiteśvara.

80 B. Frank, *Mythologies*, p. 163.

81 With lotus and leaf in the right hand, axe in the left hand, seated in Rājalilāsana (*Hōbōgirin*, I, p. 58, fig. 27). This type is called 'of the Tang' (Japanese *Tōzu*). The horse's head bears a small effigy of Amida seated on a lotus.

82 Hands joined holding a rosary, horse's head in the hair, seated in Padmāsana on a white lotus, mounted on a horse, ox or buffalo. *Ofuda* of the Entsū-ji, *Hōbōgirin*, I, p. 59, fig. 28. See also R. Van Gulik, *Hayagrīva*.

83 *Taishō*, XX, 131, 167, 168 and 271.

84 The Ono branch of the Shingon sect recognizes it as being Āryāvalokiteśvara (Japanese *Shō Kannon*).

85 A. Foucher, *Iconographie bouddhique*, I, p. 144, and II, p. 93.

86 According to L. A. Waddell, *The Buddhism of Tibet or Lamaism*, London, 1895.

87 *Taishō*, XX, 178–184.

88 *Taishō*, XX, 140, 292, 332 and 342.

89 *Hōbōgirin*, I, p. 75, fig. 35.

90 H. Maspéro, 'Le monastère de la Kan Yin qui ne veut pas s'en aller', BEFEO, IX.

91 A representation dating from the Kamakura period, attributed to Unkei and called Suigetsu Kannon, is a form of this deity. It is sometimes called Komochi Kannon. Sculptures: at the Taizan-ji of the Kiyomizu-dera in Kyōto; at the Tōkokū-ji in Nara, standing with a child seated on his left hand; at the Tokei-ji in Kamakura. Painting: back panel of the hunt (Japanese *zushi*) of Kichijō-ten at the Jōruri-ji in Kyōto (now at the Arts University in Kyōto). H. Maspéro and N. Péri, 'Le monastère de la Kan Yin qui ne veut pas s'en aller', *op. cit.*, pp. 797–807, and A. Foucher, 'La madone bouddhique', *Iconographie bouddhique, op. cit.*

92 *Monuments et Mémoires de l'Académie des inscriptions et belles-lettres*, XVII, 1910 (engraving).

93 B. Frank, *Mythologies*, p. 173. R. P. Humbert Claude, 'Maria Kannon, Iconographie martiale au Japon, durant la persécution', *L'Apôtre de Marie*, 1953, pp. 97–104.

94 Associations of women, called Koyasu-kō, under the invocation of Koyasu Kannon taken for Koyasu Myōjin, are formed in Japan to cure infertility (Lucy S. Itō, 'Japanese Confraternities, Kō', *Monumenta Japonica*, VIII, 1952, pp. 412, 414).

95 Hārītī. Also the personification of smallpox (A. Foucher, 'La madone bouddhique', *op. cit.*, plates XVIII and XIX).

96 In the *Saddharmapundarīka-sūtra*, Hārītī is in fact one of the eight Rakṣāsīs who listen to the good Law preached by the Buddha. She was then worshipped more as the protector of the *sūtra* than as the 'bestower of children' (N. Péri, *Hārītī, mère des démons*, pp. 41ff.).

97 According to legend, after her conversion, Hārītī nourished her children no longer with human blood but with pomegranate juice, which has the same colour. This is why she is represented holding a pomegranate (as in sculpture at the Onjō-ji in Kyōto, *inter alia*). Due to its many seeds, the pomegranate symbolizes fertility.

98 *Taishō*, XXI, 286 and 289.

99 A. Getty, *op. cit.*, p. 98.

100 According to A. Waddell, *The Buddhism of Tibet or Lamaism, op. cit.*, p. 360, n. 1, these 21 Tārās are: 1. Prasura Tārā (supreme valour). 2. Candrojasa Tārā (of the bright white moon). 3. Gaurī Tārā (of the colour of gold). 4. Uṣnīṣajaya (victoriously crowned). 5. Hūmdā Tārā (who pronounces the invocation Hūm). 6. Tārā the best worker of the 'three worlds'. 7. Tārā who banishes quarrels. 8. Tārā who grants supreme power. 9. Tārā the providential. 10. Tārā who dissipates grief. 11. Tārā who loves the poor. 12. Tārā the glorious. 13. Tārā the universal worker. 14. Bhrikutī Tārā, with knitted brows. 15. Tārā dispenser of prosperity. 16. Tārā who conquers the passions. 17. Sarsiddhi Tārā, who gives happiness. 18. Tārā the Immense. 19. Tārā who banishes misfortune. 20. Siddhārtā Tārā, who achieves spiritual power. 21. Tārā the All-perfect. See also A. Waddell, JRAS, 1894, pp. 63ff.

101 He represents the fifth element of the universe, ether (*ākāsa*), the others being earth (*bhū*), water (*jala*), fire (*tejas*), and air (*anila*). See discussion of these elements in M. V. de Visser, 'The Bodhisattva Ākāṣagarbha (Kokūzō) in China and Japan', *Uitgave van de Koninklijke Akademie van Wetenschappen te Amsterdam*, 1931, pp. 5–16.

102 *Taishō*, XIII, 649–656. For the explanation of the *sūtras* concerning Ākāṣagarbha, see M. V. de Visser, *op. cit.*, pp. 37–45.

103 A. Getty, *op. cit.*, p. 102.

104 A. Lloyd, *Creed of Half Japan*, p. 65.

105 These eight Bodhisattvas are, on the right, Avalokiteśvara, Ākāṣagarbha, Vajrapāni and Kṣitigarbha, and on the left, Sarvanīvaranaviṣkambhin, Maitreya, Samantabhadra and Mañjuśrī.

106 *Himitsu Jirin*, p. 294 (35 Buddhas, represented on the crown, instead of five).

107 M. V. de Visser, *op. cit.*, pp. 39–40.

108 M. V. de Visser, *op. cit.*, p. 43.

109 *Himitsu Jirin*, p. 296, 1.

110 *Taishō*, XVIII, 227 and 263.

111 These Godai Kokūzō are the following. In the centre, corresponding to Dainichi Nyorai, Hōkai Kokūzō, white in colour (in sculpture, mounted on a horse at the Kanchi-in in Kyōto, and mounted on a lion at the Jingo-ji in Kyōto), right hand in Abhaya mudrā or holding a *cintāmani*, left hand holding a spear. In the east, corresponding to Aṣuku Nyorai, Kongō Kokūzō, yellow in colour (in sculpture, mounted on an elephant at the Kanchi-in in Kyōto), right hand holding a double vajra on the breast, vertical spear in the left hand. In the south, corresponding to Hōshō Kokūzō, blue in colour (in sculpture, mounted on a horse at the Jingo-ji in Kyōto), holding a triple *cintāmani* in the right hand, a vertical spear in the left hand. In the west, corresponding to Amida Nyorai, Renge Kokūzō, red in colour (in sculpture, mounted on a peacock at the Jingo-ji in Kyōto), blossoming lotus in the right hand, vertical spear in the left hand. In the north, corresponding to Fukūjōju Nyorai, Gōyū Kokūzō, dark purple in colour (in sculpture, mounted on a Garuda at the Jingo-ji in Kyōto), a crossed vajra in the right hand, a vertical spear in the left hand.

112 Kokūzō Bosatsu-kyō and others (list in M. V. de Visser, *op. cit.*, pp. 17–18).

113 *Taishō*, XX, 607. According to Sawa Ryūken, *Butsuzō-zu-ten*, p. 88, they may also be named (in the centre) Gedatsu Kokūzō Bosatsu, (in the east) Fukutoku Kokūzō Bosatsu, (in the south) Nōman Kokūzō Bosatsu, (in the west) Segan Kokūzō Bosatsu, and (in the north) Muku Kokūzō Bosatsu. In the *Kongō-kai Mandara*, he is named Kongō-hō Bosatsu (*Vajratna*) and is found to the north of Ratnasambhava (Japanese *Hōshō Nyorai*) of whom he is one of the four acolytes. He holds a *cintāmani* in one hand and makes Varada mudrā with the other in the *Mahāmandala* (Japanese *Jōjin-ne Mandara*) and the *Sūkṣma Mandala* (Japanese

Katsuna Mandara). He corresponds to Gaganagañja in the *Samaya Mandala*, where he sits in the south, bearing three flaming *cintāmaṇis* (R. Tajima, *op. cit.*, pp. 177–178, 198, 201).

114 *Taishō*, XX, 601. Sculpture: in bronze at the Gakuan-ji in Nara. Paintings: at the Enjō-ji in Kamakura; on silk at the Kanshin-ji in Kyōto.

115 In the *Taizō-kai Mandara*, he is also called Mani Kokūzō Bosatsu (*Mani Ākāṣagarbha*) or 'yellow Kokūzō'. Sculpture: in wood, in the Tahō-tō at the Jingo-ji in Kyōto, which also contains four other effigies of Kokūzō Bosatsu.

116 This sword is rounded in the form of a *cintāmaṇi* and not pointed.

117 *Taishō*, XVIII, 8, and XXXIX, 635.

118 R. Tajima, *op. cit.*, pp. 303–304, 116–122.

119 The 'protector of the six destinies of transmigration' (*Gati*). Paintings: on silk, 'Yata no Jizō Engi' at the Kongōsan-ji in Nara; at the Yato-no-dera (fifteenth century) in Kagawa; 'Jizō Engi' (fifteenth century) in the National Museum, Tōkyō.

120 A. Getty, *op. cit.*, p. 102.

121 A. Getty, *op. cit.*, p. 104.

122 M. V. de Visser, 'The Bodhisattva Ti Tsang', *Ostasiatische Zeitschrift*, I, 1914.

123 If this *khakkhara* has six rings, it does not belong to a simple pilgrim (two rings) but to a Bodhisattva. The six rings represent the vow made by Kṣitigarbha to save the 'beings of the six ways'.

124 Banner brought back by P. Pelliot (Musée Guimet, Paris). Kṣitigarbha is represented seated on a lotus mounted on a winged lion, his usual *vāhana* (central China).

125 B. Bhattāchārya, *Buddhist Iconography*, p. 40. In this case, the images attributed to Kṣitigarbha are possibly rather representations of Maitreya.

126 Painting at the Eigen-ji in Shiga (M. Soymié, 'Les acolytes de Ti-Tsang', *Arts asiatiques*, XIV, 1966, fig. 1).

127 B. Frank, *Mythologies*, p. 165.

128 The Nichiren and Jōdo Shinshū sects do not worship him. On the other hand, due to his association with the world of the dead (hence with Amitābha), he is worshipped by the other Amidist sects.

129 B. Frank, *Mythologies*, p. 167.

130 In Japan, popular belief holds that a hideous creature by the name of Shozuka-no-Baba strips children of their clothing, then encourages them to make piles of stones to build a stairway to paradise. Kṣitigarbha consoles the afflicted children and, to save them, hides them in the wide sleeves of his robe. The Japanese in the countryside often attach small pieces of children's clothing to the statues representing Jizō, believing that he can thus clothe the children in his protection.

131 H. Weber, 'Jizō',*Kōjihōten*, Paris, 1923.

132 According to the texts, these six Jizōs can be represented differently, in at least three versions (see the illustrations opposite). A: version of the *Book of Rayu* (*Taishō*, V, 127, and Sawa Ryūken, *op. cit.*, p. 91) of the Shingon sect dating from the thirteenth century: 1. Kenko-i Jizō (Nikkō Jizō), corresponding to the gods, right hand with solar disc, left hand with a lotus supporting a crossed vajra (Japanese *katsuma*). 2. Jichi Jizō (*Dharanīdhara*), corresponding to humans, right hand in Abhaya mudrā, left hand holding a lotus supporting a sword. 3. Hōshō Jizō (*Ratnakara*) or Jōgaishō, corresponding to the Asuras, right hand in Abhaya mudrā, left hand holding a triple *chntāmaṇi*. 4. Hō-in-shu Jizō (*Ratnamudrāpāni*), corresponding to animals, right hand in Abhaya mudrā, left hand holding a lotus supporting a *svastikā*. 5. Hōshu Jizō (*Ratnapāni*), corresponding to the Pretas, right hand placed on the breast, left hand holding a lotus supporting a *cakra*. 6. Jizō (*Viṣvaparipūraka, Danda*), corresponding to the hells, right hand holding a lunar disc, left hand holding a lotus supporting a head. B: version according to the *Butsuzō-zu-i* (*Taishō*, V, 127, and H. Weber, 'Jizō',*op. cit.*). 1. Fukyūsoku Jizō (Hoshō Jizō), corresponding to the gods, holding a long-handled censer. 2. Gosan Jizō (Chiji Jizō), corresponding to humans, holding a rosary. 3. Kyūshō Jizō (Hōshō Jizō), corresponding to the Asuras, hands in Añjali mudrā. 4. Shoryū Jizō (Hō-in Jizō), corresponding to animals, holding a banner. 5. Benni (or Muni) Jizō (Darani Jizō), corresponding to the Pretas, right hand in Abhaya mudrā, left hand holding a begging bowl to feed the hungry. 6. Kōmi (or Enmei) Jizō (Keiki Jizō), corresponding to the hells, holding a pilgrim's staff in the right hand, and a *cintāmaṇi* in the left hand. This is the form most commonly represented. C: version according to the *Jū-ō-kyō* (*sūtra* of the Ten Kings, Sawa Ryūken, *Butsuzō Annai*, p. 65, Jizō Bosatsu Hosshin innen Jū-ō-kyō). 1. Yotenga Jizō, 'who brings the felicities of heaven', corresponding to the gods. 2. Hōkō-ō Jizō, 'who spreads brightness', corresponding to humans. 3. Kongōtō Jizō (*Vajradhvaja*), corresponding to the Asuras, holding a vajra banner. 4. Kongō-hi Jizō (*Vajrakarma*), corresponding to animals, the 'compassion of the vajra'. 5. Kongō-ho

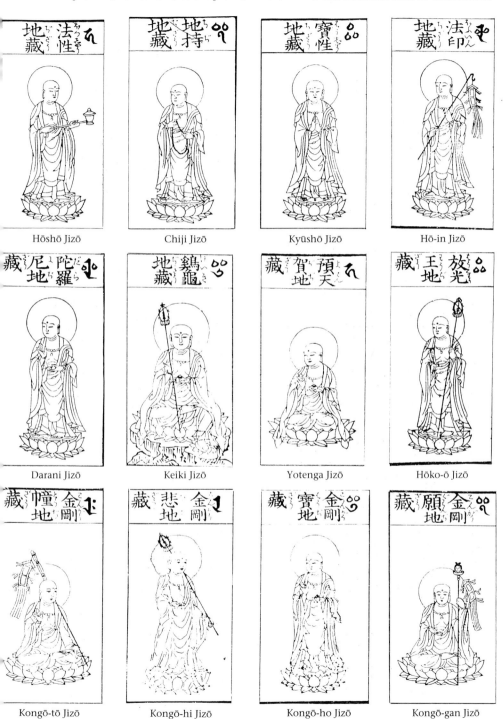

Hōshō Jizō

Chiji Jizō

Kyūshō Jizō

Hō-in Jizō

Darani Jizō

Keiki Jizō

Yotenga Jizō

Hōko-ō Jizō

Kongō-tō Jizō

Kongō-hi Jizō

Kongō-ho Jizō

Kongō-gan Jizō

Jizō (*Vajraratna*), corresponding to the Pretas, the 'treasure of the vajra'. 6. Kongō-gan Jizō, corresponding to the hells, representing the 'vow of the vajra'.

133 B. Frank, *Mythologies*, p. 167.

134 In the Enmei-ji in Kamakura there is a curious statue of a naked Jizō, with a feminine body, standing on a chequerboard. It is thought to have been taken from a legend that Jizō took the place of a woman who, having lost at gambling, was required to undress, thus sparing her shame. This Jizō is called Hadaka Jizō ('naked Jizō'); Iso Mutsu, *Kamakura*, pp. 249–250. The statue, actual size, is usually draped with clothing. At the Kakuon-ji in Kamakura, around the effigies of the Sentai Jizō, is a statue worshipped by firemen named Hitaki Jizō, and also Kuro Jizō owing to its black colour, due to a fire which it miraculously survived. Jizō Bosatsu is also considered a healer. Many of his aspects are very popular, such as those of Tawashi Jizō (or Jizō of the kitchen brush) and of Hōroku Jizō (of the earthenware plates): one offers them kitchen brushes which are used to wash a portion of the statue of Jizō corresponding to that part of the body suffering from rheumatism, and the earthenware plates when suffering from headaches. Similarly, in times of epidemics or disasters, it is customary to paint countless images of Jizō which are then thrown into the sea or a river in a ceremony called Jizō-nagashi ('Jizō floating on the waters'). This ceremony sometimes also takes place during the periods of the spring and autumn equinoxes. In 1923, for example, after the terrible earthquake that destroyed the city of Tōkyō, more than 700,000 images of Jizō were thrown into the River Sumida to attract the attention of Jizō Bosatsu to the spirits of those who had perished in the catastrophe. Prayers can also be sent to him in writing: this applies in particular to Tsunbo Jizō ('deaf Jizō') of Komagome (Hongo, Tōkyō) when one suffers from persistent coughing. The people believe that, since Jizō is deaf (forming part of the world of the dead), he cannot hear the prayers: it is therefore necessary to send them to him in writing, either by post, or by placing the written paper on the waters of a river or the sea. This Jizō is thought to be a great lover of *sake* and a cure is more likely if he is promised a bottle.

135 According to custom, women who wish to have a child must secretly 'borrow' one of the statues of the Sentai Jizō to install it in the *butsudan* (family altar) of their home. They must replace the statue after their wishes have been satisfied (Iso Mutsu, *op. cit.*, p. 71). This custom is also observed in connection with the statuettes of the '500 Arahants'.

136 At the Taima-dera in Nara, one of his representations is merged with Myōdō Bosatsu (*Sudṛṣṭi*). He makes a mudrā with the right hand.

137 'Karutoki no Jizō gao, Nasutoki no Enma gai' (Iso Mutsu, *op. cit.*, p. 116).

138 A. Getty, *op. cit.*, p. 106. Concerning these two acolytes, sometimes identified as Seitaka and Kongara Dōji, the acolytes of Fudō Myō-ō, see M. Soymié, 'Notes d'iconographie chinoise, les acolytes de Ti-tsang', *Arts asiatiques*, XIV, 1966, particularly p. 63; also S. Mochizuki, *Bukkyō Daijiten*, I, p. 675.

139 'Nehanzo', J. Troup, 'Illustrations of Buddhism', *Transactions of the Japan Society of London*, XII, plate IV.

140 *Taishō*, XVIII, 8, and XXXIX, 635. R. Tajima, *op. cit.*, pp. 108–112.

Chapter VI
Other Bodhisattvas

1 In the *Taizō-Kai*, he is sometimes called Myōkichijō or Myōon (*Mañjughoṣa*), 'He who has a marvellous voice' (to speak of the Law). T. Tajima, *op. cit.*, p. 105; B. Frank, *Mythologies*, p. 164.

2 E. Lamotte, 'Mañjuśrī', *T'oung Pao*, XLVIII, p. 1. *Inde Classique*, II, §2339, where it is translated by 'suave'.

3 W. Y Evans-Wentz, *Le livre tibétain de la grande libération* (translation Paris, 1960, p. 306): 'His adoration confers divine wisdom, the mastery of the *Dharma*, a faithful memory, mental perfection, eloquence'.

4 E. Lamotte, *op. cit.*, p. 3.

5 The list of Sanskrit and Chinese texts concerning Mañjuśrī can be found in E. Lamotte, *op. cit.*, pp. 5ff.

6 And the *Mañjuśrībuddhakṣetragunavyūha* (E. Lamotte, *op. cit.*, p. 18) and a Tibetan version of the *Avatamsaka*, declared apocryphal (see, on this subject, discussion in E. Lamotte, *op. cit.*, pp. 75ff.).

7 'He who is not warmed' and who gives rise to the four great rivers, the Indus, Ganges, Oxus and Tarim (E. Lamotte, *op. cit.*, p. 35).

8 E. Lamotte, *op. cit.*, pp. 55 ff,

9 According to the *Ajataśatrukaukrityavinodana*, vol. 629,

quoted by E. Lamotte, *op. cit.*, pp. 93–96.

10 *Ajataṣahtrurājasūtra*, vol. 626, p. 394b, 18–20, quoted by E. Lamotte, *op. cit.*, p. 95.

11 Translated by E. Lamotte, *op. cit.*, pp. 35–39.

12 Especially in Nālandā (India).

13 A. Foucher, *Etude sur l'iconographie bouddhique de l'Inde*, Paris, 1900–1905. M. Lalou, *Iconographie des étoffes peintes dans le Mañjuśrīmūlakalpa*, Paris, 1930. B. Bhattāchārya, *The Indian Buddhist Iconography*, Calcutta, 1930.

14 *Svayambhū Purāna*, B. Bhattāchārya, *op. cit.*, pp. 15–16.

15 His name is the origin of the name of the Manchus (*Inde Classique*, II, §2339).

16 P. Pelliot, *Les grottes du Touen Houang*, Paris, 1921, VI, plate 24. E. Lamotte, *op. cit.*, p. 4, n. 13.

17 P. Demiéville, 'La musique chame au Japon', *Etudes asiatiques*, Paris, 1925, I, pp. 208–9. E. Lamotte, *op. cit.*, p. 89.

18 E. O. Reischauer, *Ennin's Diary*, New York, 1955, pp. 269–270.

19 Many other works are attributed to him in the Tibetan canonical *Kañjur*.

20 *Taishī*, XXXIX, 741 and 787.

21 He represents the cause (Japanese *In*) of the ascesis of which Samkusumitarāja (Japanese *Kaifuke-ō Nyorai*) is the effect (Japanese *Ka*). 'The treasure of the inexhaustible means of salvation of the Great Compassion' (R. Tajima, *op. cit.*, pp. 69, 75).

22 R. Tajima, *op. cit.*, p. 69.

23 R. Tajima, *op. cit.*, pp. 74–5.

24 R. Tajima, *op. cit.*, p. 107.

25 B. Frank, *Mythologies*, p. 164.

26 In this connection, he is especially venerated at the temple of Abe-no-Monju-in, south of Nara. He formerly presided over the feasts of youth: sculpture on the ground floor of the five-storey Kōfuku-ji pagoda in Nara.

27 One of his epithets is Kumārabhūta, 'become a young man' or 'become a royal prince'. He was also attributed the name of Pañchaṣika, due to his youthful headdress with five braids (Buddhaghoṣa in the *Sumangalavilāsinī*, II, p. 647, quoted by E. Lamotte, *op. cit.*, p. 2, n. 3).

28 Or with a five-pointed tiara (especially in China), sometimes with an effigy of Akṣobhya of which he is the hypostasis (*Inde Classique*, II, §2339).

29 This scroll or book (*puṣṭaka*) is thought to be the treatise of fundamental wisdom, the *Prajñāpāramitā-sūtra* .

30 See illustration in Sawa Ryūken, *Butsuzō-zu-ten*, p. 79, fig. 53.

31 The designation *-ji* (Ichiji, Goji, Rokuji, Shichiji, Hachiji) corresponds to the 'authentic words' (Japanese *Shingon*). That of *-kei* (Ikkei, Gokei, Rokkei, Shichikei, Hakkei) corresponds to the number of chignons or braids.

32 These five chignons are often considered as symbolic of the five 'summits' of the Wutai Shan in China. They are sometimes ornamented with the effigies of the Five Jinas, and represent their teachings.

33 *Taishō*, XX, 675 and 715. Sculptures: in wood, at the Hannya-ji in Nara; at the Tō-ji in Kyōto. Painting: in Sawa Ryūken, *op. cit.*, p. 79, fig. 54.

34 See illustration in Sawa Ryūken, *op. cit.*, p. 80, fig. 55.

35 *Hachiji Monju Mandara*, in Sawa Ryūken, *op. cit.*, p. 81, fig. 56. Paintings: on silk, at the Shōji-in in Wakayama; at the Sekaikyūsei-kyō in Shizuoka.

36 *Taishō*, XX, 790.

37 To go from India to China by sea, perhaps conducted by the Indian King Udayāna.

38 *Kegongojusho Emaki* (the 55 stations of the Kegon), at the Tōdai-ji in Nara.

39 Sometimes called Buddhapāli, from the name of a translator of the *Tripitaka*, or Xuanzang (Japanese *Genjō*).

40 Quoted in the esoteric *sūtras* and mandalas. See illustration in Sawa Ryūken, *op. cit.*, p. 81, fig. 5, at the Sekaikyūseikyō in Shizuoka.

41 These Hachidai Dōji, all feminine, are, in the north-east, Keṣinī (Japanese *Keshini*, *Kesenī*) (*Shinshū Nihon Butsuzō zuzetsu*, *op. cit.*, p. 284), with a triple chignon and a yellow body, holding a spear in the right hand and a blue lotus in the left hand. In the south-east, Upakeṣīnī (Japanese *Uba Keshini*, *Uba Keseni*), holding a sword or a spear in the right hand, a blue lotus in the left hand. In the east, Paritrānāṣāyamatī (Japanese *Kugoe*), the 'Wisdom that saves and protects': she holds a banner or a staff surmounted by the lunar disc or a star in the right hand, and a blue lotus in the left hand. In the south, Jālinīprabhā (Japanese *Kōmō*), 'Who has the brightness of a thread', also called in Japanese *Mōkō Dōji* (R. Tajima, *op. cit.*, p. 105), who holds a rope in the right hand and a blue lotus in the left. In the south-west, Vasumatīdhvajā (Japanese *Chie-tō*), 'She who is the symbol of the Earth', with a flaming spear in the right hand and a blue lotus in the left. In the west, Vimalaprabhā (Japanese *Mukukō*), 'He who has a spotless brightness', begging bowl or *cintāmani* held in the right hand under the belly button, blue lotus in the left hand. In the

north-west, Achintya-matidattā (Japanese *Fushigie*), 'She who was given inconceivable intelligence', holds a cane in her joined hands supporting a half-moon and a star or a blossoming lotus in the right hand, a blue lotus in the left hand. In the north, Akārṣānī (Japanese *Shōjō*), holding a spear in the right hand, a blue lotus in the left hand.

42 In the *Taizō-kai Mandara*.

43 In sculpture, by the name of Gien, in a priest's apparel, and destined to preside over the meals of the monks in a refectory of the Oka-dera monastery in Nara.

44 Clay sculpture, in discussion with Vimalakīrti, at the Hōryū-ji (E. Lamotte, 'L'enseignement de Vimalakīrti', *Mélanges chinois et bouddhiques*, Institut Belge des Hautes Etudes Chinoises, Bruxelles).

45 The stories of these doctrinal discussions are related in the *Vimalakīrti-sūtra* (Japanese *Yuima-kyō*).

46 B. Frank, *Mythologies*, p. 164.

47 A. Getty, *op. cit.*, p. 47.

48 See note 46.

49 The 'treasure of prayers and inexhaustible practices' (R. Tajima, *op. cit.*, pp. 69, 74).

50 *Taishō*, XX, 132. One of his right hands is in Abhaya mudrā, the others hold a staff, a five-pointed vajra and a *cintāmani*; his left hands hold a *cakra*, lotus, rosary and bell with five-pointed vajra.

51 Four Lokapālas are mounted on the head of these four elephants, or four guardians of the east (Japanese *Shi Tennō*); wood sculptures at the Hōryū-ji in Nara, and at the Jōkoku-ji in Nara (twelfth century). Sometimes, triple *cintāmanis* replace the Lokapālas. The four elephants are also sometimes upright on a pedestal supported by eight or '1,000' elephants, all holding a double one-pointed vajra with their trunks (*Taishō*, XX, 579); *kakemono* in colours, on silk, from the twelfth century, at the Matsunoo-dera in Kyōto. In this case, in Japan, Fugen Enmei has only two arms, right hand holding a three-pointed vajra on the breast, and in the left hand a bell with a handle with a five-pointed vajra. He is sometimes be confused with Vajrasattva.

52 Found in China in this aspect at the E-mei-Shan, dating from 980 (*Présence du bouddhisme, op. cit.*, plate XXXVII).

53 *Taishō*, XX, 415 and 675. Sculptures: in wood, at the Onjō-ji in Shiga; at the Okura Museum in Tōkyō; in the Nara Museum (from the Enshō-ji and dating from the tenth century).

54 In the latter case (as in the one in note 51), Samantabhadra is identified with Vajrasattva and takes the name of Samantavajrasattva (Japanese *Fugen Kongō Satta*). He is sometimes shown seated on four recumbent and oriented elephants bearing the four Lokapālas or triple *cintāmanis* on their heads. In his 'gentle' form, Vajrasattva is sometimes merged with this form of Samantabhadra.

55 List of the ten Rākṣasīs (Japanese *Jū Rasetsunyo*) who, in the *Saddharmapūndarīka-sūtra*, accompany Samantabhadra (see illustrations opposite). 1. Lambā (Japanese *Niramba*), right hand holding a sword (Japanese *Dokko Tōken*), according to the *Shinshū Nuhon Butsuzō-zu-ten* (p. 170), or on the shoulder according to the *Butsuzō-zu-i* (3-1), and left hand holding a rosary or (according to the *Butsuzō-zu-i*) a *sūtra*. 2. Vilambā (Japanese *Biramba*, right hand catching a cloud (Japanese *hafū-un*) or holding cymbals (*Nihon Butsuzō Zuzetsu*, p. 170;*Butsuzō-zu-i*, 3-11) and the left hand holding an indeterminate object (Japanese *katsukinji*). These two Rākṣasīs are often found represented under the feet of Tobatsu Bishamon-ten (a Japanese form of Vaiśravana) with Prithivī (Japanese *Chi-ten*), the Earth. To the best of our knowledge, these are the only representations in sculpture (Kyōto Museum, perhaps of Chinese origin). 3. Kūtadantī (Japanese *Kyokushi*), with fangs, holding a tray of flowers in the hands (Japanese *khōzenbōkōge*). According to the *Butsuzō-zu-i*, she holds this tray in the right hand and, with the left, makes the gesture of taking one of the flowers. 4. Puṣpadantī (Japanese *Kashi*), 'with flowery teeth', right hand in pendent Varada mudrā, *cintāmani* in the left hand. According to another version, she holds an object (Japanese *hakegi*) in the right hand and a tray of flowers (Japanese *keban*) in the left hand. 5. Makutadantī (Japanese *Kokushi*), 'with teeth in a diadem', right hand in Abhaya mudrā, left hand holding a banner (*Butsuzō-zu-i*, 3-12), or a halberd and an object (Japanese *gunji*) in the left hand. 6. Keśinī (Japanese *Tahatsu*), 'who has lots of hair', right hand holding a banner, left hand in Abhaya mudrā (*Butsuzō-zu-i* 3-12), or right hand shaking cymbals, left hand holding a sort of sceptre (Japanese *nyobu*). (7) Achalā (Japanese *Muensoku*), right hand with sceptre (*śugyokusaku*), left hand with a garland of flowers (Japanese *kesarikko*), or a water vase (*Butsuzō-zu-i*, 3-12). 8. Mālādharī (Japanese *Jiyōraku*), 'who holds a garland'. 9. Kuntī or Kuntadharī (Japanese *Kōtei*), 'who holds a spear'. 10. Sarvasattvajohārī

The ten Rākṣasīs (see Chapter VI, n. 55)

1. Lambā

2. Vilambā

3. Kūtadantī

4. Puṣpadantī

5. Makutadantī

6. Keśinī

7. Achalā

8. Mālādharī

9. Kuntī

10. Sarvasattvajohārī

(Japanese *Datsu-issai Shujō-seiki*), 'She who takes the life force from all the beings' (i.e. causes them to die). She holds a staff in the right hand and, in the left, a three-headed club. Her hands are sometimes in worship (Añjali mudrā) (according to the *Taishō Zuzō*, IX, 555, and the *Butsuzō-zu-i*).

56 *Taishō*, XIX, 603, and XX, 660.

57 This legend could have led to the ritual suicides by fire committed in China and in countries of the Buddhist faith. See J. Filliozat, *Journal asiatique*, 1963, CCLI, Fascicule 1. J. Gernet, 'Les suicides par le feu chez les bouddhistes chinois du Ve au Xe siècles', *Mélanges de l'Institut des hautes etudes chinoises*, III, Paris, 1960. B. Frank, *Histoires qui sont maintenant du passé*, pp. 270-271.

58 *Inde Classique*, II, §2361.

59 E. Burnouf, *Introduction à l'histoire du bouddhisme indien*, Paris, 1876, pp. 221–225.

60 R. Tajima, *op. cit.*, pp. 69–70.

61 *Taishō*, XXXIX, 635. R. Tajima, *op. cit.*, pp. 114–5. R. Tajima, *Etude sur le Vairocana-sūtra*, p. 52, nn. 9–12.

62 Such as Myō-ō Bosatsu (B. Frank, *Mythologies*, p. 167; *Kata-imi et Kata-tagae*, p. 41, n. 68; *Hōbōgirin*, I, p. 15 [Aizen Myō-ō]; R. Tajima, *op. cit.*, p. 86; M. V. de Visser, *op. cit.*, pp. 124ff.) and Jise Bosatsu (*Taishōzō*, XX, 672 and 666), *inter alia*.

63 Some are represented as musician angels, like the famous one on the side of a standing bronze lantern in front of the great temple of Tōdai-ji in Nara in Japan, dating from the eighth century.

Chapter VII
The Vidyārājas

1 B. Frank, *Mythologies*, p. 167.

2 Ryūjun Tajima, *op. cit.*, p. 86.

3 *Hōbōgirin*, I, p. 15 (Aizen Myō-ō).

4 First mention in the *Azuma Kagami* on the 21st day of the 1st month of the year 1235 (B. Frank, *Kata-imi et Kata-tagae*, p. 41, n. 68).

5 M. V. de Visser, *op. cit.*, pp. 142ff. These five great Vidyārājas are grouped in the *Taizō-kai Mandara* in the west of the central quarter representing Mahāvairocana surrounded by the other Jinas and their corresponding Bodhisattvas.

6 R. Tajima, *op. cit.*, p. 288.

7 B. Lane-Suzuki, 'Fudō the Immovable', *The Eastern Buddhist*, II, Nos. 3/4, p. 130, Ōtani University Library, Kyōto, 1922.

8 *Taishō*, XVIII, 7.

9 B. Frank, *Mythologies*, p. 167.

10 I. Morris, *The World of the Shining Prince*, New York, 1964, p. 139, n. 1.

11 B. Frank, *Mythologies*, p. 168.

12 B. Lane-Suzuki, *op. cit.*, p. 144.

13 *Ibid.*, p. 143.

14 And perhaps representing a Bhairava or a Krodharāja.

15 S. F. Moran, 'The Blue Fudō, A Painting of the Fujiwara Period', *Arts asiatiques*, II, pp. 35–46, Paris, 1935.

16 M.-T. de Mallmann, 'Notes d'iconographie tantrique', *Arts asiatiques*, IX, 1962/1963, pp. 73ff.

17 R. Tajima, *op. cit.*, p. 289.

18 B. Lane-Suzuki, *op. cit.*, pp. 133, 135.

19 B. Bhattāchārya, *Gaekwad's Oriental Series*, CIX, XLI, 1925 and 1928, Baroda, p. 435 (based on Indian descriptions).

20 R. Tajima, *op. cit.*, p. 289.

21 *Taishō*, XXXIX, 633.

22 *Taishō*, XXI, 28, and XVIII, 924.

23 A particular form in sculpture, called Namikiri Fudō, standing on a rock, head inclined, is found in the Nan-in of the Kōyasan. This Namikiri Fudō 'who cuts the waves' is said to have calmed the storm in answer to a prayer by Kūkai when he was in danger on the boat that conveyed him from China in 806. He has a static pose and a thick, long braid (B. Frank, report *Annuaire EPHE*, 1961/1962, pp. 61–2).

24 Or hold a five-pointed vajra in both hands before the breast or, when seated on a lion (see n. 41), a bow, arrows, a vajra and a *cakra* (Sawa Ryūken, *op. cit.*, p. 103, fig. 77).

25 B. Lane-Suzuki, *op. cit.*, p. 135.

26 Drawing in Indian ink, in a rather individual style, on *kakemono* by Shinkai in 1282, perhaps to secure the protection of Fudō against the Mongol invaders; now at the Daigo-ji in Kyōto. See B. Frank, *Mythologies*, p. 167. *L'Art japonais à travers les siècles*, Musée National d'Art Moderne, Paris, 1958, catalogue no. 15, plate 28.

27 These two Dōji, Anokuta and Shitoku, appear to be later than the others.

28 M.-T. de Mallmann, *op. cit.*, p. 78.

29 B. Lane-Suzuki, *op. cit.*, p. 135.

30 *Ibid.*, p. 146 (temple in Tōkyō, near the River Sumida, at Fukagawa).

31 Nakamura Hajime, pp. 457–8.

32 Sawa Ryūken, *op. cit.*, p. 108. However, the *Taizō-kai Mandara* appears to make a distinction between Shōzanze Myō-ō, identified with Trailokyavijaya, and Gōzanze Myō-ō, identified with Vajrahūmkara (Japanese *Bazara-un-Kongō*)

and with Trailokyavijaya (R. Tajima, *op. cit.*, p. 85). Gōzanze presides in the south-east in the *Kongō-kai Mandara* (R. Tajima, *op. cit.*, p. 196).

33 Nakamura Hajime, *op. cit.*, p. 157.
34 These are also desire/passion (*Rāga*), hatred (*Dveṣa*) and error, losing one's way (*Moha*). *Taishō*, XXXIX, 685. R. Tajima, *op. cit.*, p. 290.
35 R. Tajima, *op. cit.*, p. 213.
36 *Taishō*, XXI, 41.
37 R. Tajima, *op. cit.*, p. 290.
38 A. Foucher reported one at Bodh-Gāyā, Bihār.
39 Umahī is sometimes called Umagō. She represents feminine curiosity.
40 R. Tajima, *op. cit.*, p. 290.
41 Paintings: in a dynamic pose, dating from 1127, at the Tō-ji in Kyōto; at the Daigo-ji (thirteenth century) in Kyōto. Gōzanze is also represented in maṇḍalas with three heads and eight arms, or with one head and four arms. He has one head and two arms in the *Taizō-kai Mandara*.
42 *Taishō-zu-zō*, I, 13.
43 Four faces and eight arms (*Taishō*, XXI, 41), three faces and eight arms (*Taishō*, XX, 133), one face and four arms (*Taishō*, XX, 545), and one face and two arms (*Taishō*, XVIII, 7). However, the most common representations are those which have four faces and eight arms (sculpture at the Daigo-ji in Kyōto, *inter alia*).
44 Sawa Ryūken, *op. cit.*, p. 109.
45 Nakamura Hajime, *op. cit.*, p. 136.
46 R. Tajima, *op. cit.*, pp. 93, 124.
47 *Taishō*, XVIII, 856. Sculptures: at the Daigo-ji in Kyōto; at the Kyaku-den of the Sangen-in in Kyōto.
48 *Taishō*, XX, 133.
49 *Taishō*, XXI, 47. A very rare form shows him with two faces and four (or 1,000) arms.
50 R. Tajima, *op. cit.*, p. 292.
51 *Butsuzō-zu-i*, II, 9a, and M. V. de Visser, *op. cit.*, p. 555.
52 Necklace of skulls and tiger skin (*Shō Enmatokukainu-ō*). *Taishō*, XXI, 73.
53 R. Tajima, *op. cit.*, p. 292.
54 *Taishō*, XX, 785.
55 *Taishō*, XXIX, 642, and XXI, 92.
56 See A. Getty, *op. cit.*, p. 164.
57 See under Samantabhadra, chapter VI.
58 *Taishō*, XVIII, 7. R. Tajima, *op. cit.*, p. 298.
59 *Taishō-zu-zō*, I, 13. R. Tajima, *op. cit.*, p. 299.
60 R. Tajima, *op. cit.*, pp. 298–9.
61 *Taishō*, XVIII, 269, and XXI, 98.
62 They also correspond to the Tathāgatas and Bodhisattvas of which they are emanations (wood sculpture, fifteenth century, but sometimes attributed to Unkei, at the Akishino-dera in Nara). They are, in the centre, Vajrapāramitā (Japanese *Kongō Haramitsu Bosatsu*), corresponding to Dainichi Nyorai, Tenbōrin Bosatsu and Fudō Myō-ō (*Taishō*, VIII, 843). In the east, Vajrahasta (Japanese *Kongō-shu Bosatsu*), corresponding to Ashuku Nyorai, Fugen Bosatsu and Gōzanze Myō-ō. In the south, Vajraratna (Japanese *Kongō-hō Bosatsu*), corresponding to Hōshō Nyorai, Kokūzō Bosatsu and Gundari Myō-ō. In the west, Vajratīkṣna (Japanese *Kongō-ri Bosatsu*), corresponding to Amida Nyorai, Monju Bosatsu and Daiitoku Myō-ō. In the north, Vajrayakṣa (Japanese *Kongō Yasha Bosatsu*), corresponding to Fukūjōju Nyorai, Seishi Bosatsu and Kongō Yasha Myō-ō. However, according to the *Ninnō-kyō* (*Taishō*, VIII, 833), the following Godairikis correspond to them: Kongō-ku Bosatsu, Ryū-ō-ku Bosatsu, and Muijū-rikku Bosatsu (only these three images exist – we cannot determine the appearance of the others, since their representations, probably rare, have been lost). Painting in the Yushi Hachimankō Jinja (ninth century in Kamamura. A 'Muijū-rikiku' is reproduced in *L'Art Japonais à travers les siècles*, catalogue no. 2, plate 20. Muijū-rikiku is sometimes called Muihōku, Raiden-ku Bosatsu, or Muryō-rikiku Bosatsu.
63 *Hōbōgirin*, I, p. 15.
64 B. Frank, *Mythologies*, pp. 168–9.
65 *Himitsujirinn* p. 6, and A. Getty, *op. cit.*, p. 8, n. 1. However, although Vajrasattva is sometimes represented seated on an elephant, Rāgarāja is always seated on a lion: he also bears the image of the head of a lion on his head or on his 'overflowing vase'.
66 According to the *Myōkyōjōchinshō*, quoted by A. Getty, *op. cit.*, p. 170.
67 'Aizen Myō-ō', *Dictionnaire historique du Japon*, Maison Franco-Japonaise, 1963.
68 *Hōbōgirin*, I, p. 16. This lion's head is sometimes surmounted by a five-pointed vajra.
69 *Taishō*, XVIII, 256.
70 *Taishō-zu-zō*, V, 23, and *Hōbōgirin*, I, p. 16, fig. 8.
71 *Hōbōgirin*, I, p. 16, fig. 7. He may then be named Ryōtō Aizen.
72 *Hōbōgirin*, I, pp. 16–17, fig. 9.
73 *Hōbōgirin*, I, p. 17. At the Taizan-ji in Harima; at the Zuishin-in in Yamashiro.
74 *Taishō*, XX, 572, and Sawa Ryūken, *op. cit.*, p. 112.
75 B. Frank, *Mythologies*, p. 169.
76 *Hōbōgirin*, I, p. 44.

77 *Taishō Issaikyō*, pp. 1237–40.
78 *Taishō*, XXI, 181, 194 and 195.
79 Sawa Ryūken, *op. cit.*, p. 118, fig. 92.
80 *Taishō*, XXI, 196.
81 H. MacCullough, *op. cit.*, p. 12, n. 25.
82 Sawa Ryūken, *op. cit.*, p. 113.
83 Information kindly provided by Bernard Frank.
84 *Hōbōgirin*, I, p. 84.
85 Sawa Ryūken, *op. cit.*, p. 113, fig. 84.
86 *Hōbōgirin*, I, p. 76.
87 Sawa Ryūken, *op. cit.*, p. 113, figs. 85 and 86.
88 Sawa Ryūken, *op. cit.*, p. 114, fig. 87.
89 *Taishō*, XXI, 144 and 149.
90 *Taishō*, XVIII, 864, and XXI, 143, 148, 153 and 155.
91 *Taishō*, XX, 133.
92 H. MacCullough, *op. cit.*, p. 12, n. 25.
93 *Taishō*, XX, 133, and Sawa Ryūken, *op. cit.*, p. 121, fig. 96 (sculpture: at the Onjō-in in Kyōto).
94 *Taishō*, XX, 122.
95 Sawa Ryūken, *op. cit.*, p. 116, fig. 91.
96 *Hōbōgirin*, pp. 147–8, fig. 62.
97 An interesting article is devoted to this aspect of Kannon in *Hōbōgirin*, I, pp. 58ff.

Chapter VIII
Feminine Deities

1 Sawa Ryūken, *op. cit.*, p. 97, fig. 73.
2 H. Weber, 'Benzai-ten', *Kojihōten*, Paris, 1923. According to the *Butsuzō-zu-i*, which gives their images (see illustrations opposite), these fifteen sons (Japanese *Jūgo Dōji*) are (two names each): 1. Jūsha (Semmui), incarnation of Ryūju Kannon: he carries a tray of *cintāmaṇis* and represents the corporation of jewellers. 2. Aikyō (Sekon), incarnation of Shō Kannon: he carries bow and arrows, and represents the military class. 3. Sanyō (Himan), incarnation of Seishi Bosatsu: holds a bowl filled with silkworms, and represents the silkworm breeders. 4. Hanki (Shitsugetsu), incarnation of Senju Kannon: bears a plate of rice on his head, and represents cooks. 5. Gyūba (Zuirei), incarnation of Yakuō Bosatsu: represents livestock breeders. 6. Shōmyō (Saikoku), incarnation of Miroku Bosatsu: holds a sword and a *cintāmaṇi*, and represents magistrates. 7. Shusen (Misshaku), incarnation of Muryōju Nyorai: holds a *sake* jar and a *cintāmaṇi*, and represents distillers. 8. Ishō (Jōki), incarnation of Marishi-ten: carries material, and represents weavers. 9. Tōchū (Daijin), incarnation of Monju Bosatsu: holds a staff supporting a bundle of ears of rice, and represents farmers. 10. Hikken (Kōsei), incarnation of Kongōshu Bosatsu: holds a brush and a writing tablet, and represents those who study and civil servants. 11. Inyaku (Jōkō), incarnation of Shaka Nyorai: he holds a *cintāmaṇi* and a key, and represents guardians. 12. Sensha (Kōmyō), incarnation of Yakujō Bosatsu: he guards a boat and a cart loaded with rice, and represents carriers. 13. Konzai (Shōjō), incarnation of Yakushi Nyorai: he represents doctors. 14. Kantai (Sekion), incarnation of Fugen Bosatsu: he holds a belt, but it is not known what trade he represents. 15. Zenzai (Otsugo), adopted son of Benzai-ten: perhaps the incarnation of Daikoku-ten. He holds a bag, and is the hero of the *Kegon-kyō*. These Jūgo Dōji are practically never represented, except in painting and in certain maṇḍalas, chiefly when Benzai-ten is worshipped independently, or when she is considered as one of the Shichifukujin. Sculpture: at the Gokuraku-ji (Kamakura period).
3 *Taishō*, XVIII, 805, XIX, 521, and XX, 614.
4 B. Frank, *Mythologies*, p. 170.
5 *Hōbōgirin*, I, pp. 63–65 and plate 8.
6 In coloured wood, Kamakura Museum, from the Enoshima-jinja, dated Bun-ei 3 (1266). She presided at the Bugaku-in, the music and dance room of the Hachiman-gū in Kamakura. She was then richly apparelled in robes of silk and jewels (J. Buhot, *op. cit.*, p. 210, §296). Sculptures: at the Sangatsu-dō of the Tōdai-ji in Nara (three arms missing); at the Sanjūsangendō in Kyōto. Paintings: on silk, at the Hōju-in in Wakayama; with Karieti-mo, Kangi-ten and Sōryōchi Taishō on the background of a *zushi* illustrating the *Konkōmyō Saishō-kyō* at the Jōruri-ji in Kyōto; in the 'Kichijō-ten Zushi' of the Fine Arts Museum in Tōkyō (perhaps dating from the eighth century, according to the *Hōbōgirin*).
7 *Taishō*, XVI, 437. On the subject of Benzai-ten, it is said that, one day, Hōjō Tokimasa (1138–1215), withdrawing to the island of Enoshima to pray, saw a woman appear clothed in a willow-green robe worn over a red shirt. This apparition made a prediction, and then, changing into an immense serpent, disappeared into the sea, leaving three scales that the Hōjō family took as the family escutcheon (Japanese *mon*). This story is related in the *Taiheiki*.
8 This is the image of Ugajin, sometimes found placed in the headdress of Benzai-

The fifteen Dōji of Benzai-ten (see Chapter VIII, n. 2)

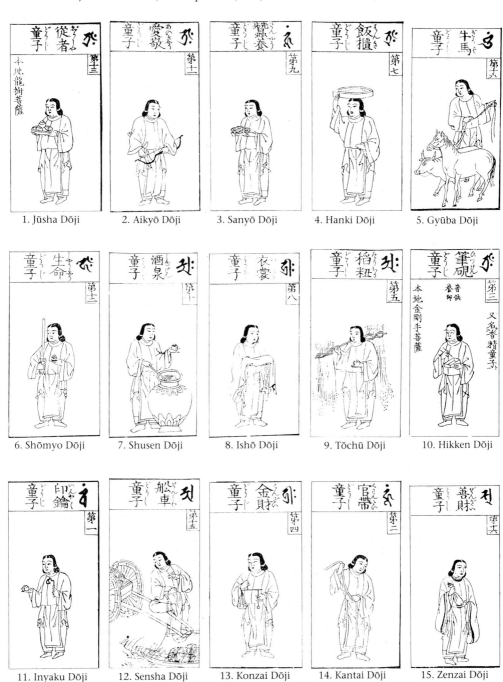

1. Jūsha Dōji 2. Aikyō Dōji 3. Sanyō Dōji 4. Hanki Dōji 5. Gyūba Dōji

6. Shōmyo Dōji 7. Shusen Dōji 8. Ishō Dōji 9. Tōchū Dōji 10. Hikken Dōji

11. Inyaku Dōji 12. Sensha Dōji 13. Konzai Dōji 14. Kantai Dōji 15. Zenzai Dōji

ten. This Ugajin (or Hakuja, white serpent)
is also represented in the form of an old
man surrounded by a large white snake,
with only the head appearing.

9 See n. 6.
10 M. Soymié, 'Notes d'iconographie chinoise,
les acolytes de Ti Tsang', *Arts asiatiques*,
XIV, 1966, p. 70. She has eight arms and
three eyes.
11 A. Foucher, *Iconographie indienne*, I,
p. 150.
12 A. Foucher, *op. cit.*, pp. 93, 144.
13 H. MacCullough, *Taiheiki*, V, p. 136.
14 B. Frank, *Mythologies*, p. 175.
15 *Ibid.*
16 *Taisho*, XXI, 266.
17 *Taishō*, XXI, 258.
18 *Taishō*, XXI, 273 and 277.
19 *Butsuzō-zu-i.*
20 A. Foucher, *Iconographie indiennes*, I,
p. 117. In the *Hindu Pantheon* by Moore,
Chandra is mounted on a chariot drawn by
an antelope. J. Troup, *op. cit.*, VIII, plate X.
21 B. Frank, *Mythologies*, p. 171.
22 *Taishō*, XVIII, 87, and XXI, 215.
23 It may be worth recalling here that, in
Hindu mythology, the Dākinīs were sorts
of Yakṣinīs reputed to drink blood and eat
human flesh, acolytes of Kālī. However, the
connection with the Japanese Dakini-ten is
not so obvious.
24 D. C. Buchanan, 'Inari', *Transaction of the
Asiatic Society of Japan*, XII, Tōkyō, 1935.
25 Mock Joya, *op. cit.*, pp. 754ff.
26 According to A. Waddell, *op. cit.*
27 According to A. Foucher, *Buddhist
Iconography.*
28 Sawa Ryūken, *op. cit.*, p. 95, fig. 69.
29 Nakamura Hajime, *Shin Bukkyō Jiten*,
p. 224.
30 He is sometimes also represented in
sculpture, although very seldom (Musée
Guimet, Paris). Daizuigu Bosatsu was the
Buddha and personal protector (Japanese
Nenjibutsu) of Toyotomi Hideyoshi
(sculpture in the Źuigudō at the Kiyomizu-
dera in Kyōto).
31 R. Tajima, *op. cit.*, pp. 124–5.
32 According to the *Kujaku-kyō-hō*
(Nakamura Hajime, *op. cit.*, p. 128).
33 *Taishō*, XIX, 440.
34 H. MacCullough, *Taiheiki*, p. 12, n. 25.

Chapter IX
Defenders and Guardians of the Buddhist Law

1 See Karl Petit, *Le Medaglie Giapponesi delle
Otto Divinità Guardiane*, Medaglia, no. 26,
Milan, 1991.
2 According to A. Getty, *op. cit*, p. 149.
3 *Makaras* are mythical sea-monsters,
sometimes thought to be dolphins or
crocodiles, often seen in sculpture
decorating temples.
4 According to A. Getty, *op. cit.*, p. 161.
5 *Taishō*, XXI, 355, and LIV, 209.
6 In the kitchens, as the god of wealth, he
also replaces the effigies of Bishamon-ten
(J. Buhot, *op. cit.*, p. 162, §208). Note in
this respect that the main pillar of a house
in the traditional Japanese style assumes
the name of *Daikoku-bashira* or 'pillar of
Daikoku', meaning 'pillar of luck and
wealth'.
7 H. Weber, *Kojihōten*, Paris, 1923. 1. Biku
Daikoku, standing monk holding a mallet
and a sword. 2. Makakara Daikoku-nyo,
woman in a Chinese robe, carrying rice on
her head or a large bag (*tawara*), which is
perhaps a poor interpretation of the veil of
night drawn by Mahākāla. 3. Ojikara
Daikoku, standing prince, armed with a
sword and a vajra. 4. Shinda Daikoki,
adolescent holding a *cintāmani* in the left
hand. 5. Yasha Daokoku, standing, holding
a *cakra* in the right hand. 6. Makara
Daikoku, man standing or seated on a lotus
leaf, holding a mallet and a bag: it appears
that this representation enjoyed popular
favour, and was considered as that of
Daikoku, the god of luck.
8 In Hyōgo, Japan.
9 A legend relates, against all the evidence,
that Fudaishi was the inventor of the
buildings intended to contain the *sūtras*
(rotating libraries, called *kyōdō* in Japan),
and built by the so-called Azekura-zukuri
technique. His two sons, shown clapping
their hands and laughing, are sometimes
called Fuwaku (or Fuken) and Fukon (or
Fujō). Sculptures: in the Kyōdō of the
Kōmyō-ji in Kamakura; at the Daikoku-ji
in Kyōto.
10 Śakradevanām Indra.
11 *Inde Classique*, II, §2269.
12 B. Frank, *Mythologies*, p. 169.
13 *Lalitavistara*, translated by Müller-Manjio,
p. 209, quoted by J. Auboyer, in 'Les
Influences et les réminiscences etrangère
au Kondō du Hōryū-ji', *Annales du musée
Guimet*, 1941, p. 94 and n. 219.
14 Amanojaku is a demon (Japanese *Oni*) who

opposes the Buddhist Law; in folk tales, he always hinders the actions of the people. According to the *Dictionnaire historique du Japon*, p. 30, article 97, his name is derived from that of the oracle Ama-no-Sagune mentioned in the *Nihon Shoki*. In the *Kojiki*, this name is written with different characters.

15 *Taishō*, XVIII, 879, XIX, 231, and XXI, 378.
16 J. Auboyer, *op. cit.*, pp. 93, 98.
17 R. Tajima, *op. cit.*, pp. 127–9.
18 *Taishō*, XV, 118.
19 R. Tajima, *op. cit.*, p. 140.
20 From the Sanskrit root *śru*, 'to hear' (see *Hōbōgirin*, I, p. 79, for the different names of Bishamon-ten).
21 B. Frank, *Annuaire EPHE, op. cit.*, 1961–1962, p. 56.
22 Kept in the Chōgosonshi-ji in Nara. Scroll no. 2 describes the miraculous cure of the Emperor Daigo, by the intercession of one of the Dōji (Kumāra) of Bishamon-ten, clothed with a 'fabric of swords', holding a sword and a rope (also attributes of Fudō Myō-ō) and who flies on the clouds, preceded by the wheel of the Law. This *emakimono* has been attributed, but without certainty, to Kakuyū (Toba Sōjō, 1053–1140).
23 *Taishō*, XXI, 228.
24 *Hōbōgirin*, I, p. 82. Bishamon-ten is the chief of the eight great Yakṣas who are reputed to be his brothers. These 'generals' surround him in the *Taizō-kai Mandara*. They are Manibhadra (Japanese *Hōken*), Pūrṇabhadra (Japanese *Manken*), Pāñcikha (Japanese *Sanshi*; by the name of Jinja Taishō, he is represented in sculpture at the Tōdai-ji in Nara and at the Reihokan of the Kōyasan), Śatagiri (Japanese *Shatagiri*), Haimavata (Japanese *Keimabata*), Viṣākha (Japanese *Bishaka*), Ātavaka (Japanese *Atabaka*), and Pañcāla (Japanese *Hanshara*), whose representations are rare apart from maṇḍalas (Sawa Ryūken, *op. cit.*, pp. 134, 136, fig. 108). Bishamon-ten also had five child acolytes (Kumāra, Japanese *Dōji*) considered as his sons and who serve him as messengers to assist the combatants or to conquer the demons of sickness. They include Nada (Japanese *Nata*), the eldest; Dakśin (Japanese *Dokkon*), the chief of his warriors; Amrita (Japanese *Zennishi* or *Kanro*), represented in sculpture by Tankei at the Sekkai-ji in Kōchi; and Kūbara (Japanese *Jōken* or *Kubara*), according to the versions of the *Sonyōshō* or the *Nashōmondō* (Sawa Ryūken, *op. cit.*, p. 134, and *Hōbōgirin*, I, p. 80). According to another list of the *Hōbōgirin*, these five Dōjis are Yakṣas charged with watching

over his person and have the names Pañcāla (Japanese *Hanjarō* or *Gojō*), Ātavaka (Japanese *Dandara* or *Kōya*), Haimavata (Japanese *Keimatsuda*), Hema (Japanese *Konsen*), and Sūciloma (Japanese *Shuitsuroma* or *Shimmō*) and Daigera or Jōshin. Bishamon-ten is also thought to have had other sons, varying in number according to the texts, including Pāñcika, already mentioned. These acolytes are also collectively called the 'five ministers' (Japanese *Go-Taishi*). They conform to the Indian tradition which made Vaiśravana the chief of the Yakṣas.

25 B. Frank, *Mythologies*, p. 170.
26 If the demon is alone, he is usually named Amanojaku (see n. 14).
27 *Hōbōgirin*, I, p. 77. They are called Godaiji and are attributed to him by various texts, including that of the *Konkōmyō-ō-kyō*.
28 In the *Dai-Hannya-kyō* he is green, and holds a trident with pennant in the right hand, his left hand placed on his hip.
29 His spear is sometimes ornamented with a pennant.
30 *Taishō*, XXI, 219.
31 *Taishō*, XVIII, 923. Sculpture: in wood at the Kawai-dera in Ōsaka, for example. Painting: at the Uesugi-Jinja, Yamagata-ken, (Heian period).
32 The Tamon-ten of the Kaidandō at the Tōdai-ji raises his right arm above his head. The Bishamon-ten at the Hōryū-ji holds a *stūpa* with five towers (perhaps representing Mount Meru).
33 *Hōbōgirin*, I, p. 76.
34 *Hōbōgirin*, I, p. 83, fig. 40.
35 See n. 24.
36 In the *Prajñāpāramitā-sūtra* (illustrated in J. Troup, *op. cit.*, p. 8 and plate II), he is white in colour and holds an arrow in his hand.
37 At the Hōryū-ji in Nara, he is mounted on a demon with a buffalo's or ox's head with a simple aureole behind the head, a staff in the right hand and a spear in the left hand.
38 Painting: in colours on silk, at the Kōfuku-ji in Nara.
39 Sometimes the opposite.
40 R. Tajima, *op. cit.*, p. 131.
41 Both hands may be supported on the spear, of which the heel rests on the ground.
42 Sometimes white, or with a green face.
43 Mainly in painting.
44 B. Frank, *Mythologies*, p. 175.
45 *Taishō*, XX, 137, XXIV, 283, and XXXIX, 580.
46 *Ibid.*

Chapter X
Groups of Deities

1 B. Frank, *Mythologies*, pp. 173–4.
2 Sawa Ryūken, *op. cit.*, p. 166. This list also has variants according to the text.
Paintings: at the Hōfuku-ji in Wakayama; at the Hōnen-ji in Kagawa; at the Daikaku-ji, the Jōfuku-ji, and the Nisin-in in Kyōto; in the Morimura Chizaemon Collection, Tōkyō; painted by Rikyū Tadanobu at the Engen-ji in Shiga.
3 Gozu is sometimes considered as being the Buddhist deification of the Shintō Kami of Izumo, Susanoo.
4 M. Soymié, *Les acolytes de Ti-tsang*, pp. 50–77.
5 M. Soymié, *op. cit.*, p. 56. *Taishō-zu-zō*, V, 540. These are the acolytes of the 'ten kings'.

6

horizon	king	corresponding deity	ceremony (after death of the believer)
west	Shinkō-ō	Fudō Myō-ō	7th day
south	Shokō-ō	Shaka Nyorai	27th day
south-east	Sōtei-ō	Monju Bosatsu	37th day
east	Gokan-ō	Fugen Bosatsu	47th day
north-east	Enma-ō	Jizō Bosatsu	57th day
north	Hensei-ō	Miroku Bosatsu	67th day
north-west	Taizan-ō	Yakushi Nyorai	77th day
south-west	Toshi-ō	Seishi Bosatsu	100th day
west	Byōdō-ō	Kannon Bosatsu	one year later
	Godōtenrin-ō	Amida Nyorai	three years later
	Renjō-ō	Ashuka Nyorai	seven years later
	Bakku-ō	Dainichi Nyorai	13 years later
	Jion-ō	Kokūzō Bosatsu	33 years later

See illustrations opposite. The thirteen 'judges' are sometimes represented together in maṇḍalas. Painting: on silk, Tanaka family (in Sawa Ryūken, *op. cit.*, p. 167). Sculptures: only ten kings at the Ennō-ji in Kamakura (by Kōyu in 1251); at the Kenchō-ji in Kamakura (by Unkei in 1250).

7

		offered to:	
The 1st week	Fudō My-o-ō.	Shō Kannon	for a hundred days;
The 2nd week	Shaka Nyorai.	Seishi Bosatsu	for a year;
The 3rd week	Monju Bosatsu.	Amida Nyorai	for three years;
The 4th week	Fugen Bosatsu.	Ashuku Nyorai	for seven years;
The 5th week	Jizō Bosatsu.	Kokūzū Bosatsu	indefinitely;
The 6th week	Miroku Bosatsu.	Dainichi Nyorai	indefinitely.
The 7th week	Yakushi Nyorai.		

The 49th day is the most important, because it is the day when the body of the deceased is fixed: he leaves the intermediate world (Tibetan *Bar-do*) to enter the world of rebirth. A Buddhist service is conducted on this day to make this 'passage' propitious and to help the deceased to reach paradise. Prayer is then

8 See A. Getty, *op. cit.*
9 According to Hackin, *op. cit.*
10 *Inde Classique*, II, §2269 and 2270.
11 Information communicated to the author by a priest of the Saidai-ji in Nara.
12 R. Tajima, *op. cit.*, p. 129. *Taishō*, XXI, 384.
13 R. Tajima, *op. cit.*, pp. 129–138.

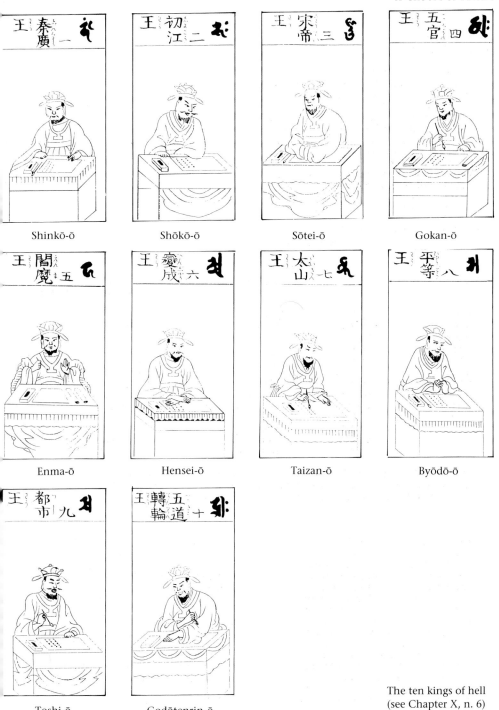

The ten kings of hell
(see Chapter X, n. 6)

14 Sawa Ryūken, *op. cit.*, p. 128.
15 Especially in the *Prajñāpāramitā-sūtra*.
16 *Taishō*, LI, 859, XIX, 379, XVIII, 162 and 34, and XXXIX, 634.
17 *Taishō-zu-zō*, I, 123, 130 and 199.
18 Kindly indicated to the author by Bernard Frank.
19 *Inde Classique*, II, §2270.
20 The elephant with three heads (sometimes with only one, but with six tusks) of Indra, Airāvata. This form appears only with the esoteric doctrines and in India in the *Jātaka*.
21 *Taishō-zu-zō*, I, 123 and 194.
22 Sculpture at the Tōdai-ji, in the Sangatsu-dō, in Nara; the pendant to Bon-ten. We are not aware of another representation of this aspect of Indra after the ninth century, at least in Japan.
23 R. Tajima, *op. cit.*, pp. 311–3.
24 *Ibid.*, p. 312.
25 *Taishō-zu-zō*, I, 14.
26 *Taishō*, XIX, 379.
27 *Taishō-zu-zō*, I, 12.
28 R. Tajima, *op. cit.*, p. 191.
29 *Ibid.*, p. 125.
30 *Taishō-zu-zō*, I, 12.
31 R. Tajima, *op. cit.*, p. 194.
32 *Taishō*, XIX, 379. Sawa Ryūken, *op. cit.*, p. 114, fig. 120.
33 *Taishō*, XVIII, 881, and XIX, 379.
34 R. Tajima, *op. cit.*, p. 195.
35 *Taishō*, XXI, 334. Sawa Ryūken, *op. cit.*, pp. 65, 146, 271.
36 Nakamura Hajime, *op. cit.*, p. 19.
37 He is represented almost exclusively in mandalas, in various ways. In his normal form, red in colour, *cakra* in the right hand, left hand closed. He is seated on a white bull, his body adorned with necklaces made with human bones. Two acolytes may accompany him (*Taishō-zu-zō*, I, 397). He may also hold a trident in the right hand and, in the left hand, a cup made of a human skull. However, the *Jūni Ku Giki* (Chinese *Shi'er Tian Gong Yigui*) describes him as being light blue in colour, with three eyes, fangs and an irritated appearance. He is accompanied by two feminine deities (*Taishō*, XXI, 386, and R. Tajima, *op. cit.*, p. 310). In other texts, his colour is blue-black, the cup held in the left hand is full of the blood of the passions and he is seated on a mat, like a Yogin (especially in the *Hizōku*, *Taishō-zu-zō*, I, 14). In the form of Daijizai-ten, he may assume other aspects, have one head and eight arms, one head and four arms, one head and 18 arms (seated on a red ram), or take a feminine form with a green face, a trident in the right hand and a bowl

of clotted blood in the left hand (*Taishō-zu-zō*, I, 127). His form is not strictly fixed in Japan, and often differs in the mandalas and the texts.
38 Sculpture in dry lacquer, at the Akishino-dera, dated 780. Destroyed by fire, the head was repaired in the ninth century and the body completely rebuilt in the twelfth century by Unkei.
39 *Taishō-zu-zō*, I, 340.
40 *Taishō*, XX, 379, and XXXIX, 635.
41 The solar disc worn by Nitten is sometimes represented with the black image of a crow with three feet at the centre, directly borrowed from Chinese folklore.
42 *Taishō*, XIX, 379.
43 According to information kindly communicated to the author by Bernard Frank.
44 *Taishō*, XIX, 379.
45 The image of this hare, very popular in Japan, originated in China. It is probably of Indian origin: one of the names of Soma (the moon) is in fact Shāshin, 'marked with a hare'. Paintings: at the Tō-ji dated 1191; the *Tenjukoku Mandarza* at the Chūgū-ji in Nara.
46 B. Frank, *Mythologies*, p. 175.
47 Legend related in the *Taiheiki* (chapter 5) *inter alia*.
48 B. Frank, *Mythologies*, p. 175.
49 N. Péri ('the god Wei-t'o'), BEFEO, XVI, no. 3, 1916.
50 See A. Getty, *op. cit.*
51 See B. Frank, *Mythologies*. He is also named Yoshino Shōten in the Sakuramoto-bō, near Nara.
52 B. Frank, *Annuaire EPHE*, 1961–1962, p. 56.
53 See on this subject B. Frank, *Mythologies*, pp. 172–3.
54 B. Frank, *Mythologies*.
55 *Taishō*, XXI, 296–299, and 322–323.
56 B. Frank, *Annuaire EPHE*, n. 2. Sculpture in the Shimoda Museum with joined sexual attributes.
57 *Taishō*, XXI, 306.
58 *Taishō*, XXI, 323.
59 *Taishō*, XXI, 297, 303, and 322–323.
60 In the *Kangi-ten Mandara*, the two bodies face each other, holding the ball of wool before their breasts. Around the principal Kangi-ten his other aspects are placed, especially those with two or six arms (Kamakura period).
61 Another form shows him with three heads with three eyes each and with four arms, holding a radish and a staff in the right hands, and a tray and a sword in the left hands.
62 G. Renondeau, 'Le Shugendō', *Cahiers de*

la *Société asiatique*, XVIII, Paris, 1965.
'Histoire des moines-guerriers du Japon',
*Bibliothèque de l'institut des hautes etudes
chinoises*, vol. XI, Paris, 1957.
63 G. Renondeau, *op. cit.*, p. 47.
64 *Ibid.*
65 *Le Taiheiki*, XXVI, quoted by G.
Renondeau, *op. cit.*, pp. 46, 48.
66 Sawa Ryūken, *op. cit.*, p. 171.
67 *Ibid.*, p. 47, n. 63.
68 *Taishō*, XVIII, 868.
69 Later representations. Sculptures: in
painted wood at the Tōdai-ji in Nara; the
most famous image of these three monkeys
(Sanbiki-zaru) is sculpted in wood and
coloured, at the Tōshōgū of Nikkō
(seventeenth century).

Chapter XI
Divine Beings and Deified Historical Figures

1 However, the deities represented in dry
lacquer at the Kōfuku-ji in Nara are
designated in the texts by different names.
They cannot be identified with certainty.
Gobūjo corresponds to the class of the
Devas, Sakara to that of the Nāgas, Karura
perhaps to that of the Garudas, Kubanda to
that of the Yakṣas, Ashura to that of the

Asuras, Kendatsuba (Kendabba) perhaps to
that of the Gandharvas, Kinnara to that of
the Kimṇaras, and Hibakara to that of the
Mahoragas. They are designated under the
title 'kings', but it is not clearly known
why.
2 Gardens of the Daitoku-ji, for example.
3 *Taishō*, XXI, 459. Sculpture: at the Jōraku-ji
in Shiga (in wood, Kamakura period).
4 These signs, together with those of the
Nijūhachi Shuku, listed below, are
described in the *Hokuto Mandara* at the
Kōzan-ji in Kyōto. They are: 1. Nichiyō
Taiyō (*Āditya*), sun, Sunday. 2. Getsuyō,
Taiin (*Soma*), moon, Monday. 3. Kayō-sei,
Keiwaku-sei (*Angāraka, Pingala*), Mars,
Tuesday. 4. Suiyō, Shinsei (*Budha*),
Mercury, Wednesday. 5. Mokuyō, Seisei
(*Brihaspati*), Jupiter, Thursday. 6. Kinyō,
Taihakusei (*Śukra*), Venus, Friday. 7. Doyō,
Chinsei (*Śanaiścara*), Saturn, Saturday.
8. Ragosei (*Rāhu*), eclipse of the south-
west, spring, head of the ascending dragon
(Nobori-ryū). 9. Keitosei (*Ketu*), eclipse of
the north-east, winter, tail of the
descending dragon (Kudari-ryū). Paintings:
Sei Mandara, on silk, at the Kumota-dera in
Ōsaka; maṇḍala at the Hōryū-ji; *Hokuto
Mandara* at the Kōzan-ji in Kyōto.

5 Planetary and astral correspondences after J. Filliozat, *L'Inde Classique*, II, pp. 729ff. (see
illustrations overleaf).

1.	(Haku)yō-gū	Meṣa	Aries
2.	(Kin)gyū-gū	Vriṣabha	Taurus
3.	(Sō)in-gū	Mithuna	Gemini
4.	(Kyo)kai-gū	Karkataka	Cancer
5.	(Shi)shi-gū	Simha	Leo
6.	(Sho)jo-gū	Kanyā	Virgo
7.	(Ten)bin-gū	Tulā	Libra
8.	(Ma-katsu-gū	Vriścika	Scorpio
9.	(Jin)ba-gū	Dhanus	Sagittarius
10.	Makatsu-gū	Makara	Capricorn
11.	(Hō-byō-gū	Kumbha	Aquarius
12.	(Sō)gyo-gū	Mīna	Pisces

6 The astral deities (Nakṣatra):

In the east:

Bō-shuku	Krittikāh	η^* in Taurus
Shi-shuku	Mrigaśiras	$\lambda*\varphi^1\varphi^2$ in Orion
Sei-shuku	Purnavasū	$\alpha\beta^*$ in Gemini
Ryū-shuku	Āśleṣāh	$\alpha^1*\alpha^2$ in Cancer and $\delta\epsilon\eta\rho\sigma$ in Hydra
Hitsu-shuku	Rohinî	α in Taurus (Aldelbaran) and $\theta\gamma\theta\epsilon*$ in Taurus (the Hyades)
San-shuku	Ārdrā	$\alpha*$ in Orion
Ki-shuku	Puṣya	$\gamma\delta*\theta$ in Cancer

The Jūni-gū: twelve signs of the zodiac (see Chapter XI, n. 5)

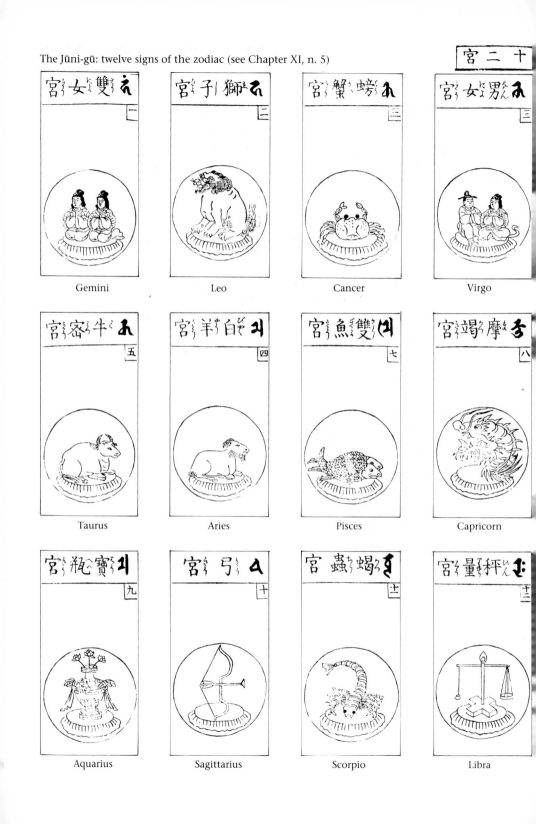

Gemini

Leo

Cancer

Virgo

Taurus

Aries

Pisces

Capricorn

Aquarius

Sagittarius

Scorpio

Libra

In the south:

Sei-shuku	Maghāh	α* in Regulus and ηγξμε in Leo
Kō-shuku	Svātī	α* in Boötes (Arcturus)
Yoku-shuku	Uttaraphalgunī	β* and 93 in Leo
Kaku-shuku	Cītrā	α* in Virgo
Tei-shuku	Viṣākhā	α²*β in Libra
Chō-shuku	Pūrvaphalgunī	δ*θ in Leo
Shin-shuku	Hasta	δγ*εαβ in Crow

In the west:

Bō-shuku	Anurādhā	βδ*π in Scorpio
Bi-shuku	Mūla	ε*–ν in Scorpio
To-shuku	Uttarāṣādhāh	σξ in Sagittarius
Jo-shuku	Abhijit	α* in Vega and εξ in Lyra
Shin-shuku	Jyeṣthā	α* Antarès στ in Scorpio
Ki-shuku	Pūrvaṣadhāh	α*βγ in Aquila

In the north:

Shitsu-shuku	Pūrvabhadrapadāh	α*β in Pegasus
Kei-shukua	Revatī	ξ* in Pisces
I-shuku	Bharanīh	α*βγ in Mosca
Heki-shuku	Uttarabhadrapadāh	γ* in Pegasus and α in Andromeda
Ro-shuku	Aṣvinī	β*ξ in Aries
Ki-shuku	Dhaniṣthāh	αβ*δγ in Delphinus
Kyo-shuku	Śatabhiṣa	λ* in Aquarius

7 Victoria and Albert Museum, London.
8 Both Los Angeles County Museum.
9 A. Getty, *op. cit.*, pp. 175–6, but every
 school has a different version.
10 M. V. de Visser, *The Dragon in China and
 Japan*, Amsterdam, 1913, p. 166.
11 According to R. Tajima. *op. cit.*
12 R. Tajima, *op. cit.*, p. 21.
13 R. Fujishima, *op. cit.*, p. 82.
14 Sawa Ryūken, *op. cit.*, p. 97, fig. 72.
15 At the Ichijō-ji, Shimozato-mura, Harima
 (1.26 m high), the principal right hand
 with a priest's sceptre (Japanese *Nyō-i*), the
 principal left hand holding a small
 reliquary.
16 *Taishō*, XX, 674.

Bibliography

The bibliography concerning Buddhism is immense. That dealing with Buddhist iconography, although sparser, is still considerable. This bibliography refers only to the most general works (the details of many others, chiefly articles, can be found in the notes). Some are readily accessible, whereas others, which are older, are out of print and can only be found in specialized libraries. We nevertheless hope that the titles given here will enable curious readers to delve deeper into the subject, and help them to locate more extensive documentation.

An Aid to the Understanding of Japanese Art, Tokyo National Museum, 1964.

Akiyama, Aisaburō, *Buddhist Hand Symbols*, Yokahama, 1939.

Akiyama, Terukazu, *La Peinture Japonaise*, Skira, Geneva, 1961.
— 'Les rouleaux enluminés (*E-Maki*) du Japon médiéval, *Présence du Bouddhisme*, France–Asie, XVIII, 172, Tokyo, 1962.

Anesaki, Masaharu, *Buddhist Art*, I, Boston, 1915.
— *Buddhist Art in Relation to Buddhist Ideals*, Boston, London, 1916.
— *History of Japanese Religion*, Tokyo, 1963.
— 'Quelques pages de l'histoire religieuse du Japon', *Annales du musée Guimet*, XLIII, Paris, 1921.
— *Religious Life of the Japanese People*, Kokusai Bunka Shinkōkai, Tokyo, 1961.

Art Guide of Nippon: Nara, Mie, Wakayama, The Society of Friends of Eastern Art, Tokyo, 1943.

L'Art Japonais à travers les siècles, Catalogue of the Musée d'Art Moderne, Paris, 1958.

Aston, W. G. *Shintō, The Way of the Gods*, London, 1905.

Auboyer, Jeannine, *Buddha* (photographs by J.-L. Nou), Seuil, Paris, 1982.

— 'Les influences et les réminiscences etrangères au Kondō du Hōryū-ji', *Annales du musée Guimet*, Paris, 1941.
— 'Moudrâ et Hasta, ou le langage par signes', *Oriental Art*, III, London, 1951.
— 'Le trône et son symbolisme dans l'Inde ancienne', *Annales du musée Guimet*, LIV, Paris, 1949.

Bandō, S., Hanayama, et al., *A Bibliography of Japanese Buddhism*, The Cultural Interchange Institute for Buddhists, Tokyo, 1958.

Bareau, André, *Le Bouddha*, Paris, 1962.
— 'Les disciples', *Présence du Bouddhisme*, France–Asie, Saigon, 1959.
— *Recherches sur la biographie du Bouddha*, BEFEO, Paris, 1970 (I) and 1971 (II).
— *Les Religions de l'Inde*: III, *Bouddhisme*, 'Bibliothèque historique, Religions de l'humanité, Payot, Paris, 1966.
— *En suivant Bouddha*, Philippe Lebaud, Paris, 1985.

Bechert, Heinz and Gombrich, Richard, *Le Monde du bouddhisme*, preface by Jeannine Auboyer, Bordas, Paris, 1984.

Beguin, Gilles, 'Bronzes Himalayens', *La Revue du Louvre*, Paris, 1976.
— *Dieux et démons de l'Himâlaya*, Grand Palais, 1977.
— *Tibet, terreur et magie*, Musées royaux d'art et d'histoire, Brussels, 1989.

Bernet-Kempers, A. J., *Ancient Indonesian Art*, Van der Peet, Amsterdam, 1959.
— *The Bronzes of Nālandā and Hindu–Javanese Art*, Brill, Leiden, 1933.

Berthier, François, *Genèse de la sculpture bouddhique japonaise*, POF, Paris, 1979.

Beyer, S., *The Cult of Tara, Magic and Ritual in Tibet*, Berkeley, California, 1973.

Bhattacharya, Benoytosh, *The Indian Buddhist Iconography*, Oxford University Press, 1925 and Mukhopādhyāya, Calcutta, 1968.
— *An Introduction to Buddhist Esoterism*, Oxford University Press, 1932.

Blonay, Godefroy de, *Matériaux pour Servir à l'histoire de la déesse bouddhique Tārā*, Paris, 1895.

Boisselier, Jean, 'A propos d'un bronze cham inédit d'Avalokiteshvara', *Arts asiatiques*, IV, Paris, 1957.
— *Asie du Sud-Est, le Cambodge*, Manuel d'Archéologie d'Extrême-Orient, Picard et Cie, Paris, 1966.

Buchanan, D. C., 'Inari, its Origin, Development and Nature', *Asiatic Society of Japan*, XII, Tokyo, 1935.

Buhot, Jean, *Arts de la Chine*, Paris, 1951.
— *Histoire des arts du Japon des origines à 1350*, Paris, 1949.
— 'La pluralité des bouddhas, les principaux personnages du panthéon bouddhique', *Bulletin de l'association française des amis de l'Orient, le panthéon bouddhique*, Paris.

Bukkyō Daijiten, Grand Dictionnaire du bouddhisme: see Mochizuki, Shinkō and Oda, Tokunō.

Bukkyō Dainenpyō, Grande Chronologie du bouddhisme: see Mochizuki, Shinkō.

Bukkyō no Bijutsu to Rekishi, Histoire illustrée de l'art bouddhique: see Gemmyō, Ono.

Burnouf, Etienne, *Introduction à l'étude du bouddhisme indien*, Paris, 1876.
— *Le Lotus de la Bonne Loi*, translation, Paris, 1852, reprinted Maisonneuve, Paris, 1925.
— *La Science des religions*, Paris, 1885.

Butsuzō Annai, Guide des images bouddhiques: see Ryūken, Sawa.

Butsuzō Ikonōgurafî, Iwanami Shōten, Tokyo, 1952.

Butsuzō-kenkyū-kai, Nishodo Shōten, Tokyo, 1934.

Butsuzō-zu-i, Manuel illustré des divinités bouddhiques, drawings by Ki Tosa no Hidenobu, 5 vols., Kyōto, 1783; reprinted Morie Shōten, 1895.

Butsuzō-zu-ten, Dictionnaire des images bouddhiques: see Ryūken, Sawa.

Bénisti, Mireille, 'Etude sur le *stūpa* dans l'Inde ancienne', *BEFEO*, I, Paris, 1960.

Chamberlain, Basil Hall, *Things Japanese*, Kelly and Walsh, London, 1905.

Charles, Pierre, 'Kannon vêtue de blanc', *Xavierana*, 146, Paris, 1936.

Chavannes, Edouard and Lévi, Sylvain, 'Les seize Arhats protecteurs de la Loi', *Journal asiatique*, Paris, 1916.

Churchward, Albert, *Signs and Symbols of Primordial Man*, London, 1910.

Clark, W. E., *Two Lamaistic Pantheons*, Harvard University Press, 2 vols., 1937.

Claudel, Paul, *Connaissance de l'Est*, Paris, 1907.

Coates, H. and Ryūgaku, Ishizuka, *Hōnen, the Buddhist Saint*, Kyōto, 1925.

Coedès, Georges, 'L'Assistance médicale au Cambodge au XVI^e siècle', *Présence du bouddhisme, France–Asie*, Saigon, 1959.
— 'Bronzes Khmers', *Acta Asiatica*, V, Paris, 1923.

Coomaraswamy, A. K., *Elements of Buddhist Iconography*, Harvard, Cambridge, 1935.
— *History of Indian and Indonesian Art*, London, 1927.
— 'Mahāyāna Buddhist Images of Ceylon and Java', *JRAS*, April 1909.
— *The Origin of the Buddha Image*, New York University Press, New York, 1927.

Dale Saunders, E., *Buddhism in Japan*, Philadelphia, 1964.
— *Mudrā*, Bollinger Series, LVIII, Pantheon, New York, 1960.
— 'Note on Shakti and Dhyāni Buddha', *History of Religions*, University of Chicago, Chicago, 1961.

Demiéville, Paul, 'Sur l'Authenticité de Ta-cheng K'i Sin Louen', *BMFJ*, II-2, Tokyo, 1929.
— 'La Musique chame au Japon', *Etudes asiatiques*, Paris, 1925.
— 'Les Versions chinoises du Milindapaña', *BEFEO*, XXIV, Paris, 1924.

Dictionnaire du bouddhisme, translated R. de Berval, Editions du Rocher, Paris, 1991.

Dictionnaire historique du Japon, Bulletin de la Maison franco–japonaise, Tokyo, 1963–.

Dōgen, *La Vision immédiate*, translated with comments by B. Faure, Le Mail, Paris, 1987.

Doré, P.-H., *Manuel des superstitions chinoises*, Zi-ka-wei, Shanghai, 1926, reprinted with introduction by M. Soymié, Centre de Publication Extrême-Orient, Paris and Hong Kong, 1970.

Dowson, J., *A Classical Dictionary of Hindu Mythology*, Routledge and Kegan Paul, London, 1961.

Eliade, Mircéa, *Aspects du mythe*, Paris, 1963.

Eliot, Sir Charles, *Japanese Buddhism*, Arnold, London, 1935.

Elisséeff, Serge, 'The Bommokyō and the Great Buddha of Tōdai-ji', *HJAS*, 1936.
— 'Mythologie du Japon', *Mythologie asiatique illustrée*, Librairie de France, Paris, 1928.
— 'Notes sur le portrait en Extrême-Orient', *Mélanges linossier*, Leroux, Paris, 1932.

Evans-Wentz, W. Y., *Le Livre tibétain de la grande libération*, Paris, 1960.
— *Tibet's Great Yogi Milarepa*, Oxford, 1928.

Fenellosa, E., *L'Art en Chine et au Japon*, adapted by A. Migeon, Paris, 1913.

Filliozat, Jean and Renou, Louis, *L'Inde Classique*, I, Paris, 1949; II, Paris, 1954.

Finot, Louis, 'Lokeshvara en Indochine', *Etudes asiatiques*, I, Paris, 1925.

Foucher, A., *L'Art gréco-bouddhique du Gandhāra*, 2 vols., Leroux, Paris, 1905, reprinted 1951.
— *Les Débuts de l'art bouddhique*, Leroux, Paris, 1911.
— 'Etude sur l'iconographie bouddhique de l'Inde', *Bibliothèque de l'Ecole des hautes etudes*, XIII, Leroux, Paris, 1900–1905.

— 'La Madone bouddhique, *Monuments et mémoires de l'académie des inscriptions et belles lettres*, XVII, Paris, 1909.

Frank, Bernard, 'Kata-imi and Kata-tagae', *BMFJ*, New Series V, 2–4, Tokyo, 1958.
— *Konjaku Monogatari*, 'Connaissance de l'Orient', *Histoires qui sont maintenance du passé*, Gallimard, Paris, 1968.
— 'Le Panthéon bouddhique au Japon', *Mythologies*, Larousse, Paris, 1963.
— *Le Panthéon bouddhique au Japon, Collections d'Emile Guimet*, Musée Guimet, Paris, 1991.
— 'Textes des rouleaux à peintures des époques de Heian et de Kamakura', *Compte-rendu annuaire EPHE*, Paris, 1961–1962.

Frédéric, Louis, 'Bouquins',*Dictionnaire de la civilisation indienne*, R. Laffont, Paris, 1987.
— *Inde, temples et sculptures*, introduction by J. Naudou, AMG, Paris, 1959.
— *Japon, art et civilisation*, AMG, Paris, 1969.
— *Sud–Est Asiatique, temples et sculptures*, introduction by J. Auboyer, AMG, Paris, 1964.

Fujishima, Ryōon, *Le Bouddhisme japonais*, Maisonneuve, Paris, 1889.
— *Les douze sectes bouddhiques du Japon*, Trismégiste, Paris, 1983.

Gakujun, Tomita, *Himitsu Jirin, Dictionnaire d'esotérisme*, Kaji Sekai Shisha, Tokyo, 1911.

Gemmyō, Onō, *Bukkyō no Bijutsu to Rekishi, Histoire illustrée de l'art bouddhique*, Tokyo, 1937.

Genzu Mandara no Sōjo: see Takata, O.

Getty, Alice, *Ganesha*, The Clarendon Press, Oxford, 1936.
— *The Gods of Northern Buddhism*, The Clarendon Press, Oxford, 1914; reprinted Tuttle, Tokyo, 1962.

Glasenapp, H. de, *Mystères bouddhistes et rites secrets du 'véhicule de diamant'*, Payot, Paris, 1944.

Godard and Fukui, 'La Chine et le Japon', *Religions du monde*, Paris, 1966.

Gonze, Louis, *L'Art japonais*, Paris, 1926.

Gordon, Antoinette K., *The Iconography of Tibetan Lamaism*, Columbia University Press, New York, 1939.

Goris, F., *We Japanese*, Yokohama, 1942.

Granet, Marcel, *La Pensée chinoise*, La Renaissance du Livre, Paris, 1934; reprinted A. Michel, Paris, 1968.
— *La Civilisation chinoise*, La Renaissance du Livre, Paris, 1929; reprinted A. Michel, Paris, 1968.

Great Temples of Nara, Catalogue of Art Treasure of Japan, 25 vols., Tokyo, 1932.

Griffis, W. E., *The Religions of Japan*, New York, 1907.

Griswold, A. B. and Luang, B. B., *Thai Images of the Buddha*, Fine Arts Department, Bangkok, 1962.

Groot, J. J. M. de, 'La Fête de Kouan Yin, déesse de la grâce divine', *Annales du musée Guimet*, II, Paris, 1886.
— *Sectarianism and Religious Persecutions in China*, Amsterdam, 1903.

Grousset, René, 'Histoire de l'Extrême-Orient', *Annales du musée Guimet*, XXXIX and XL, Paris, 1910.

Grünwedel, Albert, *Buddhist Art in India*, Quaritch, London, 1901.
— *Mythologie des Buddhismus*, Brockhaus, Leipzig, 1900.

Guhyasamājatantra, translated by B. Bhattacharya, *Gaekwad Oriental Series*, 53, Baroda, 1931.

Hackin, Joseph, *Guide catalogue du musée Guimet*, Van Oest, Paris, 1923.
— 'Mythologie du lamaïsme', *Mythologie asiatique illustrée*, Paris, 1928.
— 'Les Scènes figurées de la vie du Bouddha d'après les peintures tibétaines', *Mémoires concernant l'Asie Orientale*, II, Paris, 1916.
— *La Sculpture Indienne et tibétaine au musée Guimet*, Leroux, Paris, 1931.

Himitsu Jirin, Dictionnaire d'esotérisme: see Gakujun, Tomita.

Hizōki, Notes sur les divinités du Shingon, attributed to Kūkai or Wenpi, in the *Taishō-zu-zō*, I, Tokyo, n.d.

Hōbōgirin, Dictionnaire encyclopédique du bouddhisme d'après les sources chinoises et japonaises, under the direction of S. Lévi, J. Takakusu and P. Demiéville, Maison Franco–Japonaise, Tokyo, 1929–.

Hokusai Sketchbook (Manga): see J. A. Michener.

Iso, Mutsu, *Kamakura, Facts and Legends*, Tokyo, 1929.

Itō, Lucy S., 'Japanese Confraternities', *Monumenta Japonica*, VIII, Tokyo, 1952.

Jisl, V. L. and Vanish, J., *L'Art tibétain*, Artia, Prague, 1958.

Ken, Hisano, *Nihon no Chōkoku, Sculptures du Japon*, Bijutsu Shuppan-sha, Tokyo, 4 vols., 1943.

Kern, H., *Manual of Indian Buddhism*, Strasburg, 1896.

Kirfel, W., *Symbolik des Buddhismus*, Stuttgart, 1959.

Koboku, Ōta and Toshihiro, Awatani, *Nihon no Hotoke Sama, Bouddhas du Japon*, Tokyo, n.d.

Kuang, Lin-Li, 'L'Aide-mémoire de la Vraie Loi', introduction by P. Demiéville, *Annales du musée Guimet*, LIV, Paris, 1949.

Kubota, Kanroku, *Masterpieces Selected from the Fine Arts of the Far East*, 15 vols., Tokyo, 1913.

Lalitavistara, translated by E. Foucaux, *Annales du musée Guimet*, VI and XIX, Paris, 1884–1892.

Lalou, Marcelle, 'Le Dieu bouddhique de la fortune', *Artibus Asiae*, Ascona, 1946.
— *Iconographie des etoffes peintes dans le Mañjushrīmūlakalpa*, Paris, 1930.
— *Les Religions du Tibet*, PUF, Paris, 1957.

Lamotte, Etienne, 'L'Enseignement de Vimalakīrti', *Mélanges chinois et bouddhiques*, Brussels, n.d.
— *Histoire du bouddhisme indien des origines à l'ere Saka*, Publications Orientalistes, Louvain, 1958; reprinted 1976.
— 'Mañjushrī', *T'oung-pao*, XLVIII, 1–3, Leiden.
— *Le Traité de la grande vertu de la sagesse de Nāgārjuna, Mahāprajñāpāramitāshastra*, Louvain, 5 vols., 1944–1980.

Lane-Suzuki, Bernard, 'Fudō the Immovable', *The Eastern Buddhist*, II, Ōtani University, Kyoto, 1922.

Lauf, D. I., *Das Bild als Symbol im Tantrismus*, Munich, 1973.

Lee, Sherman E., *Far Eastern Art*, Abrams, New York, 1964.

Leroy-Davidson, D., *The Lotus Sūtra in Chinese Art*, New Haven, 1954.

Lévi, Sylvain, 'Matériaux japonais pour l'histoire du bouddhisme', *BMFJ*, Tokyo, 1927.

Liebert, Göfta, *Iconographic Dictionary of the Indian Religions: Hinduism, Buddhism, Jainism*, Leiden, 1976; 2nd edn., Sri Satguru, Delhi, 1986.

Linossier, Raymonde, 'Iconographie de la descente d'Amida', *Mélanges d'orientalisme*, Musée Guimet, Leroux, Paris, 1932.

Lloyd, Arthur, *Creed of Half-Japan*, Smith Elder, London, 1911.
— *The Praises of Amida*, Tokyo, 1908.

Lubac, H. de, *Amida*, Seuil, Paris, 1955.

MacCune, Evelyn, *The Arts of Korea*, Tuttle, Tokyo, 1962.

Malasekhara, G. M. et al., *Encyclopaedia of Buddhism*, Colombo, 1961–1979.

Mallmann, Marie-Thérèse de, 'Les Enseignements iconographiques de l'Agni-purāna', *Annales du musée Guimet*, Paris.
— 'Introduction à l'étude d'Avalokiteshvara', *Annales du musée Guimet*, LVII, PUF, Paris, 1967.
— *Introduction à l'iconographie du bouddhisme tântrique*, Paris, 1975.

Maspéro, Henri, *La Chine antique*, Paris, 1916.
— and Péri, Noël, 'Le Monastère de la Kan (ou Kuan)-Yin qui ne veut pas s'en aller', *BEFEO*, IX, pp. 797–807.

Matsunaga, Alicia, *The Buddhist Philosophy of Assimilation*, Tokyo, 1969.

Michener, J. A., *The Hokusai Sketchbook (Manga)*, Tuttle, Tokyo, 1958.

Migeon, Gaston, *Promenades aux sanctuaries de l'art*, Paris, 1926.

Mochizuki, Shinkō, *Bukkyō Dainenpyō, Grande Chronologie du bouddhisme*, Tokyo, 1909.
— and Oda, Tokunō,*Bukkyō Daijiten, Grand Dictionnaire du bouddhisme*, Tokyo, 1932–1936, reprinted 1954.

Mock, Joya, *Things Japanese*, Tokyo News Service, Tokyo, 1964.

Moran, Sherwood F., 'The Blue Fudō, a Painting of the Fujiwara Period', *Arts asiatiques*, II, Paris, 1935.

Mus, Paul, 'Bārābudur, les origines du *stūpa* et la transmigration, essai d'archéologie religieuse comparée', *BEFEO*, XXXII, 1932; reprinted Arma Artis, Paris, 1990.
— 'Le Bouddha paré', *BEFEO*, XXVIII, 1–2, Hanoi, 1928.

Müller, M., 'The Larger Sukhāvatīvyūha and the Smaller Sukhāvatīvyūha', *Mahāyāna Texts*, II, SBE, London, 1894.

Nakamura, Hajime, *Shin Bukkyō Ji-ten*, Seishin-Shobō, Tokyo, 1962.

Nanjō, Bunyu, *A Short History of the Twelve Japanese Buddhist Sects*, Maruzen, Tokyo, 1886.

Nihon no Chōkoku, Sculptures du Japon: see Ken, Hisano.

Nihon no Hotoke Sama, Bouddhas du Japon: see Koboku, Ōta and Toshihiro, Awatani.

Nihon no Setsuwa-e, Légendes illustrées du Japon, Benridō, Tokyo, 1961.

Nitschke, 'Kyōto, un urbanisme ésotérique', *Est–Orient*, I-1, Tokyo, 1967.

Okada, Amina and Nou, Jean-Louis, *Ajantā*, Imprimerie Nationale, Paris, 1991.

Oldenberg, H., *Vinayapitaka*, London, 5 vols., 1879–1885.

Ōoka, Minoru and Mori, Osamu, 'History of Japanese Architecture and Gardens', *Pageant of Japanese Art*, Tōto Shuppan-sha, Tokyo, 1957.

Pageant of Japanese Art, National Museum, Tokyo, Tōto Shuppan-sha, Tokyo, 6 vols., 1952–.

Paine, Robert Treat and Soper, Alexandre, *The Art and Architecture of Japan*, Pelican Books, London, 1955.

Panigrahi, K. C., 'Bhauma Art and Architecture in Orisa', *Arts asiatiques*, IV, Musée Guimet, Paris, 1957.

Pelliot, Paul, 'Bhaishajyaguru', *BEFEO*, III-1, Paris, 1903.
— *Les Grottes de Touen Houang*, Geuthner, Paris, 6 vols., 1920–1924.

Péri, Noël, 'Le Dieu Wei-t'o', *BEFEO*, XVI-3, Paris, 1916.
— 'Hārītī, la mère des démons', *BEFEO*, XVII, Paris, 1917.

Petrucci, R., 'Les Peintures bouddhiques de Touen-Houang (Mission Aurel Stein)', *Annales du musée Guimet*, XLI, Paris, 1914.

Présence du bouddhisme, collective work under the direction of R. de Berval, *France–Asie*, pp. 153–157, Saigon, 1959; reprinted Paris, 1989.

Przyluski, J., 'From the Great Goddess to Mahākāla', *The Indian Historical Quarterly*, XIV, New Delhi, 1938.
— 'Mudrā', *Indian Culture*, Calcutta, April 1936.
— 'Les Vidyārāja', *BEFEO*, XXIII, Paris, 1923.
— and Lalou, L., *La Bibliographie bouddhique*, Geuthner, Paris, 1930–1933; Maisonneuve, Paris, 1934–1967.

Reischauer, A. K., *Studies in Japanese Buddhism*, New York, 1917.

Renondeau, Georges, 'Le Bouddhisme au Japon', *Présence du bouddhisme, op. cit.*
— 'Le Bouddhisme dans les Nō', *BMFJ*, Tokyo, 1950.
— *Le Bouddhisme japonais, textes fondamentaux*, A. Michel, Paris, 1965.

Renou, Louis, and Filliozat, Jeanet et al., *L'Inde Classique, manuel des etudes indiennes*, Hanoi, 2 vols., 1947; Paris, 1953.

Rowland, Benjamin, *The Art and Architecture of India: Buddhist, Hindu, Jain*, Penguin, London, 1953.

Ryūken, Sawa, *Butsuzō Annai, Guide des images bouddhiques*, Yoshikawa Kōbunkan, Tokyo, 1962.
— *Butsuzō-zu-ten, Dictionnaire des images bouddhiques*, Yoshikawa Kōbunkan, Tokyo, 1961.

Saddharmapundarīka-sūtra, Le Lotus de la Vraie Loi, edited by N. Dutt, *Bibliotheca Indica*, p. 276, Calcutta, reprinted 1952; translated by E. Burnouf, Maisonneuve, Paris, 1925.

Sagara, Tokuzō, *Japanese Fine Arts*, JTB, Tokyo, 1960.

Sansom, G. B., *A Short Cultural History of Japan*, Appleton Century, New York, 1943.

Shima, Keeiryū, *A Bibliography on Japanese Buddhism*, Cultural Interchange Institute for Buddhists, Tokyo, 1958.

Sirén, Oswald, *Histoire de la peinture chinoise*, Van Oest, Paris, 2 vols., 1925–1934.

Snellgrove, D. L., *The Image of the Buddha*, London, 1978.
— *The Nine Ways of Bon*, London, 1967.

Soothill, William Edward and Hodous, Lewis, *A Dictionary of Chinese Buddhist Terms*, Kegan Paul, London, 1937.

Soper, A. C., 'Literary Evidence for Early Buddhist Art in China', *Artibus Asiae*, Ascona, 1959.

Soymié, Michel, 'Les Acolytes de Titsang', *Arts asiatiques*, XIV, Paris, 1966.

Stein, Aurel M., *Ruins of Desert Cathay*, London, 1912.
— *Serindia*, London, 1921.

Stein, Rolf A., *La Civilisation tibétaine*, Dunod, Paris, 1962; reprinted Asiathèque, Paris, 1981.
— *Le Monde en petit, jardins en miniature et habitations dans la pensée religieuse d'Extrême-Orient*, Flammarion, Paris, 1987.

Steinilber-Oberlin, *Les Sectes bouddhiques japonaises*, Crès, Paris, 1930.

Stern, Philippe and Bénisti, Mireille, *Evolution du style indien d'Amarāvatī*, Publications Musée Guimet, PUF, Paris, 1961.

Taishō Issai-kyō, Buddhist texts, the *Tripitaka*, published under the direction of Takakusu, Junjirō and Watanabe, Kaigyoku, Tokyo, 100 vols., including 12 of illustrations, 1924–1932.
— *Taishō Shinshū Daizōkyō (Zuzōbu)*, new editon of the whole of the *sūtra*, Daizō Shuppan-sha Kankōkai, Tokyo, 88 vols., including 12 of illustrations, 1932–1934.

Tajima, Ryūjin, 'Bhaishajyaguru au Japon', *BMFJ*, New Series, VI, Tokyo, 1959.
— 'Les deux grands mandalas et la doctrine de la secte Shingon', *BMFJ*, New Series, VI, Tokyo, 1959.
— *Étude sur le Mahāvairochana-sūtra (Dainichi-kyō)*, Maisonneuve, Paris, 1936.

Takakusu, Junjirō, 'Amitāyurdhyānasūtra', *SBE*, London.

Takata, O., *Genzu Mandara no Sōjo, le Tōji et la transmission des mandalas traditionnels*, Bukkyō Geijutsu 24, Ōsaka.

Takeshi, Kuno and Takashi, Inoue, 'Study of the Yakushi Triad in the Kondō, Yakushi-ji', *Acta Asiatica*, I, Tōhō Gakkai, Tokyo, 1960.

Toki, H., 'Shi-do-in-dzou', *Annales du musée Guimet*, VIII, Paris, 1899.

Tressan, Capitaine de, 'Les Influences etrangères sur la formation de l'art japonais', *Annales du musée Guimet*, XL, Paris, 1913.

Trésors d'Art Coréen, catalogue of the Musée Cernuschi, Paris, 1961–1962.

Troup, J., 'Illustrations of Buddhism from Japanese Pictures', *Transaction of the Asiatic Society of London*, XII, London, 1914.

Tsunoda, Ryūsaku, *Sources of the Japanese Tradition*, Columbia University, New York, 1958.

Tucci, Giuseppe, *Il Giappone Tradizione Storica e Tradizione Artistica*, Milan, 1943.
— 'A Propos d'Avalokiteshvara', *Mélanges chinois et bouddhiques*, IX, Brussels, 1951.
— *Théorie et Pratique du Mandala*, translated by H. J. Maxwell, Fayard, Paris, 1974.
— *Tibetan Painted Scrolls*, Rome, 3 vols., 1979; reprinted Kyoto, 1980.

Vandier-Nicolas, N., *Bannières et peintures de Touen-huang*, Paris, 1974.

Van Gulik, Robert H., *Hayagrīva, The Mantrayānic Aspect of the Horse Cult in China and Japan*, Leiden, 1935.

Visser, M. V. de, 'The Arhats in China and Japan', *Ostasiatische Zeitschrift*, X, Leipzig, 1919.
— 'The Bodhisattva Åkāshagarbha (Kokū-zō) in China and Japan', *Uitgave van de Koninklijke Akademie van Wetenschappen to Amsterdam*, Amsterdam, 1951.
— *The Dragon in China and Japan*, Amsterdam, 1913.

— 'A Japanese Painting of the Death of the Buddha in the Museum of Asiatic Art, Amsterdam', *Artibus Asiae*, X, Ascona.
— 'Die Pfauenkönigin (Kujaku Myō-ō) im China und Japan', *Festschrift für Friedrich Hirth, Ostasiatische Zeitschrift*, Leipzig, 1920.

Vogel, J.-P., *Buddhist Art in India, Ceylon and Java*, Oxford, 1936.

Waddell, L. A., *The Buddhism of Tibet or Lamaism*, London, 1895; reprinted Heritage, New Delhi, 1974.
— 'Evolution of the Buddhist Cult, its Gods, Images and Art', *The Imperial and Asiatic Quarterly Review*, London, 1912.

Waley, Arthur, 'Avalokiteshvara et la légende de Miao Shan', *Artibus Asiae*, XI, Ascona, 1925.

Weber, H., *Kojihōten*, Paris, 1923.

Werner, E. T. C., *A Dictionary of Chinese Mythology*, Julian Press, New York, 1961.

Willets, William, *Chinese Arts*, Penguin, Harmondsworth, 2 vols., 1958.

Woodroffe, Sir John, *Shakti and Shākta*, Ganesh, Madras, 1929; reprinted 1959.

Zimmer, Heinrich, *The Art of Indian Asia*, Bollinger Series, XXXIX, Pantheon, New York, 2 vols., 1955.
— 'Der Name Avalokiteshvara', *Zeitschrift für Indologie und Iranistiki*, Deutsche Morgenländische Gesellschaft, I-1, Berlin, 1926.
— *Mythes et symboles de l'Inde*, Payot, Paris, 1951.

Zōzō Meiki, Catalogue des sculptures bouddhiques, Kōkogakkai, Tokyo, 1926.

Zuroku Nihon Bijutsu, L'Art Japonais illustré, Kadokawa Shōten, Tokyo, 1964.

Zusetsu Nihon Bijutsu Shi, L'Histoire illustrée de l'art japonais, Yukata Tezawa and Minoru Ōoka, Tokyo, 2 vols., 1956.

Zuzō Daishūsei, Images bouddhiques illustrées, Bukkyō Tosho Kankōkai, Tokyo, 1932.

Index

The Sanskrit ṣ and ś
are indexed as 'sh'.
Italics indicate
illustrations; Roman
numerals refer to
colour plates.

28 Bushū 169–71
'1,000 Buddhas' 116
1,000 eyes 164

A
Abhaya mudrā 40–41,
 IV
Abhiṣeka mudrā 50
aborted babies *see*
 stillborn babies 190
absence of fear 41
Acala-Vajrapāṇi 204
Acalanātha 51, 57,
 203–8
Acalāsana 57
accessories 62–76
accomplishment of
 the Way 90–91
Ādi Buddha *35*, 129,
 146–48, 150, *II*
Āditya 266
Agni 261
Agni Purāna 34
Aizen Myō-ō 213,
 XXIII
Ajantā 22, 24, 43, 60,
 81, 177
Ajita 105
Ākāśagarbha 183–85
Akṣayamati 116
Akṣobhya *27*, 44, 112,
 125, **132–34**, 208,
 XIV
Ālīḍha 57–58
amacha 88
Amadai Kannon 161
Amarāvatī 22, 24, 81

Amaterasu Omikami
 113
Amida *39*, 46, 78,
 125, *318, 319, 320*,
 XVIII; *and see*
 Amitabha; the Pure
 Land of Amida
Amitābha 44, 45, 69,
 78, 125, **134–45**,
 173
*Amitāyurdhyāna-
 sūtra* 143
Amitāyus 135
Amoghapāśa 155
Amoghasiddhi 125,
 145–46
Amoghavajra 241
Amṛta 135
An-i-in 42
Ānanda **97**, 284
Anchi-in 44
Aṇḍīra 114
Angaja 104
Angkor *25, 59*, 154,
 256, 280
Angkor-thom 177,
 178
Ango-in 84
aniconism 80
Anila 114
animal guardians
 249–50
animal stands 60
Aniruddha 99
Añjali mudrā 48
Anoku Kannon 161
Anokuta Dōji 206
Anzan-in 44
appeasement of the
 senses 41
Apsarās *27, 57*,
 269–70
Arahants 95, 96,
 100–7
Arakan Buddha *26, XI*
Ardhapadmāsana 55
Ardhaparyaṅka 57

Ārūpadhātu (world
 without form) 36,
 152, 198
Āryajañgulī 227
Āryāvalokiteśvara
 153, 267
āsana (postures) 52-58
Asanga 121, 128, 180
asceticism 15, 89
Aśoka 17, *20*, 22, 65,
 124
Ashuka Nyorai 132
Ashura 280
Ashura-ō 170
Aśvaghoṣa 284, 285
astral deities 282
Asuka period 30, 50
Asuras 170, 262, 280
Ātāvaka 215
Ātman 16
aureoles 24, 28, 29,
 60–62
Avalokiteśvara 26, 42,
 53, 62, 67, 70, 116,
 153–80, 220, 274,
 XXI; with 1,000
 arms 164; with
 eleven heads 163
Avataṃsaka-sūtra 151
Awakening (bodhi)
 38, 44, 46, 90,
 150–3, 192
axes 67
Ayuthyā, Thailand *IV*,
 XVI

B
Bāgh 24
Baku-in 52
Banteay Chhmar 177
Barong 249
Basu Sennin 170
Batō Kannon 173
Batō Myō-ō 218
Batō-in 51
Beg-Tse 236
beggar's staff 69

begging bowl 70
Begrām 24
bells 65, 74
Benzai-ten 221, 279,
 337
'bestowers of
 children' *see*
 child-giving deities
Bhadra 102
Bhadrāsana 52-53
Bhaiṣajya-samudgata
 116
Bhaiṣajyaguru 45,
 109–16, 130, 157
Bhaiṣajyarāja 116
Bhārhut *87*
Bhṛkuṭī 155, 175
Bhūmisparśa mudrā
 44
Bhūtan *27, 283, XIV*,
 XXXII
bīja 10, 75
Bikuchi Kannon
 Bosatsu 175
Binayaka 267
Birubakusha-ten 247
Birubakusha Tennō
 170
Birurokusha Tennō
 170
Birurokusha-ten 246
Birushana 127
Bishamon Tennō 170
Bishamon-ten 242
bōdhati 15
Bodh-Gayā temple *18*
bodhi *see* Awakening
Bodhidharma 95,
 107–9
Bodhisattvas
 150–200; of
 medicine 198–99
Bofo 249
bön-po 19, 27, 283
Bon-ten 265, *XXIX*
book of scriptures 72

353

St. Louis Community College
at Meramec
Library